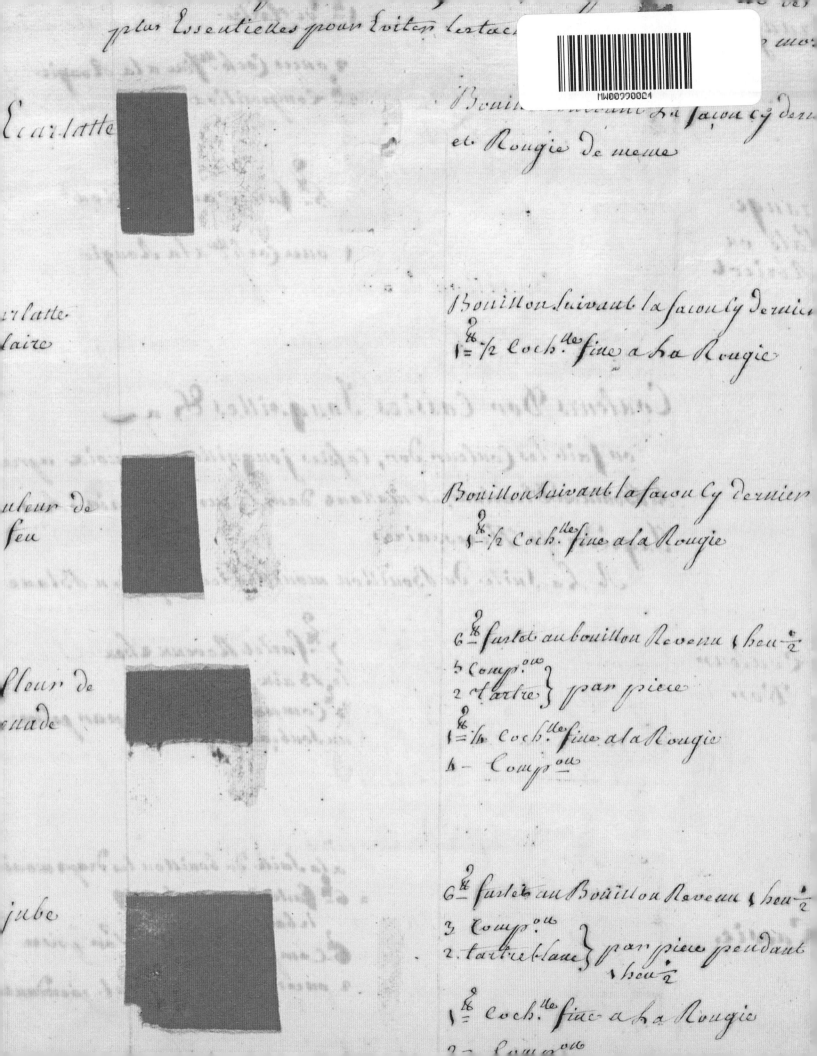

plus Essentielles pour Eviter le tache...

Écarlatte

Bouillon suivant la façon cy dessus
et Rougie de même

...rlatte
...aire

Bouillon suivant la façon cy derrier
1 = ½ Coch.le fine a La Rougie

...uleur de
feu

Bouillon suivant la façon cy derrier
1 = ½ Coch.le fine a la Rougie

...leur de
...nade

6 = furtes au bouillon Revenu ½ heu
5 Comp.on
2 tartre } par pieu
1 = ½ Coch.le fine a la Rougie
4 — Comp.on

jube

6 — furtes au Bouillon Revenu ½ heu
3 Comp.on
2 tartre blanc } par pieu pendant
½ heu
1 = ½ Coch.le fine a La Rougie
2 — Comp.on

A Red

LIKE NO OTHER

HOW COCHINEAL COLORED THE WORLD

an epic story of art, culture, science, and trade

edited by

CARMELLA PADILLA & BARBARA ANDERSON

principal photography by BLAIR CLARK

Skira *RIZZOLI* NEW YORK MUSEUM OF INTERNATIONAL **Folk Art**

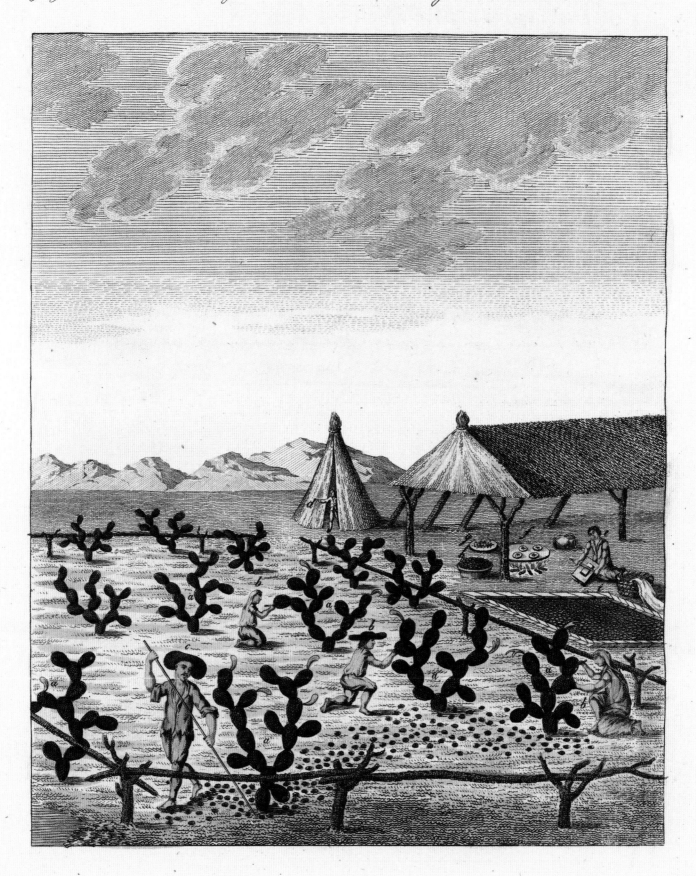

To most Europeans cochineal seemed a gift of nature, a perfect commodity that God had intended them to possess and use to their own advantage. It never crossed their minds that the dyestuff might actually be a cultural legacy—the result of the ancient Mexicans' long and successful effort to cultivate a strain of cochineal that would produce a perfect red.

—AMY BUTLER GREENFIELD
A Perfect Red: Empire, Espionage, and the Quest for the Color of Desire

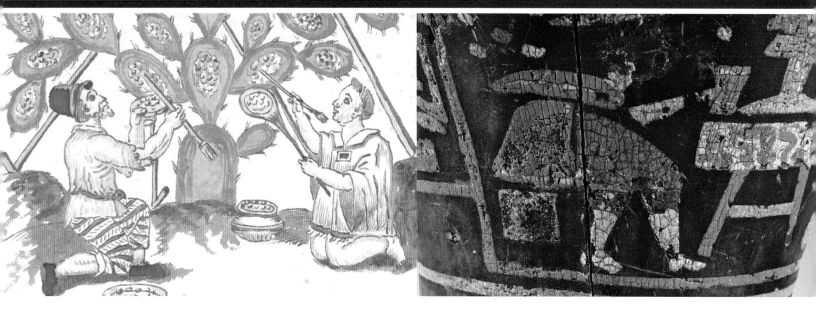

■ *indicates item is included in exhibition*

PART 4

RED THREADS
COCHINEAL IN TEXTILES

PART 5

A PRIZED PIGMENT
COCHINEAL IN EUROPEAN ART

PART 6

RETURN TO THE AMERICAS
COCHINEAL IN THE COLONIAL HISPANO AMERICAS

PART 7

A RED REVIVAL
COCHINEAL IN THE MODERN WORLD

■ *indicates item is included in exhibition*

A NOTE FROM THE DIRECTOR

MARSHA C. BOL
DIRECTOR, MUSEUM OF INTERNATIONAL FOLK ART
SANTA FE, NEW MEXICO

IDEAS FOR EXHIBITIONS COME from all sorts of sources, likely and unlikely. *The Red That Colored the World*, the exhibition that inspired this book, sprang from an especially fortuitous circumstance. When the movie *Crazy Heart* was being filmed in Santa Fe in 2008, actor and producer Robert Duvall and his wife, Luciana Pedraza Duvall, hosted a cast and crew party at the New Mexico Museum of Art, where I was then director. As a thank-you gift, Luciana gave me a special book, *A Perfect Red: Empire, Espionage, and the Quest for the Color of Desire* by Amy Butler Greenfield. Its subject is the tiny cochineal insect, one of the best red colorants in the world. As I read the book on a flight to Spain, once the global center of cochineal trade, I considered how the story of this bug, with its historic intersections in global arts and cultures, would make a wonderful exhibition topic.

Thus began a long journey, beginning with my move in 2009 to the Museum of International Folk Art. Many fine folk art objects in the museum's collections were dyed or painted with carmine, the dyestuff produced by the cochineal bug. Next I assembled a project team with the expertise and courage to take on the planning of an exhibition of global magnitude. Barbara Anderson, a historian of Hispanic art, read Greenfield's book and signed on as the lead guest curator and this book's coeditor. We added Carmella Padilla, an award-winning New Mexico author and editor, as lead book editor and guest cocurator. Nicolasa Chávez, the museum's curator of Latino/Hispano/Spanish colonial collections, was tapped as in-house curator. Donna Pierce, head of the New World Department at the Denver Art Museum, became our primary exhibition and publication consultant in the early years of exhibition development. Elena Phipps, a scholar of Andean textiles and a retired senior conservator from the Metropolitan Museum of Art, who undertook some of the earliest cochineal research, offered her specialized knowledge.

In 2010, with funding from the Terra Foundation for American Art, the museum convened experts in the history and use of cochineal. An unforeseen issue emerged at the convening:

while important historical documents described the use of cochineal, only a small number of objects were known to conclusively contain the red dye source. Only a handful of institutions had analyzed the organic reds in a select few objects by the time of our project. The curatorial team realized that our conservation department would need to undertake its own program of analysis. With the promise of contributing new scientific knowledge to the field, an already ambitious project grew bigger.

Every object considered for *The Red That Colored the World* that was not already known to have been made with cochineal required testing. Mark MacKenzie, director and chief conservator of the New Mexico Department of Cultural Affairs Conservation Department, enlisted conservation scientists Marco Leona of the Metropolitan Museum of Art, Richard Newman and Michele Derrick of the Museum of Fine Arts, Boston, and David Wenger of Philadelphia to instruct him in high-performance liquid chromatography, a specialized process in which relatively few museum scientists are trained. Scientific colleagues Marisa Gómez of Madrid's Instituto del Patrimonio Cultural de España and Estrella Sanz Rodríguez collaborated by analyzing historic Spanish works of art. In the end, hundreds of objects were tested to assemble the exhibition's impressive display of works that illustrate the wide-ranging global application of cochineal.

Meanwhile, the curatorial team assembled an impressive crew of international scholars in the Americas, Europe, and Asia whose investigations encompass cochineal in art history, science, economics, cultural history, and more. Many of their voices are included in this publication. Finally, a major exhibition implementation grant from the National Endowment for the Humanities, as well as publishing support by Skira Rizzoli of New York and the International Folk Art Foundation, allowed the museum to bring this ambitious and far-reaching exhibition and publication to the attention of an international audience. 🖋

Opposite "The nopal plant that is grown in America and produces grana," from *Reports on the History, Organization, and Status of Various Catholic Dioceses of New Spain and Peru*, 1620–1649, folio 85, Ayer Ms. 1106 D8, box 1, folder 15, Newberry Library, Chicago.

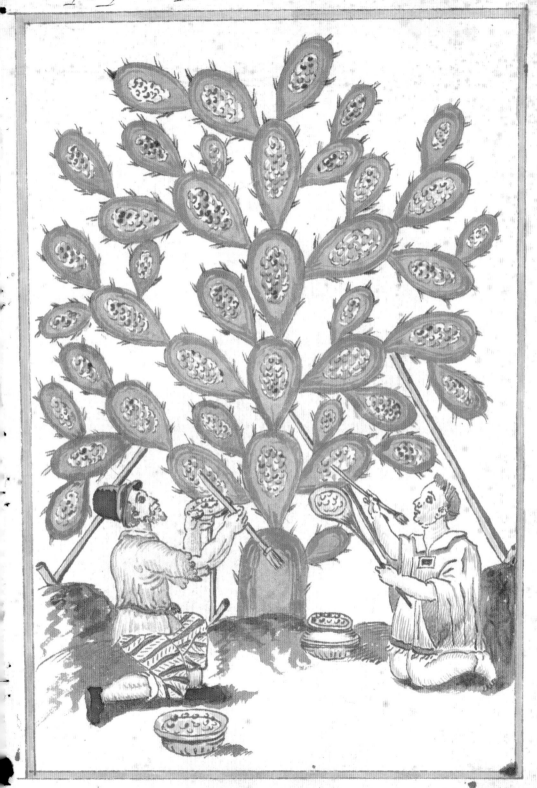

Acknowledgments

THE LEAP BETWEEN INSPIRATION AND IMPLEMENTATION OF A PROJECT of this scope is usually a leap of faith. This book, and the exhibition that inspired it, are no exceptions. We are indebted to many individuals and organizations in Santa Fe and around the globe for their support of our efforts to explore the story and scholarship surrounding the history and use in art of American cochineal.

MAJOR SUPPORT

For major support of the exhibition *The Red That Colored the World* and/or this publication, we are deeply grateful to the following public and private donors and lenders:

National Endowment for the Humanities
International Folk Art Foundation
Museum of New Mexico Foundation
Hotel Santa Fe The Hacienda and Spa
Newman's Own Foundation
Folk Art Committee/Friends of Folk Art
New Mexico Department of Cultural Affairs
New Mexico Department of Tourism
Terra Foundation for American Art

Catherine Allen and Paul Rooker
Elizabeth and James Alley
Charmay Allred
Ann Griffith Ash
JoAnn and Bob Balzer
Joan and Robert Benedetti
Nancy and Richard Bloch
Dorothy Bracey and Tom Johnson
Jean and George Callaghan
Carl and Marilynn Thoma Foundation
Mr. and Mrs. Thomas B. Catron III
Bruce Chemel
Liz Crews
Charlene DeJori
Judy and Ray Dewey
Ruth Dillingham
Rosalind and Lowell Doherty
George Duncan and Sherry Kelsey
Sheila and Kirk Ellis
Nancy and Haines Gaffner
Jane and Charlie Gaillard
Pat and Jim Hall
Nicole Hixon

Gloria S. Holloway
Barbara and Bud Hoover
Connie Thrasher Jaquith
Mary Anne and Bruce Larsen
Hank Lee and Paul Bonin-Rodriguez
Barbara Lenssen and Keith Anderson
Ann and Mark Livingston
Nance and Ramón José López
Doris Mann
Ashley and Paul Margetson
Dee Ann McIntyre
Helene Singer Merrin
Susan J. Mertes
Sandy Meseck
Doris Meyer and Richard Hertz
Edwina and Charles Milner
Marisol Navas Sacasa
Mark Naylor and Dale Gunn
Bob Nurock
Sandy and Russ Osterman
Cindi and Michael Pettit
Collins and Jon Redman
Marianne Reuter
Mara and Charles Robinson
Mary Sanger
Jacqueline and Richard Schmeal
Mr. James R. Seitz Jr.
Judy and Bob Sherman
Abe and Marian Silver
Carole and J. Edd Stepp
Suzanne and Joel Sugg
Courtney and Scott Taylor
Thornburg Investment Management
Alyce and Doc Weaver
Eileen A. Wells
William Siegal Gallery
Beverly and John Young

LENDERS TO THE EXHIBITION

Albuquerque Museum
Asociación Milana, Mala (Haria), Lanzarote, Canary Islands
Beinecke Rare Book and Manuscript Library, Yale University, New Haven
Biblioteca Medicea Laurenziana, Florence
Chiaroscuro Contemporary Art, Santa Fe
Denver Art Museum
Enesimapotencia, Consultoría y Producción Cultural, Madrid
Heard Museum, Phoenix
J. Paul Getty Museum, Los Angeles
Library of Congress, Washington, D.C.
Metropolitan Museum of Art, New York
Missouri History Museum, St. Louis
Museo de América, Madrid
Museo del Greco, Toledo
Museo del Traje, Madrid
Museo Franz Mayer, Mexico City
Museum of Indian Arts and Culture, Santa Fe
Museum of Spanish Colonial Art, Santa Fe
National Army Museum, London
Nettie Lee Benson Latin American Library, University of Texas, Austin
New Mexico History Museum, Santa Fe
New-York Historical Society, New York
The Owings Gallery, Santa Fe
Ralph T. Coe Foundation for the Arts, Santa Fe
Victoria and Albert Museum, London

Walter Anderson, Santa Fe
Conde de Tepa, Madrid
Orlando Dugi, Santa Fe
Martha Egan, Santa Fe
Alan Kennedy, Santa Monica
Ramón José López, Santa Fe
Hitomi Miyakoshi, Kanazawa, Japan
Carl and Marilynn Thoma, Santa Fe/Chicago
John C. Weber, New York

ADVICE AND EXPERTISE

In addition to the contributors whose work is featured on the following pages, we offer heartfelt thanks to the international team of scholars, scientists, professionals, and friends who provided advice, assistance, and expertise, and devoted labor in various areas of the exhibition and this publication:

Ann Hedlund: Arizona State Museum, University of Arizona–Tucson; Juan Cazorla, Cristina Masoc, Sebastiana Perera Brito: Asociación Milana, Lanzarote, Canary Islands; Michele Derrick, Richard Newman: Museum of Fine Arts, Boston; Victoria Gerard, Peter C. Keller: Bowers Museum, Santa Ana, California; John Addison: Chiaroscuro Contemporary Art, Santa Fe; Jana Gottshalk, Gina Lauren, Cindy Lawrence, Courtney Murray, Donna Pierce, James Squires, Julie Wilson: Denver Art Museum; Carlos Marichal: El Colegio de México, Mexico City; Daniel Goodman, Christine Mather: El Rancho de las Golondrinas, La Cienega, New Mexico; April Jouse, Olimpia Newman: Española Valley Fiber Arts Center, Española, New Mexico; Marisa Gómez, Estrella Sanz Rodríguez: Instituto del Patrimonio Cultural de España, Madrid; Sarah Manges, Laura Sullivan, Ernesto Torres: International Folk Art Alliance, Santa Fe; Alejandro de Ávila Blomberg: Jardín Etnobotánico de Oaxaca/Museo Textil de Oaxaca; Julian Brooks, Gail Feigenbaum, Lee Hendrix, Sally Hibbard, Thomas Kren, Frances Terpak, Nancy Yocco: The J. Paul Getty Trust, Los Angeles; Claire Barry: Kimbell Art Museum, Fort Worth; Tambra Johnson, Julie Miller, Sylvia Rodgers Albro: Library of Congress, Washington, D.C.; Diana Magaloni Kerpel: Los Angeles County Museum of Art/Universidad Nacional Autónoma de México, Mexico City; Elizabeth Cleland, Cristina Giuntini, Marco Leona, Elena Phipps, Joanne Pillsbury: Metropolitan Museum of Art, New York; Rocío Bruquetas, Concepción García Sáiz: Museo de América, Madrid; Concha Herranz Rodríguez: Museo del Traje, Madrid; Hector Borrell Rivero, Ricardo Pérez Álvarez: Museo Franz Mayer, Mexico City; David Bomford, Zahira Veliz Bomford: Museum of Fine Arts, Houston; Josie Caruso, Robin Farwell Gavin: Museum of Spanish Colonial Art, Santa Fe; Jo Kirby: The National Gallery, London; Margi Hofer: New-York Historical Society, New York; Clayton Bass, Scott Canning, Jerry Richardson: Santa Fe Botanical Garden; Margaret Rennolds Chace, Sarah Gifford, Tanya Heinrich, Christopher Steighner: Skira Rizzoli, New York; Marta Maier: Universidad de Buenos Aires; Clara Bargellini, Gustavo Curiel: Universidad Nacional Autónoma de México, Mexico City; Gabriela Siracusano: Universidad Nacional de Tres de Febrero/Consejo Nacional de Investigaciones Científicas y Técnicas, Buenos Aires; Charlene Villasenor Black: University of California–Los Angeles; Claudia Brittenham: University of Chicago; Sarah Glenn: Victoria and Albert Museum, London; George Miles, Mary Miller: Yale University, New Haven.

INDEPENDENT PROFESSIONALS

Alex Chapin, Salt Lake City; Glenna Dean, Abiquiu, New Mexico; Addison Doty, Santa Fe; Eloisa Ferrari, Madrid; James Gavin, Santa Fe; Dale Gluckman, Los Angeles; Staci Golar, Santa Fe; Peg Goldstein, Santa Fe; Manuel Gullon y de Oñate, Madrid; Jonathan Lowe, Santa Fe; Remigio Mestas, Oaxaca; Paul Pletka, Santa Fe; Georges Roque, Mexico City; Ana Roquero, Madrid; Marvin Rowe, Santa Fe; Genevieve Russell, Santa Fe; Bob Smith, Santa Fe; Cordelia Thomas Snow, Santa Fe; Fabrice Weexsteen, Paris; David Wenger, Philadelphia; Will Wroth, Santa Fe.

PROJECT IMPLEMENTATION

Finally, we are most grateful to museum director Marsha Bol, our cocurator Nicolasa Chávez, and all our colleagues working at or on behalf of the Museum of International Folk Art, the Museum of New Mexico, and the New Mexico Department of Cultural Affairs. Their knowledge, creativity, and professional support in various areas of the project helped bring a compelling and beautiful exhibition and publication to fruition:

Hannah Adelbeck, Nancy Allen, Ron Anaya, Natalie Baca, Cynthia Baughman, Steve Cantrell, Blair Clark, Jamie Clements, Allison Coburn, Caroline Dechert, Josef Díaz, Angela Duckwall, Leslie Fagre, Aurelia Gomez, Cynthia Graves, Elaine Higgins, Susan Hyde Holmes, Stephen Hutchins, Megan Jacobs, Tim Jag, Pamela Kelly, Deborah King, Daniel Kosharek, Ruth LaNore, Antoine Leriche, David J. Levine, Angelina Maestas, Mark MacKenzie, Barbara Mauldin, Laura Lovejoy-May, Cristin McKnight Sethi, Cathy Notarnicola, Christa Pack, Andy Perea, Dan Radven, Pedro Pablo Reyes, Stephanie Riggs, David Rohr, Maureen Russell, Laurel Seth, Patricia Sigala, Paul Singdahlsen, Polina Smutko, Elena Sweeney, Mina Thompson, Shelley Thompson, Patrice Tyrrell, Chris Vitagliano, Laura Waller.

—CARMELLA PADILLA & BARBARA ANDERSON
February 8, 2015

Foreword

THE POWER OF RED

CARMELLA PADILLA

IN A CONVERSATION OVER COCKTAILS, one friend asked another, "Do you know what cochineal is?"

"Cochineal?" said the other with an uncertain shrug. "I think it's a restaurant in Marfa."

Seizing the moment, I cut in. "What about red? Do you know what red is?"

He pondered only momentarily before raising his glass, a garnet pour of pinot noir. He pointed to a red coat draped over a chair and to the fireplace that flashed a rosy glow into the dimly lit bar.

"Red," he declared confidently, "is red."

As a writer seeking to gauge public understanding of the colorful subject of this book, I couldn't have imagined a better answer. In fact, this was one of many similar scenarios experienced during the course of this project as I prodded friends and strangers to provide their perceptions of the color red and of the small scale insect celebrated in this volume as its preeminent source. Ask someone to define cochineal, and you will likely encounter a puzzled expression or tentative guess. Ask someone to define red, and the response is overwhelmingly assured. One may not know what red means in a historical, cultural, or chemical sense. But, visually, everyone has a visceral knowledge of red. Therein lies its power.

Our relationship to red runs deep, through the timeless river of the human psyche and the time-bound record of human history. Across the global landscape, red's brilliant range is ever present, from forward, in-your-face, temperature-raising shades to softer pink, rose, and mauve tones. To see red is to perceive the longest and strongest visible wavelength on the color spectrum. In a potent convergence of light, reflection, and other chemical and sensory effects, the eye assigns red's striking hues to certain objects and images. At the same time, red resonates in the symbolic spaces of the mind, connecting those objects and images to beliefs, emotions, and expressions that have meaning in our particular place, culture, and time.

Red meant luck to the ancient Chinese; to the ancient Egyptians, it portended danger. In the early Arab world, red represented male vigor, whereas the most powerful men in classical Rome were called *coccinati*—"the ones who wear red." The pope proclaimed red the color of cardinals in the thirteenth century, adding to the ranks of royals, aristocrats, and other influential elites whose red robes and clothes conveyed their social status. Just as the boastful color evoked prestige and pride, it also symbolized shame, calling out the loose women of literature, from the Book of Revelation's Scarlet Woman to Hester Prynne, the adulterous protagonist in Nathaniel Hawthorne's *The Scarlet Letter*.

Red's persuasive shades have held sway through the centuries to color all areas of modern life and popular culture. From a president's red tie to a supermodel's red lips to a classic red Corvette, the color screams power, sex, perpetual youth. Red-soled shoes say fashion savvy, a red carpet signals celebrity, and a red-light district denotes desire and a certain danger. Legendary *Vogue* editor-in-chief Diana Vreeland, famous for her red lips, red nails, and scarlet-chintz-covered Park Avenue salon, called red "the great clarifier." Her Italian fashion counterpart Valentino, whose iconic red gowns epitomize the luxury and drama of the color, said simply, "Red has guts." Indeed, red's ripe beauty, energy, and mystery touch the very gut of our being: red is a heart, blood, love—the color of life itself.

If the power of red lies in its cultural and spiritual force, then the power of its representation relies on the more practical

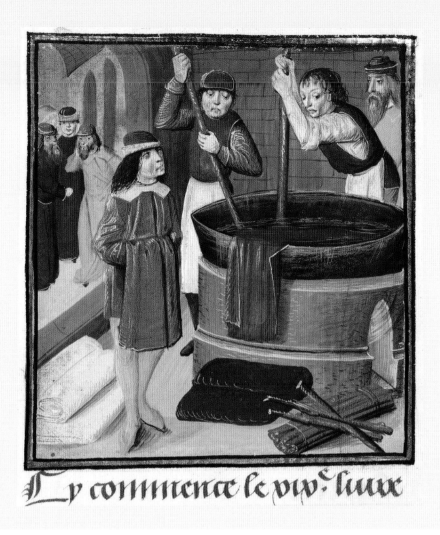

matter of its making. Throughout history, artists' finest expressions have been colored with delicate dye baths, powdered pigments, and palettes of paint concocted from natural, vegetal, and insect sources of red. European Renaissance dyers slaved over blazing hot, often toxic dye vats, refining recipes for brilliant and colorfast red dyes. Painters pursued the purest, most stable pigments to best render the reds of nature and the realism of daily life. In their quest for artistic perfection, all sought richer, redder, more efficient and enduring hues. Like a drug, red's distinctive highs and lows drove artists and their patrons to great lengths to achieve and acquire its nuances.

Which brings us back to the question of cochineal (which, for the record, is indeed the name of a restaurant in Marfa, Texas). A prized product of the Americas, cochineal is inextricably linked to the global power of red. In the 1520s, Spanish invaders encountered the American cochineal insect pressed into cake shapes in the Aztec marketplaces of Mexico, where it and its prickly pear host had been selectively bred and cultivated for centuries. Cochineal produced a perfect rainbow of reds—from pale pinks and roses to bold burgundies, crimsons, scarlets, and purples. Recognizing the dye's potent economic value,

Spain monopolized the resource, tapping into the world's red obsession to spread the insect's resplendence around the globe and reap the profits in return. The ensuing story of art, culture, politics, science, and trade forever changed the way the world used and viewed red.

This volume explores cochineal's epic story from multiple angles, including art, history, science, and economics. More than forty international scholars consider the big impact of a tiny bug on the world's comprehension and expression of red, connecting the power of red in history and today to the power of the pregnant, sap-sucking female insect that has fueled our red fever for almost five hundred years. A red like no other, cochineal has carried red to its fullest expression as artists have colored the world in vivid new hues. From the elegant, red-draped drawing rooms of history to the red-hot conversations of contemporary cocktail parlors, cochineal continues to infuse new layers of meaning into the most suggestive color of our lives.

Above Jean Du Ries, "Dyers Soaking Red Cloth in a Heated Barrel," from Bartholomeus Anglicus, *Des Proprietez des Choses*, vol. 2, folio 269, Bruges, 1482, British Library Royal Ms. 15.E.iii. Photo: © British Library Board/ Robana/Art Resource, NY.

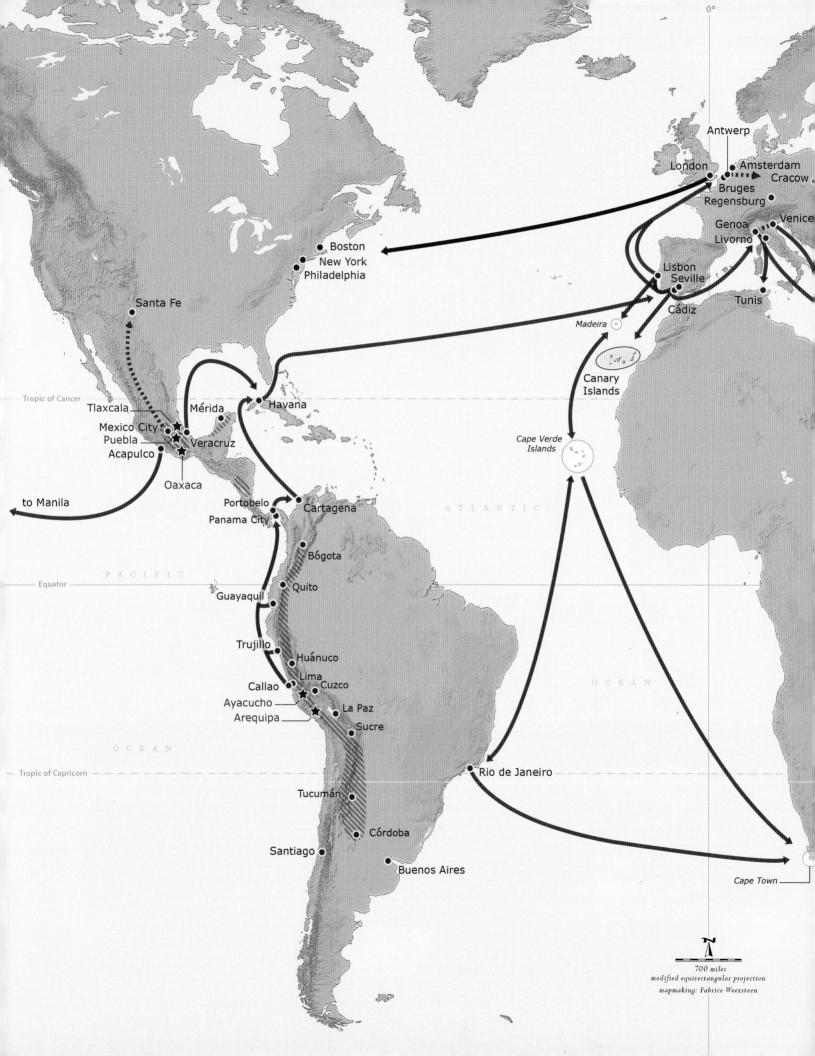

0°

Antwerp
London
Amsterdam
Cracow
Bruges
Regensburg
Genoa
Venice
Livorno
Lisbon
Seville
Cádiz
Tunis

Boston
New York
Philadelphia

Santa Fe

Madeira

Tropic of Cancer

Canary
Islands

Tlaxcala
Mérida
Havana
Mexico City
Puebla
Veracruz
Acapulco
Oaxaca

*Cape Verde
Islands*

to Manila

Portobelo
Cartagena
Panama City

ATLANTIC

Bógota

Equator

PACIFIC

Quito
Guayaquil

OCEAN

Trujillo
Huánuco
Lima
Callao
Cuzco
Ayacucho
La Paz
Arequipa
Sucre

OCEAN

Rio de Janeiro

Tropic of Capricorn

Tucumán

Córdoba

Santiago
Buenos Aires

Cape Town

N

700 miles
modified equirectangular projection
mapmaking: Fabrice Weexsteen

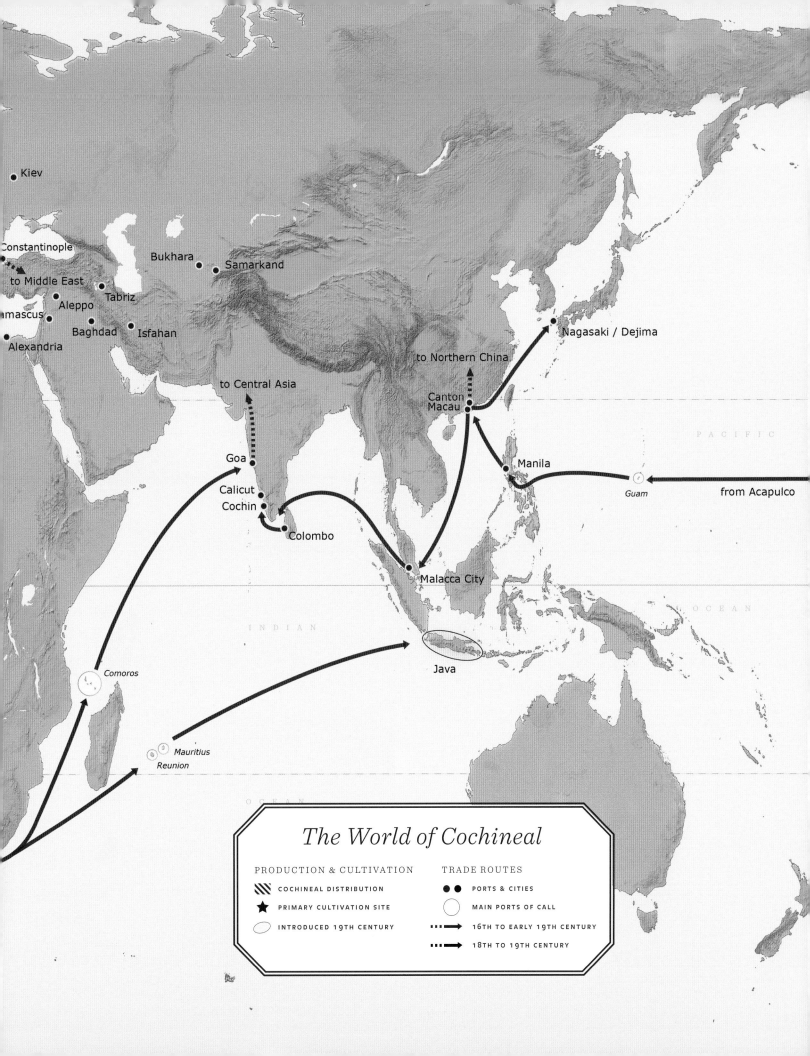

Kiev

Constantinople

to Middle East

Damascus Aleppo Tabriz

Alexandria Baghdad Isfahan

Bukhara Samarkand

to Central Asia

to Northern China

Nagasaki / Dejima

Canton
Macau

Goa

Calicut
Cochin

Colombo

Manila

Guam

from Acapulco

Malacca City

PACIFIC

Comoros

Java

Mauritius
Reunion

INDIAN

OCEAN

OCEAN

The World of Cochineal

PRODUCTION & CULTIVATION

- ▨ COCHINEAL DISTRIBUTION
- ★ PRIMARY CULTIVATION SITE
- ⬭ INTRODUCED 19TH CENTURY

TRADE ROUTES

- ● ●● PORTS & CITIES
- ○ MAIN PORTS OF CALL
- ▶ 16TH TO EARLY 19TH CENTURY
- ➔ 18TH TO 19TH CENTURY

Introduction
THE WORLD OF COCHINEAL

BARBARA ANDERSON

WHY COCHINEAL? WHY DEVOTE YEARS of work by dozens of scientists and scholars, not to mention hundreds of thousands of dollars, to investigate a color made from an insect that today is mostly considered a garden pest or an unsettling ingredient in food, beverages, and cosmetics?

The short answer is cochineal's singular and enduring importance in the history of commerce, science, politics, art, and ideas, from the pre-Columbian era in Mexico and Peru to the modern world.[1] Indeed, for reasons explored in this book, red occupies a privileged place in the color hierarchy, and American cochineal reigns as the queen of reds. A recent testament to the global fascination with cochineal is the analytical project that inspired this publication and the exhibition it accompanied in 2015 at the Museum of International Folk Art in Santa Fe, New Mexico. As it and other studies leading to it show, cochineal has captivated artists and writers since the sixteenth century. Today it continues to fascinate because of its wide cultural reach and persistent mysteries.

The Spanish Franciscan friar Bernardino de Sahagún was the first to describe and illustrate cochineal's production and various uses in Mexico in his *Historia general de las cosas de Nueva España,* completed in 1577 and interpreted in this volume by Diana Magaloni Kerpel.[2] Barbro Dahlgren de Jordan has assembled primary documents relating to various aspects of cochineal's role in Mexican history,[3] while R. A. Donkin has traced its spread around the world.[4] Raymond Lee[5] and Amy Butler Greenfield have described how the eager embrace of cochineal by the flourishing luxury textile industries in Italy and northern Europe, and its power as an economic engine controlled by Spain, focused attention on the insect's elusive physical characteristics. This led entrepreneurs such as Thierry de Menonville and Joseph Banks to attempt to capture and cultivate the insect for exploitation in their own countries.

The quest for economic domination through cochineal fueled scientific inquiry and competition to identify the bug. As Greenfield has shown, one of the earliest specimens examined under Antoni van Leeuwenhoek's new microscope in the 1680s was the cochineal bug, so urgent was its identification.[6] Most recently, Elena Phipps has examined cochineal's domination in the history of textile production and trade worldwide, identifying its use in surviving textiles from the ancient Americas to modern Europe and Asia.[7]

American cochineal dye was widely coveted for so long because of its capacity to produce an impressive range of reds for animal-based textiles, especially costly woolens and silks, in an age that craved such luxuries. As Phipps as well as Ellen Pearlstein, Mark MacKenzie, Emily Kaplan, Ellen Howe, and Judith Levinson elaborate in this volume, it was chosen among available reds for ceremonial and other significant garments and implements as early as the second century in Peru and through the Spanish colonial era. Claudia Brittenham explains that cochineal was central to artistic production in the pre-Columbian era, along with, and distinguished from, specific uses of other reds. It was cultivated in the Mixteca Alta region of Oaxaca, Mexico, probably before 600 CE; was employed for wall paintings by the Zapotecs at Monte Alban from around that time and was later used for illustrated manuscripts created by the Mixtecs; and was a source of tribute and cosmetics for the Aztecs before the arrival of the Spaniards. The eighth-century Maya murals at

Previous spread Fabrice Weexsteen, "The World of Cochineal," map of global cochineal trade, production, and cultivation, Paris, France, 2015.

Opposite José Antonio de Alzate y Ramírez, "Indian throwing cochineal into a pot full of water set over a fire to kill it," from *Memoria sobre la naturaleza, cultivo, y beneficio de la grana*, Mexico City, 1777. Colored pigments on vellum, 12¼ in. high. Edward E. Ayer Manuscript Collection, Ayer Ms. 1031, plate 8, Newberry Library, Chicago.

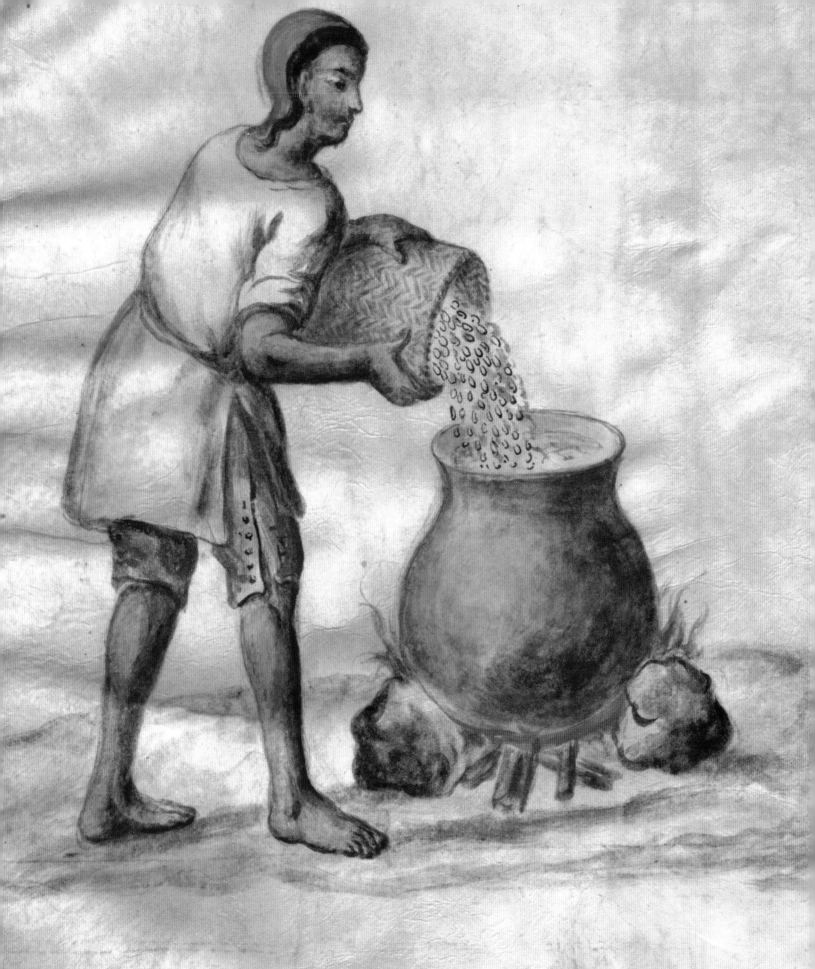

Indio arrojando la Cochinilla en una olla llena de agua, y
puesta sobre brazas para matarla.

Bonampak in Chiapas, Mexico, include abundant examples of reds in the depictions of figures. Mary Miller examines evidence that some of the Bonampak reds may be cochineal, despite long-held scholarly assumptions to the contrary.

Cochineal became the second most important Spanish export from Mexico after silver, fueling Spain's economy until the early nineteenth century, when Mexico won its independence. When exported to Europe and beyond, as Carlos Marichal and Jo Kirby relate, it rapidly replaced kermes and Polish cochineal, the traditional red dyes desired for production of luxury fabrics, Europe's most important industry from the medieval period on. The dye not only spread through the elite textile centers of Italy; it took over in Belgium, England, the Netherlands, Spain, and France. Dominique Cardon shows how it was highly regulated, and sustainably and efficiently manipulated, to produce exquisitely refined and evocatively named shades. Ana Roquero reveals recipes for the luscious shades created when the dye is mixed with various mordants.

As Kirby, Rocío Bruquetas, and Marisa Gómez tell us, cochineal made its way directly from the textile industry into other European art forms, including painting, polychrome sculpture, and decorative arts, and even to use in varnishes for the prized Cremona violins made by such masters as Guarnieri and Stradivari. Kirby traces the evolution of the forms in which cochineal was used for painting and, beginning in sixteenth-century Italy, ensuing changes in painting techniques. In the seventeenth century, Théodore Turquet de Mayerne, physician to King Charles I of England, described cochineal's use in doublets,[8] artificial jewels created with a sliver of real gem placed over cut crystal and backed by a colored ground.[9] Mayerne was a friend and observer of the court painter Anthony Van Dyck, who himself used cochineal, and Mayerne's professional contemporaries in England, such as King Charles's botanist John Parkinson, concocted medicines from cochineal. And just as Sahagún had only slightly earlier recorded the use of cochineal-based cosmetics by Mexico's harlots and witches, the English also created cochineal cosmetics for loose women with painted faces.

Francisco Pacheco, the Seville painter best known as the teacher and father-in-law of Diego Velázquez, was the author of *Arte de la pintura,* the foundational treatise on painting techniques in seventeenth-century Spain. His book details the many uses in painting for cochineal, which was offloaded and traded in his city directly from ships arriving from Mexico. While Pacheco boasted of his own prowess depicting velvets with the new source for red lake, he deferred to the mastery of his older contemporary and fellow Sevillano,

Alonso Vázquez, whose portrayal of cochineal velvets he found extraordinary.[10]

Although cochineal was commonly included in seventeenth- and eighteenth-century painting treatises, and though Pacheco singled out the painter Vázquez, the specific artists who used it have only recently been documented. The National Gallery in London has led the drive to identify cochineal and determine the nature of its use in European paintings of the early modern period and nineteenth century.[11] Thanks to its efforts, and those of the Metropolitan Museum of Art,[12] the Rijksmuseum,[13] the Art Institute of Chicago,[14] the Getty Conservation Institute and Museum,[15] and the Instituto del Patrimonio Cultural de España,[16] we now know that most major European painters were seduced by cochineal, despite their awareness that it, like all lake pigments, was fugitive. Tested examples include works by Titian, Tintoretto, El Greco, Velázquez, Zurbarán, Van Dyck, Rubens, Rembrandt, Canaletto, Reynolds, Gainsborough, Renoir, and Van Gogh, and summaries of the findings are discussed throughout this volume. Here for the first time, authors Bruquetas and Gómez also put painting and polychrome sculpture from Golden Age Spain into historical context through the lens of cochineal.

American cochineal was also introduced to Asia by European traders. The Portuguese and Dutch brought it to Japan as of the sixteenth century, as Monica Bethe and Yoshiko Sasaki explain; Italians exported it to Constantinople; and Spanish, English, and French traders sold it in the seventeenth century in Isfahan, Aleppo, and Damascus, as Cristin McKnight Sethi explains. Marianna Shreve Simpson analyzes the circumstances surrounding a lavish gift made in 1618 by Philip III of Spain to Shah 'Abbas I of Persia to demonstrate the splendor of the Spanish Empire. The most expensive component of that gift, composed of all manner of precious goods, was American cochineal. Simpson wonders how the Shah subsequently put the gift to use: as a dyestuff for rare Persian textiles or as an export good for profit? To date, only a few likely candidates from regions where Armenian cochineal had long been a staple have been tested for use of the imported American cochineal. This leaves us without a clear picture of the deliberate choices for reds by artists in Persia.

Cochineal returned as a trade item to the northernmost regions of the New World via England, which imported the Mexican dye from Spain, and exported cochineal-dyed cloth back to the English colonies in the eighteenth century. When the dye was cultivated in British Java in the late nineteenth century,[17] it reached farther inland, transported to far-flung areas first by steamboat and then by locomotive. The

presence of cochineal in textiles made in the nineteenth century by Indians of the American Plains and the Southwest has been generally accepted since the early twentieth century. Further investigations since the 1970s, primarily technical analysis by Jo Ben Wheat,[18] David Wenger, and Nora Fisher,[19] have greatly expanded the corpus of tested textiles with reds conclusively identified as cochineal.

Marsha Bol relates how Plains Indians took advantage of red trade cloth, the same as that used to make British soldiers' red coats, unraveling it to weave into ceremonial garments. Ann Hedlund examines the history of using unraveled cloth by Navajo, Pueblo, and Hispano weavers, who, she proposes, may never have made use of locally available wild cochineal. Emily Osborn chronicles a history of West Africans who also unraveled imported red cloth, in this case received from the colonial masters who sold them into slavery. Osborn also explains how strong negative associations with the color red among African American slaves' descendants have been passed on from one generation to the next.

CHALLENGES IN IDENTIFYING COCHINEAL

Today, the total number of works of art known to contain cochineal remains small. This is due to the lingering difficulty of identifying organic substances, for which spectroscopic examination is not definitive, as it is for inorganic materials. Just as the bug eluded identification before the invention of the microscope in the late seventeenth century, it is still impossible to identify the colorant in art without careful but invasive sampling and analysis. This requires an expensive and difficult chemical process known as high-performance liquid chromatography, or HPLC, which separates the organic components of a dye, lake, or other mixture. Because the reds in a given work frequently appear in areas too prominent or pristine to be compromised, only small samples can be obtained from select areas. This may limit the ability to obtain comprehensive information about a canvas, textile, sculpture, or other work in which reds appear throughout. The good news is that noninvasive methods are currently under development, led by such scientists as Marco Leona at the Metropolitan Museum of Art.

Another problem in analyzing individual works is ascertaining the origin of cochineal. In this volume, Alex Van Dam and his scientific collaborators report on their recent determination that American cochineal originated in Mexico. Their findings may perhaps put to rest the long-standing debate about whether cochineal originated in Peru, where only its wild variety has been documented, as opposed to Mexico, where it has been known as a cultivar since the pre-Columbian period.

A third challenge, as Estrella Sanz Rodríguez explains, is sorting out the direct sources for the dye in a particular work of art. This is especially important for items made far from the sites of cochineal production, such as sixteenth-century Italian paintings or seventeenth-century Persian manuscripts. It is also difficult in two historical periods. The first, as Anna Naruta-Moya explores, is the early years of importation from Mexico, when the similar but less economical Polish and Armenian cochineal were still in use. The second period spans the years beginning in the early nineteenth century, when the bug was successfully cultivated in Morocco, the Canary Islands, and Indonesia, and ending with the introduction of aniline dyes, which diminished the use of natural colorants. While scientific methodology can identify these sources, it is expensive, and scientific expertise is scarce. Deterioration of the historical materials undergoing analysis can further thwart the investigation.[20]

Testing has shown that the more that cochineal is sought in works of art, the more cochineal is found. Yet for many categories of objects in which cochineal is either suspected or known from vague historical references, scientific analysis still needs to confirm its presence. These include Mexican pre-Columbian codices (see Brittenham and Anderson, this volume); European and Mexican genre paintings depicting textile manufacture and trade from the late sixteenth century through the late eighteenth century; the previously mentioned European doublets and Cremona violins; red Inca camelid-fiber quipus, stringed objects that served a yet-undetermined record-keeping function; pink dyed textiles from the pre-Hispanic Southwest; and seventeenth-century illuminated manuscripts made in Isfahan.

The challenges, however, have given rise to opportunities for many recent investigations. Phipps and the scientific department at the Metropolitan Museum have turned up cochineal in Spanish colonial–era textiles made in Peru. Gabriela Siracusano and Marta Maier have been finding it in pigment samples from eighteenth-century Andean paintings,[21] as they discuss in this volume. And Pearlstein, Howe, Kaplan, Levinson, and MacKenzie have uncovered the use of cochineal in colonial Andean ceremonial drinking cups called keros, demonstrating the likelihood that it was a technique learned from Europeans and adapted to serve indigenous purposes.

This book brings together the results of recent technical investigations, including the Museum of International Folk Art project launched in 2009. The project's aim was to analyze objects in the museum's collections, as well as in other public and private collections,[22] to tell a more comprehensive

story of cochineal's embrace by artists around the globe. Some objects studied at the Museum of International Folk Art are similar to those analyzed by the Metropolitan Museum for Phipps's *Cochineal Red: The Art History of a Color* of 2010. Testing of the Santa Fe items expanded the data so that they could be featured in *The Red That Colored the World* exhibition. All items with cochineal featured in the exhibition, and those illustrated in this book, were scientifically tested to confirm the dye's presence, or are known from historical evidence to contain cochineal.

Many objects found to contain cochineal were from areas not previously investigated. One goal of the Santa Fe project was to expand understanding of cochineal in the viceregal and postindependence eras in the Hispanic Americas, as the substance's uses in Mexico and its northern frontier remained obscure. Chroniclers such as Sahagún tell us that cochineal was used by artists, but there is little or no definitive evidence of its use in individual works. Yet as Brittenham logically posits, cochineal was considered so valuable to the Aztecs that it would have had much wider use beyond surviving examples of inks used in historical codices. Thanks to the Museum of International Folk Art's collaborative campaign of testing by MacKenzie of the New Mexico Department of Cultural Affairs, Leona of the Metropolitan Museum, Richard Newman and Michele Derrick of the Museum of Fine Arts, Boston, and Gómez, Sanz Rodríguez, and other scientists at Madrid's Instituto del Patrimonio Cultural de España, we now have a broader view of cochineal's evolving use in its original country of cultivation.

This information is further interpreted in this volume by Gustavo Curiel's examination of cochineal in the decorative arts of New Spain and in Alejandro de Ávila B.'s journey through the ethnobotany and linguistics of Mexico's textile landscape. For his part, Curiel poses a series of important questions to point in the direction of future investigation. For example, he asks why we have cochineal in lacquerware made in Michoacán, far from the Mexican sites of cochineal production, but little evidence of its use in the painted furniture made in the center of the Mixteca Alta, the most important site.

Today in New Mexico, once New Spain's northernmost frontier, wild cochineal thrives on the prickly pear cactus. The insect was known there by the eighteenth century, as discussed by Cordelia Thomas Snow, but as Robin Farwell Gavin recounts, its mystique became so entrenched that by the early twentieth century it was the usual suspect for every red in Spanish colonial New Mexican art. Recent HPLC analysis by MacKenzie provides more definitive evidence of use, identifying cochineal in a number of works by colonial New Mexican masters dating from the later eighteenth and nineteenth centuries. These include a hide painting; an oil-on-wood *retablo* (in New Mexico the term for a religious painting) by New Mexico's first identified *santero* (saint maker); *bultos* (religious sculptures); and of course textiles. Still open to debate, until further evidence is found, is whether the colonial-era cochineal source was the local wild version seen in New Mexico today or perhaps cochineal imported to the region from Mexico via El Camino Real de Tierra Adentro.

RESISTANCE AND REVIVAL

As with almost any vast economic undertaking, the global infusion of lush cochineal reds had a darker side. In the Age of Empire, wherever cochineal was cultivated or traded, controversy followed over its perceived negative social impacts. The lords of Tlaxcala, Mexico, who were not without their own agenda, complained in 1553 to their council about the destruction of local culture in the wake of heightened cochineal production. This, they claimed, caused farmers to neglect subsistence food crops in favor of the more lucrative commercial enterprise and then to squander profits on drink and debauchery.[23] Scholars such as Jeremy Baskes have long debated the nature and scope of abuses within the Spanish system of *repartimiento*, which enabled the colonial dye trade, especially in Oaxaca.[24] Compared to the extremely harsh Dutch *Kultuurstelsel*, or cultivation system in colonial nineteenth-century Java, however, even the flawed Mexican system was relatively benign in terms of human exploitation. According to Greenfield, the Mexican tradition depended upon slow, careful tending, rendering it not only more humane but more successful economically, even as cochineal was falling from great heights of production and profit.[25]

The cachet of cochineal was in decline by the early nineteenth century and was facing eclipse in the latter part of the century for at least two unrelated reasons—one symbolic, the other practical. The first was the dye's close associations with the excesses of luxury and splendor that defined the Age of Empire. Cochineal red in early modern European and Hispanic American painting, for example, unabashedly represented the status of the rich and powerful. In literature, cochineal red sometimes described aspects of lovely but foolishly vainglorious and flashily garbed women at the English court, as in John Donne's *Satire IV* of 1597. By the end of the Napoleonic reign and the Latin American wars of independence, such excesses were disdained in favor of greater sobriety in dress and interiors, reflecting emergent democratic and

bourgeois societies. Writers began using cochineal to symbolize evils of the anciens régimes falling like dominoes in the Age of Revolution. For instance, E. T. A. Hoffmann's short story "Chained Destiny" of 1809 features a servant named Cochineal, whose brief appearance catalyzes the tragic sequence of events in the title. And in *Don Juan* of 1823, Lord Byron sounds cochineal's demise: "If from a shell-fish or from cochineal / So perish every tyrant's robe piece-meal."

The second blow to cochineal's supremacy was the invention of the much cheaper and more readily manufactured aniline dyes, whose gaudy shades became fashionable in the mid-nineteenth century. Once these synthetics were introduced, cochineal rapidly disappeared from commercial use, at least until it was demonstrated that natural dyes were more color-fast. Anilines lost some popularity, especially as the Arts and Crafts movement of the later nineteenth century returned to reverence for natural and artisanal goods over the machine-made. Inspired by this movement in the early years of the

twentieth century, Spanish designer Mariano Fortuny would lift cochineal to new heights of fashion. As Elvira González Asenjo and Lucina Llorente Llorente detail, Fortuny even combined cochineal with synthetic dyes in bold experiments that gave the ancient insect dye new life.

For its June 1939 issue, *Vogue* magazine commissioned Salvador Dalí to produce watercolor sketches of women in cochineal-colored bathing suits. Today, as Nicolasa Chávez explains, the revival continues in natural-dyed cosmetics and foods. Cochineal maintains its experimental allure in art and fashion as well, as demonstrated by artists and designers from Mexico to the Canary Islands to England to the American Southwest, where cochineal is still known and honored.

Above, left and right Cochineal on prickly pear cactus and dried cochineal bugs, Santa Fe, New Mexico, 2014. Photos © Addison Doty.

PART 1

A NEW RED
Pre-Columbian &
Early Contact Americas

THREE REDS

Cochineal, Hematite, and Cinnabar in the Pre-Hispanic Mesoamerican World

CLAUDIA BRITTENHAM

COCHINEAL WAS ONE OF MANY SOURCES of the color red in Mesoamerica. The region now encompassing modern-day Mexico, Guatemala, Belize, and Honduras abounded with plant, mineral, and even animal colorants that produced red and purple hues. Unlike the arid coastal deserts of Peru, where textiles and other perishable materials survive (see Phipps, this volume), climatic conditions in Mesoamerica do not favor the preservation of such fragile ephemera. The Mesoamerican archaeological record consists of more durable materials: stone, clay, and shell; many of the most important surfaces for red hues—wood, textiles, books, and bodies—have been lost. We can only imagine what they looked like and what use of colorants they could reveal.

Color is at once abstract and material. Color can be defined as a set of wavelengths of light that meet the human eye; red occupies the range between 620 and 730 nanometers of the visible spectrum. But color is also the result of materials and process—of colorants carefully chosen, prepared, and applied to different surfaces. Both optical and material properties can make color meaningful. In Mesoamerica, for example, red was frequently associated with the east and the rising sun;[1] the particular material used to produce the color does not seem to have been significant in this context. In other cases, the material itself carried meaning.

In addition to cochineal, we know the most about hematite and cinnabar, two durable mineral sources of red with a wide distribution in Mesoamerica and excellent survival in the archaeological record. But there are significant differences between the two: hematite was a ubiquitous pigment for fired clay and architectural painting throughout Mesoamerica, while cinnabar was rare and precious, associated with death and the tomb. Dyes from plants, including logwood (*Haematoxylum campechianum*, also called *palo de Campeche*), annatto (*Bixa orellana*, also called *achiote*), and brazilwood

(*Caesalpinia* sp.), were undoubtedly significant sources of red colors in ancient Mesoamerica, yet like cochineal they most frequently colored textiles, bodies, and other surfaces that have been destroyed by the ravages of time; it is impossible to reconstruct much of their usage.[2] What is significant is that different red colorants had different functions, because of both their material properties and their symbolic associations. Not all reds were created equal.

COCHINEAL

Cochineal was a colorant of deep economic and symbolic importance to ancient Mesoamericans. The Aztecs called it *nocheztli*, combining the words for prickly pear cactus fruit (*nochtli*) and blood (*eztli*), a fitting name for the vibrant red color produced by insects that live on the leaves of the prickly pear cactus (*Opuntia* sp.). The Mayas called it *muk'ay* or rarely, but more colorfully, *wech lu'um*, "armadillo of the soil."[3]

The Aztecs demanded sacks of dried cochineal as tribute from three subjected provinces in modern Oaxaca (figure 1.1),[4] while tribute for the province of Quauhnahuac (modern Cuernavaca) and possibly also Acolhuacan in the Valley of Mexico included mantles dyed with *nochpalli*, or cochineal dye (figure 1.2).[5] Cochineal was also bought and sold in the Aztec marketplace as prepared cakes, alongside an inferior red dye produced from the fruit of the cactus.[6] (See Magaloni Kerpel, this volume.) Cochineal thus came into the Aztec capital as both tribute and

Opposite FIGURE 1.1 *Codex Mendoza*, Mexico, ca. 1540. Pigments on European paper, 12⅞ x 9¹⁄₆₄ in. Bodleian Library, Oxford, folio 43r. This page shows the semiannual tribute payment of forty bags of cochineal (the banner glyph above each bag indicates that twenty bags are to be paid) from the province of Coayxtlahuacan in the Mixteca region of Oaxaca. The toponym for the community of Nochiztlan, the sixth glyph in the left-hand column, shows a basin of blood red liquid and a prickly pear cactus, a perfect representation for the town, whose name means "place of cochineal." Photo © Bodleian Libraries, University of Oxford/MS. Arch. Selden. A. 1 fol. 043r/The Art Archive at Art Resource/Art Resource, NY.

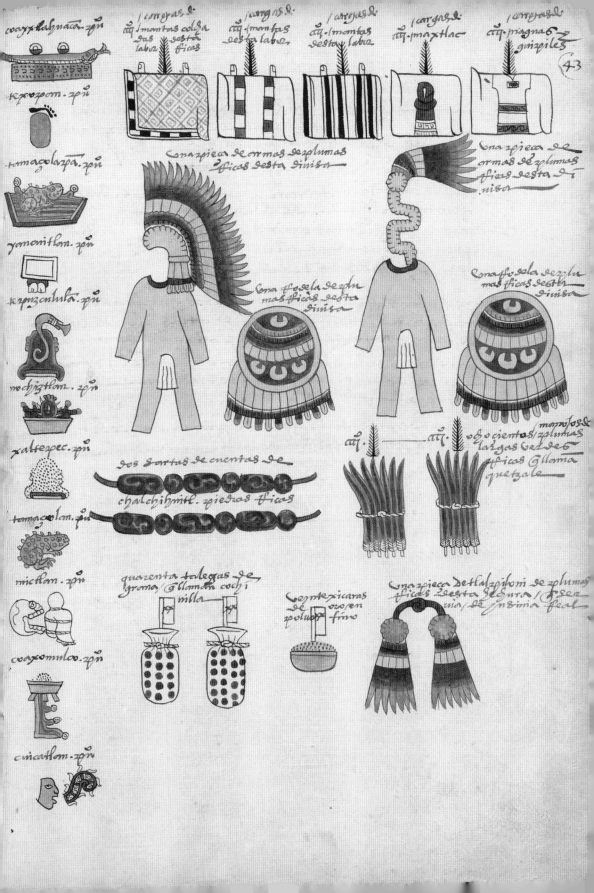

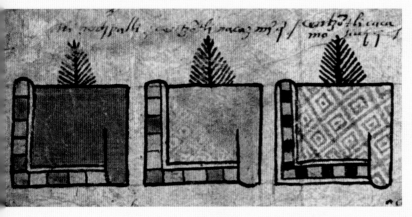

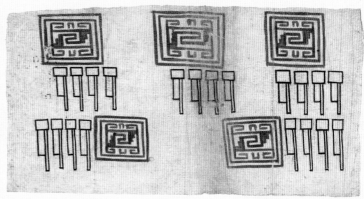

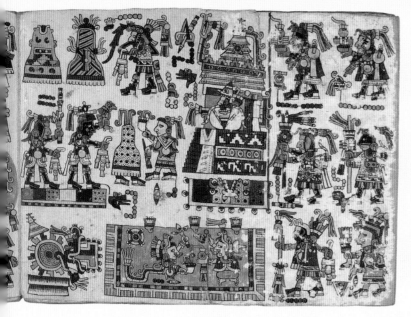

trade good, in considerable quantities. Barbro Dahlgren de Jordan calculates that the sixty-five bags of cochineal recorded as annual tribute from Oaxaca in the *Codex Mendoza* correspond to 9,750 pounds per year.[7]

What was all this cochineal used for? Cochineal's fame in Europe stemmed from its power as a textile dye, but it was most effective as a dye for animal fibers, such as wool and silk in Europe and Asia or camelid hair in the Andes. Mesoamerica, however, was notably deficient in good sources of animal fiber; instead, plant fibers such as cotton and agave predominated. Cochineal is a poor dye for these materials: it can color cotton as a dye or surface paint but requires large amounts of a mordant, such as alum, to do so.[8] Cochineal-painted cotton cloths may be what are illustrated and mentioned in testimony recorded in the *Codex Huejotzingo*. (See Anderson, this volume.) This document supporting a 1531 lawsuit

about indigenous tribute paid to the Spanish also lists costly cloths made of red rabbit fur among contested items of tribute (figure 1.3).[9]

Because it was such an effective colorant for animal products, cochineal was likely used to dye the rabbit fur in those contested textiles in the *Codex Huejotzingo*, as well as in similar preconquest Aztec textiles, and also to color deer and rabbit skins.[10] (See Miller, this volume.) If wild silk was gathered before the Spanish conquest, it might also have served as an excellent vehicle for cochineal dye. Feathers might have been dyed with cochineal and either spun for weaving or used to make feather mosaics. While the top layer of a mosaic would be made of feathers whose brilliant and iridescent colors were due to nature, feathers dyed with cochineal might form the substrate for the mosaic—fooling the unwary buyer in the marketplace.[11] These practices continued into the

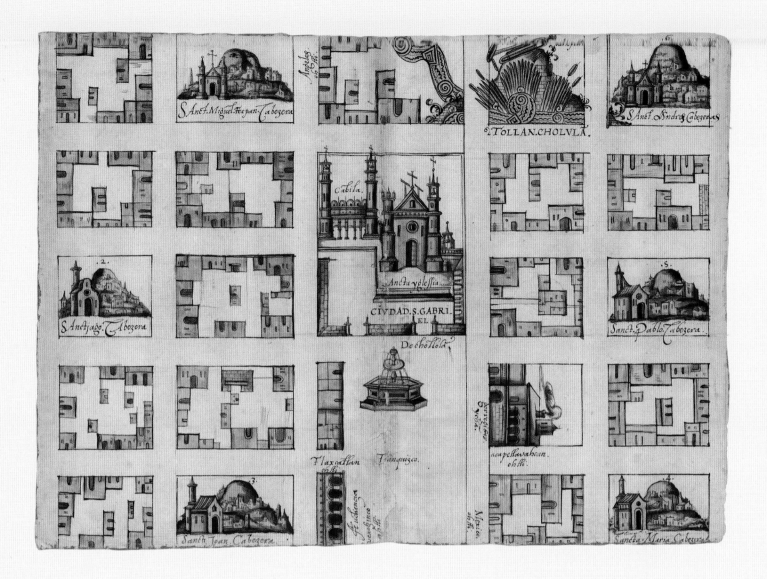

colonial period.[12] (See Anderson, this volume.) But during pre-Hispanic and Spanish colonial times alike, these uses must have been quite limited. Luxurious textile and featherwork production alone cannot account for all of the cochineal required as tribute by the Aztec Empire.

Much cochineal must have been converted into ink, used to create brilliant colors in Mesoamerican screen-fold manuscripts, sometimes called codices. One striking recent finding is that cochineal can produce a variety of hues, from a deep or bluish purple to a bright crimson red, depending on pH and other conditions of preparation of the ink.[13] Cochineal has been identified in the *Codex Zouche-Nuttall* (figure 1.4), *Codex Cospi*, and *Codex Laud* and on amate paper from La Garrafa Cave in Chiapas.[14] Its use as an ink continued into the early colonial period: its presence has been confirmed in the *Florentine Codex*; in maps accompanying the *Relaciones Geográficas*

(responses to a 1580 questionnaire from the Spanish Crown), including a 1581 map of Cholula (figure 1.5); and in the 1565 Aztec map known as the *Codex Reese* or Beinecke Map (figure 1.6).[15] Cochineal may even be the colorant used to paint images of sacks of cochineal in the tribute pages of the *Codex Mendoza*, a tantalizing equivalence of material and subject, but this has not yet been verified by testing (see figure 1.1).[16] In most of these contexts, cochineal coexisted alongside brazilwood, hematite, and even cinnabar pigments, each material assigned a role based on its hue, cost, and symbolic properties.

■ *Above* **FIGURE 1.5** *Mapa de Cholula Relaciones Geográficas*, Cholula, Mexico, 1581. Pigments on European paper, 12¼ x 17⅛ in. Nettie Lee Benson Latin American Library, University of Texas–Austin, Joaquín García Icazbalceta Manuscript Collection, JGI XXIV-1. This map was probably made by an indigenous Nahua scribe to accompany the community's response to the *Relación Geográfica* questionnaire circulated by the Spanish Crown. It likely includes cochineal as the red colorant.

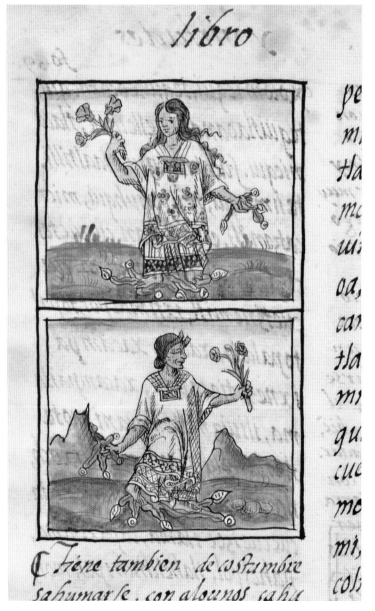

A third use of cochineal—as a cosmetic—has resonance with later European practice, including a persistent ambivalence among both Aztecs and Europeans on both sides of the Atlantic about the practice of adornment. Aztec women stained their teeth red with cochineal and might have also used it to color their faces and bodies, though other materials, such as annatto and axin, are better documented as hair and body paint among the Maya.[17] Cochineal's use is noted in the *Florentine Codex* for both respectable, married women and as a sign of the woman of ill repute, who is described in this way: "She paints her face, variously paints her face; her face is covered with rouge, her cheeks are colored; her teeth are darkened—rubbed with cochineal" (figure 1.7).[18]

Cochineal also had medicinal uses among the Aztecs. Francisco de Hernández writes that "ground cochineal, prepared [dried and stored as a round cake], and mixed with vinegar, has virtue as an astringent, and applied as a plaster cures wounds, and comforts the heart, the head and the stomach; it cleans teeth admirably well."[19] Its use for removing "scum on the teeth" is also attested in the *Florentine Codex*.[20]

Cochineal had clear economic importance to the Aztecs as a prized good of tribute and trade, its primacy evident in its privileged position at the top of the list of colorants in Book 11 of the *Florentine Codex*. Cochineal was important to the Mixtecs and Zapotecs of Oaxaca as well—they were the ones cultivating it for Aztec tribute and also for their own use. But the evidence for cochineal's pre-Hispanic use among the Maya of the Yucatán Peninsula is less clear. (See Miller, this volume.) While it had great importance as a dye, paint, cosmetic, and medicine, its main uses seem to have been small in scale, always calibrated to the cost of this precious material.

■ *Top* **FIGURE 1.6** *Codex Reese*, Mexico, ca. 1565. Hand-colored map on amate paper, 39½ x 81 x 1¾ in. Yale Collection of Western Americana, Beinecke Rare Book and Manuscript Library, Yale University, WA MSS S-2533. Purchased from Frontier America on the Walter McClintock Memorial Fund, Edwin J. Beinecke Fund, Anna R. Butler Fund, and a gift from William Reese, 1975. Cochineal has been identified as the red pigment coloring the maize plants and red boundary lines visible in this detail of the upper-right section of a map of a portion of Mexico City.

Left **FIGURE 1.7** Bernardino de Sahagún, *Florentine Codex,* Mexico, 1576–1577. Pigments on European paper, 4⁵¹⁄₆₄ x 3¹⁷⁄₆₄ in. Firenze, Biblioteca Medicea Laurenziana, Florence, Italy, Ms. Mediceo Palatino 220, book 10, chapter 15, folio 39v. Prostitutes as well as married women dyed their teeth red with cochineal in the Aztec world.

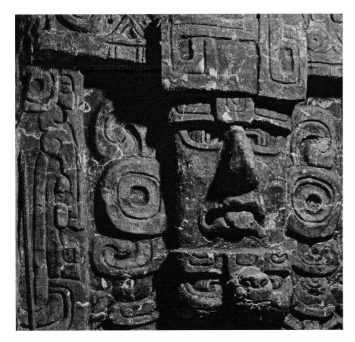

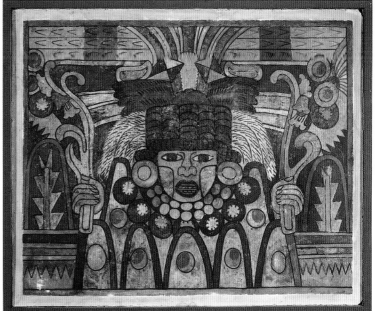

HEMATITE

Cochineal may have been a luxury in the Mesoamerican world, but hematite was ubiquitous, and this ubiquity is only magnified by its preservation in the archaeological record. Hematite is an anhydrous iron oxide notable for its blood-like color. (Goethite, a hydrated iron oxide, is yellow in color but darkens to red upon heating.) Clays containing high concentrations of iron oxides are called ochers, and their color—from red to yellow to brown—is determined by the hydration of the iron oxides and the impurities within them.[21]

Sources of hematite or hematite-containing clay ochers were readily available near many Mesoamerican communities. Because of its ease of procurement and preparation, and its superior covering power, hematite was a color of choice for large-scale architectural painting in Mesoamerica; many of the same factors account for the prevalence of hematite red barns in the United States. In Maya cities, public buildings were painted red, occasionally with touches of yellow, blue, or green pigments (figure 1.8). Stone sculptures, such as lintels and freestanding stelae, were also painted with hematite pigments.

Hematite was a frequent pigment in figural mural painting as well, the red color of choice in Teotihuacan, Zapotec, Maya, and Aztec murals.[22] While many of these mural traditions make extensive use of a warm, earthy red (see figure 1.11), the murals of Teotihuacan are notable for their use of a purplish specular hematite, shining with tiny crystalline particles that lend powerful vitality to the works in brilliant sunlight or flickering torchlight (figure 1.9).

Beyond its use on walls, hematite was one of the most important sources of color for fired clay pottery. Few colorants can withstand the heat of firing: organic materials such as

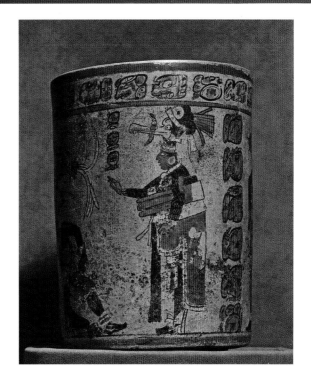

Top, left **FIGURE 1.8** Sun god mask, Yehnal structure, Copan, Honduras, Maya culture, fifth century CE. The stucco decoration on the outside of this platform, now buried deep beneath Temple 16 on the Copan acropolis, retains much of its original hematite red paint. Photo © Kenneth Garrett.

Top, right **FIGURE 1.9** Fresco fragment, Teotihuacan, Mexico, ca. 650–750 CE. Lime plaster and polychrome paint, 29¾ x 37 in. Denver Art Museum, department acquisition funds, 1965.202. The reds and purples in this painting of a frontal deity are hematite, heated to achieve different tones. Photo courtesy Denver Art Museum.

Bottom **FIGURE 1.10** Cylindrical vessel with ball game scene, Petén, Guatemala, Maya culture, 682–701 CE, Late Classic period. Ceramic, 8¹⁄₁₆ x 6¼ in. Dallas Museum of Art, gift of Patsy R. and Raymond D. Nasher, 1983.148. The red, orange, brown, and black hues on this vessel, showing lords of the Ik' kingdom playing ball, likely all came from clay slips containing hematite. Photo: Dallas Museum of Art/ HIP/Art Resource, NY.

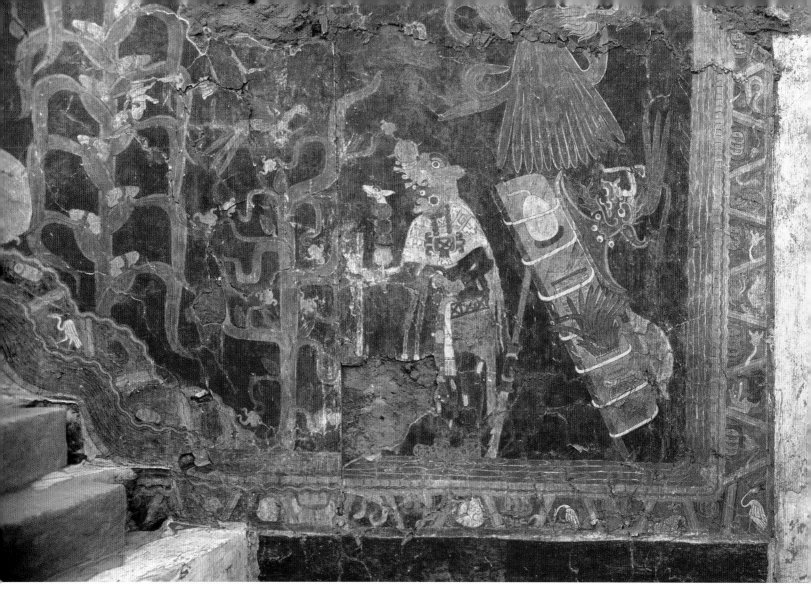

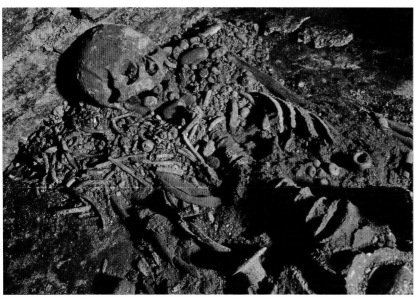

Above **FIGURE 1.11** Red Temple, Cacaxtla, Tlaxcala, Mexico, ninth century CE. In this scene, the hematite red background indicates a supernatural, underworld setting for an old merchant god and maize plants sprouting human heads. Scholars have suggested that the lowest bundle on the old merchant god's backpack may contain cochineal. Photo: Schalkwijk/Art Resource, NY.

Left **FIGURE 1.12** Interior of Margarita Tomb, Copan, Honduras, Maya culture, fifth century CE. As in so many Mesoamerican tombs, the body of the deceased—in this case an elite Maya woman, perhaps the wife of Copan's founding ruler—has been covered in a thick layer of cinnabar. Photo © Kenneth Garrett.

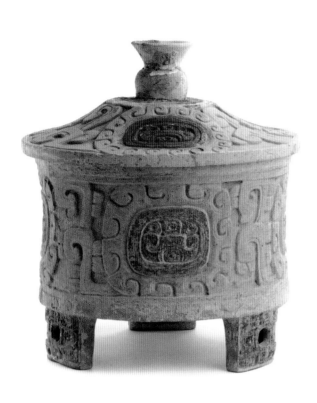

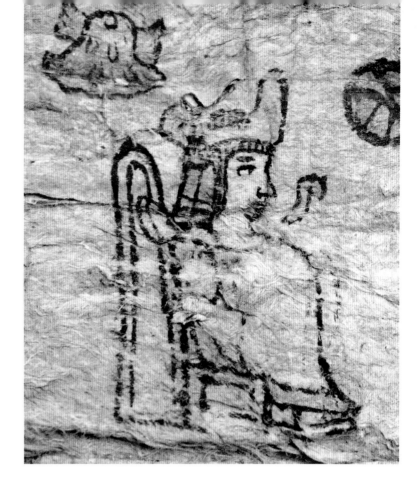

cochineal burn away; cinnabar sublimes; and many other minerals do not retain their colors.[23] But the behavior of iron oxides such as hematite and goethite when heated make them staples for pottery. They undergo dramatic color changes as they lose water during the firing process: yellows turn to reds, reds to browns, and browns to blacks. Painted onto vessels before firing as slips, or suspensions of fine clay particles in water, they account for the colorful designs on Mesoamerican pottery: most painted slips contain at least some hematite, and the red-orange-brown "earth tone" palette of most Mesoamerican ceramics owes its foundation to these pigments (figure 1.10).

Yet hematite was used on more perishable media as well. It was a color for red ink in painted books, especially in the Maya area, where it has been identified in the *Madrid Codex* and the *Grolier Codex*.[24] Hematite could not be used as a dye, but it could be painted directly onto the surface of textiles. Although it would rub off with repeated use when applied in this way, hematite is found painted on fourteenth- and fifteenth-century textiles from La Garrafa Cave.[25] Hematite and red ocher may also have been used as body paint.[26]

As hematite was abundant in the Mesoamerican world, it was easily available and applicable to a variety of surfaces. Pragmatics surely dictated much of the pigment's frequent use, but it could carry symbolic value as well. Because deposits of hematite- and iron oxide–containing red ochers often occur near rock outcroppings and especially caves, hematite retained a persistent association with the earth.[27] Its use as a background color in many mural paintings signified supernatural space, what Diana Magaloni Kerpel has termed "mythical time" in the context of Teotihuacan and Zapotec murals.[28] At the Red Temple at Cacaxtla, for example, the hematite-red background indicates an underworld setting for an old merchant god and maize plants sprouting human heads, a scene that takes place in the mythical past, before the start of the present era (figure 1.11).[29]

Above, left **FIGURE 1.13** *Lidded tripod vessel with carved decoration and cinnabar highlights, Hunal tomb, Copan, Honduras, Maya culture, ca. 437 CE. Ceramic, 8⅜ x 8½ in. Instituto Hondureño de Antropología e Historia, Centro Regional de Investigaciones Arqueológicas, Copan, CPN-C-1796. This vessel, found in the tomb of one of Copan's most famous rulers, combines a Teotihuacan shape with elaborate scrolling decoration reminiscent of the Gulf Coast. Cinnabar rubbed on the surface highlights the glyph-like cartouches and tripod supports of the vessel. Photo © Kenneth Garrett.*

■ *Above, right* **FIGURE 1.14** *Codex Reese, Mexico City, ca. 1565. Hand-colored map on amate paper, 39½ x 81 x 1¾ in. Yale Collection of Western Americana, Beinecke Rare Book and Manuscript Library, Yale University, WA MSS S-2533. Purchased from Frontier America on the Walter McClintock Memorial Fund, Edwin J. Beinecke Fund, Anna R. Butler Fund, and a gift from William Reese, 1975. Don Diego de San Francisco Tehuetzquititzin was the indigenous ruler of Mexico City from 1541 to 1554. In this detail from the map's left section, the winged shell glyph behind his head, which gives his name in Nahua hieroglyphic writing, is colored with both cochineal and cinnabar, although cochineal alone is the more usual red colorant in the map.*

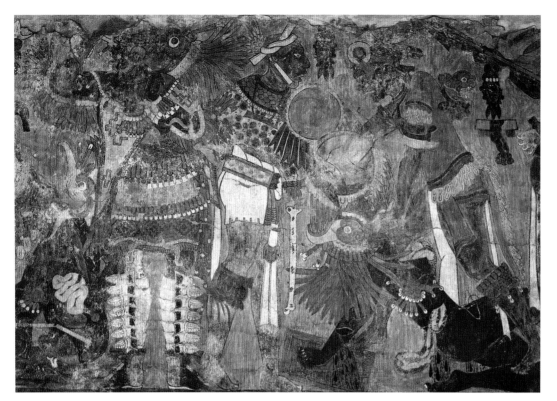

FIGURE 1.15 Battle mural, Cacaxtla, Tlaxcala, Mexico, ninth century CE. Instituto Nacional de Antropología e Historia, Mexico. The luxurious textiles worn by the standing figure on the left are painted with a red hue that combines hematite with an organic colorant, possibly cochineal. Hematite is also present in the other red and brown hues in the mural. Photo: Gianni Dagli Orti/The Art Archive at Art Resource, NY.

CINNABAR

The rarity and expense of cinnabar meant that its use could never be casual or incidental. Cinnabar, or mercury sulfide, has a bright red color; it becomes increasingly orange as the particles are more finely ground. Cinnabar occurs naturally in veins near places of recent volcanic activity, often alongside hot springs and deposits of liquid mercury. Manufactured cinnabar, sometimes called vermilion, can also be made from silvery liquid mercury, a process of alchemical transformation that must surely have affected its meaning for ancient Mesoamericans.[30] There are several sources of cinnabar in Guerrero, Querétaro, and Zacatecas in northwestern Mexico, in highland Guatemala, and in Honduras.[31] But for most people in Mesoamerica, cinnabar was a distant and exotic trade good.

Cinnabar had a persistent association with death and burial in Mesoamerica. As early as 900 to 400 BCE, at the Olmec site of La Venta, elite bodies and their grave goods were coated in quantities of cinnabar. Even more intriguing are cases where cinnabar and jade jewelry seem to have been interred without any trace of a human body.[32] Later Mesoamerican cultures also buried their elites with quantities of cinnabar, perhaps a continuation of Olmec practice.[33] In the Maya area, many royal tombs were lavishly coated with cinnabar, which was applied to bodies as well as to the outsides of mummy bundles, suggesting the belief that the pigment had some sort of preservative effect on the human corpse (figure 1.12).[34] In some cases, cinnabar seems to have been poured or painted on corpses—when mixed with water, the liquid would have looked like fresh blood.[35]

Cinnabar could also be used as a pigment on paper, frequently deployed in contrast with cochineal or hematite inks.[36] While cinnabar has no use as a prefire paint for pottery, it was occasionally applied to pottery after firing. It is the source of red and pink hues on stucco-painted ceramics at Teotihuacan and was rubbed into the surface of incised or relief-carved pottery throughout Mesoamerica to make the decoration more legible (figure 1.13). Cinnabar might also have been rubbed into the incisions of carved jades for the same effect.[37] Three stelae and an angular, abstract sculpture from the central Mexican site of Xochicalco are also coated with cinnabar, a brilliant—and expensive—variation on the Mesoamerican practice of coloring stone sculpture with hematite. In all of these contexts, the choice of cinnabar implied a display of wealth.

SEPARATE DOMAINS; MOMENTS OF CROSSING

Cochineal, hematite, and cinnabar had distinct domains and meanings. Cochineal was a material suited to perishable media—books, textiles, bodies—with medicinal as well as cosmetic functions. It was a versatile colorant, yielding a range of red and purple hues as an ink or dye. Hematite was prevalent on more durable media—architecture, stone, pottery—although it also had considerable use as a pigment for both books and textiles. Its color, too, was subject to manipulation, in this case by heating. Hematite's easy availability and relatively low cost made it an ideal colorant for all social stations and many purposes, unlike the more restricted ambits of cochineal and

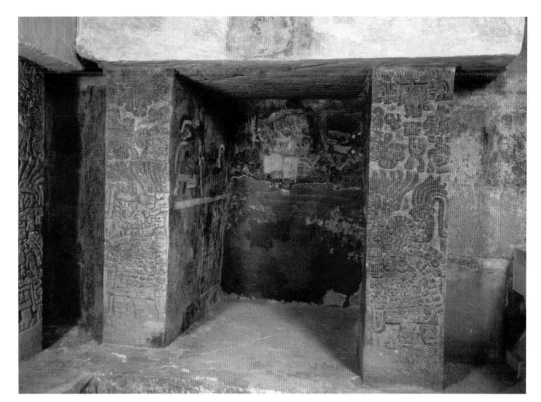

FIGURE 1.16 Tomb 5, Suchilquitongo, Oaxaca, Mexico, Zapotec culture, eighth century CE. Archive of the Project "la Pintura Mural Prehispánica en México," Instituto de Investigaciones Estéticas, Universidad Nacional Autónoma de México. Three different red pigments are used in this tomb. Zapotec red, combining cinnabar, hematite, and an organic colorant, is the background for the murals; hematite colors the bodies in the murals; and cinnabar is rubbed on the relief carvings and on the lintel above the antechamber. Photo: Direccíon General de Restauración, Instituto Nacional de Anthropología e Historia.

cinnabar. Although it found occasional use on pottery or sculpture, cinnabar long retained an association with elite burials, a special connection with the world of the dead.

Yet there were moments when each one of these three materials might be employed outside its familiar domains, used contrastively with a more familiar pigment in ways that carried significant material meaning, even when scarcely perceptible to the naked eye. This is the case on the early colonial *Codex Reese* (Beinecke Map), where the addition of cinnabar to a cochineal-red ink denotes a special status for a particular passage—the name glyph of one of Mexico City's indigenous rulers (figure 1.14).[38]

Examples of this kind of material semiotics will undoubtedly emerge in preconquest codices as their study continues, but at present, the most evocative pre-Hispanic examples are known from wall painting. At the Maya site of Bonampak, for example, cinnabar enlivens a hematite pigment in only one place in the murals of Structure 1: the band of text in Room 1 that records the dedication of the building. Here the rare and expensive pigment gives special emphasis to an important text. It may also hint at an association between cinnabar and writing.[39]

Cochineal could also be brought into the world of mural painting, precipitated onto a white clay substrate to form what is known as a lake pigment. The use of organic colorants to produce red lake pigments is known from the Maya area, from Oaxaca, and from Cacaxtla in the Puebla-Tlaxcala Valley.[40] Although the presence of cochineal—as opposed

to annatto or another red colorant—has not been definitively verified in any of these cases, one particular instance at Cacaxtla is most suggestive. Here an organic colorant is combined with hematite in a particularly luxurious passage of painting, the richly decorated textile band wrapped around a female figure's waist, perhaps hinting at textiles dyed with this very substance (figure 1.15).[41] Thus the colorant and the painted object may share the same substance.

Sometimes all three red pigments are used together, each still carrying distinct meaning. In Tomb 5 at the Zapotec site of Suchilquitongo in Oaxaca, carved relief sculpture and mural painting are integrated into a cohesive decorative program celebrating lineage and the ancestors (figure 1.16). As Magaloni Kerpel's research has demonstrated, the stone stela and stone relief carvings are rubbed with cinnabar, while the walls are painted with a very particular mixture of pigments known as Zapotec red. Combining an organic red lake, likely cochineal, with hematite and cinnabar, Zapotec red creates a color that is at once glistening and transparent in flickering torchlight, seeming to form an immaterial screen over the rock walls of the tomb. Against this evocative paint, the bodies of the ancestors painted on the walls are rendered in a simple hematite pigment, granting them a different kind of materiality than the rock behind them or the sculptures framing them.[42] Here, color and material converge to create a whole new kind of meaning.

2 RED AT COURT

Did the Maya at Bonampak Know Cochineal?

MARY MILLER

ALMOST EVERY PAINTED MALE OR FEMALE FIGURE in the three painted rooms of Structure 1 at Bonampak, a small Maya city in the Mexican state of Chiapas, features red somewhere in his or her attire. It may be as little as red *Spondylus* trim on a jade cuff. It may be in a large supernatural dragon's eye in a warrior's headdress. It may even be body paint. Only a few individuals seem to have red excluded from their costumes altogether. Notable among those who do not feature red are an enthroned ruler figure in Room 1, nearly naked captives in Room 2, and women in simple white shifts who sit on a green-and-red throne in Room 3. But by and large, we see red everywhere.

Within the three rooms, red backgrounds are the most visible. These generally are pictorial representations of walls that were themselves painted with hematite; so hematite is the logical pigment that painters deployed. Cinnabar was added to the red background of the major inscription of Room 1, which records the building's dedication, underscoring the preciousness of the script.[1] (See Brittenham, this volume). However, Diana Magaloni Kerpel's limited sampling reveals that it is likely that painters used hematite to depict the other reds throughout the paintings, even when representing red clothing, which would have been dyed or painted.

But in actuality, what were the lords and ladies of Bonampak using in 790 to make the reds they wore? To think about the red attire of the Bonampak court and to ask whether cochineal may have been in play, I consider two examples.

First, in Room 1, eight members of a musical band wear draping deer hides as part of their uniform; two trumpeters behind them wear shaggy, draping garments, perhaps old tattered and torn hides. Some of the deer hides are plain red, presumably dyed with color that did not affect the flexible hide. The trumpeters' garments are pink. One striking and otherwise solid red hide, located directly in front of the large drum player, features a painted, multicolored serpent (figure 2.1). The leader's hide depicts a wind god seated upon a deified water lily in the color scheme of a codex-style vase: brown on cream with red trim. Just as the wind sweeps the ground for the rain, the leader seems to clear the way for his followers.

Second, in Room 2, two women, the wives of Yahaw Chan Muwaan, king of the city, stand in rapt attention on the

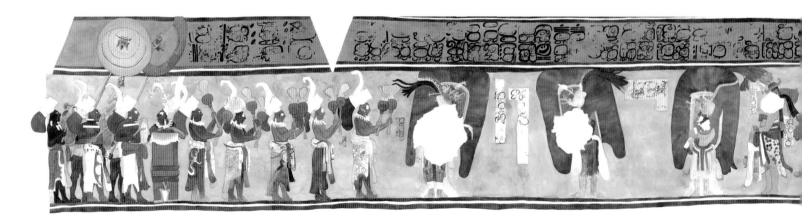

north wall. Poised on the top riser of a flight of stairs, they turn, one with frontal body and one in full profile, to address the king (figure 2.2). Around and below him, captives are arrayed on steps in states that range from resistance to the silent passivity of death. The king's chief wife is named as an *ix ajaw,* or female lord, in the text directly over her head, her status emphasized by her frontal posture. The woman in profile is an *ix sajal,* a secondary rank. Nevertheless, their costumes are identical: both women wear a simple, white, off-the-shoulder *huipil* (tunic) with a visible underskirt that falls to mid-calf. One might well see such an outfit on the streets of Mérida or Ticul today. What would never be seen is the large, handsome, solid red cloth with blue trim draped heavily over each woman's right arm, its thick folds indicating that the material is something other than the light, delicate cloth of the white dresses.

The solid red cloths of Bonampak are the only such depictions in ancient Maya art. Their juxtaposition against the women's white *huipiles* invokes the viewer to contemplate concepts of purity and menstruation in the context of human sacrifice. Below the women, beyond the reach of their bodies but not out of sight, are the bodies of captives, whose blood spurts, arcs, and falls in chaotic droplets. The representation of the two royal women and the careful separation of their white dresses and red cloths underscores their control of their bodies and the absence of captive blood.

The red cloths of the women and the red deer hides of the musicians provide two very different contexts, and two visibly distinct substrates, for a red pigment. The painter may have used the same material throughout his facture or may have selected different pigments to distinguish between the cloths and the deer hides; no study currently informs the modern viewer. Nevertheless, the red deer hides are depicted in a way that emphasizes smoothness; the soft buttery surface of a smooth hide suitably supports large-scale imagery delineating both monochromatic calligraphic renderings and rich polychrome forms. The thickness of the women's cloth is denoted by the way it gathers in their hands.

MAYA MASTERS OF COLOR

How did artisans make the reds in which these members of the court are portrayed? Were they dyed or painted? And were the Maya using cochineal in the late eighth century, at the time of the Bonampak paintings?

As Magaloni Kerpel has demonstrated, an Early Classic tomb at Monte Alban, Oaxaca, featured a probable blend of cinnabar, hematite, and cochineal, a mixture that would have borne meaning in its mixed materiality.[2] This early evidence of cochineal confirms its long-standing use in the region: shortly after the Spanish invasion in the sixteenth century, Oaxaca became a center of cochineal production, though its cultivation was already in place.

Some sources dispute the possibility of any significant Maya production of cochineal in any era. Robert Patch writes that Governor Antonio de Layseca's agents required cochineal in the 1670s but that none could be produced in Yucatán.[3] Raymond Lee cites a 1566 letter to King Philip II noting a failed attempt to raise the nopal cactus in Yucatán: due to excessive drought, the cactus simply shriveled and died.[4] Yet Lee also points out that *grana* (cochineal) was produced in Chiapas and supplied as a tributary good.

Reviewing what can be gleaned about Maya use of cochineal from Spanish colonial documents, the Xiu family papers, written in 1665, offer a compelling counterpoint. Here Don

FIGURE 2.1 Room 1, Bonampak, Mexico, Maya culture, 792 CE. Detail of musical band (bottom, right). Reconstruction, Yale University Art Gallery, gift of Bonampak Documentation Project, illustrated by Heather Hurst and Leonard Ashby.

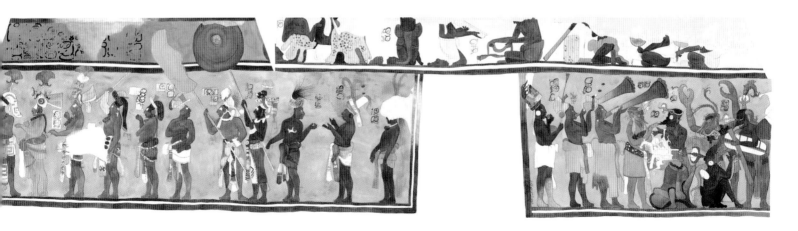

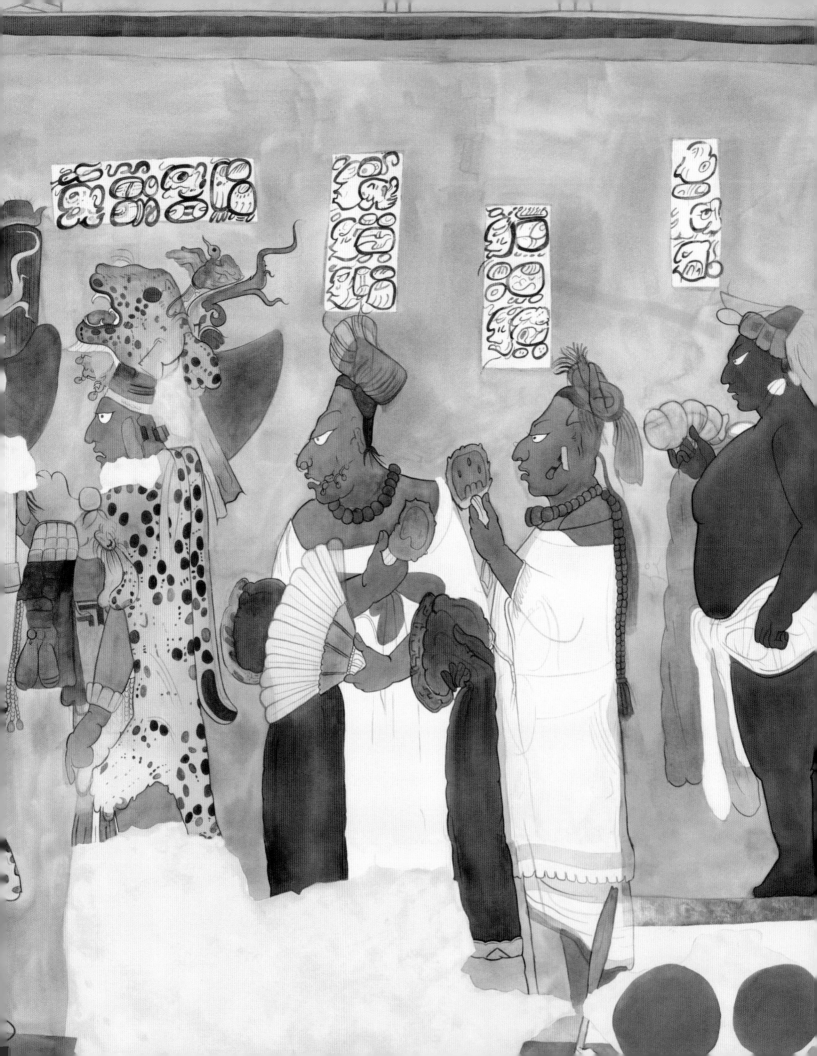

Juan Francisco de Esquivel writes, "I order that he [Juan Xiu, governor of Oxkutzcab] permit the Indians as to everything they produce beyond the amount of the tribute, with their gatherings of wax, honey, cochineal and fruits, a free sale by them in the town, or in the city and villages of Campeche and Valladolid, to whomever will pay them best, to the end that they may have money for their needs and the things they require for apparel."[5] Surely this suggests that some Maya had sufficient cochineal to sell to other Maya once the tribute was paid.

Furthermore, although some colonial records indicate that the nopal cactus may not have thrived in Yucatán, the nopal cactus can, in fact, do very well there. In 2011 the Mexican secretary of agriculture and fisheries proposed turning over hectares of henequen—the cash crop that dominated Yucatán from 1876 until modern times—to nopal. That process is now under way, with public health messages urging families in Yucatán to adopt consumption of the delicious and healthy nopal paddles. Fields of nopal dot the Yucatán landscape today. Because the goal is to yield foodstuffs rather than dyestuffs, farmers work to prevent the cochineal insect from disfiguring the plant or reducing its edible value.

Given that cochineal was known in Oaxaca well before the date of the Bonampak paintings and that the Yucatán environment lends itself to the cultivation of the nopal cactus, it is likely that the Maya at Bonampak were familiar with the powerful, durable cochineal pigment—and that it was a valued trade good in the eighth century. Yucatán was long a center of production of honey, wax, salt, and cotton, none of which leave evidence in the archaeological or epigraphic record, as well as of the critical palygorskite clay required to make "Maya blue" pigment. The Bonampak painters managed Maya blue, hematite, and cinnabar with ease as they delineated the murals themselves. Although cochineal may not have been used for painting the wall, would the Maya lords of Bonampak have used the dyestuff to yield some of their red colors for other elite use?

Dyeing cotton cloth with cochineal is not an easy process; the powerful pigment bonds most effectively with protein-rich fibers, such as the wools and silks that arrived in Mesoamerica with the Spanish invasion. The thick cloths held by the two women in Room 2 would have been made of cotton, the fiber of almost all woven fabric depicted in the paintings. Accordingly, the red cloths would probably have been dyed with another dye—perhaps logwood, less known to us today but of high value, requiring a year of preparation before use.[6]

But what about the deer hides? Bernardino de Sahagún notes that a purified cochineal was particularly suited to dyeing rabbit hides.[7] It certainly would have been the appropriate and most effective permanent dye, and of great value, for a deer hide, in itself a valued item. And given the long-lasting bond cochineal forms with animal skins and hides, the dyed hide would have lasted for generations, unlike more transitory cotton fabrics.

Lamentably, we will probably never see eighth-century garments of the sort depicted at Bonampak, except in their pictorial representation. But the Bonampak painters were masters of color, using more distinct pigments than in any other work of the pre-Hispanic past in Mesoamerica. There is every reason to believe that any dye known in any era would have been available to the masters at Bonampak as well.

Opposite **FIGURE 2.2** Room 2, north wall, Bonampak, Mexico, Maya culture, 792 CE. Detail of the wives of Yahaw Chan Muwaan (center). Reconstruction, Yale University Art Gallery, gift of Bonampak Documentation Project, illustrated by Heather Hurst and Leonard Ashby.

3 THE POLITICS OF *NOCHEZTLI*

The Florentine Codex and the Nahua World of New Spain

DIANA MAGALONI KERPEL

THE DEEP AND BRIGHT RED OF COCHINEAL was called *nocheztli* in Nahuatl, the language spoken in central Mexico by the Aztecs and their neighbors before the arrival of Europeans. According to the *Historia general de las cosas de Nueva España (General History of the Things of New Spain)*, also known as the *Florentine Codex* (1575–1577)—a twelve-volume encyclopedia about the life and culture of Nahuatl-speaking peoples before and after the conquest—*nocheztli* derives from the words *nochtli* (prickly pear cactus fruit), referring to the pads of the cactus where the cochineal insect is cultivated, and *eztli* (blood), because its crimson-colored dye looks like fresh blood.[1] Both aspects seem to have ulterior significance, for each is somehow connected to the founding of the great Aztec city of Mexico-Tenochtitlan and its imagery of blood and sacrifice.

The sixteenth-century Spanish chronicler Fray Diego Durán recounts in his *Historia de las Indias de Nueva España e Islas de Tierra Firme (History of the Indies of New Spain, Mainland and Islands)* of 1587 that the great Aztec warrior Cuauhtlequetztli was ordained by the Aztec deity Huitzilopochtli to slay Copil, who had betrayed the Aztecs; rip out his heart; and throw it in the middle of the lake. Durán's passage "Out of this heart sprouted the prickly pear cactus where later the city of Mexico-Tenochtitlan was built"[2] was carved by Aztec artists into a magnificent monument, the Teocalli of Sacred Warfare (circa 1507–1519), today held in the Museo Nacional de Antropología in Mexico City (figure 3.1). On the back of the Teocalli, which looks like a miniature temple, an amazing prickly pear cactus grows from the open mouth of a skeletal being. The skull might be that of Copil, as a vanquished powerful enemy sacrificed to Huitzilopochtli's temple. But while the cactus branches, made of spiny pads, appear to be shaped as flowered pears, they are in fact the fruits of sacrifice, exhibiting the conventional shape of a human heart in

the Aztec tradition—round and elongated with two undulating parallel lines in the center.

By casting the cactus pears as human hearts, the artist who conceived the emblem of Huitzilopochtli's vision in the Teocalli reiterated the triumph of the Aztecs over their enemies: a powerful eagle representing the Aztec sun deity (probably an avatar of Huitzilopochtli) grips the hearts of its foes and emits the sound *atl tlachinolli* (burning water), the metaphor for a sacred conflagration, a creative, foundational war. In this manner the prickly pear cactus is associated with the founding of Tenochtitlan, representing the Aztecs' Cosmic Tree.[3] Thus cochineal, in its name *nocheztli*, meaning "prickly pear cactus fruit/blood," is very likely charged with significance associated with the city, its territories, and the sacrifices made to preserve it.

The image of *nocheztli* appears in Book 11 of the *Florentine Codex*, devoted to the natural history of New Spain. The book dedicates chapter 11 to "the ways in which all colors are made," and it seems to support this claim. I refer to this chapter as the *Nahua Painting Treatise* because it details the materials that Nahua painters in sixteenth-century Mexico were manufacturing to maintain their most revered tradition of keeping and creating knowledge, referred to in Nahuatl as "*in tilli, in tlapalli*."[4] Literally translated, this concept means "the black, the red" or "the black, the many colors," since *tlapalli* was a name for the color red that could also be used to designate all colors. Thus, in the Nahua worldview, knowledge was equated with the materials used to record it: the black of the contour lines of the figures and motifs that were

Opposite **FIGURE 3.1** Teocalli of Sacred Warfare (back), Mexico, ca. 1507–1519. Volcanic stone, 48²⁷⁄₆₄ x 36⁷⁄₃₂ x 39³⁄₈ in. Museo Nacional de Antropología, Mexico City. Photo: Proyecto de Digitalización de las Colecciones Arqueológicas, courtesy Instituto Nacional de Antropología e Historia.

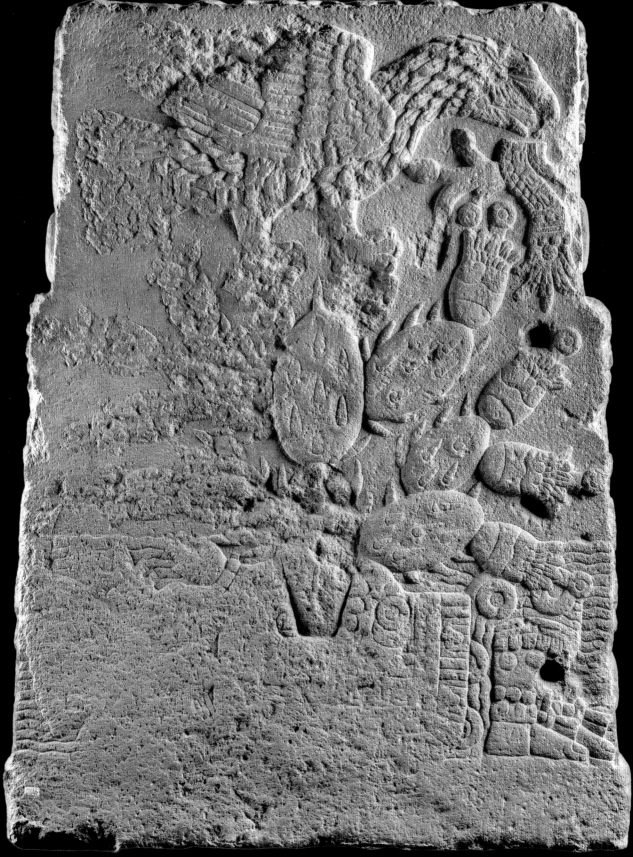

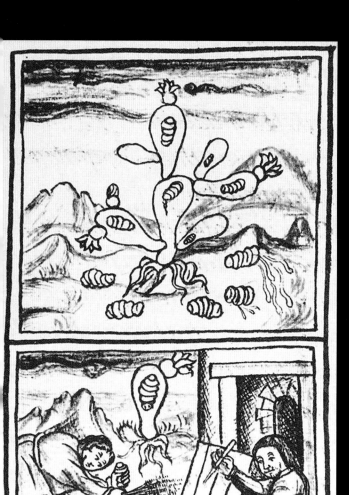

used as writing and the colors that illuminated them. In this view, the significance of cochineal is in its redness. What was painted red was probably equal in nature to anything colorful, illuminated, filled with energy.[5]

In the *Nahua Painting Treatise*, the first color mentioned is *nocheztli*. The ink drawing illustrating the text is divided into two frames (figure 3.2). In the upper section, a prickly pear cactus is shown against a mountainous landscape, covered with cochineal. The lower image shows the harvesting and killing of the bugs and an artist painting with the colorant they produce. Upon closer examination, the whole image is charged with important references. The cactus is drawn with all the traditional elements that make a tree an axis mundi, a central connection between heaven and earth: its roots belong to the underworld; its trunk represents the surface of the earth; its branches have fruits and flowers.[6] Flowery trees are associated with the concept of a bountiful and powerful city, as well as with the rituals of sacrifice that conserving that power entails. Clear examples are seen in the mural paintings in Tepantitla, Teotihuacan, circa 650 CE, in which flowery trees and reeds, as well as a ball game and a sacrifice, show Teotihuacan as a bountiful, sacred place.[7]

The cochineal insects in the drawing are shown in different stages of development, from small ones to those that have detached from the pads and are oozing red dye like blood. In the background are the famous mountains, Iztaccihuatl on the left and the Popocatepetl on the right. The two peaks are essential to the identity of Mexico City. Since the early sixteenth century, they have marked the territory of Mexico-Tenochtitlan, as shown in one of the most significant images of the conquest in Book 12 of the *Florentine Codex* (figure 3.3). The painting serves as a portent in the context of the history of the conquest because we see Hernán Cortés's army descending into the Valley of Mexico through a passage between these two iconic mountains. Why would Nahua artists have depicted *nocheztli* amid these mountains in the *Nahua Painting Treatise*? Their doing so certainly associated the image with the identity of Mexico-Tenochtitlan and its territories, both in the past, when the Aztecs ruled those lands, and in the present of New Spain.

The complexities of cochineal cultivation during the years of turmoil in the aftermath of the conquest are described by writers of the local Council of Tlaxcala (1545–1627). From the early 1520s to the 1540s, cochineal production flourished, as

■ FIGURE 3.2 Bernardino de Sahagún, *Florentine Codex*, Mexico, 1575–1577. Ink on European paper, 12⅝ x 8¹¹⁄₁₆ in. Biblioteca Medicea Laurenziana, Florence, Italy, Ms. Mediceo Palatino 220, book 11, folio 368v.

many local farmers chose to produce the dye to earn a living and abandoned the cultivation of maize. By the 1550s, however, the indigenous Council of Tlaxcala had prohibited the cultivation of cochineal "since the commoners' specializing in cochineal to the exclusion of food crops, and their consequent idleness, make disaster likely if famine should strike."[8] The concern of the native *cabildo*, or council, with the cochineal trade was multifaceted. On the one hand, members were preoccupied that the trade allowed many former commoners to acquire luxuries once reserved for the nobility: fine cloth, luxury foods, and chocolate. On the other, they were fearful that the concentration on cochineal production would result in famine, for it was already responsible for the high prices of staples that were no longer being farmed.

Nonetheless, cochineal was without doubt a source of pride and an economic resource for the Nahua in the postconquest world. By around 1577, when the image was created for the *Florentine Codex,* cochineal was well known worldwide. Indeed, the description in Spanish for *nocheztli* in Book 11 says that cochineal was exported to "China and Turkey, and almost the whole world."[9] The painting's portrayal of how cochineal was found in nature, and how it was exploited, shows how *nocheztli* brought together both the glorious Aztec past and the promising present of the Nahuas in New Spain. The image is as much a political emblem for the Nahua in New Spain as the fantastic prickly pear cactus with sacrificed hearts of the Teocalli of Sacred Warfare must have been for the Aztec rulers.

A pigment of Mesoamerica that had the power of coloring the world, cochineal seems to have been at the center of social tension locally and between the Old and New Worlds. The *Florentine Codex* is a magnificent work that casts the tension in a uniquely artistic and informative manner: written in parallel columns in both Nahuatl and Spanish, the work literally and figuratively contrasts both worldviews. The twelve volumes are lavishly illustrated with a series of freehand paintings colored with all the natural dyes and mineral pigments that conformed to the indigenous painting tradition in sixteenth-century Mexico. Cochineal is, of course, central to the tradition and to the culture from which it evolved. It is a color for worlds old and new.

FIGURE 3.3 Bernardino de Sahagún, *Florentine Codex*, Mexico, 1575–1577. Pigments on European paper, 12⅝ x 8¹¹⁄₁₆ in. Biblioteca Medicea Laurenziana, Florence, Italy, Ms. Mediceo Palatino 220, book 12, folio 115r.

TRADITION AND INNOVATION
Cochineal and Andean Keros

ELLEN PEARLSTEIN, MARK MACKENZIE, EMILY KAPLAN, ELLEN HOWE, AND JUDITH LEVINSON

KEROS, WOODEN CEREMONIAL DRINKING vessels from the Inca and colonial Andes, have been the subject of a long-standing study by the current authors and scientific collaborators.[1] Keros from the Inca period (1425–1532 CE) are simple, decorated with incised geometric designs and few, if any, applied colors (figures 4.1–4.2). Those dating to the Spanish colonial period are identified by an extensive color palette, elaborate narrative, and geometric designs (figure 4.3). While the woods used to create the vessels, and the materials used to bind the paint particles, are indigenous to South America, pigment studies conducted on keros by the same group of collaborating authors reveal material exchanges with Spain during the important contact period (1530–1750 CE).[2]

Cochineal has a long history in the pre-Columbian Americas as a textile dyestuff. But cochineal used on keros requires a lake pigment, created when carminic acid, a water-soluble red dye derived from cochineal insects or extracted from cochineal-dyed textiles, is precipitated onto a metallic salt to form particles. In a study group of twenty-three colonial Andean keros, a purplish-red colorant identified as containing carminic acid was found used alone or mixed with other pigments (figures 4.4a–4.4b). A smaller group with purplish areas of decoration does not show evidence of carminic acid, indicating that varied colorants were capable of producing similar appearances and that visual analysis alone is an unreliable indicator. New pigment replication studies, kero sample analysis, and emerging information about the distribution and development of carminic acid colorants in the Americas indicate that the use of cochineal as a lake pigment on these and other keros developed in the early Spanish colonial period and was based on recipes from Spanish sources.

CARMINE COLORANTS IN THE AMERICAS

American cochineal's rich history as a textile dye begins with its use in the Middle Horizon period in Peru (600–1000 CE).[3] The earliest pictorial and written references to the dyestuff date to the sixteenth century. Mexican codices—including the *Codex Mendoza* from 1542,[4] the *Florentine Codex* from 1576–1577,[5] and the *Cuatro libros de la naturaleza* from 1575[6]—describe the importance of cochineal as a form of tribute in the sixteenth century and the rich colors made possible through its use. Chroniclers in Peru—Bartolomé de las Casas (1527–1549) and Bernabé Cobo (1653)[7]—document uses of cochineal, referring to a variety of alum mordants, such as aluminum potassium sulfate salt, used to chemically bond the colorant to textile fibers.

Father Francisco Ximénez, writing in 1575,[8] describes the addition in Mexico of a decoction of *tézhoatl* leaves, of the *Miconia* species (possibly *Miconia chrysophylla* [L.C. Rich.] Urb. in Peru),[9] to the production of cochineal. Called *tiri* or *tire* in Peru, *Miconia* leaves are noted to be natural sources of alum.[10] In 1601 in Spain, Antonio de Herrera y Tordesillas described cakes of carminic acid and *tézhoatl*, plus additional alum, as being used by painters and by women to paint their faces.[11] More recently, Diana Magaloni Kerpel, extrapolating from Bernardino de Sahagún, proposed a mixture of carmine colorant, orchid agglutinant, and alum as a stable colorant for the *Florentine Codex* in particular and for pre-Hispanic Mexican codex painting in general.[12]

Opposite, left FIGURE 4.1 Inca kero, Ollantaytambo, Peru, ca. 1537. Wood, plant resin, pigment, 6 in. height x 3½ in. rim diameter. Universidad Nacional de San Antonio Abad del Cusco, Museo Inka, Mo MAC 5/738. Luis A. Llanos excavated this kero at the Ollantaytambo site in 1936. Photo courtesy Dr. Jorge Flores Ochoa.

Opposite, right FIGURE 4.2 Inca kero. Wood. National Museum of the American Indian, 17/7382. Photo: Ernest Amoroso.

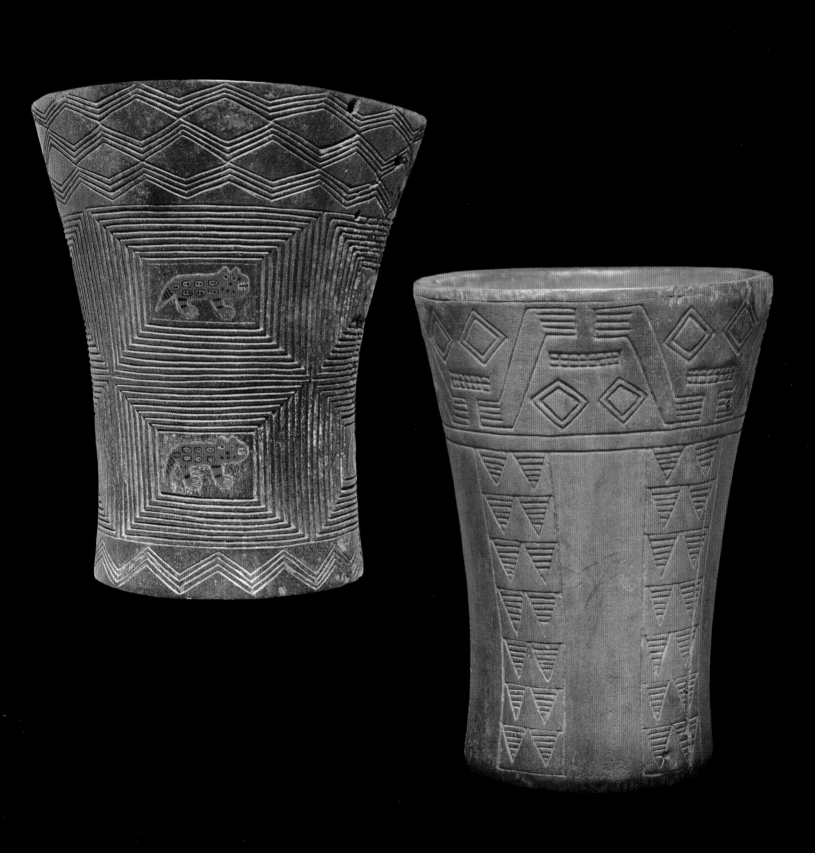

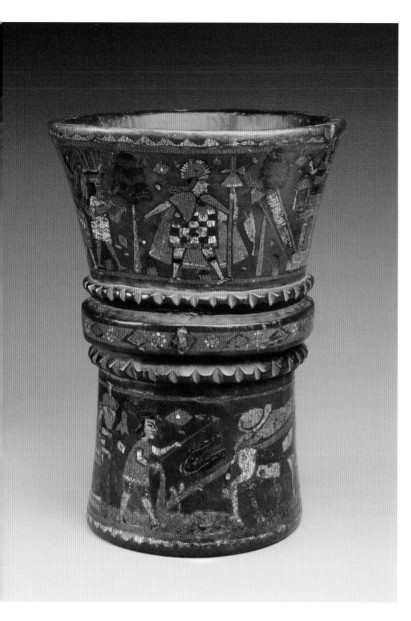

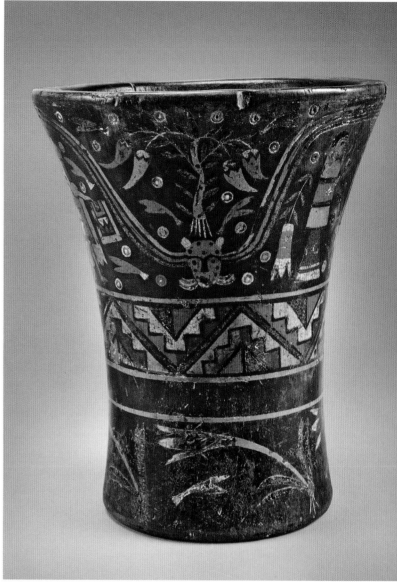

Above **FIGURE 4.3** Kero with typical pigment inlay, Peru, seventeenth to eighteenth century. Wood, plant resin, pigments, 7⅞ in. height x 6⅛ in. rim diameter. Brooklyn Museum, A. Augustus Healy Fund, 42.149.

■ *Right, top and bottom* **FIGURES 4.4A–4.4B** Kero, Peru, seventeenth to eighteenth century. Wood, plant resin, pigments, 8⅜ in. height x 6⅞ in. rim diameter. Private collection. Detail of carmine lake pigment used to create the purple-red stepped design on the right.

The addition of alum to carminic acid solutions does not guarantee that a lake pigment will be produced, however. The production of pigment particles depends on additional ingredients, including alkali calcium salts, to adjust the solution pH. While multiple historic carmine lake recipes have been transcribed, no single pH for lake production has been recorded.[13] Beginning in the thirteenth century, European artists developed technologies to produce lake pigments.[14] According to a description by Italian author Girolamo Ruscelli, publishing under the pseudonyms Piamontés and Piamontese,[15] Italian lake pigments were produced by extracting kermes, another insect-derived red dye, from dyed textiles. This process involved boiling 1 pound of scarlet textile in bleach or urine, filtering the colored liquid through cloth, and precipitating the colorant with 5 ounces of alum.[16] The pigment would then be formed into cakes or balls and dried in the shade, never in the sun.[17] A method for producing carmine lake pigment directly from insects, without extracting the dye from textiles, is credited to Antonio Neri in Italy in 1612.[18] Colorants based on carminic acid were found interchangeably with true lakes during early days of cochineal development throughout Europe.[19]

The absence of carmine lake as a pre-Columbian pigment and its presence on early postcontact codices from Mexico and South America suggest that carmine lake use in the Americas was tied to European influence. Indeed, pigments found on sixteenth-century Mexican codices with porous supports, including deerskin and amate (bark paper), confirm dated use of carminic acid as a colorant for nontextile decoration.[20] (See Anderson, this volume.) Colorants based on cochineal seem to have been so common on codices that researchers of the *Madrid Codex* remark, as if surprised, that organic reds are absent.[21] The J. Paul Getty Museum's Martín de Murúa manuscript, *Historia general del Piru*, the only Andean document to be analyzed scientifically, also shows unconfirmed evidence of organic red colorants, and Murúa mentions cochineal in his text.[22] And in his roughly contemporaneous illustrated chronicle of Andean peoples after the conquest, Felipe Guamán Poma de Ayala notes Inca regard for cochineal as a significant commodity.[23]

The use of cochineal lake pigments in Cuzquean and Altoperuvian regional oil paintings from the eighteenth century has also been confirmed by Gabriela Siracusano and collaborators.[24] (See Siracusano and Maier, this volume.) Cochineal lake is found on signed and dated paintings from 1764 in the cathedral of Humahuaca in Jujuy province in Argentina. There the pigment is used both in mixtures and as a glaze over vermilion, iron oxide, and ceruse.[25]

REPLICATION EXPERIMENTS USING COCHINEAL

Building on methods developed for the earlier study of colonial Andean keros, replication experiments were conducted using estimated proportions of dye ingredients documented in the sixteenth- to seventeenth-century Americas: cochineal insects, alum, a decoction of *Miconia laevigata* leaves as an analog for *tézhoatl*, and calcium hydroxide as a source for alkalinity (see appendix, table 4.1).[26] Not surprisingly, the alkalinity produced by calcium hydroxide was found necessary to precipitate pigment particles. Mixtures lacking this alkali produced brilliant solutions of varying color depending on ingredients and proportions, demonstrating that carminic acid can produce richly colored solutions, ranging from red-orange to purple, even if a lake pigment precipitate (particles) is lacking. The binding medium identified in thirty-six keros, and estimated for a larger study set, is a plant resin derived from the *Elaeagia* species.[27] This complex resinous mixture does not mix with aqueous carminic acid solutions; instead, solid pigment particles formed by a carmine lake are necessary to tint the resin.

Contemporary artists in Pasto, Colombia, create decorative surfaces on myriad wood forms using a related resin exuded from the plant *Elaeagia pastoensis*, known as *barníz de pasto* or *mopa mopa*. Complex preparation includes heating the resin in water, kneading in powdered pigments, and manipulating the mixture to create small colored inlays. Freshly collected *mopa mopa* was prepared following these techniques, and it was found to be hydrophobic, or impossible to mix with aqueous colorant solutions. Therefore, while aqueous binders such as gums or orchid glues are compatible with carminic acid solutions, colorants applied in *mopa mopa* require a powdered pigment. Incorporation of carmine pigments into the decorative program of keros thus points to development of a reliable lake technology, likely following the dissemination of artistic guidelines from Spain.

Applying knowledge gained about pigment mixtures from earlier analyses of keros to current replication studies, we prepared samples using *mopa mopa* and precipitated carmine lake for evaluation with and without lead white pigment. A purple-gray colorant resulted from the mixing of *mopa mopa*, which is green, with purple cochineal. Mixtures including white pigment plus carmine lake result in a gray-brown colorant. The colors closely resemble samples taken from keros, providing support for accurate replication.

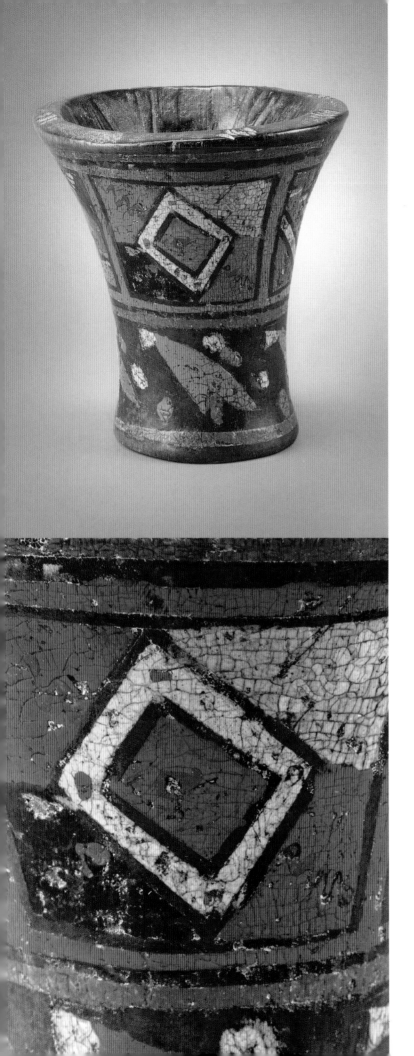

CARMINE PIGMENTS ON KEROS

Looking solely for scarlet red passages on keros as evidence of cochineal is misguided, as carmine lake decoration is found in areas of transparent purple, opaque gray-purple, pink, or peach. More ubiquitous is the red-orange hue provided by cinnabar or vermilion, often found on the same vessels. In an earlier study by collaborators Richard Newman and Michele Derrick of samples from fifty-three keros using polarized light microscopy, twenty-nine were found to include cinnabar or vermilion while nine samples were found to include organic reds.[28] Of these nine samples, three were confirmed by high-performance liquid chromatography (HPLC) as containing carminic acid.[29]

In the present study, microsamples were either reused from this earlier study or newly sampled from thirty-one keros, twenty-three of which provided evidence of carminic acid in purplish-red regions analyzed using HPLC.[30] Seven of these purplish-red regions were analyzed by x-ray fluorescence (pXRF).[31] While aluminum was too light to be detected with the instrument parameters, calcium, a common element detected in carmine lake pigments, was found in substantial to trace amounts.

CHOOSING CARMINE LAKE COLORANTS FOR KEROS

By the seventeenth century, Francisco Pacheco, a Spanish painter and author of *Arte de la pintura*, was advising artists about how best to use carmine lake pigments. Pacheco describes use of carmine as well as vermilion ground in oil, used both separately and together in paintings to depict velvet, scarlet textiles, and textiles dyed with cochineal. He also explains in great detail the addition of litharge (an opaque lead oxide pigment) to carmine, the benefits of sometimes using carmine in transparent glazes over vermilion to shift that pigment's appearance, and carmine's effectiveness for the creation of shadows.[32]

■ *Left, top and bottom* **FIGURES 4.5A–4.5B** Kero, Peru, seventeenth to eighteenth century. Wood, plant resin, pigments, 3⅜ in. height x 3¼ in. rim diameter. Private collection. Detail shows brilliant cinnabar or vermilion red areas; carminic acid lake pigment is identified in the lower left dark purple quadrant surrounding the diamond.

■ *Opposite* **FIGURE 4.6** Kero, Peru, seventeenth to eighteenth century. Wood, plant resin, pigments, 5⅜ in. height x 4¾ in. rim diameter. Private collection. Detail shows carminic acid lake pigment identified in the flesh tones and purple trousers of a male figure seated at a table.

Carmine lake used on keros is consistent with Pacheco's recommendations, which utilize the distinct properties of this pigment. It is favored for its transparency, functioning both as a glaze over the wood and as an opaque pigment on *tocapu*, concentric geometric symbols that are also prevalent on Inca textiles (figures 4.4a–4.4b and 4.5a–4.5b). It is more frequently used in mixtures for the depiction of skin tones (figure 4.6) and pink tonalities in flowers (figures 4.7a–4.7b), often with lead white and vermilion, as confirmed through pXRF analysis by the presence of lead and mercury, respectively. Such mixtures are also found depicting textured garments (see figure 4.6) and animal fur and hair (figures 4.8a–4.8b). The purplish-brown color of numerous garments was identified as being carmine, as in the case of a man's tunic (figures 4.9a–4.9b). A cross-section taken from this tunic indicates fading of the pigment colorant over time from a more brilliant purplish red.[33] Carmine lake pigments vary in photochemical stability, depending on the method of manufacture.[34]

KEROS AND QUESTIONS FOR THE FUTURE

While keros remain important symbols of Andean power and tradition, the application of carmine lake pigments shows a willingness of Andean artists to adapt and innovate with European methods of using an indigenous dyestuff as a postcontact pigment. Indeed, the appearance of carmine colorants on Andean keros suggests a well-developed understanding of lake technology. Artists' application of carmine lake pigment as glazes on keros, such as in *tocapu*-like motifs, and in mixtures with other pigments depicting animal fur, textured garments, and skin tones, further points to Pacheco's advice about pigment use in his influential Spanish painting treatise.

Though cochineal is a pigment utilized in various ways, this targeted examination confirms its wide presence as a colorant on Spanish colonial keros and one that is almost unrecognizable if looking only for a scarlet red color. For example, questions arise about the detection on multiple keros of carmine lake colorants used in broad transparent purple backgrounds surrounding inlaid designs. Such applications differ markedly from the discrete inlay method identified by the

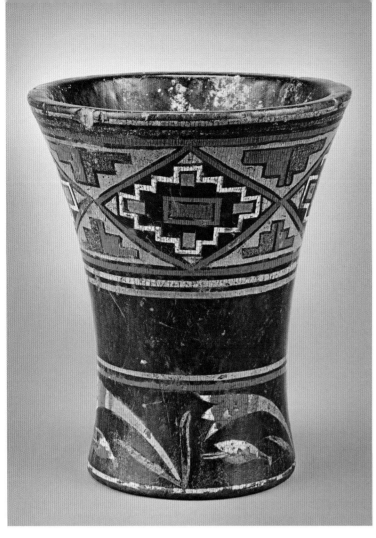

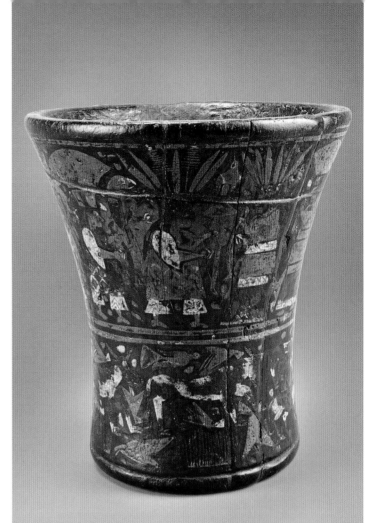

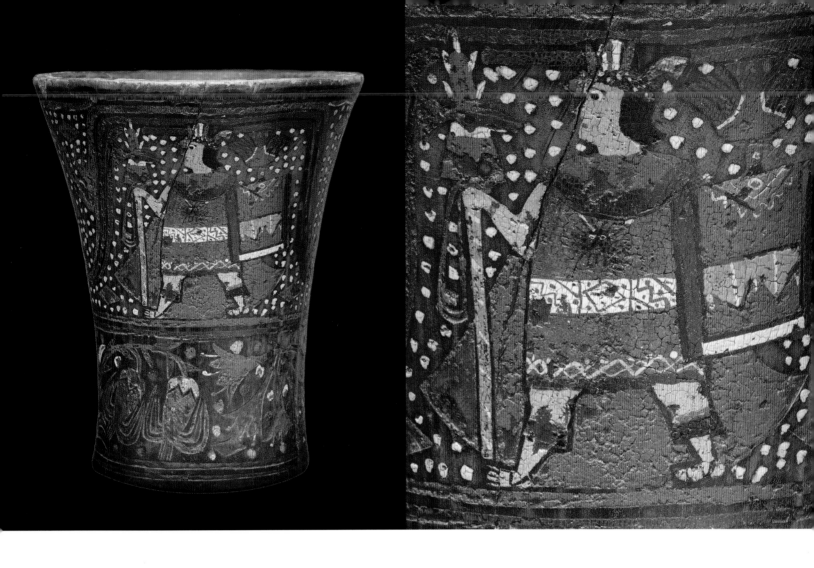

authors as typifying kero decoration and may indicate a departure from *mopa mopa* decoration.

Organic red colorants found on sixteenth-century maps and codices produced in Mexico and Peru already demonstrate the use of cochineal as a pigment in the Americas. But further study of carmine colorants on documents produced on porous supports might provide evidence of intermediate processing steps before the full production of lake pigments. In addition, the presence of a lake pigment may be more clearly pinpointed if carmine lake metallic salts, and not just carminic acid, are identified in early post-Spanish South American polychrome.

Stability of carminic acid colorants when exposed to light is another important subject for further investigation. For example, how does light-induced change influence the appearance of cochineal on keros? Lightfastness is influenced by both pigment preparation and binder properties. Replicas of traditionally prepared carmine lake pigments with *mopa mopa* are providing experimental samples for light aging to better assess the appearance of cochineal on keros. 🔲

■ *Opposite, left, top and bottom* **FIGURES 4.7A–4.7B** Kero, Peru, seventeenth to eighteenth century. Wood, plant resin, pigments, 6⅝ in. height x 5⅝ in. rim diameter. Private collection. Kero with geometric designs at the top and flowers at the base. The lower flower includes carmine lake pigment mixed with lead white (estimated) in the upper pink bud. Detail of the flower bud on the opposing side shows where existing losses enabled sampling.

■ *Opposite, right, top and bottom* **FIGURES 4.8A–4.8B** Kero, Peru, seventeenth to eighteenth century. Wood, plant resin, pigments, 7 in. height x 6½ in. rim diameter. Private collection. Detail depicts where carminic acid lake pigment was identified in the fur of a monkey surrounded by traditionally clothed Incas with plumed Indians and parrots.

Above, left and right **FIGURES 4.9A–4.9B** Kero, Peru, seventeenth to eighteenth century. Wood, plant resin, pigments, 7 in. height x 6 in. rim diameter. National Museum of the American Indian, 16/3605. Detail shows where carminic acid lake pigment was identified in the purple-brown garment of an elaborately dressed Inca. Photo: Ernest Amoroso.

PART 2

EMPIRE & EXPLOITATION

Cochineal & Global Trade

THE COCHINEAL COMMODITY CHAIN

Mexican Cochineal and the Rise of Global Trade

CARLOS MARICHAL

THE HISTORY OF MEXICAN COCHINEAL over several centuries represents a key chapter in the origins of early modern globalization, both cultural and economic. It began with the conquest of the Aztec Empire by Spanish conquistador Hernán Cortés, who as early as 1523 reported to Emperor Charles V discovery of a red dyestuff that could be valuable for Spanish and other European textile manufacturers. The Spaniards quickly appreciated the prized dyestuff, which was an essential component of the tribute paid by many indigenous peoples subject to the Aztecs. Cortés's administration adopted the tribute practice detailed in the *Matrícula de Tributos* (figure 5.1), an early sixteenth-century Mexican codex. The codex lists products paid by thousands of peasant communities to Emperor Moctecuhzoma II before his death, in 1520. Among the items destined for the Aztec court every three months from the Zapotec peoples of the central Oaxaca Valley were twenty bags of *grana cochinilla* (cochineal).

Cochineal was originally cultivated in Tlaxcala and several other regions of New Spain, but production came to be concentrated in Oaxaca by the late sixteenth century as a result of Spanish administrative policies. The considerable population density in this mountainous territory was an important precondition for the highly labor-intensive cultivation of the nopal plants on which the cochineal insect thrived (figures 5.2–5.3). Contemporary descriptions of cochineal cultivation evoke the enormous amount of meticulous peasant labor required, similar to the production of silkworms in rural China and Europe in the same era. These parallel commodity chains with peasant origins—silk from China and cochineal from Mexico—met and meshed in the leading luxury textile centers in Europe from the mid-sixteenth century onward. This fact speaks to the singular nature of early modern globalization and its economic importance to peoples on three continents.

International commerce in cochineal was of considerable complexity. Its axis originated in Mexico as the Spanish Crown fostered a virtual production monopoly on *grana fina* (fine cochineal) in Oaxaca. New Spain simultaneously was an important intermediary for other American dyes, particularly indigo (some produced in Mexico but mostly produced in neighboring Guatemala) and dyes from Campeche wood (*palo de Campeche*). Indigo was in demand in Europe for the making of blue cloths. Campeche dyes were used for deep blacks, which not only were in demand for religious ceremonies in both Catholic and Protestant countries but were in fashion among the elite, as seen in paintings of the Spanish court of Philip II. (See Brown, this volume.) Among these, however, cochineal was the most expensive of all dyes, its high price a reflection of its importance.

Cochineal often represented a higher proportion of final costs of fine cloth than other materials essential to their manufacture, including raw or processed fibers, whether wool, silk, or linens. Why was this so? While scarcity of high-quality dyestuffs played a major role, so did the great socioeconomic significance in traditional society of maintaining certain color hierarchies. One of the colors most prized by crown, church, and nobility in medieval Europe for their finest fabrics was carmine, or deep crimson. From the fourteenth century, the leading luxury textile centers, particularly Florence and Flanders, produced crimson cloth in various shades and tones using a variety of red dyestuffs. According to historian John Munro, the "medieval scarlets" owed their "splendor, fame and high cost to the dyeing process,"[1] largely because red dyestuffs (particularly those derived from insects, such as

Opposite FIGURE 5.1 *Matrícula de Tributos*, Mexico, ca. 1520–1545. Pigments on amate paper, 11²⁷⁄₆₄ x 16¹⁶⁄₃₂ in. Instituto Nacional de Antropología e Historia, Biblioteca Nacional de Antropología e Historia, folio 3v. Photo: University of Arizona Libraries, Special Collections.

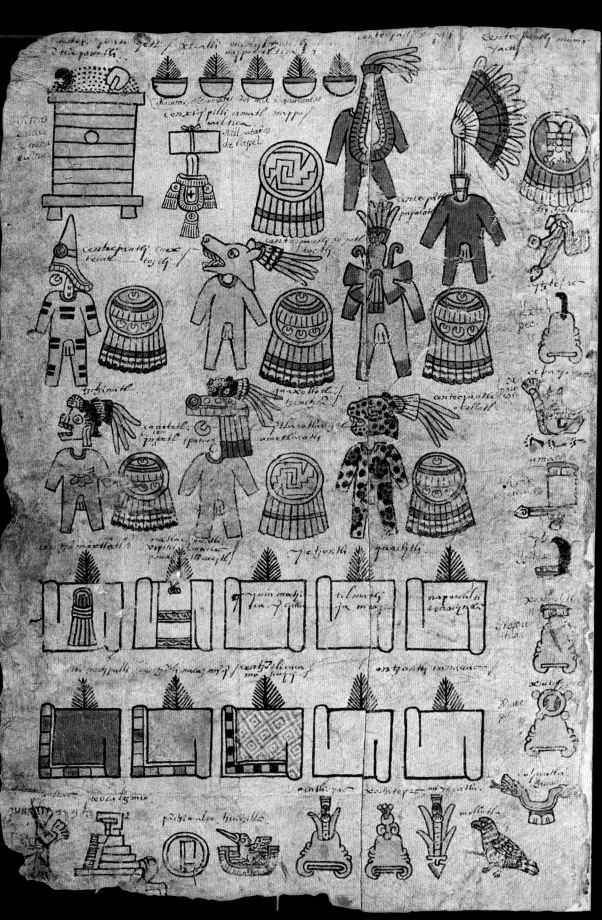

Mediterranean kermes) were quite rare and because dyeing processes were complex and required considerable technical skills. Thus expensive scarlet or crimson fabrics could be acquired only by the wealthiest members of late medieval society.

Despite the high price, from the early sixteenth century on, demand for luxury crimson and scarlet cloth climbed throughout Europe, most noticeably in England, Flanders, France, and Italy. Inevitably, the demand for high-quality, long-lasting red dyestuffs also rose. Three works are especially illuminating in this regard: Arthur Lovejoy's classic *The Great Chain of Being*; Manlio Brusatin's history of colors, *Storia dei colori*; and Elena Phipps's *Cochineal Red: The Art History of a Color*.[2] The authors argue that while other colors had similar prestige—in particular deep blue, gold, and silver, as may be observed in Renaissance paintings of the princes of state and church—the crimsons undoubtedly stood out.

Deep red silks, linens, and woolens were always in heavy demand by wealthy and powerful Europeans, whether for cloaks, robes, uniforms, dresses, and stockings or for cushions, curtains, and canopies. In 1464 Pope Paul II introduced "cardinal's purple," which was actually a deep red derived from kermes insects. In the sixteenth century, kermes dye was replaced by Mexican cochineal, which would become the standard for church gowns, cushions, curtains, and other fine cloth throughout the Catholic world. Cochineal also became the preferred dye for luxury textiles for European monarchs, military officials, and other members of the upper classes, Catholic and Protestant alike.

FIGURE 5.2 William Houston, "Cochineal Production at the Town of Guaspaltepeque," from *Dr Houston's letter to Sir Hans Sloane . . . giving an account of some plants and enclosing a draught of the town of Guaspaltepeque in the Bishopric of Oaxaca with its explanation. . . .* by William Houston, December 9, 1730. Ink on paper, 14⅜ x 19⅞ in. Royal Society Register Book Original, RS.9825, vol. 16, 1731–1732, © The Royal Society.

THE MARKET FOR MEXICAN COCHINEAL

Mexican cochineal began to appear on European markets in small quantities in the late 1520s and soon gained wide acceptance as the finest, most durable crimson dyestuff for textiles, particularly woolens and silks. According to one historical study, "Cochineal possessed from ten to twelve times the dyeing properties of kermes; it also produced colors far superior in brilliancy and fastness."[3] The dyestuff quickly won growing markets in the leading luxury textile manufacturing centers of Europe (figures 5.4–5.5), including Segovia in Spain; Suffolk in England; Florence, Milan, and Venice in Italy; Rouen, Malines, and Lyon in France; and various centers in Flanders. Recent interdisciplinary studies confirm the rapid expansion of European demand for cochineal. One laborious chemical research study of hundreds of samples of medieval and early modern dyed textiles provided "concrete evidence to substantiate the historical assertion that Mexican cochineal within fifty years of its introduction into Europe (circa 1520–30) fully displaced kermes in scarlet textile dyeing."[4]

The luxury textile industries of Italy were among the most important of sixteenth-century Europe and hence were among the major markets for expensive dyes. Substantial quantities of *grana cochinilla* sent from Veracruz to Seville and Cádiz made their way to the port of Livorno. Distinguished Spanish economic historian Felipe Ruiz Martín used the correspondence of Spanish merchant bankers to trace the exports to Florence, where a booming luxury textile industry consumed large quantities of dyes.[5] He also noted that a substantial volume of cochineal was shipped from Livorno to Venice, where it was used to dye cheaper *pannina* textiles sent to Constantinople, as well as the famous Venetian fezzes, religious caps used throughout the Muslim world. According to both Spanish and Genoese merchants involved in the trade, the crimson dyestuff was always profitable; in fact, its price quadrupled through the sixteenth century even as the volume of trade rose rapidly.

The high prices and specialized demand for cochineal probably explain why it appears prominently in the correspondence of international merchants from the sixteenth to the early nineteenth century. The possibility of cornering the market in cochineal was apparently greater than in the case of other dyestuffs. Hence cochineal was generally seen as offering more profit potential by those in a position to invest large sums in such speculations. Leading European merchants and merchant bankers became interested in cochineal because it was a high-value commodity with low weight. In this regard it was similar to other leading global commodities

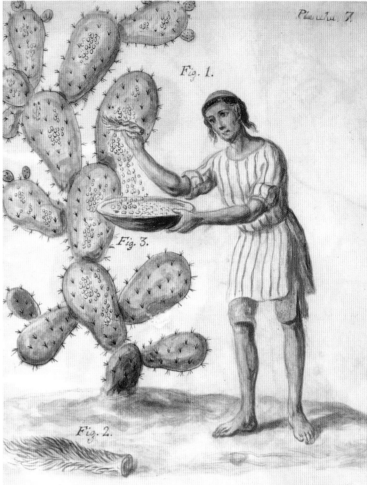

Fig. 1. Indio que recoge la Cochinilla con una colita de Venado, *Fig. 2.* dicha. *Fig. 3.* Xicalpeltle en que aparan la Cochinilla.

of the era, such as silks, pepper, spices, and precious metals. These were easily transportable by sea or land and allowed for great profits, and sometimes great losses, because of their high but fluctuating or speculative prices.

It is not strange, then, that cochineal became the object of much financial speculation. There are abundant examples from the late sixteenth century of attempts to corner cochineal markets in Europe, including manipulation of the cochineal trade by groups of leading Spanish and Italian merchant bankers, a number of them closely linked to the finances of the Habsburg monarchy. Correspondence between Spanish merchant Simon Ruiz and Italian merchants includes frequent references to cochineal.[6] Ruiz and other merchant

FIGURE 5.3 José Antonio de Alzate y Ramírez, "Indian collecting cochineal with a deer tail," from *Memoria sobre la naturaleza, cultivo, y beneficio de la grana*, Mexico City, 1777. Colored pigments on vellum, 12 ¼ in. high. Edward E. Ayer Manuscript Collection, Ayer Ms. 1031, plate 7, Newberry Library, Chicago.

FIGURE 5.4

■ Fragment

Italy, sixteenth century

Cut silk velvet with silver thread in green selvage

14 x 10½ in.

Metropolitan Museum of Art, gift of Nanette B. Kelekian,

in honor of Olga Raggio, 2002 (2002.494.469)

© The Metropolitan Museum of Art. Image source: Art Resource, NY

Italy was the center of silk production in the sixteenth century, and plush red silk velvets were among the most coveted cloths for the clothing and interiors of the wealthy and powerful. Kermes had long been the traditional source for crimson or scarlet, and proof that the dye was pure was documented in the fabric with a gold thread woven into a green selvage.[a] Cochineal was soon accepted by Venetian dyers as the superior red because of its greater saturation, colorfastness, and economy. To clearly distinguish it from kermes, a silver thread was woven through the selvage instead.

FIGURE 5.5

■ Cloak

France, 1580–1600

Red satin, couched and embroidered with silver, silver gilt, and colored silk threads; trimmed with silver gilt and silk thread fringe and tassel; lined with pink linen

38⁴⁷⁄₆₄ x 77³³⁄₆₄ in.

Victoria and Albert Museum, London, 793-1901

Cesare Vecellio, an artist from the Italian Veneto region and a relative of the painter Titian, wrote a popular costume book published in Venice in 1590. In it he writes, "Frenchmen usually wear clothing extravagant beyond all measure.... They wear woolen or silk *ferraiuoli* [wide capes], calf-length ... some decorated with woven silk trim."

This rich satin cloak with lavish embroidery, typical of around 1590, was obviously meant for a man of considerable means who could afford not only the generous width of silk but also the expensive cochineal dye. Recent scientific testing confirmed the presence of cochineal, demonstrating that the dye was already commonly used as a marker of high status in France by the late sixteenth century.

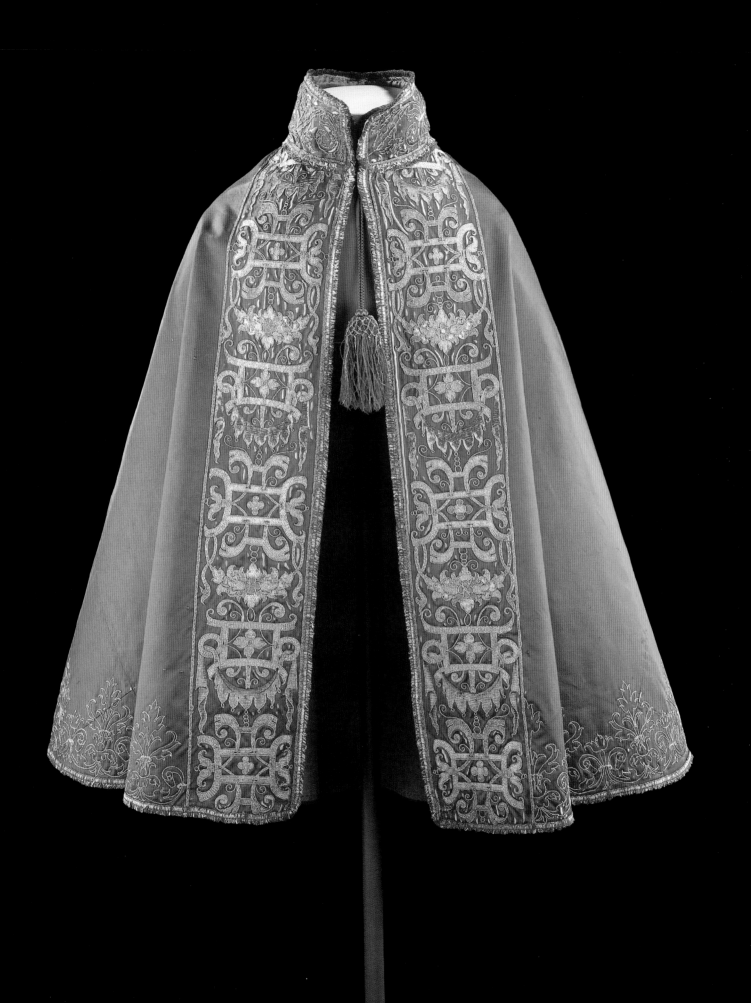

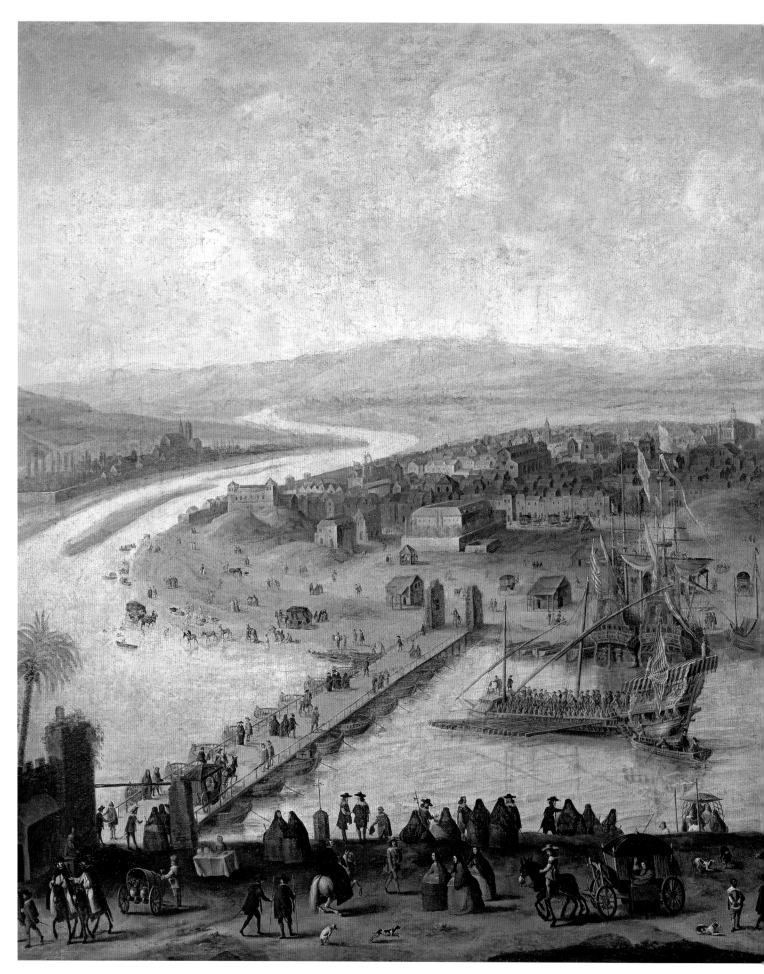

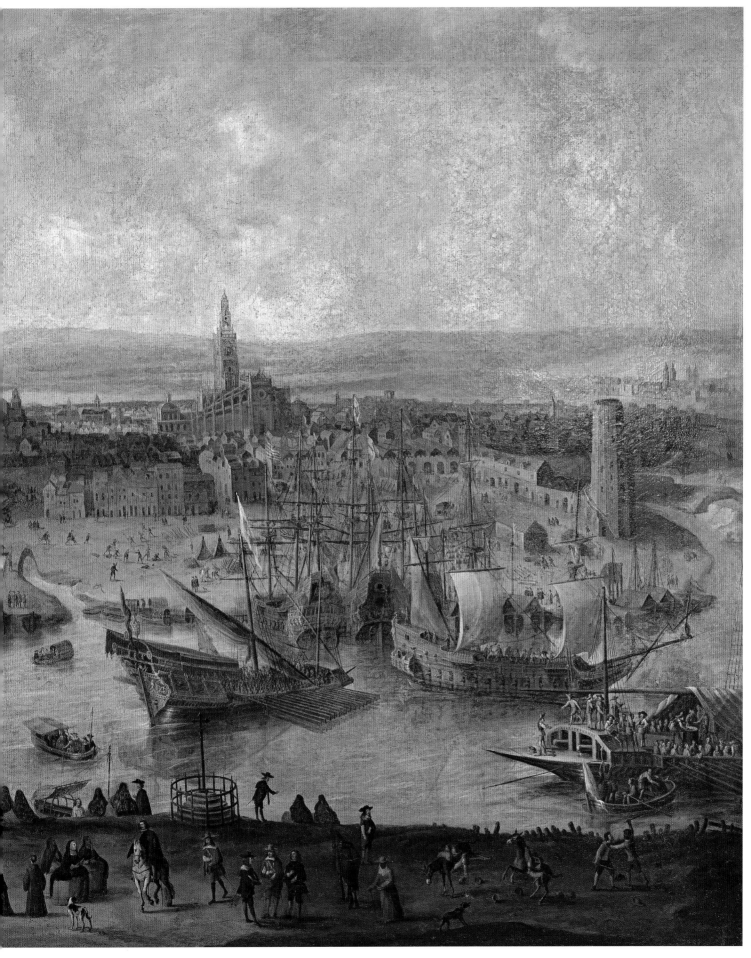

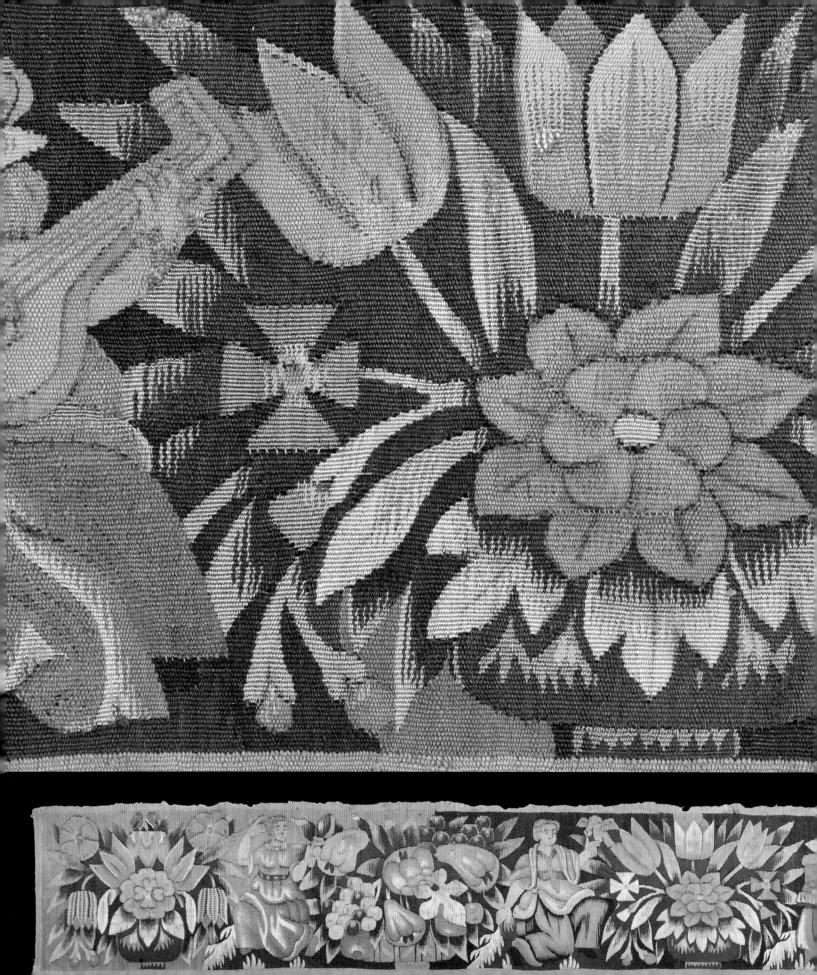

Preceeding spread **FIGURE 5.6** Unknown, View of Seville, ca. 1660. Oil on canvas, 64¹¹⁄₆₄ x 107⅞ in. Collection of the Centro Velázquez, Fundación Focus-Abengoa, Seville.

FIGURES 5.7A–5.7B

■ *The Five Senses*
The Netherlands (Gouda or Delft), ca. 1660
Wool tapestry
7½ x 77¾ in.
Museum of International Folk Art, gift of Lloyd E. Cotsen and the Neutrogena Corporation, A.1995.93.816

The Netherlands was an important cochineal trading center, from which dyestuff obtained from Spain was distributed to northern manufacturers and even reexported to Italy.[b] In this Dutch tapestry, probably a border for a larger hanging, the cochineal is in the pink-coral shades of garments and flowers. One of the newer areas of cochineal investigation attempts to determine the rate and nature of fading in organic pigments. But it is unclear whether the pink-coral color seen here is a faded version of the original or whether mordants were used to achieve the unusual shade.

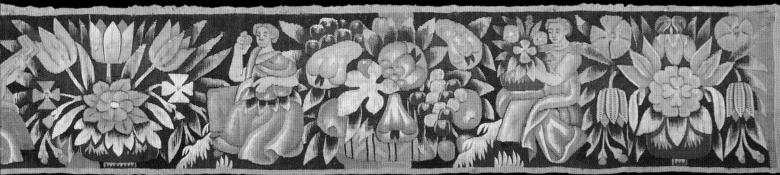

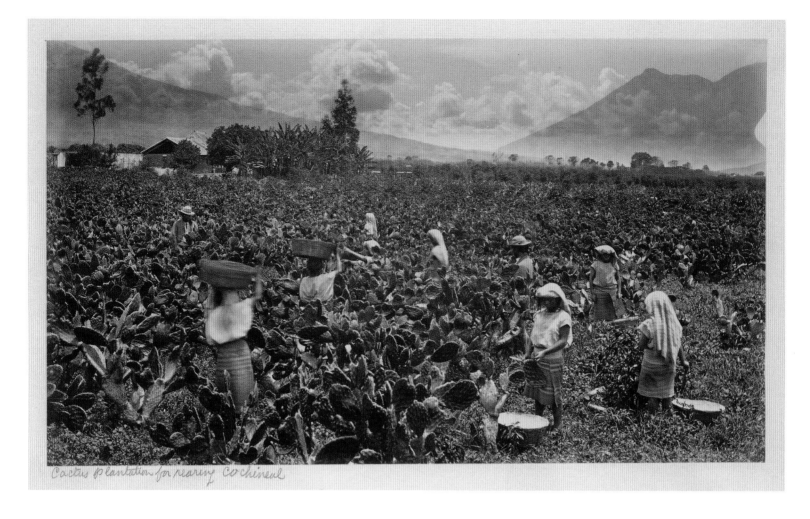

Cactus plantation for rearing Cochineal

bankers were engaged in the trade circuits linking Seville/ Cádiz, Genoa, Livorno, and Florence. Cochineal traveled from Mexico to Seville (figure 5.6) and Cádiz and from there was redistributed to the rest of Europe. Most cochineal sent to Italy went to Livorno and was transported in the same ships that carried merino wool, another high-demand commodity in the Florentine luxury textile manufacturing sector.

The most spectacular speculative cochineal operation was carried out in the late sixteenth century by the Florentine merchant banking family known as the Capponi. They, in alliance with the powerful Maluenda merchant bankers of Burgos, Spain, attempted to corner the entire shipment of cochineal arriving at Seville in 1585. In a strategy aimed at gaining a virtual monopoly on the valuable dyestuff, they also bought up the bulk of stocks in other European ports. The speculators' ambitious plans were quite successful, allowing them to push prices upward despite stiff resistance by artisans in the leading textile centers of Europe. In some cases, the resulting decline in demand obliged merchants to offer extended time spans for payment.[7]

FIGURE 5.8 Eadweard Muybridge, *Cactus Plantation for Cochineal,* San Mateo, Guatemala, 1876. Courtesy Department of Special Collections, Stanford University Libraries.

THE INTERNATIONAL COCHINEAL TRADE

Published data and information on the cochineal trade in the seventeenth century are relatively scarce and scattered, but historian Louisa Hoberman provides important information on the merchants of New Spain. According to Hoberman, one pound of cochineal, on average, cost between four and six silver pesos in the early seventeenth century. The high unit-value of cochineal, she adds, can best be judged compared to other commodities. In the 1610s, for instance, twenty-five pounds of cochineal cost sixty times more than an equivalent weight of sugar. By the 1630s, cochineal was worth thirty times the value of an equivalent weight of sugar.[8]

In the early seventeenth century, Dutch chemists became particularly active in producing new varieties of the dye (figures 5.7a–5.7b). The most notable was Cornelis Drebbel, who produced a new brilliant red dye by combining cochineal and tin. He and his daughters began making it on a considerable scale at the Stratford-on-Bow dye works in England in the 1620s. Eventually cochineal became a staple for dyeing the uniforms of military officers and the textiles and clothing of aristocrats and wealthy urban elites throughout much of northern Europe. At the same time, scarlet reds gained popularity in the French court of Louis XIV and were used at the

famous Gobelins tapestry manufactory in Paris. Meanwhile, leading European dyeing manuals highlighted techniques of preparing cochineal dyes and the types of mordants required. These can be seen in the classic French work by Jean Hellot, *Art of Dying Wool, Silk, and Cotton*, published in French in the mid-eighteenth century.[9] (See Cardon, this volume.)

The international trade in cochineal became ever more important in the eighteenth century, though it remained a Spanish commercial monopoly; practically all the valuable dye from Oaxaca was channeled via the Spanish port of Cádiz to the multifaceted European mercantile community. Speculation continued to be a common feature of trade in the dyestuff. Financial historians have identified huge cochineal speculation in 1788 by two of the leading merchant banks of Europe, Hope and Company of Amsterdam and Baring Brothers of London. The operation involved buying most of the cochineal stock in principal European ports: Cádiz, Marseille, Rouen, Genoa, Amsterdam, London, and even Saint Petersburg. It was particularly important to acquire practically all the dyestuffs received in Cádiz, since failure there would condemn the entire transaction. But the agent of the bankers at Cádiz was not entirely successful in this part of the project. Rival merchants in other ports, who likely got wind of the aims of the Hope/Baring alliance, were able to buy up substantial stocks of cochineal. As a result, the monopoly and attempts to rig prices failed, causing large financial losses to the partners in the speculation.[10]

European merchants were not alone in the international cochineal business. Some of the great eighteenth-century mercantile firms of Mexico City and Veracruz were also heavily involved in this commodity chain, both on the American side and in its connections to Europe and Asia. Studies by various historians on operations of the wealthy Iraeta merchant family of Mexico City reveal the intricacies of controlling the cochineal trade inside New Spain. Studies also highlight complex connections between Cádiz merchants and those in Asian markets, where there was considerable demand for cochineal shipped across the Pacific in the long, yearly journey of the Manila galleons.[11]

The most abundant statistical information on the Mexican cochineal trade covers the second half of the eighteenth century and the first half of the nineteenth century. This allows for an overview of cochineal production in Mexico and its relation to fluctuations in the international price of the precious red dye. Data registered at the local treasury of Oaxaca is based on annual production by weight and value, as well as on annual price trends. The long-term tendencies indicate that physical production declined from the end of the eighteenth century, while prices increased notably during the age of the Napoleonic wars and, later, during the wars of independence in Mexico.

Review of the data suggests a need for a further breakdown from the century-long trend to shorter time periods. Analysis of the quarter century spanning the years 1758 to 1783 demonstrates an age of prosperity as far as cochineal was concerned. Annual production averaged 922,600 pounds, which, at a price of almost twenty silver reals (two and a half silver pesos, or ten shillings) per pound, produced over two million silver pesos per year for local producers and merchants in Mexico; the peso was worth exactly one dollar. A marked drop in production levels in 1784 took producers and merchants to slightly less than a half million pounds per year until 1803. At the same time, prices declined slightly, hovering at an annual average of ten silver reals per pound until the turn of the century, when prices began to recover and climb.

These trends likely reflected shifts in the demand for cochineal in Europe. The shifts may have been caused by the multiplication of international wars at the end of the eighteenth century and the beginning of the nineteenth century, which certainly affected global trade. The recovery of prices was probably related to the decline in the Atlantic maritime trade, particularly after the Battle of Trafalgar. It may also be speculated that expensive scarlet cloth lost some favor with the decline in the preeminence of both the aristocracy and the church as emerging middle classes gained strength during the Industrial Revolution and during democratic revolutions in North America and Europe, all of which had extensive impacts on consumer patterns.

There were also domestic reasons for the steep reduction in Oaxacan cochineal production. These were apparently not related to the rather modest price decline; historians ascribe them to two causes. First, the plagues and demographic crisis of 1784–1785, during which more than three hundred thousand people died in New Spain, deeply affected Oaxacan peasant communities. Second, fiscal and administrative reforms restructured traditional cochineal trade locally and led to higher taxes on the commodity.[12] This complex series of new conditions—demographic, fiscal, administrative, and mercantile—disrupted production of cochineal in Oaxaca.

From 1804 to 1819, production continued to decline, but this was counteracted by a rise in the international price of the dyestuff to an average of twenty-six silver reals per pound.

After Mexico gained independence in 1821, the international price of cochineal dropped steadily as the Mexican monopoly on cochineal ended and competing production emerged elsewhere, in particular in Guatemala and the Canary Islands. Despite the fall in prices, annual production of Oaxacan *grana*, as measured in pounds, increased. This fact suggests that peasant producers sought to maintain income levels by intensifying their labors in spite of the drop in profitability. They continued to do so for decades.

A TRAGIC END

The Spanish Crown's successful maintenance of a virtual Mexican monopoly on cochineal production from the sixteenth century to 1820 was indeed remarkable. Already, by the late eighteenth century, French botanist Thierry de Menonville had smuggled some cochineal insects out of New Spain and taken them to Saint Domingue in Haiti, where he unsuccessfully attempted to promote their cultivation.[13] And from the mid-1820s, cochineal began to be cultivated successfully on a large scale in Guatemala (figures 5.8 and 5.9a–5.9b) and the Canary Islands, where cochineal became a leading export for almost half a century.

The results of the increased cultivation and production were dramatic, causing a steady price decline per pound. Oaxacan peasants responded by increasing production after 1824, although profitability was falling year by year. Their strategy to intensify cultivation of nopal and production of cochineal was actually fairly successful in maintaining the export trade in the increasingly cheaper crimson dyestuff decades after Mexican independence.

Nonetheless, as Amy Butler Greenfield demonstrates in *A Perfect Red: Empire, Espionage, and the Quest for the Color of Desire,* Oaxacan communities faced increasing difficulties by 1870 as peasants of the Canary Islands became world leaders in the cultivation and harvest of cochineal, producing up to five million pounds a year, much more than either Guatemala or Mexico.[14] At the same time, major advances were made in the chemical dye industries in Germany and Britain; natural dyes were quickly replaced by synthetic ones. This change led to steep drops in prices of and demand for natural dyes, including cochineal. The abrupt decline of the cochineal trade at that time constitutes a fundamental chapter in the nearly five centuries of global history of the extraordinary red dye, in many ways bringing it to a tragic end.

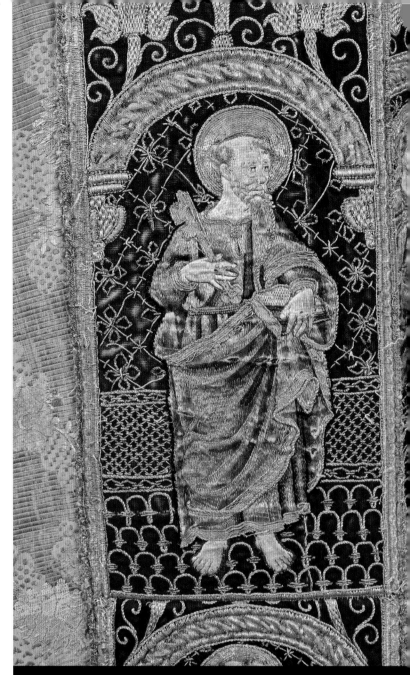

FIGURES 5.9A–5.9B

■ Liturgical vestments
Eighteenth to nineteenth century, collected in Guatemala
Velvet, metallic embroidery over silk satin
Outer layer: 45 43/64 in. long at back; under layer 51 31/32 in. long at back; overall 137 51/64 in. wide
Museum of International Folk Art, gift of Mrs. Virginia Morley Brooks in honor of her father, Dr. Sylvanus G. Morley, A10.1956.13

This vestment for the celebration of Mass was probably made for a high-ranking cleric in Guatemala, where it was acquired in the 1930s. It was likely assembled there from different textiles made in Europe or even China. The deep red velvet skirt and the silk satin cape, embroidered lavishly with cochineal threads throughout the bold design, were possibly recycled from a wealthy and devout woman's donated gown.

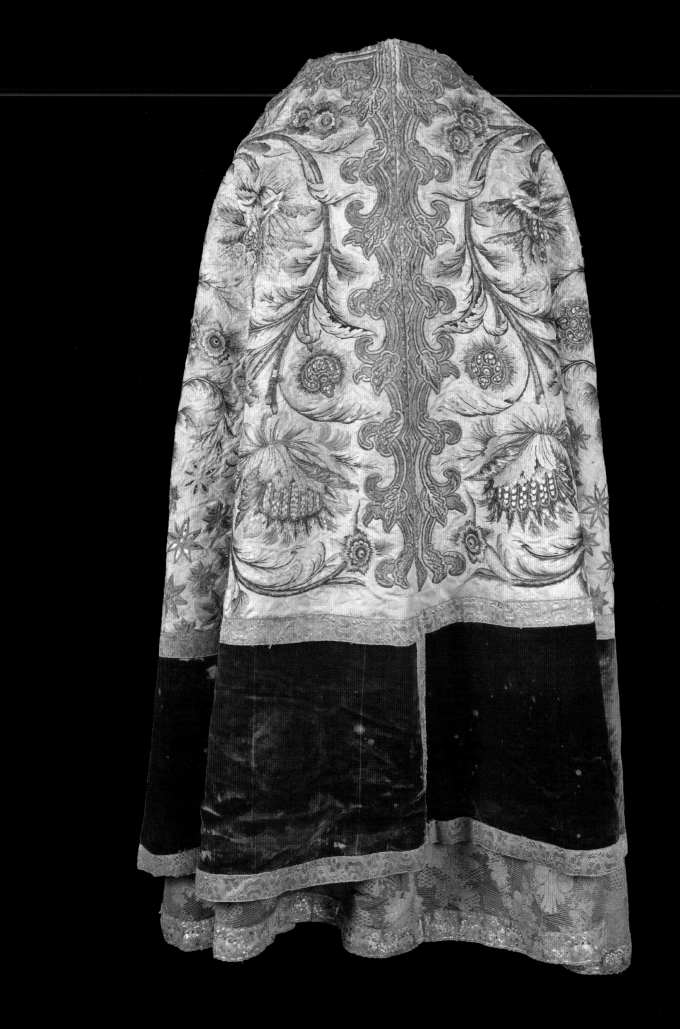

6 TO DYE FOR

The Many Reds of Asia

CRISTIN MCKNIGHT SETHI

RED IS VITAL IN ASIA. It is an auspicious color in India, worn by Hindu brides as a symbol of fertility and life and evoked in Hindi poetry as the color of love. It appears throughout China, particularly during New Year's festivals, where it represents good fortune and joy. In Persian literature it signifies bravery, power, energy, blood, and honor. And in Japan it is the color of the sun and dominates the national flag. Given red's significance, it is not surprising that red pigments and dyes have played a pivotal role in the history of art and commerce in Asia.

Prior to the arrival of American cochineal in Asia, a range of vegetal, mineral, and insect pigments were used to color objects red. Early on, the Chinese painted directly onto cloth using hematite and cinnabar and also used these substances to dip-dye silk threads before weaving. The vegetable dye madder (*Rubia cordifolia*), containing the coloring agent alizarin, was introduced in the Shang and Zhou periods (beginning around 2000 BCE).[1] By the seventeenth century CE, safflower (*Carthamus tinctorius* L.) and sappanwood (*Caesalpinia sappan*), which were already quite popular in Japan (see Bethe and Sasaki, this volume) and Indonesia, were being used in textile dyeing.[2]

Numerous alizarin-rich vegetal dyes, including those made from madder, morinda (*Morinda citrifolia*), and a regional plant called *chay* (*Oldenlandia umbellata*), were also used in India from a very early period. These along with lac, derived from *Coccus lacca*, a scaly insect similar to cochineal, made red dyes from India famous around the world.[3] Lac in particular was celebrated throughout South and Southeast Asia—especially in India, Indonesia, Burma, Cambodia, and Thailand—well before the common era and also was used in textile production in Japan and China.[4] Early Sanskrit and Pali texts make poetic reference to lac insects (called *indragopa*, meaning "those protected by Indra," the god of rain) as richly colored, velvety bugs that appear in large numbers during the start of the monsoon season.[5] In India lac was ground into a powder and used to stain leather, wool, and silk and was also used as a substitute for henna. It was also prevalent in Tibet, Persia, and other parts of western Asia, where it figured prominently in carpet production from at least the early fifth century CE.[6]

Throughout Asia, various other insects, including kermes (*Kermococcus vermilis*), Polish cochineal (*Margarodes polonicus*), and Armenian cochineal (*Porphyrophora hameli*), were used to make red pigments, dyes, and cosmetics, as well as medical compounds. (See Simpson, this volume.) Fourth-century BCE textile fragments from Turkistan show evidence of Polish cochineal, and textiles from Palmyra (in present-day Syria) dating from the first century CE contain lac, Polish cochineal, and kermes, the latter having been harvested in nearby Anatolia.[7] Armenian cochineal was prevalent in Southwest and Central Asia and was cultivated in the region around Mount Ararat. It was used in the creation of frescoes and illuminated manuscripts, was celebrated by Persian and Arab geographers writing between the ninth and fourteenth centuries, and was likely the coloring agent for the famed *cremesi* silks of Baghdad mentioned by Marco Polo.[8]

■ *Opposite* **FIGURE 6.1** Wall or tent hanging, Persia (possibly Rasht, Gilan province, Iran), mid-nineteenth century. Felted and woven wool, patchwork and cotton, silk and wool embroidery in chain and running stitches, 75³⁄₁₆ x 45¹¹⁄₁₆ in. Museum of International Folk Art, gift of Cyrus Leroy Baldridge, A.1965.31.40. The use of cochineal in Persia was established in large part by market demands in Europe and the robust trade of textiles by the British East India Company in the mid-seventeenth century. Though few Persian textiles have been scientifically tested for cochineal, this colorful hanging—which might have originally been used as a decorative element in a tent—shows that the use of the dye continued in Persia until at least the mid-nineteenth century, when aniline dyes were introduced worldwide. Notice the bright red corner details and the orange exterior border of this textile, all of which were produced using cochineal.

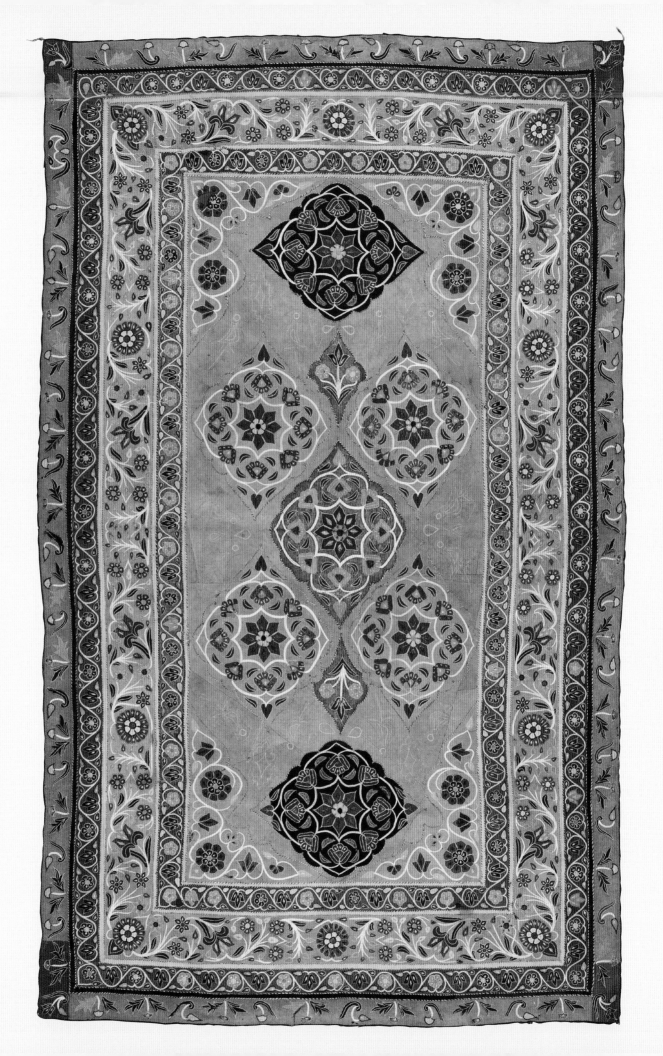

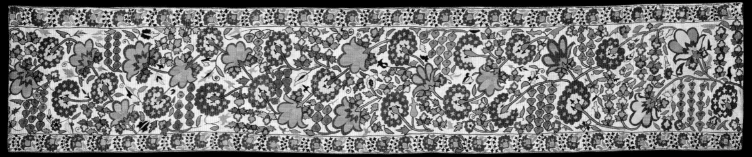

■ *Above* **FIGURES 6.2A–6.2B** Embroidered valance, Samarkand, Uzbekistan, early nineteenth century. Silk embroidery in chain and satin stitches on plain-weave linen, 17 x 90 in. Museum of International Folk Art, gift of Lloyd E. Cotsen and the Neutrogena Corporation, A.1995.93.879. This embroidered valance demonstrates cochineal's eventual overland journey from the Ottoman Empire to Central Asia. Embroidery such as the type used in this valance is commonly identified as *suzani*, a Persian word referring to intricate needlework done by Turkic peoples living in present-day Kazakhstan, Krygyzstan, Turkmenistan, Uzbekistan, China, and Russia. *Suzanis* were made by women for a bride's dowry and were typically used to decorate the interior of homes. The floral forms that dominate this cloth, including stylized carnations and tulips, are rendered in finely embroidered chain stitches on linen, which is typical of *suzanis*. The bright red petals in the large carnation motifs in the body of the cloth as well as the thin red border line at the side edges of the cloth were created using cochineal.

■ *Opposite* **FIGURE 6.3** Songket textile, Bali, Indonesia, nineteenth century. Metallic foil-wrapped thread; supplementary weft patterning (songket) on plain-weave silk ground, 36¼ x 14¹⁵⁄₁₆ in. Museum of International Folk Art, IFAF Collection, FA.1964.62.13. European travelers and merchants brought cochineal to Indonesia, from where it then made its way to China and other locations in Asia. The cultivation of cochineal on the island of Java—not far from Bali—was particularly successful, owing in large part to the efforts of European trading companies such as the Dutch East India Company. The bright red silk ground of this textile, created using cochineal, is a pleasing complement to the gold floral motifs woven in a technique known as songket. Originally closely linked to traditional princely families and used in Bali for a variety of ceremonial and festive occasions, songket textiles typically incorporate silver or gold metallic thread as a supplementary, nonstructural weft to create patterns across the body or borders of a cloth.

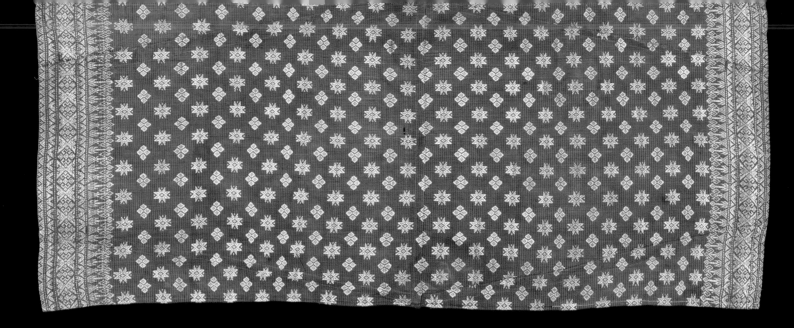

In the sixteenth century, cochineal from the Americas was introduced in Asia, where it passed along several trade routes: from the Levant into Persia (figure 6.1) and from there to India; from Constantinople and the ports of the Black Sea to Turkey and the Caspian region (figures 6.2a–6.2b); directly to India via British East India Company ships; from Amsterdam and Rotterdam to Indonesia via Dutch East India Company ships (figure 6.3); and across the Pacific, from New Spain to eastern Asia via the Philippines.[9] American cochineal was expensive and found a market primarily in the manufacture of luxury materials, such as Persian silk carpets (particularly from workshops in Isfahan, Khorasan, and Kirman) and Chinese silk brocade textiles.[10] Much of the trade of American cochineal in Asia resulted from European demands for the richly colored reds that cochineal provided, competition among European trading companies to monopolize control of cochineal coming from the Americas, and attempts to establish plantations of American cochineal in Asian colonies.

The English shipped cochineal to India beginning in the early 1600s, first to the East India Company factory in Surat and then to Ahmedabad. However, local demand was limited, and the enterprise never flourished. In fact, the Mughal emperor Aurangzeb banned the use of cochineal in northern India, and English merchants were discouraged from continuing its trade in the region.[11] A century later, a French naval officer working for the Compagnies des Indes in Pondicherry described the possibility of using cochineal to dye local textiles.[12] However, the practice did not take, likely due to the preeminence of cotton in India's textile industry and the inability of cochineal to adhere to anything but animal fibers such as wool and silk. In a final attempt to circumvent Spanish trade monopolies of cochineal from Mexico, in the late eighteenth century the British East India Company procured wild cochineal from Brazil and brought it to India, where the company embarked on a series of experiments to cultivate and process cochineal, to no avail.[13] Instead, Indian dyers preferred to use lac or madder, which they had mastered the use of to great effect.

Cochineal took several paths through Southeast Asia, where it was traded farther east and west. Spanish trade of cochineal in the early 1700s went directly from Acapulco to Manila and then made its way to China. Chinese ports, particularly Canton, were key sites of trade for American cochineal in Asia and were frequented by English, French, Dutch, Swedish, Danish, and Spanish merchants in the latter part of the eighteenth century.[14] During this time, supercargoes of the British East India Company operating in China noted in their diaries that American cochineal was being exported to China on British ships for the creation of crimson and scarlet dyes—a necessity for the English, who found soft Chinese vegetable reds made from safflower and madder to be inadequate.[15] By the nineteenth century, American cochineal was frequently moving in and out of ports in Canton and was beginning to replace lac as the superior red dye in the region.

FIVE BARRELS OF COCHINEAL

A Gift from King Philip III of Spain to Shah 'Abbas I of Iran

MARIANNA SHREVE SIMPSON

ON APRIL 8, 1614, CASTILIAN NOBLEMAN Don García de Silva y Figueroa set sail from Lisbon as the emissary of Philip III, ruler of the Habsburg Dynasty of Spain and Portugal, to 'Abbas I, ruler of the Safavid Dynasty of Iran. Don García's trip was but one in a series of exchanges begun during the late sixteenth and early seventeenth centuries generally aimed at strengthening diplomatic, military, and commercial relations between these Christian and Muslim powers. The more specific goal was to create a defensive alliance against Ottoman Turkey, then the common enemy of Europe and Iran.[1]

As was the norm for such international missions, the 1614 fleet carried several hundred gifts that Don García was to present to Shah 'Abbas on his and King Philip's behalf.[2] This substantial gift ensemble, carefully selected and laboriously assembled over several years, was itemized in several contemporary registers or inventories, as well as in the *Comentarios,* Don García's account of his voyage to Iran. One record, dated March 7, 1614, identifies the group of presents from King Philip and includes the following item:

> *Quatro mil docados de cochonilla que por orden de don Francisco de Vart, Presidente de la Casa de la Contratación de Sevilla se remeteron á Lisboa á don Estevão de Faro, que con carta mia la entregará á Don García. Fecha en Madrid á 3 de enero de [1]614.* (Four thousand ducats of cochineal that by order of Don Francisco de Vart, President of the House of Trade in Seville, were sent to Lisbon to Don Estevão de Faro, who will deliver it, together with my letter, to Don García. Dated in Madrid 3 January [1]614.)[3]

Opposite and following page **FIGURES 7.1A–7.1B** Square (front view, full and detail), Iran, Islamic, seventeenth century. Silk, brocade, metal threads, 19¾ x 19 in. Metropolitan Museum of Art, Friedsam Collection, bequest of Michael Friedsam, 1931 (32.100.461). © The Metropolitan Museum of Art. Image source: Art Resource, NY.

Don García himself provides other noteworthy information and observations about the same gift:

> *Cinco grandes barriles en que venían treinta arrouas de cochinilla, que es con se tiñe la finíssima color carmesí, cosa de mucha estima y de las de mayor precio que venían en todo el presente.* (Five large barrels containing thirty arrobas of cochineal that makes the finest carmine color, a thing of much value and of the greatest cost of the entire present.)[4]

The specifics of this particular item and its incorporation into the diverse gift collection transported by Don García are more detailed than the listings for the many other presents. In short, the transfer of five large barrels containing 30 *arrouas* (arrobas) of cochineal, the equivalent of 750 pounds and valued at four thousand ducats—more than eighty-two thousand silver pesos in contemporary currency—was authorized by the head of Spain's central commercial office for the Indies and was shipped to an agent in Lisbon for delivery to Don García.[5] The Habsburg ambassador himself characterized the cochineal in superlative terms, extolling its properties as a colorant and both its absolute and relative worth. Judging from the values recorded for other items—for instance, a dozen silver vessels, including six large urns bearing the royal coat of arms, three large basins, and three aquamaniles, altogether valued at fifty-two hundred ducats—Don García may have exaggerated the worth of the five barrels and their contents. It is possible, however, that pound for pound, the cochineal did monetarily outweigh everything else within the gift cargo bound for Iran.

Although Don García regarded cochineal as an expensive substance, and presumably as an especially precious or unique offering for the Persian ruler, in the end, the gift did not seem to make any particular impression in Iran. Indeed, when the

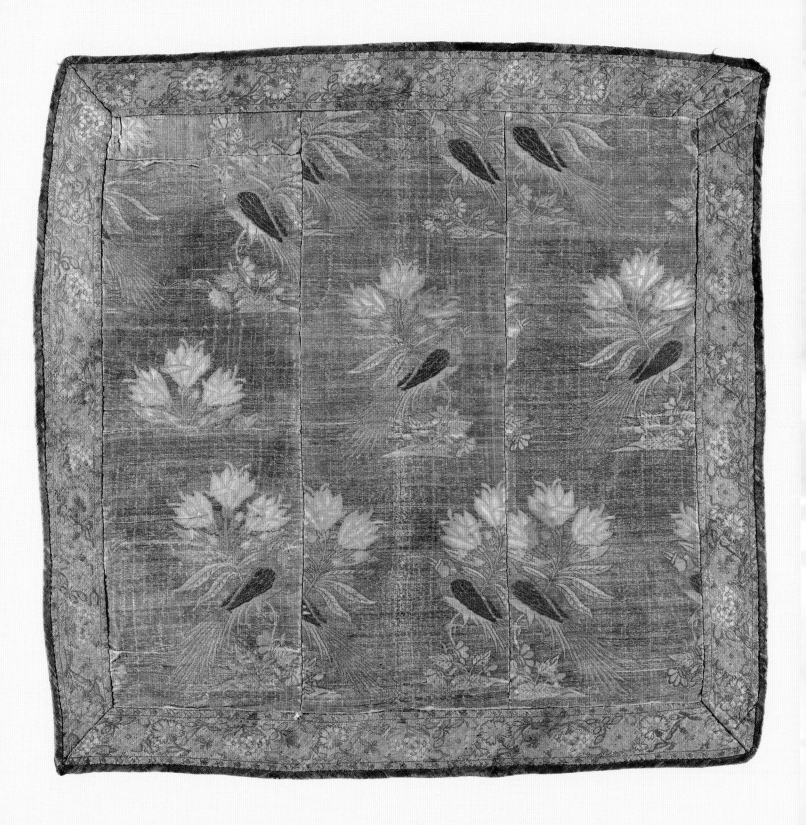

kermes—entered the Persian dye repertoire has yet to be firmly established. It is generally understood, however, that cochineal was being imported into Iran through trade routes from the Levant during the sixteenth century. Iran's potential as an important market for cochineal was underscored by recurring references to the detrimental effects on trade created by ongoing warfare between Ottoman Turkey and Safavid Iran and to the anticipated commercial advantages of peace in correspondence between merchants in Italy and Spain dating from 1580 to 1582.[8] Likewise, Spanish documents from the last quarter of the sixteenth century mention Persia (Iran) among the countries where cochineal was held in high esteem, and an English source of 1618, the same year Shah 'Abbas received Philip III's gifts, reported that Iran was getting cochineal from Turkey and Barbary (North Africa) and exporting it to India.[9] Thus the five barrels brought by the Habsburg delegation hardly would have constituted a novelty at the Safavid court. In short, the gift may have held greater significance for its donor than its recipient.

As for the use of cochineal in Safavid Iran, recent conservation testing has confirmed that American, as well as Armenian, cochineal was the source for bright red motifs, including animals, figures, and inscriptions, in selected silk textiles and carpets from the sixteenth and seventeenth centuries (figures 7.1a–7.1b).[10] Analysis of sixteenth-century Persian paintings also might help determine a more precise time frame for the appearance of American cochineal in Iran. It is tempting to suppose that red textiles attributable to the reign of Shah 'Abbas were dyed with the *Dactylopius coccus* received from Philip III. And if such a fanciful notion can obtain, it is equally tempting to imagine that the Persian verse "There has never been a garment of such beauty," on one of the silks now known to have been woven with cochineal threads (figure 7.2), was inspired by the cloth's perfect red.[11]

On the other hand, given the apparent Safavid practice of recycling or redistributing gifts,[12] it is just as likely that the five Habsburg barrels were never even opened in Iran and instead were consigned straightaway for export to India.[13] Thus one monarch's costly gift may have become another's commercial commodity, thereby bringing cochineal's intercultural circulation full circle. 🖉

ambassador and his party finally reached their destination after over four years of travel and presented the Habsburg gifts at the Safavid court in Qazvin on July 16, 1618, the only object known to elicit any reaction was a large crystal chest with gold columns, which Shah 'Abbas admired "as a rare and valuable thing."[6] The seemingly indifferent Safavid reception of cochineal raises two separate issues about the dyestuff: one concerning its presence or availability in Iran prior to 1618, and the other regarding the possible use or disposition of the 750 pounds brought by Don García.

As in other visual traditions, the color red was ubiquitous within works of Islamic art, including those created in Iran during medieval and early modern times, and with multiple compositional treatments, aesthetic effects, and symbolic associations.[7] As described in treatises from as early as the eighth to tenth centuries and as confirmed by twentieth-century scientific analysis, Persian artists and artisans used many different natural and synthetic substances of regional origin for their red colorants. The pigments and dyes created a wide range of shades and tones, each known by a distinctive name. Insects that were particularly prized for producing a deep and bright crimson color included various aphid species of the *Coccus* genus, such as *Porphyrophora hameli*, indigenous to Azerbaijan and Armenia, and *Kermococcus vermilis* (or *Kermes vermilio*), whose expanse stretched from the Mediterranean across the Fertile Crescent and into the Iranian plateau.

Exactly when *Dactylopius coccus* (cochineal)—with its capacity to create even more brilliant red dyestuff than

Opposite **FIGURE 7.2** Textile (panel) depicting a scene from Nizama's Khamsa, Iran, Islamic, sixteenth–seventeenth century. Silk, metal-wrapped thread; double-weave, 25¾ x 14⅜ in.; 8 pounds. Metropolitan Museum of Art, Fletcher Fund, 1946 (46.156.7). © The Metropolitan Museum of Art. Image source: Art Resource, NY.

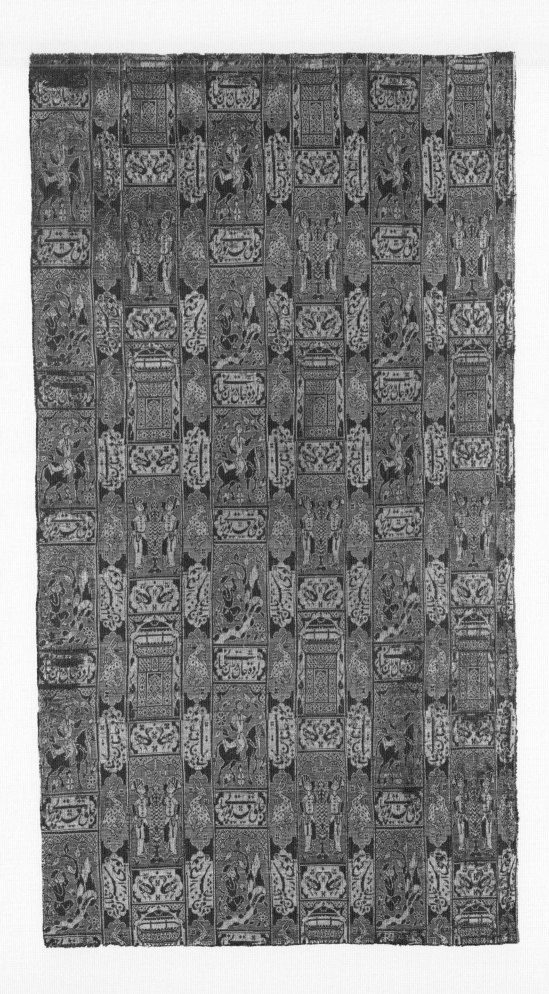

8 REDS IN THE LAND OF THE RISING SUN

Cochineal and Traditional Red Dyes in Japan

MONICA BETHE AND YOSHIKO SASAKI

WHILE COCHINEAL FROM THE FAR WEST was becoming the rage in sixteenth-century Europe, only a small ripple reached the Land of the Rising Sun. A cochineal-dyed Spanish velvet decorating a surcoat (*jinbaori*) of the military lord Uesugi Kenshin speaks of a short-lived Spanish trade with Japan in the sixteenth century. Another surcoat, said to have been worn by the daimyo Kohayakawa Hideaki and now in the Tokyo National Museum, has appliquéd sickles on cochineal-dyed "*shōjō* scarlet" wool (*rasha*). In the early seventeenth century, the finance minister to the new Tokugawa shogun, Ieyasu, sent the Kyoto merchant Tanaka Shōsuke on a year-long trip to Mexico. He reportedly brought back numerous red woolen textiles, grape wine, and a purple-dyed wool, which he presented to the shogun.[1]

In 1635 Japan restricted European trade to the Dutch, resulting in the continued use of scarlet Dutch wool, primarily for military surcoats (figure 8.1) with bold appliqué and firemen's coats (figures 8.2–8.3). These bright red coats became the standard uniform for the shogunal guards known as *okachigumi*.[2] In 1800 love of the rich red led the eleventh Tokugawa shogun, Ienari, to order Kyushu resident Takashima Sakubei to cultivate cochineal and sheep. But with only an instruction book and a few samples procured from the resident Dutch, he failed miserably.[3]

When Japan reopened its doors to world trade in the second half of the nineteenth century, cochineal (*yōkō*), or "Western red," was introduced as a cheap dye source, along with synthetic dyes. Cochineal lake pigment had been used in

Opposite **FIGURE 8.1** Red wool *jinbaori* surcoat with Nabeshima ginger crest, Japan, nineteenth century. Dutch *rasha* wool, stenciled leather edging, silk cord tie, and embroidery on the Nabeshima crest, 34 x 27½ in. Arthur M. Sackler Gallery, Smithsonian Institution, Washington, D.C., gift of Victor and Takako Hauge, S2009.2. The red wool in this military surcoat may be dyed with cochineal.

paintings somewhat earlier,[4] a practice that continues today. Cochineal is now used in Japan primarily as a food coloring, but it has also been taken up by some modern textile dyers. Yoshioka Tsuneo and Yamazaki Seiju, leading masters of traditional Japanese natural dyeing, include cochineal in their instruction books. It is sold in the Kyoto dye supply store Tanaka Nao both as dried bugs and as powder.

LAC

Trade restrictions aside, the Japanese were no strangers to imported dyes from scale insects. Already in the eighth century, sticklac (*shikō*), commonly known as lac—with secreted resinous pigment from the insect *Kerria lacca*—was found in the medicinal stores in the Shōsōin repository at Tōdaiji in Nara.[5] A Chinese medicinal book from 659 notes that in addition to its curative value, lac could be used as a pigment and as shellac on wood. Indeed, recent investigations have found that a red stain on carved eighth-century ivory rulers (*bachiru no shaku*) was derived from lac.[6]

By the fifteenth century, lac dye was commonly transported in the form of *enji-wata* (rouge cotton); the condensed dye was absorbed into cotton fibers and dried (figure 8.4). First produced in India, *enji-wata* was made in large quantities in Suzhou, the southern part of China, during the Ming and Qing dynasties. It was exported to the Ryūkyū Kingdom for dyeing *bingata*, stenciled and freely drawn paste-resist cloths (figure 8.5). According to records from the seventeenth and eighteenth centuries, large "sheets" of *enji-wata* also entered Japan through Nagasaki.[7]

The attraction of *enji-wata* grew with the popularity of *yūzen* dyeing in the late seventeenth century (figure 8.6). *Yūzen* employed rice paste drawn in freehand outlines onto silk as a resist. Dyes were then brushed into the delineated areas. Often the background color was applied using a wide, flat brush.

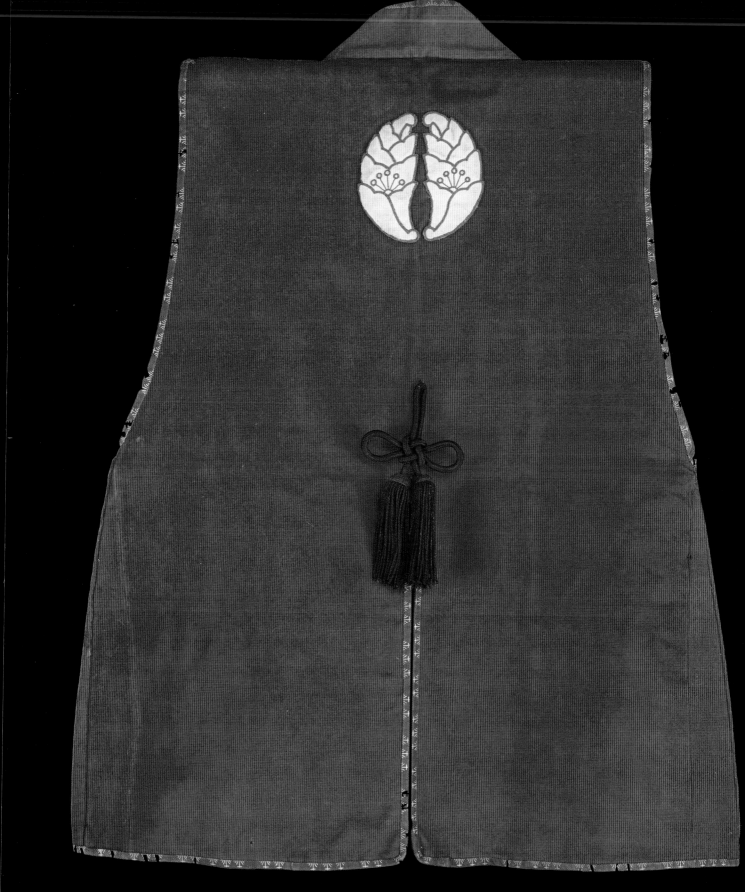

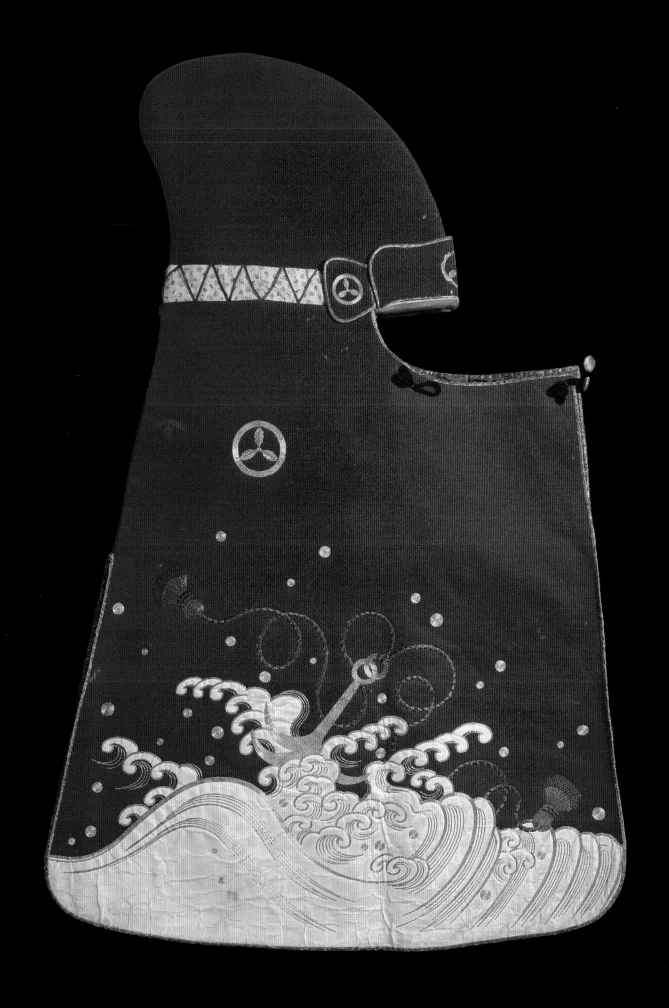

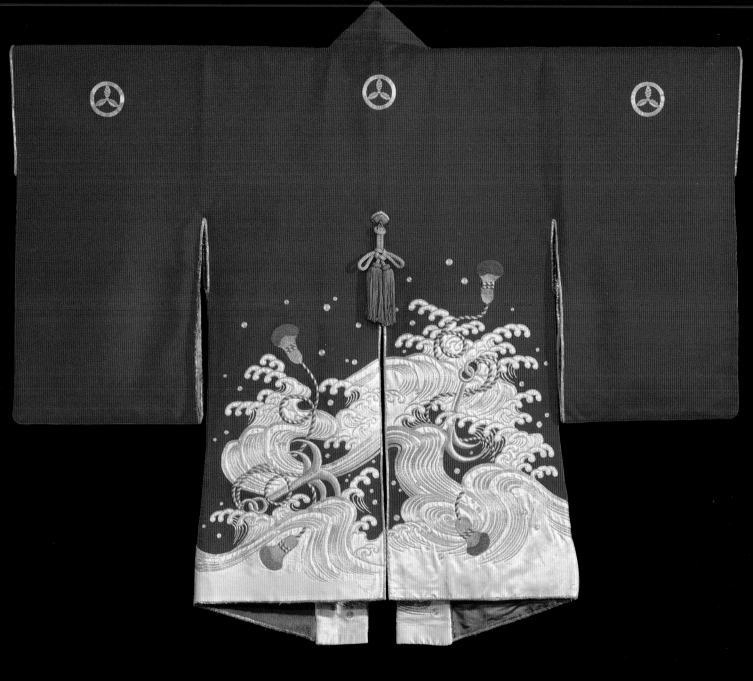

Opposite **FIGURE 8.2**

■ Firefighter's hooded cape *(shōbō zukin)*
Japan, eighteenth–nineteenth century, Edo period
Wool with gold- and silk-thread embroidery and appliqué
36½ x 23 in.
John C. Weber Collection

Above **FIGURE 8.3**

■ Firefighter's ceremonial coat *(kajibanten)*
Japan, eighteenth–nineteenth century, Edo period
Wool with gold- and silk-thread embroidery and appliqué
38 x 48 in.
John C. Weber Collection

Based on evidence from items scientifically analyzed to date, the majority of red Dutch trade fabrics were dyed with lac, a dyestuff readily available through Southeast Asian trading partners. The dye for the woolen fabric in this particular set of garments, however, is cochineal, likely acquired through the robust inter-European trade between Spain and the Netherlands.

The coat *(kajibanten)* and hooded cape *(shōbō zukin)* were likely used only for ceremonial purposes. A sturdier coat, often made of leather, would be worn for actually fighting a fire. The hooded cape covered all but the firefighter's eyes, offering additional protection.

Despite the Japanese preference for warm yellowish reds over the cold bluish red derived from insect dyes, reconstituted *enji-wata* was desired, since it could be brushed directly onto cloth. The much-loved safflower (*Carthamus tinctorius* L.) scarlet dye, on the other hand, required immersion in a vat.[8]

SAFFLOWER, MADDER, AND SAPPANWOOD

The colorant in *enji-wata* was not always lac. In Han Dynasty times (206 BCE–8 CE), the Yanzhi Mountains were famous for their safflower, a lake pigment that could be absorbed into cotton fibers. When the Han routed the Xiongnu, the latter lamented, "Having lost our Yanzhi Mountain, our women have lost their rouge." Safflower-based pigments for cosmetics continued to be used throughout East Asia, being popular in Edo-period Japan, and are still produced in small quantities today. Documents confirm that safflower *enji-wata* was produced at least through the seventeenth century.[9] It is therefore likely that the *enji-wata* listed as a pigment for Buddhist statues in eighth-century Shōsōin documents was made with safflower rather than lac.[10]

The thistle-like safflower, whose yellow petals produce a beautiful scarlet when soaked in alkali, was cultivated in Japan as early as the third century.[11] Its attraction resounds in poems from the eighth-century *Man'yōshū* anthology. One verse compares the hidden scarlet at the base of its yellow petals to a secreted desire. Another warns that safflower, though alluring, is a fugitive ladylove. A third touchingly exclaims, "Were you a safflower, I would want to dye you into my sleeves, and take you with me."[12]

Safflower scarlet was disparaged by the Chinese as an "intermediate" color, in contrast to the "correct" red shades produced

Above **FIGURE 8.4** *Enji-wata,* lac dye absorbed in cotton and dried for Chinese export. Photo courtesy of Sachio Yoshioka.

by madder, which, according to the Chinese theory of "five agents," was associated with the south, summer, fire, and decorum.[13] Consequently, Japanese madder was widely used in classical times and was included in color-coded ceremonial dress. The earliest Japanese record of dye ingredients, the *Engishiki,* notes the use of rice and ash lye for dyeing madder roots; the former was used to leach the latent yellow, the latter as an alkaline mordant to set the color.[14] Repeated immersions produced the beautiful deep red seen in fourteenth-century armor lacings preserved at the Kushibiki Hachiman shrine in Aomori; tests reveal that they were dyed with Japanese madder.[15]

By the sixteenth century, Japanese madder dyeing had all but ceased, with safflower becoming the main source of elite red dyes.[16] Already popular in the Heian period (794–1185) as shades in the layered colors (*kasane iro*) and matched colors (*awase iro*) that formed the basis of female aesthetic expression, safflower grew in importance as improved methods of cultivation and processing were developed.[17]

The cost of dyeing a single robe in safflower scarlet was high, and sumptuary laws forbade all but the military and court nobility from wearing safflower-dyed robes. Inventive dyers for the increasingly rich townspeople found ways to circumvent this restriction, imitating scarlet using sappanwood (*Caesalpinia sappan* L.) imported from Southeast Asia and top-dyeing it with warm yellow from gardenias.

Importation of sappanwood dates to the eighth century, when it was used as a wood stain, fabric dye, and medicine. Shades of sappanwood-dyed maroon feature in Heian layered costumes. In the Edo period (1615–1868), with adroit, newly developed use of mordants and top-dyeing, this single dye source could produce a spectrum of hues, from rich reds to dark purples. In addition, the dye was stable enough to be adapted for brush dyeing, a technique central to *yūzen* production. Documents suggest that some *enji-wata* (of inferior grade) was made from condensed sappanwood dye mixed with shell powder (*kaigara gofun*).[18]

IDENTIFYING JAPANESE RED DYE SOURCES

To identify the source of a color dyed centuries ago, art historians and dyers have relied on their thorough knowledge of how each dye ages and fades. Comparison of selvage colors with exposed colors, experimentation in following old recipes, and documentary research have helped experts create templates for dye identification. Recently, scientific dye analysis has brought another dimension to the process of identification.

Work done at the Kyoto Institute of Technology has included chemical analysis of red dyestuffs in *enji-wata,* which ceased to be produced in China around the late nineteenth century, resulting in details of its ingredients and manufacture being lost.[19] Fifteen sheets of *enji-wata,* of unknown date but most likely from the mid- to late nineteenth century, were analyzed chemically to identify their red colorants. Each sample of *enji-wata* came from a different source, among them a *yūzen* dyer, a Buddhist image artisan, and a Japanese painter.[20] The sheets were subjected to a series of tests. The first, an analysis of inorganic ingredients by scanning electron microscopy and energy dispersive x-ray spectroscopy (SEM-EDX), eliminated the possibility of mineral pigments.

Next, reflectance spectroscopy showed eight sheets to have been made with anthraquinone (insect) dyes.[21] To corroborate this finding, they were used to dye silk, and methanol extracts from the dyed silk were tested with high-performance liquid chromatography (HPLC) using a photodiode array detector. While both samples 1 and 5 obtained peaks at fourteen minutes, typical of lac, only Sample 1 also showed a peak at eleven minutes, typical of cochineal. As a final check, their mass spectrometry was taken by electrospray ionization (ESI). Sample 5 turned out to have only laccaic acid A, the main red colorant of lac, while Sample 1 contained both laccaic acid A and carminic acid, the main red colorant in cochineal.[22]

Lack of specific dating makes clear-cut conclusions impossible, but within the context of all fifteen *enji-wata* examples, it might be conjectured that the seven pure lac samples retain the traditional composition, while Sample 1 reveals experimentation with combining cochineal with traditional lac. Seven *enji-wata* sheets were found to contain sodium chloride, pointing to the use of synthetic dyes, which were introduced to Japan in 1862 and perhaps slightly earlier to China. A parallel can be found in innovative approaches to pigments used in paintings and prints in the second half of the nineteenth century. In this case, cochineal appears alongside synthetic dyes, often used in combination with other dye-based lake pigments.[23]

Top **FIGURE 8.5** *Bingata,* child's ceremonial robe with flowers of the four seasons on a light blue ground, Japan, late Edo period, nineteenth century. Bast fiber, 29¹⁷⁄₃₂ x 26⁴⁹⁄₆₄ in. Kyoto Institute of Technology Museum and Archives, AN.113. The reds include lac.

Bottom **FIGURE 8.6** *Kosode,* Japan, middle Edo period, eighteenth century. White silk with checkers and horse racing scene in *yūzen* dyeing and embroidery, 50²⁵⁄₆₄ x 50¹⁵⁄₁₆ in. Kyoto National Museum, IK 334. The checkers at the shoulder are tie-dyed safflower, while the red leaves and horse decorations are dyed with lac.

Although it is impossible to rule out the presence of cochineal dyes on textiles (as opposed to pigments on paintings) before the mid-nineteenth century, chemical analysis of samples of Edo-period *yūzen* fabrics from the mid-eighteenth century through the nineteenth century done at the Kyoto Institute of Technology disclosed that six samples contain anthraquinone derived from insects.[24] All six were dyed with lac and not cochineal; the nondestructive reflection visible spectra and their second derivative spectra showed characteristic plural peaks. The well-preserved samples also made it possible to distinguish differences in the wavelengths of absorption minimums in the second derivative reflection visible spectra at around 10 nanometers.

Though done with only a small selection, the *yūzen* dye analysis corroborated documentary evidence on the predominance of lac as the main insect substance used to dye fabric in Japan during the Edo period. After Japan opened its doors to the West, the picture became more complex. To what extent the rest of Asia may have adopted cochineal as a textile dye remains unclear. 🔴

RED ECHOES OF ENSLAVEMENT
Cochineal Red, West Africa, and the Slave Trade

EMILY LYNN OSBORN

RED TEXTILES, OF WHICH AT LEAST SOME were made with cochineal, reached Africa and became woven into the transatlantic slave trade. In effect, red fabrics played an important material, cultural, and political role in the African trade for slaves. As European merchants who sailed Africa's coastlines learned, it was not only European nobility and aristocrats who sought to adorn themselves in scarlet cloth. Kings and chiefs in West Africa also associated red with power, wealth, and elevated status. Consequently, European merchants who traveled the West African coast used imports and gifts of red cloth to establish trade relations.

Cochineal red thus helped spawn a web of connections that linked different places and peoples, from the Americas to Europe to Africa and back to the Americas. But for some, the red cloth that traveled the Atlantic basin did much more than connect—it seduced, reduced, and exploited. Various oral histories and narratives collected from African Americans in the early twentieth century indicate that red cloth helped to account for the enslavement and forced transportation of their ancestors from Africa to the Americas.

Tracing the travels of cochineal red brings into the same frame three histories that are often approached separately: that of the Iberian conquest and occupation of the Americas, that of Renaissance Europe, and that of the transatlantic slave trade. This preliminary investigation further suggests that cochineal acted as an important and heretofore overlooked driver of mobility and enslavement in the early modern Atlantic world.

Opposite Signare. Lithograph by Jacques-François Llanta in David Boilat, *Esquisses Sénégalaises; physionomie du pays, peuplades, commerce, religions, passé et avenir, récits et légendes* (Paris: P. Bertrand, 1853), New York Public Library. In Senegal, women referred to as *signares* helped broker trade relations between Europeans and Africans, including the trade in slaves. They became known for their distinctive and elegant mode of dress, which often included imported red cloth. Photo: New York Public Library/Art Resource, NY.

A COLOR OF THE SLAVE TRADE

When Spanish conquistadors swept into Mexico in 1517, they found a blood-red dye popular among Aztec elites. At that time, the best red dye produced in Europe was made by Venetians, whose strict guild rules and protocols kept secret the recipes they used to derive dye from different varieties of parasitic bugs. The Mexican cochineal bug was related to these European insects. But unlike European dyers, who painstakingly culled erratic supplies of the bugs from their natural environment, the Aztecs and others enjoyed a steady supply of cochineal red dye from domesticated bugs. Although cochineal bugs are delicate and vulnerable to temperature fluctuations, humidity, and rain, farmers in the Mixteca and Oaxaca regions managed to cultivate the insect, increasing its size and dye-producing capacity, in fields of prickly pear cactus, its preferred habitat. It was no small ethnobotanical endeavor: it took around seventy thousand insects to produce 1 pound of cochineal's vivid red dye.[1]

By the 1560s cochineal was New Spain's most valuable export after silver and was a desirable commodity in a European landscape riddled with religious and political conflicts. In 1597, for example, English pirates stole 27 tons of cochineal from a Spanish convoy.[2] In the mid-seventeenth century, Oliver Cromwell redesigned the infantry coats of the British army and colored them cochineal red.[3] Those red coats were used by the British army for more than two centuries, and the 1776 defeat of their wearers in North America marked the independence from Britain of the thirteen colonies of the United States.

Less well known is the fact that those cochineal red English coats also found their way into the interior of West Africa. René Caillié, a French explorer who traveled through West Africa in the 1820s, was one of the first Europeans to visit

Llanta lith. P.Bertrand, éditeur, rue St André des Arcs 55. Imp. Lemercier, Paris.

SIGNARE.

the African interior and to describe its daily life in detail. He spent some weeks in the city of Kankan, then the commercial and political capital of a small Islamic state. There, during a holiday, he witnessed the town's imam, or religious leader, leaving the mosque after prayers, accompanied by a group of young men wearing "old red uniforms of British soldiers." Those red army coats had likely been procured by local traders in the port city of Freetown, Sierra Leone, where British troops and men-of-war were posted to combat the Atlantic slave trade, which the English had declared illegal in 1807. For the wearers of those red coats in Kankan, located 400 miles from the coast and well beyond the reach of British laws and edicts, the garments no longer indicated British affiliation or military membership. Rather, they were treated as luxury items, valued for their color, style, and rarity.[4]

As Caillié's observation in Kankan indicates, Africans, like Europeans, had long concerned themselves with adornment and coloration. Indeed, textiles had figured into the interactions of European and African elites since the Portuguese had first started to move down the African coastline in the late fifteenth century. Colleen Kriger, who has written on the history of cloth in what is today Lagos, Nigeria, notes that oral traditions locate textiles firmly within the origins of European–African commercial transactions. According to Kriger, when the first Europeans arrived, the king of Lagos was Oba

Akinsemoyin. He received from those European traders a gift of velvet cloth, and "in a gesture both shrewd and deferential, he immediately sent the cloth to his superior, the Oba of Benin, saying that only his majesty was worthy of possessing it. The Benin King welcomed the gift and urged Oba Akinsemoyin to continue his relations with the slave trader."[5] Such narratives pinpoint the desire for imported cloth by African elites as generative of the slave trade, while observations and writings of European travelers reveal that the cloth they desired was often colored red.

Above Jean-Baptiste Labat, *Voyage of the Chevalier Des Marchais in Guinea*, 1725–1727. Editor: chez Pierre Prault, Paris. Inv. GE DD-2987 (8238). Bibliothéque Nationale de France (BnF), Paris. Detail showing clothing worn by rulers of Whydah on the lower Guinea coast in the early eighteenth century. According to European visitors and merchants, local elites wore imported velvet and silk clothes of various colors, including scarlet. This splendor was paid for in slaves. © BnF, Dist. RMN-Grand Palais/Art Resource, NY.

Opposite Frédéric Etienne Joseph Feldtrappe, *Traite des Nègres* (The Slave Trade), early nineteenth century, after a painting by George Morland. Cotton, roller printed, 101 x ⅓ in. Metropolitan Museum of Art, Rogers Fund, 1926 (26.189.2). This textile, which features copies of images from abolitionist engravings, highlights the danger that Europeans and slave trading posed to African families. While the choice of the color red for these toile cloths (silk, cotton, or linen printed with patterned scenes) likely reflected the popularity of this color in Europe, this hue shares a deep connection to the slave trade, since red cloth helped facilitate the commerce in human beings. © The Metropolitan Museum of Art. Image source: Art Resource, NY.

TRAITE DES NÈGRES.

In the early 1600s, a German visitor to the West African kingdom of Benin remarked on the great value placed on the color red in that realm. Rules akin to the sumptuary laws of Europe dictated that only the king and other elites could wear red coral, beads, and cloth. In Benin and elsewhere, Europeans used luxurious red textiles, likely made with cochineal, to initiate diplomatic transactions that helped pave the way for commercial exchanges. In 1701 a representative of the Dutch West India Company offered the king of Asante (in present-day Ghana) a host of gifts, including a mirror, an umbrella, and "red velvet cloth with gold lace border."[6] Likewise, an English visitor to Benin observed in a 1745 book, "It is the practice here for masters of vessels to pay the king a visit soon after their arrival and . . . on these occasions the black monarch receives a handsome present, consisted of a piece of silk damask, a few yards of scarlet cloth, and some strings of [red] coral."[7] When that visitor, William Smith, gained an audience with the monarch, he noted that the king "received me with much politeness, particularly after the fine flashy piece of red silk damask, which I had brought with me as a present for him, had been unfolded."[8] Later in the eighteenth century, the king of Dahomey hosted European guests wearing a "European style coat of gold-embroidered red velvet."[9]

While West African weavers and dyers had long managed a robust domestic market for their products, they faced the same challenges as Europeans in fixing certain colors, including red, into textiles. The European trade presented African artisans with a new source of red, and they often used imported red cloth as a raw material. Traveler John Adams, writing about a region near Dahomey, observed that West African artisans made "cloth of various patterns . . . both of cotton and grass . . . into which they frequently weave threads taken from the red India silk teffity [taffeta]." They did this, he explained, because they had "no red dye which they can render permanent."[10]

Among the Yoruba, who associated red with the color of Shango, god of thunder, weavers likewise unraveled red cloth imported from Europe and rewove the thread into ceremonial textiles.[11] It is not clear at this point if those red threads were necessarily made with cochineal; by the end of the eighteenth century, different grades of red cloth entered Africa, bound for

Left, top and bottom Textile sample book, British, 1771. Paper, cloth binding, with attached samples of fustian, 9 x 5¼ x 2¾ in. Bound pages: 8¼ x 4⅝ in. Metropolitan Museum of Art, Rogers Fund, 156.4 T31. This page and detail of a fabric swatch from a textile sample book reveal some of the patterns and colors of cloth that European merchants exchanged for slaves in West Africa. Memories of enslavement among African Americans in the United States often make reference to red flannel, which European merchants traded along the African coast. © The Metropolitan Museum of Art. Image source: Art Resource, NY.

specific markets and clients. Nonetheless, it seems reasonable that the webs of commerce that traversed the Atlantic introduced at least some of Mexico's cochineal red into African worlds of ritual, commerce, and enslavement.

THE RED HANDKERCHIEF

If red textiles, some of them made with cochineal, helped facilitate the slave trade, what does the color red mean to Africans who ended up in the United States and their descendants? To answer this question, it is useful to draw upon interviews conducted in the 1930s, during the Great Depression, many with African Americans. These interviews are problematic and inconsistent, as other scholars have pointed out, yet used with caution and care, they can still cast light on slave life and its legacies.[12] It is also possible to use the interviews to learn something about the color cosmologies of African Americans in the post-Reconstruction era.

For example, some interviews make passing mention of the process of spinning and weaving that occupied slave women in the antebellum South. A former slave named Esther Green recalled that "women would spin and weave cloth . . . [then they] would dye [the] cloth different colors, mostly red and blue."[13] Preston Klein remembered that his mother, a former slave, used to dye cloth after she spun it and that she made fine red cloth "that wouldn't fade neither."[14] Katie Arbery of Arkansas noted that her brother warned her against wearing a "red dress" he had given her to go milking; he worried that it would prove too attractive to some of the field hands working nearby.[15] And former slave Cindy Kinsey observed that when she was a girl, her clothes had no colors and were "mostly dark"—save for one good dress of "bright red cotton," which had been dyed on the plantation.[16]

Although the precise time period to which the interviewees refer is not always clear, the fact that a slave or a sharecropper would own red clothing marks a sea change in the circulation of color. In the early eighteenth century, red textiles would have been prohibitively expensive for someone from the lower ranks of the social spectrum in England, the American colonies, or Africa. But in 1857 a significant change had taken place in the circulation of the color red with the invention of a synthetic red dye. Red, and many other colors, could now be obtained far more cheaply than was previously possible, even after cochineal production had spread throughout the Americas and exports had reached millions of tons a year. By the late nineteenth century, colored cloth, including red, had become much more accessible to people even with limited means. Color was cheap.

But for some African Americans, the availability of the color red did not erase its ties to the slave trade. Some linked the color to the loss of their homeland and their liberty. The motif of a red handkerchief figures frequently into oral histories and accounts of how Africans came to the United States. In an interview, ex-slave Mariah Callaway explained, "My grandfather came directly from Africa and I never shall forget the story he told us of how he and other natives were fooled on board a ship by the white slave traders using red handkerchiefs as enticement. When they reached America, droves of them were put on the block and sold to people all over the United States."[17] Shack Thomas, a centenarian living in Florida at the time of his interview, described a father who was a "native of the West Coast of Africa." Thomas elaborated, "When [my father was] quite a young man, [he] was attracted one day to a large ship that had just come near his home. With many others he was attracted aboard by bright red handkerchiefs, shawls and other articles in the hands of the seamen. Shortly afterwards, he was securely bound in the hold of the ship, to be later sold somewhere in America."[18]

Unsurprisingly, some academic historians would dispute these accounts of enslavement and their suggestion that Africans were simply tricked into servitude by the allure of red cloth. These particular oral accounts do not address, for example, the power dynamics, social complexities, and violence that made people into slaves, all of which played critically important roles in the production of slaves bound for the Americas. At a more abstract level, however, these narratives convey a fundamental truth about the seductive power of red cloth in that they reflect how the desire of African elites for imported red fabric, the best of which may have been made with American cochineal, helped to generate and sustain the Atlantic slave trade. Even if average West African men and women had not been drawn onto slave ships by banners of red cloth, red textiles undeniably helped lubricate commercial ties between African leaders and European elites. In that regard, the motif of red cloth serves to represent the enslavement of hundreds of thousands of Africans.

That perspective on the color red explains why Thomas's father, who attributed his captivity to the allure of "bright red handkerchiefs," could not tolerate wearing anything of a scarlet hue. As his son explained, he "hated the sight of it."[19] Red may have become cheap by the early twentieth century, but among at least some African Americans, the color had not lost its grim association with captivity, enslavement, and the loss of their homeland. ✹

PART 3

COCHINEAL
& SCIENCE

POINT OF ORIGIN

Genetic Diversity and the Biogeography of the Cochineal Insect

ALEX VAN DAM, LIBERATO PORTILLO MARTÍNEZ, ANTONIO JERI CHÁVEZ, AND BERNIE MAY

COCHINEAL INSECTS ARE A SOURCE of carminic acid, which has long been used to dye everything from fabric to food. Members of the scale insect superfamily Hemiptera: Coccoidea, they form a diverse group of mainly sap-sucking insects with at least thirty families and numbering more than eight thousand species. Female scale insects have a simplified morphology, or form and structure, lacking all trace of wings. Males are minute, with a single pair of wings and no mouth parts.

Within the Coccoidea superfamily, the cochineal insect comprises a small family, the Dactylopiidae, which is made up of ten described species within the genus *Dactylopius*.[1] The specific scientific name of the cochineal insect is *Dactylopius coccus* Costa (also *D. coccus*).

Dactylopiidae infest cacti across a wide geographical range. *Dactylopius* has a disjunct distribution, with five native species in North America, including Mexico, and five indigenous South American species ranging from Peru southward, particularly in northern Argentina. Among these, *D. coccus* is the only species to be distributed across both North and South America. This unusual distribution, coupled with archaeological evidence of its use as a prominent red dye, has long raised suspicions that cochineal was traded between pre-Columbian west Mexican and Andean societies.[2]

Cochineal prefers *Opuntia ficus-indica*, the prickly pear cactus, as its host plant over other cactus species, though it can also feed on the nopal cactus (*Nopalea* spp.). Both cacti have their origins around current-day Oaxaca, Mexico, leading some scholars to believe that cochineal is native to Mexico.[3] Others argue that, despite the geographic origins of its preferred host plant, cochineal is native to South America, where it can be found reproducing without human assistance. In Oaxaca, on the other hand, cochineal is commonly cultivated in protected farms.[4] Another argument is that

wild cochineal insects switched from an ancestral host to the prickly pear in South America and then spread northward as the cactus was introduced across continents.

The utility of ecological data and archaeological records in determining the geographic origins of cochineal has been controversial. Archaeological evidence supports that cochineal was cultivated or gathered for use as a brilliant red dye by Mixtecs and Zapotecs in Oaxaca, Mexico, and by Incas in southern Peru, for more than one thousand years.[5] Thus far, pre-Columbian archaeological evidence is better preserved and appears earlier in the archaeological record in Peru than in Mexico.[6] But the archaeological record in Mexico is incomplete, as the country's humid climate (compared to Peru's dry mountain climate in the west-central Andes and on the Pacific coast) has resulted in fewer extant artifacts over time. The situation calls for a less biased method to shed light on the geographic origins of cochineal. DNA markers are ideal for such a task.

DNA MARKERS IN PHYLOGENETICS

Phylogenetics is the study of evolutionary relationships between groups of organisms. Basically, it involves family trees that chart a particular classification of life. There are many different types of phylogenies, which trace patterns of shared ancestry between lineages and which use DNA data. All of them rely upon the basic premise of homology (similarities in form and development based on direct or common descent) of molecular markers used in a particular study.

This study of cochineal used mitochondrial DNA (mtDNA), a type of DNA that is maternally inherited. This group of insects

Opposite José Antonio de Alzate y Ramírez, "Front and back views of male and female cochineal insects," from *Memoria sobre la naturaleza, cultivo, y beneficio de la grana*, Mexico City, 1777. Colored pigments on vellum, 12¼ in. high. Edward E. Ayer Manuscript Collection, Ayer Ms. 1031, plate 1, Newberry Library, Chicago.

Plancha 1.

Fig. 1. El Macho de la grana visto por la parte inferior con Microscopio de mucho aumento.

Fig. 2. El mismo visto por la parte superior.

Fig. 3. Fig. 4. Las Cochinillas vistas con el mismo Microscopio, la *Fig. 3.* le representa vista por la parte inferior, y la 4. por la superior, quando se ven en esta Figura no caminan por las Pencas; tan solamente se les observan dos Ojos, y no se distinguen los Machos de las Hembras.

uses paternal genome elimination as its mode of inheritance to sperm or egg cells. One would therefore expect a similar pattern of evolution from both nuclear DNA (DNA from the nucleus) and mitochondrial DNA markers, if they were evolving at the same speed and not linked to other genes under selection.

Some genes evolve at different speeds, depending upon how much room they have to carry out their particular cellular functions. Genes that are highly vital to key cellular functions tend to undergo less change over time; if they change too much, they will lose their key functions and the cell will die. MtDNA was chosen for this study because it evolves fairly rapidly and has been used for the last twenty years to do similar work.

THE INITIAL FINDINGS

Cochineal insects were collected from three different farms in Oaxaca, Mexico, as well as from thirty-eight locations from the Lima province and the Sierra Central region of Peru. A widely distributed subset of eight locations from Peru was chosen for further DNA sequencing. Additionally, a collection that historically came from Mexico was sampled at Madeira Island, a Portuguese archipelago in the North Atlantic Ocean north of the Canary Islands.

There is relative dissimilarity among the insects sampled, with more genetic diversity in the samples from Mexico, including those from Madeira, than in the Peruvian samples. Generally, the geographic location where a population or species originates links well to the center of genetic diversity.[7] The collections from both Peru and Madeira showed low mtDNA diversity, indicative of patterns similar to other introduced species.[8] The evidence thus shows that the center of genetic diversity is Mexico, indicating that Oaxaca is the geographic origin of this species.

While the genetic origins of cochineal are in Mexico, the Peruvian cochineal population, given the data here, represents a unique genetic line that could be referred to as Peruvian cochineal. The same applies to the cochineal population from Madeira and Mexico. All three locations—Mexico, Peru, and Madeira—reflect unique genetic patterns that could not have survived without human care. The fact that present-day mtDNA lineages of cochineal insects are extant due to human care seems to indicate that the insects are true domesticates, as their wild ancestors are most likely extinct. As for the question of when the Peruvian population was moved south from Mexico, further research using more DNA markers from the nuclear genome—or a more detailed phylogenetic analysis of the mtDNA—is required.

Above Nicolas Hartsoeker, from *Essay de dioptrique (On the Magnifying Power of a Lens),* Paris, 1694. New York Public Library, Science, Industry, and Business Library. Hartsoeker published the first picture of a magnified cochineal insect. Photo: New York Public Library/Art Resource, NY.

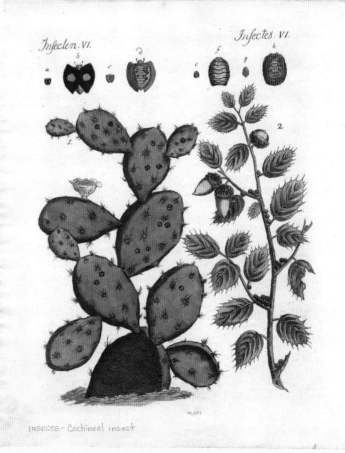

Above Antoni van Leeuwenhoek, from "A Letter from Mr. Antony Van Leewnenhoek [*sic*] F.R.S. Concerning Cochineel," Delft, Holland, March 21, 1704. The Royal Society, London, *Philosophical Transactions*, 1704–1705, vol. 24, nos. 289–304, 1614–1628, 10.1098/rstl.1704.0026. Van Leeuwenhoek, a draper by trade, published the first detailed images of the cochineal insect as seen under the newly invented microscope. © The Royal Society.

Right Friedrich Justin Bertuch, *Insecten VI, Insectes VI*, Weimar, Germany, Industrie-Comptoir, 1792–1843. Plate mark 9 x 7 in. New York Public Library, Mid-Manhattan Picture Collection. Photo: New York Public Library/Art Resource, NY.

CRIMSON TO SCARLET

From American Tradition to European Experimentation

ANA ROQUERO

TWO THOUSAND YEARS AGO IN AMERICA, dye makers created colors for all time, whereas in eighteenth-century Europe, dye makers created colors for the fashion of the moment (figure 11.1). No dye has lent itself to dyers' persistent search for red tones and shades as well as one that comes from several species of insects of the superfamily Coccoidea, in particular cochineal and kermes. However, American loyalty to the technological tradition of dye making contrasts with the European urge to experiment.

From what is known from historical documents, dye makers in pre-Columbian America obtained or modified the color crimson from cochineal by making use of alum—*kollpa* in Quechua and *tlalxócotl* in Nahuatl—as well as saltpeter (potassium nitrate)—*zuca* in Quechua and *tequisquitl* in Nahuatl. Dyers also used plants of the Melastomaceae family, which store aluminum, as a mordant. Francisco Hernández, in his *Historia natural de la Nueva España*, points out that the utility of the bush known as *tezhuatl* (*Miconia* spp.) is that "it prepares and perfects the little worm that dyes things scarlet."[1] In the same vein, Felipe Guamán Poma de Ayala reports in his *El primer nueva corónica y buen gobierno* that in pre-Columbian Peru, girls picked flowers known as *tire* (*Miconia* spp.) for the storage rooms of the Inca "for dyeing wool" (figure 11.2).[2] Then, as today, dyers must have used vegetal ash, whose alkaline quality turns crimson toward purple, and acidic plants, which turn it toward scarlet, to modify the cochineal hues.

The dye maker's delight in the range of possible reds can be seen in the 1540 *Plictho de l'arte de tentori*, the first compilation of dyeing procedures put into print. Thirty-three recipes

for red using cochineals of the genus *Porphyrophora* and using kermes (*Kermes vermilio*) appear in the publication—far more than its twenty-one recipes for black, six for blue, and five for yellow. By the eighteenth century, dye making was still a trade in transition between alchemy and chemistry. Theories such as *flogisto*, related to combustion, still explained the origin of colors, but the science-minded methodology of the Enlightenment deemed it necessary to understand the processes of dyeing using applied chemistry.[3]

At the time, accuracy in the practice of a trade was considered synonymous with progress. Surprisingly, according to Pierre Joseph Macquer, what led the field in the "art of dyeing" was the art of mixing faux colors, "because as regards the dyeing of silk one always prefers beauty to lasting quality."[4]

THE PREDOMINANCE OF SCARLET

The noun *scarlet* originally meant a wool fabric of excellent quality, preferably dyed using kermes. This was such a common usage that the fabric and the color, an intense red obtained using an acid bath, became synonymous. Early in the seventeenth century, using tin as a mordant for cochineal, the brightest scarlet was produced. Holland led the way in this practice, and although all of Europe was producing this dye, in the eighteenth century, scarlet dye was commonly called Dutch red or fire red. In 1752 Jean Hellot, author of a pioneering treatise on dyeing, provided a transcription of an eighteenth-century dyer's recipe for "Fire Colored Scarlet." He wrote:

> There is not a dye-maker who does not have his special twist for making scarlet, and each one is sure that his is better than all the others. But the outcome depends solely on the quality of the cochineal, of the water used, and of the way the tin solution is prepared, what dye-makers call "Mixture for Scarlet." As it is this concoction that

Opposite **FIGURE 11.1** Francisco de Goya, *The Duchess Cayetana with White Dress*, Spain, 1795. Oil on canvas, 76½ x 51¼ in. The duchess's white dress is highlighted by a crimson sash and two bows of silk, possibly painted with cochineal. Fundación Casa de Alba, Liria Palace, Madrid.

gives the intense fire-red to the dye from cochineal, that without this acid brew would be naturally crimson, I am going to describe the way of preparing it that has given me the best results.[5]

FIRE COLORED SCARLET

PHASE ONE: Prepare the Mixture

- Spirits of niter (nitric acid) 8 ounces
- River water 8 ounces
- Ammonia salt (very white) ½ ounce

This to make nitro-hydrochloric acid (*agua regia*)[6] because nitric acid by itself does not dissolve tin.

- Saltpeter (potassium nitrate) 2 *dracmas*

Dissolve an ounce of English tin in drops in the nitro-hydrochloric acid (to get the drops, pour the melted tin from some height into a bowl of cold water).

- Dissolve the granules of tin.

PHASE TWO

The next day, prepare the concoction for the scarlet (for one pound of wool)

- Clear river water 10 *azumbres*

Heat until lukewarm and add:

- Cream of tartar 2 ounces
- Cochineal powder 1.5 *dracmas*

Heat to the point of boiling and add:

- Mixture 2 ounces

This mixture quickly changes the color of the nitro-hydrochloric acid bath from the crimson that it was to the color of arterial blood.

When it begins to boil, put in the wool (which was previously soaked in hot water), stir without stopping for an hour and a half. Take out and wring out (it will be pink).

PHASE THREE: Color Bath

- Clear water (the clarity of the water is very important)
- Starch ½ ounce
- Cochineal 6.5 *dracmas*

A bit before the bath solution boils:

- Concoction 2 ounces

Put the wool in and remove it for an hour and a half. Take out, wring out and wash in the river.

One ounce of cochineal is plenty per pound of wool, to make it beautiful, and with enough color . . . if, however, you want it stronger . . . put in 1 or 2 more dracmas; but it will lose its brightness and luster if you go beyond that.[7] [figure 11.3]

AN ERA OF ENTHUSIASTIC EXPERIMENTATION

Beyond the successful use of tin, one gets the impression that lab technicians compulsively tested the reaction of cochineal with whatever else they could get their hands on. Hellot, for example, undertook the following experiments with cochineal dye[8]:

COCHINEAL +

Zinc dissolved in niter (potassium nitrate) = purple slate
Salt of Saturn (crystallized lead acetate) = lilac
Bismuth dissolved in niter = turtle dove gray
Copper dissolved in niter = dirty carmine
Silver from the crucible dissolved in niter = cinnamon a bit chestnut colored
Arsenic = vivid cinnamon
Gold dissolved in nitro-hydrochloric acid = speckled chestnut
Mercury dissolved in niter = like the above
Glauber's salt (sodium sulfate) = very bad gray
Urine salt (ammonia) = bad gray
Bismuth = violet

Above **FIGURE 11.2** Vicente Sánchez, *Miconia* spp., Mariquita, Colombia, ca. 1783–1791. Paper, tempera, approximately 24 x 18 in. Royal Botanical Garden, Madrid, collection of botanical drawings of the Real Expedición Botánica al Nuevo Reino de Granada (1783–1817), Celestino Mutis, DIV. III 2580.

Did these experiments have a practical use? The vestments of eighteenth-century courtiers were not washed, and normal use of an item in daylight or in a candlelit chamber was not likely to cause enough discoloration to discourage their use. However, customs of the time, like throwing urine in the streets, produced unexpected chemical reactions (figure 11.4). As Hellot so colorfully described:

> *The very air could make the colors lose their original vividness, and this loss is not the same everywhere, rather it is related to the diverse matter of which the air is composed. In the country, for example, and particularly at higher elevations, a scarlet cloth keeps its vivid shine much longer than in big cities where vapors of urine and alkali are abundant. In the same way, mud in the country, that apart from the main highways, is not anything more than dirt diluted in rain water, does not stain scarlet as does city mud in which there is urine and, perhaps, dissolved iron, as in the mud of Paris.*[9]

Quite literally, cochineal and its interactions were a matter of daily life. Its chemical reactions and recipes for its coveted redness would continue to pique scientific interest throughout the eighteenth century and into the early nineteenth century in the quest to preserve the dye's brilliant hues. 🐚

Top **FIGURE 11.3** Ana Roquero, reproduction following Jean Hellot's 1752 recipe for scarlet. Wool, 10 x 10 in. Photo: Pedro Laguna.

Bottom **FIGURE 11.4** Stockings of faded crimson, Spain, eighteenth century. Silk. Museo del Traje, Madrid, Centro de Investigación del Patrimonio Etnológico, CE 001172.

FINER THAN THE COCHINEAL OF NEW SPAIN

Painting of the Natural, Civil, and Geographic History of the Kingdom of Peru

ROCÍO BRUQUETAS

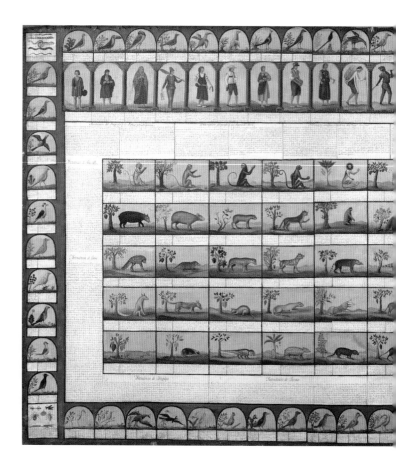

IN THE COLLECTION OF THE Museum of Natural Science in Madrid is a singular work of art, *Painting of the Natural, Civil, and Geographic History of the Kingdom of Peru,* of 1799 (figure 12.1a). The painting presents, through images and explanatory inscriptions, a detailed synthesis of the history of Peru, from the founding of the Inca kingdom to the eighteenth century. It shows the administrative organization of the Spanish viceroyalty and its economic activity, including the sources of wealth of the Peruvian territories. It also details Peru's natural history and the customs of its inhabitants from ancient times to when the painting was made.

The oil and ink on canvas is executed in a rectangular format with horizontal orientation and is composed of 195 scenes distributed around a central map of the viceroyalty of Peru. A frieze near the top divides the country's social and human anthropology into "civilized" and "savage" nations, while a surrounding framework illustrates the flora and fauna of the region. These figures are set against a landscape backdrop with text that mentions their geographic setting, their usefulness, and their taxonomic classifications.

Of particular interest, in the lower left section of the canvas is the image of a bird identified as a "Cargach" with a prickly pear cactus, whose pads are flecked with cochineal bugs, called *magno* in Quechua (figure 12.1b). An accompanying inscription proclaims the superiority of *magno*:

> *Tuna o Higo Palla: que reproduce el celebre tinte magno o cochinilla, de que hacen mucho uso aq[uello]s n[a]t[u] rales mas fina que la de N[ueva] E[spaña].* (Prickly Pear or Native Fig: that produces the celebrated dye *magno* or cochineal, of which the native people make much use, finer than that of N[ew] S[pain]).

Although many Spanish colonial paintings depict flowers, animals, people, and products of the hemisphere, this is the only one that includes cochineal, one of the most important and representative products. Basque economist José Ignacio de Lequanda Escarzaga was the author of the extensive text that accompanies the images. He was a nephew of Don Baltasar Martínez Compañon, the bishop of Trujillo (Peru) and an eminent man of the Enlightenment. Lequanda collaborated with him in his scientific work and accompanied him on his official visit to the province from 1782 to 1785.[1] Lequanda was in charge of the finances of the viceroyalty of Peru from 1767 to 1797 and was also adviser to Viceroy Gil de Taboada Lemos y Villamarín. In 1796 the viceroy charged Lequanda with editing a memorial in which Prime Minister Manuel Godoy ordered the creation of a "magnificent

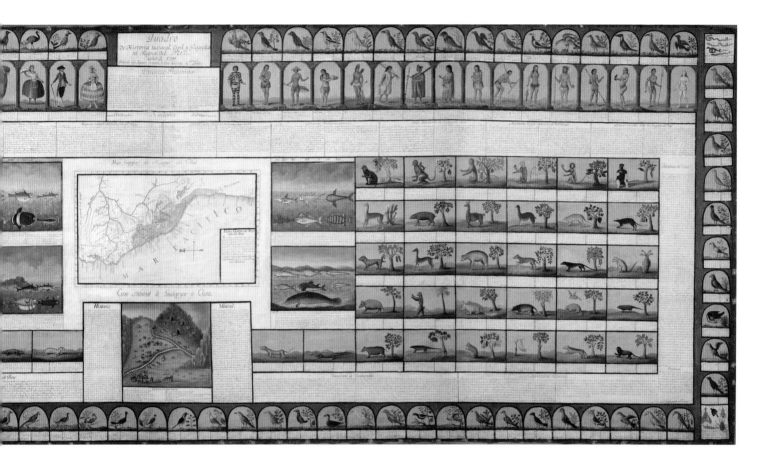

painting" for the office of the "Supreme Secretary of the Royal Hacienda of the Indies."

The painting is signed by Louis Thiébaut, from a family of French engravers about which little is known. The models for his work were taken from illustrations in *Trujillo del Perú* by Martínez Compañon. These in turn were based on drawings by the naturalist Thaddäus Hænke of the Malaspina expedition and other scientific expeditions in Peru. 🖉

Above and right **FIGURES 12.1A–12.1B** Louis Thiébaut and José Ignacio Lequanda Escarzaga, *Painting of the Natural, Civil, and Geographic History of the Kingdom of Peru*, Peru, 1799. Oil and ink on canvas, 130⁵/₁₆ x 46²¹/₃₂ in. National Museum of Natural Sciences, Madrid, 0605011100001. Whole painting and detail of lower left section showing "Prickly Pear or Native Fig: that produces the celebrated dye *magno* or cochineal, of which the native people make much use, finer than that of N[ew] S[pain]."

PROOF POSITIVE
The Science of Finding Cochineal

ESTRELLA SANZ RODRÍGUEZ

COCHINEAL IS ONE OF THE MOST significant red dyes used throughout history. Its main sources are plant parasites from the Coccidea family extracted from American (*Dactylopius coccus* Costa), Polish (*Porphyrophora polonica* L.), and Armenian (*Porphyrophora hamelli*) cochineal.[1] Polish and Armenian cochineal were the major sources in Eurasia until the late sixteenth century, when they were almost entirely replaced by American cochineal.[2]

Vast and valuable historical information about where, when, and how natural dyes, including cochineal, were employed is now complemented by chemical analysis, without which information about dyes used in the manufacture of a specific historical object is purely hypothetical. Analytical proof confirms the presence of a particular dye and supports the historical-artistic profile for the object under study.

While the main chemical component of all cochineal sources is carminic acid (ca), they also contain kermesic acid (ka), flavokermesic acid (fk), an unknown compound called dactylopius coccus II (dcII), most likely 7-C-glycoside of fk,[3] and other still unidentified minor compounds, such as dactylopius coccus IV (dcIV) or dactylopius coccus VII (dcVII). It is possible to distinguish between Polish and other cochineals because the former contains a high proportion of kermesic acid. Distinguishing between American and Armenian sources, however, is challenging because of their very similar compositions.[4]

Much effort has been made to develop an analytical method that exactly identifies cochineal species to aid in dating and determining the origin of artworks. The most referenced is the method proposed by Jan Wouters and Andre Verhecken in 1989.[5] The authors concluded that discrimination between the three cochineal species could be achieved by evaluating the proportion of dcII, fk, and ka and that data

obtained from real samples has to be compared with that of reference standards. Nonetheless, a 2011 study by Ana Serrano[6] suggested that this method made it possible to misidentify Armenian cochineal as a species of the American genus. Given the complexity of the subject, the authors suggested that principal component analysis (PCA), a statistical technique for finding patterns in highly complex interdependent data, be applied for data interpretation. They studied sixty-three historical specimens from seven cochineal species and found that the overlapping of data plots for the Armenian and American species could be overcome by using PCA.

Despite these encouraging results, any laboratory dedicated to this kind of analysis needs to undergo its own method development process. Achieved extraction efficiencies and the response of different detection techniques for each of these complex compounds may vary widely. One major drawback is the lack of suitably matched reference materials. Furthermore, both aforementioned methods are based on quantification of minor components in the dye, a task that becomes increasingly difficult when working with what are commonly very small sample amounts. Frequently, only carminic acid can be identified, as the concentrations of minor compounds fall below the quantification limit. Having access to other sources, such as documentary evidence about dating and origin, is then crucial.

Opposite **FIGURE 13.1** El Greco, *Saint Matthew* (from the Apostles series), Spain, ca. 1610–1612. Oil on canvas, 39⅜ x 31½ in. Museo del Greco, Toledo (CE23346). American cochineal was identified by LC-DAD-QTOF as the dyestuff employed for painting the robe of *Saint Matthew*. Ellagic acid, a component of oak galls, was also found, indicating that the dyestuff was extracted from weighted silk. Photo: Tomás Antelo, Instituto del Patrimonio Cultural de España, Madrid.

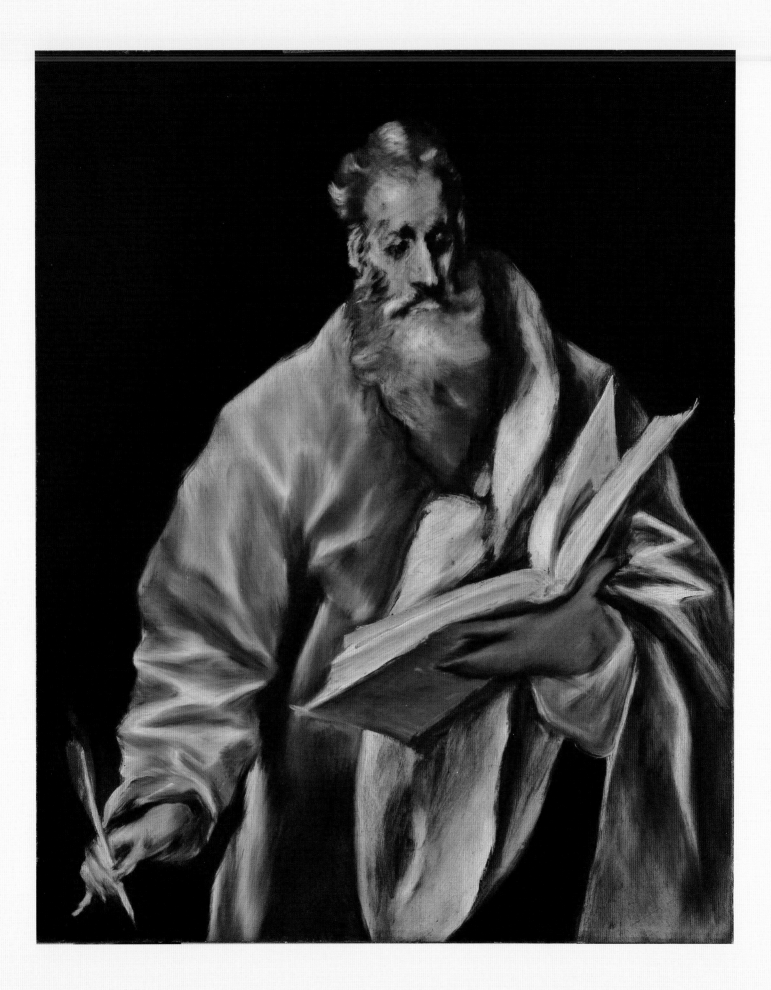

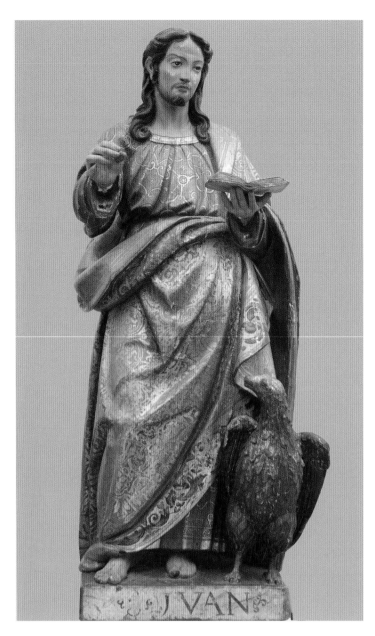

ANALYZING COCHINEAL IN PICTORIAL, SCULPTURAL, AND TEXTILE WORKS

In a study to analytically confirm the use of cochineal in the manufacture of thirty-two art objects from Spain and Mexico, liquid chromatography coupled with a diode array detector and a mass spectrometer with a quadruple-time-of-flight analyzer (LC-DAD-QTOF) was used. This system allows an unmistakable identification of carminic acid, the main component in cochineal.

The system's functioning may be simplified as follows: in an LC module, the sample solution is pumped through a column packed with a powdered solid, which creates specific chemical interactions that cause the different compounds to move at different velocities and to separate. The result is a chromatogram, where each peak corresponds to a compound characterized by its retention time, or the time needed to pass through the column. A diode array detector at the end of the column records the ultraviolet-visible (UV-vis) spectrum for each separated component. After that, the quadruple-time-of-flight analyzer provides their mass accuracy and mass-mass (MS/MS) spectrum, which is exclusive to and unique for each compound. Each compound is thus characterized by four analytical parameters: retention time, UV-vis spectrum, mass accuracy, and MS/MS spectrum. These powerful analytical capabilities, together with high sensitivity, make the system an invaluable tool for the detection and identification of natural dyes in microsamples from artworks.

In this case, thirty-nine samples from several different sources in Spain were analyzed (see appendix, table 13.1). Among these were pictorial and sculptural artworks from different museums and monasteries included in the restoration and conservation program of the Department for Investigation and Formation of the Instituto del Patrimonio Cultural de España (IPCE) in Madrid. The cultural repositories where

Opposite **FIGURES 13.2A–13.2B** Pedro de Raxis (painter) and Pablo de Rojas (sculptor), *Saint John the Evangelist*, Cathedral of Granada, Spain, sixteenth to seventeenth century. Polychromed and gilded wood, 57⅞ x 20⁵⁄₆₄ in. The red dyestuff employed to create the red *estofado* (painting over gilding) was identified as American cochineal by LC-DAD-QTOF. Photo: José Puig, Instituto del Patrimonio Cultural de España, Madrid.

Above **FIGURE 13.3** Pedro de Raxis, *Assumption and Coronation of the Virgin*, Spain, 1567–1600. Panel painting, 27⁶¹⁄₆₄ x 18⁵⁷⁄₆₄ in. Fundación Lázaro Galdiano, Madrid. The small red sample available from this painting allowed the detection of carminic acid, the main component of cochineal. Considering this within the context of the artwork, it can be concluded that the organic pigment source is American cochineal. Photo: José Puig, Instituto del Patrimonio Cultural de España, Madrid.

these works are housed include the Museo del Greco in Toledo and the Monastery of Nuestra Señora de Guadalupe in Cáceres. Samples from paintings and textiles from the Museo de América in Madrid were also analyzed, as well as samples from garments from the Museo del Traje in Madrid. Analysis took place in the laboratories of the IPCE.

Two different extraction procedures were applied, depending on whether the sample was from a textile or a painting/polychromy. Both methods were applied as follows:

METHOD 1: TEXTILE SAMPLES[7]

Step 1: Samples were placed in a conic vial and treated with 200 μL of a methanol:formic acid:water mixture (15:25:60, v/v/v) for ten minutes at 50 to 55 degrees Celsius. The solvent was then evaporated under nitrogen current.

Step 2: Two hundred μL of a methanol:dimethylformamide mixture (MeOH:DMF) (1:1, v/v) was added to the dry residue and heated for five minutes at around 90 degrees Celsius. The solution was then transferred to 0.2-μm Spin-X nylon filters (microcentrifuge filters) and centrifuged at 6,000 rpm for ten minutes. The filtrate was evaporated to dryness under nitrogen current and the residue was redissolved in 5 to 10 μL of MeOH:DMF (1:1, v/v) solution. After being shaken in vortex for one minute, the extract was injected onto the LC-DAD-QTOF system.[8]

METHOD 2: PAINTING AND POLYCHROMY SAMPLES[9] (figures 13.1–13.3)

Step 1: Samples were placed in a conic propylene vial and treated for ten minutes at 60 to 65 degrees Celsius with 200 μL of a mixture of hydrofluoric acid (4N):methanol (50:50, v/v). The solvent was then evaporated under nitrogen current.

Step 2: Identical to Step 2 in Method 1.

CONFIRMING COCHINEAL

The use of American cochineal was verified in all samples but one. Table 13.1 shows the results. Except for three samples, cochineal was the main dye used for red coloring. This conclusion is based on the unequivocal identification of carminic acid by a combination of analytical data.

Considering this information within the historical context of the objects studied, all of which date no earlier than the late sixteenth century, it can be concluded that the source of the dye or lake pigment in these objects is American cochineal. (For a historical discussion of the textiles tested, see Vázquez García and Seco Serra, and González Asenjo and Llorente Llorente, this volume. For a historical discussion of the paintings and sculptures sampled, see Bruquetas and Gómez, this volume.) These results support existing historical information about the widespread use of American cochineal as a dye and lake pigment after American trading began in the sixteenth century.

In addition to domestic cochineal from Mexico, *Dactylopius coccus* Costa, nine additional species of American cochineal can be found in South and Central America.[10] Unfortunately, the analytical method developed at the IPCE for the identification of natural dyes does not allow discrimination among them. Consequently, all cochineal dyes detected in this study were identified as American cochineal only. Other natural and synthetic dyes, such as brazilwood, tannins, barberry, dyer's broom, indigo, madder, old fustic, and Rhodamine B, were also identified as having been mixed with cochineal.

PART 4

RED THREADS
Cochineal in Textiles

SHADES OF RED

Color and Culture in Andean Textiles

ELENA PHIPPS

RED—THE COLOR OF FERTILITY, BLOOD, life, and death—was deeply important to the cultures of the Andes. But what shade of red?

According to Inca origin myths, Mama Huaco, considered the primogenitor of Inca culture, was born wearing a pink *acsu* (Inca-style wrapped dress). Pachamama, the powerful earth mother of Andean prehistory, was conceptualized by the indigenous people as a being who walked the earth wearing a long red dress that swept along the ground.[1] With the Spanish introduction of Catholicism in the sixteenth century, remnants of this association between red garments and sacred images lingered, notably in depictions of the Virgin Mary. The Virgin, traditionally represented in European paintings wearing a blue mantle, was shown in certain eighteenth-century Andean paintings wearing a red garment, her body taking the form of a mountain and creating a visual conflation with Pachamama.

During Inca times, red was the symbol of kingship and nobility. The Sapa Inca, or supreme ruler, wore red garments, such as the fringe of office—the *mascaypacha*—on his forehead. Red also formed the *ahuaqui*, the protective circle around Sapa Inca's upper body, on the yoke of his royal tunic and those of members of his royal army (figure 14.1). Inca women of high status, particularly among the *accla*—cloistered women who were responsible for weaving fine cloth and producing *chica*, a corn beer used in all ritual ceremonies—also wore red garments.[2] Among them, a select group of young women classified as the *waiuru* and considered the most beautiful wore garments of red, yellow, and black. In the Quechua and Aymara languages of the Inca Empire, *waiuru* (sometimes spelled *huayuru*) indicated the highest degree of beauty—the equivalent of the Spanish *hermosísimo*, according to Diego Gonzáles Holguín's seventeenth-century

Quechua language dictionary. *Waiuru* was also the name of a special red seed, *Ormosia coccinea*, from the *selva*, a tropical region of the eastern slope of the Andes. Although poisonous, the small red seed with a black spot was considered a standard of beauty and perfection.[3]

In the early seventeenth century, the indigenous Andean author Felipe Guaman Poma de Ayala provided nuanced insight about the garments of Inca nobility in his illustrated manuscript *El primer nueva corónica y buen gobierno* (1615–1616).[4] In the document, intended as a letter to King Philip III of Spain about the history of Inca culture and the conditions of early Spanish colonial life and government, Guaman included specific descriptions of the colors of tunics worn by each of the Inca kings. To describe the colors, he used three Spanish terms for red: *colorado, rosado*, and *encarnado*.[5] *Colorado*, presumably, was an earthen or orangish red; *rosado* a pinkish red; and *encarnado* a deep blood red.

How pre-Columbian Andean dyers achieved these shades of red is not fully understood. In a culture with no written language until the arrival of the Spanish in the early sixteenth century, Andean artisans did not record their artistic processes of dyeing and weaving. Instead, tangible evidence of their deep knowledge of color and the textile arts is found in examples that have been preserved. These require examination from a number of perspectives. Investigations into the sources of red colorants in the Andes—which have accelerated in recent years with growing interest in the subject of materials and the materiality of color—have revealed the basic components.[6] (See Pearlstein et al., this volume.)

Opposite **FIGURE 14.1** Martin de Murúa, "Sinchi Roca," *Historia del origen y genealogía real de los reyes Incas del Piru,* Peru, 1590. Paper, ink, pigments, vellum, leather, 11¹³⁄₁₆ x 7⅞ in. Sean Galvin Collection, ms. folio 10r. Photo courtesy Juan Ossio.

SinchiRoca. 2
raura panaca

llaca chequi

colcan rata

EXPANDING THE PALETTE OF ANDEAN REDS

Red colorants are found in some of the earliest Andean textiles in the form of mineral pigments rubbed into the fibers and/or painted on the surface, using some type of binding medium. These reds range from a purplish red, often associated with hematite, to orange-red shades, generally produced by ground powders of lead and cinnabar or forms of iron oxides and ochers. These mineral pigments were generally used on cotton (figure 14.2). It was also possible to create reds from other natural sources, including roots, flowers, seed pods, barks, and insects. These organic colorants were used to dye fibers from camelids, a family of animals that live at high altitudes and include llamas, alpacas, vicuñas, and guanacos. Because of their proteinaceous nature, the fibers could be dyed with a much broader range of organic materials than could cotton. Their availability expanded the weaver's and dyer's palette.

One of the earliest red-dyed, camelid-hair textiles was found on the southern coast. It is a narrow band woven in double cloth whose powerful, religiously significant designs are associated with stone-cut monuments from the northern religious sanctuary of Chavín de Huantar. The cloth incorporates deeply saturated rusty, orangish-red yarns. Though it has not been tested scientifically, this extraordinary band's orange-red color was likely made with the roots of *Relbunium,* a shrub that grows in the region. The use of this dye during the seventh or sixth century BCE (or possibly earlier) has also been documented in other weavings with complex religious iconography from the south coast of Peru.[7]

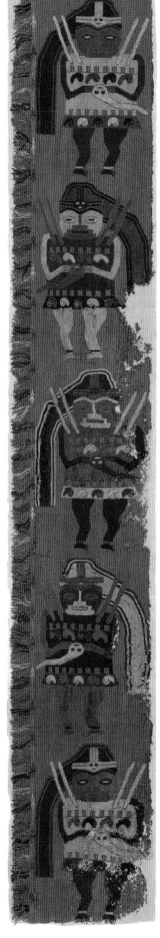

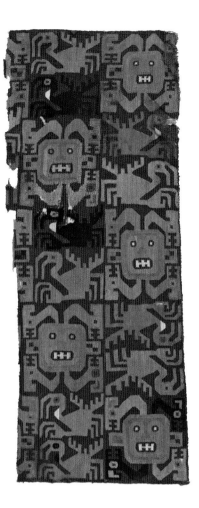

Top, left **FIGURE 14.2** Painted textile (Chavin style), Carhua, Peru, ca. ninth–seventh century BCE. Pigment, dye-painted cotton, 25¹⁹⁄₃₂ x 24⁶¹⁄₆₄ in. Fowler Museum, University of California–Los Angeles, x86.2929. © Fowler Museum at UCLA. Photo: Don Cole.

Middle **FIGURE 14.3** Border fragment, Peru, Paracas, first century BCE– second century CE. Camelid hair, cotton, 43½ x 6¾ in. Metropolitan Museum of Art, gift of George D. Pratt, 1933 (33.149.87). © The Metropolitan Museum of Art. Image source: Art Resource, NY.

Top, right **FIGURE 14.4** Textile fragment, Peru, Recuay, fourth–sixth century CE. Camelid hair, 32½ x 13 in. Metropolitan Museum of Art, gift of George D. Pratt, 1930 (30.16.7). © The Metropolitan Museum of Art. Image source: Art Resource, NY.

These early somber religious textiles prefigure a blooming of color seen in extraordinary burial textiles found in the Paracas Peninsula from around the sixth century BCE through approximately the first century CE. Red dominates the palette of multilayered burial shrouds consisting of elaborately embroidered textiles, which are unparalleled in their quality of execution and iconographic complexity. Camelid hair—previously not associated with the generally cotton-based textile production of the coastal cultures of Peru—predominates in these astonishing textiles.

It is around this time of the highly skilled Paracas-period artisans, and that of the closely related neighboring Nasca weavers who followed, that a new shade of red—a bright, bluish-red color—was introduced. Surprisingly, dye testing of a number of samples from archaeological textiles from the region shows that this new red was achieved through the use of *Relbunium*—the same root dye source for the majority of red from the south coastal cultures of Peru through this early period (figure 14.3).[8] Up to this period, however, most *Relbunium* reds had a brownish or rusty red hue, likely due to the mineral content of the local water. The puzzle is: What inspired this new red? And how was it produced?

Had dyers in the region discovered new sources of mineral-free water? Had they changed their methodology for harvesting and extracting the dye, enabling production of a clearer, brighter color? Or was the transformation due to aesthetic considerations, namely the desire to produce a different shade of red? If the latter, the artisans must have had access to models of this new color. These models, I believe, would have originally been made with another dye—cochineal—carried in the form of textiles from the highlands to the coast through cultural transmission and trade.

While these questions cannot be definitively answered, two major cultural shifts occurred along the south coast shortly after the rise of skilled dyeing by Paracas artisans. The first took place with the creation of a cochineal-like color produced with the traditional relbunium plant root, though with a refinement of the regional dyeing process. The second followed the introduction of the cochineal dyestuff itself.[9] The result was a transformation of the color palette of the Andes. Why cochineal was not seen earlier is unclear. Was the insect not available, or have textiles from the insect's place of origin simply not been preserved? The fact that textiles from early highland cultures have, for the most part, not been preserved has skewed knowledge of the region's early textile traditions, making investigation of this subject even more difficult.

CULTIVATING KNOWLEDGE AND USE OF COCHINEAL

The knowledge and use of cochineal as a source for the brilliant bluish-red color may have come from the geographic region at the mid-range of the highlands. From here it may have been transmitted to the coast by people traveling with already-dyed materials or transporting the dyestuff for trade.[10] Establishment in the lower altitudes of the prickly pear host cactus (*Opuntia* spp.) required for cochineal's cultivation and sustenance soon followed. While there is some dispute among the scientific community as to the origins of both the cactus and the insect (see Van Dam et al., this volume), a likely origin of cochineal use in South America may be located in the southern section of the Andes, in the mid-altitude region where the cactus thrived.[11] This is the same region where, from around the third century CE, textile evidence has been preserved and where cochineal was the primary source of red dye for textiles from at least that period on (figure 14.4).

Examination and testing of examples from the Metropolitan Museum of Art found that all the major cultures of Peru from the northern coast to the southern highlands—including the later Nasca (circa 300–700), Moche (circa 400–800), Wari and Tiwanaku (400–1100), Chimu (1150–1450), and Inca (circa 1450–1532)—used cochineal as their primary red colorant.[12] What kinds of reds were found? How were they achieved? And why did a culture favor particular formulations of the variable color?

As a dye, cochineal is sensitive to many aspects of the dyeing process, including components of the dye bath, and the resulting color can vary considerably. Also, as a dye, cochineal requires a mordant, generally a mineral salt, to bind the fiber to the dye molecules. The type of mordant, such as alum, iron, or even tin, will greatly influence shade and hue. The quality of water, as well as additives to the dye bath, including acids from citrus or alkalies from various sources, will also impact the shade of color. (See Roquero and Cardon, this volume.) As a result of these artisan and cultural practices, cochineal red can vary from deep purple to crimson to orange-red.

Expert dyers, therefore, achieved an incredibly wide range of colors. Wari dyers, for example, seemed to favor deep crimson red for their woven tapestry garments (figure 14.5). Chimu and Chancay dyers from the later periods in the central coast used cochineal in its simplest, bright pink form (figure 14.6). Cultures such as the Inca modulated their red colors, creating a deep orange-red and a deep magenta using only cochineal as the dye source. The blood red color identified by Guaman may have been a mixture of colorants. Analysis of the red dye used

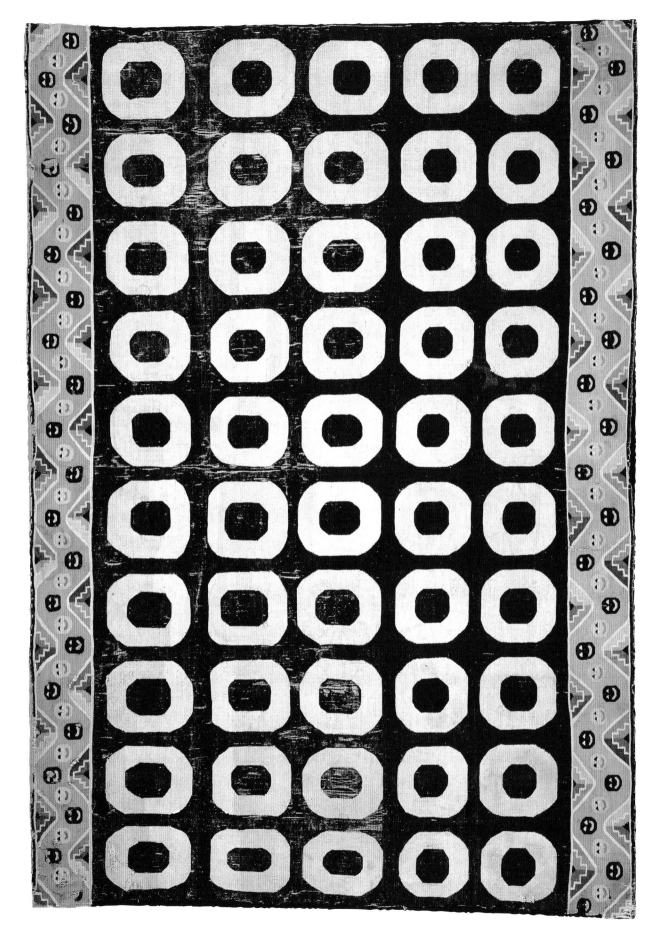

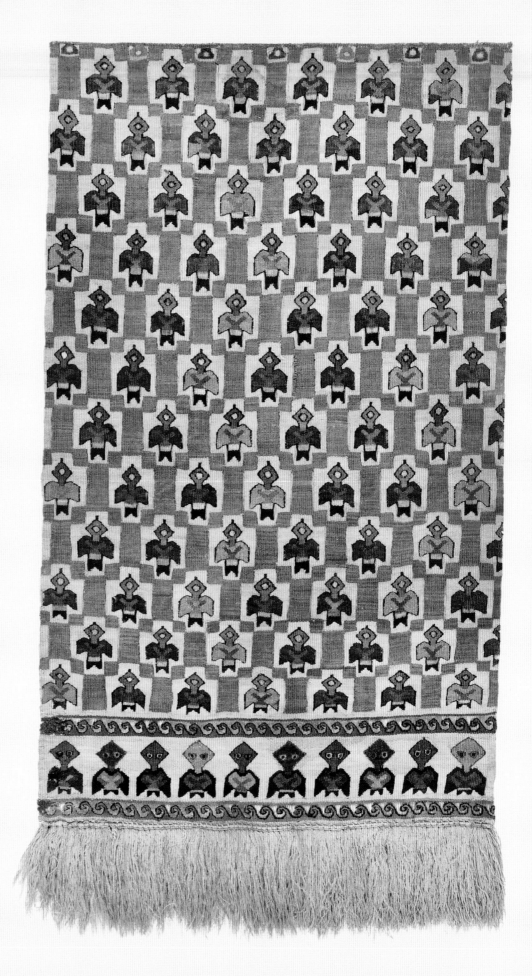

Opposite **FIGURE 14.5** Mantle fragment, Peru, Wari, 650–900 CE. Camelid fiber, cotton; tapestry weave, 30⁵⁄₁₆ x 43⁷⁄₆₄ in. Royal Ontario Museum, Toronto, Canada, 931.11.1.

■ *Right* **FIGURE 14.6.** Loincloth, central coast Peru, 1100–1400 CE. Wool, cotton, 27¹⁵⁄₁₆ x 15¹⁵⁄₁₆ in. Museum of International Folk Art, gift of Lloyd E. Cotsen and the Neutrogena Corporation, A.1995.93.1261.

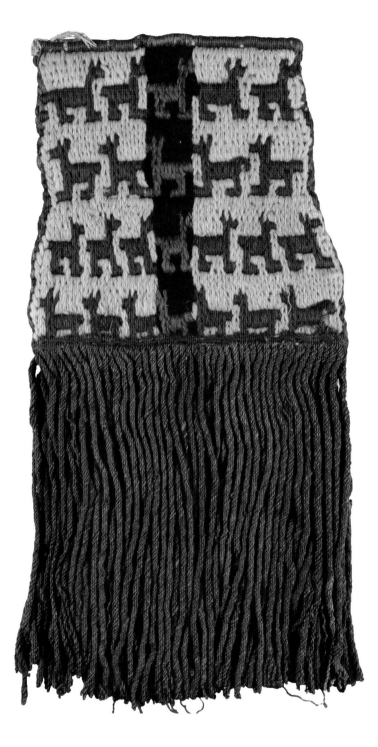

for the thick fringe (reminiscent of the royal *mascaypacha*) on a fifteenth- to sixteenth-century Inca bag revealed cochineal with a secondary yellow dye (figure 14.7).[13] This yellow colorant would have toned down the bright pink hue that naturally occurs with cochineal dyeing.[14] Andean dyers were specialists in producing a wide range of colors with a minimal amount of dyestuffs. A single cochineal dye bath could produce various shades of red on natural white, gray, coffee-color, or even black camelid hair. Dyers also understood how to manipulate color through variations in mordants. Bernabé Cobo, in his *Historia del Nuevo Mundo* of 1653, was the first to note the use of a mordant that allowed a dyer to modify a red dye bath to achieve a blue hue.[15] An example of this process can be seen in a *camisa*, or tunic, woven with red and purple yarns from the far south coast of Peru or northern Chile (figure 14.8).[16] Testing of the tunic revealed that cochineal was the only dye used to create both colors.

Producing a purple color is normally associated with a two-step dyeing process using indigo for blue and a red dye. With no indigo present in the *camisa*, the purple was likely achieved through a combination of mordant and dye bath modifiers that shifted the cochineal red to its bluest hue. Indigo blue is rarely found in Inca textiles for reasons not yet understood. But in this *camisa* it is present in other areas—in the green yarns used in the stripes, dyed with indigo and a yellow dyestuff. While the makers of this *camisa* must have had access to indigo, they likely chose to economize, using the more abundantly available cochineal instead. The process of achieving the purple-blue color with the single red dyestuff required special knowledge and skill nonetheless.

The red-blue combination was a particularly important duality, or color pairing, in the Andes, perhaps stemming from the ability of cochineal to produce two colors from one source. Spanish colonial documents note that special garments of red and blue, called *sucullu*, were part of ceremonial activities, notably for coming-of-age rituals. Ceremonial garments from the sixteenth century onward, particularly in the highlands, also feature extensive use of red and blue.[17]

A small Spanish colonial tunic from Bolivia—intended to clothe a statue of Christ—presents another set of color issues. Finely woven in tapestry, the tunic has cochineal red on one side and indigo blue on the other, with the addition of silk and metallic threads. In its materiality, its anagrams of Christ and Mary on front and back, and its use of Inca *tocapu*, or rank insignia designs, this special garment represents the cross-fertilization of Christianity and Andean belief systems. The weaving process adds another interesting feature: the blue

side was woven on a red warp, and the red side on a blue warp. Because this was tapestry-woven—with the design areas formed by the horizontal weft yarns—the colored vertical warp yarns are hidden, forming an interior color space. This is quite rare for tapestry weaving in the Andes, another indicator of the very special and sacred nature of this small garment.[18]

Other colonial-era textiles, also special in character but with less ritual context, have a similar feature called *tornesol*. Also known as dove's breast due to an iridescent effect, similar to that seen on the birds, *tornesol* is composed of tightly spun and woven alpaca yarns, generally with black warps that cover the textile surface.[19] Contrary to the tapestry tunic previously described, where the pattern is formed by the weft yarns, *tornesols* are warp-faced fabrics with hidden wefts, often of pink cochineal yarns made of silk or fine alpaca.

■ FIGURE 14.8 Man's *camisa* (tunic), Chile, Arica (?), sixteenth–seventeenth century. Camelid hair, feathers; discontinuous warp and warp patterning, 35¼ x 54½ in. Metropolitan Museum of Art, gift of John B. Elliott through the Mercer Trust, 2000 (2000.160.25). © The Metropolitan Museum of Art. Image source: Art Resource, NY.

These textiles often formed the woven cloth of women's dresses and mantles from the sixteenth through the early twentieth centuries. Though barely visible, the pink cochineal yarns glisten in the sunlight when the cloth is in motion, folded, or creased. In a visual play of light and color, the cochineal pink causes a unique shimmering effect as it contrasts with the black surface, creating a metallic brilliance.

In the highlands, weavers not only perfected the dyeing process for creating cochineal colors, but they incorporated spinning and weaving techniques to enhance the visual effects and textures of the colors with depth and sheen. *Lloque*, for example, a system of spinning to the left, was used by Aymara weavers for special ceremonial tunics that juxtaposed yarns spun in different directions (left or right). This alternation of yarns in the warp created the visual effect of a striped surface, though in fact no change in color or weaving technique occurred. This effect is often seen within pink stripes, especially at the edges of Aymara mantles (figures 14.9a–14.9b), as the cochineal pink spectrum of color absorbs and reflects light.

Andean weavers further expanded their palette by combining or plying cochineal-dyed yarns with yarns of another color. The bicolored yarns created an effect called *chimi,* which adds texture and nuance to the woven cloth. While *chimi* can be produced in a variety of colors, it is found most often in seventeenth- to nineteenth-century textiles that mix cochineal and natural brown, creating a lively and variegated color (figures 14.10a–14.10b and 14.11.)

Tornesol, lloque, and *chimi* enabled Andean weavers to utilize the special dyes available to them, notably cochineal, to create new types of color and texture. In part, their development was a creative response by Andean weavers to the imported European silks and patterned and textured cloth brought by the Spanish to the Americas. The Spaniards, in turn, sought raw materials from the Andes and brought them to new markets along global sea routes. The story of worldwide trade in cochineal, and its impact on the Spanish economy and the textile industry at large, has been well documented.[20] (See Marichal, this volume.) Further investigation on the reach of cochineal from the Americas in global art and culture is still unfolding. 🪲

Opposite, left, top and bottom **FIGURES 14.9A–14.9B** Tunic (full and detail), Bolivia, Aymara, eighteenth–nineteenth century (?). Camelid hair; warp-faced plain weave, 29 x 43 in. Metropolitan Museum of Art, bequest of John B. Elliott, 1997 (1999.47.230). Detail view highlights the effect of *lloque*, a system of alternating yarns spun to the right and to the left, which creates the visual impression of stripes in a herringbone design. © The Metropolitan Museum of Art. Image source: Art Resource, NY.

Opposite, right, top and bottom **FIGURES 14.10A–14.10B** Woman's mantle (front view and detail), Bolivia, Aymara, nineteenth–twentieth century. Camelid hair, 38½ x 36½ in. Metropolitan Museum of Art, bequest of John B. Elliott, 1997 (1999.47.263). © The Metropolitan Museum of Art. Image source: Art Resource, NY.

Above **FIGURE 14.11** Ceremonial mantle, Bolivia, Aymara, eighteenth–nineteenth century. Camelid hair, 41 x 77¼ in. Metropolitan Museum of Art, bequest of John B. Elliott, 1997 (1999.47.251). © The Metropolitan Museum of Art. Image source: Art Resource, NY.

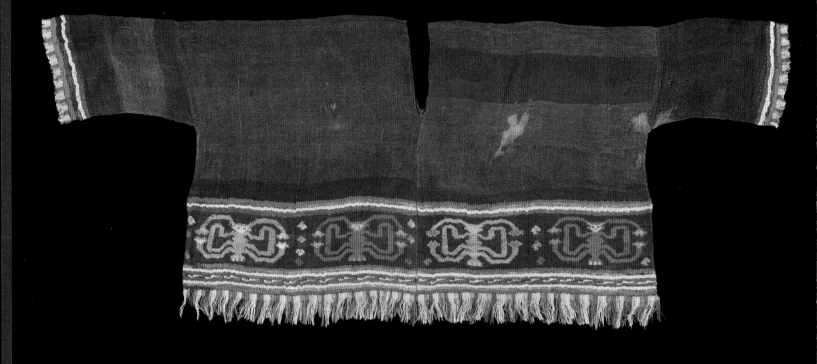

■ Shirt
Central coast, Peru, Chimu, 1100–1300 CE
Wool, cotton
49½ x 19½ in.
Museum of International Folk Art, gift of Lloyd E. Cotsen
and the Neutrogena Corporation, A.1995.93.1245

Typical of textiles of the Chimu culture, all the different reds in
this elaborately figured garment were achieved with cochineal.

■ Rug (floor or wall covering)
Peru, late eighteenth–early nineteenth century
Wool
80 x 70½ in.
Museum of International Folk Art, gift of Lloyd E. Cotsen
and the Neutrogena Corporation, A.1995.93.821

The Andean weaving tradition continued in the Spanish colonial
era, with artisans utilizing the same dyes, fibers, and weaving
techniques. With new cultural influences, hybrid design styles
combining pre-Columbian, European, and even Asian motifs
evolved. Several of the various shades of red in this tapestry were
found to be made with cochineal and different mordants.

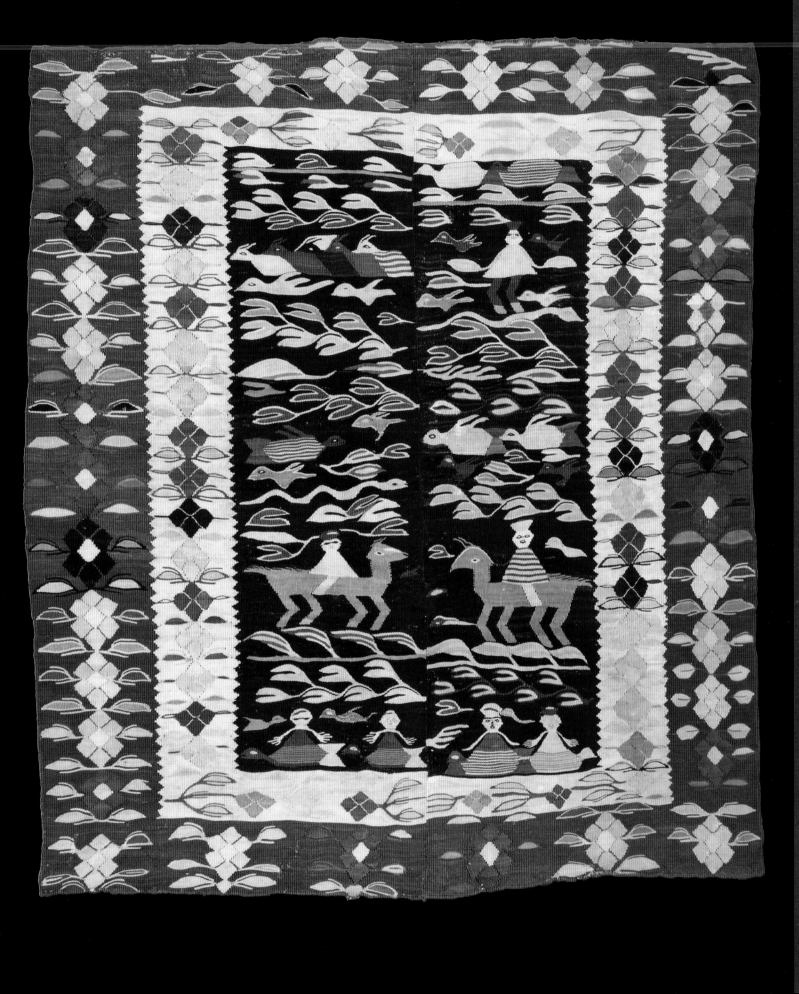

BLEEDING THREADS

Cochineal in Mexican Textiles

ALEJANDRO DE ÁVILA B.

Antes cuando iba la peonada a trabajar en una milpa,
coloradeaba el mezquite donde colgaban los lonches.
[Formerly, when the laborers went to work
in a maize field, the mesquite tree where they hung
all the lunch bags would look bright red.]

—DOÑA ELVIRA MARTÍNEZ ÁVILA,
EL PARAÍSO, SAN LUIS POTOSÍ, 1977

IN JUNE OF 1978, AS I GATHERED information for my bachelor's thesis in anthropology, I arrived in Cañada de Yáñez in the state of San Luis Potosí. The people there, as in dozens of communities I visited in that state and in the adjacent regions of Guanajuato, Tamaulipas, Nuevo León, and Aguascalientes, speak no indigenous languages and view themselves as no different from the general population of Mexico. Nevertheless, I was surprised to find that throughout the vast area I traversed during three consecutive summers, women had used the Mesoamerican spindle and backstrap loom until quite recently to weave bags, napkins, sashes, and even cloth for skirts and other garments. *Costales* (tortilla bags) were prized homespun textiles, kept by elderly ladies as mementoes of their weddings, when such weavings were presented ceremoniously as proof of the bride's skill and readiness for married life. In many villages, women pointed out that their old bags no longer boasted the deep reds they loved to behold when the *costales* were new; the synthetic colorants had bled away and faded. In Cañada de Yáñez, however, I found that almost all the bags remained crimson, as they had been dyed with cochineal (figure 15.1).

A man I befriended told me that he remembered talking with the storekeeper in town who provided the weavers with the precious, colorfast red. The old merchant would send letters all the way to Oaxaca to order the dyestuff, which would arrive in the mail. My friend's memories went back to the 1950s, when it was still the custom for every young woman to bring a new *costal* to her wedding. The weavers quit making them a few years later. Cochineal producers in Amatengo and other municipalities in the Valley of Oaxaca stopped raising the insects at about the same time.

The wool in two double-cloth bags I acquired in Cañada de Yáñez has been tested recently at the Museo Textil de Oaxaca (MTO) to confirm that carminic acid (or carmine, the chemical signature of *Dactylopius coccus*, the cochineal insect, and its relatives), indeed accounts for their richly saturated reds.[1] Its presence has also been corroborated in *costales* woven hundreds of kilometers to the north, in small settlements in the state of Nuevo León, not far from the Texas border.[2] Beautifully patterned in a warp float technique, those bags probably date from the late 1800s and early 1900s (figure 15.2). In my rambling undergraduate travels, I encountered additional old weavings and even embroideries (figure 15.3) dyed with cochineal in distant localities, an indication that the insect had been used extensively in that region before it was displaced by synthetic colorants.

As production of the dyestuff waned in the south, its use shrunk to a single community in the north, Cañada de Yáñez, the only place where I found weavers who still remembered using it. Looking at textiles from other areas in Mexico, the same trend appears again and again. Carmine is present in the crisp embroidery on *sabanillas* (white mantles for ceremonial occasions) made by Otomí or Mazahua women for their own use in the highlands north of Toluca in the state of Mexico in

Opposite **FIGURE 15.1** *Costal* (tortilla bag), Cañada de Yáñez, San Luis Potosí, Mexico, ca. 1950. 18⁹⁄₁₀ x 12⁴⁄₁₀ in. Museo Textil de Oaxaca, COS0272. The dark red thread is hand-spun wool dyed with cochineal, while the white thread is industrially spun cotton. The weave of the *costal* is double cloth, whereas the ribbon shows a different structure with transposed warps. The reverse of the bag is inscribed with the name of its owner. Photo: Manuel Soria.

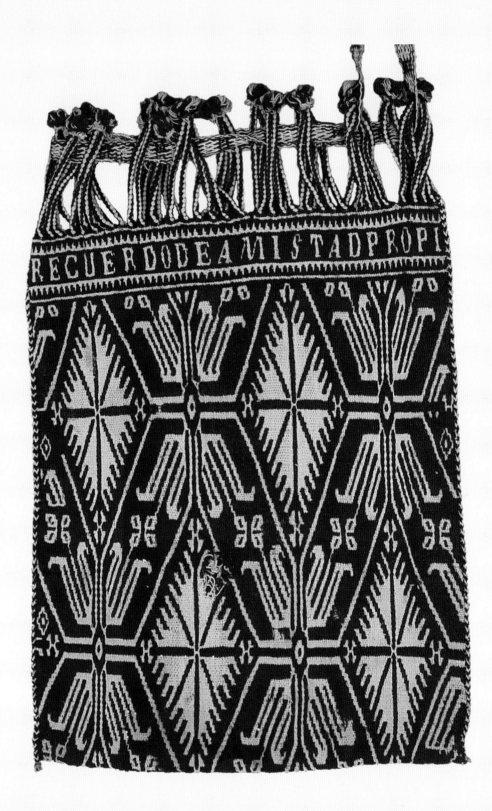

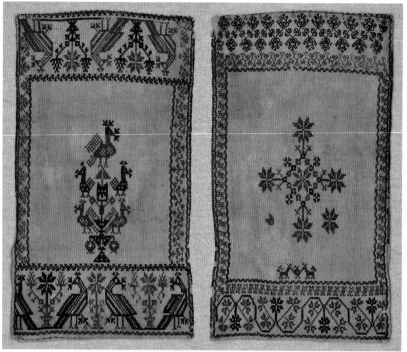

the late nineteenth or early twentieth century (figure 15.4). A few years later, when those garments became popular as bedspreads in urban households, the hand spun woolen stitches were replaced by yarns dyed with a fugitive synthetic red and other garish colors.[3] A *quechquémitl* (a short, closed, cape-like women's garment) worn in nearby Mazahua communities displayed wine red warps throughout the webs (figure 15.5);[4] these would later be emulated with an industrial colorant. All the examples from western Mexico in the MTO collection that have been tested have turned out to be commercial dyestuffs, but carmine may be present in some early Purépecha and Huichol weavings.[5] Similarly, textiles examined from the Gulf of Mexico watershed have yielded negative results for cochineal,[6] although a number of publications report its use in that region up to the early 1900s.

In southeastern Mexico, carminic acid is rarely confirmed on Tzotzil and Tzeltal brocading from highland Chiapas (figure 15.6).[7] In Guatemala, cochineal-dyed supplementary wefts of silk have been documented in weavings from Quetzaltenango made before 1930, and the dyestuff also shows up in certain woolen tapestries.[8] By far the greatest variety of occurrences of the insect colorant from the late nineteenth to the mid-twentieth century is attested in Oaxaca. Salient examples on wool are the wraparounds from Mitla (figure 15.7) and other Zapotec communities in the central valley (figure 15.8), as well as the embroidery on Mazatec skirts from Huautla de Jiménez (figure 15.9).[9] Silk dyed with cochineal has been verified on ceremonial *posahuanques* (sarong-like skirts) worn in the coastal Mixtec town of Jamiltepec (figure 15.10) and in rebozos (shawls) from the Zapotec municipalities of San

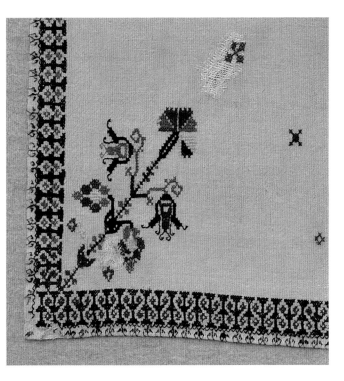

Bartolo Coyotepec (figures 15.11a–15.11b)[10] and San Pedro Quiatoni (figure 15.12). Even in Oaxaca, however, many of the textiles that were thought to feature the indigenous red have been shown to hold fuchsine, magenta, or other synthetic dyes. Disproven instances include silk warp stripes on *posahuanques* from Tututepec and Pinotepa de Don Luis (Mixtec), as well as supplementary wefts, spun of the same fiber, brocaded on garments from Santiago Ixtayutla (Mixtec) and San Bartolo Yautepec (Zapotec).[11]

Based simply on the number of distinct textile traditions using cochineal that survived into the twentieth century, one would be tempted to guess that southern Mexico was the insect's center of domestication. That conjecture is supported by the diversity of fibers recorded to have been dyed historically with *Dactylopius*. In addition to the wool and silk examples mentioned above, the colorant is present in at least five surviving pieces of uncertain provenance that were woven or embroidered with cotton that was spun or twisted with duck down and that probably date to the seventeenth or eighteenth century (figure 15.13).[12] Cochineal conferred a deep red to rabbit hair in a tapestry fragment that may go back to the 1500s or 1600s,[13] which corroborates the observations of Bernardino de Sahagún and others that *tōchohmitl* (the Nahuatl name for rabbit hair) was colored with "cactus blood." The Mixteca Alta was a center of production of these animal fibers; members of the indigenous nobility in Yanhuitlán specialized in dyeing *tochomite* (the Hispanicized term for rabbit hair) in the sixteenth century, trading it all the way to Guatemala, and seventeenth-century merchants from Teposcolula would take hundreds of feathered *huipiles* (women's tunic-like garments) to sell in the Maya highlands.[14] Most intriguingly, a report written by a parish priest in the mountains south of the city of Oaxaca toward the end of the eighteenth century states, in spite of recent assertions to the contrary, that *zacatillos* (females after laying their eggs) were specifically chosen to dye cotton as well as locally raised silk: "The Indians, to dye cocoon silk or cotton thread, use the aforesaid [*zacatillos*], and only in case of great need will they use any other [kind of cochineal]."[15]

RECIPES, MORDANTS, AND BIOGEOGRAPHY

While no historic or ethnographic examples of cellulose fibers dyed with carminic acid have been recorded in Mexico,[16] a procedure to color cotton with *cochinilla* (cochineal) was remembered by a ninety-five-year-old Zoque man interviewed in Tuxtla Gutiérrez, Chiapas, around 1980.[17] His recipe involved the leaves of *Jatropha curcas*, a shrub or small tree in the poinsettia family, claimed to act as a fatty mordant. Other native plants were used together with cochineal to dye wool in Chiapas: *Eugenia acapulcensis* of the guava family was employed by the highland Tzotzil people.[18] In modern Oaxaca, weavers in Santa Ana del Valle use an unidentified species of *Eugenia* and a plant known in Zapotec as *balagan*.[19] Their neighbors in Teotitlán travel to the Isthmus of Tehuantepec to collect *Miconia argentea* (a plant in the family Melastomataceae),[20] and dyers in nearby Mitla utilize leaves called *balagláj* and *balaguuguín*.[21] Other members of that plant family, known by the Nahuatl name of *tezhuatl*, were combined with *Dactylopius* by dyers in central Mexico in the sixteenth century. These continue to be used in the town of Hueyapan in northern Puebla, where they have been identified as *Conostegia xalapensis* and *Miconia* sp.[22]

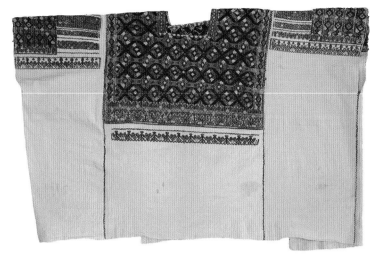

Accumulation of aluminum, valuable as a mordant, is a prominent feature of the Melastomataceae.[23]

In the communities I visited in San Luis Potosí in the 1970s, several plants had been used in preparation for dyeing, a procedure called *jebar la lana*. [*En*]*jebar* is an old Spanish verb derived from the Arabic term for alum. *Tunas de cardo*, the acidic fruits of a wild cactus (*Cylindropuntia imbricata*),[24] were used specifically for cochineal. Other native plants were used in recipes to mordant wool for synthetic colorants, which may have been combined earlier with *Dactylopius*; among these were *varaduz* (*Eysenhardtia polystachya*), *flores de biznaga* (the blossoms of a spherical cactus), and *yerba de San Nicolás*.[25] Such variety of species employed within the range of traditional carmine dyeing must reflect a long history of use and diversification.

Looking closely at the biogeographical affinities of the plants involved in cochineal recipes, as in Mesoamerican textile fibers and colorants in general, it seems significant that the main genera, like the insect itself and the plants it feeds on,

Above, left **FIGURE 15.6** Ceremonial *huipil* (women's tunic-like garment), Tzotzil or Tzeltal community in the highlands of central Chiapas, Mexico, late 1800s or early 1900s. 28 x 41⁹⁄₁₀ in. Museo Textil de Oaxaca, HUI0135. The warp and weft are of hand-spun cotton; the supplementary wefts, which create the designs, are of hand-spun wool dyed with cochineal and industrially spun cotton dyed with indigo and synthetic colorants. This *huipil* was probably worn by a woman holding office together with her husband in the indigenous hierarchy of government and religion. Photo: Manuel Soria.

Above, right **FIGURE 15.7** Detail of a Zapotec wedding skirt, Mitla, Oaxaca, Mexico, ca. 1940. 105½ x 61⁸⁄₁₀ in. Museo Textil de Oaxaca, ENR0183. The warp and weft are of hand-spun wool dyed with cochineal and other natural colorants, woven on a backstrap loom in three webs in a patterned weave. The warps are made to float over the wefts to create the small, repetitive motifs. The design is controlled mechanically by the heddles of the loom. Photo: Jorge López López.

are of Neotropical distribution, or endemic (restricted in the wild) to Mexico and the adjacent regions. The plants and animals of Nearctic or boreal (centered in the northern latitudes of both hemispheres) affinity in this assemblage are few and used locally only. This finding is unexpected, since human population density has been highest since antiquity in areas above 2,000 meters in altitude in the Basin of Tenochtitlan and other highland regions, where northern elements are diverse and abundant in the flora and fauna. The bias toward Neotropical lineages in the most refined arts of Mesoamerica, such as carmine-dyed textiles, suggests that these technologies were developed early on in the lowlands to the south, where boreal affinities in the biota are minimal.[26]

INFERENCES FROM LINGUISTICS

Indigenous terminology associated with the insect colorant and weaving reinforces the hypothesis that cochineal has been managed intensively in Mexico for quite a long time. The Zapotec names for the red ceremonial skirts worn in the Valley of Oaxaca are a compelling example. The solid color type used in Tlacolula and other towns (see figure 15.8) is called *byuug*, which appears to be a primary term that is not analyzable etymologically. This contrasts with the everyday wraparound *zu'ùu'dy*, which seems to derive from a verb that refers to wearing clothing.[27] Some of these skirts were woven on a treadle loom, but the finest pieces were of a single, four-selvage web made with very tightly spun wool in diamond twill. To finish impeccably such heavy, long, and wide fabrics involved considerable stamina; men wove them by standing and leaning back on a backstrap loom, as attested by old photographs. These beautifully colored and masterfully crafted skirts are some of the most remarkable, unsung textiles in Latin America.

The names for the traditional wraparounds worn in Mitla, less than 15 kilometers from Tlacolula, are quite different. Cochineal-dyed wedding skirts, made of three webs with multicolored stripes in a patterned weave, were called *ladbej* ("cloth-wind," a poetic but puzzling etymology for a rather heavy garment).[28] Each of the units of design in the stripes received a specific designation: *nagáš* ("black"), *bišúij* ("little snake"; *culebrita* in Spanish), *bisié'e* ("chocolate bean" or *cacao*), and *šro'ób* ("dear maize seed" or *maicito*) (see figure 15.7).[29] A more sober ceremonial skirt, made in allover *nagáš* weave, was called *lad muraad* ("cloth-purple," borrowed from the Spanish *morado*) and was dyed with indigo and *balaglaj*, or with cochineal mixed with ferrous sulfate and indigo.[30] Such a detailed lexicon, which evokes Mesoamerican agriculture and religious beliefs, must encapsulate a long historical trajectory.

The nomenclature for *Dactylopius* itself reveals an early familiarity with the insect. The most diverse terminology has been documented in the Otomanguean languages, which occupy the dry highlands of central Mexico and Oaxaca, where cochineal was probably domesticated and where the earliest textiles in Mesoamerica known today were excavated.[31] An early vocabulary for Otomí (a member of the Otopame branch in the western division of the family) lists *yovëxttä, youë,* and *yotavë* as "*grana que está por afinar*" (unprocessed cochineal) and adds the Nahuatl term *nōcheztli* ("cactus-blood").[32] The language of San Pedro Amuzgos (belonging to the most divergent lineage of the Mixtecan branch in the eastern division) has *kí⁵ndio'*[35] (singular *kí⁵tzio'*[35]) for *cochinillas, grana*; in Copala Triqui (representing an early offspring of the Mixtecan branch), *cochinilla* is designated as *xcuu³ tōn²* ("insect blood").[33] In Mixtec itself, the group of closely related languages spoken by the most intensive producers of the dyestuff since pre-Columbian times,

Top **FIGURE 15.8** Detail of a Zapotec ceremonial skirt, Valley of Oaxaca, Mexico, early twentieth century. 145¹⁄₁₀ x 35⁸⁄₁₀ in. Museo Textil de Oaxaca, ENR0100. The warp and weft are of fine hand-spun wool dyed with cochineal, woven on a backstrap loom in a single web in diamond twill. Photo: Jorge López López.

Middle **FIGURE 15.9** Detail of a Mazatec ceremonial skirt, Huautla de Jiménez, Oaxaca, Mexico, ca. 1950. 35⁴⁄₁₀ x 40⁶⁄₁₀ in. Museo Textil de Oaxaca, ENR0163. The ground fabric includes both industrial and handwoven cotton cloth, embroidered with hand-spun wool dyed with cochineal and possibly vegetal indigo, in a raised, triple-crossed stitch. Photo: Cecilia Salcedo and Jorge Márquez.

Bottom **FIGURE 15.10** Detail of a Mixtec ceremonial *posahuanque* (sarong-like wraparound skirt), Jamiltepec, Oaxaca, Mexico, ca. 1930. 59⁸⁄₁₀ x 50⁴⁄₁₀ in. Museo Textil de Oaxaca, ENR0097. The weft and part of the warp are of hand-spun cotton dyed with indigo, with warp stripes of hand-spun cotton dyed with shellfish (*Purpura pansa*) and hand-spun silk grown in the Mixtec highlands and dyed with cochineal. This was woven on a backstrap loom in three webs, using a patterned weave like the Zapotec wedding skirt from Mitla (figure 15.7). Photo: Jorge López López.

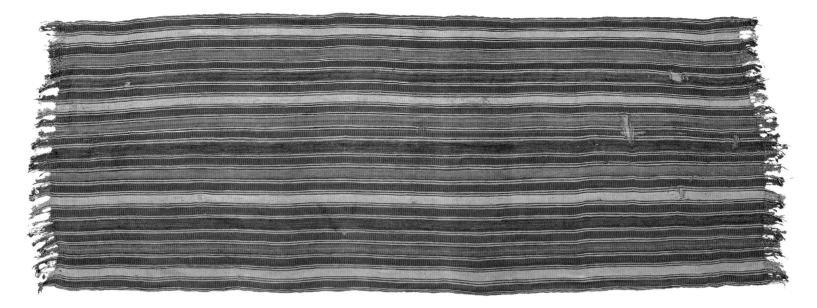

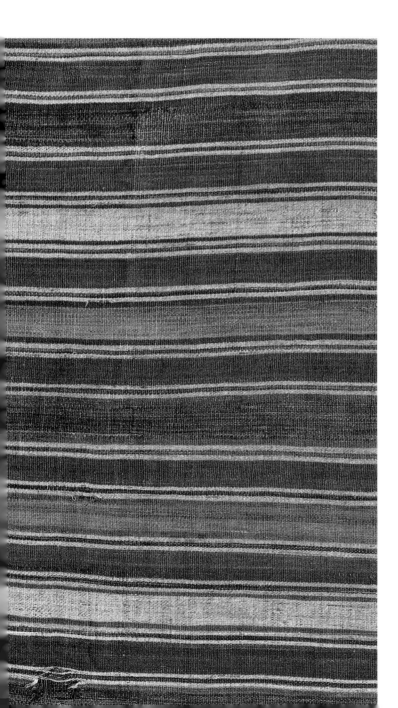

Above and left FIGURES 15.11A–15.11B Zapotec rebozo (full and detail), San Bartolo Coyotepec, Oaxaca, Mexico, late nineteenth century. 89⁸⁄₁₀ x 31½ in. Museo Textil de Oaxaca, REB0101. The weft and part of the warp are of hand-spun, locally grown silk dyed with cochineal. The white and blue stripes are also of local silk, left undyed or colored with plant indigo. The purple stripes are of hand-spun cotton dyed with shellfish. The rebozo was woven on a backstrap loom in a single web in warp-faced plain weave, with knotted fringes. It was worn by a descendant of the indigenous nobility in the coastal Mixtec town of Tututepec. Photos: Jorge López López.

Opposite, left FIGURE 15.12 Detail of a Zapotec rebozo, San Pedro Quiatoni, Oaxaca, Mexico, ca. 1940. 70⁹⁄₁₀ x 31¹⁄₁₀ in. Museo Textil de Oaxaca, REB0040. The warp and weft are of hand-spun cotton, with stripes of cochineal-dyed hand-spun silk, grown in the mountains of northern Oaxaca, and shellfish-dyed hand-spun cotton. The rebozo was woven on a backstrap loom in a single web in warp-faced plain weave, with knotted fringes. Photo: Jorge López López.

Opposite, right FIGURE 15.13 Bottom fragment of a *huipil* web, central or southern Mexico, seventeenth or eighteenth century. 12⁴⁄₁₀ x 21⁷⁄₁₀ in. Museo Textil de Oaxaca, HUI0513. The warp combines hand-spun cotton, silk, and wool; the structural and supplementary wefts are also of hand-spun silk, wool, and cotton. The latter include two-ply threads twisted with duck down, of natural white color and dyed with cochineal and other colorants. The piece was woven on a backstrap loom as the end of a four-selvage web; the technique alternates bands of rep weave with rows of brocaded designs using reciprocal supplementary wefts. Photo: Jorge López López.

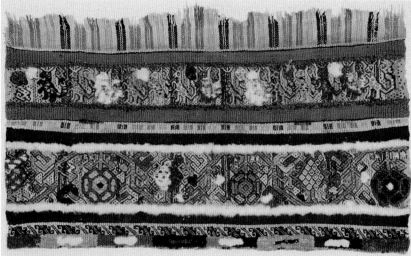

cochineal is called *ndukun*; it has been recorded as *ndu²ku²* in Cuicatec, an offshoot of Mixtecan.[34] The close resemblance suggests that Cuicatec may have borrowed the Mixtec name recently, conceivably in the Spanish colonial period, when religious and civil authorities promoted expansion of the insect into areas where it had not been raised earlier.

In the Popolocan branch (eastern division), the term in Huautla Mazatec, where cochineal was used formerly to dye silk, was transcribed tentatively as *čó'ši'indé*; in the Popoloca language of San Luis Temalacayuca it is known as *ku²na³we² ka¹ndya¹* ("animal-paint nopal").[35] Zapotecan (also in the eastern division) is represented by four entries: *baguùu'g* in San Lucas Quiaviní, *beguug* in Mitla, *bwa* in Chichicapan, and *má biǎa* ("animal nopal") in San Juan Mixtepec (Miahuatlán district).[36] Variation among the first three is especially significant, since they represent closely related forms of Zapotec spoken only a few kilometers apart. Finally, outside the Otomanguean family, designations include *no'ñ* in Coatlán Mixe, *galmojua* in Petacaltepec (highland) Chontal, *bon* and *ch'uj* in Tzotzil, *muk'ay* in Yucatec Mayan, and *niniqua tzihquipu* ("flesh-colored fruit-pit") in Tarascan.[37]

There is no hint of loanwords among the multiple names for cochineal recorded in the languages of the Otomanguean peoples and their neighbors, with the possible exception of Cuicatec. In contrast, the Zapotec (*còhui, gwa*) and Mixtec (*quèhui, kiwi, kivi*) names for *Indigofera* and *Justicia spicigera* (a prominent blue dye, often combined with indigo) seem to have been borrowed from Totonac *ki'wi'* and the proto-Mixe-Zoquean **kuy* ("tree"). The same root may be evident in the Eastern Ch'olan and Yucatec Mayan *kiwi'* ("annatto," also a colorant).[38]

The disparity is even greater when the vocabulary for the dyestuff is compared with the nomenclature for cacao (*Theobroma cacao*), a crop introduced from South America that achieved great cultural significance in Mexico and Guatemala. The names in Nahuatl (*cacahuatl*), Tarascan (*k'ahékua*), Tzotzil (*kokov*), and Totonac, Huave, and Yucatec Mayan (*kakaw*), as well as other Mesoamerican languages, all relate to the proto-Mixe-Zoquean term **kakawa* for the chocolate bean (although the direction in which the term was borrowed has been hotly debated).[39] Based on linguistic evidence alone, one could deduce that cochineal, unlike cacao, was not brought north from the Andes. Furthermore, in most cases (except for Tarascan, Nahuatl, Triqui, Mixtepec Zapotec, Popoloca, and possibly Mazatec), the designations for the insect appear to be primary terms that do not resemble each other in their sound patterns. The compound names, moreover, are not semantic calques (they are not based on a shared meaning), which again suggests independent origins. This lack of correspondence seems particularly significant, since lexical calques are very frequent in Mesoamerica.

In the case of Mixtec, the absence of the *ti-* classifier (found on most animal terms and practically all arthropod names, with the notable exception of domesticated bees) is likely an indication of a highly managed species, in analogy with cultivated plants, where class markers are omitted as well.[40] In stark counterpoint to cochineal's nominal heterogeneity in Mexico, the dyestuff is singly designated along a 3,000-kilometer stretch from Ecuador to northern Argentina as *macnu/magno* in Quechua and *makhnu* in Aymara.[41]

A USE BEFORE TEXTILES

Patterns of variation in the contemporary Otomanguean lexicons allow reconstruction of a set of plant and animal terms in the *Ursprache* (the mother language that gave rise to the family): widespread cognates for *dog, nopal cactus, maguey plant,* and *agave fiber* all derive from words in the ancient tongue, but *cochineal* and *cotton* are not among them; nor is *maize*.[42] In view of this evidence, the questions arise: Why was cochineal so salient as to deserve independently coined names in several lineages in the family, at an early enough date to account for the variation evident in Zapotec and probably other groups? What can explain the insect's apparent lack of importance during the earliest stage of Otomanguean history, such that an ancestral term was not bequeathed to the daughter languages? The oldest evidence for loom-woven textiles found so far in Mesoamerica—an imprint on a pottery shard from the period 1500–900 BCE[43]—is rather late. The development and diffusion of spinning and dyeing techniques for rabbit hair, down, and other dye-friendly fibers must have involved a lengthy interval after people began to weave. The textile horizon is too shallow, it seems, to account for such great diversification in the terminology for a colorant.

Body paint seems a likely antecedent for fiber dyeing (figure 15.14). *Achiote* (annatto; *Bixa orellana*), and *jagua* (genipap; *Genipa americana*) grow in the lowlands from southern Mexico to northern Argentina. The prominence of both plants among contemporary indigenous peoples from Panama to Paraguay emphasizes the usefulness of colorants that penetrate the skin; they may be more effective cultural resources than mineral pigments in the Neotropical realm. Cochineal, which follows the wide altitudinal gradient of its hosts, the prickly pear cacti (*Opuntia*), would be a good candidate in the dry highlands of Mesoamerica, where *achiote* and *jagua* will not grow. *Indigofera* (a lowland plant that yields indigo), on the other hand, probably requires elaborate processing to be applied on the skin, as it does for dyeing textiles, so it could not be a firsthand choice. Both annatto and genipap prevent insect bites and may have antiseptic benefits.[44] Similarly, a repellent effect of carminic acid on ants and other insects is well supported by experimental observations,[45] and it has been suggested to possess antibiotic and cytostatic (suppressing the growth of tumors) properties.[46] Conceivably, cochineal also protects the dermis from sunburn, since fabric dyed with carmine has been found to block ultraviolet radiation significantly better than cloth colored with madder.[47]

In South America, people encourage annatto and genipap shrubs and trees in the vegetation surrounding their settlements; in some cases, they are actively cultivated in village gardens. The propagation of prickly pear and cochineal by early horticulturalists in Mesoamerica would parallel the management history of *achiote* and *jagua* in the Amazon and Orinoco basins. Long before full-fledged agriculture and weaving arose around 1500 BCE, body paint made with cochineal could have marked affiliation to specific, culturally

FIGURE 15.14 The cochineal insect used as body paint; a dilute solution of ground cochineal was dabbed directly on the skin. For the blood red dots, the solution was mixed with the mashed flesh (greenish in color) of the fruit of *Opuntia pubescens,* a widespread species of cactus with an acidic pulp. The same solution mixed with lime (calcium oxide) was used to achieve the purple circles. Photographer and model: Geovanni Martínez Guerra, Jardín Etnobotánico de Oaxaca, August 2014.

differentiated communities as societies gradually became more complex and as population density increased slowly with incipient crop management.[48] This proposal fits well within the time frame for the internal diversification of the main linguistic families in the region.[49] It also agrees with the dates for domestication of cochineal estimated on the basis of mitochondrial DNA from three populations in the Valley of Oaxaca, plus stocks transplanted in Peru and Madeira.[50] (See Van Dam et al., this volume.) The use of cochineal as body paint during the pre-Formative period could explain the heterogeneity in its nomenclature today, unlike that of indigo and cacao, which appear to become significant only in the pre-Classic and Classic stages, with growing social stratification and the rise of multiethnic, polyglot cities like Teotihuacan.[51]

COCHINEAL IN RITUAL

Symbolic significance of the color red may have provided an additional motivation for management of the insect. The ritual value of cochineal is testified by diverse, but poorly known, voices among historical accounts and living memory. Until recently, wild or feral *Dactylopius* was used in a context that had nothing to do with weaving. In the Mixtec town of San Juan Mixtepec (Juxtlahuaca district, Oaxaca), men who had taken a life were buried with cochineal in their coffins. As Carlos Macedonio Sánchez Bautista recalled in 1985:

> *That's what he had to take with him, it was the belief, when the deceased was going to arrive as in heaven, with the god, he was going to request the blood of the man he had killed, that's why he took the cochineal with him, that was like the blood, if he had that with him he would go through, if not, he couldn't.*

Conversely, among the highland Chontal people of Oaxaca, real sacrificial blood was drawn in a ceremony to propitiate growth of the insect, a service for which we have a moving transcription. The nopal caretaker who offers the ritual expects that the Great Miracle will ask, "Where is the blood, the plate of blood, the plate of (copal) gum that will be given to him?"[52] The "sprinkling of blood" and the "dripping of blood" are mentioned repeatedly, as is the "sweeping of the blood" after the ceremony is over. In the script for the ritual, the organ that pumps blood serves as a metaphor for both domesticated cochineal ("my offspring, my heart") and its wild relative ("the other heart"). The deities are asked to please tell *Dactylopius coccus* not to leave and not to be afraid of its competitor, *la cochinilla cimarrón* [*sic*] ("the runaway cochineal"). In true Mesoamerican fashion, the two insects are assigned symbolic numbers: nine for the cultivated species; seven for its wild counterpart ("when they bring 7, the 9 dies"). The former is admonished to eat the nine plates of sprinkled blood presented to it.

At the beginning of the service, seven pieces of copal are offered to each of thirteen animals, as well as to mountain slopes (where evil spirits roam), to the "owner" Comtasquillă (a series of owners, spirits, and miracles are addressed in the ritual), and to thorns (a formidable nuisance in raising the insect). The vernacular Spanish names for some of the species to be honored with incense match closely the "enemies" listed in various chronicles about the production of cochineal in Oaxaca that date from the 1700s: *armadillo, jícara, gusano culebra* (*culebrilla* in the old documents), and *gusano de espina* (*agujilla*).[53] Evidently, the ceremony sought to appease predators that might diminish the harvest. The eight or more insects that prey on *Dactylopius coccus* in Mexico, vis-à-vis only one reported in the Andes, are a further line of evidence to argue that it was domesticated by the Otomanguean peoples and their neighbors.[54]

The Chontal ritual bespeaks anxiety lest the precious little animal flee back to the wilderness; it urges the Master of the Mountain to "go bring the cochineal god and the thread god," promising to raise and to fatten the insect, "sowing the blood and the gum" to prevent "the other heart" from coming.[55] The liturgy can be read as deep ecological memory, where predation and competition are given tangible form and where a sense of the ultimate origin of the insect in a predomesticate state seems to manifest. To codify that knowledge in symbolic terms must have involved considerable experience and time, again indicative of a local development.

Sacralization of the insect was not restricted to the Chontal people. A series of letters written by local authorities of the Catholic Church in the 1600s concerning "idolatry" refer to a specific deity, named Coqueelaa in Zapotec, who protected nopalries in the town of Sola. A white female turkey was sacrificed to Coqueelaa, and the man who was to plant the cacti abstained from sex and bathed on three consecutive mornings.[56] Supplicatory ceremonies for cochineal involving bird sacrifices, blood sprinkling, and copal burning were also held in Nahuatl-speaking central Mexico.[57]

In the Chontal ritual, the male gods Lanŏ Mojuă (*el dios cochinilla*) and Lanŏ Cucuĭ (*dios hilo;* "thread god"), and Lanŏ Mojuă lăcucuĭ (*el dios cochinilla su hilo;* "the thread of the cochineal god"), are invoked less frequently than the female Lanŏ Caponĕ (*diosa nopal*, where the initial *L* is not marked as a fricative consonant). There are no comments on this

god–goddess opposition in the notes that accompany the transcription, but it seems significant that it should surface in the ritual in light of the role played by red-dyed thread and blood-stained cloth in the gender ideology of some contemporary communities in Mexico. In a myth recorded in the Nahuat-speaking town of Tzicuilan in northern Puebla, the Virgin of Conception is weaving a *quechquémitl* when a hummingbird alights on her warp. She shoos it away, but it keeps pestering her. Angered, she hits it with her batten; the blood of the wounded bird stains her threads. Feeling sorry, she embraces it in her breast, which makes her pregnant. She gives birth to a boy and a girl who become the sun and the moon. The weaver who narrated the story added in the end: "That's why the *tencahuipil* [the local name for one type of *quechquémitl*] has a red band that represents the blood of the little bird."[58]

Sex, blood, and cloth are linked together dramatically in a version of the sun and moon myth that was recounted to me in Chilixtlahuaca, a Mixtec settlement in the mountains of southeastern Guerrero. The twins, in this case both male, first kill Titia'a, a multiheaded eagle monster, brocaded today on the breast of local *huipiles*, and take out its shiny eyes. Afterward they encounter a lady "wrapped in her fabric, like a cocoon," who tells them she wants to rule the world. They give her a fruit that makes her sleepy and then dare each other to "do something to her," but they find that her vagina has teeth. After chopping them off with a rock, they rape her. She awakes drenched in blood and sees the twins rising in the sky, to become the sun and the moon with the eyes of the monster. In her rage, she casts her cloth over the earth. Because of that curse, women have their menses.[59]

While other myths recorded in Mexico elaborate further on the male–female opposition, these two examples illustrate how weaving is still linked symbolically with fertility and how such narratives can illuminate specific instances of textile and dyestuff usage. In Tzicuilan and neighboring villages, women of childbearing age wore the *tencahuipil,* a red-banded *quechquémitl,* for the festivity of the patron saint.[60] Similarly, unmarried women in western Chinantec communities in northern Oaxaca traditionally wear white *huipiles,* whereas the wedding garment donned by married women for fiestas boasts bright red wefts. As mentioned earlier, the cochineal-dyed *byuug* and *ladbej* were the prototypical wedding skirts in the Valley of Oaxaca, while in San Luis Potosí, crimson *costales* were the foremost *donas*, ritual gifts presented by the bride and the mother of the groom.

In the 1950s, young women in the Chinantec town of Usila began to smear fuchsine, a synthetic purple, on the red sections of their *huipiles*.[61] The introduction of fugitive dyes like fuchsine led to innovative, intentional bleeding of threads for decorative and perhaps symbolic effect in at least six areas of Mexico; for three of these regions, a number of nineteenth-century examples show that stable colorants had been used previously.[62] In fact, cochineal-dyed wool on some Mazatec embroidered skirts (see figure 15.9) shows a blend with fuchsine, which must have been added purposefully to stain the cotton cloth beyond the needlework.[63]

It is likely that carminic acid was formerly used as a paint to achieve the same outcome in other regions. An extraordinary *huipil* that must date from the 1800s shows a red colorant, probably cochineal, which was dabbed on the cotton warps in the top section of the central web, where the weft is of dark red *hiladillo* (locally raised silk), surely dyed with the insect.[64] By far the most delicate textile I know from all of Mesoamerica, woven with incredibly finely spun cotton, this was likely worn as ceremonial attire by a member of the indigenous aristocracy somewhere in Oaxaca (figure 15.15). To add a red colorant to a red weave must have obeyed some powerful ideology indeed.

RECAPITULATION

As witnessed with the weavers of Cañada de Yáñez, cochineal production remained part of a subsistence economy in southern Mexico that involved long-distance trade until the mid-twentieth century. The use of carmine in textiles for local consumption must have died out at that time, since no skirts, *huipiles,* or *costales* dyed with the insect have been dated reliably in the 1960s or 1970s. A few years later cochineal would be revived for the folk art market, mainly in woolen tapestries used as rugs, made in Teotitlán del Valle and nearby communities in Oaxaca for sale in Santa Fe and elsewhere.

The versatility of carminic acid allowed it to make the transition from body paint to textiles, European pictorial art, and edible dyes, and then back to lipstick. Annatto and genipap lack that virtue, although they are both widespread in tropical Latin America, where they are still used in food and medicine. The genetics of *Dactylopius coccus,* among the myriad species domesticated in the world since antiquity, point to an enigmatic history of two-lineage admixture and transcontinental introduction by seafaring traders long before Columbus.[65] Dye recipes, indigenous names, and rituals for cochineal offer insights into that saga. They are no less eloquent than DNA samples as testimonies of human ingenuity. 🕸

FIGURE 15.15
Central panel of a *huipil*
Southern Mexico (probably Oaxaca), nineteenth century
52⁴⁄₁₀ x 62⁶⁄₁₀ in.
Museo Nacional de Antropología, 24253(59)6.37al-40

The exceedingly fine warp and weft seem to be of hand-spun cotton
woven on a backstrap loom in plain weave in three webs. Locally grown
silk, dyed with cochineal, was used for the weft in the top section of the
central web. After weaving, additional cochineal was smeared on the
cotton warp in the same part of the garment. Industrially woven silk
ribbon was sewn around the neck and used as a horizontal band below it;
this is embroidered with silk floss, which may have been imported from
China, possibly dyed with synthetic colorants. Photo: Jorge Vértiz.

Manuscript on the silk weaving and textile stamping industries
Mexico City, September 2, 1783–March 2, 1793
European paper with fifteen tipped-in textile samples
12 x 8½ x ½ in.
Brooklyn Museum, Carll H. de Silver Fund, 44.188

This page was part of a set of documents and fabric samples compiled between 1783 and 1793 at the request of the viceroy of Mexico for the king of Spain to demonstrate the types of textiles available in local markets and produced in Mexico City and vicinity. The cotton cloth is block printed in floral designs, representing a Mexican response to the popularity of Indian calicos, which were traded extensively during the seventeenth and eighteenth centuries in Europe and throughout the Americas.

While European textile manufacturers were experimenting to create their own versions of this highly popular fabric from India using madder dye, Mexican producers found a way to print with locally produced cotton fabric and abundantly available cochineal dye. This example from the Brooklyn Museum—one of three identical sets put together in the late eighteenth century (the other two are in the Archivo de Indias in Seville)—may be the earliest example of cochineal used for a printed cotton fabric in the era of global trade. —*Elena Phipps*

■ Sampler with eagle, cactus, and
cactus flowers or cochineal bugs
Mexico, 1862
Linen, cotton, silk
10⅝ x 6½ in.
Museum of International Folk Art, gift of Florence Dibbel Bartlett,
A.1954.1.1

The pink-red threads in this embroidery were analyzed in several
locations and found to be dyed with cochineal. A prickly pear
cactus, possibly sprinkled with cochineal bugs, is shown at the
far right of the central panel with two other iconic symbols of
Mexican culture, the eagle and the snake.

■ Sarape
Saltillo region, Mexico, ca. 1750–1800
Wool, cotton
93 x 63 in.
Museum of International Folk Art, IFAF Collection,
gift of the Fred Harvey Collection, FA.1979.64.101

The origins of the Saltillo sarape, defined by a striped or solid ground that sets off
a central diamond shape, are obscure, but the type may have been conceived by
the Tlaxcala Indians. As allies of the Spaniards, the Tlaxcalans were frequently
sent north to colonize and bring various types of expertise to the frontiers. In
many cities of the viceroyalty, including Santa Fe and Saltillo, they formed
their own barrios (neighborhoods). There they shared their weaving tradition
and perhaps also their familiarity with cochineal, which they had cultivated in
Tlaxcala, a center for the dye source that was almost as important as Oaxaca.

■ Rebozo
Mexico (Querétaro or Saltillo?), ca. 1800
Warp striped, embroidered with flat stitches; cotton,
silk, metallic threads
88⁹⁄₁₆ x 28¾ in.
Museum of International Folk Art, IFAF Collection,
gift of the Fred Harvey Collection, FA.1979.64.66

The beautiful embroidery and style of costumes worn by the
cavorting couples and dueling men would seem to point toward
the late eighteenth century. Two cherry red thread samples—one
of a flower and leaf, the other of a tree trunk—were tested. Both
revealed cochineal.

NOT ONLY RED

Cochineal in the Eighteenth-Century European Woolen Cloth Industry

DOMINIQUE CARDON

BY THE EIGHTEENTH CENTURY, American cochineal had become the main source of scarlet, the most prestigious color among the hundreds of shades that routinely emerged from the huge tin and brass cauldrons (weighing from 200 to more than 300 kilograms) used in the dye works of the large woolen cloth manufacturers flourishing in several regions of Europe. Among the wealth of documents preserved in the archives of the main textile centers, particularly precious are those illustrating the beauty of these colors, with cloth samples attached to clothiers' sample cards, showing assortments to be found in a bale, or, even better, attached to dyers' books. One document, the recently published *Mémoires de teinture: Voyage dans le temps chez un maître des couleurs* (*Memoirs on Dyeing: Meeting with a Master Dyer of the Eighteenth Century*),[1] offers unexpected keys to understanding the extraordinary economical and ecological use of this exotic dyestuff at a royal manufacture in the south of France. The company produced cloth for exportation to the Levant—the eastern and southern Mediterranean countries of the Ottoman Empire—and beyond to India, China, and Latin America.

The volume of production in this branch of the textile industry was enormous: from this manufacturer in 1764 alone, 1,375 pieces of fine cloth were exported, amounting to nearly 51 kilometers with an estimated total weight of about 15,000 kilograms. In an international context of intense competition between Dutch, English, and French cloth producers, the beauty and quality of the dyes were essential assets. Echoing the report of a French merchant in the Levant, the author of the authoritative *Le Parfait négociant* (*The Perfect Merchant*), Jacques Savary, stresses that "the Turk, the Armenian and the Persian are very particular about colours. . . . It is the vividness of the colours of the cloth that causes them to be bought."[2]

At the top of the list of "high" or "strong" colors that could win a market were three that could be obtained from cochineal: scarlet, crimson, and *soupe au vin* (wine soup). The difference between the former and the two others, the author of *Mémoires* explains, depended on the mordanting process: "The colour that is given naturally by the fine cochineal employed without acid ranges from lilac grey to crimson. There is an infinity of shades between these two. . . . By using acids one makes them vivid, bright and orangey."[3] While crimsons and *soupes au vin* were still mordanted with a variety of native or manufactured alums, which hardly modified the color of the dye, it had by then become possible to create new ranges of more or less orangey scarlets from cochineal thanks to the invention, attributed to Dutch scientist Cornelis Drebbel (1572–1633), of a new mordant obtained by dissolving granulated tin in nitric acid (*aqua fortis*).[4]

THE COST OF PRESTIGE

The second half of the century brought a "latent permanent crisis" in the trade.[5] After winning the favor of eastern Mediterranean elites by including five pieces of "high colors" per bale of cloth (figure 16.1), French manufacturers gradually had to reduce their offerings to four, three, or only two pieces of scarlet, crimson, or wine soup per bale (figure 16.2). Cochineal was the most expensive of the dyestuffs they used, the only one whose price was indicated by the pound and not by the quintal (hundredweight). The manufacturers were particularly sensitive to price fluctuations of cochineal, which were largely due to recurring wars between France and England and their respective allies. They were also strictly bound

Opposite **FIGURE 16.1** Assortment of colors in a bale of cloth divided into two bundles, presented by Pierre Gout, a clothier from Carcassonne, France. Two scarlets figure in the first bundle; two scarlets and one flame scarlet in the second. Archives départementales de l'Hérault, C 2514, September 18, 1751. Photo: Dominique Cardon.

Voila En déus Ballotx cést La balle

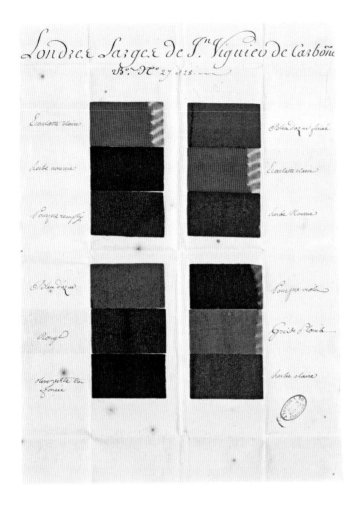

by the French system of royal regulations, originally devised to ensure the high quality of cloths and dyes and their prestige among foreign customers. A decree by the French king's council on April 18, 1713, forbade manufacturers to dye any piece of good-quality cloth into scarlet, crimson, or wine soup with less than 1.75 pounds of cochineal. This amounted to 7 to 7.5 percent of the weight of dry cloth, as opposed to the 5.3 percent described by Anglo-American dyer William Partridge as the usual proportion used at the time by his father, a broadcloth producer of the Stroudwater area in the west of England, the region most famous for its scarlets.[6]

It was very difficult for French manufacturers and their dyers to cheat on the quantity of cochineal used because of the series of quality controls to which cloth pieces were subjected before being allowed to be exported via Marseille. Examples of the best qualities of broadcloth dyed with the regular amount of fine cochineal were deposited in all the control centers, allowing the conformity of the color of each piece of cloth to be visually assessed by comparison with the standard (figure 16.3). Numerous sources prove that controllers were quite good at spotting pieces lacking the right intensity of color, which they describe as *affamées* (famished). Frauds were severely punished: not only were the faulty pieces redyed into less prestigious colors at the clothier's expense, he had to pay a heavy fine.[7]

Clothiers' accounts preserved in the Archives départementales de l'Hérault allow evaluation of the proportional cost of cochineal in the production of a bale of cloth. One was composed of twenty "half pieces," including five dyed in "high colours."[8] While the cost of dyeing the noncochineal colors amounted to 5 to 8 percent of all production costs—dyestuffs and labor included—the cost of cochineal alone equaled 5 percent of total production costs. By comparison, the wages of weavers and their bobbin winders accounted for only 7.3 to 8 percent of the production cost of a bale.[9] To ease somewhat the burden of such considerable investments, the government waived part of the import duties it normally imposed

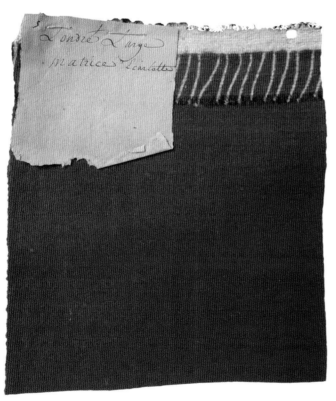

Left, top **FIGURE 16.2** Color assortment corresponding to a bale composed of two bundles, sent on July 15, 1758, from the manufacture of La Terrasse in Carcassonne, belonging to the Marcassus family. It includes only two scarlets. Archives départementales de l'Hérault, C 5550. Photo: Dominique Cardon.

Left, bottom **FIGURE 16.3** *Matrice* (standard) of scarlet for the quality of cloth named Londre Large (Broad London). The selvage has been covered with cotton cloth for reasons of economy, well explained by William Partridge on page 123 of his dyeing treatise: "Cloth, intended for scarlet, or any other cochineal colour, is always girt-webbed, to prevent the lists from taking the dye, as it would, being heavy and coarse, absorb much of the cochineal." Archives départementales de l'Hérault , C 5550. Photo: Dominique Cardon.

on cochineal for cloth producers of Languedoc exporting to the Levant. "Passports of cochineal" were issued to the producers each year, allotting each a portion of the 210-*quintaux* (10,279-kilogram) mark weight of duty-free cochineal, based on volume of production (figures 16.4a–16.4b).[10]

But even this demonstration of goodwill was not helpful enough. The manufacturers had to devise other ways to recoup their investment in cochineal, cleverly using the precious dyestuff down to the last colorant molecule.

RECYCLING COCHINEAL

When using fine cochineal (*cochenille fine ou mestèque*) for scarlets, a small part (0.3 percent of the weight of the dry cloth piece) of the compulsory 1.75 pounds was added to the tin-mordant bath (the bouillon). This slightly colored mordant bath, having been used once, was not thrown away. It could be reused to compose dye baths with fustic (*Cotinus coggygria* Scop.), the source of a bright orange dye used in proportions ranging from 20 to 28 percent of the dry weight of a piece of cloth (figure 16.5). With the addition of tin mordant and "a little" madder, the bath produced a gold color (*couleur d'or*). Without madder but with a tiny amount of cochineal

(0.5 percent), the bath gave a *cassie* yellow (color of the flower of *Acacia farnesiana* [L.] Willd.). With only fustic and tartar (around 4 percent) added, it produced a daffodil yellow (*jonquille*). Without any addition at all, the pale shade obtained from this recycled mordant bath was called *biche* (doe).[11]

The dye bath for scarlet that followed the mordant bath was called *rougie*. It was prepared with the rest of the 1.75 pounds of cochineal and more tin mordant (13 to 16 percent). After being used for the first time to dye regulation-quality scarlet, dye baths were reused in an extraordinary succession of processes. First they could serve as the basis of mordant baths for another scarlet, with no cochineal needed to be added at the mordanting stage, only the tin mordant. They could also be used as mordant baths for a series of paler red to purplish-pink shades, such as *vessinat* (the color of vetch flowers), *griotte* (amarelle cherry), and cherry. For top-dyeing over one of the blue shades obtained from the woad-and-indigo vat,

FIGURES 16.4A–16.4B Passports of cochineal granted by the intendant of Languedoc, France, to, respectively, Jacques Gout, for 100 pounds of duty-free cochineal for the year 1778, and Mr. Marcassus of La Terrasse, for 268 pounds of duty-free cochineal for the year 1758. Archives départementales de l'Hérault, C 2230. Photo: Dominique Cardon.

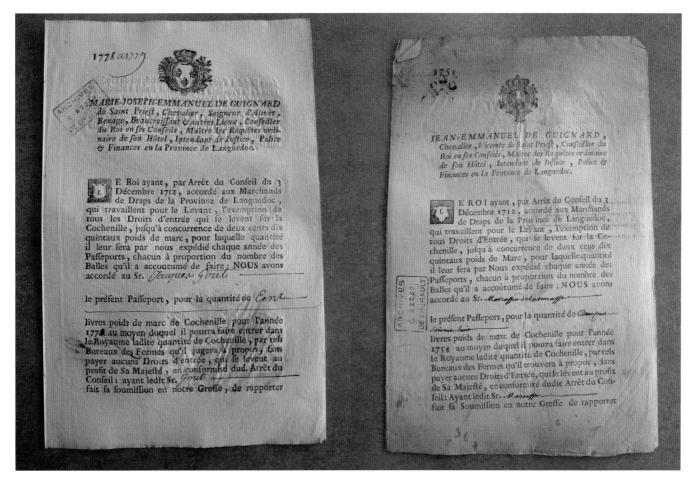

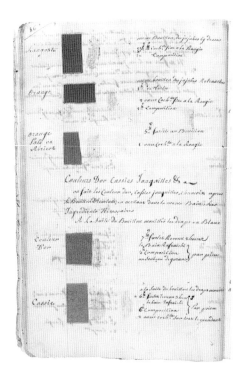

a *rougie* could be recycled as a mordant bath for purples and violets. After that, the same mordant bath could be used again for paler purplish shades such as lilac, *gorge-de-pigeon* (dove breast), mauve, and *gris-de-lin* (linen gray). Lastly, a scarlet dye bath could be reused to compose a special mordant bath, with varying quantities of tin mordant and fustic, for the whole range of "flame colors" (*couleurs de feu*).

Although fustic was normally classified as *petit teint* (not fast enough for good-quality textiles) and forbidden to be used, an exception was made for the woolen cloth producers of Languedoc because the brilliant flame colors it gave when associated with cochineal were extremely popular among the Levant elite. Consequently, a mordant bath for a regular scarlet could be recycled as a mordant bath for "flame scarlet," also dyed with 1.75 pounds of cochineal, as well as for the range of colors called pomegranate flower, jujube, lobster, orange, and apricot (figure 16.6). These were produced with high proportions of fustic (up to 24 percent) in the mordant bath and by decreasing quantities of cochineal (from 5 to 0.25 percent) in the dye bath.[12]

But that was not all: instead of being recycled into mordant baths, a scarlet dye bath could be used for dyeing again, once or even twice. Recycled for the first time with a small amount (2 to 4 percent) of cochineal added, it formed dye baths for the *vessinat*, *griotte*, and cherry pinks (figure 16.7); with no more cochineal but a little gallnut, it produced a *gris-de-prince* (prince gray); and without anything, it made a shade called *chair* (flesh). Used a second time with minor additions of tin mordant, cochineal, and tartar, the dye bath

for cherry gave a pink, while that for *vessinat* gave a peach flower color (figure 16.8). And without any addition, the dye bath that had already given a flesh color produced an even paler shade, "pale flesh" (figure 16.9).

When used for top-dyeing over different shades of woad-and-indigo blues, and with the addition of decreasing quantities of cochineal, the initial dye bath for scarlet gave purples and violets. After this first reuse, it was recycled again for the paler shades of lilac, dove breast, mauve, and linen gray (figure 16.10). The utmost degree of economy was reached with a range of shades obtained from dye baths consisting of a mordant bath made with an already-used dye bath for scarlet, to which small amounts of fustic, madder, or tin were added. The results were pale pinkish-beige colors called café au lait (coffee with milk), *chocolat au lait* (chocolate with milk), and *chamois* (fawn) (figure 16.11).

The purpose of this complex succession of recycling processes (called *suites*) was evidently to exhaust the mordant baths and dye baths, which were initially rich in costly tin mordant and even more expensive cochineal. The processes had to follow each other in quick sequence, requiring an amazingly clever management of workshop equipment and space. Jean Hellot, the author of a famous treatise on dyeing published in 1750, explained, "If the dyers cannot find time to use these baths for the second and third time within the next twenty-four hours, the colour of the bath gets spoilt, and the liquor, which was of the colour of a rose, becomes turbid and entirely loses this colour." On the other hand, Hellot continued, when one manages a smooth succession

 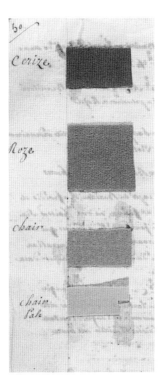

of all the possible recycling options, "one saves a lot of fuel and time."[13]

The result of such adroit management of resources is reflected in a list of the colors of one hundred half pieces of "Londrins Seconds" cloths exported to the Levant in July 1751—from the very manufacture where the author of the *Mémoires* was to work a few years later. Each of the ten bales sent together included a half piece of scarlet. The ten dye baths in which they were produced had obviously been superbly recycled: half of them had been reused to obtain colors needing the addition of fustic (five pieces of flame scarlet and five pieces of jujube were distributed among the half bales); the other half had been used to obtain a range of colors without fustic, including some (five pieces of *griotte* and five purples) that had been top-dyed over a woad-and-indigo blue. A further recycling stage may have produced the five pieces of pink and five pieces of linen gray also found on the list, while recycling of the mordant bath with fustic would have given five more pieces dyed into *cassie* yellow.[14] All together, the color of forty-five out of the one hundred half pieces in the lot were derived from a mordant bath or a dye bath for scarlet and the successive recycling of the precious tin and cochineal they contained.

AN EXAMPLE FOR TODAY?

Via the long recycling chain described above, every bit of the coloring power of fine cochineal was fully exploited. What's more, compared with the highly polluting effluents of modern dye plants, the complete exhaustion of mordant and dye baths kept effluents from the manufacturers fairly innocuous.

However, the commercial success of the fine cloths dyed with the range of colors resulting from this succession of ever-more-diluted dye baths very much depended on cultural, psychological, and political factors. Had the French court and French *élites* not been considered fashion leaders in many parts of the world at this time, it might have been difficult for clothiers in the ports of the Levant to convince their customers to adopt these new shades, so different from the intense reds commonly associated with cochineal.

Left to right, from opposite page

FIGURE 16.5 Page 46 of *Mémoires de teinture*. From top to bottom, samples of colors called *langouste* (lobster), orange, pale orange or apricot, gold, and *cassie*. Photo: Dominique Cardon/Pierre-Norman Granier.

FIGURE 16.6 Page 45 of *Mémoires de teinture*. From top to bottom, samples of scarlet and colors named flame, pomegranate flower, and jujube. Photo: Dominique Cardon/Pierre-Norman Granier.

FIGURE 16.7 Page 52 of *Mémoires de teinture*. From top to bottom, samples of wine soup and the colors vetch flower and *griotte* (amarelle cherry). Photo: Dominique Cardon/Pierre-Norman Granier.

FIGURE 16.8 Page 49 of *Mémoires de teinture:* linen gray (above) and peach tree flower. Photo: Dominique Cardon/Pierre-Norman Granier.

FIGURE 16.9 Page 50 of *Mémoires de teinture*. From top to bottom, samples of cherry, rose, flesh, and pale flesh. Photo: Dominique Cardon/Pierre-Norman Granier.

FIGURE 16.10 Page 51 of *Mémoires de teinture*. From top to bottom, samples of purple, violet, lilac, dove breast, and mauve. Photo: Dominique Cardon/Pierre-Norman Granier.

FIGURE 16.11 Page 47 of *Mémoires de teinture*. From top to bottom, samples of daffodil, *chamois*, doe, coffee with milk, and chocolate with milk. Photo: Dominique Cardon/Pierre-Norman Granier.

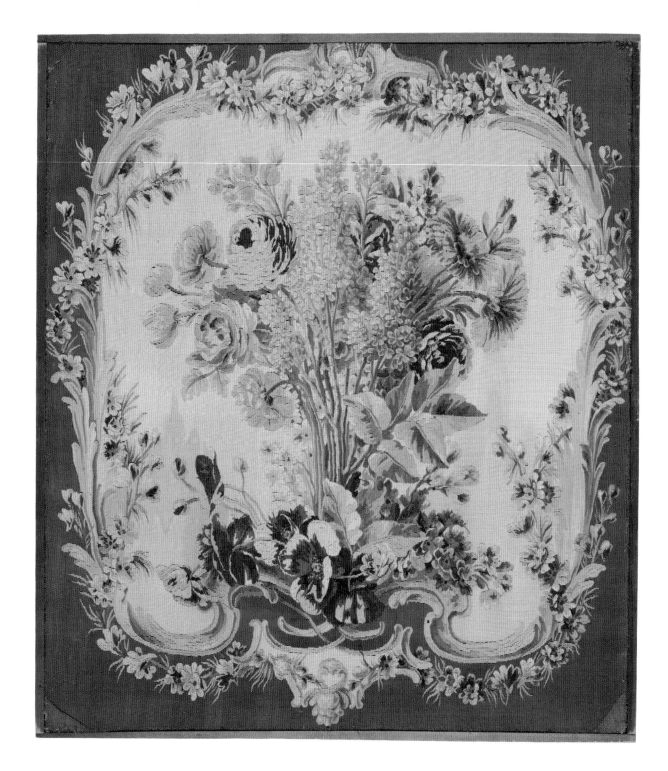

MAURICE JACQUES

■ Chair back upholstery panel

Manufacture Nationale des Gobelins

France, ca. 1760–1789

Silk, wool (twenty-four to twenty-six warps per inch)

25½ x 22¼ in.

Metropolitan Museum of Art, gift of Ann Payne
Blumenthal, 1943 (43.163.18)

© The Metropolitan Museum of Art. Image source:
Art Resource, NY

The Gobelins tapestry works was founded in Paris in 1662 by Jean-Baptiste Colbert, Louis XIV's minister of finance, for the purpose of creating tapestries for the king's palaces. Production was strictly regulated, and dyes were classified into categories by quality. Cochineal, called in French *mestèque* or *texcale*, after the Mexican Mixtec or Tlaxcala areas associated with its production, was especially valued for reds and was given the designation *bon teint*, or "good dye," because of its exceptional color saturation and colorfastness.

The delicate Rococo style popularized in France in the mid-eighteenth century was particularly well suited to the many shades of reds and pinks that cochineal could achieve. A good example is this chair back cover festooned with flowers.

This is one of twenty-eight chairs made for the room in which
Napoleon Bonaparte assembled his cabinet at Malmaison, the
primary residence he shared with his wife, Josephine, during the
consulate period, which ended in 1804. The deep red cochineal-
dyed upholstery was intended to reinforce the image of power that
the first consul consciously projected through his every act and
accoutrement. Red was the color most associated with the power
of the ancient Romans, and the chair's red wool and silver trim may
have been meant to evoke a military uniform. Indeed, Napoleon's
understanding of cochineal as a superior red was expressed through
his offer in 1811 of "a prize of 20,000 *livres* to the person who will
find how to give wool by means of madder a solid vivid color . . .
which most closely resembles cochineal scarlet."[a]

DRESSING RED

Cochineal Red in Eighteenth-Century Garments from the Museo del Traje

ELENA VÁZQUEZ GARCÍA AND IRENE SECO SERRA

STOCKINGS, SHOES, AND A WOMAN'S corseted jacket: all are part of the same private collection that came to the Museo del Traje (Costume Museum) in Madrid, Spain, in the 1930s. All are from the eighteenth-century Rococo period. And recent scientific analysis of the items reveals the presence of cochineal red in all of them.

The items come from the private collection of the Guiú family of Catalonia and were donated following a 1925 exhibition of apparel.[1] The show's success led to the establishment of a permanent costume museum, today's Museo del Traje. According to a comment in the guide to the 1925 exhibition,[2] the Guiú Collection was part of the exhibition, though it is uncertain whether the cochineal red stockings, shoes, and jacket were among the items on display.

Very little is known about the Guiú Collection except that it was put together by Don Francisco Guiú during the late nineteenth and early twentieth centuries.[3] While museum archives confirm accession of the pieces, there is no documentation of the items other than an isolated mention in a letter stating that Carmen Guiú inherited them from her father, the above-mentioned Don Francisco, when the family was living in Paris. Nonetheless, using analysis and a few known facts about fashion in the period in which they were made, it is possible to piece together a general story of these rare red items.

The silk *zapatos*, or shoes (figure 17.1), were made for a man in about 1740. They are flat soled with florid gold-thread embroidery; their buckles are missing. Despite their elegant presentation, given their width and type of sole, the shoes were likely made for domestic use.

Also made for a man, the *medias*, or stockings (figure 17.2), were crafted from red silk using a mechanical stitch. On the front of each stocking is a clock-shaped design embroidered in gold thread of the highest quality. The survival of both detailed and delicate stockings is a rare occurrence.

Finally, the *jubón*, a whalebone or corseted woman's jacket (figure 17.3), was created between 1740 and 1760. Made from four panels of silk—or more precisely, with a weave called *faya francesa* that consists of a silk warp and linen weft—the piece boasts three-quarter sleeves, a broad neckline, and a polychrome floral motif on a red background. The front and back are finished with a raised stitch, and the front left side has what remains of a short waist skirt. The jacket was adjusted for fit by means of seven hand-sewn eyeholes through which a string, now lost, was passed. In the front of the jacket, a series of cellulose and whalebone stays are stitched in, giving the garment its compelling name. Although made to wear as an outer garment, the jacket at the same time served the constrictive function of a traditional undergarment, the corset.[4]

Of the twenty-five eighteenth-century items of men's and women's clothing made with red cloth housed at the Museo del Traje, these three cochineal red items are the oldest. It is uncertain which of the other eighteenth-century items were dyed with cochineal, although it seems probable that at least some of them were. Given that the museum's total eighteenth-century collection comprises almost five hundred pieces, it might seem that cochineal, or the color red in general, was little used in clothing of the period. However, analysis of the red-cloth items must keep in mind a fundamental factor: the limited time frame of the items' manufacture, mostly between 1740 and 1770. Thus, if placed in their principal chronological context of the Rococo period of 1730 to 1760, the red articles are proportionally rather abundant.

■ *Opposite* FIGURE 17.1 *Zapatos* (shoes), Spain, ca. 1740. Silk, leather, gold thread, 3¾ x 10⅝ x 3½ in. Museo del Traje, Madrid, CE000866, Ministerio de Educación, Cultura y Deporte. Photo courtesy Museo del Traje.

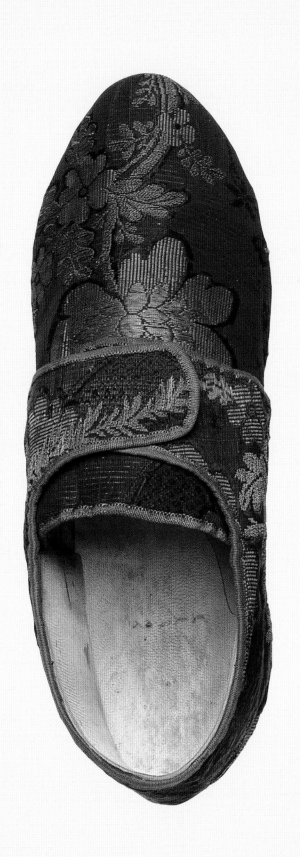
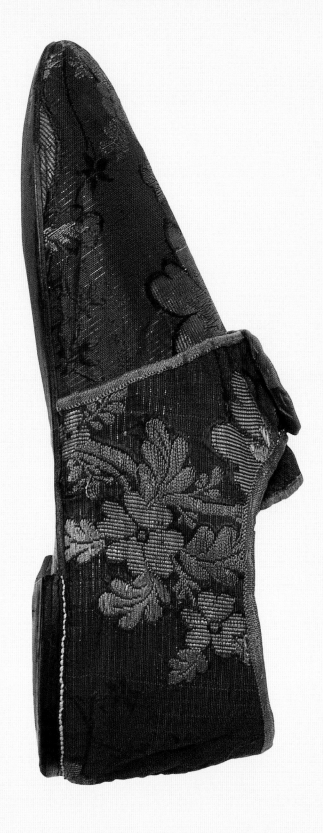

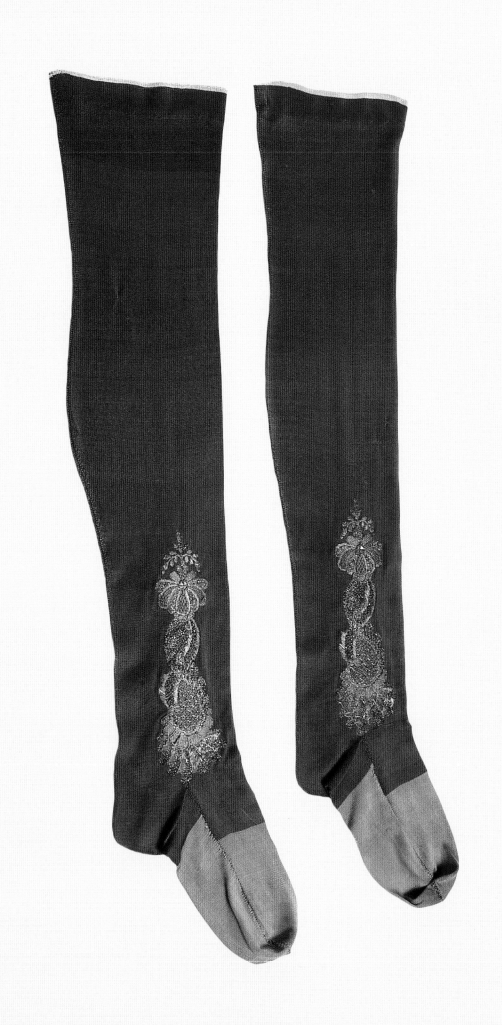

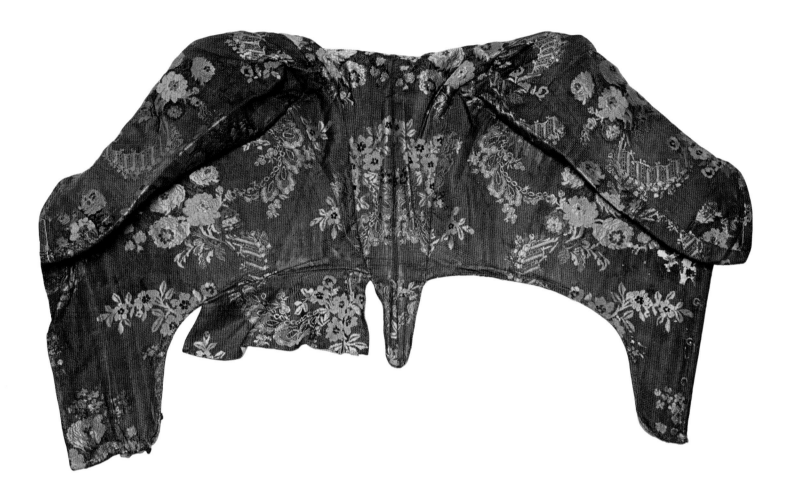

The Rococo era is customarily associated with France, the nation that set the rules for style in the eighteenth century. Although visual and written documentation shows women's red dresses, men's long red coats, and red textiles from that time, red is certainly not the color most depicted in pictorial representations of the French Rococo style. Above all, pink ruled the period, followed by such pastel shades as yellow and blue-gray.

Despite the preeminence of French style in the eighteenth century, the speed with which new ideas spread, as well as the presence in Spain of silk works of quality and prestige, makes it difficult to determine with certainty the provenance of many clothing articles of the time. Indeed, only in a few cases is the provenance of an item known, and it is not always possible to ascertain where the article was made. In the case of the three cochineal red pieces from the Museo del Traje, only the woman's corseted jacket can be said with certainty to be of local fabrication, although the origin of the cloth is uncertain.

As in France, pictorial evidence does not support a special attraction to red in Spain during the Rococo period, but such an attraction does seem to be present in Spanish America. Thus, in terms of the relatively significant number of Rococo-period red items in the collections of the Museo del Traje—including the cochineal-dyed socks, shoes, and corseted jacket—it appears any special preference for red in Spain is likely owed to nineteenth- and twentieth-century collectors, such as Don Francisco Guiú, from whom the pieces were acquired.

■ *Opposite* **FIGURE 17.2** *Medías* (stockings), Spain, eighteenth century. Silk, gold thread, 24⁷⁄₁₆ x 13⅜ x 8¼ in. Museo del Traje, Madrid, CE000777, Ministerio de Educación, Cultura y Deporte. Photo courtesy Museo del Traje.

■ *Above* **FIGURE 17.3** *Jubón* (corseted jacket), Spain, ca. 1740–1760. Silk, flax, hemp, metal, taffeta, French falla, 16½ x 29½ in. Museo del Traje, Madrid, CE000610, Ministerio de Educación, Cultura y Deporte. Photo courtesy Museo del Traje.

18 RECYCLED REDS

Raveled Insect-Dyed Yarns in Blankets of the American Southwest

ANN LANE HEDLUND

THE SOUTHWESTERN LANDSCAPE is infused with red. Derived from iron oxide and other minerals, red hues appear in soil, rocks, cliffs, and rivers. Native Americans who lived in the Southwest thousands of years ago created textiles, pots, and baskets in reddish and orangey browns from earthen sources. By the 1700s they were also using vermilion, a mineral pigment from cinnabar (mercuric sulfide) that appears in European and American trade records and that imparted a deep red to deerskin, fabric, and other materials.

Beyond mineral-based red-browns, plant-derived colorants from alder tree bark, mountain mahogany root bark, black sunflower seeds, purple corn, and other plants added reds, pinks, and purples to the indigenous palette. By the 1880s, brighter and more versatile reds had arrived in the form of European, coal tar–based synthetic colorants. Trade cloth tinted with these aniline red dyes had come into use in the West by the late 1800s, as native and other craftspeople edged or lined garments and bags with it and found other uses for such cloth. (See Bol, this volume.)

The most interesting source of red, however, was cochineal bugs. The earliest known appearance of cochineal-dyed yarns in the Southwest is in fragments of Navajo dresses (*biil*) and blankets (*beeldléí*) found in historic-period archaeological sites dating from the 1790s to the early 1800s.[1] These reds made their way into Navajo blankets and garments, as well as into nonnative southwestern textiles, in a roundabout manner—only after foreign, manufactured yarns and cloth were dyed with imported cochineal and exported to North America (figures 18.1a–18.1b and 18.2).

Beginning in the early 1500s, dried cochineal insects were shipped in enormous quantities and at high expense, from Mesoamerica to Spain and beyond, where their extracted dyes were applied to commercial wool yarns and fabrics of European and Near Eastern manufacture. (See Marichal, this volume.) Commercially woven wool fabric first entered the Southwest among the supplies of early Spanish explorers, such as Francisco Vásquez de Coronado, beginning in 1540. After 1598 lengths of trade cloth reached the Southwest via El Camino Real de Tierra Adentro from Mexico, and after 1821 along the east–west Santa Fe Trail. Eventually, European and Near Eastern imports were augmented by Mexican and American mill products. Known generically as *bayeta* in Spanish or baize in English, the flannel-like materials varied in weave, texture, yarn structure, and finish, with their universal popularity attributed to their brilliant reds (figures 18.3–18.4).[2]

By the late 1700s, both Native American and Spanish American weavers in the Southwest were obtaining lengths of red trade cloth and skeins of red yarn—some of it dyed with cochineal originally exported from Mesoamerica and applied to fibers in Europe and the Near East. The cloths were recycled by unraveling or further hand processing and were rewoven into Pueblo (figure 18.5), Navajo, and Hispanic textiles. But several long-standing issues and questions remain. These include whether the presence of wild cochineal insects in the Southwest today indicates a local source for dyeing; whether the cochineal dyestuff cultivated and prepared in Mesoamerica entered the Southwest in sufficient quantities for application to local hand spun yarns;

Opposite **FIGURES 18.1A–18.1B** Kit Carson robe, Taos, New Mexico, pre-1850. Beaver pelt mantle lined with red wool fabric. Balanced diagonal twill weave (2/2), mill-woven, with red S-spun warp and weft yarns, mill-spun and dyed with 100 percent cochineal, 60 x 53 in. New Mexico History Museum, Department of Cultural Affairs, 09474.45. According to museum records dated March 16, 1929, this plush beaver robe was made in the Carson family before 1850, possibly by Kit Carson himself. This was the period when the legendary and controversial trapper, scout, and soldier trapped beaver in New Mexico. Depicted here are the full robe's fur exterior and a detail of its hand-stitched red wool lining made from imported trade cloth.

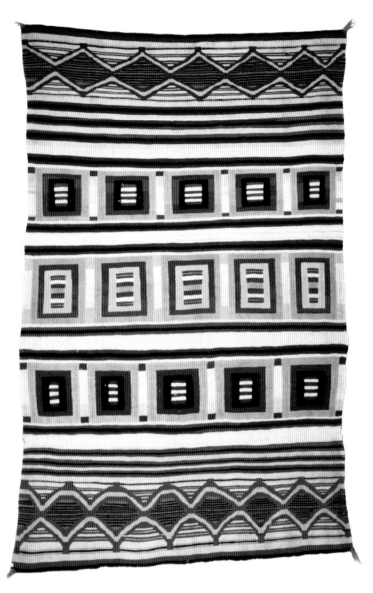

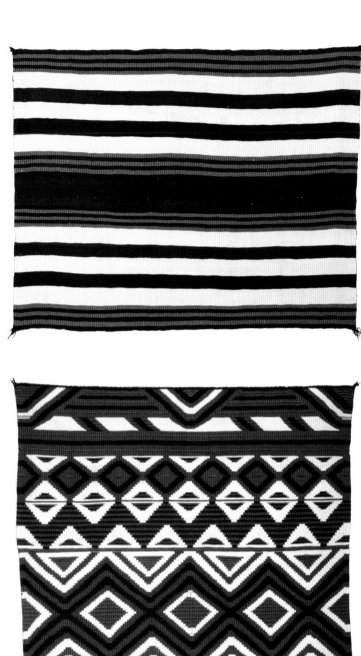

Above **FIGURE 18.2** Navajo sarape, Navajo Nation, Arizona or New Mexico, late Classic period, ca. 1864–1875. Maroon, red, and pink raveled wool weft yarn (two–three Z-spun strands) dyed with 100 percent cochineal; pink Saxony wool weft yarn (3zS) dyed with 100 percent cochineal, 77 x 50 in. Arizona State Museum, E-2853. Photo: Arizona State Museum, University of Arizona.

Right, top **FIGURE 18.3** Navajo chief blanket, Phase I variation, Navajo Nation, Arizona or New Mexico, ca. 1850–1865. Red raveled wool weft yarn (three–four S-spun strands) dyed with 100 percent cochineal, 59½ x 74 in. Museum of Indian Arts and Culture, Laboratory of Anthropology, 9118/12.

Right, bottom **FIGURE 18.4** Navajo sarape with small poncho neck slit, Navajo Nation, Arizona or New Mexico, Classic period, ca. 1840–1860. Red raveled wool weft yarn (Z-spun, paired) dyed with 100 percent cochineal, 65½ x 51 in. Arizona State Museum, E-2724; Joe Ben Wheat Southwest Textile Database ID 58. Photo: Arizona State Museum, University of Arizona.

Opposite **FIGURE 18.5** Manta, Acoma Pueblo, New Mexico, ca. 1860–1880. Red raveled wool weft yarn (2zS) dyed with 80 percent cochineal and 20 percent lac, 44 x 58 in. Arizona State Museum, E-9990. Photo: Arizona State Museum, University of Arizona.

and whether other insect dyes, such as Indian lac and Mediterranean kermes, were present in the raveled reds. Furthermore, by what processes did people transform trade cloth into a creative resource? How varied were the materials and how can they be used as diagnostic tools to identify and date undocumented textiles today?

COCHINEAL DYESTUFF IN THE AMERICAN SOUTHWEST?

Two types of cochineal are distinguished in modern-day Mexico: fine cochineal (*Dactylopius coccus*) and eight species of wild cottony cochineal, including *Dactylopius opuntiae*.[3] Through time, human-driven selection enlarged the insect's body size and diminished its waxy white protective covering, which allows the insect to adhere to its prickly pear host and makes it resistant to wind and rain. This process of domestication thereby increased the relative amount of carminic acid as a source for red dye.

In addition to the widely known presence of cochineal on various prickly pear cacti in Mesoamerica and South America, the American Southwest hosts a native or wild bug of the same genus, albeit much smaller and not domesticated. Indeed, whereas yields from *D. coccus* are 15 to 25 percent, wild cochineal yields a much lower concentration of carmine colorant, from 2 to 7 percent by dry weight.[4] Identified in southern Arizona and Mexico as *Dactylopius opuntiae*,[5] the insect lives on local, native prickly pear species such as the widespread *Opuntia engelmannii* and sometimes on non-native prickly pears in area gardens. Facing an infestation of this parasite, urban and rural gardeners may be advised by local nurseries to hose off the white substance in which the insects encase themselves. With the slightest touch, the cottony mass exudes a brilliant spot of red.

The western U.S. range for prickly pears, and presumably for native wild cochineal, stretches from California to Texas and from Colorado to the Mexican border. The distribution includes the Hopi Indian mesas in Arizona, the Navajo Nation of Arizona and New Mexico, and parts of New Mexico where Pueblo Indian and Hispanic villages have been located for hundreds of years. Cochineal's presence appears to be ecologically constrained but not culturally governed, as there is no indication of cochineal domestication in the Southwest.

The wild bugs were thought to be too small and proportionately too waxy for productive use as a dyestuff.[6]

In addition to the wild bugs' physical limitations, no concrete material evidence shows that local insects were harvested for dyes to be applied on textiles produced by Pueblo, Navajo, or Spanish American weavers. There have been no confirmed textile examples of hand-spun yarn in which fibers were locally dyed with cochineal or other insect dyes, nor has any documentary, ethnographic, or known anecdotal evidence of such dyeing practices in the Southwest been reported to date. Furthermore, there is no archival or ethnographic support for insect-based dyestuffs being imported to the Southwest for application on Pueblo and Navajo textiles before the twentieth century.[7]

During their early research, Kate Peck Kent and Joe Ben Wheat each considered the possibility of imported cochineal being used by Navajos as a native-applied dyestuff, but both later rejected this notion. Wheat summarized his point of view in a 1982 letter to Kent: "I have never seen a Navajo native-spun yarn dyed with cochineal, nor have I ever found any documentary evidence that they even used cochineal. Documents in the 1865 period flatly state they dye only with indigo, using yarn and bayeta for all other colors."[8]

The case for cochineal dyeing is just as tenuous in Spanish American textile production and records. The argument for active cochineal dyeing in New Mexico during the nineteenth century reaches back to the Spanish colonial arts revival period of the 1920s and 1930s in New Mexico, when local preservationists sought to revive and perpetuate artistic techniques and materials presumably used during the colonial period. E. Boyd, writing in the 1950s, carried forward assumptions about the local use of cochineal. Seeking evidence for the raw dyestuff in New Mexico, Ward Alan Minge

Opposite, left, top FIGURE 18.6 Spanish American blanket, Lemitar, Rio Abajo, New Mexico, ca. 1800–1850. Native hand-spun white cotton warp (2zS) and weft (Z-spun, singles); cotton said to have been grown at Lemitar. Dark pink mill-spun wool weft yarn (very fine 3sZ, reverse direction of Saxony spinning) dyed with 100 percent cochineal, 78 x 46 in. Museum of Northern Arizona, 2203/E1870; Joe Ben Wheat Southwest Textile Database ID 1051.

■ *Opposite, right* FIGURE 18.7 Vallero star blanket, Spanish American, Rio Grande Valley, New Mexico, ca. 1855–1870. Red Saxony wool weft yarn (3zS) dyed with 100 percent cochineal, 90 x 46½ in. Museum of International Folk Art, IFAF Collection, FA.1967.43.3.

Opposite, left, bottom FIGURE 18.8 Spanish American blanket, Rio Grande Valley, New Mexico, ca. 1820–1850. Native hand-spun white cotton warp (2zS) and weft (Z-spun, singles). Red raveled wool weft yarn (one–two Z-spun strands and 2zS) dyed with 100 percent lac, 98 x 45 in. Collection of the Spanish Colonial Arts Society Inc., Museum of Spanish Colonial Art, L.5-62-74; Joe Ben Wheat Southwest Textile Database ID 1003. Photo: Addison Doty, courtesy Museum of Spanish Colonial Art.

noted "pounds of *carmesí* (cochineal)" among the many goods listed as being brought from Mexico to New Mexico. It is unclear whether this information derived from a single document or multiple sources, where the record occurred, or how the original Spanish wording appeared.[9] Subsequent articles have generalized and expanded on Minge's statement: "Documents record the importation of pounds of *carmesí* (cochineal) into New Mexico in the 1830s."[10] Wheat repeats this as well, although it is unclear whether he is discussing the dyestuff or already dyed yarns and fabric.[11]

Complicating matters, it was common in the twentieth century to interpret the term *vermilion* to mean cochineal in historical documents.[12] This is likely a mistranslation and may obscure reality—when the term *vermilion* is ignored, there is little mention of cochineal in trade records. When cochineal does appear, it seems insufficient in quantity for yarn or fabric dyeing and was likely used for painting, making cosmetics, or other small-scale activities. (See Gavin and Caruso, this volume.) Although cochineal was used as a lake pigment in Spanish colonial paintings in New Mexico (see Anderson; Siracusano and Maier; and Pearlstein et al., this volume), Mexican trade records mention the red colorant in relatively small amounts.[13] It is doubtful that enough would have been released from Spanish control for use as a textile dye.[14]

ANALYZING RED DYES IN SOUTHWESTERN TEXTILES

When did Southwest textile scholars begin investigating cochineal and other red dye sources in raveled yarns from red cloth? Washington Matthews describes *bayeta* and mentions raveled yarns but makes no mention of any source for the "bright scarlet." Charles Amsden, citing U. S. Hollister as his authority, casually recognized cochineal as "the usual colorant of bayeta." For his part, Hollister gives no clues to his source. George Pepper mentions *bayeta* as a source of "a rich lasting red" but refrains from specifying the dyestuff. And H. P. Mera's commentary on Navajo "ravelings" from *bayeta* mentions cochineal in passing only as a pre-aniline dye.[15]

The first analytical confirmation of cochineal in southwestern textiles occurred in the 1970s when industrial chemist Max Saltzman consulted with the Museum of International Folk Art on a pioneering study of nineteenth-century New Mexican Hispanic Rio Grande blankets and *colchas* (embroidered bed coverings). Working with museum textile curator Nora Fisher, he tested fifty-five samples using spectrophotometric analysis in the ultraviolet and visible spectra. In their summary, the pair report that "all of these samples of

cochineal-dyed yarn are commercially prepared 3- and 4-ply yarn." In the same volume, Dorothy Boyd Bowen and Trish Spillman note that "cochineal appears mainly in imported commercially dyed factory-spun yarn" (figures 18.6–18.7). Along with the confirmation of cochineal in raveled yarns came the surprise that lac (*Laccifer lacca*), an insect dye from southern Asia, was sometimes present instead of (figure 18.8), or in combination with, cochineal.[16]

Meanwhile, by 1972 Joe Ben Wheat had embarked on his groundbreaking long-term study of more than thirteen hundred Native American and Spanish American textiles from public collections. This work led to his collaboration with a Museum of International Folk Art team on Hispanic textiles and his contribution of several chapters to *Spanish Textile Traditions of New Mexico and Colorado*. In the book, as exceptions to their findings of cochineal in commercially dyed and spun yarns, Bowen and Spillman presented two blankets with single-ply wool wefts described as hand-spun wool and tested by Saltzman as 100 percent cochineal-dyed. Wheat analyzed the first in 1973, identifying the red crimson yarn as "handspun wool" but qualifying the description with a footnote: "Some of this in the diamonds resembles raveled." In the same textile, the presence of a single-ply pink yarn presumed to contain cochineal (not tested) substantiates the presence of raveled materials and puts the hand-spun designation in question.[17] The second blanket contains "bundled strips of cochineal[-dyed wool] and cochineal[-dyed wool] 'fuzz' spun with white weft," attesting again to the presence of raveled materials (figure 18.9).[18]

In 1981, following Saltzman's successful use of spectrophotometric tests, David Wenger, a medical researcher with expertise in textile analysis, began working with Wheat to test well-documented Pueblo, Navajo, and Hispanic blankets. This work led to the characterization of three-ply saxony yarns as 100 percent cochineal-dyed (figure 18.10) and to the identification of cochineal and lac used in specific proportions in raveled yarns (figure 18.11).[19] Cultivated for its dye properties on certain oak and other trees in India and the Near East, and introduced to England in 1796, lac was reported by Bancroft in 1814 to be more lightfast and cheaper than cochineal. These qualities, plus its duller hue, prompted the combining of lac with cochineal on commercial European yarns. According to research by biologist Harold Colton, lac insects also grow in the American Southwest, on creosote bushes, but they reportedly have no usable dye properties.[20]

Ultimately, Wenger tested around 350 samples from more than three hundred textiles. The brief histories, descriptions,

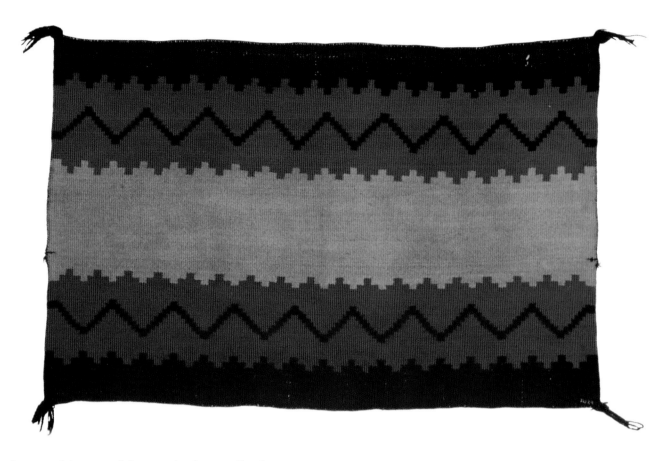

analyses, and images of these and other textiles from more than forty public collections are available online at the Joe Ben Wheat Southwest Textile Database.[21]

Kermes (*Kermes vermilio*), an insect from the Mediterranean region of southern Europe and Turkey, represents a third historically and technologically significant source of insect-based red dye. Containing about one-tenth (1 to 2 percent) of the coloring matter per volume of dried insect of cochineal (10 to 20 percent), kermes red is sometimes compared in hue to the mineral-based vermilion red pigment.[22] According to Ana Roquero, the insect was well-known to the Spanish textile industry, with kermes-dyed wool fabrics exported to Mexico from Spain at least during the mid-sixteenth century.[23] This led some researchers to question whether kermes-dyed yarns might have appeared in the Southwest.

Above **FIGURE 18.11** Navajo twill-woven manta, Navajo Nation, Arizona or New Mexico, ca. 1870–1875. Red raveled wool weft yarn (S-spun, paired) dyed with cochineal (54–55 percent) and lac (45–46 percent). Coral pink raveled wool weft yarn (Z-spun, singles) dyed with synthetic, 31 x 47 in. Arizona State Museum, E-2859; Joe Ben Wheat Southwest Textile Database ID 94. Photo: Arizona State Museum, University of Arizona.

■ *Opposite* **FIGURE 18.12** Navajo sarape, Navajo Nation, Arizona or New Mexico, late Classic period, ca. 1865–1875. Red raveled wool weft yarn (two shades/types, both Z-spun) dyed with 100 percent cochineal. Red mill-spun wool weft yarn (three shades/types, all 3zS) likely dyed with 100 percent cochineal, 73 x 52 in. Museum of Indian Arts and Culture, Laboratory of Anthropology, 9108/12.

But standard spectrophotometric analysis cannot distinguish between cochineal and kermes; the two diverge chemically on the basis of one glucose (sugar) molecule. If kermes was present in any of the raveled southwestern reds, it would not be revealed through spectrophotometry. In 2006 Kathleen Duffy sought and developed more sensitive measures by changing dye extraction methods and using high-performance liquid chromatography (HPLC) in addition to spectrophotometry. Duffy successfully analyzed samples from the Arizona State Museum textile collection to show that kermes was not present and can likely be excluded from the southwestern record.[24]

Other efforts to identify insect dyes in southwestern textiles have produced corroborating results.[25] Thus, based on present knowledge and lacking contradictory data, it appears that red wool materials found in southwestern textiles that were dyed with cochineal, with or without lac, were obtained from already spun yarns colored with sources from outside the American Southwest.

UNRAVELING RED CLOTH

As early as 1787, historical documents show the Spanish government placing orders for *vaieta de grana*, or cochineal-dyed *bayeta* cloth, to reward certain Navajo Indians "because of good conduct." Wheat's studies of historical documents found numerous names and descriptions of the specific types of

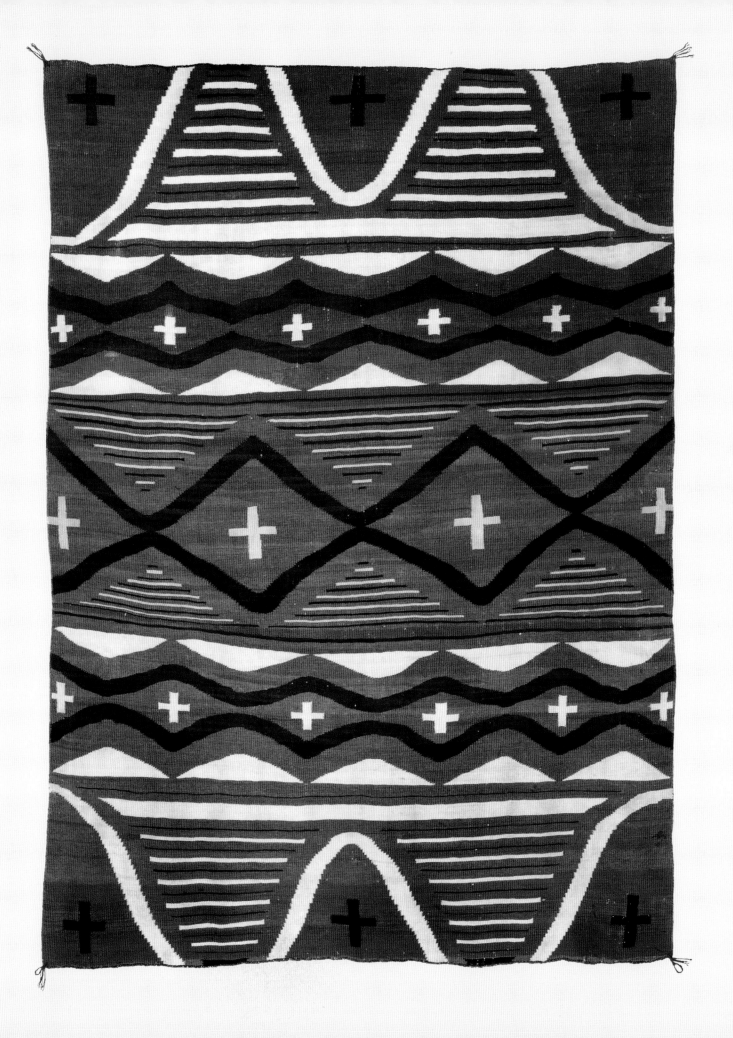

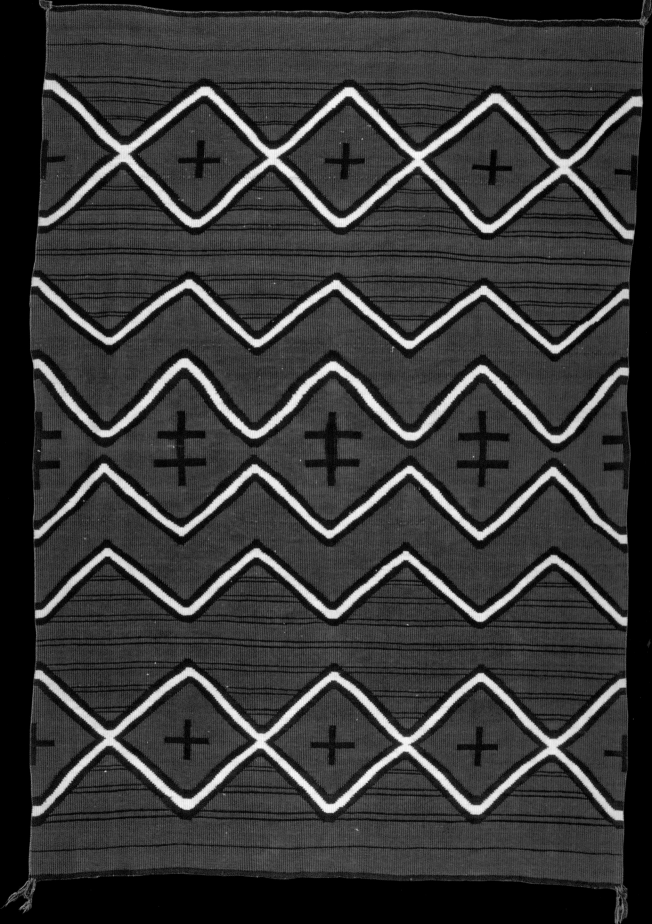

fabric that may have been unraveled. Defining the cloth contextually rather than by its particular physical properties, he concluded, "The term bayeta should be used for any cloth that was raveled to provide colored threads" in Native American and Spanish American weaving.[26]

Unraveling cloth to obtain usable threads for other projects is not unique to the Southwest.[27] (See Osborn on African unraveling, this volume.) However, Pueblo, Navajo, and Spanish American weavers achieved remarkable feats of recycling—unraveling yarns from whole bayeta cloth and reweaving them into their own handwoven fabrics. Studies of raveled yarns in extant Native American and Spanish American blankets and garments have revealed suites of characteristics that shift nearly decade by decade through the nineteenth century. The variations reflect the ever-changing nature of the trade cloths themselves and were likely due to different trade sources, evolving industrial practices, and other historical and technological factors.

From empirical evidence, extant yarns unraveled from bayeta and rewoven into handmade southwestern textiles can be characterized by direction of spin (S or Z); relative quality (fine, medium, or coarse) and size; and use as singles or multiples (from pairs to as many as ten). Other factors include the worsted (straight, smooth) or woolen (fuzzy, spiraling) quality of spinning; dyes (cochineal, lac, a combination, or synthetics) and their penetration (solid or speckled); color saturation (deep or light); and tones (crimson, scarlet, pinks, and purples).[28]

How was the recycling of yarns and fibers actually accomplished? Although records have not revealed the specifics of how southwestern weavers unraveled bayeta fabrics, some probable techniques can be reconstructed through analysis of extant historic fabrics, logical speculation, and experimentation with new materials. For the recarding of fibers into multicolor specialty yarns, such as pinks and heathered grays, twentieth-century documentation of practices among southwestern weavers shows the way (see figure 18.9).

Unraveling fuzzy wool yarns from whole cloth is a sticky process, particularly where the cloth's surface has been brushed, fulled, or felted to any degree. Unraveling even a smooth cotton cloth to produce fringe along a hem attests to the ways in which warp and weft yarns bind together to thwart the unraveler. British textile writer Jessica Hemmings uses the term unpicked to describe the unweaving of cloth.[29] Given that each pass of weft through a loom's warps is called a pick in weaverly jargon, this term for undoing the fabric is apt.

Cutting cloth into strips represents the most efficient, and least wasteful, approach to obtaining raveled yarns for weaving, and surplus wool fibers for carding, newly hand-spun yarns. It is logical that southwestern weavers unraveled imported bayeta cloth by cutting it into narrow strips and pulling the short ends from the fabric. This would automatically result in a hank of parallel threads that were relatively easy to handle as a weft bundle. The long raveled strands were used singly if their weight matched that of the weaver's hand-spun wool yarns. Alternately, from two to as many as ten strands were incorporated into the weaving as a loose bundle of yarns. The short leftover strands removed from the cloth strip could be carded together with locally sourced white wool (or that of sheep of other colors) to produce a blended pink. They could also have been recarded and respun into solid red yarns.

Evidence is clear for Navajos cutting narrow pieces of imported fabric to create intact cloth strips for weaving, much like those used in rag rugs. This was also done by Spanish American weavers (see figure 18.9). H. P. Mera devotes a chapter to the subject of "cloth-strip blankets of the Navajo." Showing the original fabrics' over-under structure of plain weave, or the diagonal texture of twill weave, these strips appear prominently in a number of handwoven Navajo blankets. Sometimes the edges of the cloth frayed, resulting in a chenille-like quality, which Wheat alternately called heavy terry cloth, Turkish towel, or tufted. Both Mera and Wheat discussed this technique as a relatively late phenomenon, restricted to the 1870s and 1880s, though neither author extrapolated the original way in which most, if not all, raveled yarns likely were obtained. Wheat verged on this notion when he analyzed one saddle blanket "in which [the] principal material consists of strips of raveled flannel with most [but not all] of the cross threads removed."[30]

The prodigious efforts of Native American and Spanish American weavers to obtain red from foreign sources represent a fascinating story. Clearly, imported bayeta cloth provided a ready material for southwestern ingenuity. Today, cochineal-dyed yarns in historic southwestern textiles serve as critical diagnostics for dating undocumented textiles and identifying their cultural contexts (figures 18.12–18.13). Beyond technological feats, these labors emphasize the aesthetic appeal of red and the artistic intent of many nineteenth-century weavers. 🌸

■ *Opposite* FIGURE 18.13 Navajo sarape with small poncho neck slit, Navajo Nation, Arizona or New Mexico, mid-Classic period, ca. 1865. Red raveled wool weft yarn (one–two S-spun strands) dyed with 100 percent cochineal, 72 x 48 in.; slit length 4⅞ in. Courtesy of The Owings Gallery, Santa Fe, New Mexico.

WRAPPED IN STROUDING

Trade Cloth and the American Indians of the Plains

MARSHA C. BOL

PLAINS INDIANS ARE RENOWNED FOR their tanned hide clothing decorated with fringe, paint, feathers, and beads. When nonnative fur traders entered the Great Lakes and Plains region of mid-America beginning in the eighteenth century, they brought a type of natural-dyed wool, termed stroud cloth or strouding, to trade with native peoples. Indians residing along the Great Lakes traded beaver pelts and furs for stroud cloth, while Plains Indians took it in exchange for buffalo robes. Native women who made their family's clothing quickly recognized the benefits of this ready-made cloth. Constructing clothing from a length of strouding took much less effort than scraping and stretching a deer, antelope, elk, or buffalo hide and then tanning it using a preparation made from the animal's brains.

The Lakota people, along with other Plains tribes, disliked trapping, favoring hunting buffalo and other game on horseback instead. Beginning in 1830 with the development of steamboat transportation on the Missouri River, trading for tanned buffalo robes became more important than trading for beaver pelts. It was more convenient and quite profitable to ship the heavy robes to trading ports downriver and then to ship large amounts of trade goods back up.[1] In 1832 American painter George Catlin observed, during a journey up the Missouri River, "This Fort [Pierre] is undoubtedly one of the most important and productive of the American Fur Company's posts, being in the center of the great Sioux country, drawing from all quarters an immense and almost incredible number of buffalo robes, which are carried to the New York and other Eastern markets, and sold at a great profit."[2] The Lakotas prospered from the riverboat trading economy as traders traveled to their villages with goods, including stroud blankets and cloth, needles, and awls.

Stroud cloth held particular attraction for native peoples primarily for its vibrant red and deep blue hues, which were not available to native artists in their natural surroundings. The cloth was produced in the town of Stroud in Gloucestershire, England, and shipped to North America particularly for trade with native peoples. Cochineal dye was used to produce the intense, durable red color of this plain-weave woolen cloth. Also known as broadcloth, it was fulled and carded to shrink and thicken the fabric, which was produced in varying grades or qualities.[3] This cloth, in a fine grade, was used for the famous redcoat uniform of the British king's army (see page 162).

Stroud cloth was dyed by the piece rather than dyed as yarn. Its selvages, or finished edges called lists, were bound on tenterhooks for stretching and dyeing. When the selvage binding was removed, it left an undyed white edging known as a saved list. Saved lists were quite popular with native peoples, who used them as design elements in finished garments and blankets.[4]

Fur trade with the Lakotas effectively ended in 1869 when the U.S. government ratified a treaty with various Sioux tribal divisions, thereby creating the Great Sioux Reservation. In his address to the assembled Sioux crowd, U.S. general John B. Sanborn stated, "By this treaty you will agree to remain at peace with the whites. By this treaty we shall agree to protect you from the inroads of our people and keep them out of a portion of your present country described in the treaty. We shall agree to furnish you supplies in clothing and other useful articles."[5] Known as annuity goods, these supplies, including stroud cloth and blankets, were to be issued regularly to the tribes.

■ *Opposite, left* **FIGURE 19.1** Headdress with trailer, Lakota, South Dakota, late nineteenth century. Tanned hide, eagle feathers, owl feathers, horns, glass beads, fur, wood, cotton, horsehair, silk, 62½ x 18 x 10 in. Museum of International Folk Art, gift of Florence Dibell Bartlett, A.1995.1.899 AW.

■ *Opposite, right* **FIGURE 19.2** Headdress, Cheyenne (?), Wyoming, late nineteenth century. Tanned hide, eagle feathers, horsehair, fur, glass beads, wool, 39 x 19 x 28 in. Museum of International Folk Art, gift of Florence Dibell Bartlett, A.1995.1.187 AW.

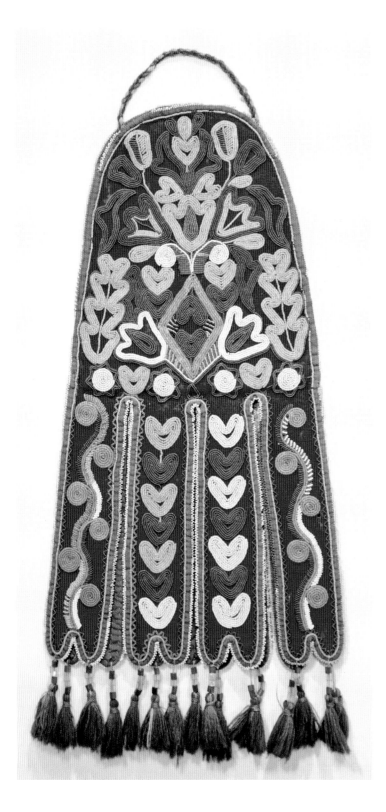

■ FIGURE 19.3 Octopus bag, Tahltan tribe, Northwest Coast, United States, ca. 1860–1870. Wool, cloth, beads, 21¹⁷⁄₆₄ x 9²⁷⁄₃₂ in. Photo: Ron Spencer, courtesy Ralph T. Coe Foundation for the Arts.

In 1882, when the Lakotas hunted their last buffalo, and with game scarce as well, cloth replaced animal hides for making clothing, tepees, and various other items. Woolen stroud cloth was favored as it had some of the same qualities as tanned hides: it was semiwaterproof and could be decorated with beads and feathers.

A CULTURE OF RED

It is not surprising that red stroud cloth held particular appeal for Plains people when it became available. Culturally, the color red was already used to indicate status within the tribe. Wearing red stroud cloth called out those who could afford to trade for it due to their success in hunting buffalo and other game. Any family member clothed in red strouding was a walking advertisement for the prowess of the hunter in the family.[6]

Plains peoples had long been using local substances to create red paint. Women collected a natural earthen-yellow ocher that, when baked, turned red. After drying, balls of this red earth were pounded into powder, ready to be mixed with buffalo fat for painting the face and body. When mixed with hot water or sizing, the powder was converted into paint for use on hide robes, shields, men's shirts, and other objects.[7] In the second half of the nineteenth century, Chinese vermilion became a welcomed trade item in exchange for hides. As Ella Deloria, Dakota anthropologist, noted in her fieldwork in the 1930s, "In olden times, to dress up was called to make red, because the major part of dressing up was applying red face paint. Today . . . to make oneself red, or to make her red, means to dress up fancily."[8]

In Lakota oral literature, red is referred to repeatedly as a sacred color, far outweighing references to other colors. For example, red body paint was used in connection with the Sun Dance. As James R. Walker, the physician at Pine Ridge Reservation in South Dakota from 1896 to 1914, recorded about the Sun Dance: "He should then instruct the Candidate that the sacred color red upon the hands sanctifies them so that they may handle sacred things; that while he is a Candidate his hands should be painted red; and if he dances the Sun Dance to completion he will be entitled to paint his hands red at any time during the remainder of his life."[9]

For Lakota peoples, red was for the most part associated with the sun and with blood, both menstrual and from battle wounds. The color found particular expression in quillwork and body paint. Red body paint served as protection and also enhanced one's spiritual and physical capabilities.

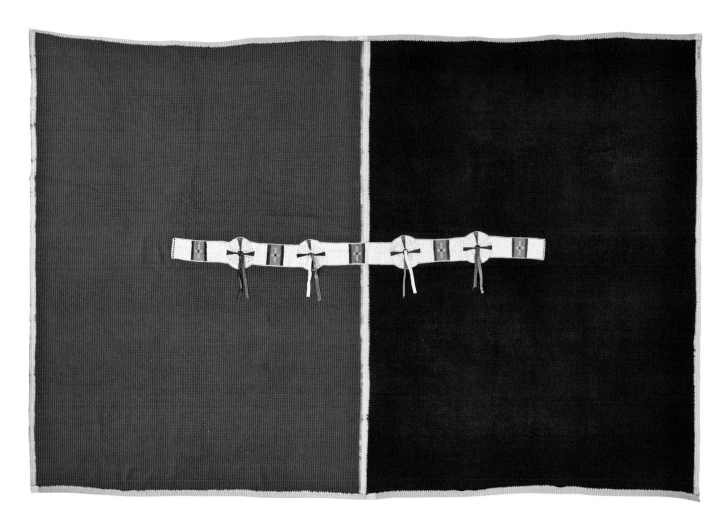

Red stroud cloth found its way onto nearly every object imaginable. Eagle feather headdresses with long feather trailers were secured by a strip of red strouding (figures 19.1–19.2). Men's leggings, breechcloths, bags, and fancy horse gear were fashioned with red strouding as the background (figure 19.3). Ever smaller pieces of the precious cloth were used to bind feathers to headdresses, protect the necks of fine women's dresses, and add splashes of brilliant color to men's bow cases.

Young Lakota men prized special stroud cloth blankets, which they used when courting women (figure 19.4). Made for a young man by his elder sister, this blanket enhanced his ability to attract and capture a woman's interest. The suitor wrapped the couple together in the large blanket so that they might hold a private conversation, concealed from the prying eyes of the community (figure 19.5). While most courting blankets were made from blue strouding with a beaded blanket strip as decoration, a few distinctive blankets were composed of both blue and red stroud cloth.

In many Lakota homes today, revered objects fashioned from strouding are still stored in trunks, where their brilliant hues are preserved, and are brought out to wear on special occasions. Culturally and historically, they serve as a connective thread to those who came before. 🔸

■ *Top* **FIGURE 19.4** Courting blanket, Lakota, no date. Wool, beadwork, ribbon, skin, 73½ x 108½ in. Denver Art Museum, Native arts acquisition funds, 1947.143. Photo courtesy Denver Art Museum.

■ *Bottom* **FIGURE 19.5** Untitled (Courting Scene), Wohaw (Wo-Haw, Beef, Wolf Robe, Gu hau de), Kiowa (Gaigwa), Fort Marion, Florida, ca. 1877. Paper, pencil, colored pencil, 8¼ x 11¼ in. Missouri History Museum, St. Louis, 1880.13.41.

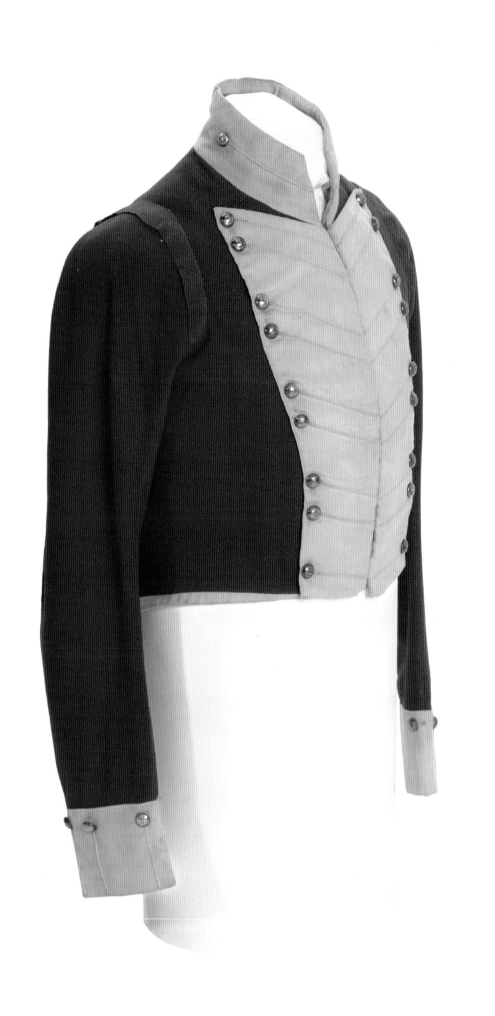

■ Coatee of General Sir William Napier
Great Britain, early nineteenth century
Wool with cotton lining, metal buttons and fasteners
28¹⁵⁄₁₆ x 15³⁵⁄₆₄ in.
National Army Museum, London, 1963-09-322-1

The iconic British military red coats were made of local red woolen
stroud cloth, produced in the town of Stroud in Gloucestershire,
England. The cloth was exported to the American colonies along the
Eastern Seaboard. Beginning in the eighteenth century, it was especially
prized by Plains Indians as well as by Navajo and other southwestern
tribes. In a clear example of cochineal's social and economic
significance at all levels of society, high-ranking officers in the British
army had their coats made from stroud cloth dyed with cochineal.
The uniforms of enlisted men, on the other hand, were dyed red with
madder, a cheaper, duller insect dye.

■ Needlework picture of an Indian princess
Boston, ca. 1750
Wool and silk on linen
10¾ x 13¾ in.
Metropolitan Museum of Art, gift of Mrs. Screven Lorillard, 1953
(53.179.13)
© The Metropolitan Museum of Art. Image source: Art Resource, NY

Cochineal use in the British colonies has not been widely studied, but
we know that Philadelphia paint seller Samuel Wetherill sold the dye in
his shop.[a] This needlework picture from Massachusetts is one of a few
tested examples from the British colonies along the Eastern Seaboard in
which cochineal was found, in this case, in a thread from the princess's
pink dress.[b]

A PRIZED PIGMENT

Cochineal in European Art

THE COLOR OF POWER

Red in the Portraiture of the Spanish and British Empires

MICHAEL A. BROWN

ONE OF THE REMARKABLE shared traits in painted portraiture throughout the early modern Atlantic world is the predominance of the color red in garments worn by portrait subjects and in the drapery that typically frames such compositions. Many other colors appear repeatedly in portraits: black depicts the clothing of widows as well as Spanish subjects during periods when sumptuary laws forbade the wearing of bright colors, while white represents clothing worn by members of various Catholic religious orders. But throughout history, variants of red, from purple to burgundy to scarlet, are inextricably linked to royal identity.

In the early modern period (1525–1800) global trade, market economies (especially in the Netherlands), and the vast imperial reach of Spain and Britain provided access to American cochineal and transformed its brilliant dye into liquid gold. As a wealthy mercantile class emerged, red became its color of choice. Famously, it was also the choice of the British military, fraught with imperial and Christological symbolism.

Just as the wearing of red was variously dictated by legislated proscription, royal privilege, or military protocol, its prominence, as well as its frequent association with cochineal, in the painted portraiture of early modern Spain, its North and South American colonies, and the fledgling United States and Canada, was a consciously chosen indicator of power and social status. As such, from the sixteenth to the nineteenth century in the Atlantic world, red never went out of fashion.

THE ROYAL RED

Like the kings, queens, cardinals, military commanders, presidents, and princes who wore—and wear—it, the color red is bound to the history of empire and the economies of global trade networks. While the discovery and export of cochineal were among the most economically significant consequences

of the sixteenth-century Spanish conquest of Mexico, red has been linked to royalty since ancient and biblical times. From the purple cloaks worn in the mosaic portraits of Emperor Justinian and Empress Theodora in San Vitale, Ravenna, to the burgundy silk velvet saddle and sash in Titian's *Charles V on Horseback*, various shades of red have served to signify royalty for centuries.

Red also reached beyond the royalty of empire to depict both Christian and indigenous nobility, establishing Christological and royal connotations of the color that would inform its use in portraiture of the early modern period. In examples throughout the history of art, red is the color of the robe used by Roman soldiers to cloak Jesus as "king of the Jews," as memorably seen in El Greco's monumental painting *Disrobing of Christ*. In the painting, now in situ in the Cathedral of Toledo sacristy (where the clergy dress), El Greco's red dominates; it takes on greater significance in proximity to portraits of bishops in red vestments hanging nearby and the actual red vestments kept in the room. In this context, red is understood to signify not only royalty and sanctity but also sacrifice.

It must not have been coincidental that facing his execution, the Inca king Túpac Amaru consciously chose to dress in a crimson doublet and mantle dyed in American cochineal, imported from Spain according to royal legislation.[1] Amaru also wore the royal Inca *mascaypacha* (headdress), with a red tassel signifying his imperial status, which can be seen in numerous postconquest portraits of Inca rulers. The choice of red not only linked Amaru to the martyrdom of Christ the king, it referred clearly to Amaru's royal Inca genealogy. The

Opposite **FIGURE 20.1** Diego Velázquez, *King Philip IV of Spain* (also known as *Philip IV at Fraga*), Spain, 1644. Oil on canvas, 52⅜ x 38½ in. The Frick Collection, New York, 1911.1.123. © The Frick Collection.

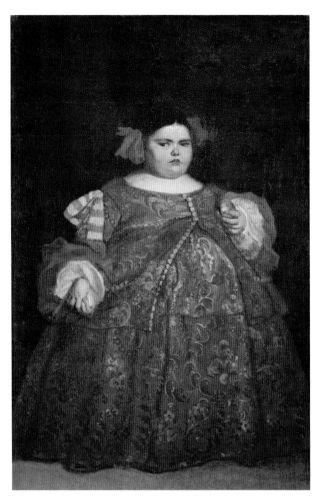

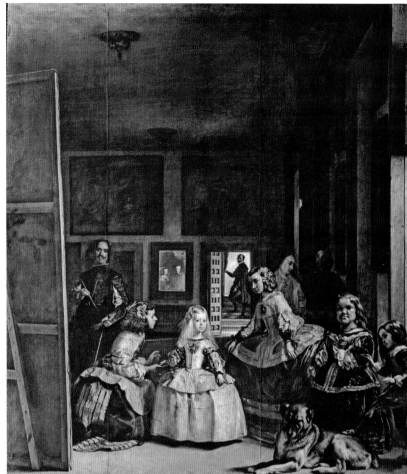

shared and disparate connotations of the color red would thus be immediately understood by both Spanish and indigenous witnesses.

When cochineal—the new labor-intensive and exceedingly expensive source of superior red dye—was identified, only the world's wealthiest patrons could afford it. Red thus figures prominently in the portraiture of the Spanish court, in images such as Juan Pantoja de la Cruz's *Infanta Isabella Clara Eugenia* and Diego Velázquez's *Philip IV at Fraga* (figure 20.1). The latter portrait captures the king in his role as military commander, complete with sword and field general's baton, dressed in sumptuous salmon and silver. The king's costume is especially noteworthy as it would not have complied with Spain's stringent sumptuary laws, authored by Philip himself, which took effect on March 1, 1623, appropriately the first day of Lent,[2] a time when Catholics are encouraged to abstain from material pleasures. Such legislation was periodically suspended when deemed necessary by the king, as during the visit to Madrid of Prince Charles of Wales (later Charles I of England), who, judging from the sizable corpus of his portraits, was another keen proponent of red attire.[3] In general, however, sumptuary laws applied to the king, which makes the Fraga portrait all the more meaningful.

In the portrait, commissioned on the occasion of Philip's victory over Catalan rebels in Lérida on the Aragon–Catalonia border, the crimson *sobreveste* (a sleeveless surcoat usually worn over armor) over the golden yellow jerkin not only emphasizes Philip's allegorical position as a victorious and "most handsome Mars" but presents him in the colors of the kingdom of Aragon.[4] In the outfit, the king fully became the nation he ruled. The clothing was unusual enough to be richly described by court chronicler José Pellicer y Tovar upon Philip's visit to his troops. Pellicer records that when Philip's loyal Catalan exiles in Madrid borrowed the portrait to celebrate the victory in Lérida, the painting was displayed in their Benedictine Church of San Martín beneath a canopy of gold—by which he almost certainly means a red textile with gold brocade, a tradition known as the "cloth of honor." In this extraordinary presentation, the portrait became a living surrogate of the king, dressed in the colors of his Aragonese and

Above, left **FIGURE 20.2** Juan Carreño de Miranda, *Eugenia Martínez Vallejo*, Spain, ca. 1680. Oil on canvas, 65 x 42⅛ in. Museo Nacional del Prado, P646. Photo: Erich Lessing/Art Resource, NY.

Above, right **FIGURE 20.3** Diego Velázquez, *Las Meninas*, Spain, ca. 1659. Oil on canvas, 126⅜ x 110⅝ in. Museo Nacional del Prado, P01174. Photo: Album/Art Resource, NY.

Catalan subjects.[5] Such lavish displays of portraits of kings and viceroys under crimson textile baldachins, or canopies, were found throughout New Spain.[6] But perhaps in no other royal portrait does a single color take on such profound significance as does the red in *Philip IV at Fraga.*

In the court of Philip IV, royal reds extended to portraits of court dwarves and jesters. Brilliant examples include Velázquez's *Don Sebastián de Morra* and Juan Carreño de Miranda's famed *Eugenia Martínez Vallejo* (figure 20.2), whose red dress was a gift from the king.[7] These court portraits simultaneously celebrate the sacred wonders of human abnormality and poke fun at the monarchs themselves, with the sitters serving as comic foils for the royals. This is surely the reason that in Velázquez's *Las Meninas* (figure 20.3), little Nicolas Pertusato, one of the companion-foils of the royal children, is dressed in crimson and lace.

A brief consideration of red's role in this Velázquez masterpiece brings up several points related to the broader exploration of American cochineal. First, Velázquez's deployment of red in this work is deliberately spare yet is concentrated for maximum visual and symbolic impact. The passages of red stand out amid the painting's muted, naturalistic palette, serving both as an iconographic parallel and a compositional counterpoint to his careful disposition of American objects in silver and earthenware. Red brushstrokes suggest the ribbons and bows worn by the Infanta Margarita, her ladies in waiting, and the clothing of Nicolas, who playfully rouses the mastiff. But the most significant passages in this color are seen in the traditional red cross of the Order of Santiago that adorns Velázquez's breast and in the mirror reflection of the king and queen, who are framed by a swath of shimmering red drapery. This textile, like that being drawn aside by the queen's *aposentador* (chamberlain), José Nieto, in the background, is known in estate inventories as a *cortina de puerta*, a door curtain. Such deep red curtains were made of either lightweight wool or *tafetan* (silk taffeta), both dyed crimson using American cochineal,[8] the dyes alternately referred to as *grana* and *carmesí.*

Whether or not Velázquez intended to reference Spain's vast, cochineal-fueled empire, cochineal-dyed draperies, along with the other American objects in the painting, were a fact of court life.[9] Based on documentary evidence and technical analysis, *Las Meninas* can be securely dated to the months following Velázquez's election to the Order of Santiago, which took place on November 29, 1659.[10] This is significant because the placement and justifiable prominence of the cross of the Order of Santiago, which was traditionally red, was not added as an afterthought either by Velázquez, or by King Philip, as in

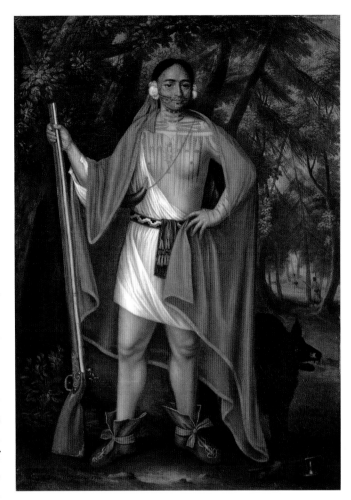

popular legend. Just as the red *cortina* reflected in the mirror highlights the king and queen's royal status and the scope of the Spanish Empire, the red cross of Santiago at once records Velázquez's elevation to the order and emphasizes the nobility of the art of painting itself.

In the American realms of Britain, as in those of Spain, use of the color red is consistent in meaning: royal, noble, holy, wealthy, virtuous. In 1710 Queen Anne of England commissioned the Dutch painter Johannes Verelst to portray the visit of four Iroquois visitors to her London court. These "kings" of North America's First Nations are shown wearing red cloaks to signify their assumed royalty to a European audience (figure 20.4).[11] Such royal connotations also encompass portraits of viceroys of New Spain, such as *Don Matías de Gálvez y Gallardo* by Andrés López. The viceroy's contemporary, U.S. president George Washington, also wears the royal red in Gilbert Stuart's famed *Lansdowne Portrait* (figure 20.5), whose date coincides with the high point of cochineal's profitability in London and is roughly contemporary with Goya's

Above **FIGURE 20.4** Johannes Verelst, *Sagayenkwaraton (Baptized Brant). Named Sa Ga Yeath Qua Pieth Tow, King of the Maquas,* London, 1710. Oil on canvas, 36 x 25½ in. Library and Archives Canada, John Petre Collection, c092418.

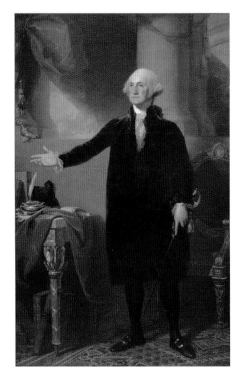

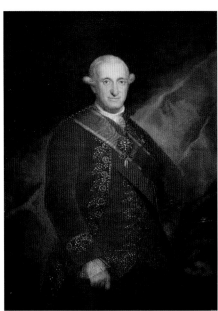

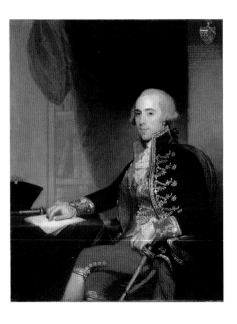

spectacular *Charles IV* (figure 20.6).[12] In this context, red transcended political boundaries to take on a universal connotation of power and prestige.

THE POWER OF THE PURSE: WEALTH AND STATUS IN THE NEW WORLD

Nonroyal uses of red also abound. In Gilbert Stuart's 1794 portrait *Josef de Jaudenes y Nebot* (figure 20.7), depicting the young Spanish diplomat in New York, the crimson was likely specified by the sitter to emphasize his self-inflated social and political status.[13] Perhaps most obviously, red is the defining hue in portraits of clerics in liturgical vestments, garments that likely would have been dyed with cochineal. In certain cases, red proliferates in remarkable fashion, as in Juan Rodríguez Juárez's masterly portrayal of Don José Pérez de Lanciego y Eguilaz, archbishop of Mexico, painted in 1714 (figure 20.8). Don José's striking red garment dominates the composition, connecting the prelate and his companion, who is likely his nephew, as though it were a textile bloodline.

As was the fashion in most parts of Europe, crimson, rose, pink, and scarlet also became the eighteenth-century colors of choice for many fashionably dressed Spanish females in North and South America. The Mexican *Portrait of a Young Woman with a Harpsichord* exudes youthful beauty and studied elegance. (See Anderson, this volume.) The girl's wealth is suggested by her lavish red gown, while her high degree of learning and sophistication is clearly indicated by the sheet music at the instrument, which she points to with a decorous gesture. Ladies in Lima also liked red; it dominates Pedro José Díaz's life-size composition *Doña María Rosa de Rivera, Countess of Vega del Ren* (figure 20.9), in which the subject is shown wearing a spectacular Chinese-inspired dress.[14] A portrait of Doña María's close friend, *Doña Rosa María Salazar y Gabiño, Countess of Monteblanco and Montemar*, likely also painted by Díaz, shows the sitter in a rich rose-colored dress adorned with dazzling ribbons and timepieces. Combined with such impressive displays of jewelry, women's red-and-pink costume was a universal signifier of wealth. In fact, women's outfits and adornment in New World portraiture are often more elaborate than those of their European counterparts because these women were wealthier than the nobility in their mother countries. Furthermore, as the lavish *Portrait of Don Fernando de Musitu Zalvide* by Juan de Sáenz (figure 20.10) proves, red and pink were not limited to Latin American females, but worn by all the fashionable elite as expressions of wealth and style.

A BRILLIANT RED SURPRISE

The stylistic evolution of painted portraiture differed in important ways between Spain and England and their American colonies.[15] However, along with some shared compositional conventions, the common predominance of red, both in attire and accoutrements, and in the frequent depiction of cochineal-dyed textiles, functioned to legitimize social status, political authority, ancestry, and cultural identity.

Taking red's significance one step further, consider the portrait of the Countess de la Vega del Ren (see figure 20.9) alongside the later portrait of George Washington by Gilbert Stuart (see figure 20.5). Both compositions hold in common another brilliant red surprise: the cochineal used to dye the European textiles in the portraits must have crossed the Atlantic at least twice, eastward first as raw material to make dye in the Netherlands or England, then westbound as finished textiles for an American market. Thus, commercially and artistically, red served as a bridge connecting the vast and varied realms of the Atlantic world. And after the full exploitation of American cochineal, red's visual and iconographic power was harnessed for a rich abundance of meanings, functioning as no other color before or since.

Opposite, left, top **FIGURE 20.5** Gilbert Stuart, *George Washington (Lansdowne Portrait)*, Germantown, Pennsylvania, 1796. Oil on canvas, 97½ x 62½ in. National Portrait Gallery, Smithsonian Institution; acquired as a gift to the nation through the generosity of the Donald W. Reynolds Foundation, NPG.2001.13. Photo: National Portrait Gallery, Smithsonian Institution/Art Resource, NY.

Opposite, left, center **FIGURE 20.6** Francisco de Goya, *Charles IV*, Spain, 1789. Oil on canvas, 50 x 37 in. Museo Nacional del Prado, P7107. Photo: Album/Art Resource, NY.

Opposite, left, bottom **FIGURE 20.7** Gilbert Stuart, *Josef de Jaudenes y Nebot*, New York City, 1794. Oil on canvas, 50¾ x 39¾ in. Metropolitan Museum of Art, Rogers Fund, 1907 (07.75). © The Metropolitan Museum of Art. Image source: Art Resource, NY.

Opposite, right **FIGURE 20.8** Juan Rodríguez Juárez, *Portrait of Don José Pérez de Lanciego y Eguilaz*, Mexico, 1714. Oil on canvas, 86 x 53½ in. Denver Art Museum, gift of Frederick and Jan Mayer, 2013.350. Photo courtesy Denver Art Museum.

FIGURES 20.9 AND 20.10 *following spread*

La Sra Dª María Rosa de Rivera Mendosa y Ramos Galbán, Borja Maldonado, y Muñoz Ojeda, y
Caballero, Condesa de la Vega del Ren, Natural de esta Ciudad, muger legitima del Sr Dn Matias Vaz
quez de Acuña y Menacho, Conde de la Vega del Ren.

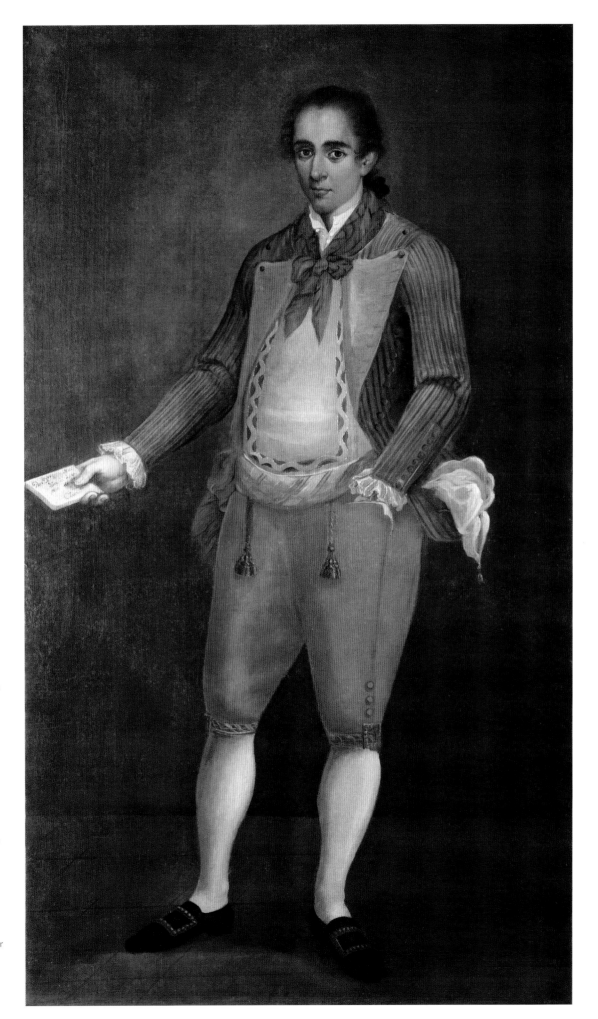

Opposite **FIGURE 20.9** Pedro José Díaz, *Doña María Rosa de Rivera, Countess of Vega del Ren*, Lima, Peru, ca. 1780. Oil on canvas, 78⅞ x 52⅜ in. Marilynn and Carl Thoma Collection. Photo courtesy Denver Art Museum.

Right **FIGURE 20.10** Juan de Sáenz, *Portrait of Fernando de Musitu Zalvide*, Mexico, 1795. Oil on canvas, 64¾ x 36¾ in. Denver Art Museum, in memory of Frederick Mayer, with funds from Lorraine and Harley Higbie, Marilynn and Carl Thoma, Patrick Pierce, Alianza de las Artes Americanas, and department acquisition funds, 2008.27. Photo courtesy Denver Art Museum.

"ONE OF THE MOST BEAUTIFUL REDS"

Cochineal in European Painting

JO KIRBY

ONE OF THE MOST NOTABLE developments in western European dyeing practice before the nineteenth century was the introduction of dyes from the Americas. Among the dyes first imported in the early decades of the sixteenth century were indigo and several varieties of dyewood, including logwood, which was new to European dyers and produced grays, lilacs, and blacks. All quickly became important items of trade.

However, of all the new dyes brought from the Americas, the most valuable and significant, both commercially and technologically, was cochineal. This scale insect found on the prickly pear cactus was already cultivated for its crimson dye in Mexico and the Peruvian Andes before the arrival of the Spanish conquistadors. Use of the dye by the local population must have been observed and its properties recognized by the Spaniards during their incursion through Mexico in 1519–21; reports dating from 1523 indicate that by that time cochineal was known in Spain, although no shipment is recorded until 1526.[1] In addition to its introduction into European dyeing practice, cochineal would significantly impact the technology of pigment making in Europe with its development as the pigment carmine, described by Henri Gautier in 1687 as "one of the most beautiful reds for use in watercolour."[2]

The recognition of the potential importance of cochineal is related to the fact that in fifteenth- and sixteenth-century Europe the cost of dyeing crimson or shades of purple was extremely high. Before American cochineal appeared in Europe, the dye was obtained from various species of scale insects, which were tiny, costly, and required in large quantity. Kermes (*Kermes vermilio* Planchon), found on the kermes oak in maritime scrubland areas around the Mediterranean, gave a crimson- or scarlet-red dye and was only used on the highest quality wool and silk. The resemblance of dried kermes insects to grain is perhaps responsible for the common medieval name for grain, the Italian *grana*.[3] An even more expensive purplish-crimson dye was obtained from members of a different family of scale insects found on the roots or underground stems of various plants in uncultivated grasslands or steppes in eastern Europe and parts of Asia. These include so-called Polish cochineal (*Porphyrophora polonica* Linnaeus) and the Armenian or Ararat insect Armenian cochineal (*Porphyrophora hamelii* Brandt). The Armenian insect is larger than the Polish but has a high fat content and a lower yield of dye in use; therefore, more is needed when dyeing.[4] Considering the properties of their dyestuffs, their geographical distribution, and what can be learned from historical documentary sources, the Polish insect can probably be identified with the *chermisi minuto* and the Armenian with the *chermisi grosso*, which are recorded in Italian fifteenth- and sixteenth-century dyeing treatises and trading records. Both were used almost exclusively for silk.

Above and opposite FIGURES 21.1A–21.1B Titian, *The Holy Family with a Shepherd,* Venice, ca. 1510. Oil on canvas, 39 x 54¾ in. The National Gallery, London, NG4. Whole painting and detail of the Virgin and Child showing glazing of folds in the Virgin's dress using kermes and madder lakes. © The National Gallery, London/Art Resource, NY.

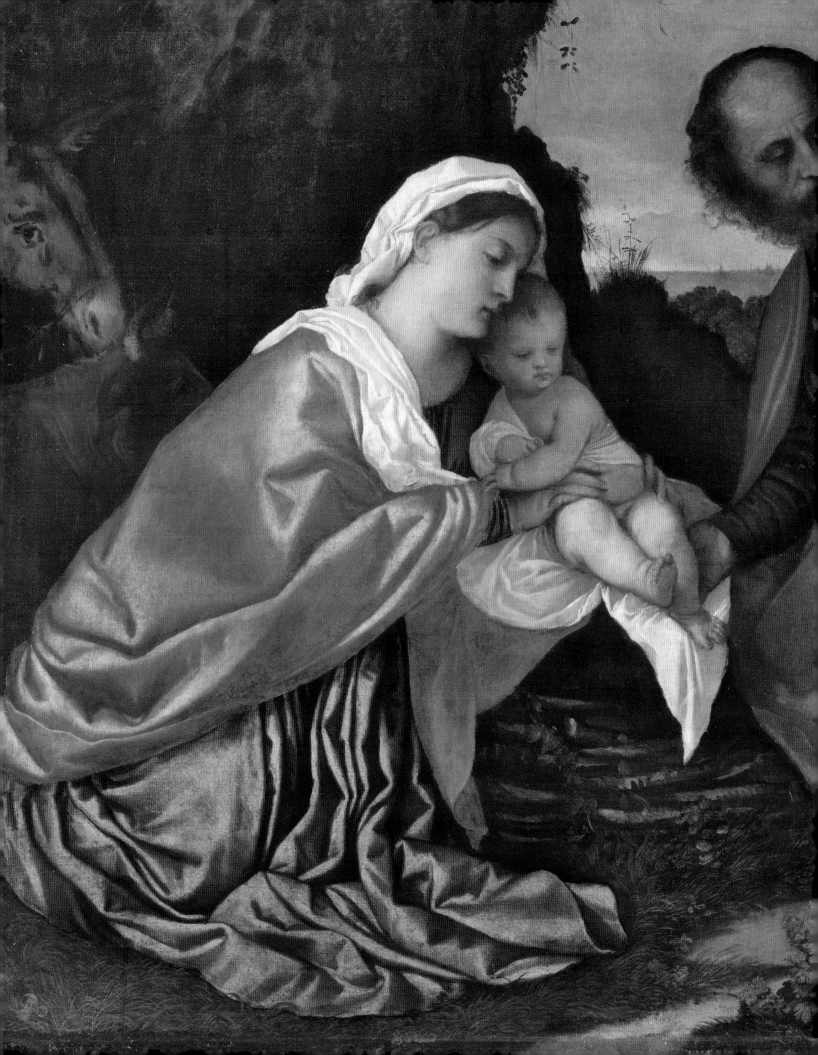

Sixteenth-century traders and silk dyers would have observed that the dye from New World cochineal is similar in color to that given by the Old World *chermisi minuto* and *grosso*. In fact, the principal colorant, carminic acid, is the same, although the New World insect, *Dactylopius coccus* Costa, is from a different insect family. The difference is that cochineal contains about eighteen to twenty-five times as much carminic acid as the *chermisi* insects,[5] and about ten times as much dye content as kermes. American cochineal was far easier to farm and harvest, and much more efficient and economical to use, than the Polish and Armenian species. Thus, once traded in Europe, cochineal was a highly prized and commercially valuable product for the Spanish economy.

By the late 1550s, when figures for trade in individual commodities become available, substantial, if fluctuating, amounts of cochineal were arriving in Seville: from an annual average of 1,792.4 arrobas[6] between 1556 and 1560 to 7,500 arrobas between 1596 and 1600, equivalent to 20,612.6 to 86,250 kilograms, respectively.[7] From Seville, cochineal was exported to other European trade centers, including Florence, Venice, Antwerp, and Rouen.[8] According to the Florentine merchant Lodovico Guicciardini, cochineal was also re-exported from Antwerp to France and several Italian cities, including Ancona, Milan, and Venice.[9]

Once Spain began to export cochineal, it was adopted remarkably rapidly across Europe. In Italy, for example, New World cochineal was in use in Florence in 1542 and was permitted for use in dyeing by the cotton and silk guild of Perugia in January 1543. It was introduced and tested in Venice in February 1543 and, after some initial questions over its quality, Venice became one of the most substantial users of the dye from the 1550s onward.[10] By 1548, in the second edition of his commentary on the works of the Greek physician Dioscorides, the Sienese physician Pietro Andrea Mattioli would observe that "they bring a new sort of *cremesino* from the west Indies by way of Spain, which, by already being used copiously in Italy, has made the price of silk fabrics of this colour far lower."[11]

SIXTEENTH-CENTURY LAKE PIGMENTS BEFORE 1550

For painters, the implications of the new dye were no less important, but one step removed. Crimson dyes were used in the preparation of translucent red pigments, seen in greatest effect in the red glazes modeling the folds and shadows of draperies in fifteenth-, sixteenth-, and seventeenth-century European paintings (figures 21.1a–21.1b). In order to be used as a pigment and mixed with the binding medium, the dye must be in solid form. To achieve this, it was precipitated onto a suitable substrate, most commonly a form of amorphous hydrated alumina. This type of pigment is known as a lake.

Evidence from pigment recipes and from the analysis of red lake pigments used in paintings suggests that, during this period, dyes from kermes and both Old and New World cochineal were extracted from dyed textile clippings or shearings, not from the insects directly.[12] This indirect method of dye extraction probably relates partly to the cost of the scale insects and is thus the most economical use of the dye. Consequently, any change in the availability of these dyes to textile dyers would be reflected in the lake pigments used by painters. Very little is known about the links between dyers, weavers, shearers, and others involved in the textile industry and pigment makers, but from the pigment maker's point of view, the method is very convenient: the laborious work of extracting and purifying the dye, leaving behind those constituents in the raw material that might affect the color, has already been done by the dyer. The same method of dye extraction was also used for madder pigments; in this case the source was shearings of dyed wool, rather than the madder root with its complex properties and range of dye constituents. Whether from kermes, cochineal, or madder, experiments have shown that the color of pigments obtained by indirect dye extraction is often cleaner and brighter than that obtained using dye extracted directly from the raw material.[13]

The materials used by sixteenth-century Venetian painters have been well studied and their use of lake pigments prepared from different dyes can be conveniently set in the context of Venetian dyeing. Venice was also a center for pigment manufacture with a reputation for the production and supply of high-quality pigments, including red lake pigments.[14] The red lake pigment dyestuffs were identified in a selection of sixteenth-century Venetian paintings (see appendix, table 21.1; many of the analyses were carried out in the Scientific Department of The National Gallery, London). The pattern of usage illustrated indicates that, through the 1540s, painters used pigments containing kermes, lac, madder, and soluble redwood (sappanwood or brazilwood) dyes. Microscopic examination of paint sample cross-sections shows that, very frequently, lakes containing kermes dyestuff were underpainted with madder lakes (see figure 21.1b). While this may have been done for reasons of economy—kermes pigments are likely to have been expensive—the painter also may have wanted the particular color effected by the vibrant, slightly orange-red madder lake.

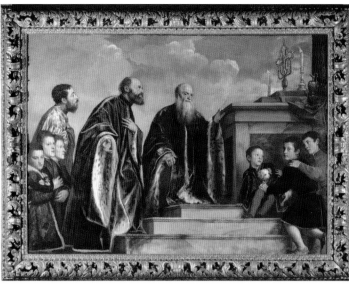

FIGURES 21.2A–21.2B Titian, *The Vendramin Family, Venerating a Relic of the True Cross,* Venice, begun ca. 1540–1543, completed ca. 1550–1560. Oil on canvas, 81⅛ x 113⅝ in. The National Gallery, London, NG4452. Whole painting and detail of Gabriel Vendramin and the young men behind him. © The National Gallery, London/Art Resource, NY.

Notably, before 1550, the presence of dyes from Old World cochineals in lake pigments is very uncommon. Indeed, there is only one example of Polish cochineal in *The Adoration of the Kings*[15] of 1475–80 from the workshop of Giovanni Bellini. The same is true in paintings from Florence and other parts of Italy: crimson lake pigments made from kermes and lac dyes are widely used, but apparently not those derived from Old World cochineals. Allowing for the fact that, during this period, the names for red lakes often give little indication of the dye present, a similar pattern is suggested by evidence from accounting records for work done or materials purchased by painters: *lacca, lacca fine, lacca di cimatura* and *lacha di grana* are names for lake pigments that occur throughout the sixteenth century, whereas *lacha cremesin* or *cremese* or *lacca fine di chermisi,* names suggesting lakes containing dye from a variety of cochineal, occur from the 1570s.[16]

In the fifteenth and sixteenth centuries, Polish and Armenian cochineal were extremely expensive dyes, used for the most costly silks. If dyed silk clippings were used for recycling these dyes, little of this material found its way into the hands of pigment makers. Perhaps any pigments prepared from these dyes were too expensive for large-scale use on an altarpiece or other easel painting, and were more widely used on the small, exquisite scale of manuscript illumination. Perhaps they were also more commonly used closer to home in eastern Europe.

THE IMPACT OF COCHINEAL

From the 1550s, or a little earlier, the picture changes: some variety of cochineal is increasingly used, as indicated during analysis by the presence of carminic acid (see appendix, table 21.1). This trend is also seen in the works of individual painters, including Titian and Tintoretto. In his first campaign in the early 1540s on the huge painting of the *The Vendramin Family, Venerating a Relic of the True Cross*[17] (figures 21.2a–21.2b), Titian used kermes lake with a little lac lake to paint the gown of the central figure in red, probably Gabriel Vendramin. When he and the workshop returned to the work in the 1550s, cochineal lake was used.[18]

Jacopo Tintoretto's links with the textile industry, and the dyeing trade in particular, are well known:[19] his father was a dyer (*tintore*), hence the painter's nickname as the son of a

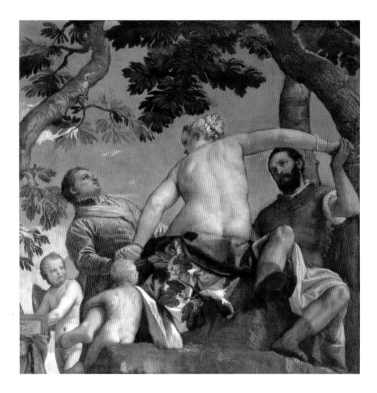

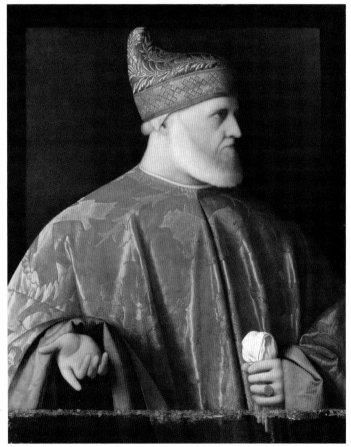

dyer (Tintoretto). While the painter used the red lake pigments available with an almost profligate exuberance, the range of pigments he used at any one time is similar to that used by other painters. From the evidence available at present, it is difficult to say if Tintoretto had preferential access to red lake pigments, as has been suggested. It is true, however, that he used them in large quantity and with a greater freedom than his contemporaries.

It is unfortunately quite difficult to distinguish between dyes extracted from New World cochineal and Armenian cochineal in pigments because the characteristic minor constituent commonly used for this purpose is rarely detectable.[20] This is partly because paint samples are small, and partly because the minor constituent may be present in a much reduced amount in the silks from which the dye is extracted. As a result, the identification of "cochineal" (see appendix, table 21.1) should, strictly speaking, refer to either Old or New World cochineal. However, it is no coincidence that carminic acid-containing lake pigments in Venetian painting only occur after the arrival of New World cochineal in Italy and its acceptance by Venetian dyers, to the point where identification of the use of such pigments becomes routine. It is probable that, as dyers' use of American cochineal increased through the 1550s, cochineal-dyed silk waste became easily available to the pigment makers, who took full advantage. It is thus likely that the cochineal pigments identified (see appendix, table 21.1) were made using dye derived from the American cochineal insect and not the Armenian or Polish insect. The explanation for the trace of carminic acid detected with the kermes lake used by Lorenzo Lotto in the *Portrait of Giovanni della Volta and his Family*,[21] completed in 1547, is not clear, but perhaps it is due to the presence of what would be the most widely used lake pigment in years to come: American cochineal.

Cochineal gives a slightly bluer crimson pigment than kermes, as seen in the bluish-pink jacket of the man in Paolo Veronese's *Unfaithfulness*[22] of about 1575 (figure 21.3). The cuffs of Doge Andrea Gritti's garment in Vincenzo Catena's portrait[23] painted between 1523 and 1531, for which a kermes lake was used, are a slightly warmer pink (figure 21.4). A cochineal lake made in the traditional way from dye extracted from silk is, in fact, quite similar in color to the long-established lac pigment prepared directly from the raw material, as was used, for example, by Giovanni Battista Cima da Conegliano in *The Incredulity of Saint Thomas*[24] (figures 21.5a–21.5b). Given the widespread availability of the bluish-crimson lac lake, painters would not particularly miss a pigment made using dye from Old World cochineal

FIGURES 21.5A–21.5B Giovanni Battista Cima da
Conegliano, *The Incredulity of Saint Thomas*, Venice,
ca. 1502–1504. Oil on synthetic panel, transferred from
poplar, 115¾ x 78½ in. The National Gallery, London,
NG816. Whole painting and detail of apostle at the right.
© The National Gallery, London/Art Resource, NY.

insects. However, the crimson of pigments made from kermes or Old World cochineal was associated with expensive crimson textiles; by painting with them, the artist was depicting conspicuous consumption and high quality. It is uncertain if lac, which was rarely used for silk dyeing in Italy, would share this association.

As the century progressed, Venetian dyers used New World cochineal for dyeing cheaper silks and wool.[25] This would result in an ever-increasing amount of dyed textile material for use by pigment makers; the use of cochineal pigments increased accordingly (see appendix, table 21.1). Pigments made from kermes and lac were still used, even in the following century, but their use declined to an ever greater extent.

A TECHNOLOGICAL INNOVATION: COCHINEAL CARMINE

Traditional cochineal lakes continued to be used into the nineteenth century, but the fact that cochineal was so rich in dye led to one of the most interesting developments in pigment technology: the coloring matter was made available in pigment form that did not require preparation of a conventional lake. This discovery is said to have been made in Pisa in the 1580s, the result of an accidental addition of acid to a medicinal preparation of cochineal extract and cream of tartar, which caused precipitation of the dyestuff.[26]

Experiments on cochineal continued in the following decades in Italy and across Europe. At some point it was discovered that if cochineal dye was extracted using water previously boiled with some astringent plant material, a little potash alum was added and the solution was left to stand, the dye eventually precipitated in usable quantities. Several of the earliest known recipes for the pigment, known as carmine in English, French and Italian, are French.[27] (See Roquero and Cardon, this volume.) According to Antonio Palomino y Velasco, writing in the third volume of *El Museo pictórico y escala óptica* (Madrid, 1715–24), the name for the pigment in Spanish was *laca di Francia*.[28] Thus the successful development of the pigment may initially have been in France.

Carmine seems to have come into use during the second half of the seventeenth century; in 1694, French apothecary Pierre Pomet described the pigment as "the most precious and magnificent commodity one obtains from cochineal Mestique."[29] It was initially used only as a watercolor; it was too expensive for use in oil and was said to darken and to dry poorly.[30] It was also an extremely strong, deep red. Painters were accustomed to the handling properties of conventional,

traditionally made cochineal lakes on alumina substrates: they knew how much oil they could take up, how their translucency combined with a high tinting strength, and how to balance this against other pigments. But the strongly colored carmine was difficult to handle; only Prussian blue, an eighteenth-century invention, and indigo were as powerful. These blue pigments were usually mixed with lead white; lakes were still widely used as glazing pigments and mixture with this opaque white would not give the desired effect.

When carmine came to be more widely used in oil, lack of translucency could be mitigated by the addition of a translucent extender such as starch (flour), which, unlike lead white, is translucent in oil. Starch also gave bulk to the pigment, making it easier for the painter to use without losing the strength of the color, and enabling the pigment maker to make his pigment go further. In fact, many eighteenth-century cochineal lakes seem to have been strongly colored, and these, too, were sometimes extended with starch. A pigment of this type was used by Canaletto in *A Regatta on the Grand Canal*,[31] painted in about 1740 (figures 21.6a–21.6b). The starch grains present in the cochineal lake pigment used by the artist have a characteristic appearance when examined under the microscope using polarized light microscopy (figure 21.6c).[32]

The most characteristic feature of carmine is that, unlike a typical cochineal lake, it contains very little substrate; hence its strong color. The English painter Sir Joshua Reynolds is documented as using carmine a great deal, notably (and notoriously) in painting flesh tints when it was mixed with white. Under these circumstances it is light-sensitive, like other cochineal pigments.[33] Used full strength, as in the coat of Reynolds' *Lord Heathfield of Gibraltar*,[34] painted in 1787, it has retained its color (figure 21.7).[35]

The most dramatic development in the technology of carmine pigment came at some point during the eighteenth century, possibly in Germany: the use of tin salts (usually tin dissolved in aqua regia to give tin [IV] chloride) to precipitate the dyestuff. This gave a vivid, opaque, scarlet pigment with a substrate of tin (IV) oxide. The use of tin salts had been prefigured in textile dyeing in the previous century by the use of a tin mordant with cochineal, giving bright scarlet cloth. These extremely strongly-colored pigments were widely used throughout the nineteenth century[36] (figure 21.8) in parallel with more traditional cochineal lakes with hydrated alumina substrates. Very frequently, similar to other strongly colored pigments like Prussian blue, the

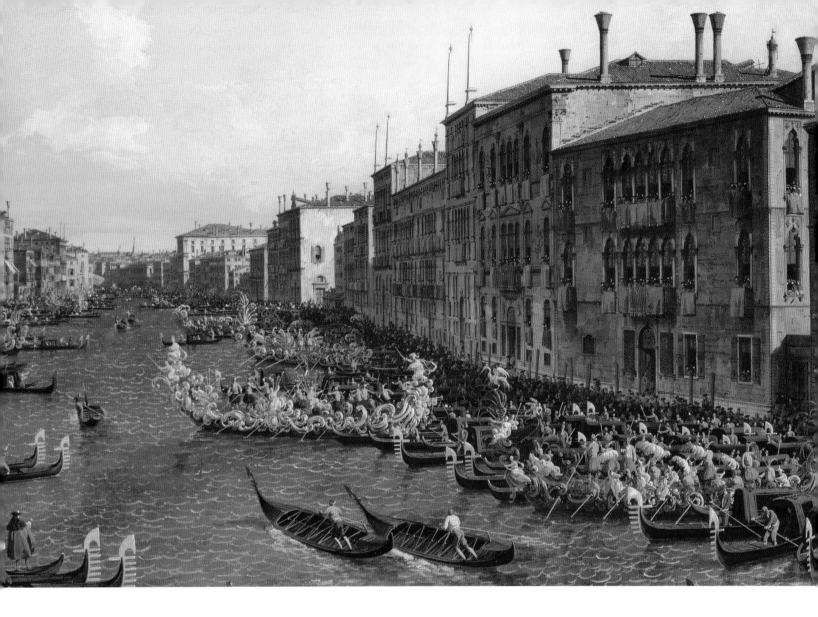

Top and above, left **FIGURES 21.6A–21.6B** Canaletto, *A Regatta on the Grand Canal*, Venice, ca. 1740. Oil on canvas, 48¹⁄₁₆ x 72¹⁵⁄₁₆ in. The National Gallery, London, NG4454. Whole painting and detail of gondolas at the right. © The National Gallery, London/Art Resource, NY.

Above, right **FIGURE 21.6C** Canaletto, *A Regatta on the Grand Canal*. The National Gallery, London, NG4454. Unmounted sample of reddish-purple paint from velvet on the gondola examined under a microscope in transmitted light, crossed polars, showing particles of deep pink cochineal lake and large round starch grains with a characteristic dark cross. Photographed at a magnification of 400x. © The National Gallery, London.

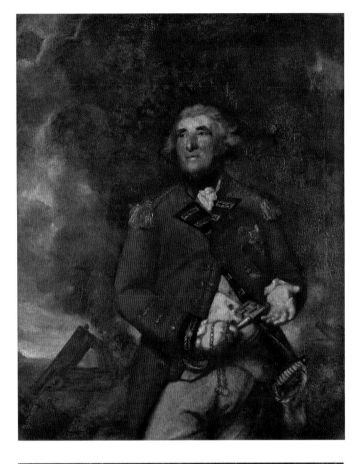

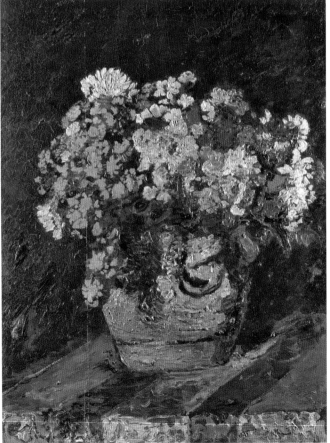

pigment was extended, often with starch, which made it less dense and easier to handle.[37] However, it should be noted that many nineteenth-century pigments were intensely colored. Paint manufacturers sometimes added extenders of starch, calcium carbonate, or other inert white salts, more or less according to the grade of tube paint being sold. This enabled them to economize on the use of expensive pigment without affecting the color.[38]

Throughout the eighteenth century and the early nineteenth century, many recipes for cochineal pigments, both carmines and lakes, were available; it is clear that this was a sophisticated and varied industry. There were many uses for the pigments and many grades were available, from the cheapest lake to the most expensive Nacarat carmine. In mid-nineteenth-century France, only madder pigments could compete in the number and range of red lake pigments available. The different hues typical of cochineal and madder pigments are demonstrated in *Louis-Auguste Schwiter*,[39] painted between 1826 and 1830 by Eugène Delacroix (figure 21.9).[40]

This state of affairs is rather different to that in the sixteenth century, when cochineal had to compete with pigments from other scale insect dyes. However, by the eighteenth century, and certainly by the nineteenth century, painting technique was to some extent becoming more direct, with less emphasis on a traditional build-up of layers with a final glaze of transparent red. In the four centuries or so that they have been available, cochineal pigments have thus evolved as a significant part of the painter's palette—the most important coloring material the Americas have produced. 🍍

Top **FIGURE 21.7** Sir Joshua Reynolds, *Lord Heathfield of Gibraltar,* London, 1787. Oil on canvas, 55⅞ x 44¹¹⁄₁₆ in. The National Gallery, London, NG111. © The National Gallery, London/Art Resource, NY.

Bottom **FIGURE 21.8** Adolphe Monticelli, *A Vase of Wild Flowers,* Marseille, probably 1870–1880. Oil on wood, probably mahogany, 24 x 18½ in. The National Gallery, London, NG5015. The bright red flowers were painted using a pigment in which cochineal dye had been precipitated onto a tin (IV) oxide substrate; this strongly colored pigment had been extended with starch. Monticelli is known to have used paints made by Lefranc et Cie. © The National Gallery, London/Art Resource, NY.

Opposite **FIGURE 21.9** Eugène Delacroix, *Louis-Auguste Schwiter,* Paris, 1826–1830. Oil on canvas, 85¾ x 56½ in. The National Gallery, London, NG3286. The lining of the sitter's hat shows the contrasting colors of madder and cochineal lakes. Here Delacroix used an orange-red madder lake, one of a large range available at the time, and a dark red cochineal pigment on a tin (IV) oxide substrate extended with starch. © The National Gallery, London/Art Resource, NY.

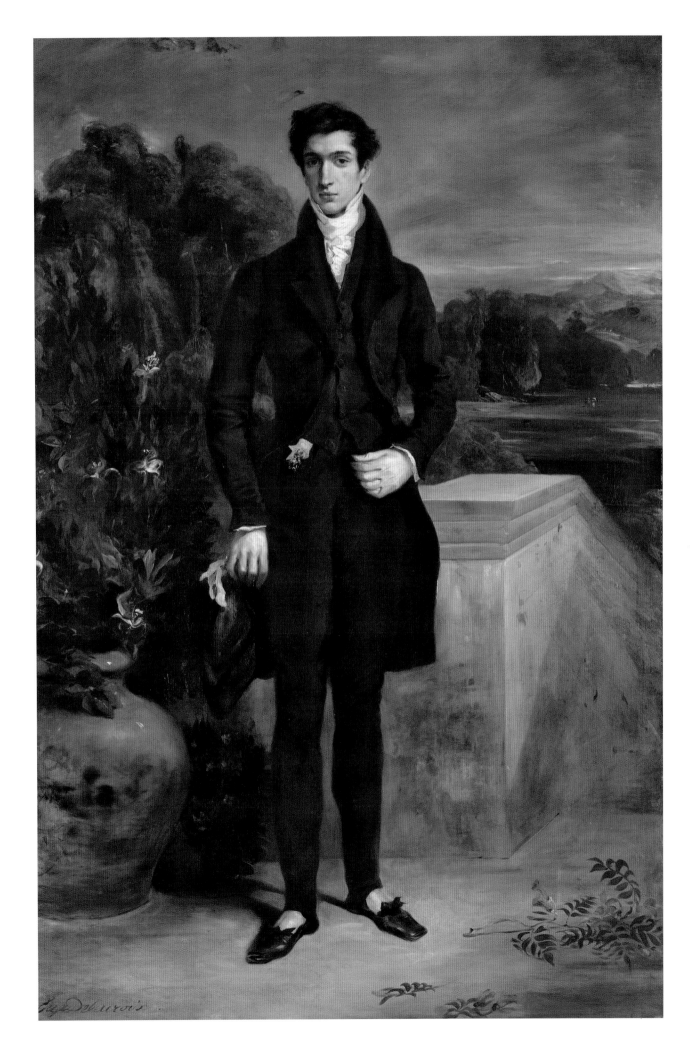

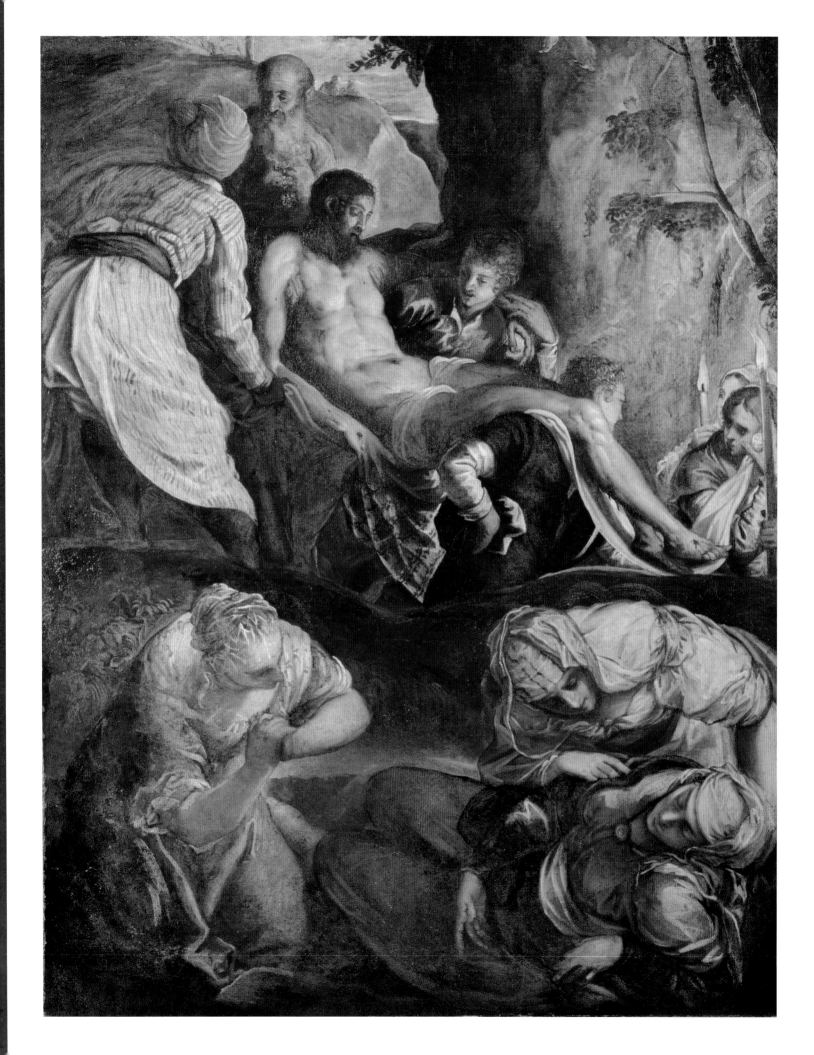

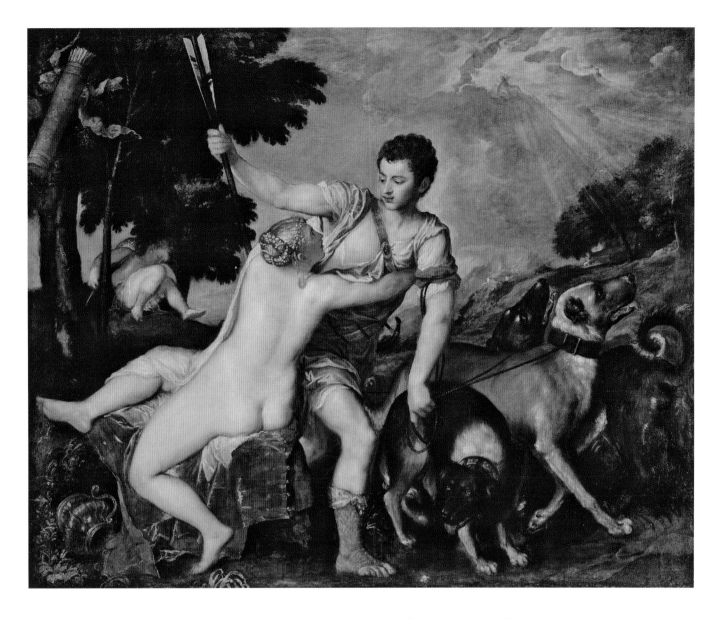

TINTORETTO (JACOPO ROBUSTI)
Christ Carried to the Tomb (Deposition of Christ)
Italy, ca. 1590
Oil on canvas
64⁹⁄₁₆ x 50 in.
National Gallery of Scotland, NG 2419

TITIAN (TIZIANO VECELLIO)
Venus and Adonis
Italy, ca. 1555–1560
Oil on canvas
63 x 77⅜ in.
J. Paul Getty Museum, 92.PA.42

Some of the earliest Venetian painters to use cochineal were closely involved with Venice's thriving textile industry. The great sixteenth-century painter Jacopo Robusti is better known by his sobriquet Tintoretto, meaning "little dyer," bestowed upon him in reference to his father's profession. Tintoretto's local commissions included altarpieces for the private family chapels of wealthy textile merchants, further attesting to his strong connections to cloth and dyes.

Analyses of samples from select Tintoretto paintings show his masterly manipulation of cochineal in glazes. This created shimmering effects in the sumptuous silk and velvet garments in which his portrait sitters or religious subjects were depicted, as seen in Christ's loincloth in *Deposition of Christ*.[a]

The cochineal Tintoretto used to portray fabrics in paint echoed the cochineal with which fabrics would have been dyed in practice.

Shortly after Mexican cochineal was embraced in Venice as the best dye for luxurious silks and velvets, it was adopted by local painters. They bought it from the same color sellers that dyers bought from or they precipitated it in water from scraps of discarded fabrics obtained from local tailors. Analysis of this painting revealed that the red velvet draperies of Adonis's tunic and Venus's chair contain cochineal-dyed fibers, indicating that a lake was made from *lacca di cimatura de grana*, or cloth shearings. Other organic red dyes were mixed with the cochineal, a common practice in the sixteenth century, as painters took what shearings they could get.[b]

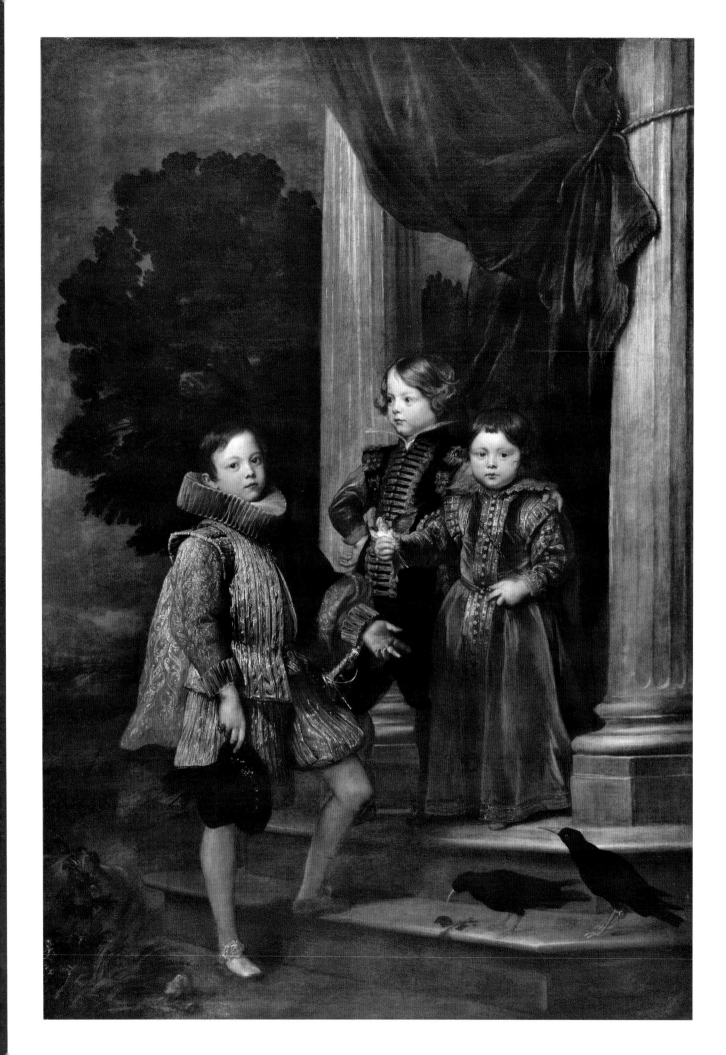

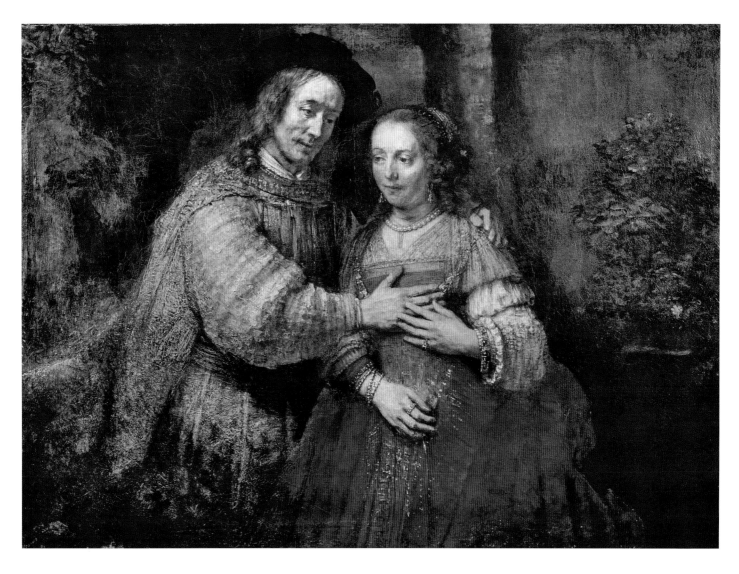

ANTHONY VAN DYCK
The Balbi Children
Painted in Genoa, ca. 1625–1627
Oil on canvas
86⁷⁄₃₂ x 59²⁹⁄₆₄ in.
The National Gallery, London, NG6502
© The National Gallery, London/Art Resource, NY

Van Dyck's relationship with cochineal probably began in his youth in Antwerp, where his father was a successful textile merchant with business contacts in Italy and where his teacher was Peter Paul Rubens, who was tied by marriage to the silk industry and used cochineal as a lake. In 1622 van Dyck was invited to Genoa by his father's colleague Gio Agostino Balbi, whose wealth derived from the silk and wool industries, as is amply displayed in this portrait of his children. The portrait shows the children not only dressed in opulent silks and velvets but surrounded by them. The textiles are especially scintillating because of van Dyck's use of cochineal glazes.[c] Indeed, as Ashok Roy of The National Gallery, London, observed:

> [The artist's] method of painting for the children's clothes, and
> particularly for the large hanging curtain, involves a more extensive
> glazing technique than is seen in his earlier work and, in fact, is not
> much used later. This presumably reflects an interest in Venetian
> methods of drapery painting for which glazes, particularly red lakes . . .

> play such an important part. The background curtain to the right is
> a most elaborate piece of drapery painting and involves undercolours
> consisting of orange-toned pure vermilion mixed with white and red
> earth, and then further modeled in two contrasting paints, one based
> on deep blue indigo and the other on a rich crimson red lake, likely to
> have been prepared from cochineal. The final shimmering effect of the
> shot colours was achieved by glazing and scumbling with further red
> lake, red lake mixed with indigo, and pure indigo.[d]

REMBRANDT (HARMENSZ VAN RIJN)
The Jewish Bride
The Netherlands, 1667
Oil on canvas
47⁵³⁄₆₄ x 65³⁵⁄₆₄ in.
Rijksmuseum, on loan from the City of Amsterdam,
A. van der Hoop Bequest, SK-C-216
Photo: Album/Art Resource, NY

In this portrait of a contemporary couple portrayed as historical figures from the Old Testament, Rembrandt followed a practice common among his European peers, applying a thick, dark red cochineal glaze over an orange-red vermilion to give depth and luminosity to the cloak of the bride.[e]

187

VINCENT VAN GOGH
Shoes
France, 1888
Oil on canvas
18 x 2¾ in.
Metropolitan Museum of Art, purchase,
The Annenberg Foundation Gift, 1992 (1992.374)
Image © The Metropolitan Museum of Art.
Image source: Art Resource, NY

Although few paintings from this period have been tested, this one by van Gogh showed cochineal on the flooring and on the shadow inside of the right shoe.[f]

PIERRE-AUGUSTE RENOIR
Madame Léon Clapisson
France, 1883
Oil on canvas
32 x 25¾ in.
Mr. and Mrs. Martin A. Ryerson Collection, 1933.1174
Art Institute of Chicago

Recent investigation of a section of canvas hidden by the frame of this portrait revealed a much more vivid purple-red coloration in the background than the subdued and translucent cool blue-gray tones of the exposed surface. This made clear that Renoir's original palette was a much hotter one than was generally understood of the painter, as can be seen in this digitally recolored image of what the original must have looked like. Another surprise was that the pigment turned out to be carmine lake made from cochineal. Fugitive as it was, cochineal was thought to have been replaced by this time in European palettes by aniline, or synthetic, dyes.[g]

CARMINE OF THE INDIES

Cochineal in Spanish Painting and Sculpture (1550–1670)

ROCÍO BRUQUETAS AND MARISA GÓMEZ

THANKS TO THEIR STRONG textile industries, Venice and Florence were, from the late Middle Ages, the main providers of red lakes throughout Europe. Lakes were made by the cooking in bleach of *tundiduras*, strips of cloth dyed with *Kermes vermilio* (the famous *scarlatti di grana*) and occasionally combined with brazilwood (*Caesalpinia brasilensis*) or madder (*Rubia tinctorum*). The Low Countries also made high-quality red lakes from madder, achieving much-admired purplish reds and the transparent, enamel-like carmines of Flemish painting. Although the presence of carmine from Flanders has been confirmed in sixteenth-century Castilian commerce,[1] documents show a general preference for the lakes from Florence, whose prestige lasted through the century.

In the 1570s, some twenty years after the arrival of American cochineal in the port of Seville, a new red lake, called carmine from the Indies, made its appearance in Spanish markets. One of its first references is in a 1565 estate inventory of the deceased master Pelegrín, a painter in the court of Philip II, where 3 ounces of "carmine from the Indies" purchased in Toledo for royal works is listed among other pigments.[2] That same year, one-half ounce of carmine from the Indies was listed in the inventory of materials belonging to Luis Vélez, a painter from Medina del Campo.[3] From then on, cochineal red shows up in auction inventories and the inventories of spice shops and drugstores. It is also mentioned in the terms of contracts for paintings, which confirms its growing availability.

CARMINE IN COMMERCE AND ARTIST CONTRACTS

In 1576 the workshop of the Escorial (the royal palace built by Philip II) purchased carmine of the Indies.[4] In the 1580s the dye was listed among the expenses of Niccolò Granello, Federico Zuccaro, and other Escorial painters.[5] Among the places the new dye was traded was Medina del Campo, which, along with Seville, had become an important distribution center for cochineal. The city was also the headquarters of major firms that dealt in American dye-related products.

There is abundant information about the trade in cochineal, its economic value for the Spanish Crown, and the extraordinary progress it generated in the European textile industry. (See Marichal, this volume.) However, historical documentation is sparse with regard to who produced cochineal lakes in Spain and how they did so. Furthermore, the possibility that prepared lakes were brought to Spain from New Spain and Honduras has yet to be disproven.

The lack of information may have to do with the traditional secrecy associated with artistic practices, which remained in the hands of chemists, pigment makers, and painters in remote places. Still, one notice concerning painter Jerónimo Sánchez Coello, brother of Alonso Sánchez Coello, the portrait painter of Philip II, points to his possible involvement in the distribution of American cochineal. Sánchez, known primarily for his 1574–1577 stay in the Italian workshop of Titian, where he made a number of copies, was also in charge of getting pigments for Philip II.[6] Upon returning to Spain, around 1582, he

Opposite, top row FIGURES 22.1A–22.1B Francisco Giralte (sculptor) and Alonso Sánchez Coello (painter), *The Coronation of the Virgin*, main altar screen, Church of El Espinar, Segovia, ca. 1565–1577. Gilded and polychrome wood, 67²¹⁄₆₄ x 339⁷⁄₃₂ in. (full altar screen). Detail of altar screen and detail of paint and gilding on the Virgin's mantle. Photo: José Baztan, Instituto del Patrimonio Cultural de España, Madrid.

Opposite, bottom row FIGURES 22.2A–22.2B Juan de Tovar, Francisco Linares and/or Francisco Giralte (sculptors) and Diego de Urbina and others (painters), *The Assumption of the Virgin*, main altar screen, Basilica of Nuestra Señora de la Asunción de Colmenar Viejo, Madrid, ca. 1566–1584. Gilded and polychrome wood, 49⁷⁄₂₂ x 45⁴³⁄₆₄ in. (full altar screen). Detail of altar screen and detail of iridescence on the Virgin's mantle. Photo: José Loren, Instituto del Patrimonio Cultural de España, Madrid.

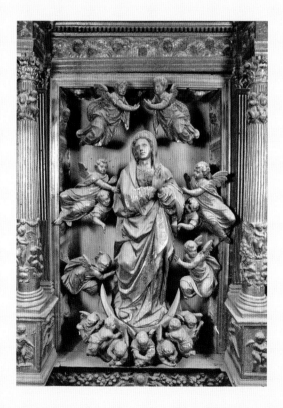

went to Seville, where he spent a good part of his artistic energy exporting paints to America. In 1588 he oversaw the quality of the pigments that Juan Girón was to use to paint and gild a chapel in the Monastery of Santa María de Jesús. Sánchez also provided 12 pounds of carmine of the Indies to the tradesman Pedro Aguilar de la Sal as payment-in-kind for paints that Aguilar sold in America.[7]

Interest in the new red can be seen in the terms of artist orders for works of art. One of the earliest, from June 17, 1578, is an order for the painter and gilder Cristóbal de Herrera to make an altar screen for the church in San Pablo in Palencia. Here it is requested that the grooves of the columns and pilasters be "some of a very good blue and the others of carmine of the Indies."[8] An August 18, 1587, order for Pedro de Herrera, a painter and resident of Medina del Campo, requests an altar screen for the chapel of San Andrés el Real in Medina, in which "the colors that are used must be very good, carmine of the Indies and carmine from Florence."[9] And while a clear preference for Italian lakes is seen through the last years of the sixteenth century, the fact that some contracts expressly demand the use of carmine from Florence instead of American red indicates a growing demand for the latter. Such is the case of a contract with Alonso Sánchez Coello for an altar screen in San Eutropio de El Espinar (1574). It reads, "Moreover that everything be painted with very fine colors and that the reds be from Florence and not from the Indies."[10]

The court painters for Philip II, many of them Italian, contributed to the prolonged fame of Florentine and Venetian lakes. Painters ordered them from Venice, the prime European market for art materials, usually in the name of Titian, Tintoretto, or Jerónimo Sánchez. Some early seventeenth-century contracts continued to show a preference for Florentine red. For example, the 1614 agreement with Bartolome de Cárdenas for altar screens for the Monastery of Nuestra Señora de Belén in Valladolid expresses that "the lakes or carmines should be from Florence and not the ones from Seville."[11] According to the painter and essayist Francisco Pacheco, this preference owes to the greater stability of Florentine red "for oil paint, better from Florence than from the Indies, and it is surer and more lasting, although the Honduran product is not bad."[12]

But as the century goes on, appreciation for carmine from the Indies grows. An interesting example is seen in the terms arranged with Vicente Carducho for the main altar screen of San Antonio de los Portugueses in 1632, which call for exclusive use of carmine from the Indies.[13] For his part, Carducho, in his treatise *Diálogos de la pintura* (Madrid, 1633), remains loyal to the Italian tradition, including "carmine from Florence in pellets" among the colors used for oils and reserving American red for watery temperas.[14] On the other hand, the anonymous author of the seventeenth-century *Tractado del arte de la pintura* clearly favors American red on this point, writing that "the best is from Honduras, then from Florence, and the worst is from Granada."[15]

Document sources throughout the period use various names for cochineal lakes that relate to the place of manufacture or trade (Venice, Florence, the Indies, Honduras, Granada, Madrid), the form in which the cochineal was marketed (in pellets or as a cake, tablets, or cylinders), and its different grades (fine, low, ordinary). One anonymous manuscript declares, "The carmine that comes in pellets is the worst, and there are three kinds of tablets, the brightest is the best."[16] To these should be added the lakes from Holland and Paris,[17] which gained some reputation in the eighteenth century but were considered by Antonio Palomino y Velasco, another noted treatise author, as "false" and unable to dry.[18] Palomino also distinguishes between "fine carmine," obtained with cochineal and alum, and "ordinary carmine," from cochineal and plaster of Paris.[19]

Although both were expensive, the carmines of Florence and the Indies maintained a considerable difference in price through the sixteenth century. The previously mentioned estate document of master painter Pelegrín records the difference in 1565: twenty-two reals per ounce for Venetian red and seven reals per ounce for red from the Indies.[20] A 1627 tax imposed on red from the Indies by the Council of Madrid was six reals per ounce, the same as on carmine from Florence, while the tax on the "ordinary" carmine was only twenty-four *maravedis* per ounce.[21] By 1680 the price of the American product had surpassed that of the Florentine.[22]

The competition between Florentine and American carmine was based more on the different methods of fabrication than on color. Nonetheless, it should be noted that Florentine dye makers produced carmines by starting with scarlet cloth dyed with American cochineal. Therefore, a large percentage of the famous lacquers from Florence contained carmine of the Indies as their principal colorant.

CARMINE IN POLYCHROME SCULPTURE AND PAINTING

In his pioneering treatise on painting, Pacheco emphasized carmine's qualities of transparency and intensity: "It is a color with a lot of body and, yet, it is so clear that it can be used as a glaze."[23] In polychrome sculpture, as in paintings, red lakes were used in two ways: mixed with other pigments to get

shades and tones of pinks, violets, or carmines, or for transparent tints over opaque grounds or metal panels, a process known in the period as *trasflorar* or *bañar*. In some cases, the lake was diluted in the agglutinant with the objective of achieving maximum transparency, forming a very thin tint with no visible granulation over the gold. In others, it was mixed with opaque pigments to get a specific tonality: with vermilion, red lead oxide, and lead white to get reds and pinks or with azurite and lead carbonate for violets. Sometimes these tones were intensified with a final glaze of carmine itself.

In a recent study by the Instituto del Patrimonio Cultural de España (Institute of Cultural Patrimony of Spain) in Madrid,[24] American cochineal was found in a number of examples of Spanish painting and polychrome sculpture. (See also Sanz Rodríguez, this volume.) The items selected for analysis represent a period of great splendor in Spanish art—from the second half of the sixteenth century and the beginning of the seventeenth century—a time that coincides with the start and consolidation of the use of carmine of the Indies in Europe. Among these are several examples of polychrome mannerist sculpture with magnificent painting over gilding (known as *estofado)* from Castile and Andalusia: the main altar screen from the parish church of Colmenar Viejo in the province of Madrid, made between 1566 and 1584; a group of images from the lost altar screen of the Chapel of the Virgen de la Antigua in the Cathedral of Granada (1589); and the main altar screen from the Church of San Mateo de Lucena in Córdoba (1573–1579 and 1598–1607). Painting examples include the Apostles series by El Greco (1610–1614); a group of paintings by Francisco Zurbarán from the Monastery of Nuestra Señora de Guadalupe in Cáceres (1638–1643), as well as one from the workshop of Zurbarán from a private collection; and the main altar screen of the Church of Las Mercedarias of Don Juan de Alarcón in Madrid, created between 1654 and 1657.

For the most part, analysis of these works identified components of cochineal lake as the main dye. However, in some cases, residual components from shearings were detected. Others colorants, such as from brazilwood, were noted in other cases. The results of the analyses are discussed below. (See also Chapter 13, appendix, table 13.1, this volume, for an overview of the works in question, including their classifications, origins, and attributions.)

In painting, crimson tints were used profusely to imitate brocade over gold and silver through the first third of the sixteenth century, about the time the taste for gold background and decoration was abandoned. In polychrome sculpture,

however, this technique continued until the end of the Baroque period. The incorporation of classically inspired Renaissance motifs—the "elegant caprices of the grotesques," as Pacheco called them—executed with a technical ability unequaled in later periods, notably enriched the polychrome decoration of Renaissance and Baroque altar screens. Carmine was frequently used for the robe in Marian images, colored red by a combination of glazes with various motifs—seraphs, plant forms, arabesques, and fantastic creatures—done with a graver or the tip of a brush. Some magnificent examples are found in *The Coronation of the Virgin* on the altar screen of El Espinar (1565–1577) (figures 22.1a–22.1b), in which carminic acid from the cochineal has been detected in the red glaze over gold in the Virgin's tunic.

Fine and abundant examples of this technique, done over high-quality gold leaf, are also found on the altar screen of Colmenar Viejo in the province of Madrid, where cochineal was identified in red areas. The painting and polychromy, done by Diego de Urbina, Alonso Sánchez Coello, Hernando de Ávila, and Santos Pedril, shows translucent

FIGURE 22.3 Contract stating "specifications for the painting and gilding of the altar screen of San Eutropio of El Espinar," including the type of red required. Archivo Provincial Histórico de Segovia, Protocols Section, no. 180. Photo: José Baztan, Instituto del Patrimonio Cultural de España, Madrid.

glazes over gold or on grounds of layered opaque pinks where the lacquer was mixed with white lead and blue pigments to achieve iridescent shades of red (figures 22.2a–22.2b). Carmine was also combined with white lead and shaded with vermilion, red earth, or other pigments for the polished flesh tones of the Virgin and other figures. It is interesting to contrast this analysis with the contract for the altar screen at El Espinar,[25] which demanded carmine from Florence (figure 22.3). Both works were made about the same time, and both were worked on by Sánchez Coello and his helper Pedril, whose records confirm his familiarity with carmine from the Indies. The insistence on carmine from Florence in the contract for El Espinar does not contradict results of the analysis of Colmenar Viejo, as by then the Florentines were making lakes from fabrics dyed with American cochineal.

Moving to another region, images of saints from the now-lost altar screen of the Chapel of the Virgen de la Antigua, in the Cathedral of Granada, provide representative examples of polychrome sculpture in the Andalusian mannerist style, in which there is abundant use of carmine from cochineal. The sculpture is the work of Pablo de Rojas of Granada, whose nephew, Pedro de Raxis, did the painting. Raxis, called "the father of painting fabric" by his contemporaries, established a workshop as a painter, gilder, and altar screen maker that had enormous success throughout Andalusia. His much-praised talent can be seen in the ornamented robes of the group of saints: the imitation of brocade, jewels in relief, ample trim, and scenes painted with the tip of the brush are outstanding displays of his skill, as is his use of opaque and transparent tones of crimson (figures 22.4a–22.4b and 22.5a–22.5b).

A sculpture of the crucified Christ in the Seminary of San Cecilio in Granada (circa 1580) is another example of Raxis's painting ability. The magnificent sculpture, also attributed to

Left, top row **FIGURES 22.4A–22.4B** Pedro de Raxis (painter) and Pablo de Rojas (sculptor), *Saint Gregory,* Cathedral of Granada, Spain, 1589. Gilded and polychrome wood. Full sculpture and detail of the head. Photo: José Puig, Instituto del Patrimonio Cultural de España, Madrid.

Left, middle row **FIGURES 22.5A–22.5B** Pedro de Raxis (painter) and Pablo de Rojas (sculptor), *Saint Stephen,* Cathedral of Granada, Spain, 1589. Gilded and polychrome wood. Full sculpture and detail of the sgraffito of the dalmatic. Photo: José Puig, Instituto del Patrimonio Cultural de España, Madrid.

Left, bottom row **FIGURES 22.6A–22.6B** Pedro de Raxis, *Christ Crucified,* Seminary of San Cecilio, Granada, Spain, 1580. Gilded and polychrome wood. Details of head and feet and painting depicting flesh and drops of blood. Photo: José Puig, Instituto del Patrimonio Cultural de España, Madrid.

Rojas, is of intense realism, with a face and muscular body expressing extreme suffering. Its polished flesh tones are achieved using oil paint with white lead and small amounts of vermilion, cochineal, and, very carefully, dyer's broom and azurite. These extraordinary flesh tones, combined with the blood that flows from the wounds, achieved by applying layers of carmine from cochineal, confer on the image a powerful veracity (figures 22.6a–22.6b).

The main altar screen of San Mateo de Lucena in Córdova is a prime example of a large-scale altar screen in the Andalusian mannerist style. The sculpture was carved by Jerónimo Hernández and Juan Bautista Vázquez, who completed the work in 1579. It was not until nineteen years later that a local painter, Antonio Mohedano Gutierra, was hired to do the painting, finishing the job in 1607. Pacheco considered Mohedano to be the equal of Raxis, one of the outstanding artists in the field.[26] Mohedano's talent is seen in the technical and decorative abundance of the altar screen, which boasts large areas of gilded wood tinged with glazes that give bronze effects, and in rich mannerist designs of foliage, garlands, putti, candlesticks, and more. Carmine from cochineal is present in the bluish flesh tones of the figures and in the broad palette used to paint their garments.

In painting, cochineal was used in a manner similar to sculpture. It was mixed with other pigments to get a particular effect or tonality and used in transparent glazes over opaque grounds. El Greco used it in pinks, violets, and his unmistakable reds and crimsons, applied over carmine washes on sketches of irregular thickness. The foundation of his splendid color scheme was his Venetian training, which links him to the modern world.

In the artist's Apostles series in the Museo del Greco in Toledo—his *Saint John, Saint Matthew,* and *The Savior,* which date from his final period[27]—carmine from cochineal appears as the major component (figures 22.7a–22.7b). Here, carminic acid is accompanied by glycosides of flavokermesic acid and ellagic acid, whose proportions closely resemble the makeup of American cochineal. The ellagic acid is a by-product of the process of extracting color from dyed silk; the acid was initially applied to enrich the fabric with tannins. The samples taken from this series constitute the only case in the study in which the dye was obtained by means of shearings.[28] The resulting red primer was mixed with azurite in small amounts to tint it either an intense red or more brown for El Greco's characteristic earth tones. The artist added pigments of the highest quality to the mix, which, due to their intensity and cost,

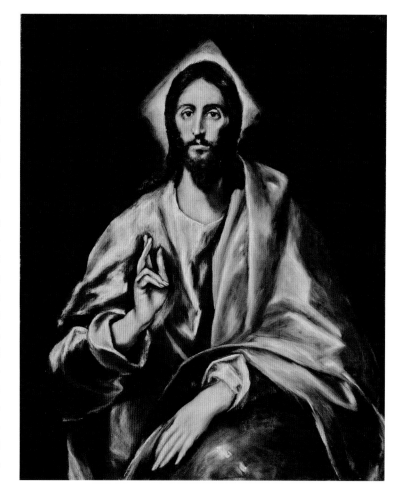

■ FIGURES 22.7A–22.7B El Greco, *The Savior* (from the Apostles series), Toledo, Spain, ca. 1608–1614. Oil on canvas, 39¹⁷/₃₂ x 31³⁷/₆₄ in. Museo del Greco, Toledo, IPCEGRE-GS1(CE00001). Full painting and detail of sleeve. Photo: Tomás Antelo, Instituto del Patrimonio Cultural de España, Madrid.

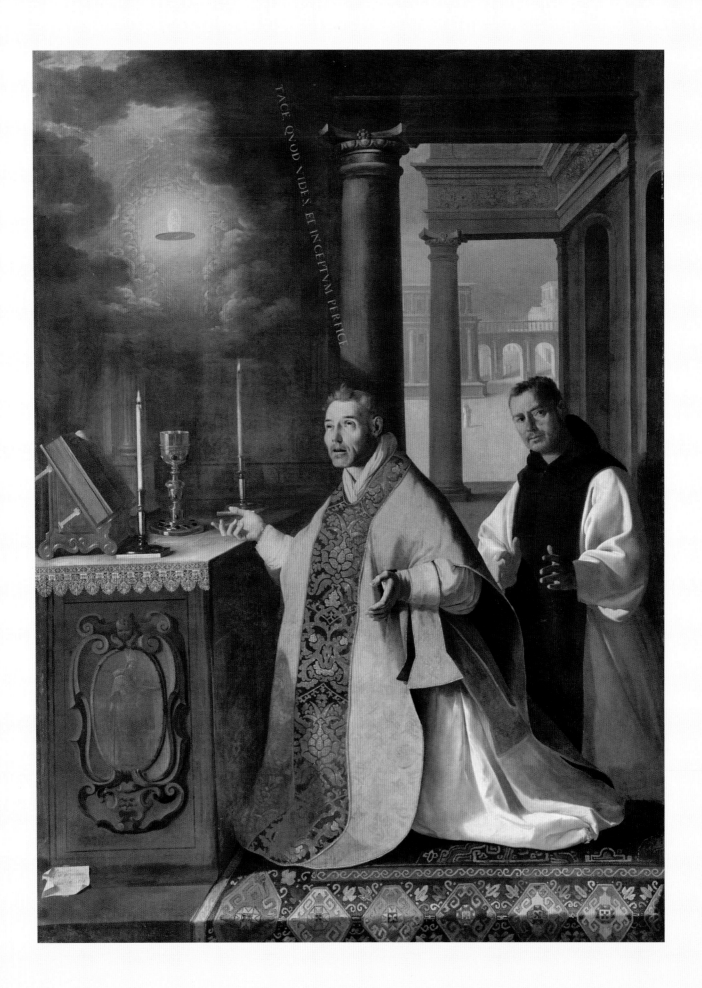

TACE QVOD VIDES ET INCEPTVM PERFICE

were usually reserved for the final glazes. This fact shows the importance that El Greco gave to the primer as the color base, which he let show through in some places.

A series of significant paintings by Francisco de Zurbarán, attributed to the artist's late period, are in the Monastery of Nuestra Señora de Guadalupe in Cáceres. Located in the sacristy (1638–1639) in the Chapel of San Jerónimo (1640–1643) and in the altar screens in the church choir, these and other works analyzed display an extensive use of carmine from cochineal (figures 22.8 and 22.9a–22.9b).[29] Zurbarán, like Jerónimo Sánchez Coello, must have had easy access to carmine lake given his well-known activity as an exporter of paintings and paint materials to America. In these paintings, one can admire Zurbarán's signature deep crimsons, achieved with mixtures of white lead or vermilion in the carmine lake, followed by carmine glazes that accented the shadows or enhanced the background colors.

Another painting attributed to Zurbarán, *Saint Nicholas of Bari*,[30] is in the church choir (figure 22.10). This work shows certain differences reminiscent of paintings done in Madrid, such as the use of gray oil-based primer and ultramarine blue. Yet cochineal was also used freely to paint the curtain and the tablecloth, with a small amount of vermilion mixed in to lend a more vibrant color in the lights. In this case, the carminic acid from cochineal is mixed with dye from brazilwood (*Caesalpinia* spp.).

A piece done in the style of Zurbarán, *The Emperor Domitian on Horseback*, from a private collection, is of special interest for the pictorial model influenced by Zurbarán's workshop and intended to meet the demand for paintings in New Spain. In this case, analysis was limited to the red and various layers of paint. Carmine from cochineal was identified as the main component in the horse's gear (figure 22.11).

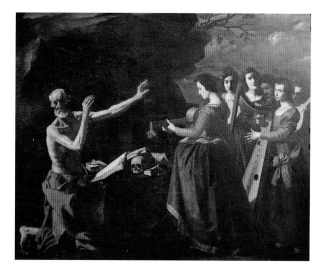

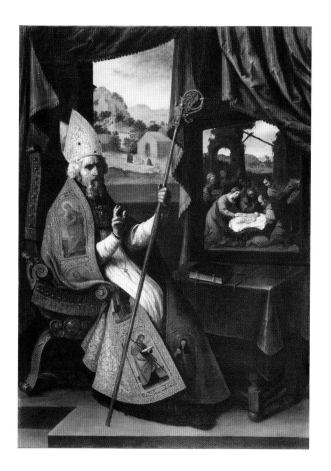

Opposite **FIGURE 22.8** Francisco de Zurbarán, *The Mass of Father Cabañuelas*, Monastery of Nuestra Señora de Guadalupe, Cáceres, Spain, 1639. Oil on canvas, 113²⁵⁄₆₄ x 81 ⁷⁄₆₄ in. Photo: Tomás Antelo, Instituto del Patrimonio Cultural de España, Madrid.

Right, top and middle **FIGURES 22.9A–22.9B** Francisco de Zurbarán, *The Temptations of Saint Jerome*, Monastery of Nuestra Señora de Guadalupe, Cáceres, Spain, ca. 1640–1643. Oil on canvas, 53⁴⁷⁄₆₄ x 114³⁄₈ in. Full painting and detail of the mantle of Saint Jerome. Photo: José Puig, Instituto del Patrimonio Cultural de España, Madrid.

Right, bottom **FIGURE 22.10** Francisco de Zurburán, *Saint Nicholas of Bari*, Monastery of Nuestra Señora de Guadalupe, Cáceres, Spain, ca. 1658–1669. Oil on canvas, 92⅛ x 68⁵⁷⁄₆₄ in. Photo: Tomás Antelo, Instituto del Patrimonio Cultural de España, Madrid.

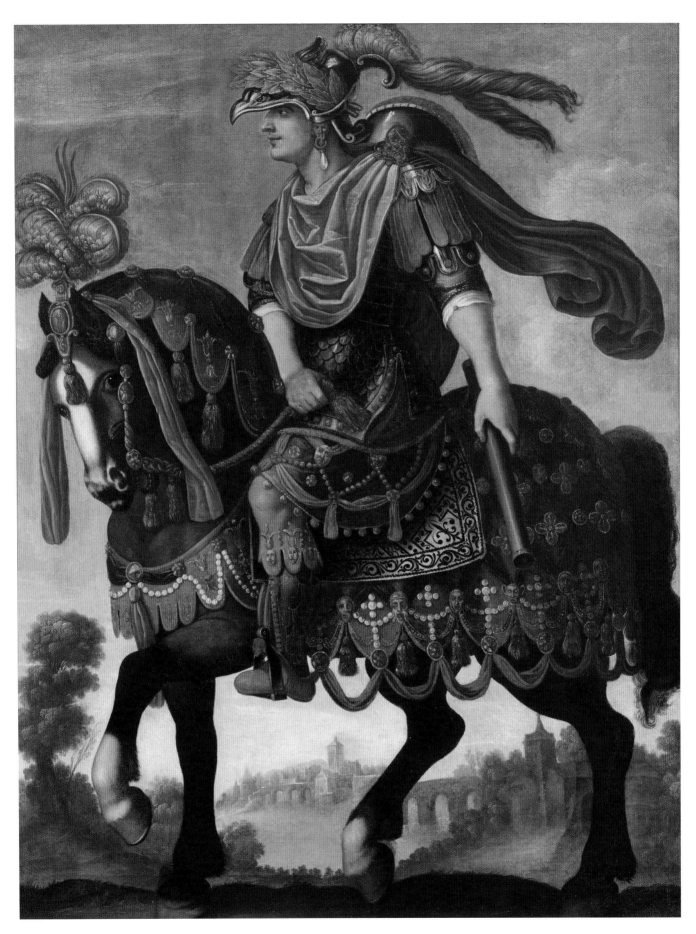

Finally, the main altar screen of the Church of Las Mercedarias, made by Don Juan de Alarcón in Madrid, is a good example of Madrid baroque (figures 22.12a–22.12b). Attributed to Juan de Toledo, a painter with few known works, the painting is composed of a large central canvas depicting the Assumption of the Virgin as she is being received by God the Father, as well as Christ surrounded by a choir of angels and saints. Two lesser canvases—*Saint Anthony of Padua* and *Saint Raymond Nonatus*—are also included. Cochineal was found in the latter—in the red folds of the angel's tunic, in Toledo's sketch of the composition, and in his pinks and carmines.[31]

As a result of this study, it can be affirmed that, at least from the last third of the sixteenth century, cochineal was the basic dye used for red lakes in Spanish painting and polychrome sculpture. Faced with the scarcity of information given in historical sources, however, the questions remain: What method was used to obtain the carmine from the Indies and where was it manufactured?

■ *Opposite* **FIGURE 22.11** Workshop of Francisco de Zurbarán, *The Emperor Domitian on Horseback*, Spain, ca. 1650. Oil on canvas, 98¹⁄₁₆ x 73⅝ x 2 in. Courtesy of Conde de Tepa. Photo: Santiago Mijangos Hidalgo-Saavedra.

Above, left and right **FIGURES 22.12A–22.12B** Juan de Toledo, *Saint Raymond Nonatus*, painting and main altar screen, Church of Las Mercedarias, Convent of Don Juan de Alarcón, Madrid, Spain, ca. 1654–1657. Oil on canvas, 51³⁄₁₆ x 332⁹⁄₃₂ in. (full altar screen). Photo: Joaquin Gómez de Llarena, Instituto del Patrimonio Cultural de España, Madrid.

UNKNOWN
■ Title page
Genealogical book
Spain (probably Seville), late seventeenth century
Vellum, paper, watercolor, gold leaf
12³⁄₁₆ x 8⅜ x 9¹⁄₁₆ in.
Museum of International Folk Art, IFAF Collection,
gift of the Fred Harvey Collection, FA.1979.64.136

It would not be a surprise to discover that within a century after
cochineal's arrival in Spain, its use was especially widespread in
Seville, the port city where the dyestuff was off-loaded and traded.
This illuminated book traces the lineage of the prominent Montes
de Oca y Bohorquez family, who may have migrated from Seville to
Mexico, where the book was acquired. Its palette of pink-tinged red
ink has tested positive for cochineal, which may have been chosen
because its high cost would have been a clear marker of the family's
social status.

JOSÉ DE RIBERA
■ *An Oriental Potentate Accompanied
by His Halberd Bearer*
Naples, Italy, ca. 1625–1630
Point of the brush with carmine red ink, possibly
from cochineal, squared in pen and brown ink
9¹⁄₁₆ x 5⁵⁄₁₆ in.
J. Paul Getty Museum, 91.GA.56

Ribera trained as a painter in Valencia, in his native Spain, but
migrated to Rome by around 1611. He later moved to Spanish Naples,
where he remained until his death. In early modern Europe, as in
pre-Columbian Mexico, cochineal was the preferred ink base for many
drawings and documents. The pale quality of the red ink in Ribera's
drawing is not necessarily due to fading but rather to the dilute
solution of the lake pigment. This created a delicate effect deliberately
sought by draftsmen and scribes.

Joseph de Ribera f.º 1626.

Josepa clana

INTERWEAVING EUROPE AND CENTRAL ASIA
Connections in Ethnobotany, Folklore, and Polish Cochineal

ANNA NARUTA-MOYA

OF THE OLD WORLD INSECTS used as sources for red dye—kermes, lac, Armenian (or Ararat) cochineal, and Polish cochineal—the latter may have had the widest distribution in a nontropical habitat. Kermes was limited to areas that could sustain the kermes oak, mainly the Mediterranean coastal areas. Armenian cochineal (*Porphyrophora hamelii*) grows principally in saline marshes in Armenia and Azerbaijan.[1] The insect that came to be known as Polish cochineal (*Porphyrophora polonica)* was commonly found throughout the Palearctic ecozone, earth's largest ecozone, extending from Europe to northern Africa to the northern and central parts of the Arabian Peninsula and to Asia north of the Himalayan foothills.[2] Specific areas where Polish cochineal has been documented include central and eastern Europe (including France), the Ukraine, Asia Minor, the Caucasus, Turkestan, and western Siberia. The dyestuff was also known as far east as China. It is yet unknown whether areas other than eastern Europe produced the dye in commercial quantities.

The host plant characteristically associated with Polish cochineal, the herbaceous perennial knawel (*Scleranthus perennis*) (figure 23.1), is a member of the carnation family. Unlike American cochineal, grown primarily on the prickly pear cactus, Polish cochineal is known to grow on at least twenty other genera that favor light and sandy soils, including the strawberry.[3] Harvesting the insect requires digging up the host plant, removing the insects from the roots, and replanting the host.[4]

Polish cochineal dye is ancient, long known to have been used by the early Slavs. The dyestuff's current common name is relatively recent and comes from the trade dominance once held by the kingdom of Poland, a political entity that existed from about 1000 into the late 1700s, when it was absorbed by the Russian Empire.[5] Known in the later period as the Poland-Lithuanian Commonwealth (1569–1795), an entity with a single king, the area stretched northward into Estonia and former parts of the Kievan Rus (which flourished from the late ninth century to the mid-thirteenth century) and included nearly all of present-day Ukraine.[6] It was one of the largest and most populous political units in Europe during the sixteenth and seventeenth centuries.

Cochineal was farmed on large plantations in the east of the empire and was known to have been of extreme economic importance during the Jagiellonian Dynasty (1386–1569), when it served as legal tender among traders and in court disputes.[7] A portrait of Polish nobleman and general Stefan Czarniecki (1599–1665) (figure 23.2) demonstrates its importance for the nobility—themselves known as *karmazyni,* or carmines, for their garments dyed in brilliant cochineal red.[8] Rembrandt captures the lavishness of this look in *The Girl in a Picture Frame* (figure 23.3) and in the bright scarlet cloth in *Lisowczyk,* or *The Polish Rider* (figure 23.4).[9] The first printed book on dyeing, Giovanventura Rosetti's 1548 *Instructions in the Art of the Dyers,* included recipes for traditional Venetian reds made of Polish cochineal either by itself or mixed with madder and/or kermes.[10]

CONNECTING OLD WORLD AND NEW WORLD DYES

The effect of the introduction of American cochineal on the production and use of Polish cochineal is an area requiring more research, though testing of paintings through high-performance liquid chromatography (HPLC) has enabled more accurate identification of and distinction between dyestuffs extracted from Old and New World cochineals.[11]

Opposite FIGURE 23.1 Johann Phillip Breyn, "Life cycle of the Polish cochineal (*Porphyrophora polonica*) on the host plant *Scleranthus perennis*, 1731," from *Historia naturalis cocci radicum tincttorii quod polonicum vulgo audit* (loose plate at front). Academy of Natural Sciences Library, Philadelphia, QL471.B76 1731.

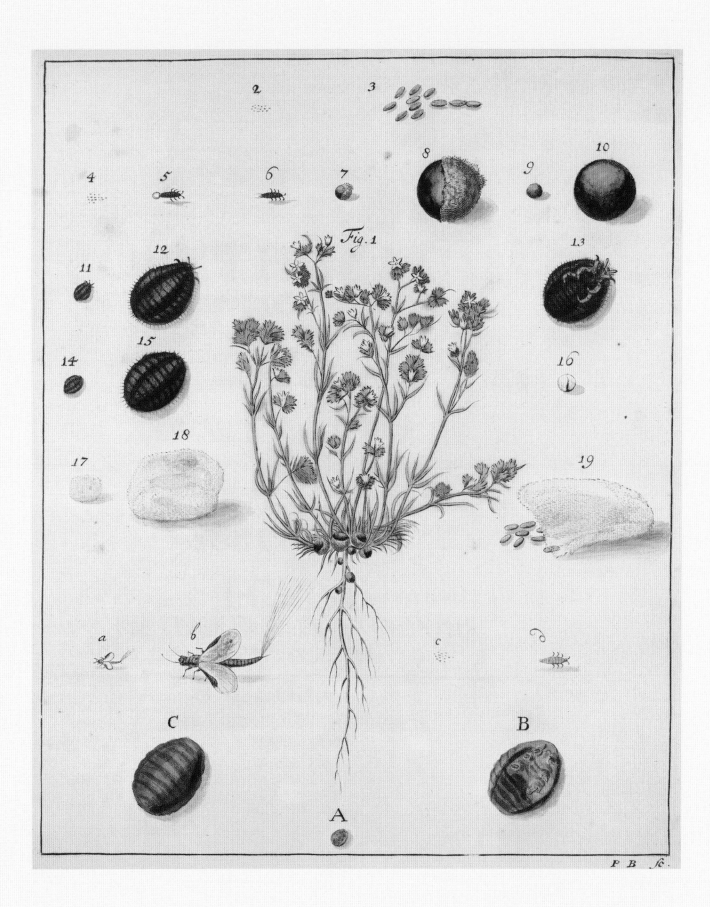

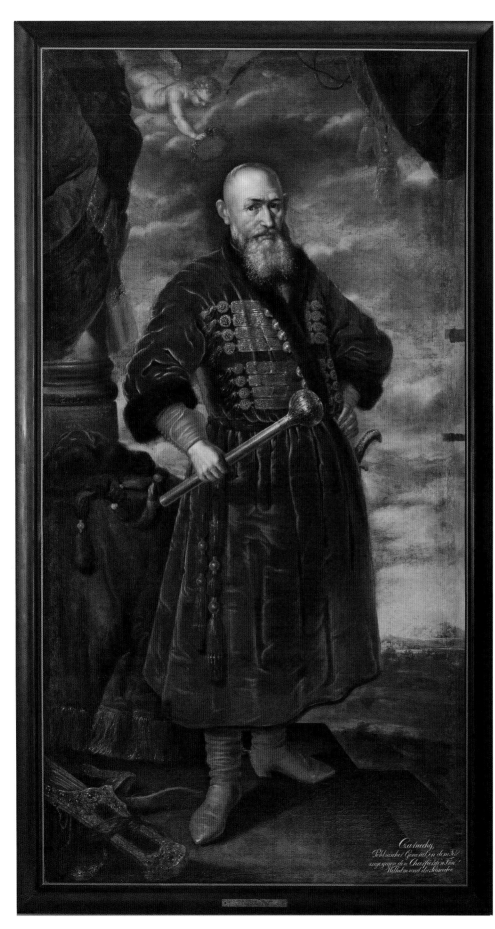

Czarnecki,
Feldmarschal General en dem Felt...
...gegen die Churffürsten zu...
Wilhelm und die Schweden.

Left **FIGURE 23.2** Brodero
Matthiesen, *Portrait of Stefan
Czarniecki*, Polish-Lithuanian
Commonwealth, 1659. Oil on
canvas, 89⅘ x 46⅘ in. The Royal
Castle, Warsaw, ZKW/3411. Photo:
Andrzej Ring.

Opposite, top **FIGURE 23.3**
Rembrandt (Harmensz van Rijn),
The Girl in a Picture Frame, The
Netherlands, 1641. Oil on panel,
41½ x 29⁹⁄₁₀ in. The Royal Castle,
Warsaw, ZKW/3906. Photo:
Andrzej Ring.

Opposite, bottom **FIGURE 23.4**
Rembrandt (Harmensz van Rijn),
The Polish Rider, The Netherlands,
ca. 1655. Oil on canvas, 46 x 53⅛
in. The Frick Collection, Henry Clay
Frick bequest, 1910.1.98. © The
Frick Collection.

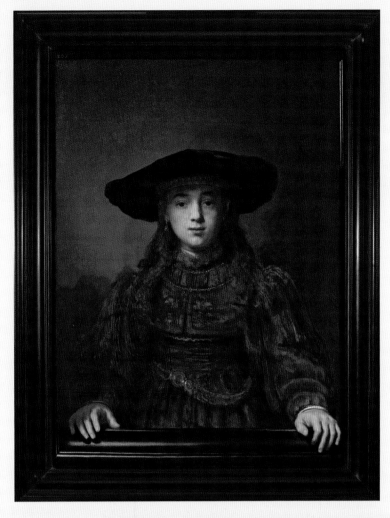

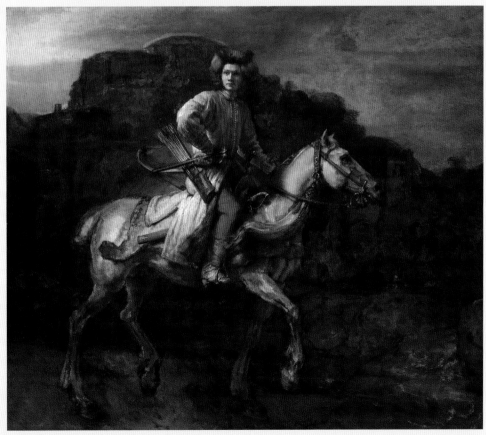

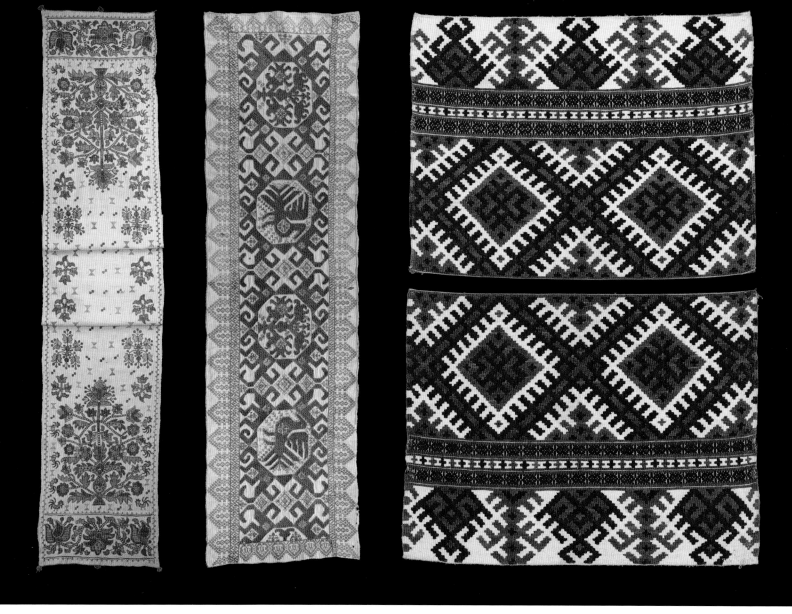

Above, left **FIGURE 23.5** Towel, Russian, early nineteenth century. Linen, cotton, 17½ x 104 in. Brooklyn Museum Costume Collection at the Metropolitan Museum of Art, gift of the Brooklyn Museum, 2009; gift of Mrs. Edward S. Harkness in memory of her mother, Elizabeth Greenman Stillman, 1931 (2009.300.3460). Polish cochineal left its imprint in the red embroidery characteristic of Slavic culture and its descendant groups. The tree of life, an important pre-Christian symbol, is featured in this early nineteenth-century Russian *rushnyk*, a ritual cloth embroidered with ancient symbols. © The Metropolitan Museum of Art. Image source: Art Resource, NY.

Above, middle **FIGURE 23.6** Bed curtain border, Russian, late eighteenth century. Linen, cotton, 59 x 17 in. Brooklyn Museum Costume Collection at the Metropolitan Museum of Art, gift of the Brooklyn Museum, 2009; gift of Mrs. Edward S. Harkness in memory of her mother, Elizabeth Greenman Stillman, 1931 (2009.300.3431). Earlier embroideries in this tradition, such as this late eighteenth-century example, are less pictorial, instead using more geometric symbols. © The Metropolitan Museum of Art. Image source: Art Resource, NY.

Above, right **FIGURE 23.7** Towel border, Russian, ca. 1840–1870. Linen, 16 x 11½ in. Brooklyn Museum Costume Collection at the Metropolitan Museum of Art, Gift of the Brooklyn Museum, 2009; gift of Mrs. Edward S. Harkness in memory of her mother, Elizabeth Greenman Stillman, 1931 (2009.300.3459a, b). As exemplified in this embroidery, red is the color of life, the sun, fertility, and health. © The Metropolitan Museum of Art. Image source: Art Resource, NY.

Opposite **FIGURE 23.8** Dress, Ukraine, ca. 1960s. Linen, cotton, 45 x 59 in. (with sleeves extended). Museum of International Folk Art, gift of the Girard Foundation Collection, A.1981.42.737. The word for "red" was also the word for "beautiful" or "splendid" in Old East Slavic. The energy and protection that could be provided by red embroidery led to its continued importance in clothing.

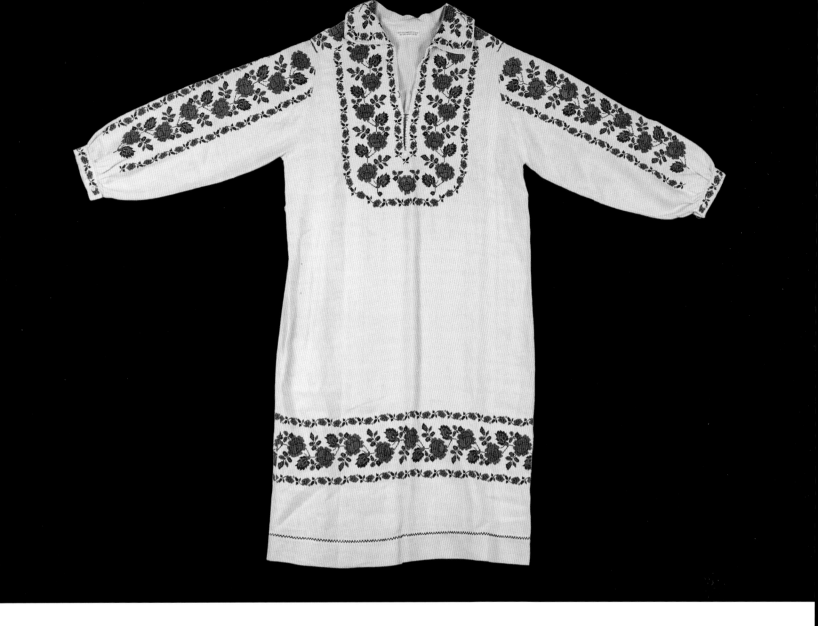

(See Kirby, this volume.) Historical accounts also attest that Polish cochineal was being used in the Old World well after the introduction of the less expensive American cochineal and sometimes in conjunction with the New World product.[12]

Documented use of Polish cochineal continued well past the sixteenth century. A 1672 study on the use and benefit of Polish cochineal relays its local use by peasants as well as its trade to "Turks," a generic term denoting Turkic peoples specifically and Central Asian tribes in general.[13] The Turks used Polish cochineal as cosmetic coloring for the ends of women's fingers. In Afghanistan it was used as decorative coloring for horsetails. Speaking to significant local use by peasants, red boots (see figure 23.2) became emblematic for the Kievan Rus and later in the Russian and Ukrainian traditions. Red embroidery (figures 23.5–23.8) came to exemplify traditional needlework for clothing and ritual use. Farther west, a 1750

French study by Jean Hellot, considered the first systematic treatise on wool dyeing, discusses both Polish and American cochineal, while in England, the *Philosophical Transactions of the Royal Society* of the 1760s recorded a number of newly created scientific descriptions of Polish cochineal.[14] And natural dye historian William Leggett noted that as late as 1792, a "considerable quantity" was sent every year to Venice.[15]

After the Russian Empire absorbed Poland in 1768 and began expanding into Central Asia in the 1800s, Polish cochineal was reestablished as an export product in Central Asia. Bukhara, Uzbekistan, is recorded as being the site of trade extending into both Kabul and Herat in Afghanistan and into Kashgar in eastern Turkestan, now Xinjiang Uyghur, an autonomous region of China.[16] But the commercial production of Polish cochineal did not spring into being without precedent. By the twelfth and thirteenth centuries, Christian

POLISH COCHINEAL AND CULTURAL PRACTICE

As with American cochineal, one of the most interesting aspects of Polish cochineal is the antiquity of its relationship to humans and their cultural practices. The Catholic Church's claim on Polish cochineal, for example, redefined long-held indigenous practices around cochineal collection and use.

In pre-Christian tradition, the designated day for collecting cochineal was Kupula Day, named for the Slavic goddess of sexuality, herbs, and fertility, as well as for the bonfires traditionally lit on the summer solstice.[21] In Christian times, the June 24 saint's day (and birthday) for Saint John the Baptist fell near the actual day of the summer solstice. By renaming Polish cochineal Saint John's blood and claiming it for the church, the church attempted to at once reinterpret a strong pre-Christian tradition and redefine a suite of important solstice practices. As in other areas of the world, the church caused major shifts in indigenous religious practices.[22] Even so, many pre-Christian traditions survived. These include pagan symbols shown in Ukrainian embroideries of the tree of life (see figures 23.5–23.6) and of the ancient Slav great mother goddess Mokoš (figure 23.9).

Etymology provides another bridge to understanding the origins and relations of otherwise unrecorded cultural practices. Slavic etymology speaks to long use of the root words for cochineal; the Slavic words for *red, worm* (as the insect was thought to be), *June* (the month the insect is ready for harvest), and Polish cochineal all have the same root.[23] Furthermore, part of the traditional Slavic practice for summer solstice was to search for *Ruta graveleons* L., also known as *chervona ruta* or rue. While rue bears yellow flowers and is never naturally red, according to lore, the plant is semimagically transformed to red on the solstice.[24] Finding the plant on the solstice gives one "the power to see beneath the earth, where secret treasures [are] hidden."[25] These folkloric associations between plant, color, and time serve as ways of telling and remembering how to collect the valuable red dye source from the earth. This practice is not dissimilar to that described by Diana Magaloni Kerpel in relation to Zapotec tomb paintings in Oaxaca.[26]

Science, specifically HPLC testing of curated and excavated textiles, allows examination of cultural practices and Polish cochineal to reach further back in time. Among the earliest known artifacts containing Polish cochineal is an embroidered textile in the collection of the Metropolitan Museum of Art, dating from the second century BCE to the first century

monasteries in central and eastern Europe required local farmers to give an annual tithe of Polish cochineal, which the church termed Saint John's blood.[17] Some of the cochineal may have been consumed locally in the production of illuminated manuscripts or in weaving done by German monks and nuns.[18] Still unknown quantities of cochineal required each year by the abbots were passed into the commercial trade.[19]

Growing on plant species that thrive on poor and disturbed soils, the Polish cochineal insect proved resilient through the twentieth century, remaining common in Poland well into the 1960s. Today, however, the increase in concrete and asphalt paving and other development of its habitat have greatly diminished the insect's populations there and in the Ukraine.[20]

FIGURE 23.9 Towel border, Russian, ca. 1780–1820. Linen, silk, 16½ x 16½ in. Brooklyn Museum Costume Collection at the Metropolitan Museum of Art, gift of the Brooklyn Museum, 2009; gift of Mrs. Edward S. Harkness in memory of her mother, Elizabeth Greenman Stillman, 1931 (2009.300.3442). The Slavic great mother goddess Mokoš is symbolized in this design as the tree of life, expressing agricultural fertility. While the ancient symbols are retained, the lower band also incorporates new symbols, possibly a church or a factory. © The Metropolitan Museum of Art. Image source: Art Resource, NY.

CE and identified simply as Central Asian.[27] The dye source is also identified in permafrost-frozen remains of the Pazyryk archaeological culture, where it was used in textiles found in a fourth-century grave of a woman in southern Siberia (figure 23.10).[28] This pushes the known use of Polish cochineal back before the Rus and the Slavs to at least the time of the Iron Age Sarmatians and Scythians, underscoring a long history of early Iranian and other tribal interconnections in modern-day Ukraine through trade, migration, and shared rule.[29]

Centuries later, intercultural connections in cochineal persist. Traditional Ukrainian folk dress, preserved and constructed today by modern practitioners, still bears the crimson blaze of native Polish cochineal. Farther east, Central Asian textile artists are reclaiming natural dyes and beginning to work again with cochineal, currently imported from the Americas.[30] As local and international scientific, archival, folkloric, and artistic research continues, these historical interweavings of traditions will undoubtedly have more to teach and reveal.

FIGURE 23.10 Scythian saddle cover with applied felt decoration showing a griffin attack, Barrow 1, Pazyryk, Altai, fifth century BCE. Felt, 47 x 23½ in. State Hermitage Museum, 1295/150. Excavations into the permafrost in Siberia have recovered remarkably preserved textiles that remain vivid and are able to be tested for dye types. Polish cochineal makes an appearance in this felt saddle cover of the Pazyryk culture of the Altai Mountains (where Russia, China, Mongolia, and Kazakhstan come together). Photo: State Hermitage Museum/HIP/Art Resource, NY.

PART 6

RETURN TO THE AMERICAS

*Cochineal in the
Colonial Hispano Americas*

"MORE REDDISH THAN GRAIN"
Cochineal in Colonial Andean Painting

GABRIELA SIRACUSANO AND MARTA MAIER

IN 1639 DR. PEDRO SÁNCHEZ de Aguilar, canon of the Cathedral of La Plata (now Sucre, Bolivia) in the province of Charcas at the viceroyalty of Peru, wrote a report warning the Royal Council of the Indies to pay attention to several idolatrous practices taking place in the region of Yucatán, where he had visited. In addition to advising prevention of the use of wine and *pulque*, a native alcoholic beverage, because they provoked the performance of idolatrous rituals and delusions, Sánchez de Aguilar reported different cases of miracles believed to be divine messages against idolatry—such as images of the Virgin that sweated substances, bloody rains, and the apparition of elves. He wrote about the case of a demon or elf that had appeared to his aunt in Valladolid (Yucatán) in 1560. After being continuously harassed by this creature, the woman had given him a slap "leaving his face more reddish than grain."[1]

The expression in those times was common, but in New Spain it had particular significance, for grain (*grana* in Spanish) was a common term for cochineal. Sánchez de Aguilar continued his tale by pointing out the relevance of the so-called grain in the local commerce. He also referred to a *cédula real* (royal decree) by which the natives would teach and learn "to grow grain, that today … is being harvested, and planting nopal tunas in which they grow," so that they would forget their "false Gods, as the high idleness by which they are known, seems to be the reason of their misfortune and idolatrous sin."[2]

In a single, brief comment at the end of his text, Sánchez de Aguilar mentioned that before finishing and sending his book to press, another book had come into his hands: Pablo Joseph Arriaga's *El extirpación de la idolatría en Peru*. The book had helped Sánchez de Aguilar gain a deeper understanding of indigenous idolatrous practices, but within a new region: the highlands, plateaus, and valleys of the ancient Tawantinsuyu, the four directional realms that constituted the Inca Empire.[3]

Arriaga's book does not mention cochineal in relationship to idolatrous practices, though it does so in reference to other pigments from the Andean mineral world.[4] What, then, were the uses of cochineal grain in ancient Peru? And how was cochineal introduced into Peruvian artistic practices during the Spanish colonial period?

CHRONICLING COCHINEAL IN PERU

The presence of cochineal in Peru during pre-Columbian times has been widely studied.[5] Different words are used to name it in early written Spanish colonial sources. The anonymous *Arte y vocabulario en la lengua general del Peru,* published in 1586 and 1603, as well as Diego González Holguín´s *Vocabulario* of 1608, refer to fine grain as *macnu* or *magnu*, while the chromatic term linked to it appears as *puca*.[6] Ludovico Bertonio's *Vocabulario de la lengua aymara* of 1612 calls it *makhno*, a kind of cake by which "they dye wool red,"[7] and offers different words for the colors obtained by its use. This reference to cochineal as an herbal cake specifically discusses the way it was processed for dyeing purposes,[8] which explains why the word *magno*, included several times in Felipe Guaman Poma de Ayala's *Nueva corónica* (circa 1615) in reference to cochineal, has been interpreted as "dried herb." While denouncing the abuses of parish priests in Peru, Guaman mentions that they asked for "silver and more silver" and that in each town they required a tribute of "twenty cakes of *magno*" a week, resulting in 120 cakes of *magno* offered by three or four towns. The high price and quality of *magno*, discussed together with other dyeing colors mentioned by Guaman, show that he was talking about the importance of cochineal in Andean life since ancient times.

Opposite **FIGURE 24.1** Attributed to Matheo Pisarro, *Our Lady of the Rosary of Pomata,* Church of Casabindo, Jujuy, Argentina, ca. 1690. Oil on canvas, 57⁸⁷⁄₁₀₀ x 41⅓ in. Archive of the Instituto de Investigaciones sobre el Patrimonio Cultural, Universidad Nacional de San Martín, Buenos Aires. Photo: Diego Ortiz.

Textiles are the main cultural objects where cochineal, as a red dye, would have been used, even before domination by the Inca. From Paracas (first century BCE to the second century CE) to Moche (fifth and sixth centuries) to Wari (sixth to eleventh centuries), cochineal was applied in dyeing cotton and camelid hair textiles, sometimes in combination with the roots of *Relbunium*, an American plant. Cochineal brought radiant reds to a whole universe of natural creatures and sacred figures on tunics, bags, and mantles used for ritual burial practices. Three late-Wari-period mantle fragments and one Wari textile fragment from Arequipa, all in the collection of the Museo Etnográfico Juan B. Ambrosetti at the University of Buenos Aires in Argentina, show the presence of cochineal in their borders. Acid hydrolysis of microsamples from the fibers of these textiles and further analysis by high-performance liquid chromatography (HPLC) have revealed the presence of carminic acid, the main component of cochineal.[9] Analysis of the red fibers by scanning electron microscopy and energy-dispersive x-ray spectroscopy (SEM-EDS) have indicated an elemental composition compatible with the use of alum as mordant.

The extension of cochineal consumption in pre-Inca times, from the northern to the southern Peruvian highlands, is also attested by the identification of red cochineal in the Doncellas archaeological site (1000 to 1450 CE) at the Jujuy Puna in Argentina. Analysis by HPLC of a microsample extracted from a textile fragment found there indicated a mixture of purpurine and carminic acid as the red colorants. Purpurine is the main colorant in *Relbunium* roots, in contrast to madder roots, which contain a mix of alizarine and purpurine.[10]

With the arrival of the Incas by the mid-fifteenth century, red colors, as well as blue, green, yellow, and white hues, came to be identified with the royal family. The empire used these colors as symbols of power and nobility, while earthy colors, from beige to brown, identified the people who were dominated. This distinction represented not only glorification of chromatic colors that appeared in the rainbow but also a sort of social and political chromatic control. Textiles exhibiting cochineal, together with indigo blue (*añil* in Spanish), the other main organic dye, symbolized high status. Indeed, all noble Inca garments, including *unku*, *mascaypacha*, and *llautu*, were woven with cochineal-dyed cotton and camelid threads.

With the Spanish arrival to the American continent, cochineal erupted into the European markets, revolutionizing the prevailing economic model. (See Marichal, this volume.) Like *añil*, cochineal was a taxed commodity whose route of trade could be traced from the port of Veracruz to Cádiz and Seville, then to Genoa, Livorno, Venice, Antwerp, and other European cities. It returned to the Americas in the shape of cakes (*panes*) at a higher cost. After arriving at the Peruvian port of Callao, it was distributed to Cuzco, La Paz, Arica, La Plata, and Potosí, a strong market for trade through the southern regions of Peru and the north of Argentina. In a letter to the king of January 2, 1566, describing the virtues of the land of the *real audiencia* (royal audience) and the region of Tucumán, as well as the provinces of the Jurís and Diaguitas, all of them in Argentina, the learned Juan de Matienzo, *oidor* (judge) of Charcas, relates the following:

> What may be taken to Spain from this land is gold, for there is much, most fine cochineal, that is not only grain, but even crimson, for there is endless, and 'tis exceeding prized.[11]

Pedro Sotelo de Narváez's account of 1582 also mentions cochineal as one of the abundant commodities in the Santiago del Estero region, and the dyestuff's presence as a product exported to Potosí from Tucumán is recorded from the sixteenth century.[12] Likewise, in his *General Relation of the Town of Potosí*, Lewis Hanke mentions the product's arrival among other prized exports at the city's marketplace:

> Sacred paintings and engravings from Rome, hats and textiles from England; glass from Venice, white wax from Cyprus, Crete and the Mediterranean coast of Africa, grain, glass, ivory and precious stones from India . . . cochineal, vanilla, cacao and precious stones from New Spain and the West Indies.[13]

In 1591 Father José de Acosta commented on how cochineal arrived in Spain:

> Famed Cochineal of the Indies, with which the fine Grain is dyed, left to dry, and once dry is brought to Spain, which is a rich and stout commodytie: this Cochineal, or Grain is worth many ducats the arroba. In the fleet of the year eighty seven, five thousand six hundred and seven and seventy arrobas of Grain arrived that amounted to two hundred and eighty three thousand seven hundred and fifty pesos, and 'tis usual for such wealth to come every year."[14]

Although Acosta remarked at not having found cochineal in Peru, Father Bernabé Cobo in the seventeenth century would mention the colorant, which he called *magno* or *magna*, as present in Peruvian lands.[15] Also worthy of mention are observations on the subject by José Eusebio de Llano Zapata, an eighteenth-century Limean polymath, mathematician,

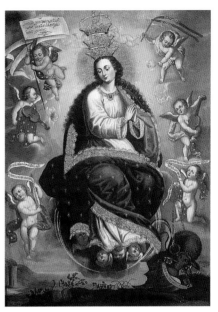

Left **FIGURE 24.2** Attributed to Matheo Pisarro, *Military Angel* (series of military harquebusier angels), Church of Casabindo, Jujuy, Argentina, ca. 1700. Oil on canvas, 47⁶/₂₅ x 32⁶⁷/₁₀₀ in. Archive of the Instituto de Investigaciones sobre el Patrimonio Cultural, Universidad Nacional de San Martín, Buenos Aires. Photo: Diego Ortiz.

Right **FIGURE 24.3** Basilio de Santa Cruz Pumacallao, *Immaculate Virgin Victorious over the Serpent of Heresy*, Peru, ca. 1680–1700. Oil on canvas, 69³/₃₂ x 50²⁵/₆₄ in. Museo de Arte de Lima, Gift of Matilde Gamarra Hernández, restored with sponsorship of the 2155 School of Business, V-20-0045.

astronomer, and naturalist. According to Marco Jiménez de la Espada's 1890 edition of Bernabé Cobo's *Historia del Nuevo Mundo*, Zapata commented:

> *The first time it was brought from Mexico to Spain was around the year 1543, certified by Leon Pinelo, the clerk at the Seville House of Commerce; and that the druggists distinguish four species: feral, rambling, montigenous, and fine. He concludes by maintaining that the cochineal insect is bred in Peru, as apparent from the assertions of Herrera and Pinelo, and also from his personal observations in Tucumán and Buenos Aires, where he saw it being sold on strings, and in Lima, the live insect on the nopals or tunas.*[16]

Finally, grain is also a common listing in eighteenth-century inventories of the Jesuit Guarani missions.[17]

ACQUIRING A NEW KNOWLEDGE OF COCHINEAL

How did Andean painters apply cochineal in their works of art? Although Andean societies share a long tradition of managing cochineal for dyeing, the introduction of a European visual system to Andean spectators and artists—including an unknown compositional and iconographic organization as well as new materials and techniques—involved acquisition of a completely new knowledge of how to manage the red substance.

Red was the color of Christ's blood and cloak, of the Virgin's tunic, and of high political and religious hierarchies. Together with cinnabar, hematite, and minium, cochineal—ground with oils and resins—brought light and shades to those and other details. Spanish treatises, such as those by Vicente Carducho, Francisco Pacheco, and Antonio Palomino, together with Alexo Piamontes's and Bernardo Monton's books of secrets,[18] offered recipes for cochineal's manipulation within the art workshops of Cuzco, Potosí, Quito, and all the Collao region. With regard to techniques for painted canvases,[19] the red carmine was almost exclusively used in lake form to work certain areas of the picture or, as the Spanish would say, to bathe an area previously painted with a coarser layer, as a glaze. Cochineal would also be mixed with lead white for carnations (flesh tones) and with other colors to obtain purple and reddish tones. Consider the following examples:[20]

Artistic production at the Jujuy Puna[21] in Argentina in the last decades of the seventeenth century was related to the powerful intervention of the marquis of Tojo, Don Juan José Campero y Herrera. He ruled his *encomienda*[22] for many years and promoted the construction of chapels and churches filled with retables, paintings, and sculptures. The inventory of his goods, completed by 1718, after his death, declared that he had two leather coffers full of grain and bags with other pigments.[23] Together with the Cuzquean and Altoperuvian paintings he bought, probably in the Potosí market, is a group of canvases attributed to the workshop of Matheo Pisarro, who might have worked directly under Campero's patronage.[24]

Two of these paintings, now at the Church of Casabindo, show the presence of cochineal. In the *Our Lady of the Rosary of Pomata* (circa 1690), a cochineal layer was applied

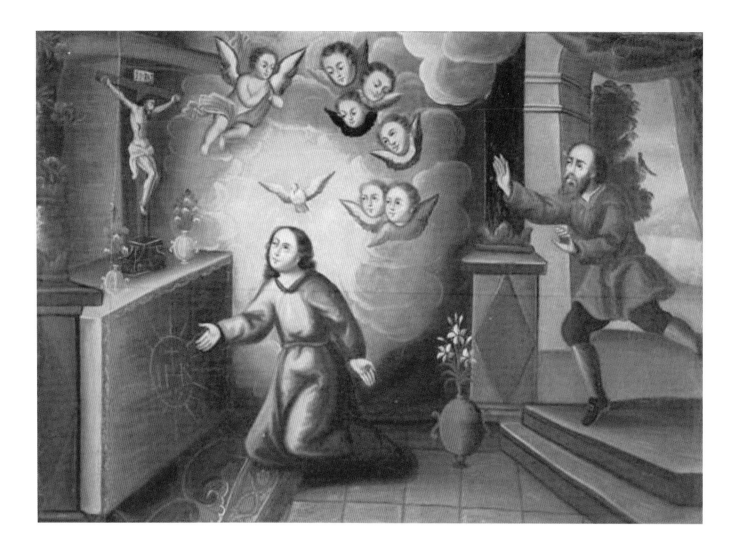

upon finely worked layers of vermilion, yellow, and lead white to bring out the luster of the brocade in the Virgin's cloak (figure 24.1). A similar usage can be identified in the red feathers of *Military Angel* (circa 1700) (figure 24.2), one of a series of military angels with harquebus in which two heavily applied layers of minium and vermilion are bathed in a cochineal red lake.

In the same period, the Cuzco painter Basilio de Santa Cruz Pumacallao applied cochineal on the red cloths and flesh of the *putti* in his *Immaculate Virgin Victorious over the Serpent of Heresy* (circa 1680–1700) from the Museo de Arte de Lima collection (figure 24.3). For the cloths, he mixed cochineal with minium; for the flesh tones he applied a small amount of cochineal in lead white over a layer of hematite.[25]

Many paintings from eighteenth-century Cuzco workshops also confirm the use of cochineal. In paintings from a series of the life of Saint Catherine of Siena in the Convent of Saint Catherine at Córdoba province in Argentina, the colorant appears as a final layer in such details as the red cloak of Christ or the wings of an angel,[26] or as a lake over orpiment in the *Saint Catherine in Glory* canvas.[27] It is also ground with indigo to obtain a dark purplish tonality, as in *The Father of Saint Catherine Sees the Holy Spirit above Her* (figure 24.4). This use virtually disregards what manuals such as one by Palomino advised on this mixture:

> *Indigo is carmine's mortal enemy; and thus must never be mixed with it, for both are lost, and the product of the two is a loathsome colour and 'tis not known which it is.*[28]

Cochineal mixed with minium, which produces a red lead color that is also a siccative, or drying substance, is also common, as identified in the Saint Rose series of the same convent. Finally, investigations of a series of kings and prophets of Israel (1764) painted by Marcos Zapata (also Zapaca), who was active in Cuzco between 1748 and 1764, have also revealed the presence of carmine. In this case, it is either bathing an iron oxide or directly applied as carmine-based lake over the ground, as seen in *Isaiah* (figure 24.5).

Opposite **FIGURE 24.4** Unknown, *The Father of Saint Catherine Sees the Holy Spirit above Her* (series of the life of Saint Catherine of Siena), Convent of Saint Catherine, Córdoba, Argentina, eighteenth century. Oil on canvas, 40⁴⁷⁄₅₀ x 56⁶⁹⁄₁₀₀ in. Archive of the Instituto de Investigaciones sobre el Patrimonio Cultural, Universidad Nacional de San Martín, Buenos Aires. Photo: Diego Ortiz.

Left **FIGURE 24.5** Marcos Zapaca (or Zapata), *Isaiah* (series of kings and prophets of Israel), Humahuaca Cathedral, Jujuy, Argentina, 1764. Oil on canvas, 80⁷⁄₁₀ x 64²⁴⁄₂₅ in. Archive of the Instituto de Investigaciones sobre el Patrimonio Cultural, Universidad Nacional de San Martín, Buenos Aires. Photo: Diego Ortiz.

From the ancestral uses of cochineal in pre-Inca times to the eighteenth-century Spanish domain, all of the aforementioned cases confirm the persistence and continuity of the use of cochineal—be it imported or developed by small local production—in the South American region. By 1802 Bohemian naturalist and Malaspina expeditioner Thaddäus Hænke would promote the convenience of breeding this insect on the southern coasts of the Rio de la Plata:

> Grain or cochineal . . . occupies a preferred place within other dyes. This insect is harvested at the city of Punta de San Luis, Governance of Cordoba del Tucuman, and still in other Southern American regions, but mainly in the Oaxaca valley, from which it is sent to the Peninsula's harbours. . . . It is the only dye of the kind that is used in all Europe. The foreign chemists still work hard to thwart this powerful branch of our commerce, trying to analyse by all means a substance that could imitate the permanent texture of this precious colour, that the Spanish have abandoned—or look with great indifference. . . . This [commerce] is capable of rising the inhabitants to the highest grade of wealthiness: as they still use the wild one for dyeing threads, wool and cotton.[29]

Hænke's remarks acknowledge both the survival of a tradition that never disappeared in the region and the possibility of changing local cochineal production practices through good enterprise. As in Mexico, cochineal had always been considered by Spanish people in Peru as associated with prosperity and wealth.[30] Eradicating idolatry was, of course, just an excuse to monopolize the resource. For the ancient inhabitants of the Andean highlands, cochineal represented the material that dyed and incarnated the warp and weft of sacred and noble textiles. These cultural practices would not stop; instead, they would be resignified in the elaboration of Spanish colonial Peruvian tapestries and textiles.[31] For the painters of the viceroyalty of Peru, cochineal would play an important role in achieving technical solutions to aesthetic and creative problems, as well as in their representation of a whole new iconography in the South American Spanish territories. 🌀

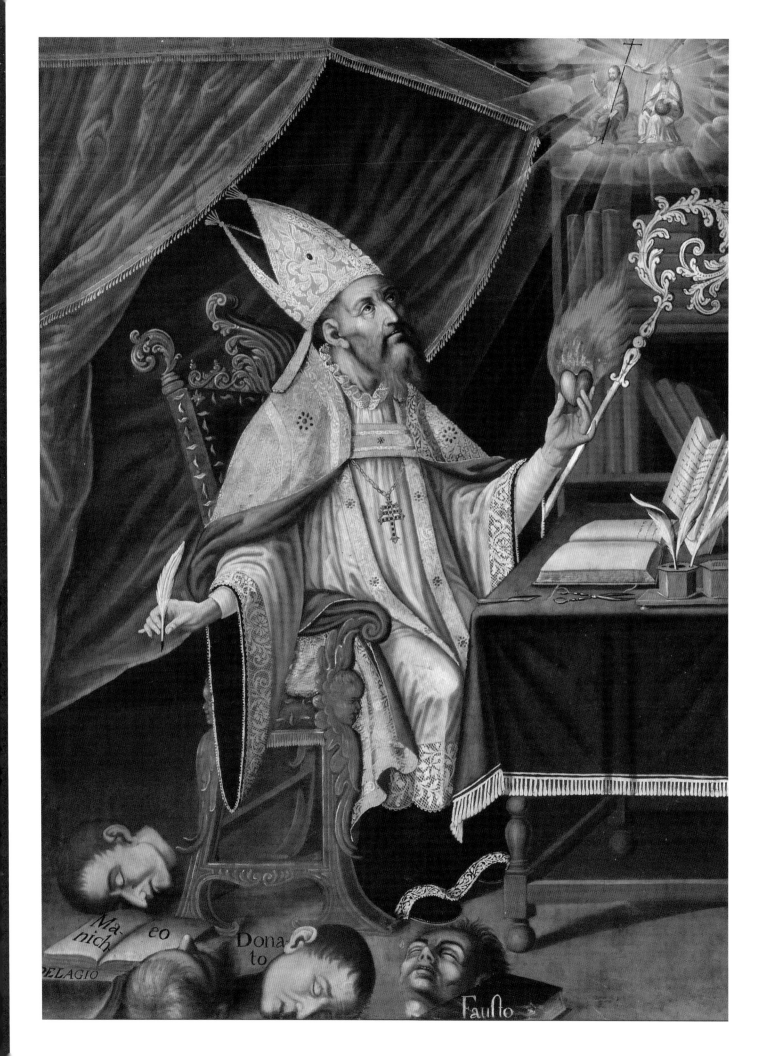

Ma
nich eo

Dona
to

PELAGIO

Faufto

MELCHIOR PÉREZ DE HOLGUÍN (?)

■ *Saint Augustine*
Bolivia, late seventeenth century
Oil on canvas
48¹³⁄₁₆ x 35⁷⁄₁₆ in.
New Mexico History Museum, Department
of Cultural Affairs, gift of the International
Institute of Iberian Colonial Art, 2005.27.31

This is a particularly beautiful example of a
composition that originated in Europe and
circulated around the colonial Americas. It
shows the bishop-saint seated at his desk,
contemplating a flaming heart and rejecting
the pagan heads scattered over the floor as he
writes. Of the vivid reds dominating the painting,
perhaps the most important is the heart, which
is depicted with cochineal.

UNKNOWN

Saint Rose of Lima
■ Alto Peru, eighteenth century
Oil on canvas
65⅜ x 41⁷⁄₁₆ in.
New Mexico History Museum, Department
of Cultural Affairs, gift of the International
Institute of Iberian Colonial Art, 2005.27.43

Paintings of this patron saint of Lima, capital of
the Spanish viceroyalty of Peru, were common
throughout the Andes, where wild cochineal
had been used for textiles since at least the
second century. In the Spanish colonial period,
its use extended to oil paintings of Christian
subjects favored by the Spaniards. In this
example, a border of roses honors the saint's
name while imitating Flemish paintings of the
previous century. Cochineal was identified in the
transparent glaze of the rose at the saint's throat.

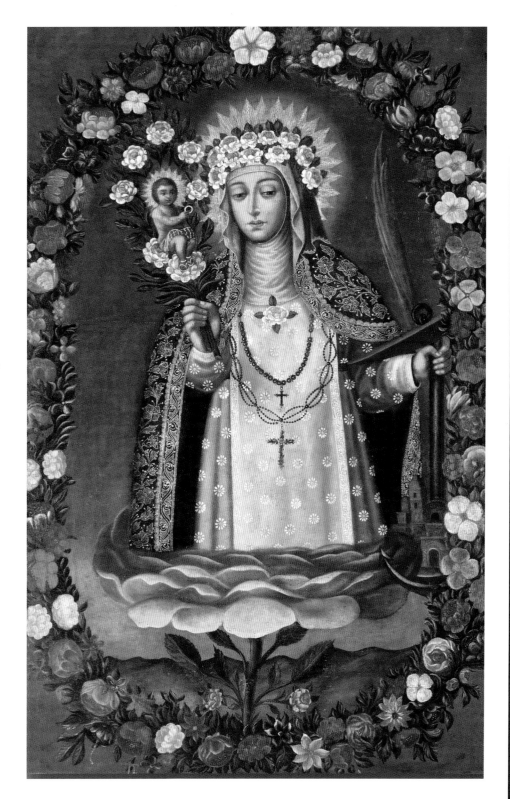

PAINTING IN NEW SPAIN

Conveying Meaning through Cochineal

BARBARA ANDERSON

FROM THE PRE-COLUMBIAN ERA through the Spanish colonial period, Mexican artists appear to have deliberately chosen cochineal from among all the reds available for various forms of painting.[1] However, we must remain somewhat speculative about indigenous production in the pre-Columbian and early contact periods, as only one postcontact manuscript has been examined using high-performance liquid chromatography (HPLC). Others have been examined spectroscopically, providing evidence that leans heavily toward but does not cross the line to conclusive identification. Yet because cochineal was demanded as tribute by the Aztecs and its use in textiles was probably limited to dyed fur and painted cotton, the most common textile in Mexico, its high value must also have been predicated on other uses in painting. (See Brittenham, this volume.)

Of native customs dating before Spanish contact, and presumably still observable at the time of his writing, Bernardino de Sahagún explained in the *Florentine Codex* of 1576–1577 that *grana* (cochineal), when purified and made into "small bread" shapes, was called *tlaquauac tlapalli,* or fine *grana*: "It is sold in the market in this form to painters and to dyers of rabbit skin."[2] The text of the *Florentine Codex*, in which cochineal is thought to have been used extensively, also explains cochineal production and illustrates its use by painters (see Magaloni Kerpel, this volume), as well as by harlots and witches, who, in another form of painting,[3] tinted their lips with it. Thus it does not seem reckless to suggest that when paintings seem to incorporate cochineal based on appearance combined with historical evidence, they likely do.

The earliest known paintings in which cochineal use has been postulated, according to Magaloni Kerpel, are in pre-Columbian Zapotec tombs. Among these are Monte Alban Tomb 204 from Period I (circa 200 BCE), Monte Alban tombs 104 and 105 from the Classic period (600–750 CE), and Tomb 5 at Cerro de la Campaña in Suchilquitongo (circa 750 CE). In each, cochineal predominated in a mixture of three organic reds, plus small amounts of hematite at Monte Alban and of hematite and cinnabar (vermilion) at Suchilquitongo. The mixture produced "Zapotec red," a transparent, reflective background that set off the hematite red human figures and created an otherworldly space through manipulation of the reds.[4] Later, in Oaxaca, especially in the Mixteca Alta center of cochineal production, historical and genealogical manuscripts from between 1150 and 1520, including the *Codex Zouche-Nuttall, Codex Becker, and Codex Cospi,* share a transparent red that indicates probable use of cochineal, based on spectroscopic examination.[5]

Although a greater variety of painted objects emerged in the viceregal era, manuscripts from the period have been subjected to more scientific scrutiny than other object types, providing information about probable cochineal use. Cochineal and other reds have been found in the Mapa de Cuauhtinchan number 2 from the Puebla region and dating to the mid-sixteenth century;[6] in a deerskin map from the same period in central Mexico;[7] in the *Codex Huejotzingo* of around 1531 and also from the Puebla region;[8] and in maps of Ameca, Atlatlauca, and Cholula, all dated around 1581.[9] The *Codex Reese,* or Beinecke Map, dated around 1560, is the only Mexican manuscript from either the pre- or post-Hispanic era in which cochineal has been definitively identified through HPLC.[10]

The choice of cochineal in Mexican painting was apparently made not only on the basis of its arresting color qualities but

■ *Opposite* FIGURE 25.1 *Codex Huejotzingo,* Mexico, ca. 1531. Pigments on maguey paper, 20½ x 8 in. Library of Congress, Washington, D.C., Manuscript Division, Harkness Collection, ms. 1531, drawing 3.

because it embodied particular meanings that carried certain continuities of association from the pre-Hispanic to the viceregal period. With regard to the reds in the mural paintings of Tomb 5 at Suchilquitongo, Magaloni Kerpel asserts that the hematite red extracted from below the earth's surface depicts the Zapotec underworld, while the red of the cochineal insect, which lives aboveground and is the primary element in so-called Zapotec red, represents that world.[11] She notes a similar usage of reds to convey meaning related to time in the sixteenth-century *Florentine Codex* and Beinecke Map. In Book 4 of the former, which treats the Aztec calendar, day signs referring to precontact dates are colored mostly with cochineal while postcontact events are depicted using the European pigment minium.[12] Of the Beinecke Map, Magaloni Kerpel writes that three horizontal red lines represent "movement through space and time," as in the pre-Columbian *Codex Selden* and *Codex Bodley*. In addition, she stresses the symbolic importance of maize through its depiction with the colorant. For Magaloni Kerpel, the application of vermilion over cochineal on the map, in the spiny oyster shell forming the name of Don Diego de San Francisco Tehuetzquititzin, is significant, as the colors are almost identical; one could have been used to the exclusion of the other without changing the appearance of the red. She asserts that this use of both reds is similar to the deliberate combination, in the Zapotec tombs, of references to the underworld through the red of the mineral hematite and to this world through the cochineal red made from an insect given life by the sun.[13]

INDIGENOUS AND TRANSPLANTED APPROACHES TO COCHINEAL

The probable cochineal in the *Codex Huejotzingo* (figure 25.1) depicts objects of high value and specifically coveted as tribute, such as textiles of painted cotton and dyed rabbit fur. (See Brittenham and Marichal, this volume.) The *Codex Mendoza*[14] and *Matrícula de Tributos*[15] show bags (*zurrones*) of cochineal cakes from the town of Coixtlahuaca in the Mixteca Alta. While neither manuscript has undergone HPLC analysis, the transparent red cochineal cakes could have been depicted by the substance itself.

Another indigenous form of "painting" in which cochineal figured was the so-called feather mosaic or feather painting (*amantecayotl*). Unique to Mexico in the pre- and postcontact eras, the genre is highly prized for the iridescent

■ FIGURES 25.2A–25.2B Unknown, *Saint Anthony*, Mexico, seventeenth century. Feathers and paper on copper, 11⅛ x 8 in. Denver Art Museum, gift of Frederick and Jan Mayer, 2011.424. Full painting and detail of sample site showing cochineal in border. Photo courtesy Denver Art Museum.

optical shifts of its natural and dyed feathers when viewed in changing light. To the Aztecs, red feathers, often cochineal-dyed, were valued for tribute and ceremonial regalia. The art of featherwork was so dazzling to the Spaniards that they included it in the curriculum of native schools, such as San José de los Naturales, established in Mexico City soon after their arrival to communicate Christian subject matter for purposes of conversion in Mexico or of liturgical pomp in Europe. Its beauty was grasped immediately in Europe, where objects of great importance such as bishops' miters, which were embellished with feathers in Mexico, were given as gifts to higher clergy and nobility with Spanish connections.

The Spanish humanist Felipe de Guevara, writing at the court of Philip II, where he saw both Mexican cochineal and feather painting, interrupted his treatise on European art to marvel that "they are blessed in colors, now being of earth, now of juices of various herbs, without counting cochineal, which is the rarest carmine. It is also just to concede that the Indians brought something new and rare to art with bird-feather painting."[16]

Most surviving colonial-era feather paintings contain some red, often now so faded that its effects are difficult to conjure. Only a devotional panel depicting Saint Anthony (figure 25.2a) has been scientifically proven to employ cochineal, now very pale pink, in two of four sites analyzed by Mark MacKenzie, director of conservation for the New Mexico Department of Cultural Affairs. The cochineal was found in the border decoration in the lower left corner (figure 25.2b), but the same shade is also seen in the hem of the saint's garment, which could not be sampled.

Along with European styles and subject matter, techniques involved in painting in oil on canvas, copper, and wood were introduced to New Spain by Spanish and Flemish painters who migrated there in the sixteenth and early seventeenth centuries. As several Spanish painters came from Seville, where cochineal was off-loaded from ships arriving from the New World and where painters were already using cochineal as a red lake to create glazes to effect luminosity in painted representations of silks, taffetas, and velvets, it is not surprising to find it in the works they produced in New Spain. For example, Andres de Concha, a Seville native who arrived in Mexico in 1568 and died there in 1612, spent much of his time in the cochineal hub of the Mixteca Alta. Red lakes have recently been identified by Javier Vázquez as cochineal in Concha's paintings at Coixtlahuaca.[17]

Francisco Pacheco (1564–1644) provides the first evidence of cochineal's link between the Old and New Worlds. Probably the most highly respected painter and teacher in Seville before the rise of his pupil and son-in-law Diego Velázquez, Pacheco described the proper use of cochineal throughout *Arte de la pintura,* his treatise on painting techniques, first published posthumously in 1649. He singled it out for the imitation of velvets, remarking that "with this carmine color, I have made some very convincing velvets, but all lag behind those of my friend Alonso Vázquez, who was unequaled in this."[18] Vázquez left Seville for Mexico City in 1603 and died there in 1607, leaving only two securely attributed paintings: *The Martyrdom of Saint Hippolytus,*[19] which includes a red mantle upon which the fallen saint lays his head, and *The Immaculate Conception,*[20] with a striking curved arrangement of billowing red draperies on the Virgin and angels. Neither painting is known to have undergone pigment analysis, but it is unlikely that this acclaimed master of cochineal velvets would have declined to use it in his adopted Mexico City, where he would have found it considerably cheaper to acquire than in Spain.

DOCUMENTING COCHINEAL

Viceregal Mexican paintings had not been tested for cochineal using HPLC until the Museum of International Folk Art in Santa Fe, New Mexico, initiated an analytical project in 2011. Working in partnership with the Santa Fe museum, Marco Leona of the Metropolitan Museum of Art identified cochineal in *Saint Michael and the Bull* by Sebastián López de Arteaga (figure 25.3). López de Arteaga, another Seville native, immigrated to Mexico around 1640. By then he was already a trained master and undoubtedly familiar with the works of fellow Sevillanos Diego Velázquez (figure 25.4) and Francisco de Zurbarán, both of whom are known to have used cochineal.[21] (See Bruquetas and Gómez, this volume.) In *Saint Michael*, López de Arteaga follows Pacheco's recommended practice of using cochineal as a lake, specifically in the red draperies swirling behind the saint. The draperies create a strong diagonal compositional thrust anchored by the similarly hued, yet untested, red silk border in the bishop's chasuble in the lower left corner.

Other colonial Mexican paintings found to contain cochineal date from the later seventeenth century through the eighteenth century and include paintings on canvas, wood, and copper supports. The latter was frequently used in conjunction with a genre prominent in New Spain, the so-called *casta* painting, a type usually produced in a series of twelve or sixteen panels depicting the perceived range and characteristics of racial

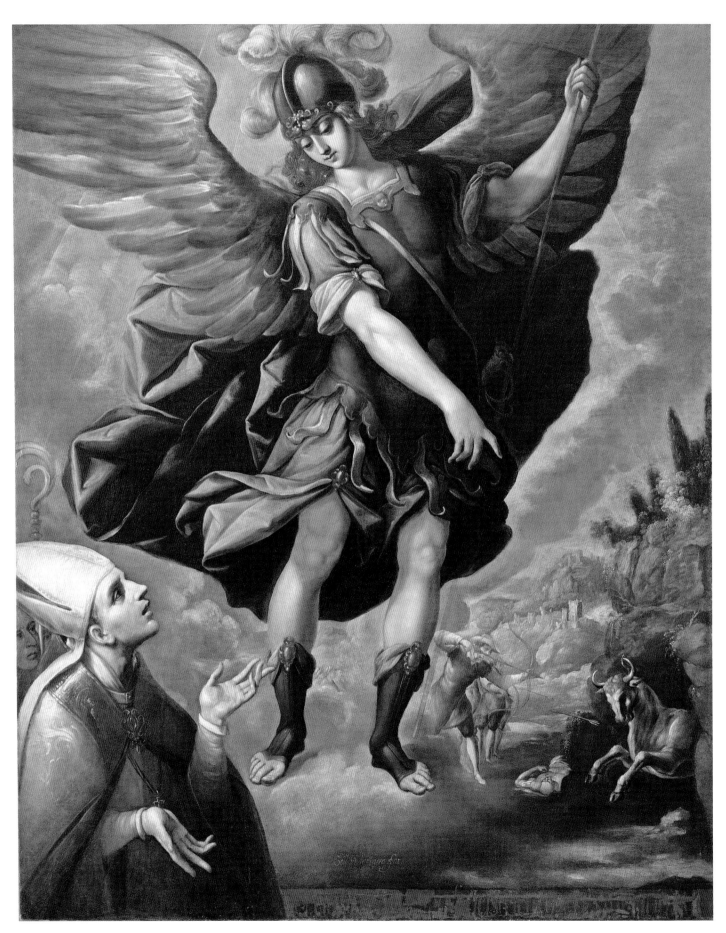

Velázquez, perhaps the most important
painter of Spain's golden age, was born
and trained in Seville, where cochineal
was off-loaded and traded upon arrival
from Mexico. His teacher and father-
in-law was Francisco Pacheco, whose
posthumously published *Arte de la
pintura* (Seville, 1649) was one of
the seminal treatises on painting in
that era. Pacheco devoted much of
his writing to the use of cochineal in
painting, particularly in the depiction
of soft flesh tones and the lush velvet
draperies so prized at the time. While
in Seville, and possibly still under the
tutelage of Pacheco, Velázquez depicted
the draperies of Saint John with
cochineal, according to analysis by The
National Gallery, London.[a]

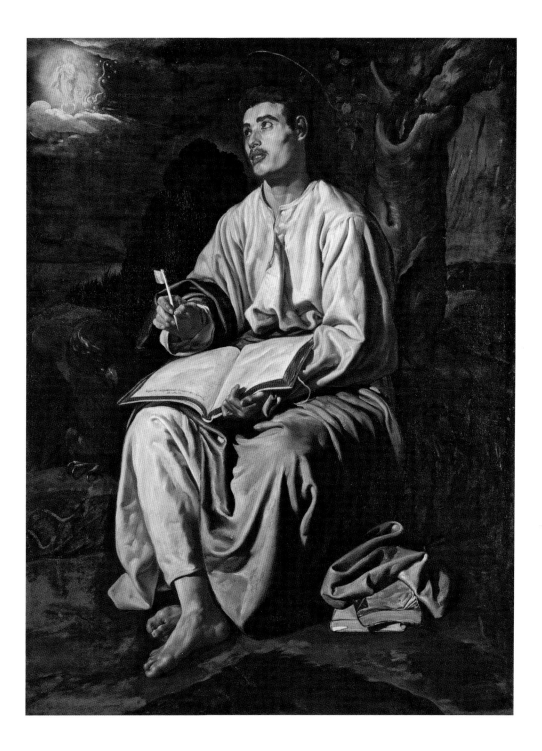

de Castizo y Española 3
Español.

mixtures created through intermarriage in the Hispanic New World. In many examples, a well-to-do white Spaniard and his racially diverse family inhabit a handsomely appointed interior decorated with textiles depicted using cochineal (figure 25.5).[22] Cochineal has also been discovered in another characteristically New Spanish painting form called *enconchado*, in which mother-of-pearl is embedded into areas of oil paint and, like featherwork, seductively exploits the light-capturing properties of natural materials. *The Betrothal of the Virgin* (figure 25.6) demonstrates the spectacular, luminous effect created by a cochineal glaze not only over red pigment but also over a shell inlay, giving the latter a rosy veiled surface.

■ *Opposite, top* **FIGURE 25.5** *From Purebred Creole and Spaniard: Spaniard* (*de castizo y española: español*), Mexico, 1775–1800. Oil on copper, 14 x 19¹⁹⁄₆₄ in. Museo de América, Madrid, 00052. Photo courtesy Museo de América.

■ *Opposite, bottom* **FIGURE 25.6** *The Betrothal of the Virgin*, Mexico, ca. 1676–1725. Oil and mother-of-pearl on wood, 36¹³⁄₁₆ x 48¹³⁄₁₆ x 2¹¹⁄₆₄ in. Museo de América, Madrid, 00172. Photo courtesy Museo de América.

Below **FIGURE 25.7** Cristóbal de Villalpando, *Joseph Claims Benjamin as His Slave*, Mexico, ca. 1700–1714. Oil on canvas, 59½ x 82⅝ in. Denver Art Museum, gift of Frederick and Jan Mayer, 2009.761. Photo courtesy Denver Art Museum.

Artists known to have used cochineal include Cristóbal de Villalpando (figure 25.7), Juan Correa or his circle (figure 25.8), and Miguel Cabrera. Most samples taken from their oil paintings, as well as from painting and lacquer on furniture and other decorative arts on wood (see Curiel, this volume), were of depictions of textiles, either in garments, wall coverings, or drapery swags.[23] In the *Ex-voto to Saint Anthony*, dating around the mid-eighteenth century (figure 25.9), MacKenzie found cochineal over vermilion in an area of shadow in red drapery, as instructed by Pacheco in his treatise.[24] This technique preserved the expensive cochineal for nuanced application by a master painter over the cheaper colors underneath, which were often left to his workshop assistants.

Two other sampled paintings showed different employment of cochineal. The depiction of the sheen of petals in a flower border in a second *enconchado*, the *Circumcision of Christ*, indicates the same use of the colorant as seen in the border of the *Saint Anthony* feather painting (see figure 25.2b) and in an eighteenth-century still life with cochineal-glazed flowers by the Dutch artist Jan Van Huysum (figure 25.10). Another example of cochineal use is in the enigmatic *Portrait of a*

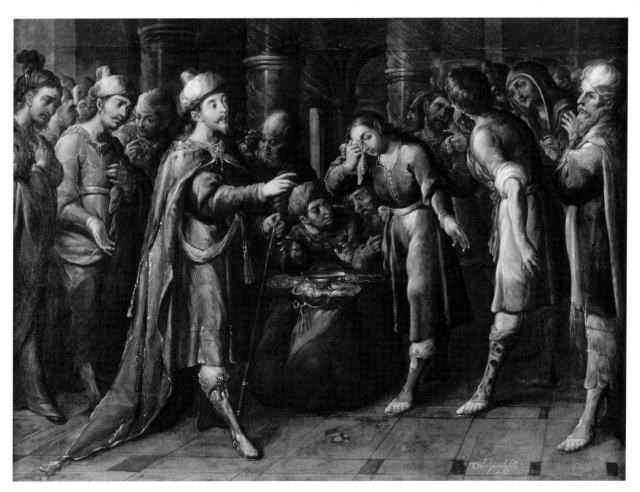

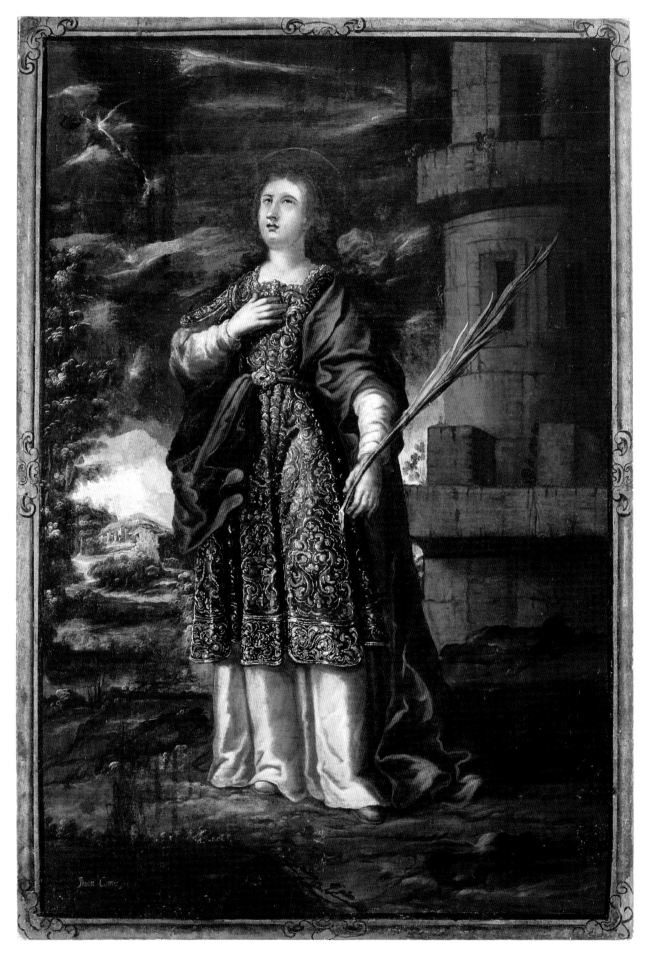

Young Woman with a Harpsichord (figures 25.11a–25.11b). In addition to a deep shadow in the splendid gown, cochineal colors the red letters on the white instrument keys.

In European painting, cochineal lake also produced soft, pink-tinged flesh, especially of women and children. Even in the late eighteenth century, when cochineal was generally considered too fugitive a colorant, certain artists, such as Joshua Reynolds in England, stubbornly continued to use it because of its verisimilitude.[25] No samples could be taken from flesh depicted in any of the viceregal Mexican paintings in Santa Fe, Denver, or Madrid, so it is not yet possible to conclude that the use of cochineal in viceregal Mexico mirrored the scope of its application in Europe. But it is clear that most of the recommendations of Pacheco and his contemporaries, such as Roger de Piles, were followed. Future testing may uncover cochineal in earlier and possibly other forms of painting in New Spain, such as illuminated manuscripts. What we know now is that cochineal's beauty and versatility made it a mainstay in Mexican painting for well over a thousand years, linking two different artistic traditions that met in one place and shared a reverence for color's ability to convey meaning by engaging the eye.

Opposite **FIGURE 25.8** Juan Correa (?), *Saint Barbara*, Mexico, late seventeenth to early eighteenth century. Oil on canvas, 83⅛ x 57⅛ in. New Mexico History Museum, Department of Cultural Affairs, gift of the International Institute of Iberian Colonial Art, 2005.27.02.

■ *Above* **FIGURE 25.9** *Ex-voto to Saint Anthony*, Mexico, mid–eighteenth century. Oil on canvas, 15 x 33 in. Collection of the Spanish Colonial Arts Society Inc., Museum of Spanish Colonial Art, gift of the Fred Harvey Company, 1954.077. Photo: Addison Doty, courtesy Museum of Spanish Colonial Art.

FIGURES 25.10 AND 25.11A–25.11B *following spread*

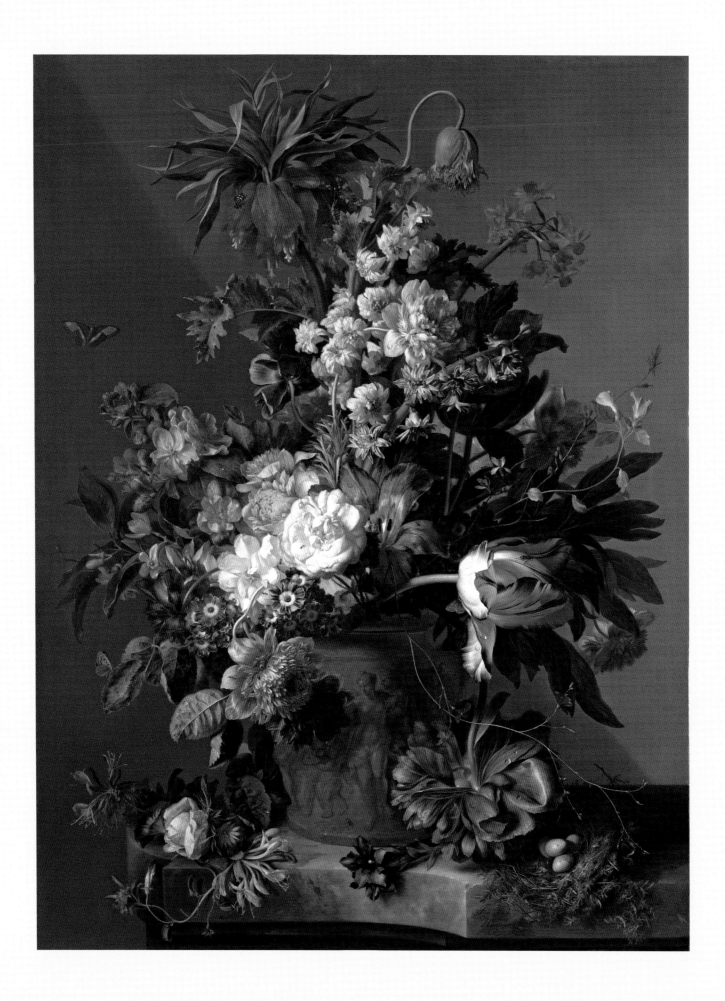

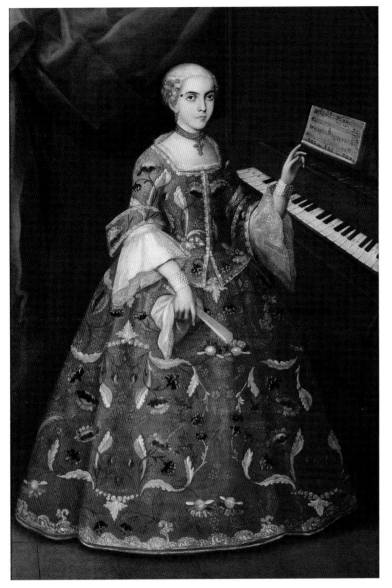

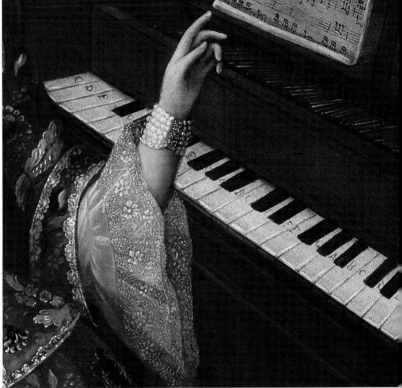

FIGURE 25.10
JAN VAN HUYSUM
Vase of Flowers
Netherlands, 1722
Oil on wood panel
31¼ x 24 in.
J. Paul Getty Museum, 82.PB.70

FIGURES 25.11A–25.11B
UNKNOWN
■ *Portrait of a Young Woman with a Harpsichord*
Mexico, early eighteenth century
Oil on canvas
61⅝ x 40⅜ in.
Denver Art Museum, gift of Frederick and Jan Mayer, 3.2007
Photo courtesy Denver Art Museum

Although seventeenth- and eighteenth-century painting treatises and manuals commonly describe methods for creating glossy flower petals with glazes of cochineal lakes, most paintings examined for cochineal with high-performance liquid chromatography (HPLC) to date have been sampled in areas of clothing. In this still life, however, two flowers—a reddish-orange marigold and an unidentified flower in pure red—were analyzed and found to contain mordants indicating the presence of an organic lake. The lake was later found to be entirely consistent with cochineal.[b]

NOCHEZTLI–BLOOD OF THE PRICKLY PEAR

Cochineal in Domestic Furnishings in New Spain and Mexico

GUSTAVO CURIEL

THROUGHOUT HUMAN HISTORY, the color red has carried innumerable symbolic meanings, some of them related to religion, political power, and social prestige. With the European discovery of America in 1492, two long-established cultures, the Mesoamerican and the European, came together. In both cultures, the color red carried multiple meanings that in some cases fused in a syncretistic way in the viceroyalty of New Spain.

Viceregal artisans dyed and painted a variety of objects in different shades of red. Recent scientific investigations have confirmed the presence of cochineal as a dye in the decoration of furniture and luxury goods for daily use in the viceroyalty of New Spain and in nineteenth-century Mexico.[1] This important discovery has led to new questions about the use of the prized *nocheztli*—"blood of the prickly pear" in Nahuatl, the Aztec language—and the meaning of the color red in viceregal society. It has also opened a significant and novel field of investigation full of angles and planes still unknown.

THE BADGE OF SOCIAL PRIVILEGE

The display of ultraluxurious furniture—the badge of the most privileged social levels of viceregal New Spain—was one way that dominant elites presented themselves. Such furniture shared space in mansions and palaces with exquisite works of silver, fine porcelain, striking enameled ceramics, pottery of fine imported red clay, sumptuous textiles, precious feather mosaics, illustrated screens, iridescent chessboards of nacre (mother-of-pearl), and objects marked with the heraldic shield of their owners, indicating that these were very special possessions. Owing to its high quality and rarity, much of this fine woodwork was also exported to Europe and other parts of viceregal America.

Generally speaking, luxury furniture was made to specific order, and many examples were utilitarian pieces of obvious high quality. These were not plain objects; the materials used in their manufacture were always expensive, precious, unusual, and rare. These examples of *carpintería de lo blanco* (white woodwork) had a high market value and were considered exceptional pieces by their makers and buyers alike.

A fine lacquer *papelera* (a piece of furniture for keeping papers and other writing materials) from the Franz Mayer Museum in Mexico City is a good example (figure 26.1).[2] Made in Pátzcuaro, Michoacán, the eighteenth-century work was created in the so-called Workshop of Mythological Themes.[3] According to Sonia Pérez Carrillo, the iconography includes scenes related to moralizing myths from the writings of the Roman poet Ovid. One side of the piece depicts Diana, Roman goddess of the hunt; the other depicts Diana at her bath with the mortal Actaeon looking on. The front doors display a lavish triumphal cart featuring a woman with a scepter, possibly representing the moon, and four women pulling it forward.

In the interior of the *papelera*, on the drawer fronts, a vegetal trail of flowers and fruits is painted on a bluish background. Created with obvious joy, the images convey a festive environment of luxury and exuberance. Some of the drawers boast views of rural architecture with an ample use of red. Golds and shades of carmine or cochineal predominate, though there are also brushstrokes of green. It is on this part of the piece that cochineal was detected. The off-white background on the exterior emphasizes hints of gold applied with the tip of a brush, the rich carmine red clothing of the figures, and

■ *Opposite* **FIGURE 26.1** Workshop of Mythological Themes, *Papelera* (writing chest), Mexico, eighteenth century. Pine, lacquer, iron, 28⁵⁄₁₆ x 38 ¾ x 22⁹⁄₁₆ in. Colección Museo Franz Mayer, Mexico City, CBD-0012.

the exquisite bunches of flowers that frame the mythological scenes. These elements resemble leather cutouts executed in the mannerist style. An Asiatic influence also characterizes some of the plant forms and other landscape elements.

With its complex iconography and seamless merging of artistic materials and styles, this is no doubt an erudite work intended to reflect the refined humanist spirit of New Spain. In its day, this *papelera* had great economic worth, as cochineal was a very costly dye. Iconographically, it displayed a learned knowledge of the classics, derived from the humanism that arrived in the Americas by means of European engravings. Additionally, the lacquerware of Pátzcuaro highlights iconographic elements from the local landscape while at the same time incorporating Asian forms. The pieces are therefore blended works that imitate Asian lacquer works with different artistic languages. All this tells us that this

exceptional piece was destined for display in the luxurious interior of a house of the viceregal elite, a demonstration of the owner's advanced educational background and superior social and cultural stratum.

Another significant example of luxury woodwork that has been proven to have cochineal is a cushioned sewing box, also made in Pátzcuaro, from the Museum of International Folk Art in Santa Fe, New Mexico (figures 26.2a–26.2b).[4] This practical household item from the late eighteenth or early nineteenth century was used in doing fine lacework. It was intended for use by women of the most economically favored levels of viceregal society, women who spent many hours in the visiting rooms of the houses and palaces of New Spain creating lacework and embroidery. The reds that adorn the wardrobes of the figures, engaged in amorous pursuits with courtly *sprezzatura* (an Italian word expressing refined social behavior),[5] are where the highly sought carminic acids were found. The underside of the lid has two portraits—of a gentleman and a lady—indicating that this was an extravagant wedding gift.

A large number of surviving sewing boxes manufactured in the same place are similarly shaped and adorned. In fact, this successful style was copied in numerous production centers of the viceroyalty and in nineteenth-century Mexico. These small pieces of furniture were used in the creation of bobbin lace and other works with braided thread. New Spain imported large quantities of Flemish, French, and Italian lace, but lace was also made locally with thread spun from the tough fiber of maguey, the century plant. The boxes all have an elongated form with a cushion on top covered with the finest fabric, though in this case the cushion has been lost. Inside, several compartments were used to store scissors, metallic threads, bundles of silk, ribbons, needles, and thimbles of silver and gold. One also frequently finds portraits of wealthy young couples, sweethearts whose images "magically" appear when interior lids are opened.

These pieces have a very feminine and festive character. The cushions were decorated with delightful scenes of daily life, mainly of courtship, bucolic landscapes with willows, couples with their servants, and country homes with pitched,

■ *Left, top and bottom* FIGURES 26.2A–26.2B Sewing box and cover, Pátzcuaro, Michoacán, Mexico, late eighteenth or early nineteenth century. Wood, paint, metal, gold leaf, 4¾ x 17⁵⁄₁₆ x 5 in. Museum of International Folk Art, IFAF Collection, anonymous gift, FA.1993.12.1.

■ *Opposite* FIGURE 26.3 *Batea* (tray), Pátzcuaro, Michoacán, Mexico, ca. 1701–1750. Wood, paint, 42⅛ in. diameter. Museo de América, Madrid, 06921. Photo courtesy Museo de América.

wood-shingled roofs. Many of these pieces came from the well-known workshop of the noble indigenous craftsman José Manuel de la Cerda (active in 1763).[6] However, a precise chronological study of these magnificent works is yet to be done. Judging by the types of clothing worn by the figures on some of the cushions, the boxes can be dated to the beginning of the nineteenth century, but they display decorative motifs linked to the celebrated chinoiserie of French rococo, so in vogue in decorative repertories of the past that they had by then become, by force of repetition, established landmarks of style.

Undoubtedly, *bateas* (lacquerware trays) from Michoacán were utilitarian items of the first order; those from Pátzcuaro, Peribán, and Quiroga particularly stand out. The trays had various household uses but were always opulent pieces,

worthy of displaying grand coats of arms as well as inscriptions referring to the noble lineage of their owners. Because of their decorative richness and elaborate iconographic messages, many of these trays were hung in rooms where guests were received; their display denoted the social rank of their owners. In high society, the trays played an important part in the protocol of *servicio de salvas,* or service of distinction, a social etiquette of great refinement when offering food.[7]

Scientific analysis of one of these trays, from the collection of the Museo de América in Madrid, Spain,[8] detected the presence of cochineal (figure 26.3). It is a very large item that, according to Pérez Carrillo, was made in the eighteenth-century "Workshop of the Four Flowers" in Pátzcuaro.[9] Generous amounts of red are evident in the decoration—in the flowers, the canopy that covers the main scene, the clothing of

the figures, and the brackets formed by dynamic plant motifs. Various themes of daily life and hunting scenes are also depicted, evidence of the owners' prominence on the social scale. The story of the central medallion, which includes a masculine figure with a royal crown and three women, is yet to be discovered.

In general, three decorative influences are clearly present in lacquerware trays and furniture from Pátzcuaro: European, Novohispano, and Asiatic. These types of lacquerware are examples of the borrowing from other artistic vocabularies that can be found in the art of New Spain. Technically speaking, the presence of cochineal on a black background, alternating with loose brushstrokes of green, blue, gold, yellow, white, and brown, serves to build the profusion of flowers. This fruitful exchange of elements of style and the consequent appropriation of technique and decoration from Europe, Asia, and the earth itself are characteristics of the lacquerware art of Pátzcuaro. These works serve to identify and demonstrate the desire to be different from Creole society—that is, society consisting of Europeans born in the New World. By possessing pieces such as these, the New World Spaniard codified the values that made him different from the peninsular Spaniard.

Other significant lacquer works are from present-day Guerrero, where pieces from the area of Olinalá have a preeminent place in the considerable production of lacquerware from that state. The work is characterized by skilled hands and rich color, as well as a display of technical ability. It was in Olinalá that the famous technique of "striping" was invented in the eighteenth century. The process consists of superimposing thick coats of lacquer, which are then scraped away using sharp, pointed instruments to create figures, principally animals. Lacquer is also applied to a smooth surface with no additional coats; these areas are then decorated with paint or gild using small brushes. Two towns near Olinalá that are also known for their *jícaras*, or varnishes, are Temalacatzingo and Acapetlahuaya. In the latter place, Carlos Espejel in 1973 reported the use of cochineal on small lacquered bowls.[10]

Cochineal was detected on a beautiful lacquered chest in the collection of the Museum of International Folk Art,[11] made in Olinalá in the mid-nineteenth century (figures 26.4a–26.4b). The wood used is *lignáloe* (*Bursera linaloe*), which has an agreeable aroma that drives insects away and therefore works well to keep textiles safe. The piece has lacquer backgrounds embellished with brushwork.

Clearly European in style, this type of furniture was made for wedding gifts or as very special presents for important people. Trunks used by betrothed women, commonly known as *baúles de donas* (damsels' trunks), held possessions that the bride was bringing to the marriage, such as bedding, clothing, and fabrics, and featured painted inscriptions of brides' names. Other chests also had the name of the owner; for example, a man with a university degree or a high-ranking military officer. Both are examples of personalized furniture.

The dazzling decoration on the lacquered chest displays two imaginary scenes of colorful urban vistas, one of them a seaport. These strong images of the business of daily life occupy the entire front of the trunk as well as part of the lid, though the cities depicted are fictitious. One frequently observes in this type of trunk that architectonic motifs are repeated, like tracings, throughout the piece, fitting as best they can into the space allotted. Other scenes and motifs from daily life shown here include a pair of lovers framed by graceful bouquets, garden architecture, vases with bouquets, animals, snow-covered volcanoes, fountains, and even games of cards.

In addition to a variety of civil and religious buildings, as well as arcades and plazas open to the sky, the front of the trunk portrays numerous figures of diverse social strata, from families out strolling to merchants to coachmen. Fountains, street lamps, carriages, mountains, trees, and streets with marked vanishing points are also displayed. The main buildings have balconies, and the spires of churches stand out against the intense red sky. In the upper right section, four bulls burst forth, putting a folksy stamp on the scene. Perhaps this is a depiction of a pleasant Sunday, and the bulls will be those in the bullring that day.

The back part of the lid features two intriguing dogs with long white manes. In the background are ducks, large squirrels, and birds that slice through the sky. In the center is the national seal of Mexico, with the eagle, the serpent, and the prickly pear; over these native emblems is a symbol of liberty. Large birds and other animals are painted on the sides of the trunk (figure 26.4b), without any relationship to the figures in the main scenes. A multitude of flowers arranged in bands frame the stories and complete the decoration, but one rectangular space with no decoration captures attention. Appearing on the front of the lid, the space is painted

■ *Opposite* FIGURES 26.4A–26.4B Chest, Olinalá, Guerrero, Mexico, ca. 1850. Wood, paint, 15 x 33 x 13 in. Museum of International Folk Art, IFAF Collection, FA.1979.25.1.

■ FIGURES 26.5A–26.5B *Escritorio* (writing chest), Mexico, probably Michoacán, eighteenth century. Hardwood, gesso, paint, gold leaf, iron, 15⅜ x 19⅝ x 16½ in. Collection of the Spanish Colonial Arts Society Inc., Museum of Spanish Colonial Art, gift of Mrs. H. M. Greene, 1956.089.

yellow and was intended to hold the name of the trunk's owner. In this case, however, the name does not appear.

IMITATING LUXURY

The production of furniture using cochineal in the decor was not restricted to pieces destined only for the wealthiest strata of viceregal New Spain. A good number of "minor pieces" of home furnishing adhere, in one way or another, to the excellent models of luxury that the elite acquired. Made for middle-class members of viceregal society, these carpentry items imitated or copied luxury paradigms, but with very different materials and artistic qualities. The following items in which carminic acid was found offer proof of the above.

An *escritorio*, or writing chest (figures 26.5a–26.5b), from the Museum of Spanish Colonial Art in Santa Fe, New Mexico,[12] is decorated with curled trails of flowery vegetation, perhaps representing acanthus leaves, and exhibits lively brushstrokes of red. The fronts of the drawers also show a large quantity of carmine. Regrettably, current research cannot identify the chest's exact location of manufacture, though furniture such as this, painted to imitate lacquer finishes, appears in the inventories of many private estates. The finish is alternately listed as "faux lacquer," "lacquer Chinese style," or "paint that imitates lacquer." A field calling for additional research is that relating to painting that imitates the lacquers of both Asia and New Spain.

From the beginning of the sixteenth century, there developed a marked preference for painted furniture, in contrast to the austere furniture of Spain, especially that of Castile. Painted viceregal furniture was soon deemed worthy of export to the Iberian Peninsula, owing to its unusual, curious, or novel qualities.[13] By the eighteenth century, painted figures were appearing on all areas of decoration—the backs, sides, lids, drawers, covers, fronts, feet, and more—of a great number of pieces of New Spanish furniture. Large and small desks, wardrobes, chests of drawers, consoles, sofas, screens, headboards, and other items were filled with elaborate bouquets of flowers, scenes from daily life, trees, landscapes, and hunting scenes. Asian pagodas, gardens, parasols, willows, human figures based on Oriental prototypes, and other motifs were inspired by Asian arts arriving on the Manila galleons, which traveled between the Philippines and Acapulco, as well as by European chinoiserie that entered the viceroyalty through the port of Veracruz on the Gulf of Mexico.[14]

The color red has a preeminent place in almost all the polychromatic furniture mentioned. Brief descriptions found in legal documents (such as dowries, wills, diaries, and other accounts)

demonstrate the very concise way that painted furniture was described among other examples of luxury household goods: a "red bed," a "table given color," a "painted chest," a "red screen." These documents, however, do not indicate clearly whether or not the furniture features figurative painting.[15]

The writing chest under discussion has wrought-iron elements of average quality, reinforcing the idea that this writing box was made for midlevel viceregal society. In general, well-forged iron was reserved for high-quality furniture. Pleasant to look at and certainly colorful, this type of desk was sold in town squares, markets, and regional fairs but also by *mercachifles*, or traveling vendors. In other words, such writing desks were marketed through informal commerce, never in stores specializing in high-quality furniture, such as those in the famous Parián (a market building on the main plaza) or under the Arcade of Traders in Mexico City (on the east side of the great plaza). It is worth mentioning that this painted woodwork has a sort of "provincial" flavor to it, a label not intended to denigrate or lessen the work. Indeed, this class of goods exemplifies well a multiracial society with

clear aesthetic tastes, the result of complex internal artistic dynamics in response to unique local customs, with formal codes and specific materials.

At the top of the writing box is a wide compartment to hold pens, sheets of writing paper, blotters, and other implements of the "art of writing." Kept in the front drawers were love letters, playing cards, bits of silver, a multitude of trinkets, loose pearls, and other random stuff. The residents of New Spain spent time accumulating pieces of furniture for writing even though many did not know how to write. Without doubt, this fact had to do with a stage setting at the service of power: the larger the quantity of furniture and implements for writing, the greater the social prestige of the owners. Using such a desk to write orders or keep the books of a business was the equivalent of being, or appearing to be, a great lord or a *persona principal*, as was said in viceregal times.

FIGURE 26.6 Painted chest, Mexico, late nineteenth century. Wood, paint, iron, 18¼ x 30¾ x 17¼ in. Museum of International Folk Art, A.2014.61.10.

■ **FIGURE 26.7** Straw appliqué box, Mexico, nineteenth century. Pine, maple, paint, straw, 5½ x 8 x 4 in. Collection of the Spanish Colonial Arts Society Inc., Museum of Spanish Colonial Art, bequest of Alan and Ann Vedder, 1990.080.

Another example of midlevel viceregal furniture in which cochineal has been identified is an odd trunk from the Museum of International Folk Art (figure 26.6).[16] On its front face, as the main scene, is a curious little boat with eleven people, all of them men wearing hats with high crowns. The piece comes from the second half of the nineteenth century and is Mexican, though regrettably, the exact place of its manufacture cannot be identified. Carmine from cochineal covers a significant portion of the trunk. The back, where one can make out sketchy traces of a big flower, is totally painted with carmine red, its clear sense of economy in decoration suggesting that it is a piece of furniture to be put against a wall. The boat and some of the flowers that surround and decorate the narrative scene are also red.

Another item with cochineal, a small box adorned with inlaid straw, belongs to the Museum of Spanish Colonial Art (figure 26.7).[17] In studies carried out on the decorative piece, which may have been used to hold small items, cochineal was detected along the bottoms of the side panels. Carmine also appears on rectangular surfaces, above which geometric dentils go around the body of the box. Again, it is not possible to assign a specific place of manufacture, and it is feasible to think that the box is more modern than the previous pieces discussed, perhaps from the last quarter of the nineteenth century. With its straw, the box illustrates an innovative use of an affordable everyday material to imitate the luxurious ivory or shell inlay that distinguishes the elaborate marquetry work of Europe and New Spain.

As these items illustrate, the world of cochineal as it applies to luxury household goods is complex and far-reaching. At this time, based on this preliminary investigation, one can present only working hypotheses. Still, many compelling questions arise to take this research further in the future. How did painters get red-toned lacquer? In what other furniture from the eighteenth and nineteenth centuries is cochineal employed? Were only the dyes of finest quality used in decorating the best pieces? Did elite luxury items decorated with cochineal directly lead to other goods of the material culture being dyed cochineal red? Did folding screens and headboards with large areas of red use cochineal? Did the workshops that used cochineal keep their recipes secret? Did the distinctive red color used in Guerrero and Michoacán come from Oaxaca? Where did the workshops that made furniture purchase cochineal? How much did it cost to color a wedding chest from Olinalá with the "blood of the prickly pear"? Did ladies' trunks from Oaxaca have cochineal in their decoration as well? When a piece of furniture was sold, was the buyer told that it had the famous dye in its decoration? Were there counterfeits? Did the extensive use of carmine in an object make it much more expensive than objects that used other reds?

Finally, and most importantly for future studies, in furniture that does have carmine, is all the red cochineal?

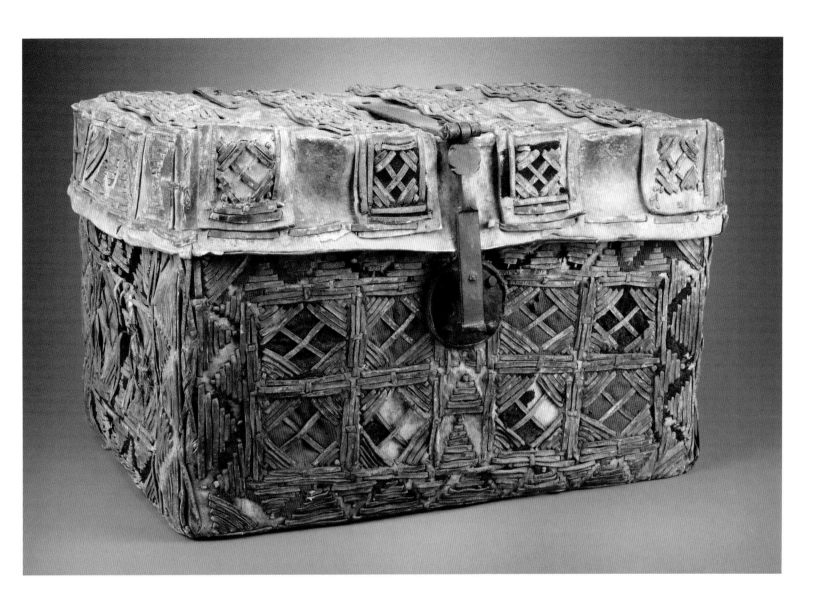

Petaca (trunk)
Bolivia (?), nineteenth century
Leather, wool, metal
15⅞ x 26¼ x 18½ in.
Museum of International Folk Art, gift of the
Historical Society of New Mexico, A5.1960.6

The significant production in viceregal times of deluxe *petacas*, or travel trunks, is another example of the widespread use of carminic acid. Typically covered with tanned, decorated leather, these were also used for days in the country, when wealthy inhabitants of the viceroyalty visited vacation places near the city or went to the woodlands to hunt. These unusual items evoke their pre-Hispanic name—from the Nahuatl *petlacalli*, a box made from palm leaves— and are embroidered with tough thread made from pita, the fiber of the maguey or century plant. The most ostentatious *petacas* are showy displays of technique that include leather and natural fibers (reed grass and pita), as well as costly wrought ironwork used for ribs, faceplates for locks, iron rings, and latches. Usually, the decoration shows extraordinary narrative scenes related to courtship, love, the dance of Moctezuma, and horse rides in the country. The trunks were made large to hold a variety of belongings; smaller ones had interior compartments to hold different implements required for the

making and drinking of chocolate. Inventories of goods list the small trunks as *petacas chocolateras*. They were kept close at hand for the proper preparation and consumption of the most famous drink in the viceroyalty.

This interesting leather *petaca* from the Museum of International Folk Art is decorated with considerable amounts of cochineal. The nineteenth-century item has as much tanned leather as natural leather, and it does not look anything like the famous embroidered *petacas* typical of New Spain. The piece has more in common with leather trunks from the highlands of nineteenth-century Bolivia, prompting the question: Are we dealing with a South American piece dyed in the region of the Andes? Even before the Spanish arrived, the viceroyalty of Peru had and traded cochineal in considerable quantities. Here is a fine example of its use in a *petaca* whose design is distinctive to another region where cochineal was held in high esteem. —*Gustavo Curiel*

LOOKING FOR RED IN ALL THE WRONG PLACES

Cochineal in Spanish Colonial New Mexico

ROBIN FARWELL GAVIN AND JOSIE CARUSO

IN 1776 FRAY FRANCISO Atanasio Domínguez was sent from the headquarters of the Franciscan Province of the Holy Gospel in Mexico City to inspect the missions of the Custody of the Conversion of St. Paul in New Mexico, which were under its jurisdiction. His inspection resulted in the most complete and detailed extant report of missions and towns in eighteenth-century New Mexico. Even cochineal did not escape his perceptive gaze. Of the church at San Esteban at Acoma Pueblo, he wrote: "Below there is a small bronze bell, a board dais, and a beautiful carpet dyed with cochineal, which the Indians wove in Father Pino's time."[1]

Domínguez noted the use of cochineal at least twice more in his inventory. Describing the high altar at Santo Domingo Pueblo, he stated: "There is a well-made platform of small beams and a very large carpet, dyed scarlet with the stuff called cochineal, in little squares (of the kind ordinarily used for tablecloths), which Father Zamora furnished." And at the Church of San José at Laguna Pueblo, he recorded: "The altar table is stone, with an altar stone which the King gave, ordinary lectern, two small bronze bells, a well-made board dais, a small carpet dyed with cochineal."[2]

These appear to be some of the earliest documentary references to the use of cochineal in Spanish colonial New Mexico. They are made even more compelling by the fact that Domínguez implied that two of these textiles were locally made. He noted the carpet from Santo Domingo for its checkerboard pattern, typical of both the locally produced *jerga* (a twill-woven fabric generally used for packing material and floor coverings) and Pueblo mantas (woven fabrics used as wearing blankets).[3] He attributed the Acoma carpet to Indian weavers "in Father Pino's time" at the pueblo, between 1750 and 1767.[4] But what did a Franciscan friar know about cochineal? How are we to interpret his observations?

First, it is of note that Domínguez mentions cochineal at all, as he does not itemize any other dyes in his descriptive inventory. Secondly, determining the nature of these three textiles is complicated by the absence of locally woven textiles from this period with which to compare them. The best that can be done is to explore possibilities based on other documentary evidence combined with known patterns of development in nineteenth-century New Mexican textiles.

The first possibility is that some or all of the textiles were woven locally from local wool yarn and were dyed with imported or native cochineal. This possibility seems unlikely, however. Although the Pueblo people were spinning their own yarn, there is no physical evidence of local yarns dyed with cochineal in any southwestern weaving that predates the early twentieth century. (See Hedlund, this volume.) Correspondingly, there is a large body of pre-1870 southwestern textiles in which all the yarns, with the exception of the red ones, are hand-spun. The red yarns in these textiles were unraveled from imported cochineal-dyed cloth or imported commercial yarns, strongly suggesting a local incapability for dyeing wools red.

■ *Opposite* **FIGURE 27.1** *Colcha* (embroidered bedspread), New Mexico, late eighteenth to early nineteenth century. Wool warp and weft, wool embroidery, hand-spun handwoven *sabanilla* (base cloth), hand-spun undyed and vegetal-dyed one-ply wool yarn, commercial three-ply wool yarn, 78 x 58¼ in. Collection of the Spanish Colonial Arts Society Inc., Museum of Spanish Colonial Art, Santa Fe, gift of Mary Cabot Wheelwright, 1958.041. The only commercially spun and dyed yarns in this piece are the reds in the fringe and the body. The finer three-ply yarn used in the fringe tested positive for carminic acid; the heavier, more orange-toned three-ply yarn in the body did not. Although the latter yarn has not been tested for other dyes, the *colcha*'s early date and southwestern context suggest that the colorant in the body may have been lac. Photo: Addison Doty, courtesy Museum of Spanish Colonial Art.

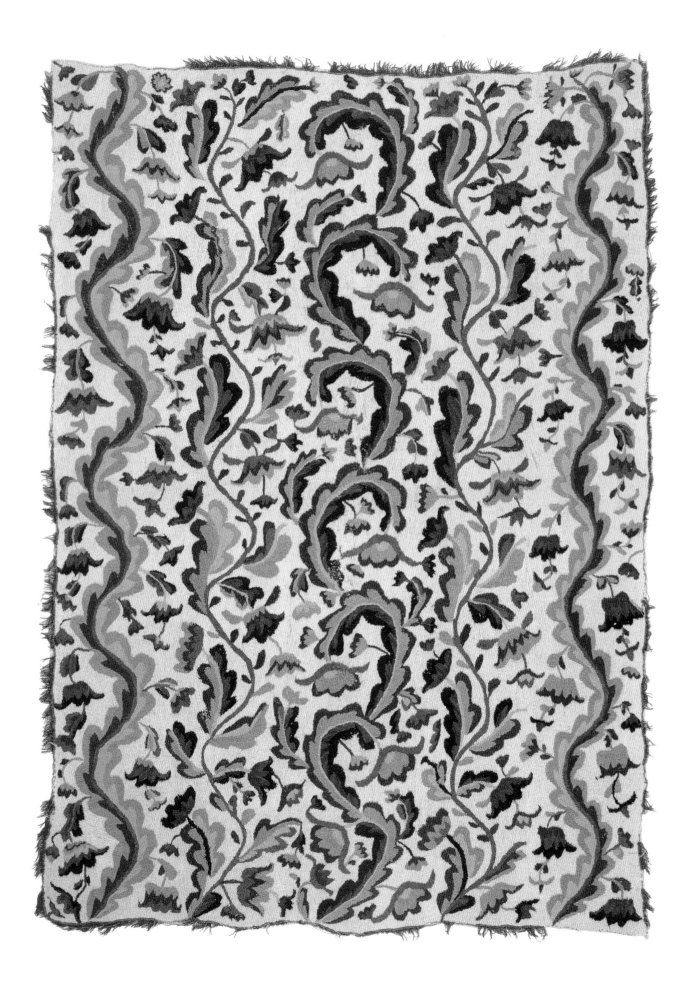

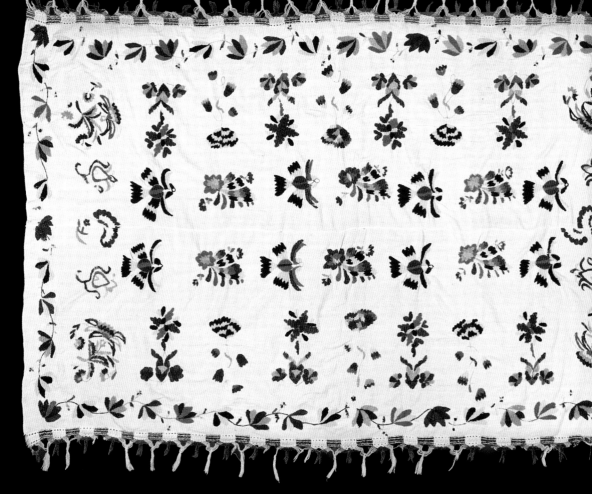

The next, more plausible possibility is that some or all of the carpets were woven locally from raveled yarns. The fabrics from which raveled yarns were taken—*bayeta* and related wool cloths—were imported to New Mexico from Mexico in ever-increasing quantities from the late sixteenth to the mid-nineteenth century. These fabrics were available to Navajo, Pueblo, and Hispano weavers, who used them in blankets (see Hedlund, this volume) and in *colcha* embroideries (figures 27.1–27.2). Although the earliest documentary evidence for the use of raveled yarn in the Southwest is from 1788,[5] given the enormous quantities of fabric available, it is not unreasonable to suggest that the technique of raveling may have been in use by the mid-eighteenth century.

A third possibility is that one or more of the carpets may have been imported or assembled from imported components. The carpet at Santo Domingo is described as "very large . . . in little squares (of the kind ordinarily used for tablecloths), which Father Zamora furnished." If not a reference to locally produced *jerga*, "little squares" (called *quadritos* by Domínguez) may refer to small, square, red table covers of the type depicted in an eighteenth-century Mexican *casta* painting, a

genre that depicted the ethnically diverse population of New Spain in the context of household interiors and other scenes from daily life.[6] As with woven *jerga* or mantas, the squares would have been sewn together to make a large carpet. Fray Antonio Zamora, the resident friar, made extensive donations of imported goods to the church, including bugles, mirrors, vestments, ceremonial linens, and a new Franciscan missal.[7] His donation of an imported carpet, or its component parts, would make sense. And the fact that Domínguez singles out this dye in his inventory further suggests the likelihood of its being imported and rare rather than locally available.

The 1784 inventory of the estate of Don Juan Antonio Fernandes of Santa Fe indicates that powdered cochineal was by then available for use in New Mexico. During the inventory's compilation, Fernandes's wife, Doña María de Sena, placed before the witnesses and the *alcalde mayor* (chief magistrate), Don Antonio José Ortiz, 2 pounds of indigo (*añil*), valued at sixteen pesos, and 1 pound of carmine (usually understood to be powdered cochineal), valued at six pesos.[8] The value of both the indigo and the carmine is substantial compared to other inventory items—for example, fifteen skeins of finely

spun red-dyed yarn (*tochomite encarnado*) at six pesos and ten pairs of leather shoes at fifteen pesos—suggesting that both dyestuffs were imported.

EVIDENCE OF COCHINEAL RED

If cochineal was not used for local dyeing of textiles, as some scholars believe, then how was it used? The earliest evidence to date for the use of cochineal as a pigment is found in an oil-on-canvas map dating to about 1758 by *santero* (saint maker) and cartographer Bernardo Miera y Pacheco (figure 27.3). Miera y Pacheco, a Spaniard by birth, lived in New Mexico from 1754 until his death in 1785 and is credited with starting the *santero* tradition in New Mexico.[9] The author of many of the altar screens and sculptures in New Mexico's churches, he painted with oil paints, which are not known to have been produced locally. A 1751 document records his purchase of oil paints in El Paso del Norte.[10] Without earlier evidence for local use of cochineal, it appears that Miera y Pacheco may have introduced this red to New Mexico. His image of Saint Raphael, dated 1780 and commissioned by Doña Apolonia de Sandoval (figure 27.4), has also tested positive for cochineal.

Indeed, Miera y Pacheco's contemporaries, as well as the artists who followed, all seem to have had access to cochineal. Only one other, the anonymous artist known as the Eighteenth-Century Novice, worked with oils. His oil-on-wood image of Our Lady of Saint John of the Lakes also has tested positive for cochineal (figure 27.5). Also working in the eighteenth century was an artist tentatively identified as Fray Andrés Garcia.[11] His sculptures of the Holy Family and of Saint Joseph were painted with water-based pigments, including red that has tested positive for cochineal (figures 27.6–27.7). All other artists working in colonial New Mexico seem to have used water-based pigments. These were likely prepared locally, using techniques learned from the Native American community.[12]

Unlike dyeing wool for textiles, preparing small batches of pigments would not have required excessive amounts of cochineal. Thus one could make a case for cochineal being produced locally. According to Cordelia Thomas Snow and Glenna Dean, cochineal could have been produced locally from native insects, but like the wild bugs themselves, the quantities were limited.[13] While several New Mexico painted works dating to the late eighteenth and early to mid-nineteenth century have tested positive for the pigment, it is impossible to determine at this point whether the artists who made them used local or imported cochineal. However, the amount of pigment needed for any one of these images would have been small enough to be handled by local production, or would have enabled an artist to stretch the costlier imported powder over several works of art.

Several notable nineteenth-century *santeros* integrated cochineal into religious *bultos* (sculptures) and *retablos* (paintings). The artist known as Molleno, identified by an inscription on the back of a *retablo*, worked in the early nineteenth century and perhaps is best known for the altar screens at the church in Ranchos de Taos. He used cochineal red on a hide ground, early evidence of cochineal use in this medium in New Mexico. (See also Thomas Snow, this volume.) Molleno was a student of the Laguna Santero, who also employed hide in the red backdrop of a cochineal-painted *nicho* (niche) (figure 27.8). A *bulto* of Our Lady of Saint John of the Lakes (figure 27.9) attributed to Pedro Antonio Fresquís, who was responsible for the early nineteenth-century altar screens at Our Lady of the Rosary Church in Truchas, New Mexico, also has evidence of cochineal pigment.

A *bulto* of the Holy Child of Prague painted with cochineal (figure 27.10) is the work of *carpintero* (carpenter) Antonio Casados, one of the artists in an informal workshop in nineteenth-century Santa Fe. Casados worked with *santero* brothers José and Rafael Aragón and José Manuel Benavides (Santo Niño Santero),[14] whose *bulto* of Saint Librada (figure 27.11) also revealed evidence of cochineal. Together these artists created *santos* for many northern New Mexico churches. Another unidentified nineteenth-century artist used cochineal to create a striking red image of Our Lady of Guadalupe, the patroness of the Americas who is highly revered in New Mexico (figure 27.12).

Another possible use for the homegrown variety of cochineal was cosmetic, as it is sometimes used today. A number of historical references note the use of both whiting and rouge by New Mexican women to protect their skin from the sun. Only one of these specifically mentions carmine. In her 1955 autobiographical novel *Romance of a Little Village Girl*, Cleofas Jaramillo describes the women in her New Mexican village dressing for a fiesta in the early twentieth century: "The women used the high window sills as dressing tables, resting their mirrors against their oil lamps while they applied the red carmine to their cheeks and the white *albayalde* [a white powder made from clay] to their faces and necks."[15]

Earlier references attribute the rouge to other sources. Josiah Gregg, writing in 1831, stated: "The belles of the ranchos and villages have a disgusting habit of besmearing their

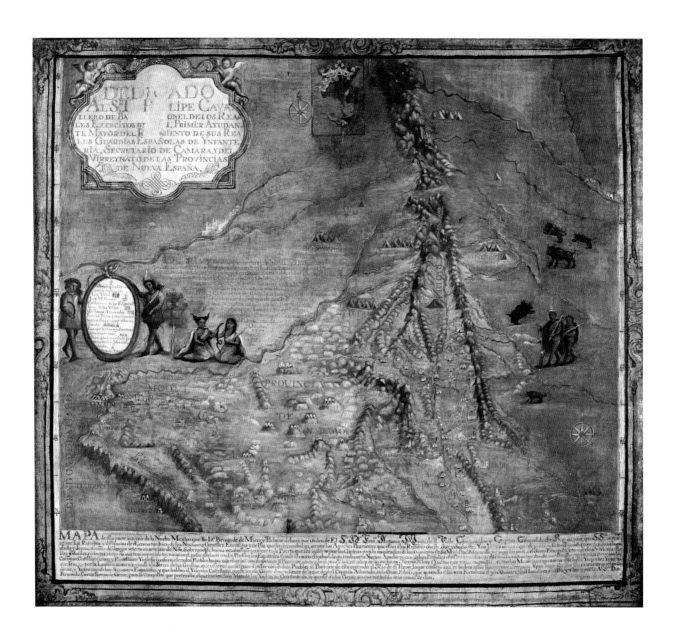

FIGURE 27.3

BERNARDO MIERA Y PACHECO

■ *Map of Nuevo México*

Santa Fe, ca. 1758

Oil on canvas

42½ x 39 in.

New Mexico History Museum, Department of Cultural Affairs,
9599.45

Each of six samples from this impressive map by a pioneering colonial New Mexican cartographer and *santero* (saint maker) tested positive for cochineal, establishing the earliest physical evidence for the pigment's use in New Mexico. The findings demonstrate that carmine pigment was used for deeper hues of red, as in the drapery folds on the cherub to the right of the upper left cartouche, possibly in combination with vermilion, whose lighter, brighter hues are used to achieve shadowy effects. Cochineal was identified in the red necklace on the figure to the left of the oval cartouche at middle left and in a red detail of the gilded crown at top center. Miera y Pacheco also used cochineal effectively in the map's red text, both in the lettering on the oval cartouche at middle left and in the free-flowing lettering to its right. For the latter text area, two reds were used for each character: a bright scarlet red, possibly vermilion, and a deeper cochineal-based red. Together the two reds produce a limning effect.

FIGURE 27.4
BERNARDO MIERA Y PACHECO
■ *Saint Raphael*
Santa Fe, New Mexico, 1780
Oil on wood panel
39½ x 23¾ x 1½ in.
Collection of the Spanish Colonial Arts Society Inc., Museum of
Spanish Colonial Art, Santa Fe, gift of Dr. Frank E. Mera, 1954.077
Photo: Addison Doty, courtesy Museum of Spanish Colonial Art

This is the only known dated *retablo* (religious painting) by Miera y
Pacheco, the earliest identified *santero* in New Mexico. It also provides
the earliest evidence of cochineal use on a New Mexican *retablo*. Six
samples from the saint's cape and staff, various flesh tones, and the
frame were tested; all of them registered positive for the pigment. The
strong presence of other colorants suggests that the cochineal was
mixed with other pigments.

FIGURE 27.5
EIGHTEENTH-CENTURY NOVICE
■ *Our Lady of Saint John of the Lakes*
New Mexico, late eighteenth century
Oil, gesso, hand-adzed ponderosa pine
23½ x 15 in.
Museum of International Folk Art, museum purchase, A.1964.46.1

Cochineal grows wild in New Mexico, but it is not known whether the
insect could have been harvested in sufficient quantities for use as a
dye or pigment in the Spanish colonial era. Whether local or imported
from Mexico, cochineal has been found in tested Spanish colonial New
Mexican paintings and polychrome sculptures (*bultos*) dating from
the late eighteenth century. In this *retablo*, cochineal is present in the
drapery and in the fleur-de-lis, ribbons, and other red embellishments
on the Virgin's cape.

■ *Above, left* **FIGURE 27.6** Fray Andrés Garcia (also known as Provincial Academic II), *The Holy Family*, southern New Mexico, early to mid-nineteenth century. Water-based pigments on cloth and wood, 9⅜ x 9⁵⁄₁₆ x 3¾ in. Museum of International Folk Art, IFAF Collection, gift of the Fred Harvey Collection, FA.1979.64.53. Both samples taken from the dress of the Virgin in this holy trio showed the presence of cochineal. Though not tested, the reds in the garments of the Christ Child and Saint Joseph appear to be the same hue as the dress, suggesting that cochineal was used throughout.

■ *Above, right* **FIGURE 27.7** Fray Andrés Garcia (also known as Provincial Academic II), *Saint Joseph*, southern New Mexico, early to mid-nineteenth century. Water-based pigments on cloth and wood, 9½ x 8½ x 6⅞ in. Museum of International Folk Art, IFAF Collection, gift of the Fred Harvey Collection, FA.1979.64.51. Cochineal was found in samples taken from the bottom back hem of Saint Joseph's robe. The same original colorant extends throughout the saint's garment.

faces with the crimson juice of a plant or fruit called *alegría* [cockscomb], which is not unlike blood; as also with clay and starch."[16] In 1846 Lieutenant James W. Abert commented on women he saw carrying water from the Pecos River in *ollas* (jars) on their heads: "Many of the young women had their faces hidden under a thick coat of whitewash, and many had bedizened their faces with the juice of the poke berry."[17] And in her 1846–1847 account of traveling the Santa Fe Trail between Missouri and Mexico, Susan Shelby Magoffin also noted this unique custom, writing, "Another Spanish beauty, I saw this evening, with her face painted, a custom they have among them when they wish to look fair and beautiful at a 'Fandango,' of covering their faces with paint or flour-paste and letting it remain till it in a measure bleaches them. These I saw one of them had paste—and with it more the appearance of one from the tombs than otherwise. Another had hers fixed off with red paint which I at first thought was blood."[18]

THE ROMANCE OF COCHINEAL

Other than these possible limited uses, cochineal does not seem to have played a large role in Spanish colonial and nineteenth-century New Mexico. But this changes in the late nineteenth and early twentieth century, gaining momentum with statehood in 1912, as a concerted effort to promote Santa Fe as a tourist destination got under way.[19]

A conscious decision was made to promote New Mexico's Native American and Spanish past in romantic though not always accurate ways. The movement led to the establishment of the Fred Harvey Company, the Historical Society of New Mexico, the societies for the Revival of Spanish Colonial Arts and the Restoration and Preservation of Spanish Missions of New Mexico (both of which later merged into the Spanish Colonial Arts Society), and other preservation-minded organizations.

In the 1930s, riding the wave of a decade of success of the preservationist movement, two shops—The Spanish Arts (1930–1933) and the Native Market (1934–1940)—operated in Santa Fe, both carrying and marketing crafts made by local Hispano artists.[20] Some of these artists were encouraged by preservationists to incorporate cochineal into their work. Two receipts from the Native Market show purchases of cochineal by the shop's owner, Leonora Frances Curtin, a prominent Hispano arts supporter. One, dated January 15, 1934, records Curtin's purchase of 20 pounds of cochineal; the other notes a buy of 13 pounds. Both purchases were made from Fezandie & Sperrle of New York City at $.55 a pound.[21] The cochineal was sold, presumably in Santa Fe, at $1.80 a pound—a sizable markup that undoubtedly added to the dyestuff's perceived value and

■ *Above, left* **FIGURE 27.8** School of the Laguna Santero, *Nicho* (niche), New Mexico, late eighteenth to early nineteenth century. Wood, hide, gesso, water-based pigments, 23 x 27⅝ x 4⅜ in. Museum of International Folk Art, gift of the Historical Society of New Mexico, A5.1957.28. Cochineal was found in three samples taken from the painted wooden framework of this *nicho*, which likely was made for home use as an altar in which to display and venerate a favorite *santo* (saint) or *santos*. No samples were tested from the hide backdrop, though the interior draperies are rendered in the same red hue. The shallow paint layer throughout the work suggests all-original color.

■ *Above, right* **FIGURE 27.9** Pedro Antonio Fresquís (also known as the Truchas Master), *Our Lady of Saint John of the Lakes*, New Mexico, early nineteenth century. Water-based pigments on cloth and wood, 11 x 7½ x 1³⁄₁₆ in. Museum of International Folk Art, gift of the Historical Society of New Mexico, A5.1954.43. Pigment samples taken from the hem and front of the saint's gown tested positive for cochineal. The original paint layer demonstrates a refined artist's hand. He used complicated painting techniques and a combination of cochineal and vermilion to achieve the desired red hue.

■ *Above, left* FIGURE 27.10 Antonio Casados, *Holy Child of Prague,* New Mexico, mid-nineteenth century. Water-based pigments on wood, 13⅛ x 6 x 3⁷⁄₁₆ in. Museum of International Folk Art, bequest of Charles D. Carroll, A.1971.31.209. Antonio Casados is thought to have been a member of a nineteenth-century Santa Fe workshop of *santeros* and *carpinteros* (carpenters) that created many of the extant images and altar screens from late colonial and Mexican-period New Mexico. Samples taken from the hem of the robe at both the front and back of the figure contain cochineal. The mostly original colorant extends throughout the saint's garment.

■ *Above, right* FIGURE 27.11 José Manuel Benavides (also known as Santo Niño Santero), *Saint Librada,* New Mexico, mid-nineteenth century. Pine, gesso, water-based pigments, 14⅝ x 8½ x 2⁷⁄₁₆ in. Museum of International Folk Art, bequest of Charles D. Carroll, A.1971.31.91. One pigment sample was taken from the left arm where it attaches to the body, and one was taken from the front lower right hem. The sample from the figure's arm tested positive for cochineal while the other did not. Multiple layers of paint on the piece demonstrate a long history of use and several painting campaigns, making it unclear whether the cochineal pigment dates to the original paint layer or a later restoration.

■ *Opposite* FIGURE 27.12 Unidentified artist, *Our Lady of Guadalupe,* New Mexico, nineteenth century. Water-based pigments on wood panel, 13¾ x 10¼ x 1¾ in. Museum of International Folk Art, bequest of Cady Wells, A9.1954.58R. One sample was taken from the frame of this *retablo,* and one was taken from the dress of the Virgin. Both showed the presence of cochineal. Like many New Mexican *retablos,* this one has been touched up in places through time, but much of the original cochineal-derived color layer is still visible on the surface.

mystique. Indeed, these are far larger quantities and values than those mentioned in the colonial estate inventory of Don Juan Antonio Fernandes.

Also in the 1930s, the New Mexico Department of Vocational Education produced a series of bulletins in the form of mimeographed copies with blue paper bindings—often referred to as blue books. One of these, the *Vegetable Dyes Bulletin,* distributed in 1935, includes several recipes for different colors of red—all produced with cochineal. In their introduction, authors Dolores Perrault, an instructor of weaving and spinning classes at Taos Vocational School; Brice H. Sewell, state supervisor of trade and industrial education; and Mabel Morrow, director of arts and crafts at the U.S. Indian School in Santa Fe, write:

> *All of the plants having dye properties that are given in this bulletin are native to most of the sections of the Southwest, with the exception of the indigo, cochineal and brazilwood, which are imported from foreign countries. These have been in use in New Mexico since the coming of the Spaniards and have been stock articles of trade until very recent modern times. [emphasis added]*

> *. . . . It is a matter of record that the red in many of the early blankets was made by unraveling red bayeta cloth for which the demand was so great that it was a stock article from the earliest days of Spanish trade until the American occupation. The cost of the cloth was always high and it is not reasonable to assume that the Indians would have purchased this cloth to produce their red if they could obtain a satisfactory red from native dyes. Cochineal and brazil-wood, bought from traders and imported from Mexico, were sometimes used [by Indian weavers] as they were cheaper than bayeta cloth. The Spanish-colonial weavers nearly always used the cochineal or brazilwood.*

In fact, contrary to the *Vegetable Dyes Bulletin, bayeta* is far more common in colonial inventories than imported cochineal dyestuff. It is thus more likely that local weavers used predyed *bayeta* rather than purchasing powdered cochineal to dye their yarns. Morrow, who is credited in the text with having a great deal to do with the revival of the use of vegetable dyes, was also among those women who helped revive Native American arts and crafts.[22] However, in doing so she and others involved in the revivalist movement imparted their own romanticized version of the past, including the

myth that New Mexicans used cochineal in dying their yarns. This myth was incorporated into both the scholarly record and the popular consciousness of the early twentieth century.

Despite the good intentions and positive long-term impacts of the preservationists' efforts, it may be here that exaggerated notions of the extent of cochineal use in colonial New Mexico began to take root. The blue books were distributed statewide, and items made in vocational classes according to their instruction were carried in The Spanish Arts and Native Market shops. Some of the items also made their way into public and private collections. As the largely undocumented interpretation of the widespread use of cochineal in colonial New Mexico spread among artists, teachers, collectors, museums, and beyond, it became part of the state's folklore. 🔴

RECONSIDERING COCHINEAL IN SPANISH COLONIAL NEW MEXICO

Questions for the Future

CORDELIA THOMAS SNOW

CONSIDERABLY SMALLER THAN the domesticated cochineal cultivated for centuries in Mexico, native cochineal flourishes in the United States north of Mexico wherever prickly pear cactus grow. It is found in New Mexico, Arizona, southern Colorado, and the Hill Country of Texas. As early as the mid-eighteenth century, it was identified along the Eastern Seaboard in South Carolina and Georgia, including at the former Spanish mission site of Saint Catherines Island off the coast of Georgia.[1] Today in New Mexico, tiny cochineal bugs are seen clinging to cactus pads inside a waxy white, Kleenex-like covering. When squashed, the bugs produce the same lovely red dye that fueled the economic success of the Spanish Empire, although not in the quantities produced by their domesticated cousins.

It is not clear whether New Mexico founder Juan de Oñate and his expedition found native cochineal grown in the area when they settled at San Gabriel del Yunque in 1598 or if his successor, Pedro de Peralta, observed it growing in the Santa Fe area when he established the provincial capital there in 1610. But given the importance of cochineal to Spain from the late sixteenth century, when New Mexico was under Spanish control, the idea that either local or imported cochineal had an early presence in Spain's northernmost colony should not seem far-fetched.

Since no woven goods of any sort dating from the initial period of Spanish colonization survive today, cochineal use by known local artisans is elusive until the late eighteenth century. As Robin Farwell Gavin and Josie Caruso discuss in this volume, it was then that Santa Fe *santero* (saint maker) Bernardo Miera y Pacheco used the dye on an oil-on-canvas map dating to around 1758, allowing us to definitely point to a specific instance of cochineal use in New Mexico.[2] In addition, archival evidence from the early Spanish colonial era in New Mexico points to individuals whose travels and trades would presumably support cochineal's presence in the colony.

This tempts us to consider some practical and plausible scenarios for its acquisition and use and to ponder some questions for possible future research.

With the spread of cochineal red from the Americas to Europe and back to the Americas beginning in the sixteenth century, it is not hard to imagine that fabric or clothing dyed with cochineal might have been brought to New Mexico as early as the Oñate settlement at San Gabriel. In fact, it was highly likely that Oñate, his son, Cristóbal, and several colonists who accompanied the expedition all owned clothing that had been dyed with cochineal. A 1600 inventory from the Oñate expedition lists goods carried by Spanish aristocrat Doña Francisca Galindo, including two satin dresses—one "red with sashes and gold trimming" and the other "crimson embroidered in gold"—and a bedspread and pillows of "crimson taffeta trimmed with lace."[3] Since these were clearly cherished textiles designated by Galindo to accompany her to New Mexico from New Spain, might they have been dyed with cochineal? After arriving in the province, most Spanish women likely made their own clothing using imported fabric or had clothing made in Mexico. These were transported to San Gabriel and Santa Fe over El Camino Real de Tierra Adentro, the primary trade route between Mexico City and Santa Fe, which provided a direct connection

■ *Opposite* **FIGURE 28.1** Molleno, *Saint James*, New Mexico, ca. 1805–1845. Water-based pigments on hide, 59 x 38⅝ x 1½ in. Museum of International Folk Art, gift of the Historical Society of New Mexico, A5.1952.13. Best known for creating the nineteenth-century altar screens at Ranchos de Taos, New Mexico, Molleno here directly applied pigments on hide, a technique practiced by Pueblo Indians in New Mexico prior to the Pueblo Revolt. Molleno's painting depicts the story of Saint James, the patron saint of Spain, who led the defeat of Muslim invaders. Several samples of red were taken from throughout the piece, including from the flag, the saint's cloak, and the stitch-like elements adorning gear on the horse's rump. Pigments from the blood-stained landscape and from one of the slain victim's lips were also sampled. All the samples, which represent the visible original paint layer, demonstrate Molleno's use of cochineal.

■ *Bota* (chap), one of a pair, New Mexico, nineteenth century. Leather, thread, cochineal-dyed *bayeta* cloth, 18¼ x 24⅜ x ⅜ in. Museum of International Folk Art, gift of the Historical Society of New Mexico, A5.1952.50. Evidence of the availability of imported cochineal-dyed *bayeta* cloth in New Mexico by the seventeenth century is clear, though it is not until the nineteenth century that examples of its use by weavers, tailors, or other artisans become abundant. In this example of one of the few *botas* (chaps) extant from nineteenth-century New Mexico, we see the refined hand of a tailor at work in creating an item that was an important part of the cowboy (*charro*) culture in Mexico and New Mexico. As seen here, *botas* were often elaborately decorated with leather stamping and colorful embroidery, and colorful *bayeta* was applied as cloth decoration. Both the embroidery thread and red wool *bayeta* tested positive for cochineal.

■ *Bota* (chap), one of a pair, New Mexico, nineteenth century.

and access to European and Mexican goods throughout the Spanish colonial period. Again, this leads to the question of whether those fabrics were dyed with cochineal.

Some colonial-era settlers, particularly weavers, seamstresses, tailors, painters, and other artisans, were more likely than others to be familiar with cochineal and its uses. Although few tradesmen are mentioned among seventeenth-century settlers in New Mexico, according to Fray Angélico Chávez, Francisco Garcia (Holgado), a twenty-two-year-old weaver said to have been born in San Gabriel, was living in Santa Fe in 1632. He later relocated to the Salinas missions at Tajique and Cuarác (Quarai), and ultimately to Isleta.[4] He was still practicing his trade between 1659 and 1661, when he was forbidden by Governor Bernardo López de Mendizabal "to make cloth for the habits of the Franciscans" in New Mexico.[5] Franciscan habits of the time were dyed with indigo, a nonnative dyestuff that had to be transported to New Mexico from Mexico. It is not known whether Holgado used cochineal to dye any of the raw materials he used for weaving. But given his familiarity with indigo, another dye found in the Americas whose trade was profitable for Spain, one might assume that he was also familiar with the trade and use of cochineal as a dyestuff.

Beginning in the early eighteenth century, several weavers are known to have been active in the Santa Fe area. Diego Manuel Baca and his brother, Cristóbal, who resided at El Rancho de las Golondrinas in La Cienega, just south of Santa Fe, shared a log of Campeche wood, which they presumably used to dye wool and other material.[6] Prized as a source of brownish-red to purplish-black dyes, this wood would have been imported to New Mexico from Campeche in southeastern Mexico and was considered valuable enough that each of the brothers listed the logwood in their estate inventories. While there is no way of knowing whether the brothers used cochineal in their craft, could its absence in their inventories be attributed to the fact that it was more difficult to acquire than Campeche wood and too expensive to use?

Unlike weavers, there is no record of tailors known to be living in New Mexico before the 1680 Pueblo Revolt, when the Spaniards were run out of the province by Pueblo Indians, with nearly all traces of their occupation destroyed. However, we assume such artisans must have lived in the colony before the revolt. With Don Diego de Vargas's reclamation of New Mexico for Spain in 1693, at least seven tailors indicated a willingness to settle in the former colony. Those who completed the journey included Miguel Garcia de la Riva, who was identified specifically in the muster rolls as a weaver of silk, and Manuel Rodriquez, who was listed simply as a weaver.[7]

Each weaver was recruited for the resettlement effort in Mexico City and undoubtedly would have been familiar with Spain's most valuable dyestuff. Indeed, if you look at the lists of materials given to families recruited in Mexico in 1693 for the recolonization effort, you see *escarlata* (scarlet) used to describe yard goods and for making petticoats, in addition to various *bayetas* (imported dyed wool cloths).[8] As a specialist in weaving silk, De la Riva in particular would have had knowledge of cochineal as a superior source for dyeing silk. Both weavers would have carried their knowledge of cochineal with them to Santa Fe.

By October 1721, tailors were apparently in some demand in New Mexico. It was then that Santa Fe resident Vicente de Armijo directed preparation of a contract for his son, Salvador Manuel de la Cruz y Armijo, to serve as an apprentice to master tailor Joseph Garzia of El Paso del Norte.[9] Beyond its rarity, the four-year contract is fascinating for various reasons, including the fact that, by age ten, Salvador Manuel knew how to read and write.[10] Unfortunately, we do not know if the boy completed his apprenticeship and remained in El Paso or if he returned to Santa Fe to practice his trade.[11]

In 1661 Antonio Gonzales, *protector de indios*,[12] filed suit on behalf of ten native painters regarding hides that had been delivered to Governor Bernardo López de Mendizabal for which payment had not been received. The painters hailed from various pueblos: Nicolás and Diego from Nambe; Antonio Hondoguaque of Cuyamungue; Agustín and Miguel from San Lazaro; Bartolomé and José from Galisteo; Juan and Diego from San Juan; and Alonso of Tesuque. Each was said to complete the painting of one elk skin per day.[13] We don't know whether any of these artisans integrated cochineal into their hide paintings, but as Farwell Gavin and Caruso discuss in this volume, we know that native artisans taught Spanish artisans techniques for using natural dyes to make water-based pigments. Thus when the early nineteenth-century Spanish artist known as Molleno used cochineal on a large-scale hide painting of Saint James (figure 28.1), could he have been perpetuating a practice of using cochineal that dated to before the Pueblo Revolt?

Although the earliest documented use of cochineal in New Mexico appears to be that of artist and cartographer Bernardo Miera y Pacheco during the last half of the eighteenth century, I believe there is insufficient evidence to state positively that hides, textiles, and clothing dyed with cochineal were unknown in the colony before 1750. More research needs to be done in the archives of Mexico and Spain, where the use of cochineal is well known.

A RED REVIVAL
Cochineal in the Modern World

NEW COLORS, OLD TINTS
Uncovering Fortuny and Cochineal

ELVIRA GONZÁLEZ ASENJO AND LUCINA LLORENTE LLORENTE

MARIANO FORTUNY Y MADRAZO (1871–1949), son of the celebrated Spanish painter Mariano Fortuny y Marsal and Cecilia de Madrazo y Garreta, of the famous Madrazo painting dynasty, worked in varied fields, both technical and artistic, during his multifaceted life. He explored the art of illumination with artificial light, scenography, and photography while also developing work in the fields of painting, engraving, sculpture, printing, textile design, clothing, and theater. Born in Granada and educated in Paris, he ultimately made Venice the primary residence from which he traveled the world.

Fortuny's creative genius was forged in the enlightened and creative ambience in which he was raised. Fortuny's father chose Granada, the most Arab city in the West, as the family home and also chose Hispano-Moresque art as inspiration and atmosphere in his paintings. The younger Fortuny's first exposure to textiles was through a collection begun by his parents, whose passion for artistic materials led them to compile diverse cultural examples that fostered his interest in and study of fabrics. Without doubt, however, his dedication to textile design was a natural consequence of his concept of "the totality of a work of art." The idea was introduced to him by Rogelio de Egusquiza, who opened the world of engraving and etching to Fortuny and acquainted him with the work of German composer Richard Wagner. This transcendental discovery led Fortuny to the world of theater, the center around which all his works would eventually revolve.

Fortuny's early experimentation with theatrical light and color at the turn of the twentieth century enhanced his understanding of the play of light and color on fabric, inspiring his first textile designs for the stage. In 1901 he patented a stage lighting technique based on a system of indirect, diffuse light controlled by filters that changed color and intensity. The domed Fortuny Cupola was devised to concentrate light on the stage from the rear, making the light a protagonist in the scene and allowing the stage manager "to mix the colors for the scene, to paint in the theater as on a palette."[1] His discoveries attracted the favor of Gabrielle D'Annunzio, who in 1899 invited him to collaborate in the staging of *Francesca da Rimini* and to design the wardrobe of Italian actress Eleonora Duse, who later inspired his dramatic Eleanora dress (figures 29.1a–29.1b). From then until his death, Fortuny engaged in his most important work in the areas of apparel and textile design.

FORTUNY AND TEXTILE WORKS

Fortuny's understanding of the textile arts, and his revalidation of artisanal work, evolved in relation to the Arts and Crafts movement, led by William Morris, Walter Crane, and Henri van de Velde. He shared their philosophy—which emerged in response to the Industrial Revolution and the introduction of chemical dyes in 1856—of using materials of the highest quality worked with artisanal care. At the same time, he connected to the idea, advocated by German schools, that semi–mass production of some items did not diminish their identity as artistic objects.

Fortuny entered a world of fashion on a wave of Oriental influence and extraordinary enthusiasm for the Russian ballet *Schéhérazade*, whose costumes were designed by León Bakst and featured bright colors. Society adopted Bakst's gaudy palette, abandoning the pale pink, faded mauve, swan

■ *Opposite* **FIGURES 29.1A–29.1B** Mariano Fortuny, Eleonora dress, Venice, 1930–1940. Silk, metal, and glass paste; velvet with metal and blown-glass print, 60⅛ x 57½ x 28⅜ in. Museo del Traje, Madrid, CE088362, Ministerio de Educación, Cultura y Deporte. Full dress and side detail. Photo courtesy Museo del Traje.

Previous spread Mariano Fortuny, waistband detail of pleated silk Delphos in purplish red, Venice, 1920–1930. Museo del Traje, Madrid, CE088438, Ministerio de Educación, Cultura y Deporte. Photo courtesy Museo del Traje.

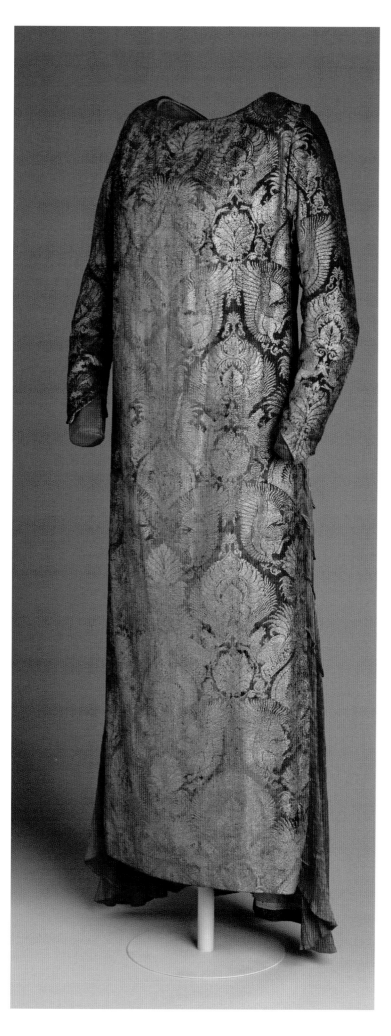

white, dawn gray, jojoba, wild rose, earth green, and grape shades that were so much a part of the Belle Epoque.[2] Fortuny found common ground with other designers of the day, including the great French designer Paul Poiret, with whom he agreed that the textile itself was more important than what was made from it. Poiret was licensed to sell Fortuny's textiles in his shop in Paris before Fortuny opened his own store there in 1913.[3] In 1925 Fortuny and Poiret,[4] along with the young Italian designer Maria Monaci Gallenga, participated in the famous Exposition Internationale des Arts Décoratifs et Industriels Modernes in Paris, where Gallenga won the grand prize with a work inspired by the Venetian tradition of Fortuny.

His creative influence aside, Fortuny's work was completely different from any of his design contemporaries. From the formal point of view of cutting and sewing, Fortuny designs were characterized by great simplicity and moderation, concepts at the forefront of changes in style. His creations were distinguished by the quality of the cloth, the originality of the colors, and the decorative repertory of motifs from all cultures and eras. For example, his idea of stamping fabric was inspired by the discovery of a fragment of stamped linen at an excavation on the island of Crete in 1906.[5] Perhaps more than anything, his works displayed a singular interest in the Venetian Renaissance and its prominent representation of the color red.

Decadent and inspiring, Venice was traditionally linked to the trading and production of magnificent silk fabrics—many of them red—and to dyers with a high level of technical skill. In keeping with this tradition, Fortuny chose materials of the best quality, applying decoration using different printing techniques and tools—stamps, metal plates, rollers, batik, serigraph, *pochoir*, gelatin print, photographic imprint, and diamond point. He employed all their variations and possibilities,[6] modernizing some and inventing others, under the strictest conditions of secrecy and jealously guarding his patented techniques.[7] He and his wife, dressmaker Henriette Negrin, produced their designs in the Pesaro Orfei Palazzo in Venice, their residence and the present-day Museo Fortuny. In 1919 he started a factory in an ancient convent on the island of Giudecca, where he produced textile designs for set decoration.

FORTUNY AND COCHINEAL

A constant in Fortuny's career was his meticulous study of color and its use on cloth, canvas, and paper, as well as the techniques of past masters, Titian and Tintoretto in particular. His large library in the Pesaro Orfei Palazzo holds numerous volumes about the processes of dyeing, color and its chemical

composition, printing on textiles, and more.[8] A strong indicator of the value he placed on his colors is found in the private appraisal of his estate done between 1939 and 1943; the estate included "coloring materials (many of which cannot be found in the marketplace)."[9] In 1933 Fortuny marketed Tempera Fortuny,[10] a paint collection with a varied repertory of colors, with which he was able to imitate the palette used by the majority of the Venetian masters, whose formulas he went on perfecting throughout his life. His friend René Piot took charge of advertising and distributing these colors to painters of the *grandes écoles* of Paris and in the United States. As Claudio Franzini noted in a 1999 biography of Fortuny, "they were numerous, his artist contemporaries, who consulted him and asked his advice about the composition and mix of colors: among them John Singer Sargent, Gustav Klimt, Pierre Bonnard, Emile Bernard, and Maurice Denis."[11]

In an age in which new, mass-produced synthetic pigments were available, attractive, and used by many of the artists of the day, Fortuny used natural colors in an ongoing and widespread manner. Among them was cochineal, with which he bestowed upon his pieces a palette of unequaled tones of red. Recently, a series of physical and chemical analyses of textiles and articles of clothing made by Fortuny has made it possible to detail with greater precision the way in which the so-called Magician of Venice worked, especially with cochineal. The studies prove his use of the dye not only by itself but sometimes in combination with other dyeing materials, some natural and some synthetic. Though, to a certain extent, the studies uncover Fortuny's very personal touch as he dyed or painted his fabrics, the results do not destroy the sense of wizardry and mystery that the artist and his work inspire.

In 2013 the Museum of International Folk Art in Santa Fe, New Mexico, arranged for the analysis of samples from four items from the Mariano Fortuny Collection in the Museo del Traje (Costume Museum) in Madrid, Spain. The study[12] (see Sanz Rodríguez, this volume) confirmed that in all the samples save one, the main component used by Fortuny for dyeing the textiles was carminic acid, the main colorant of cochineal. The study also confirmed the use of cochineal in

Opposite, left, top **FIGURE 29.2** Mariano Fortuny, pleated silk Delphos in purplish red, Venice, 1920–1930. Silk and glass paste; satin and blown-glass pleat, 53⁵/₃₂ x 34³¹/₆₄ in. Museo del Traje, Madrid, CE088438, Ministerio de Educación, Cultura y Deporte. Photo courtesy Museo del Traje.

■ *Opposite, left, bottom and right* **FIGURES 29.3A–29.3B** Mariano Fortuny, pleated silk Delphos in orange, Venice, 1920–1930. Silk and glass paste; satin and blown-glass pleat, 41 x 14⁵/₈ in. Museo del Traje, Madrid, CE088439, Ministerio de Educación, Cultura y Deporte. Full dress and detail of fit from sleeve to shoulder. Photo courtesy Museo del Traje.

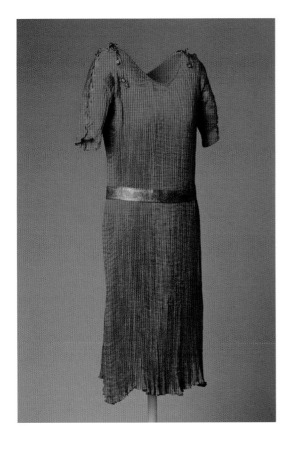

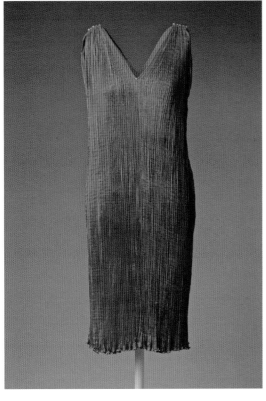

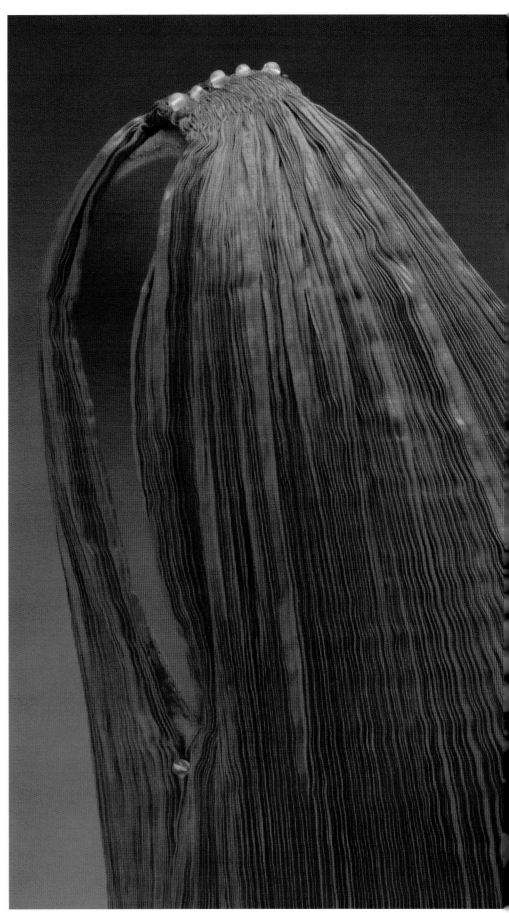

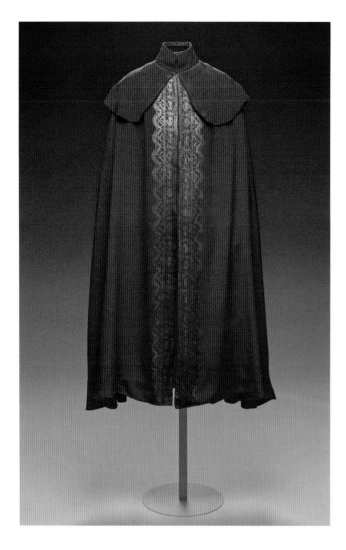

combination with other natural dyes. The results are in keeping with a pioneering study by the Art Institute of Chicago,[13] which identified in some Fortuny pieces the use of cochineal in combination with brazilwood (*Caesalpinia sappan* L.).

In an example from the 2013 study, Fortuny's pleated, reddish-purple silk Delphos (figure 29.2) was found to have fustic or *fustete Americano* (*Chlorophora tinctoria* L.) in a very low concentration, along with cochineal as the main dye. By contrast, in Fortuny's orange pleated silk Delphos (figures 29.3a–29.3b), the two dyes are used in equal proportions.

Of particular relevance is the scientific confirmation of Fortuny's use of cochineal together with some of the first synthetic dyes of the nineteenth century. Such is the case of his 1930–1940 Eleonora dress (see figures 29.1a–29.1b), designed in honor of his first theatrical muse, Eleonora Duse. Although the entire surface of the smooth velvet dress is dyed with cochineal, the pleated satin that marks the side seams and the sleeves reveals a mixture of cochineal and the synthetic dye Rhodamine 6 (Basic Violet 10). One of the first synthetic dyes, marketed in

1887, Rhodamine 6 gives a fluorescent radiance that Fortuny employed to highlight the dress, and the actress, on stage.

Despite a long-standing belief that Fortuny never used synthetic dyes,[14] analysis of certain Fortuny pieces at the Whitworth Art Gallery before a show in 1998 noted the presence of some synthetics,[15] though the researchers were able to identify only natural dyes: indigo, brazilwood, cochineal, and fustic. The 2013 study revealed the important finding that the designer sometimes deemed artificial colorants alone worthy of use to achieve red. For example, in his short full silk cape of 1931–1940 (figure 29.4), chemical components for the color red were detected, though their precise makeup could not be identified.

Fortuny's use of cochineal, either independently or mixed with other natural or artificial dye materials, was unique to each piece. Each was dyed by hand, possibly by bathing the cloth successive times to fix multiple coats, like glazes in painting, or to obtain chromatic shading and iridescence of unequaled, inimitable beauty. The interaction of mordant substances used in this process must also be considered. These elements fixed the color in the fabrics, contributing to the attractiveness of Fortuny's textiles and their varied palette of cochineal tones, from carmine to purple to scarlet.

A 2010 Museo del Traje analysis of a lovely wool and silk caftan dyed entirely with cochineal[16] (figures 29.5a–29.5b) revealed that Fortuny used brass to make gold-like decoration and used aluminum for silver. He employed a protein substance, albumin (from egg white), as an agglutinant to apply and fix the metals. The substance, which Fortuny's father had used in his oil paintings on canvas,[17] also promoted shine. While most handmade textiles involve the use of starch (a kind of cellulose) for this purpose, it leaves a stiffness that was not to Fortuny's liking. He sought a quality in the fabric that would respect the feminine form and mold itself to it, a revolutionary concept for his time, and he discovered a technique to achieve this end.

Finally, Fortuny's personal touch is perhaps best seen in the Delphos—his signature dress (see figures 29.2 and 29.3a–29.3b). This design consists of a double-pleating technique that at once supports the fabric and emphasizes the iridescence generated by the pigments and surface treatments. As a finishing touch to the process, as only a painter would do, Fortuny enlivened the fabric with free brushstrokes in another shade.

FUSING ART, FASHION, AND SCIENCE

With regard to identifying the distinct kind of cochineal used by Fortuny, the analytic method did not allow for significant differentiation; it revealed only the general designation American cochineal of the genus *Dactylopius coccus* Costa. However, it

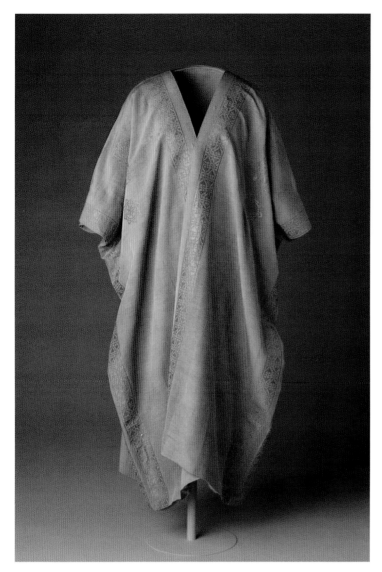

could be American cochineal produced in the Canary Islands, where production had grown since the 1830s until the discovery of aniline dyes in Germany at the start of the 1870s. On display in the Museo Fortuny today are the metal cans in which the designer kept his pigments, some containing cochineal and others containing *palo de Campeche* (logwood) and saffron. Written on the labels is "Sender: Spain. Madrazo."

It must be noted that beginning in the eighteenth century, and in spite of the dominance of cochineal, red dye made from madder from the Middle East was reappearing. Called Turkish red, it was used to dye cotton cloth because cochineal, applied

Opposite **FIGURE 29.4** Mariano Fortuny, cape, Venice, 1931–1940. Silk, glass, and metal; Gros de Nápoles print, 44³/₃₂ x 142³³/₆₄ in. Museo del Traje, Madrid, CE088430, Ministerio de Educación, Cultura y Deporte. This cloak is an example of the designer's occasional use of synthetic dyes to achieve the color red. Photo courtesy Museo del Traje.

Above, left and right **FIGURES 29.5A–29.5B** Mariano Fortuny, caftan, Spain, ca. 1920. Silk and metal; Gros de Nápoles and crepe with print, 50²⁵/₃₂ x 47¼ in. Museo del Traje, Madrid, CE088389, Ministerio de Educación, Cultura y Deporte. Full caftan and detail of metallic decoration on back side. Photo courtesy Museo del Traje.

with the traditional methods, scarcely worked with vegetable fibers. In Fortuny's case, however, it has been confirmed that he was capable of dyeing both cotton and linen using cochineal, a fact that displayed his great technical ability and earned him the reputation as a magician. The analysis from the Art Institute of Chicago provided evidence of this ability, but it was not until 2000,[18] during conservation work on Fortuny textiles that have graced the walls of the auditorium of the Complutense University of Madrid since 1927, that it was confirmed that all the fabric was cotton and that the dye employed was cochineal.

The enduring validity of Fortuny's creative capacity rests on several pillars: the Arab influences of his birthplace in Granada; his family's artistic and intellectual roots; his residence in Venice, the most hybrid of European cities; and his inspiring travels, particularly to the Far East. He integrated the ideas and ways of both the Orient and the Occident to generate new artistic forms. An expert in modern techniques, he also tried to revive traditional methods. Today the works of Fortuny continue to stand as clear examples that art, fashion, and science can go hand in hand. 🕮

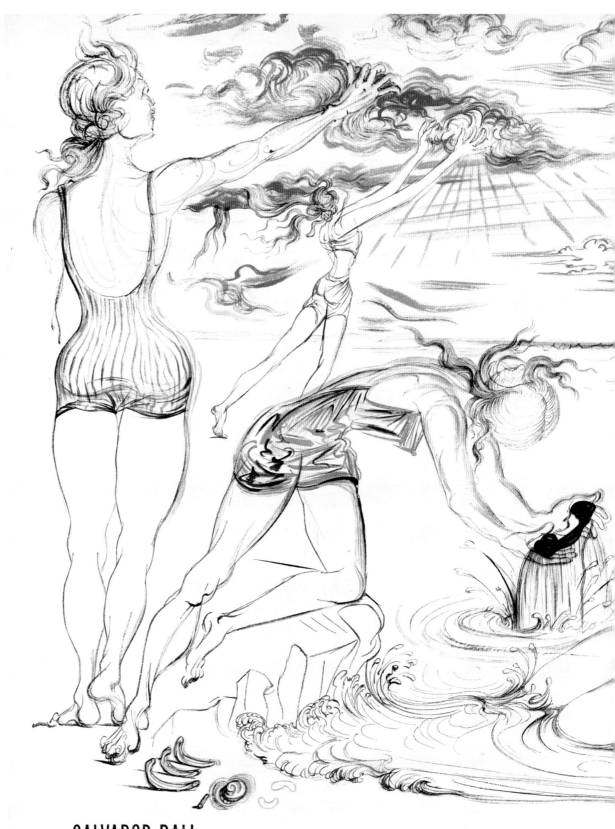

SALVADOR DALI interprets for us here the new alkali-greens, cyanide-violets, cochineal-pinks,

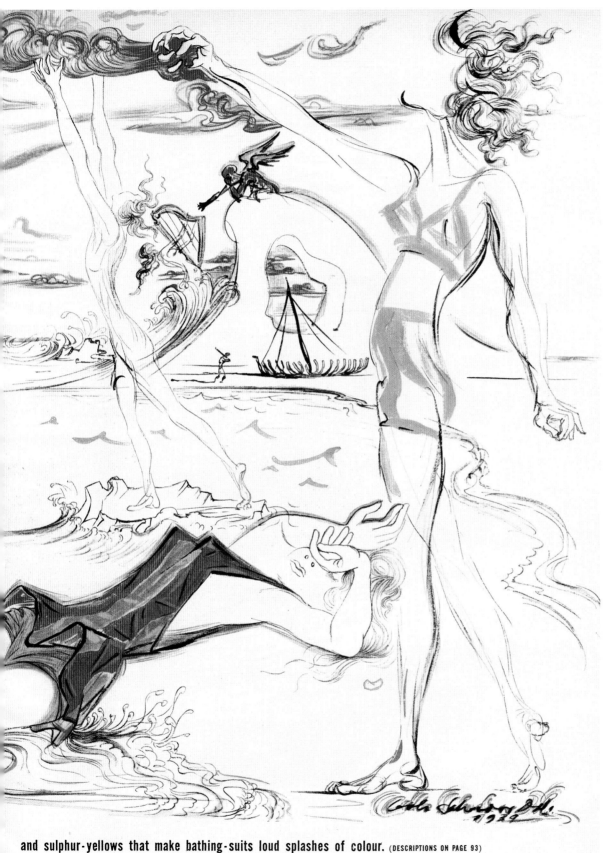

and sulphur-yellows that make bathing-suits loud splashes of colour. (DESCRIPTIONS ON PAGE 93)

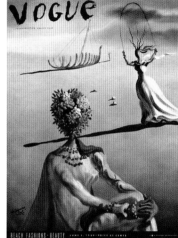

SALVADOR DALÍ

Left Sketches of models
in bathing suits, *Vogue*,
June 1, 1939, pages 121–22
Above Vogue magazine cover,
June 1, 1939
Photos: Dali/Vogue;
© Condé Nast

When *Vogue* editors commissioned
Salvador Dalí to interpret the
"loud splashes of colour" that
distinguished the hottest new
bathing suit hues of the summer of
1939, the artist gave cochineal pink
a prominent place amid vibrant
greens, violets, and yellows. The
artist's dreamlike sketches evoke
the lazy haze of a summer's day and
affirm the return of cochineal as a
desirable, fashion-forward colorant
in the early twentieth century.

CARMINE AND EARTHLY DELIGHTS

Cochineal in Cosmetics, Contemporary Craft, Fashion, and the Strawberry Frappuccino

NICOLASA CHÁVEZ

THE USE OF CARMINE in traditional arts had almost completely died out by the twentieth century; cochineal had been replaced by synthetic dyes, which were cheaper and easier to acquire in large quantities. Although cochineal was no longer exported on a grand scale for the art market, its survival through the second half of the twentieth century was largely due to the food and cosmetics industries. In 1938 the U.S. Food and Drug Administration (FDA) began a push to rid food and cosmetics of dangerous chemical dyes. Carmine, the dyestuff extracted from the cochineal insect, was a safe and available natural alternative. Now referred to as Natural Red 40 by the FDA and E120 food color by the European Union, carmine, a noncarcinogenic natural protein purported to cause few allergies, was recognized early on as a perfect substitute for synthetic dyes. It was such an ideal fix, yet few knew the colorant was a crushed insect.

By 1998, however, reports of severe allergic reactions by a small percentage of the public had prompted the Center for Science in the Public Interest (CSPI), a consumer health and nutrition advocacy organization, to submit a petition to the FDA, asking that the colorant be listed by its true name on food and cosmetic labels. On January 5, 2009, the FDA finalized a recommendation to require the designation "carmine" or "cochineal extract" on labels, with the ruling to take full effect by January 5, 2011.[1] Some believe the ruling was made due to coffee giant Starbucks's use of carmine in its Strawberry Frappuccino, a rose-colored blended milk drink. However, news of Starbucks's use of the crushed-bug coloring did not appear until March 2012, when a company barista reported to the This Dish Is Vegetarian website that the popular drink is not vegan. The global vegan community so vehemently voiced its opposition that the Strawberry Frappuccino was eventually pulled from the menu.[2]

Aside from the Frappuccino flap, as well as a 2013 CSPI online petition campaign to convince Dannon to stop using the insect to color thirteen fruit-flavored yogurts,[3] the use of carmine as a natural alternative to synthetic dyes persists in the twenty-first century food and cosmetics industries. Carmine colors everything from maraschino cherries, cheddar cheese, yogurts, and ice cream to grenadine, lipstick, eye shadow, and rouge. Currently, the two largest producers of cochineal are Peru and the Canary Islands. These are followed by Mexico, Ecuador, and Bolivia, where small pockets of cochineal use still exist within traditional communities.[4]

In Peru, where roughly 85 percent of the world's cochineal is produced, with most reserved for export,[5] use of the dye continues in several Andean villages. In Chinchero, weaver Nilda Callañaupa Álvarez is the founder and director of the Centro de Textiles Tradicionales del Cusco, a nonprofit textile center that oversees a large network of weaving cooperatives throughout the Cuzco region. The center's weavings are noted for their high-quality craftsmanship; stellar examples of traditional Andean techniques, including the use of natural dyes; and designs rooted in Inca rituals and folklore. Works by Callañaupa and other weavers not only preserve the textile traditions of native villagers, they have become popular with collectors from around the world, providing vital economic support for village weavers. Callañaupa has passed down her knowledge of color and traditional methods to her daughter Fidelia Callañaupa Quispe, who produces contemporary hand-spun alpaca textiles using natural dyes. In one woman's shawl, Fidelia used cochineal to achieve a classic deep burgundy whose brilliance is offset by another natural hue, indigo blue (figures 30.1a–30.1b).

■ *Opposite* FIGURES 30.1A–30.1B Fidelia Callañaupa Quispe, woman's shawl (full and border detail), Chinchero, Cuzco, Peru, 2008. Alpaca fiber, sheep wool, cochineal, indigo, 37⅜ x 42½ in. Museum of International Folk Art, IFAF Collection, FA.2008.69.1.

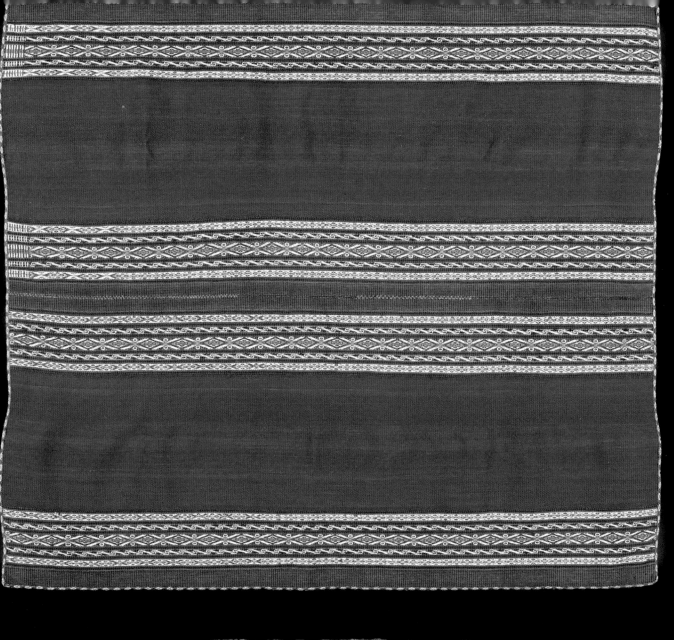
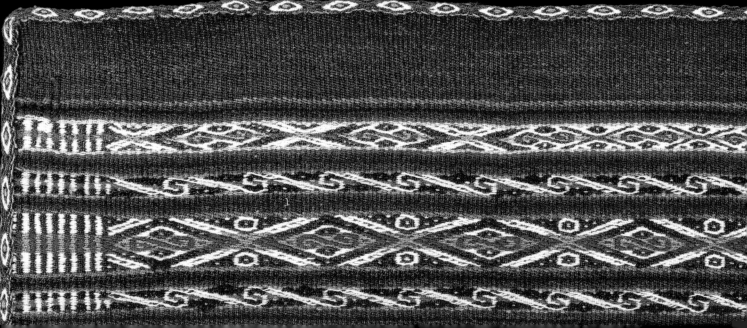

■ FIGURE 30.2 Pompeyo Berrocal Evanan, *tabla* (painted board), Sarhua, Ayacucho, Peru, 2011. Wood, cochineal, natural pigments, 37½ x 7½ x ¾ in. Museum of International Folk Art, IFAF Collection, FA.2011.39.1. The painting depicts a couple harvesting cochineal from the prickly pear cactus by brushing the bugs into a basket. The bottom panel shows the couple selling their produce at the market; buyers weigh the insects and determine an agreeable price. The various shades of red and orange in the *tabla* were created using cochineal.

Pompeyo Berrocal Evanan uses cochineal and other natural pigments to paint wood panels that illustrate daily life in his native land. The tradition of the painted *tabla* comes from Berrocal's hometown of Sarhua, in Ayacucho, Peru, where *tablas* are made as gifts that document family activities and histories. Created by the spiritual godfather of a family, a *tabla* is given to a relative who builds a new home or forms a new family via marriage or birth. The panels depict family members conducting everyday work or chores through a series of vertical images or vignettes from the family's story. For one *tabla*, made in 2011 (figure 30.2), Berrocal used cochineal pigment to depict the harvesting of the bug, its processing as powder, and its transport to the local market for sale. This contemporary narrative work emphasizes the continued use and importance of the dyestuff in Andean art and culture.

Oaxaca, Mexico, is perhaps the best-known producer of cochineal and, some scholars maintain, is its place of origin. (See Van Dam et al. and de Ávila B., this volume.) As in Peru, cochineal use in Oaxaca has been continuous since pre-Columbian times. But Peru is the world's largest exporter of cochineal, whereas most of the production in Oaxaca is for use by regional artists, who widely use carmine in their various works of art.

In Teotitlán del Valle, a Zapotec village renowned for its rich textile traditions, Bulmaro Pérez Mendoza follows in the tradition of generations of family members who have practiced the village's signature weaving craft. Pérez, a ninth-generation weaver, creates rugs and floor runners utilizing ancient Zapotec techniques and designs, as well as more contemporary weavings inspired by traditional Zapotec symbolism and the Oaxacan countryside. His use of natural dyes and his dyeing expertise distinguish his work (figures 30.3a–30.3f). One exceptional floor runner by Pérez was dyed entirely with cochineal and pecan shells (figure 30.4). Here the weaver mixed cochineal with several different mordants to produce shades of light coral, brownish purple, deep scarlet, and burnt sienna.[6] The four shades of cochineal are offset against the greenish brown produced by the pecan shells to create the ancient *caracol* (snail) pattern, which in the Zapotec tradition represents the four directions and stages of life.

Cochineal use endured in Oaxaca in the twentieth century, even as other cultures abandoned it and other natural sources in favor of synthetic dyes (figures 30.5–30.6). Today, many contemporary artists are representing a new generation of experimentation. Silk rebozos are the specialty of Moisés Martínez Velasco and his family in San Pedro Cajonos, who harvest some 120,000 silkworms twice a year in one of the few Oaxacan

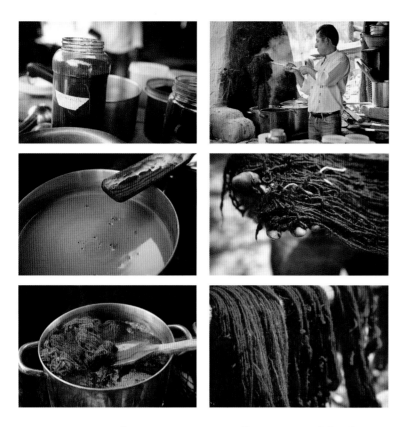

communities that continue to raise silk. Starting with his family's farm-raised silkworms, Martínez takes seven days to hand-spin, dye, and weave each of his fine contemporary rebozos. He then expertly uses cochineal to produce various shades of carmine-based color, from deep scarlet to lilac to coral pastel.[7]

Martínez also creates cochineal-dyed ponchos and *huipiles* (tunics), often recreating traditional designs in unique contemporary hues to suit a growing tourist market. For one extraordinary handwoven man's *huipil* made in 2014, Martínez overdyed a lighter shade of indigo with cochineal to create a rich berry effect with violet undertones (figure 30.7). Finally, he hand-cuts and shapes silk scraps into flower petals that bloom into cochineal-red necklaces that reflect the beauty of Oaxaca's botanical riches (figure 30.8).

Also in Teotitlán del Valle, sisters Sara and Sofía Ruíz Lorenzo use natural dyeing techniques learned from weavers in their village to create traditional Zapotec ornamental candles for weddings, feast days, funerals, and other rituals. Their large-scale beeswax candles boast elaborate designs from nature, particularly delicate roses and other floral motifs, with hand-shaped petals dyed in boldly colored shades of cochineal, from pale pink to fuchsia to deep scarlet (figures 30.9a–30.9b). The tabletop candles are central to traditional Zapotec weddings, used as customary dowry gifts and as elegant appointments for church altars for the wedding ceremony. The Ruiz sisters also sell their sculpted candles to collectors, who travel to Teotitlán del Valle to buy the work or who meet the candle makers at regional and international folk art markets.

Above, left **FIGURES 30.3A, 30.3B, 30.3C, 30.3D, 30.3E, AND 30.3F** Bulmaro Pérez Mendoza of Teotitlán del Valle, Oaxaca, Mexico, demonstrates cochineal dyeing techniques at a July 15–16, 2014, workshop at El Rancho de las Golondrinas living history museum in La Cienega, New Mexico. Photos © Genevieve Russell.

■ *Above, right* **FIGURE 30.4** Bulmaro Pérez Mendoza, floor runner, Teotitlán del Valle, Oaxaca, Mexico, 2014. Wool, cochineal, pecan shell, 115 x 32¼ in. Museum of International Folk Art, IFAF Collection, FA.2015.2.1.

- *Opposite, top left* **FIGURE 30.5** *Huipil* (tunic), Usila, Oaxaca, Mexico, nineteenth to twentieth century. Wool, cotton, cochineal, 33⅛ x 33½ in. Museum of International Folk Art, IFAF Collection, FA.1971.71.100. The introduction of synthetic dyes in the 1850s prompted many traditional artisans to abandon the labor-intensive processes of working with cochineal for the ease, vividness, and economy of anilines. In the cochineal heartland of Oaxaca, however, indigenous artisans continued to utilize their abundant native resource in everyday and ceremonial garments.

- *Opposite, bottom* **FIGURE 30.6** Diamond-twill skirt fabric, San Antonio Castillo Veliz, Oaxaca, Mexico, ca. mid-1950s. Wool, cochineal, 156 x 36 in. Courtesy of Walter Anderson. According to Oaxacan textile expert Remigio Mestas,[a] the intricate diamond pattern in the refined twill weave of this lushly colored skirt fabric likely places its origin in the small town of San Antonio Castillo Veliz, in the area of the archaeological site of Mitla. Based on the threads used in this fabric, and the fact that, about 1970, weavers stopped making the style of skirt for which the fabric would have been used, Mestas estimates that it dates from the mid-1950s, demonstrating cochineal use in the town well into the twentieth century.

- *Opposite, top right* **FIGURE 30.7** Moisés Martínez Velasco, men's *huipil*, San Pedro Cajonos, Villa Alta, Oaxaca, Mexico, 2014. Silk, cochineal, indigo, 37½ x 23⅜ in. Museum of International Folk Art, museum purchase, A.2015.1.1.

- *Above* **FIGURE 30.8** Moisés Martínez Velasco, *collar* (necklace), San Pedro Cajonos, Villa Alta, Oaxaca, Mexico, 2014. Silk, cochineal, metal, 18½ x 11⅜ in. Private collection.

- *Right, top and bottom* **FIGURES 30.9A–30.9B** Sara Ruíz Lorenzo and Sofía Ruíz Lorenzo, beeswax candles, Teotitlán del Valle, Oaxaca, Mexico, 2009. Beeswax, cochineal, natural dyes, plastic, foil, paper, 48 x 19½ in. (30.9a), 18 x 7½ in. (30.9b). Museum of International Folk Art, gift of Laura Widmar and Sergio Tapia, A.2015.6.3a,b.

NEW EXPRESSIONS IN AMERICAN COCHINEAL

Compared to the pre-Columbian roots of cochineal in Mexico and Peru, the cochineal tradition on the Canary Islands is relatively new. The bug arrived on the islands in the 1830s from Cádiz, Spain, then the major port of entry for cochineal from the Americas. Throughout the nineteenth and early twentieth century, cochineal was among the major agricultural items produced in the Canary Islands, for both export and local use. But competition from synthetic dyes, as well as from large-scale exports from countries that produced cochineal in larger quantities, such as Peru, caused the decline of production on the islands.[8]

The volcanic island of Lanzarote, today best known for ecotourism and wind technology, is the site of a recent resurgence in the popularity of cochineal. With little rainfall and a desert environment, the island provides the perfect atmosphere for farming and harvesting the dyestuff. More than 110 registered volcanoes offer abundant volcanic ash, which is used to fertilize the island's cochineal farms (figures 30.10a–30.10b).

This resurgence comes after a period of decline, however. By the end of the twentieth century, cochineal production in Lanzarote had become endangered. The number of farmers harvesting the bug had dwindled, and many farms had been abandoned. Young people took jobs in the booming tourist industry at the island's popular coastal resort areas, while the average age of farmers was between seventy and eighty.

In 2003 Asociación Milana was formed to protect and preserve Lanzarote's cochineal tradition. The association developed a long-range plan to revitalize the island's agricultural communities and to create educational and economic opportunities for its residents. The initiative, titled El Rescate de la Cultivo de la Cochinilla (the Rescue of the Cultivation of Cochineal), is considered vital to the social and cultural health of the island. While some of the dyestuff was traditionally produced for export, today a large percentage is used in schools, in traditional arts and crafts workshops for adults, and by local artisans.[9] Cochineal has also been incorporated into the arts of palm-leaf basket weaving and wood furniture carving. For the wooden pieces, cochineal is applied as a stain. For the baskets, the palm leaves are also stained, in various shades of red, pink, and purple.

Asociación Milana, which shares space with the public school in the town of Mala, conducts workshops and other educational activities for tourists, houses visiting artists-in-residence, and exhibits their work. Every September, an artisanal market, the Feria Insular de Artsanía, showcases the work of local artists who use cochineal.[10] The organization's Ruta de la Cochinilla (Cochineal Trail) introduces tourists and other visitors to large cactus farms and local artists and designers in an effort to spread knowledge of the history and continued use of cochineal.

Local fashion designers have been particularly inspired by the cochineal resurgence, using traditional techniques to create hand-dyed silks, crocheted hats, scarves, handbags, *tocados* (headdresses), brooches, necklaces, and earrings. Most recently, dyers and designers have collaborated on elegant evening attire and casual wear showcasing a rainbow of cochineal-derived colors: deep garnet, cherry red, fuchsia, rose, pale pink, deep purple, lilac, and lavender. Of particular interest are shades of silver gray and jet black, which result from a mixture of carmine, iron oxide, and a high percentage of sulfate. Of these, solid black, which sometimes appears with hints of deep purple,[11] is the most difficult cochineal-derived color to achieve.

COCHINEAL BY DESIGN

Around the globe, outside of regions where cochineal has a continuous history of cultural meaning and use, pockets of contemporary fashion designers have followed in the footsteps of early twentieth-century design icon Mariano Fortuny, experimenting with the dye since at least the mid-1990s. Among them is London-based designer Cathryn Avison, who is best known for producing embroidered clothing and lace fabric for film and theater. Avison uses cochineal and other natural dyes to enhance the multiple hues of her embroidered designs. A featherlight dress of embroidered silk chiffon and organza made by Avison in 1996 boasts cochineal in the palest shade of shell pink, almost angelic in hue (figure 30.11).

At the same time, innovative use of cochineal continues in Spain's contemporary design circles. In 2014 the Full Integration Design (FID) collaborative formed in Madrid. FID combines the talents of contemporary Spanish designers with the techniques of traditional artisans to provide viable and creative employment opportunities for people with learning disabilities. The group's principal objective is to achieve the social and economic inclusion of the disabled population into the design and fashion worlds.[12] The program brings Spain's top designers together with regional artisans to create hats, handbags, and shoes. The pieces are crafted by learning-disabled workers, helping to build their self-confidence and autonomy. The resulting works are at once artistic, modern, and functional. One of the collaborative's first creations, a *tocado* (fascinator), was created from jute dyed with cochineal from Lanzarote (figure 30.12).

In Japan, meanwhile, women of the embroiderers' guild in Kanazawa began to experiment with cochineal after learning that the dye was used for a brief time in their country. (See Bethe and Sasaki, this volume.) Hitomi Mayakoshi, a longtime member of the guild, creates contemporary kimono sashes for use within the community. Her hand-stitched cherry blossoms are the rosiest of the cochineal palette. She is currently handing down her craft to her daughter Ayami.

Opposite **FIGURES 30.10A–30.10B** Lanzarote, Canary Islands. Fields of prickly pear cactus, the host of the cochineal insect, fill the landscape of Lanzarote, where cochineal farming is undergoing a resurgence. Detail shows a cotton-like mass of cochineal bugs on a cactus pad. Photos © Bob Smith.

■ *Top* **FIGURE 30.11** Cathryn Avison, ensemble (dress and scarf), United Kingdom, 1996. Embroidered silk, chiffon, organza, cochineal. Dress: 48³⁄₁₆ x 25¹⁹⁄₃₂ in.; scarf: 74¹³⁄₃₂ x 22³⁄₆₄ in. Victoria and Albert Museum, London, T.127:1 to 4-1996 HHK28.

■ *Bottom* **FIGURE 30.12** Full Integration Design (FID), *Art, of Course, tocado* (fascinator), jute, cochineal, garnet, metal, 5½ x 7⅞ in. Enesimapotencia, Consultoría y Producción Cultural, Madrid.

In the United States, particularly in the American Southwest, artists are taking inspiration from the centuries-old story of the cochineal insect to create works that reference its long and unique history of use. Rather than fabric, Gayle Crites of Golden, Colorado, dyes hand-pounded bark, which she describes as "some of the world's oldest cloth,"[13] with natural dyes to create an organic canvas for expressions that connect history to modernity. Her 2014 *Then Now-Now Then* (figure 30.13), which combines bark from Samoa, silk from Japan, and cochineal from Mexico, is part of a body of work that addresses timeless themes of water and flow to illuminate "the tangled problems we face in using and preserving humanity's lifeblood."[14] Crites's lyrical, free-flowing work is a metaphor for the longevity and use of the ancient *nochetzli*, "blood of the prickly pear," from pre-Columbian times to today. At the same time, it is a highly contemporary work, an abstract, maplike merging of color and texture awash in cochineal-based shades of berry, peach, and pale orange-red.

Hailing from Tselani, Arizona, on the high country of the Navajo Nation, Santa Fe–based weaver D. Y. Begay is a fourth-generation artist born to the Totsoni' (Big Water) Clan and born for the Tachinii' (Red Running into Earth) Clan people.

While unraveling yarn from imported, cochineal-dyed *bayeta* cloth was a common practice of Navajo weavers by the eighteenth century, Begay continues a family tradition of female weavers who herd and shear sheep, card and spin wool, and harvest plants for dyeing. The weaver is best known for evocative landscape tapestries that express her spiritual connection to the land through her use of natural dyes, including cochineal. *Palette of Cochineal*, woven by Begay in 2013, is a multihued ode to the versatility and compelling natural beauty of the dyestuff, its earthy shades of cochineal shifting from red-orange to brown-orange to burgundy to deep purple (figure 30.14). The colors achieved by cochineal, Begay says, "lend themselves to the colors of the desert Southwest, the buttes and mesas."[15] The deep brown hue bordering the piece is natural wool.

Begay, who also frequently uses madder and brazilwood to achieve the color red, says that cochineal was not commonly used by her mother, grandmother, or other elder Navajo weavers. However, her appreciation of the varied shades of red that cochineal can yield has developed "because of its history, the story of how it arrived in the Southwest, and the ways that weavers are using cochineal today."[16] Begay's

interest in and experimentation with the dye deepened in 2012 at a weaving conference in Cuzco, Peru, where she had the opportunity to purchase cochineal. In 2013 the Heard Museum commissioned her to create a weaving with "the incentive to produce as many colors as I could using cochineal."[17] In an artist statement written upon completing *Palette of Cochineal,* Begay describes her process of experimentation and discovery in working with the substance. She sums up the experience of many contemporary artists and designers who are finding new avenues of expression in an ancient dye:

> Palette of Cochineal *is comprised of 22 shades of color harvested from thousands and thousands of dried tiny insects. The collection of colors . . . is derived from stories and experiments in my dye shed. One of the most profound memories during one of my dyeing marathons transpired when my father was visiting from the Navajo reservation. . . .We had a wonderful conversation about how the tiny insects are used to produce many shades of red and purple. Cochineal was a foreign commodity to him and he didn't know of any other weavers that used the insects for obtaining the tantalizing colors we were creating that day. The*

> *dyeing process for* Palette of Cochineal *consisted of working and experimenting with numerous dye baths. I was able to achieve many of the colors by controlling the alkalinity in the water. Some dye baths include combinations of other dye materials such as madder, pomegranate and alkanet to achieve light and dark shades of red and purple. Every dye bath goes through multiple dips until the color is completely exhausted. . . . Weaving* Palette of Cochineal *unveiled rich, glorious and unimaginable colors from those tiny bugs.*[18]

■ *Opposite* **FIGURE 30.13** Gayle Crites, *Then Now-Now Then,* Golden, Colorado, 2014. Brush and *sumi* ink on *siapo* (hand-pounded bark) from Samoa, cochineal from Mexico, silk from Japan, 72 x 72 in. Chiaroscuro Contemporary Art, Santa Fe. Photo courtesy Chiaroscuro Contemporary Art.

■ *Above* **FIGURE 30.14** D. Y. Begay, *Palette of Cochineal,* Santa Fe, New Mexico, 2013. Wool, cochineal, 33 x 48 in. Collection of the Heard Museum, Phoenix, Arizona, 4732-1. Gift of the Heard Museum Council in honor of Werner Braum, the Max M. and Carol W. Sandfield Philanthropic Fund of the Dallas Jewish Community Foundation as recommended by Norman L. Sandfield, and the Bruce T. Halle Family Foundation at the recommendation of Diane and Bruce Halle and in honor of Harvey and Carol Ann Mackay. Photo courtesy of the Heard Museum.

ROMANTIC REVIVAL

Cochineal in Contemporary New Mexican Hispano Art

NICOLASA CHÁVEZ

NEW MEXICAN HISPANO ART has long integrated several varieties of red achieved by the use and mixing of various pigments, including cochineal. Recent scientific testing confirms cochineal's history of use by eighteenth- and nineteenth-century New Mexican Hispano artists, though the extent of that use is debatable. (See Gavin and Caruso, this volume, and Thomas Snow, this volume.) While some scholars believe that the colorant was a primary source of red, others point to it as only one option among several, in many cases hardly used at all. The discussions of whether or not cochineal was a "traditional" New Mexican color source go hand in hand with ongoing debates about what constitutes traditional Spanish colonial–style art in New Mexico. Wherever one stands on these matters, there is no arguing that a romantic fascination with the cochineal insect and the spectacular color it produces has led to a rise in the popularity and use of cochineal in New Mexican Hispano art since at least the 1970s.

Indeed, for many contemporary New Mexican artists working in the Spanish colonial style, use of cochineal is directly linked to a nostalgic desire to preserve New Mexico's unique Hispano art history, which spans more than four centuries and ever-shifting cultural influences under the governments of Spain, Mexico, and the United States. Historically, cochineal was incorporated into meaningful works of art and everyday items for the home. The most widespread use was in popular regional textiles, including Rio Grande–style weavings and *colcha* embroideries. (See Hedlund, this volume, and Gavin and Caruso, this volume.) It was also used by *santeros* (saint makers) to make *retablos* (religious polychrome paintings on wood) and *bultos* (three-dimensional sculptures), as well as by artists who produced paintings and other works on hide.

This long history of cochineal use has a firm hold on the imaginations of Hispano artists working in the same art forms today. Whether producing works that directly replicate Spanish colonial New Mexican prototypes, or contemporary innovations inspired by tradition, many artists have found common ground and personal expression through cochineal. In the following examination of works by living artists, we find that their motivations and techniques vary, with shared considerations of color and cultural identity. Through the connection to cochineal use in the past, we might also chart a possible course for the colorant's use in New Mexican art in the future. 🌵

Opposite

TERESA ARCHULETA-SAGEL

■ *Gemini Blues (Tristeza Gemini)*
Española, New Mexico, 1992
Wool, indigo; single-ply hand-spun and commercial wool yarns
55 x 32½ in.
Collection of the Spanish Colonial Arts Society Inc.,
Museum of Spanish Colonial Art, 1993.007
Photo: Addison Doty, courtesy Museum of Spanish Colonial Art

In the 1970s, a groundbreaking study at the Museum of International Folk Art tested dyes used by early New Mexican Hispano weavers, revealing valuable information about their use of cochineal.[1] This research stimulated great interest in natural dyes among northern New Mexican Hispano weavers, who sought to learn, preserve, and perpetuate the specialized dyeing techniques used in historic Rio Grande–style textiles. Española native Teresa Archuleta-Sagel was among the young weavers who immersed themselves in natural dyeing processes and practices. She quickly emerged as a master in the use of traditional weaving materials and techniques.

Archuleta-Sagel's weaving was also influenced by her own poetry, as in the weaving series *Gemini Blues,* created in 1992. The series merges nineteenth-century design motifs and techniques with the artist's poetic vision and voice.[2] Here, as in historic weavings, Archuleta-Sagel uses only natural dyes to express a traditional Rio Grande–style pattern featuring a central chevron. While varying shades of indigo cover the background, she uses cochineal sparingly and strategically in the chevron and for select border effects.

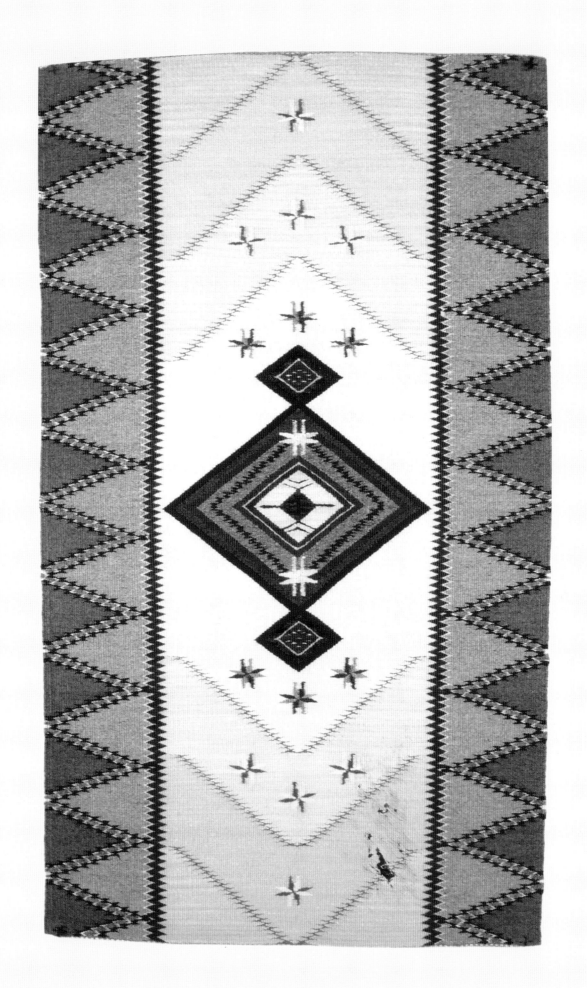

LISA TRUJILLO

■ *Crazy at Heart*

Chimayó, New Mexico, late 1990s to early 2000s
Natural hand-spun wool, cochineal, logwood
72 x 48 in.
Museum of International Folk Art, museum purchase with funds from
the Robert and Margot Linton Endowment, A.2015.3.1

Lisa Trujillo uses cochineal to create weavings that represent and refresh traditional Rio Grande–style designs. Trujillo and her weaver husband, Irvin, own Centinela Traditional Arts in Chimayó, a northern New Mexico village. The town's cultural and economic histories have been deeply connected to the weaving trade since the nineteenth century, and multiple generations of Trujillo weavers in Chimayó have perpetuated the craft. In addition to operating a store and cultural center, the Trujillos are internationally recognized as contemporary weaving masters who hand-dye wool on site.

For her part, Trujillo deftly controls the depth and brightness of her cochineal-derived colors: "The first batches will always come out richer and darker, with the next batches lightening up with each dipping."[3] The process is reflected in her weaving *Crazy at Heart*, which features a Chimayó pattern, a traditional design that is normally depicted as a central motif. Here Trujillo expands the design to cover the entire textile. Trujillo used deep scarlet from the first stage of the dye bath for the central pattern, while the design elements in the background showcase the paler shades of the second and third dye batches. Although the background also highlights natural white and natural brown bands, the majority of patterns are woven from pale pink "leftover yarn that nobody else wants."[4]

MONICA SOSAYA HALFORD

■ *Spanish Colonial Chest Designs*
Santa Fe, New Mexico, 2014
Cotton, wool, vegetal dyes, cochineal
55⅝ x 26¾ in.
Museum of International Folk Art, museum
purchase with funds from the Robert and Margot
Linton Endowment, A.2015.4.1

A resourceful, use-what-you-have philosophy is a
staple of traditional New Mexican Hispano art and
is illustrated by the art of *colcha* embroidery. *Colcha*
involves a special technique in which long stitches,
tacked down with a couching stitch, are used to
create designs that are seen only on the front of the
piece, while the back is nearly bare. This technique
provided functional and beautiful works for the
home without wasting yarn.

Contemporary *colcha* embroiderer Monica Sosaya
Halford makes use of leftover yarns to create both
traditional and contemporary embroidered works.[5]
At eighty-four, Sosaya Halford is currently the oldest
artist participating in Santa Fe's Spanish Market, an
annual showcase for New Mexico's Spanish colonial
art traditions. While she also makes *retablos* and
paints on hide, she is well known for her figurative
colcha creations and works that feature vines and
floral designs based on historic patterns.

Although Sosaya Halford switches between
synthetic yarns and natural wool yarns, and does
not dye her own wool, she has through the years
acquired a cache of various cochineal-based shades,
from red to rose to pink, shared by her weaver and
colcha-embroiderer friends. In her 2014 piece
Spanish Colonial Chest Designs, she makes use
of a wide variety of reds, pinks, roses, and corals to
interpret the scenic figurative painting that appears
on historic lacquer chests from Guerrero and other
Mexican locales, which themselves were often
painted with cochineal. (See Curiel, this volume.)

JAMES CÓRDOVA

■ *Santa Cristina (Saint Christina)*
Santa Fe, New Mexico, 2013
Hand-carved jelutong and pine, homemade rabbit skin–based gesso,
cochineal and other ground mineral and vegetal pigments, piñon-
resin varnish, wax
24 x 14¾ x 9½ in.
Carl and Marilynn Thoma Collection

Cochineal connects the story and symbolism of Saint Christina, the daughter of a powerful magistrate who was martyred by arrows, in this contemporary sculpture by noted *santero* James Córdova. Córdova painted Santa Cristina's cape with several washes of cochineal to represent her elite status, her spiritual royalty, and the blood she shed.[6] Practically speaking, Córdova chose the magenta hue of the cochineal to contrast with the saint's golden robe, painted with yellow ocher. Cochineal's resonance with the other natural reds used in the work—the floral wreath, the floral motifs and red outline on the base, and the red highlights in the vestments and on the cross behind Christina—was intended to tie the piece together.

Córdova says the organic, unpredictable nature of cochineal makes it both difficult and delightful to work with: "I am always surprised by the quality of the hue that comes out of the ground cochineal, which I prepare myself. I am never quite sure what I'm going to get: a deep and rich purple, a warmer crimson, or something else. In some cases, I combine it with other pigments to change the hue to what I want (indigo, for example, to move from crimson to purple), but in *Santa Cristina*, I left it unmixed because I was so pleased with its natural hue. The scrolls and flourishes on her cape are painted with indigo, which I think produces a nice effect and helps signify the saint's elite status."[7]

FELIX LÓPEZ

■ *Restaurando el Caído*
(Restoring the Fallen One)
Española, New Mexico, 2014
Pine, aspen, handmade gesso, straw,
cochineal, indigo, madder, walnut, white
and yellow earth
24 x 21½ x 17½ in.
Museum of International Folk Art, museum
purchase, A.2015.5.1

Like some of their Spanish colonial
predecessors, Felix López and other
contemporary *santeros* use cochineal in
making traditional religious paintings
(*retablos*) and sculptures (*bultos*). For his
part, López credits weaver Teresa Archuleta-
Sagel, who grew up in his hometown of
Española, with introducing him to the
colorant.[8]

While López regularly uses other sources
of red, including madder and red ocher, he
chose to use cochineal for his 2014 sculpture
*Restaurando el Caído (Restoring the Fallen
One)*. Specifically, he applied the pigment to
color the Christ figure's robe. When used alone
and applied directly to gesso, cochineal often
turns the purplish red seen in the robe. López
describes this natural hue as reminiscent
of Renaissance paintings that depict Christ
in purple as opposed to bright red, which is
commonly associated with fire, flames, and the
devil. He used madder to achieve an orange-
red on the robe of the fallen figure. His choice
of whether or not to use cochineal red depends
as much on the subject matter and style of a
piece as on the color he wishes to achieve.

ARLENE CISNEROS SENA

■ Altar screen triptych

Santa Fe, New Mexico, ca. late 1990s

Pine, gesso, piñon varnish, cochineal, indigo, black walnut,
iron oxide, gold leaf, metal hinges

18⅜ x 18½ x ⅞ in.

Museum of International Folk Art, IFAF Collection, 2005.44.11

Santera Arlene Cisneros Sena creates deep scarlet and purple hues from cochineal. These have become signature colors in the artist's traditional color palette, which is derived from all-natural pigments. "I love using cochineal," she says. "Scarlet is one of my favorite hues. It is the most dramatic and bold, without being bright."

Cisneros Sena was careful when first learning to use cochineal because it is difficult to work with. "Cochineal requires great care," she says. "If it is not mixed or used correctly it will turn black once it hits the air." After much experimentation, Cisneros Sena found the perfect balance, drying the insect over a four-month period in the sun, then mixing the crushed bug with the proper additives, such as cream of tartar and alum, to achieve a "good, true scarlet cochineal shade."[9]

Unlike other artists who use cochineal occasionally or sparingly, Cisneros Sena has made purples and scarlet a prominent feature in her art—from the borders of her *retablos* to the clothing and robes of her hand-painted community of saints, including the Virgin of Guadalupe depicted in her altar screen triptych. For the Virgin's robe, Cisneros Sena used a deep rose hue that varies from dark to light. The robe's floral and vine-like designs are reminiscent of early brocades. She creates the patterns using a sgraffito or *estofado* technique in which the top, darker layer of cochineal pigment is scratched away to reveal a pattern and lighter shade underneath. The four saints that surround the Virgin are also dressed in capes and robes of a deep scarlet hue, which stands out brilliantly next to dark indigo.

RAMÓN JOSÉ LÓPEZ

■ *La Aparición de la Virgin de Guadalupe a Juan Diego*
(The Apparition of the Virgin of Guadalupe to Juan Diego) (copper engraving series)
Santa Fe, New Mexico, 2012 (copperplate)
and 2014 (prints)
Copper, 100 percent rag paper, cochineal, indigo, lamp black, yellow ocher, green earth, black walnut
Prints: 14⅞ x 11⅛ in.; copperplate and print: 14⅞ x 22¼ in.
Collection of the artist
Photo: Lynn Lown, courtesy Ramón José López

Ramón José López works in a variety of capacities—as a *santero*, silversmith, hide painter, illustrator, and calligrapher—and is known for his ambitious and innovative twists on New Mexican Spanish colonial art traditions. He began working with cochineal during the mid-1980s, learning from women from the Española Weavers' Guild who were experimenting with natural dyes. Since then he has integrated the pigment into different works in wood and hide. He particularly likes using cochineal for blood on images depicting Christ because, he says, the pigment "gives [blood] that deep scarlet hue."[10]

Most recently, López has experimented with cochineal pigment on copperplate engravings that he produces entirely by hand. For a series of five copperplate prints, *The Apparition of the Virgin of Guadalupe to Juan Diego,* López used cochineal to color the deep red roses that represent the Virgin. This highly symbolic application is not only a thoughtful merging of material and meaning in relation to the story of the apparition of the Virgin of Guadalupe, patroness of the Americas, but also represents the cross-cultural meaning of the red rose as a global symbol of love. López also utilized cochineal to color other elements in the various prints in the series— from the rosy tones of the Virgin's robe, to the peach flesh tones of the cherubs who surround her, to the pink checkerboard floor tiles of the bishop's residence, to the cherry red blossoms of the prickly pear cacti that dot the landscape. Although he uses a variety of sources for reds, López says cochineal acts just like any other water-based pigment, inspiring him to use it as much for its practical considerations as for its potent colorations.

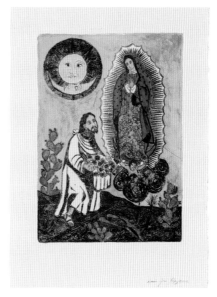 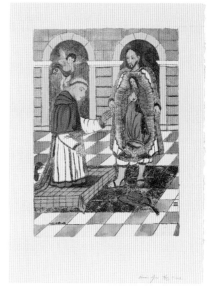

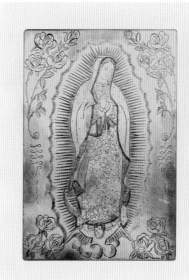 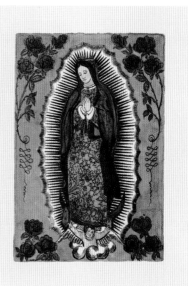

RED COLLECTION

Orlando Dugi's Cochineal-Inspired Fashion Design

CARMELLA PADILLA

RED, IN ALL ITS TRENDSETTING tones, has colored countless modern fashion statements, from Valentino's trademark red collections to Nancy Reagan's red power suit to everywoman's little red party dress. Yet with the exception of Spanish fashion visionary Mariano Fortuny in the early twentieth century, few fashion designers have been known to develop entire collections around cochineal. Four years into his fashion career, with his cochineal-inspired Red Collection, Santa Fe–based designer Orlando Dugi hopes to be a twenty-first-century exception.

In 2014, as the thirty-six-year-old self-taught designer began planning a collection to celebrate the power of women, he imagined a pre-Columbian matriarchal society whose wealth and dominance were expressed in luxurious red gowns. The subject called for "a royal color"[1] to convey the timeless beauty, elegance, and life-giving spirit of women. Though Dugi had never worked with natural dyes, it wasn't a far leap to choose cochineal, the most royal of red dyes, as the source of a color palette to capture the essence of affluence. The choice was a natural progression in a career that merges the historic influences of Dugi's Navajo culture with the contemporary sensibilities of an up-and-comer intent on creating an original design aesthetic.

Born in rural Grey Mountain, Arizona, on the Navajo Nation, Dugi was raised in Flagstaff but kept close connections to the reservation. Art was "a way of life" in Dugi's family: his father and grandmother were noted bead artists who taught him to bead at five years old; his mother made jewelry; and his grandmothers wove textiles and sewed their own clothes. Dugi learned to use a sewing machine in seventh-grade home economics class, but his most valuable instruction in fashion and adornment was instilled through the Navajo tradition of "dressing for the holy ones" in sumptuous velvet and satin ceremonial wear and silverwork. Moving to Santa Fe in 2011,

he advanced these age-old cultural expressions as he began to blend textiles and beadwork into a contemporary vision.

Dugi made his first foray into fashion in 2010 at Santa Fe's internationally respected Indian Market, where his hand-beaded evening clutches and his first beaded evening gown won the market's clothing contest. His introduction to cochineal came later, when he worked at a Santa Fe art gallery specializing in historic native textiles. Among these were vibrant red, nineteenth-century Navajo weavings made from raveled yarns from imported cochineal-dyed *bayeta* cloth. Drawn to the story and color of *bayeta*, he turned to the Internet to learn about cochineal. There he discovered step-by-step guides to cochineal dyeing, from prepping fabrics to using mordants to achieve different hues. Though he found a few New Mexico sources for small quantities of cochineal, he learned that imported Peruvian cochineal was available in bulk from British Columbia. Accessing the far-flung source made perfect sense to Dugi, who described the transaction as "history repeating itself; Navajo people got *bayeta* cloth through trade."

Above Orlando Dugi, original sketch of Red Collection evening gown, Santa Fe, New Mexico, 2014. Courtesy of the artist.

■ *Opposite* Orlando Dugi, evening gown (from the Red Collection), Santa Fe, New Mexico, 2014. Hand-dyed silk duchesse satin, silk organza, and silk thread; cut glass and sterling silver beads, French coil, Swarovski crystals, vintage beads and crystals; lining of duchesse satin and tulle, 63 x 52 in. Collection of the artist.

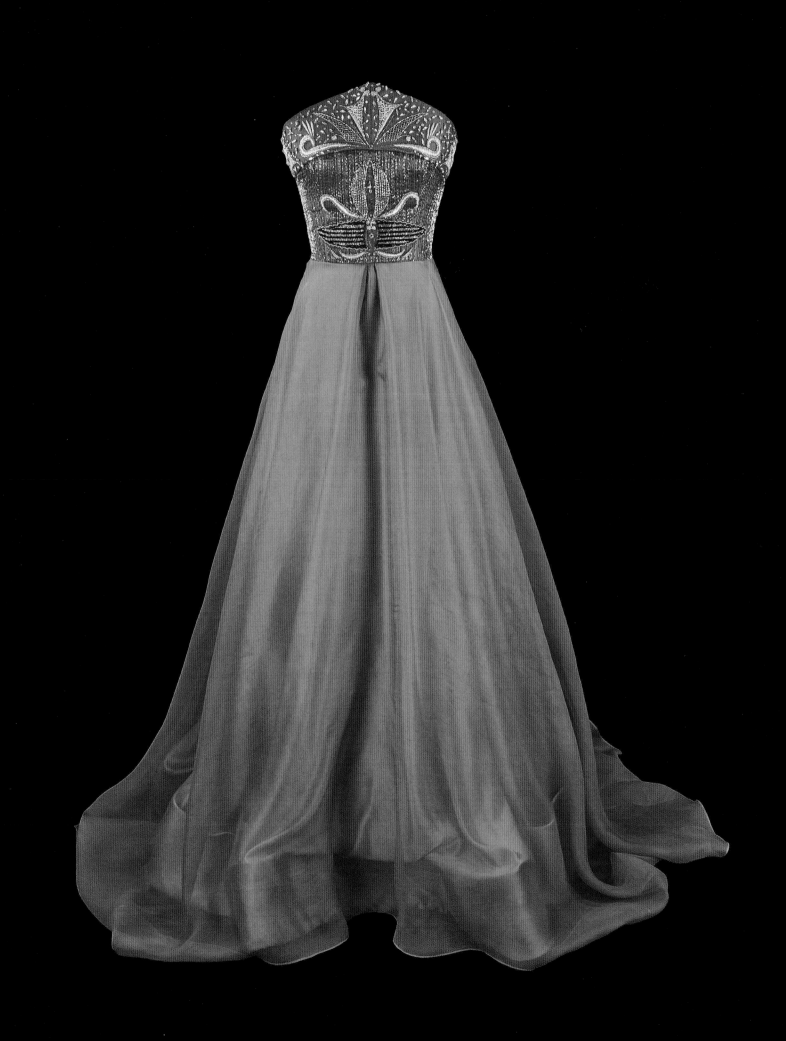

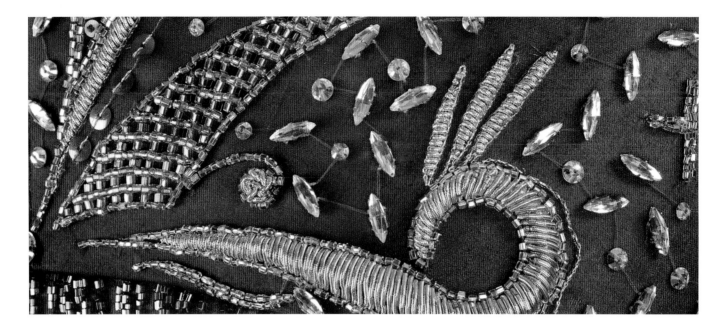

Dugi's storyline for his new collection featured "a precontact matriarchal society, maybe around the time of Chaco Canyon. Because they are such a wealthy civilization, they can afford to import things like red cloth." While there are three men's garments in the collection, the concept "is a complete gender role reversal in which the men are dominated, more like slaves who are subservient to the women." The men's pieces are also dyed in cochineal but are made of a fabric that is "very see-through, almost as if the men are not there. The focus is on the women."

Original sketches from Dugi's ten-piece Red Collection show women in confident, fully present cochineal hues—from lavish reds to coppery oranges to splendid purples, pinks, and peaches. But as Dugi began experimenting with the dye, he quickly learned that achieving his vision would require a delicate balance between his artistry and the alchemy of cochineal. He began by dyeing swatches, getting "purples first, then reds, oranges, pinks. I played with it a lot, learning that the dye is really potent and really sensitive to anything that touches it." The true test would be to work with a large amount of fabric and to produce a consistent color throughout.

Dugi embarked on his first dress from the collection, depicted in a commanding red monotone in his original sketch. Dugi planned to dye 8 yards of silk duchesse satin for the gown's underlayer and 8 yards of silk organza on top. He wanted to combine cochineal with cream of tartar for his desired royal red hue, but with his first dye bath, made using tap water from his studio, the cloth turned purple instead. For the next round he used distilled water for the dye bath but made the mistake of rinsing the fabric in the shower; reacting to grout in the floor tiles and to Dugi's rubber gloves, the dye ran, spotted, and shifted hue. Finally, as Dugi gained working knowledge of his materials, the singular red he envisioned evolved into a range of red-based shades.

The satin skirt took on a coral tint—"because satin is heavy, and I didn't use enough cochineal"—while the organza turned deep cherry. It was a happy accident; layered together, the weighty satin and the wispy organza made for a spectacular coral red. Above the waist, Dugi dyed a strapless bodice classic crimson. This he embellished with hand-beaded designs inspired by patterns from his favorite Pueblo Indian pottery collections. Interpreting eighteenth- to twentieth-century Acomita, McCarty's, and Polacca motifs, Dugi shaped and set feathery scrolls, swirls, and curves in glass, silver, and vintage stones. Bejeweled and crown-like, the dramatic bodice enhanced the glamour and sophistication of the gown's silhouette, making it all the more majestic.

From hem to crown, Dugi's lush and variegated study in cochineal involved a full three months of experimentation and handwork: one month to dye and construct the gown, two months to bead the bodice, and time to hand-dye six spools of cochineal red thread—30 yards each—with which to stitch it all together. In the fall of 2015, the Red Collection took a turn on the runway at Oklahoma Fashion Week in Oklahoma City. There, in material and meaning, the artist and his cochineal muse brought the cochineal story full circle. 🐚

■ *Above and opposite* Orlando Dugi, evening gown (from the Red Collection), Santa Fe, New Mexico, 2014. Front detail and rear view of hand-dyed and hand-beaded bodice stitched with cochineal-dyed silk thread. Collection of the artist.

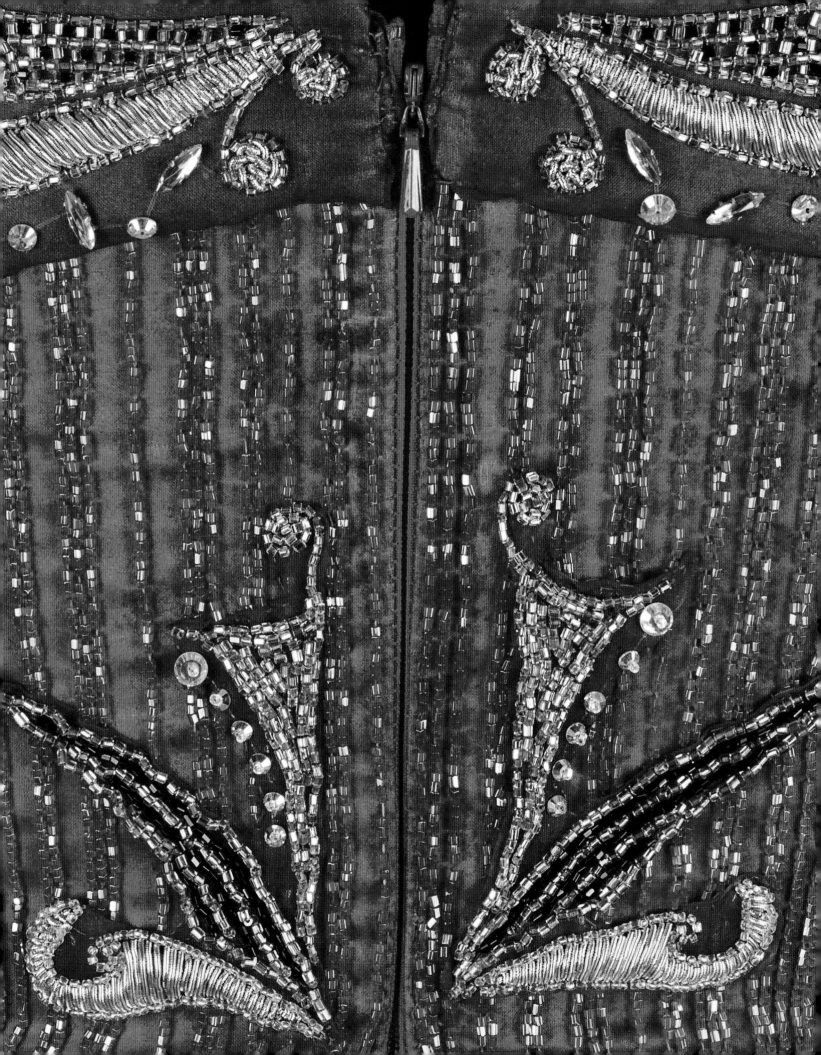

INTRODUCTION (ANDERSON)

1. See particularly Robin A. Donkin, "Spanish Red: An Ethnogeographical Study of Cochineal and the Opuntia Cactus," *Transactions of the American Philosophical Society*, n.s., 67, part 5 (September 1977): 1–84, and Amy Butler Greenfield, *A Perfect Red: Empire, Espionage, and the Quest for the Color of Desire* (New York: HarperCollins, 2005).

2. Ms. Mediceo Palatino 218–20, Biblioteca Medicea Laurenziana, Florence. See also Gerhard Wolf and Joseph Connors, eds., *Colors between Two Worlds: The Florentine Codex of Bernardino de Sahagún* (Florence: Harvard University Press, 2011).

3. Barbro Dahlgren de Jordan, *Nocheztli: economía de una región* (Mexico City: José Porrúa e Hijos, 1963).

4. Donkin, "Spanish Red."

5. Raymond Lee, "American Cochineal in European Commerce," *Journal of Modern History* 23 (1951): 205–24.

6. As early as 1770, the dye was used by scientists to stain cells to obtain visual contrast under bright-field microscopy; Randy O. Wayne, *Light and Video Microscopy* (London: Academic Press, 2013), 81.

7. Elena Phipps, *Cochineal Red: The Art History of a Color* (New York: Metropolitan Museum of Art, 2010).

8. Donald C. Fels Jr., *Lost Secrets of Flemish Painting: Including the First Complete English Translation of the De Mayerne Manuscript, B. M. Sloane 2052* (Floyd, VA: Alchemist, 2001), 176, 180, 294, 306.

9. Charles William King, *Antique Gems: Their Origin, Uses, and Value as Interpreters of Ancient Art* (London: John Murray, 1866), 90–91.

10. Francisco de Pacheco, *Arte de la pintura, su antigüedad y grandezas*, 1649 (Madrid: Ediciones Cátedra, 2009), 485.

11. Many articles by Jo Kirby Atkinson, Marika Spring, Ashok Roy, and others in the *National Gallery Technical Bulletin* discuss red lakes in general and cochineal in particular.

12. Phipps, *Cochineal Red.*

13. Karin Groen, "Investigation of the Use of the Binding Medium by Rembrandt: Chemical Analysis and Rheology," *Zeitschrift für Kunsttechnologie und Konservierung* 11 (1997): 207–27.

14. Kenneth Chang, "How This Renoir Used to Look," *New York Times*, April 20, 2014.

15. Ulrich Burkmaier, Arie Wallert, and Andrea Rothe, "A Note on Early Italian Oil Painting Technique," in *Historical Painting Techniques, Materials, and Studio Practice*, ed. Arie Wallert, Erma Hermens, and Marja Peek (Los Angeles: Getty Conservation Institute, 1995), 117–30.

16. Estrella Sanz Rodríguez, "Confirmacón mediante LC-DAD-QTOF de la presencia del colorante cochinilla en una serie de muestras de pinturas policromías y tejidos procedentes de obras datadas a partir del s. XVI," unpublished report for the Museum of International Folk Art, Santa Fe, NM, 2012; Marisa Gómez, "Los materiales de la policromía: empirismo y conocimiento científico," in *Retablos: técnicas, materiales, y procedimientos* (Valencia: Grupo español de conservación, 2004), 13–15.

17. See Greenfield, *Perfect Red,* chapter 16.

18. "Joe Ben Wheat Southwest Textile Database," Arizona State Museum, 2014, http://www.statemuseum.arizona.edu/coll/textile/jbw_southwest_textile_database.

19. Nora Fisher, ed., *Rio Grande Textiles* (Santa Fe: Museum of New Mexico Press, 1994).

20. Ana Serrano, "The Red Road to Iberian Expansion: Cochineal and the Global Dye Trade," *ARCHLAB Access Report*, 2011, https://www.academia.edu/3616899/.

21. Gabriela Siracusano, *El Poder de los colores: De lo material a lo simbólico en las prácticas culturales andinas, sigos XVI–XVIII* (Buenos Aires: Lugar, 2005).

22. These included the New Mexico History Museum and the Museum of Spanish Colonial Art, both in Santa Fe; the Denver Art Museum; and the Museo de América and Museo del Traje in Madrid. Mark MacKenzie, chief conservator for the New Mexico state museums; Marco Leona of the Metropolitan Museum of Art; Richard Newman and Michele Derrick of the Boston Museum of Fine Arts; and Estrella Sanz Rodríguez contributed greatly to this effort.

23. See Kenneth Mills, William B. Taylor, and Sandra Lauderdale Graham, *Colonial Latin America: A Documentary History* (Wilmington, DE: Rowman and Littlefield, 2002), 113–16.

24. See Jeremy Baskes, *Indians, Merchants, and Markets: A Reinterpretation of the Repartimiento and Spanish-Indian Economic Relations in Colonial Oaxaca, 1750–1821* (Stanford, CA: Stanford University Press, 2000).

25. Greenfield, *Perfect Red*, 209–34.

CHAPTER 1 (BRITTENHAM)

1. Stephen D. Houston et al., *Veiled Brightness: A History of Ancient Maya Color* (Austin: University of Texas Press, 2009), 13, 27–28, 71, 78; J. Eric S. Thompson, "Sky Bearers, Colors, and Directions in Maya and Mexican Religions," *Contributions to American Archaeology* 2, no. 10 (1934): 209–42.

2. Dominique Cardon, *Natural Dyes: Sources, Tradition, Technology, and Science* (London: Archetype Publications, 2007), 263–89, 312–17; Houston et al., *Veiled Brightness*, 59–61, 103–109. For annatto in particular, see María Luisa Vázquez de Agredos Pascual, Antonio Fernando Batista de dos Santos, and Dolores Julia Yusá Marco, "Annatto in America and Europe: Tradition, Treatises, and Elaboration of an Ancient Color," *Arché: Publicación del Instituto Universitario de Restauración del Patrimonio de la UPV* 4–5 (2010): 97–102.

3. Bernardino de Sahagún, *Florentine Codex: General History of the Things of New Spain*, trans. Arthur J. O. Anderson and Charles E. Dibble (Santa Fe, NM: School of American Research, 1950–1982), 11:239.

Elodie Dupey García suggests that the multivalent Nahuatl word *tlapalli* ("red," "colored," "dyed") may in some cases refer specifically to prepared cochineal, while *nocheztli* is the Nahuatl term for cochineal insects in their unrefined form; see Elodie Dupey García, "Les couleurs dans les pratiques et les représentations des Nahuas du Mexique central (XIVe–XVIe siècles)" (PhD thesis, École Pratique des Hautes Études, Paris, 2010), 45–49; see also Alonso de Molina, *Vocabulario en lengua castellana y mexicana y mexicana y castellana*, facsimile of 1571 edition (Mexico City: Editorial Porrua, 1970), folio 66v. For Maya terms, see Alfredo Barrera Vásquez, *Diccionario Maya Cordemex: Maya-Español, Español-Maya* (Mérida, Yucatán: Ediciones Cordemex, 1980), 537, 917; Ralph L. Roys, *The Ethno-Botany of the Maya*, Tulane University Department of Middle American Research Publication 2 (New Orleans: Department of Middle American Research, 1931), 337.

4. *Codex Mendoza*, folios 43r–45r; Frances F. Berdan and Patricia Rieff Anawalt, eds., *Codex Mendoza* (Berkeley: University of California Press, 1992), 2:102–11. Although not recorded in the *Codex Mendoza* or the *Matrícula de Tributos*, Fernando de Alva Ixtlilxóchitl states that the Gulf Coast province of Tochtepec paid four hundreds bags of cochineal in annual tribute to Texcoco; Fernando de Alva Ixtlilxóchitl, *Obras históricas*, ed. Alfredo Chavero (Mexico City: Universidad Nacional Autónoma de México, Instituto de Investigaciones Históricas, 1965), 2:198.

5. *Matrícula de Tributos*, folio 3v; see Berdan and Anawalt, *Codex Mendoza*, 2:39, 2:42–43.

6. Sahagún, *Florentine Codex*, 11:239–40.

7. Barbro Dahlgren de Jordan, *La grana cochinilla* (Mexico City: Universidad Nacional Autónoma de México, 1990), 391. This calculation assumes that bags of cochineal recorded in tribute registers were the same size as standardized colonial-era bags of the insects.

8. In a study of nineteenth-century Guatemalan textiles, Robert Carlsen and David Wenger found no

cochineal used on cotton, although it was used extensively on wool and silk, even after the introduction of synthetic dyes. See Robert S. Carlsen and David A. Wenger, "The Dyes Used in Guatemalan Textiles: A Diachronic Approach," in *Textile Traditions of Mesoamerica and the Andes: An Anthology*, ed. Margot Blum Schevill, Janet Catherine Berlo, and Edward B. Dwyer (Austin: University of Texas Press, 1991), 369–73. Cochineal might instead have been painted onto the surfaces of textiles, perhaps mixed with an alum mordant, though this process would result in streaky color, poorer adhesion, and a more fragile surface. Irmgard Johnson proposes that cochineal is one of the colorants painted onto textiles from Chiptic Cave in Chiapas, but no testing has verified this assumption; Irmgard W. Johnson, "Chiptic Cave Textiles from Chiapas, Mexico," *Journal de la Société des Américanistes* 43 (1954): 140–44. Cochineal is not one of the colorants on the La Garrafa Cave textiles, although analysis did reveal hematite as a textile paint; María Elena Landa, ed., *La Garrafa: Cuevas de la Garrafa, Chiapas. Estudio y conservación de algunos objectos arqueológicos* (Puebla, Mexico: Gobierno del Estado de Puebla, Centro INAH-Puebla, 1988), 65.

9. J. Benedict Warren, *The Harkness Collection in the Library of Congress: Manuscripts Concerning Mexico: A Guide* (Washington, DC: Library of Congress, 1974): 109–10, 118–21. Cochineal was also identified through visual inspection as a possible colorant for the red-painted textiles in this document; see Sylvia Rodgers Albro and Thomas C. Albro II, "The Examination and Conservation Treatment of the Library of Congress Harkness 1531 Huejotzingo Codex," *Journal of the American Institute for Conservation* 29, no. 2 (1990): 105.

10. Sahagún, *Florentine Codex,* 10:77, note 11; 11:242 (see *tezuatl* entry).

11. The *Florentine Codex* cautions, "The bad feather worker [is a] [fraudulent] embellisher of feathers, a treater of feathers with glue. He sells old, worn feathers, damaged feathers. He dyes feathers, he dyes those which are faded, dirty, yellow, darkened, smoked." Sahagún, *Florentine Codex,* 10:61.

12. Elena Phipps, "Cochineal Red: The Art History of a Color," *Metropolitan Museum of Art Bulletin* 67, no. 3 (Winter 2010): 16–17. See Sahagún, *Florentine Codex,* 9:93–97 for a detailed description of featherworking procedures.

13. The same study found that logwood could produce a similar range of colors by manipulation of the same factors; Piero Baglioni et al., "On the Nature of the Pigments in the *General History of the Things of New Spain: The Florentine Codex,*" in *Colors between Two Worlds: The Florentine Codex of Bernardino de Sahagún*, eds. Gerhard Wolf and Joseph Connors (Florence: Harvard University Press, 2011), 86–93.

14. Marisa Álvarez Icaza Longhoria, personal communication, 2013. For the *Codex Cospi*, see Costanza Miliani et al., "Colouring Materials of Pre-Columbian Codices: Non-invasive *in Situ* Spectroscopic Analysis of the Codex Cospi," *Journal of Archaeological Science* 30 (2011): 4, 6. For La Garrafa, see Landa, *La Garrafa,* 225.

15. Baglioni et al., "On the Nature of the Pigments," 82–93; Mary Elizabeth Haude, "Identification of Colorants on Maps from the Early Colonial Period of New Spain (Mexico)," *Journal of the American Institute for Conservation* 37, no. 3 (1998): 255; Diana Isabel Magaloni Kerpel, "The Traces of the Creative Process: Pictorial Materials and Techniques in the Beinecke Map," in *Painting a Map of Sixteenth-Century Mexico City: Land, Writing, and Native Rule*, ed. Mary Miller and Barbara Mundy (New Haven, CT: Yale University Press, 2012), 81–83; Richard Newman and Michele Derrick, "Analytical Report of the Pigments and Binding Materials Used on the Beinecke Map," in Miller and Mundy, *Painting a Map,* 95–96.

16. Jorge Gómez-Tejada, personal communication, 2014.

17. Alfred M. Tozzer, *Landa's Relación de las Cosas de Yucatan: A Translation*, Papers of the Peabody Museum of American Archaeology and Ethnology (Cambridge, MA: Harvard University Press, 1941), 89, 193. Note that Tozzer misidentifies the "red worm" in this passage as cochineal when evidence suggests that it is instead an insect known as axin or niin (*Llaveia axin*); see Roys, *The Ethno-Botany of the Maya,* 337. Axin is named as a body paint in the *Florentine Codex* as well; see, for example, Sahagún, *Florentine Codex,* 10:55.

18. Sahagún, *Florentine Codex,* 8:47–48; 10:55. Note that in both contexts, the text is explicit that cochineal is the material for applying to the teeth, but it uses more generic terms for the application of other colorants: "*motlãnochezua*, momaicujloa, moquechicujloa" and "mixtlapaloatzaaluia, coacantlapaluia, motlamiaoa, *motlannochezuia*" (emphasis added); this is also true in the Spanish text, Bernardino de Sahagún, *Historia General de las Cosas de Nueva España*, trans. Angel María Garibay Kintana (Mexico City: Editorial Porrúa, 1975), 469, 562.

19. Francisco Hernández, *De la naturaleza, y virtudes de las plantas, y animales que estan receuidos en el uso de medicina en la Nueua España* (Mexico City, 1615), 33; translation mine.

20. Sahagún, *Florentine Codex,* 10:147.

21. Houston et al., *Veiled Brightness,* 64.

22. Diana Isabel Magaloni Kerpel, "El espacio pictórico teotihuacano. Tradición y técnica," in *La Pintura mural prehispánica en México I: Teotihuacán,* ed. Beatriz de la Fuente (Mexico City: Universidad Nacional Autónoma de México, Instituto de Investigaciones Estéticas, 1995), 206–208; Diana Isabel Magaloni Kerpel, "El arte en el hacer: técnica pictórica y color en las pinturas de Bonampak," in *La Pintura mural prehispánica en México II: Área maya Bonampak,* ed. Beatriz de la Fuente and Leticia Staines Cicero (Mexico City: Universidad Nacional Autónoma de México, Instituto de Investigaciones Estéticas, 1998), 69, 73–75. See also Diana Magaloni, "Materiales y técnicas de la pintura mural maya," in *La Pintura mural prehispánica en México II: Área maya,* ed. Beatriz de la Fuente and Leticia Staines Cicero (Mexico City: Universidad Nacional Autónoma de México, Instituto de Investigaciones Estéticas, 2001), 173, 180–87; Diana Isabel Magaloni Kerpel, "The Hidden Aesthetic of Red in the Painted Tombs of Oaxaca," *Res* 57/58 (2010): 60, 68–71; Diana Isabel Magaloni Kerpel et al., "Cacaxtla, la elocuencia de los colores," in *La Pintura mural prehispánica en México V: Cacaxtla,* ed. María Teresa Uriarte and Fernanda Salazar Gil (Mexico City: Universidad Nacional Autónoma de México, 2013), 174–82; María Luisa Vázquez de Ágredos Pascual, *La pintura mural maya: materiales y técnicas artísticas* (Mérida: Centro Peninsular en Humanidades y Ciencias Sociales, Universidad Nacional Autónoma de México, 2010), 92–97.

23. Houston et al., *Veiled Brightness,* 66–68.

24. David Buti et al., "Non-Invasive Investigation of a Pre-Hispanic Maya Screenfold Book: The Madrid Codex," *Journal of Archaeological Science* 42 (2014): 175, 176; José Luis Ruvalcaba et al., "The Grolier Codex: A Non Destructive Study of a Possible Maya Document Using Imaging and Ion Beam Techniques," *Materials Research Society Proceedings* 1047 (2007): 299–306.

25. Landa, *La Garrafa,* 65.

26. Ralph L. Roys, *The Indian Background of Colonial Yucatan* (Washington, DC: Carnegie Institution of Washington, 1943), 24.

27. Magaloni Kerpel, "Hidden Aesthetic"; Diana Magaloni Kerpel, "Painters of the New World: The Process of Making the *Florentine Codex,*" in Wolf and Connors, *Colors between Two Worlds,* 65–66. For a suggestion that hematite extraction from caves had a substantial ritual element, see James E. Brady and Dominique Rissolo, "A Reappraisal of Ancient Maya Cave Mining," *Journal of Anthropological Research* 62, no. 4 (2006): 471–90. Elodie Dupey García suggests that for the Aztecs, red ocher, or *tlahuitl,* also had an association with solar heat, perhaps related to color changes that occur when iron oxides are heated; see Elodie Dupey García, "The Materiality of Color in the Body Ornamentation of Aztec Gods," *Res* 65/66 (2014–2015), in press.

28. Diana Isabel Magaloni Kerpel, "Teotihuacán: el lenguaje del color," in *El color en el arte mexicano,* ed.

Georges Roque (Mexico City: Universidad Nacional Autónoma de México, Instituto de Investigaciones Estéticas, 2003), 186, 196–201; Magaloni Kerpel, "Hidden Aesthetic," 70–71.

29. Claudia Brittenham, *The Murals of Cacaxtla: Portraits of an Ancient Central Mexican Community* (Austin: University of Texas Press, 2015), 145–82, especially 177.

30. Conversely, liquid mercury can be made from cinnabar by heating it and collecting the mercury as it evaporates, but it is not clear that Mesoamericans used this technique. See David Pendergast, "Ancient Maya Mercury," *Science* 217, no. 4559 (1982): 534.

31. Houston et al., *Veiled Brightness*, 57, 65; Pendergast, "Ancient Maya Mercury," 533–34.

32. Philip Drucker, *La Venta, Tabasco: A Study of Olmec Ceramics and Art*, Smithsonian Institution Bureau of American Ethnology Bulletin 153 (Washington, DC: United States Government Printing Office, 1952), 63–64, 68–72. For an argument that there were juvenile bodies in these "pseudo-burials," see Billie Follensbee, "The Child and the Childlike in Olmec Art and Archaeology," in *The Social Experience of Childhood in Ancient Mesoamerica*, ed. Traci Ardren and Scott R. Hutson (Boulder: University Press of Colorado, 2006), 267–69, 275–76, note 45.

33. For cinnabar in burials and offerings at Teotihuacan, see Julie Gazzola, "Los usos del cinabrio en Teotihuacán" (PhD thesis, Université Panthéon-Sorbonne, Paris, 2000).

34. The data are too extensive to compile here. See summaries in Vera Tiesler, "Life and Death of the Ruler: Recent Bioarchaeological Findings," in *Janaab' Pakal of Palenque: Reconstructing the Life and Death of a Maya Ruler*, ed. Vera Tiesler and Andrea Cucina (Tucson: University of Arizona Press, 2006), 30, 35, 45–46; Ellen Bell et al., "Tombs and Burials in the Early Classic Acropolis at Copan," in *Understanding Early Classic Copan*, ed. Ellen Bell, Marcello Canuto, and Robert Sharer (Philadelphia: University of Pennsylvania Museum of Archaeology and Anthropology, 2004), 133, 137, 139, 147–49, 152, 155–56; James L.

Fitzsimmons, *Death and the Classic Maya Kings* (Austin: University of Texas Press, 2009), 81–83; Estella Weiss-Krecji, "The Maya Corpse: Body Processing from Preclassic to Postclassic Times in the Maya Highlands and Lowlands," in *Jaws of the Underworld: Life, Death, and Rebirth among the Ancient Maya*, ed. Pierre R. Colas, Geneviève Le Fort, and Bodil Liljefors Persson (Markt Schwaben, Germany: Verlag Anton Saurwein, 2006), 79–80. Note that although Fitzsimmons and Weiss-Krecji treat cinnabar and hematite as interchangeable pigments, every time the red pigment coating the corpse in a tomb has been tested, it has been identified as cinnabar.

35. Fitzsimmons, *Death and the Classic Maya Kings*, 83.

36. Magaloni Kerpel, "Traces of the Creative Process," 81–83; Newman and Derrick, "Analytical Report," 95–96; Haude, "Identification of Colorants," 255–56.

37. Some of this effect, particularly on objects from tombs, may result from an overall saturation of the tomb with cinnabar. In other cases it results from modern intervention; Barbara Kerr, personal communication, 2005.

38. Magaloni Kerpel, "Traces of the Creative Process," 81–83; Newman and Derrick, "Analytical Report," 95–96.

39. Magaloni Kerpel, "El arte en el hacer," 75. Cinnabar may be the source of the red color smeared behind an early text from the site of San Bartolo, and it may also be associated with a text in the murals of Ek' Balam; see Vázquez de Ágredos Pascual, *La pintura mural maya*, 97–101.

40. Magaloni Kerpel, "Hidden Aesthetic"; Magaloni Kerpel et al., "Cacaxtla," 178–82; Vázquez de Ágredos Pascual, *La pintura mural maya*, 102–103.

41. Magaloni Kerpel et al., "Cacaxtla," 178–82.

42. Magaloni Kerpel, "Hidden Aesthetic," 67–71.

CHAPTER 2 (MILLER)

1. Brittenham, this volume, points to the importance of this use of cinnabar; Diana Isabel Magaloni Kerpel, "El arte en el hacer: técnica

pictórica y color en las pinturas de Bonampak," in *La Pintura mural prehispánica en México II: Área maya Bonampak*, ed. Beatriz de la Fuente and Leticia Staines Cicero (Mexico City: Universidad Nacional Autónoma de México, Instituto de Investigaciones Estéticas, 1998).

2. Diana Magaloni Kerpel, "The Hidden Aesthetic of Red in the Painted Tombs of Oaxaca," *Res* 57/58 (2010): 71–72.

3. Robert W. Patch, *Maya and Spaniard in Yucatan, 1648–1812* (Stanford, CA: Stanford University Press, 1994), 87–88.

4. Raymond L. Lee, "Cochineal Production and Trade in New Spain to 1600," *The Americas* 4, no. 4 (1948): 464.

5. Diego de Landa, *Yucatan before and after the Conquest*, tr. William Gates (New York: Dover, 1978), 130.

6. Diana Magaloni Kerpel, "Painters of the New World: The Process of Making the *Florentine Codex*," in *Colors between Two Worlds: The Florentine Codex of Bernardino de Sahagún*, ed. Gerhard Wolf and Joseph Connors (Florence: Harvard University Press, 2011), 61.

7. Piero Baglioni et al., "On the Nature of the Pigments in the *General History of the Things of New Spain*: The *Florentine Codex*," in Wolf and Connors, *Colors between Two Worlds*, 86.

CHAPTER 3 (MAGALONI KERPEL)

1. Bernardino de Sahagún, *Historia general de las cosas de Nueva España*, facsimile ed. (Mexico City: Archivo General de la Nación, 1979), folio 372v.

2. Diego Durán, *The History of the Indies of New Spain*, trans. Doris Heyden (Norman: University of Oklahoma Press, 1994), 32.

3. Doris Heyden, *The Eagle, the Cactus, and the Rock: The Roots of Mexico-Tenochtitlan's Foundation Myth and Symbol*, BAR International Series 484 (Oxford: Archaeopress, 1989), 14–22.

4. Diana Magaloni Kerpel, *Colors of the New World: Artists, Materials, and the Creation of the Florentine Codex* (Los Angeles: Getty Research Institute, 2014), 16–25.

5. Diana Magaloni Kerpel, "Painters of the New World: The Process of Making the *Florentine Codex*," in *Colors*

between Two Worlds: The Florentine Codex of Bernardino de Sahagún, ed. Gerhard Wolf and Joseph Connors (Florence: Harvard University Press, 2011), 47–78.

6. Alfredo López Austin, *Cuerpo Humano e Ideología*, vol. 2 (Mexico City: UNAM, 1989), 65–72.

7. Maria Teresa Uriarte, "Tepantitla, el juego de pelota," in *La Pintura Mural Prehispánica en México, Teotihuacán, Estudios*, ed. Beatriz de la Fuente (Mexico City: Instituto de Investigaciones Estéticas, UNAM, 1996), 227–90.

8. James Lockhart, Francis Berdan, and Arthur J. O. Anderson, *The Tlaxcalan Actas: A Compendium of the Records of the Cabildo of Tlaxcala (1545–1627)* (Salt Lake City: University of Utah Press, 1986), 51.

9. Sahagún, *Historia general*, folio 372v.

CHAPTER 4 (PEARLSTEIN ET AL)
ACKNOWLEDGMENTS
The authors wish to thank the following individuals for their contributions to this research: Martha Egan from Santa Fe, New Mexico, who provided access to many of the keros in the current study, Jesús Rodrigo Botina Papamija, Maria Cecelia Alvarez White, and Steve Kramer, who made receipt of *mopa mopa* for experimentation possible, Jo Kirby Atkinson, who answered questions about carmine chemistry, and Odile Madden, who first observed purple-brown pigments on keros.

1. E. Kaplan, E. Pearlstein, E. Howe, and J. Levinson, "Análisis técnico de keros pintados de los períodos Inka y colonial," *Iconos: revista peruana de conservación, arte, y arqueología* 2 (1999): 30–38; E. Pearlstein, E. Kaplan, E. Howe, and J. Levinson, "Technical Analyses of Inca and Colonial Painted Wooden Keros," *Objects Specialty Group Postprints* 6 (1999) 94–111; Richard Newman and Michele Derrick, "Painted Kero Cups from the Inka and Colonial Periods in Peru: An Analytical Study of Pigments and Media," in *Materials Issues in Art and Archaeology*, vol. 6, ed. Pamela B. Vandiver, Martha Goodway, and Jennifer L. Mass (Warrendale, PA: Materials Research Society, 2002), 294–96.

2. Tony Frantz, Ellen G. Howe, Emily

Kaplan, Richard Newman, Ellen Pearlstein, Judith Levinson, and Odile Madden, "The Occurrence of a Cristobalite-Anatase-Bearing White Pigment on Wooden Andean Keros" (unpublished manuscript, 1998); Javier G. Iñañez, *Preliminary Report: Lead Isotope Analysis of Kero Samples by LA-MC-ICP-MS* (Washington, DC: Smithsonian Museum Conservation Institute and University of Maryland, 2010).

3. Mary Elizabeth King, "Analytical Methods and Prehistoric Textiles," *American Antiquity* 43, no. 1 (1978): 89–96; Elena Phipps, *Cochineal Red: The Art History of a Color* (New York: Metropolitan Museum of Art, 2010); A. Wallert and R. Boytner, "Dyes from the Tumilaca and Chiribaya Cultures, South Coast of Peru," *Journal of Archaeological Science* 23 (1996): 853–61; Jan Wouters and André Verhecken, "The Coccid Insect Dyes: HPLC and Computer-ised Diode-Array Analysis of Dyed Yarns," *Studies in Conservation* 34 (1989): 189–200.

4. Frances F. Berdan and Patricia R. Anawalt, *The Essential Codex Mendoza* (Berkeley: University of California Press, 1997), iii, 93.

5. Charles E. Dibble and Arthur J. O. Anderson, eds., *Florentine Codex: General History of the Things of New Spain* (Santa Fe, NM: School of American Research and University of Utah, 1963), x, 13.

6. Francisco Ximénez, *Cuatros libros de al naturaleza y virtudes de las plantas y animales de uso medicinal en la Nueva España, 1571–1576* (Mexico City: Oficina Tip. de la Secretaría de Fomento, 1888), 55–56.

7. Both reviewed in G. A. Fester, "Los colorants del Antiguo Peru," *Archelon* 22 (1940): 231–34.

8. Ximénez, *Cuatros libros*, 55–56.

9. Margaret A. Towle, *The Ethnobotany of Pre-Columbian Peru* (Chicago: Aldine Publishers, 1961), 73.

10. Ana Roquero, *Tintes y tintoreros de América: catálogo de materias primas y registro etnográfico de México, Centro América, Andes Centrales y Selva Amazónica* (Madrid: Ministerio de Cultura, Instituto del Patrimonio Histórico Español, 2006); Ana Roquero, "Identification of Red Dyes in Textiles from the Andean Region," Textile Society of America Symposium Proceedings, 2008, http://digitalcommons.unl.edu/tsaconf.

11. Gabriela Siracusano, *Pigments and Power in the Andes: From the Material to the Symbolic in Andean Cultural Practices, 1500–1800*, trans. Ian Barnett (London: Archetype Publications, 2011), 43, note 169.

12. Diana Magaloni Kerpel, "The Traces of the Creative Process: Pictorial Materials and Techniques in the Beinecke Map," in *Painting a Map of Sixteenth-Century Mexico City: Land, Writing, and Native Rule*, ed. Mary E. Miller and Barbara E. Mundy (New Haven, CT: Yale University Press, 2012), 81.

13. Jo Kirby Atkinson, Marika Spring, and Catherine Higgett, "The Technology of Eighteenth- and Nineteenth-Century Red Lake Pigments," *National Gallery Technical Bulletin* 28, no. 1 (2007): 73.

14. Rocío Bruquetas Galán, *Técnicas y materiales de la pintura española en los siglos de oro* (Madrid: Fundación de apoyo a la historia del arte hispánico, 2002), 180.

15. Ibid., 206, note 284.

16. Ibid., 180.

17. Ibid., 206, note 284, citing A. Piamontés in Madrid, 1591.

18. Atkinson et al., "Technology," 70–74.

19. Ibid., 74–75.

20. Sylvia Rodgers Albro and Thomas C. Albro II, "The Examination and Conservation Treatment of the Library of Congress Harkness 1531 Huejotzingo Codex," *Journal of the American Institute for Conservation* 29, no. 2 (1990): 97–115; Piero Baglioni et al., "On the Nature of the Pigments of the *General History of the Things of New Spain:* The *Florentine Codex*," in *Colors between Two Worlds: The Florentine Codex of Bernardino de Sahagún*, ed. Gerhard Wolf and Joseph Connors (Florence: Harvard University Press, 2011), 47–78, 86; Mary Elizabeth Haude, "Identification of Colorants on Maps from the Early Colonial Period of New Spain (Mexico)," *Journal of the American Institute for Conservation* 37, no. 3 (1998): 240–70; C. Miliani et al., "Colouring Materials of Pre-Columbian Codices: Non-Invasive *in Situ* Spectroscopic Analysis of the Codex Cospi," *Journal of Archaeological Science* 39 (2012): 672–79; Richard Newman and Michele Derrick, "Analytical Report of the Pigments and Binding Materials Used on the Beinecke Map," in *Painting a Map of Sixteenth-Century Mexico City: Land, Writing, and Native Rule*, ed. Mary E. Miller and Barbara E. Mundy (New Haven, CT: Yale University Press, 2012), 91–100.

21. D. Buti et al., "Non-invasive Investigation of a Pre-Hispanic Maya Screenfold Book: The Madrid Codex," *Journal of Archaeological Science* 42 (2014): 166–78.

22. E. Phipps, K. Trentelman, and N. Turner, "Colors, Textiles and Artistic Production in Martín de Murúa, *Historia General del Perú* in the J. Paul Getty Museum," in *The Getty Murúa: Essays on the Making of Martín de Murúa's* Historia General del Piru, *J. Paul Getty Museum Ms. Ludwig XIII 16*, ed. Thomas Cummings and Barbara Anderson (Los Angeles: Getty Research Institute, 2008), 133, 137–38.

23. Roquero, "Identification of Red Dyes."

24. A. Seldes et al., "Green, Yellow, and Red Pigments in South American Painting, 1610–1780," *Journal of the American Institute for Conservation* 41, no. 3 (2002): 234, 236–37; Siracusano, *Pigments and Power*, 19–20.

25. Ibid. See also Siracusano and Maier, this volume.

26. Dibble and Anderson, *Florentine Codex*; Ximénez, *Cuatros libros*.

27. Richard Newman and Michele Derrick, "Painted Kero Cups," 294–96.

28. Ibid., 299–300.

29. Ibid.

30. The HPLC includes an Agilent 1100 binary pump with automatic selector valve, a vacuum degasser, an autosampler thermostated column compartment, and a diode array detector. The software is Chemstation B.03.02. A Porroshell C18 reverse-phase 100 x 2.1 millimeter column with 2.7-micron particles was used, as it performed best on near nanogram quantities of carminic acid present in tiny samples, and the HPLC machine was fitted with new stainless tubing of 0.12 millimeters diameter. The diode array detector was set up to record all signals for 254, 540, 440, and 330 nanometers. The 254- and 540-nanometer signals were the primary identification signals. The eluents were HPLC-grade acetonitrile (ACN) with 0.1 percent formic acid added and HPLC-grade water with 0.1 percent formic acid added. All solvents used were HPLC grade. Standards were carminic acid and the aluminum lake of carminic acid, both from Sigma-Aldrich. Alizarin and lac were also prepared from analysis-grade stock. The samples to be tested and the standards were made up in about 5 percent boron trifluoride from Sigma-Aldrich. The 10 percent stock ampoule was diluted with HPLC-grade methanol. A gradient elution method was used, beginning with 55 percent A (water with 0.1 percent formic acid) and 45 percent B (ACN with 0.1 percent formic acid), rising to 100 percent B (ACN with 0.1 percent formic acid). Carminic acid and carmine standards were run with all sample analysis. Pigment samples were placed in a plastic microcentrifuge tube, to which 0.5 milliliters of about 5 percent boron trifluoride in methanol were added. After twenty-four hours, the samples were centrifuged at 3,500 rpm for thirty minutes; 40 to 60 microliters of the supernatant were taken with an automatic pipettor and put into a reduced-volume autosampler vial. Particularly small samples were sometimes concentrated in a digitally controlled laboratory dry bath. If the sample had evaporated to dryness, 60 to 80 microliters of HPLC-grade methanol were added and then centrifuged, and 40 microliters of the supernatant were taken for analysis.

31. A Bruker Tracer III-SD portable X-ray fluorescence unit with a silicon drift detector was used to conduct analysis of the kero sample sites. No vacuum unit was available, so the testing protocol was amended. Given that wood, the main material of the keros, is largely "transparent" to X-rays, it was decided to use settings of 30 KV, 60 microamps, and a pulse length of 227; the filter used was "blue" number 4. This has a window of 1 mil titanium. The integration time was standardized at 120 seconds, which provided a good signal-to-noise ratio. The "nose" of the pXRF unit was positioned to be

centered and lightly touching the area of interest on the kero. Bruker software S1PXRF version 3.8.3 was used to capture the XRF spectra. It was then opened in Bruker Artax software version 7.4.0.0 for analysis. Bayes deconvolution was used for final element selection and best spectra fit. The elements rhodium and palladium were deleted from the identified elements, as they are artifacts of the pXRF unit.

32. Francisco Pacheco, *Arte de la pintura: su antigüedad y grandezas,* 1649 (Madrid: Manuel Galiano, 1866), 79–80.

33. O. Madden, *Brown Resin-Bound Colors on Keros* (Washington, DC: National Museum of the American Indian, 1998).

34. Gianna Favaro, Costanza Miliani, Aldo Romani, and Manuela Vagnini, "Role of Protolytic Interactions in Photo-Aging Processes of Carminic Acid and Carminic Lake in Solution and Painted Layers," *Journal of the Chemical Society, Perkin Transactions* 2 (2002): 192–97; Kevin Jorgensen and L. H. Skibsted, "Light Sensitivity of Cochineal. Quantum Yields for Photodegradation of Carminic Acid and Conjugate Bases in Aqueous Solution," *Food Chemistry* 40 (1991): 25–34; David Saunders and Jo Kirby, "Light-Induced Colour Changes in Red and Yellow Lake Pigments," *National Gallery Technical Bulletin* 15 (1994): 79–97; Klaas Jan van den Berg et al., "Fading of Red Lake Paints after Vincent van Gogh: An Interdisciplinary Study Involving Three De Mayerne Projects," in *Reporting Highlights of the De Mayerne Programme,* ed. Jaap J. Boon and Ester S. B. Ferreira (The Hague: Organisation for Scientific Research, 2006), 90–96; Yassin Zidan, H. E. Eldeen Hassan, and Kh. El-Nagar, "Studies on Dyeing with Cochineal and Aging of Silk Dyed Fabric," in *Scientific Analysis of Ancient and Historic Textiles: Informing Preservation, Display and Interpretation: Postprints,* ed. Rob Janaway and Paul Wyeth (London: AHRC Research Centre for Textile Conservation and Textile Studies, Archetype Publications, 2005), 246–49.

CHAPTER 5 (MARICHAL)

1. John Munro, "The Medieval Scarlet and the Economics of Sartorial Splendour," in *Cloth and Clothing in Medieval Europe,* ed. N. B. Harte and K. G. Pointing (London: Heineman, 1983), 39.

2. Arthur Lovejoy, *The Great Chain of Being* (Cambridge, MA: Harvard University Press, 1936); Manlio Brusatin, *Storia dei colori* (Turin: Einaudi, 1983); Elena Phipps, *Cochineal Red: The Art History of a Color* (New York: Metropolitan Museum of Art, 2010).

3. Raymond Lee, "American Cochineal in European Commerce, 1526–1625," *Journal of Modern History* 23 (1951): 206.

4. Judith H. Hofenk de Graaff, "The Chemistry of Red Dyestuffs in Medieval and Early Modern Europe," in Harte and Pointing, *Cloth and Clothing in Medieval Europe,* 75.

5. Felipe Ruiz Martín, *Lettres marchandes échangées entre Florence et Medina del Campo* (Paris: École Pratique des Hautes Études, 1965), in particular chapter 6.

6. Ibid., chapter 6 and appendices. The mercantile correspondence of Simón Ruiz is among the richest of Europe from that time, including more than six thousand letters, now in the collection of the University of Valladolid.

7. Ibid., 125–28.

8. Louisa Schell Hoberman, *Mexico's Merchant Elite, 1590–1660: Silver, State, and Society* (Durham, NC: Duke University Press, 1991), 121–22.

9. Jean Hellot, "The Art of Dyeing Wool, Silk, and Cotton," (*L'Art de la teinture de laines et des etoffes de laine en grand et petit teint*), 1750; Open Library, 2012, http://archive.org/stream/artofdyingwoolsi00hell#page/n9/mode/2up.

10. For a fascinating description see Marten G. Buist, *At Spes Non Fracta: Hope and Company, 1770–1815, Merchant Bankers and Diplomats at Work* (The Hague: Martinus Nijhoff, 1974), chapter 15.

11. The best source continues to be William Lyle Schurz, *The Manila Galleon* (New York: E. P. Dutton, 1959).

12. See Jeremy Baskes, *Indians, Merchants and Markets: A Reinterpretation of the Repartimiento and Spanish-Indian Economic Relations in Colonial Oaxaca, 1750–1821* (Stanford, CA: Stanford University Press, 2001); Brian R. Hamnett, *Politics and Trade in Southern Mexico, 1750–1821* (Cambridge: Cambridge University Press, 1971); Alicia Contreras Sánchez, *Capital comercial y colorantes en la Nueva España en la segunda mitad del siglo XVIII* (Zamora: El Colegio de Michoacán/Universidad Autónoma de Yucatán, 1996); and Carlos Sánchez Silva, *Indios, comerciantes y burocracia en la Oaxaca poscolonial, 1786–1860* (Oaxaca: Instituto Oaxaqueño de las Culturas, 1998); all of them take this view.

13. María Justina Sarabia Viejo, *La grana y el añil: técnicas tintóreas en México y América Central* (Seville: Escuela de Estudios Hispanoamericanos/Fundación del Monte, 1994), 35–36.

14. Amy Butler Greenfield, *A Perfect Red: Empire, Espionage, and the Quest for the Color of Desire* (New York: HarperCollins, 2005), chapter 16.

CAPTIONS

a. Luca Mola, *The Silk Industry of Renaissance Venice* (Baltimore: Johns Hopkins University Press, 2000), 129.

b. Phipps, *Cochineal Red,* 29.

CHAPTER 6 (SETHI)

1. Cheng Weiji, ed., *History of Textile Technology of Ancient China* (Beijing: Science Press, 1992).

2. Nobuko Kajitani, "Traditional Dyes in Indonesia," in *Indonesian Textiles: Irene Emery Roundtable on Museum Textiles 1979 Proceedings,* ed. Mattiebelle Gittinger (Washington, DC: Textile Museum, 1979); John Gillow, *Traditional Indonesian Textiles* (London: Thames and Hudson, 1992); Sung Ying-Hsing, *T'ien Kung K'ai-wu* (Chinese Technology in the Seventeenth Century), trans. E-tu Zen Sun and Shiou-chuan Sun (University Park: Pennsylvania State University, 1966); Eric Trombert, "Cooking, Dyeing, and Worship: The Uses of Safflower in Medieval China as Reflected in Dunhuang Documents," *Asia Major,* 3rd ser., 17, no. 1 (2004): 59–72. Alfred Bühler and EberhardFischer suggest that dyeing materials red using madder was not popular in Indonesia early on due to the prevalent use of cotton and the inability of many red dyestuffs to adhere to cotton fibers. See Alfred Bühler and Eberhard Fischer, *Clamp Resist Dyeing of Fabrics* (Ahmedabad, India: Calico Museum of Textiles, 1979) and Matiebelle Gittinger, *Master Dyers to the World: Technique and Trade in Early Indian Dyed Cotton Textiles* (Washington, DC: Textile Museum, 1982), 21–22.

3. Gittinger, *Master Dyers,* 19–29. See also R. J. Forbes, *Studies in Ancient Technology,* vol. 9 (Leiden: E. J. Brill, 1956).

4. B. C. Mohanty et al., *Natural Dyeing Processes of India* (Ahmedabad, India: Calico Museum, 1987), 261; Mira Roy, "Dyes in Ancient and Medieval India," *Indian Journal of History of Sciences* 13, no. 2 (1978); R. A. Donkin, "The Insect Dyes of Western and West-Central Asia," *Anthropos* 72, no. 5/6 (1977): 847–80.

5. Siegfried Lienhard, "On the Meaning and Use of the Word *Indragopa,*" *Indologica Taurinensia* 6: 178.

6. Donkin, "Insect Dyes," 865.

7. Ibid., 861.

8. Ibid., 851–63.

9. William Crookes, *A Practical Handbook of Dyeing and Calico-Printing* (London: Longmans, Green and Company, 1874); Raymond L. Lee, "American Cochineal in European Commerce, 1526–1625," *Journal of Modern History* 23, no. 3 (September 1951): 205–24; Donkin, "Insect Dyes," 865.

10. Donkin, "Insect Dyes," 865. For a discussion of the use of cochineal and other dyes in Persian and Indian carpets, see Daniel Walker, *Flowers Underfoot: Indian Carpets of the Mughal Era* (New York: Metropolitan Museum of Art, 1997). For a discussion of the increased commercialization of Chinese silk during the Ming period (fourteenth to seventeenth centuries), when American cochineal was introduced in the region, see Shelagh Vainker, *Chinese Silk: A Cultural History* (New Brunswick, NJ: Rutgers University Press, 2004), 135–45.

11. Cited in Donkin, "Insect Dyes." While the exact *farman* issued by Emperor Aurangzeb is unknown, the ban on cochineal may very well have been connected with the high

insurance rate applied to it—higher than cash or any other commercial products—to secure its safe travel from Surat to Agra, as noted in a chart of inland insurance rates from 1655 in Irfan Habib; *Essays in Indian History: Towards a Marxist Perspective* (New Delhi: Tulika Books, 1995). Thus the ban may have been a response to the expense of trading and transporting cochineal rather than to any prohibition on its use for aesthetic or social reasons.

12. P. R. Schwartz, "French Documents on Indian Cotton Painting: (1) The Beaulieu MS., c. 1734," *Journal of Indian Textile History* 2 (1956): 9–11.

13. James W. Frey, "Prickly Pears and Pagodas: The East India Company's Failure to Establish a Cochineal Industry in Early Colonial India," *Historian* (2012): 245.

14. Isidore Hedde, *Description méthodique des produits divers recueillis dans un voyage en Chine par Isidore Hedde de 1843 à 1846 et exposés par la Chambre de commerce de Saint-Étienne* (Saint-Étienne, France: Impr. de Théolier aîné, 1848), 175; *Returns of Trade at the Treaty Ports in China, for the Years 1868, 1869, and 1870*, part 1: *Abstract of Trade and Customs' Revenue Statistics, from 1864 to 1870* (Shanghai: Customs' Press, 1870); *Returns of Trade at the Ports of China Open by Treaty to Foreign Trade for the Year 1867*, part 1: *Foreign Trade* (Shanghai: Imperial Maritime Customs' Press, 1867); Donkin, "Insect Dyes," 867.

15. Leanna Lee-Whitman, "The Silk Trade: Chinese Silks and the British East India Company," *Winterthur Portfolio* 17, no. 1 (Spring 1982): 41, pulled from volumes 27, 37, 48, and 58 of Factory Records, China Materials, India Office Records of the India Office Library and Records, London.

CHAPTER 7 (SIMPSON)

1. For recent discussions of this complex history, see Luis Gil Fernández, *El Imperio Luso-Español y la Persia Safávida*, 2 vols. (Madrid: Fundación Universitaria Española, 2006–2009); Willem Floor and Edmund Herzig, eds., *Iran and the World in the Safavid Age* (London: I. B. Tauris, 2012); Rudi Matthee and Jorge Flores, eds., *Portugal, the Persian Gulf and Safavid Persia* (Louvain, Belgium: Peeters, 2011).

2. For a succinct introduction to this mission in English, see Luis Gil, "The Embassy of Don García de Silva y Figueroa to Shah 'Abbas I," in Floor and Herzig, *Iran and the World in the Safavid Age,* 161–80. For a fuller discussion of the gifts, see Marianna Shreve Simpson, "Gifts for the Shah: An Episode in Hapsburg-Safavid Relations during the Reigns of Philip III and 'Abbas I," in *Gifts of the Sultan: The Arts of Gifting at the Islamic Courts,* ed. Linda Komaroff (New Haven, CT: Yale University Press, 2011), 125–39; Carla Alferes Pinto, "Presentes ibéricos e 'goeses' para 'Abbas I: A produção e consumo de arte e os presentes oferecidos ao Xá da Pérsia por García de Silva y Figueroa e D. frei Aleixo de Meneses," in *Estudios sobre Don García de Silva y Figueroa e os "Comentarios" da embaixada à Pérsia (1614–1624),* ed. Rui Manuel Loureiro and Vasco Resende (Lisbon: Centro de História de Além-Mar, 2011), 245–78. For a general context, see Marianna Shreve Simpson, "The Arts of Gifting between Safavids and Hapsburgs," in *The Companion to Islamic Art and Architecture,* ed. Finbarr Barry Floor and Gülru Necipoğlu (Hoboken, NJ: John Wiley and Sons, forthcoming).

3. Raymundo Antonio de Bulhão Pato, ed., *Documentos Remettidos da India* (Lisbon: Typographia da Academia Real das Sciencias, 1885), 2:119–20. My thanks to Juan Gil for clarifying that the president's name was actually Francisco Duarte.

4. Manuel Serrano y Sanz, ed., *Comentarios de D. García de Silva y Figueroa* (Madrid: La Sociedad de Bibliófilos Españoles, 1903), 2:83.

5. I am grateful to Carla Philips and Carlos Marichal for their advice on various technical points regarding the shipment, weights, and prices of cochineal. That the 750 pounds for Shah 'Abbas were shipped in barrels from Seville to Lisbon to Iran is of some note, since the prevailing view is that in the sixteenth century, the material was packed and transported in sacks (*zurrones* or *sobornals*) within Mexico and then transferred into cases (*cajones*) or bales for export from New Spain to Europe; R. A. Donkin, "Spanish Red: An Ethno-geographical Study of Cochineal and the Opuntia Cactus," *Transactions of the American Philosophical Society,* n.s., 67, part 5 (September 1977): 18. On the other hand, a merchant's letter of March 14, 1585, mentions the arrival in Florence of a shipment of six hundred barrels (*barriles*) of cochineal; Felipe Ruiz Martín, *Lettres marchandes échangées entre Florence et Medina del Campo* (Paris: École Pratique des Hautes Études, 1965), 366–67, letter 410. Another minor issue regarding these five barrels is whether they contained cochineal in the form of cakes or, as seems more likely, loose insects; Donkin, "Spanish Red," 18–19. If the latter, then each barrel could have held 10.5 million insects, given the oft-cited calculation of seventy thousand insects per pound; Amy Butler Greenfield, *A Perfect Red: Empire, Espionage, and the Quest for the Color of Desire* (New York: HarperCollins, 2005), 39. As for the gift's monetary value of four thousand ducats, this would put the unit price per arroba at over 133 ducats, considerably more than the price per unit documented for cochineal exported from the Indies to Spain during 1596–1600 and even higher than during the preceding fifteen years. From 1611 to 1615, however, the amount of cochineal exported to Spain came to 2,143.2 arrobas per annum (a sharp drop from the period 1581–1610), making the thirty arrobas sent to Iran in 1614 a tiny percentage of the regulated trade in this commodity; Carla Rahn Phillips, "The Growth and Composition of Trade in the Iberian Empires, 1450–1750," in *The Rise of Merchant Empires: Long-Distance Trade in the Early Modern World, 1350–1750,* ed. James D. Tracy (Cambridge: Cambridge University Press, 1990), 79–81, 88. Slightly different figures are given in Louisa Schell Hoberman, *Mexico's Merchant Elite, 1590–1660* (Durham, NC: Duke University Press, 1991), 120–22. For further discussion of cochineal prices, plus methods of packing and shipping, see Carlos Marichal, "Mexican Cochineal and the European Demand for American Dyes, 1550–1850," in *From Silver to Cocaine: Latin American Commodity Chains and the Building of the World Economy, 1500–2000,* ed. Steven Topik, Carlos Marichal, and Zephyr Frank (Durham, NC: Duke University Press, 2006), 76–92; Jeremy Baskes, "Seeking Red: The Production and Trade of Cochineal Dye in Oaxaca, Mexico, 1750–1821," in *The Materiality of Color: The Production, Circulation, and Application of Dyes and Pigments 1400–1800,* ed. Andrea Feeser et al. (Farnham, UK: Ashgate Publishing, 2012), 101–17.

6. Simpson, "Gifts for the Shah," 135–37.

7. Marianna Shreve Simpson, "Why My Name Is Red: An Introductory Inquiry," in *And Diverse Are Their Hues: Color in Islamic Art and Cultures,* ed. Jonathan Bloom and Sheila Blair (New Haven, CT: Yale University Press, 2011), 271–303.

8. For a typical comment about the Ottoman ("el turco")–Safavid ("el sofi" or "el zufi") conflict and its hoped-for conclusion, see Ruiz Martín, *Lettres marchandes échangées*, 172, letter 214, dated May 15, 1582.

9. Raymond L. Lee, "American Cochineal in European Commerce, 1526–1625," *Journal of Modern History* 23 (September 1951): 211.

10. Elena Phipps, "Cochineal Red: The Art History of a Color," *Metropolitan Museum of Art Bulletin* 67, no. 3 (Winter 2010): figures 72–74. Other pieces of the cochineal-dyed textile reproduced in figure 72 are known. See Carol Bier, ed., *Woven from the Soul, Spun from the Heart: Textile Arts of Safavid and Qajar Iran, 16th–19th Centuries* (Washington, DC: Textile Museum, 1987), catalog number 25. Phipps (page 44) refers to Dutch and English shipments of American cochineal to Iran and Turkey in the seventeenth and eighteenth centuries, but without documentation. See also Elena Phipps and Nobuko Shibayama, "Tracing Cochineal through the Collection of the Metropolitan Museum," Textile Society of America Symposium Proceedings, 2010, http://digital commons.unl.edu/tsaconf/44.

11. For the textile's complete poem, by an unidentified poet, see "The Collection Online," Metropolitan Museum of Art, 2014, http://www.metmuseum.org/collection/the-collection-online/search?ft=46.156.7.

A somewhat different translation appears in Bier, *Woven from the Soul*, 184.

12. Rudi Matthee, "Gift Giving in the Safavid Period," in *Encyclopaedia Iranica*, ed. Ehsan Yarshater (New York: Biblioteca Persica Press, 2001), 10: 609–14; Marianna Shreve Simpson, "The Morgan Bible and the Giving of Religious Gifts between Iran and Europe/Europe and Iran during the Reign of Shah 'Abbas I," in *Between the Picture and the Word: Manuscript Studies from the Index of Christian Art*, ed. Colum Hourihane (Princeton, NJ: Princeton University Press, 2005), 146.

13. Such appropriation or repurposing could have been considered perfectly justifiable in light of what happened to fifty bales of silk that 'Abbas I sent to Philip III several years earlier. The shah had intended the silk to be sold in Europe, but it was accepted at the Habsburg court as a gift. Simpson, "Gifts for the Shah," 126.

CHAPTER 8 (BETHE/SASAKI)

1. Gotō Shōsaburō, *Sanpuki*, 1611–1615, National Institute of Japanese Literature, www.nijl.ac.jp/pages/database.

2. Discussed in Amelia Peck, ed., *Interwoven Globe* (New York: Metropolitan Museum of Art, 2013), 178.

3. Sachio Yoshioka, *Nihon no iro o aruku* [Japanese Color Strolls] (Tokyo: Heibonsha Shinsho, 2007), 60–61.

4. See Elizabeth W. Fitzhugh, John Winter, and Marco Leona, "Pigments in Later Japanese Paintings," *Freer Gallery of Art Occasional Papers*, n.s., 1 (2003): 11.

5. Nara National Museum, *Shōsōinten* [Exhibition of Shōsōin Treasures] (Nara, Japan: Nara National Museum, 2003), 67.

6. Rikiya Nakamura, "Color Analysis," *Shōsōin Kiyo* [Bulletin of the Shōsōin] 35 (2013): 66–69.

7. Tsuneyoshi Yoshioka, *Tennen senryō no kenkyū* [Study of Natural Dyes] (Kyoto: Mitsumura Shoin, 1974), 160. Yoshiko Sasaki, Masanori Sato, Mari Omura, and Ken Sasaki, "Dye Analysis of Braids Used for Japanese Armor Dating from the 14th to 16th Century," *Dyes in History and Archaeology* 21 (2008): 37–50, mentions ten thousand sheets of

enji-wata imported yearly.

8. Textile historian Ken Kirihata discusses this preference in "*Yūzen* Dyeing: A New Pictorialism," in *When Art Became Fashion*, ed. Dale Carolyn Gluckman and Sharon Sadako Takeda (Los Angeles: Los Angeles County Museum of Art, 1992), 125. The mistaken use of *cochineal* for *enji* here is a translator's slip.

9. Song Yingxing, *Tiangong Kaiwu* [The Exploitation of the Works of Nature], Kyushu University, 2013, http://record.museum.kyushu-u.ac.jp/tenko/tenko/index.html; Yoshiko Sasaki et al., "Enji-wata ni mochiirareta akairo seibun no kagaku bunseki" [A Chemical Analysis of Red Dyestuffs Used for *Enji-wata* (Rouge-cotton)], *Bunkazai Hozon Shūfuku Gakkaishi* [Journal of the Japan Society for the Conservation of Cultural Property] 56 (2013): 39.

10. Historiographical Institute of Tokyo University, *Dai Nihon Komonjo Shōsōin hennenmonjo* vol. 3 [Great Old Japanese Document: Chronological Edition of Shōsōin Documents 748–53] (Tokyo: Tokyo University, 1968), 254.

11. Masaaki Kanehara, "Kafun ga kataru kodai benibana" [Pollen and Safflower in Ancient Times], *Nihon Bunkazai Kagaku Gakkai Gappō* [Annals of the Japan Society for Scientific Study of Cultural Properties] 57 (2008): 1–4.

12. The *Man'yōshū* poems alluded to here are 1993, 4109, and 2827. Lojima Nariyuki et al., eds., *Nihon Koten Bungaku Shūsei* [Compilation of Japanese Classical Literature] (Tokyo: Shogakukan, 1973, 1975), 3:86, 3:276, 4:271.

13. For an overview of this essential Chinese worldview, see William Theodore de Bary, Wing-Tsit chan, and Buron Watson, *Sources of Chinese Tradition*, vol. 1 (New York: Columbia University Press, 1964), 199.

14. Torao Toshiya, ed., *Engishiki* [Codes of the Engi Era] (Tokyo: Shūeisha, 2007), 927.

15. Yoshiko Sasaki et al., "Dye Analysis," 119–26. They identified madder through gas-MS spectrum but found it low in alizarin and found it to have an anthraquinone-group peak pattern typical of Japanese madder.

16. For a discussion of safflower dyes

and cultivation in Japan, see Monica Bethe, "Reflections on *Beni*: Red as a Key to Edo-Period Fashion," in Gluckman and Takeda, *When Art Became Fashion*, 133–53.

17. For layered colors, see Lisa Dalby, *Kimono* (New Haven, CT: Yale University Press, 1993), 240–69.

18. Yoshiko Sasaki et al., "Dye Analysis," table 1 (cf. 8) lists Japanese references from 1690, 1721, and 1887.

19. What follows summarizes Yoshiko Sasaki, Ryohei Fukae, and Ken Sasaki, *Bunkazai Hozon Shufuku Gakkaishi* [Annals of the Conservation and Preservation of Cultural Properties] 56 (2013): 37–50.

20. They were acquired variously—from deceased painters' storehouses, directly from China, and inherited by family dye houses. Thus their dates range from Edo to Meiji. Some may be later imitations.

21. This appeared in their reflection visible and second derivative spectra.

22. Laccaic acid A was the main red colorant of the lac, having a molecular ion of 536 and product ions from m/z 536 and m/z 492. The carminic acid had a molecular ion of 491 and product ions from m/z 447.

23. Ongoing research into dye-based pigments on Meiji-period woodblock prints is being conducted by Henry Smith of Columbia University in conjunction with Marco Leona at the Metropolitan Museum.

24. T. Yano, Y. Sasaki, S. Kawakami, M. Hosoki, Y. Nakamura, and K. Fujii, abstract, thirty-fourth annual meeting of the Japan Society for the Conservation of Cultural Property, 2012.

CHAPTER 9 (OSBORN)

1. Amy Butler Greenfield, *A Perfect Red: Empire, Espionage, and the Quest for the Color of Desire* (New York: HarperCollins, 2005), 39–40.

2. Ibid., 111.

3. Ibid., 141.

4. René Caillié, *Voyage à Tombouctou*, 2 vols. (Paris: La Découverte, 1996), 1:312.

5. Colleen E. Kriger, *Cloth in West African History* (Lanham, MD: AltaMira Press, 2006), 6.

6. Ibid., 35.

7. William Smith, *A New Voyage to Guinea: Describing the Customs,*

Manners, Soil, Manual Arts, Agriculture, Trade, Employments, Languages, Ranks of Distinction, Climate, Habits, Buildings, Education, Habitations, Diversions, Marriages, and Whatever Else Is Memorable among the Inhabitants, 2nd ed. (London: J. Nourse, 1745), 29.

8. Ibid., 30–31.

9. Kriger, *Cloth in West African History*, 35.

10. John Adams, *Remarks on the Country Extending from Cape Palmas to the River Congo, Including Observations on the Manners and Customs of the Inhabitants* (London: G. and W. B. Whitaker, 1823), 79–80.

11. Kriger, *Cloth in West African History*, 36.

12. Michael Gomez uses these interviews in a similar way, and he likewise discusses references to the "red flannel" motif in narratives of enslavement. Michael Gomez, *Exchanging Our Country Marks: The Transformation of African Identities in the Colonial and Antebellum South* (Chapel Hill: University of North Carolina Press, 1998), chapter 8.

13. "Us chillin wore shoes like grownups," *Born in Slavery: Slave Narratives from the Federal Writers' Project, 1936–1938, Interviews Conducted in Alabama*, Library of Congress, March 23, 2001, http://memory.loc.gov/cgi-bin/query/S?ammem/mesnbib:@band%28@field%28NUMBER+mesn%29+@field%28STATE+@od1%28Alabama%29%29%29::heading=Interviews+Conducted+in+Alabama.

14. "Jeff Davis used to camouflage his horse," *Born in Slavery: Slave Narratives from the Federal Writers' Project, 1936–1938, Interviews Conducted in Alabama*, Library of Congress, March 23, 2001, http://memory.loc.gov/cgi-bin/query/S?ammem/mesnbib:@band%28@field%28NUMBER+mesn%29+@field%28STATE+@od1%28Alabama%29%29%29::heading=Interviews+Conducted+in+Alabama.

15. "Interview with Arbery, Katie," *Born in Slavery: Slave Narratives from the Federal Writers' Project, 1936–1938, Interviews Conducted in Arkansas*, Library of Congress, March 23, 2001, http://memory.loc.gov/cgi-bin/query/S?ammem/mesnbib:@band%28@

field%28NUMBER+mesn%29+@
field%28STATE+@od1%28Arkansa
s%29%29%29::heading=Interviews+
Conducted+in+Arkansas.

16. "Slave Interview with Cindy Kinsey, Former Slave," *Born in Slavery: Slave Narratives from the Federal Writers' Project, 1936–1938, Interviews Conducted in Florida,* Library of Congress, March 23, 2001. http://memory.loc.gov/cgi-bin/query/S?ammem/mesnbib:@band%28@field%28NUMBER+mesn%29+@field%28STATE+@od1%28Florida%29%29%29::heading=Interviews+Conducted+in+Florida.

17. "Interview with (Mrs.) Mariah Callaway," *Born in Slavery: Slave Narratives from the Federal Writers' Project, 1936–1938, Interviews Conducted in Georgia,* Library of Congress, March 23, 2001. http://memory.loc.gov/cgi-bin/query/S?ammem/mesnbib:@band%28@field%28NUMBER+mesn%29+@field%28STATE+@od1%28Georgia%29%29%29::heading=Interviews+Conducted+in+Georgia.

18. "Shack Thomas, Centenarian," *Born in Slavery: Slave Narratives from the Federal Writers' Project, 1936–1938, Interviews Conducted in Florida,* Library of Congress, March 23, 2001, http://memory.loc.gov/cgi-bin/query/S?ammem/mesnbib:@band%28@field%28NUMBER+mesn%29+@field%28STATE+@od1%28Florida%29%29%29::heading=Interviews+Conducted+in+Florida.

19. Ibid.

CHAPTER 10 (VAN DAM ET AL)

1. G. Perez-Guerra and M. Kosztarab, "Biosystematics of the Family Dactylopiidae (Homoptera: Coccinea) with Emphasis on the Life Cycle of Dactylopius coccus Costa," *Bulletin of the Virginia Agricultural Experiment Station* 92 (1992): 1–90; G. De Lotto, "On the Status and Identity of the Cochineal Insects (Homoptera: Coccoidea: Dactylopiidae)," *Journal of the Entomological Society of Southern Africa* 37 (1974): 167–93; A. R. Van Dam and B. May, "A New Species of Dactylopius Costa (Dactylopius gracilipilus sp. nov.) (Hemiptera: Coccoidea: Dactylopiidae) from the Chihuahuan Desert, Texas, U.S.A," *Zootaxa* (2012): 33–39.

2. Robin A. Donkin, "Spanish Red: An Ethnogeographical Study of Cochineal and the Opuntia Cactus," *Transactions of the American Philosophical Society*, n.s., 67, part 5 (September 1977): 1–84.

3. L. C. Rodríguez, U. Pascual, and H. M. Niemeyer, "Local Identification and Valuation of Ecosystem Goods and Services from Opuntia Scrublands of Ayacucho, Peru," *Ecological Economics* 57 (2006): 30–44; L. Portillo, "Origen de Dactylopius coccus Costa (Hemiptera: Dactylopiidae): ¿Norte o Sudamérica?" *Dugesiana* 12 (2005): 1–8.

4. Donkin, "Spanish Red"; Portillo, "Origen."

5. Elena Phipps and Nobuko Shibayama, "Tracing Cochineal through the Collection of the Metropolitan Museum," paper presented at the Textile Society of America Twelfth Biennial Symposium, Lincoln, NE, October 6–9, 2010; Donkin, "Spanish Red"; Portillo, "Origen"; A. Serrano et al., "Analysis of Natural Red Dyes (Cochineal) in Textiles of Historical Importance Using HPLC and Multivariate Data Analysis," *Analytical and Bioanalytical Chemistry* 401 (2011): 735–43; O. Deveoglu, E. Torgan, and R. Karadag, "Identification of Dyestuffs in the Natural Pigments Produced with Al3+, Fe2+ and Sn2+ Mordant Metals from Cochineal (Dactylopius coccus Costa) and Walloon Oak (Quercus ithaburensis Decaisne) by HPLC-DAD," *Asian Journal of Chemistry* 22 (2010): 7021–30; D. A. Peggie, A. N. Hulme, H. McNab, and A. Quye, "Towards the Identification of Characteristic Minor Components from Textiles Dyed with Weld (Reseda luteola L.) and Those Dyed with Mexican Cochineal (Dactylopius coccus Costa)," *Microchimica Acta* 162 (2008): 371–80; J. A. N. Wouters and N. Rosario-Chirinos, "Dye Analysis of Pre-Columbian Peruvian Textiles with High-Performance Liquid Chromatography and Diode-Array Detection," *Journal of the American Institute of Conservation* 31 (2011): 237–55.

6. Donkin, "Spanish Red"; G. M. Feinman, L. M. Nicholas, and H. R. Haines, "Classic Period Agricultural Intensification and Domestic Life at El Palmillo, Valley of Oaxaca, Mexico," in *Seeking a Richer Harvest: The Archaeology of Subsistence Intensification, Innovation, and Change* (New York: Springer, 2007); Portillo, "Origen."

7. F. Nardi et al., "Population Structure and Colonization History of the Olive Fly, Bactrocera oleae (Diptera, Tephritidae)," *Molecular Ecology* 14 (2005): 2729–38; A. V. Suarez and N. D. Tsutsui, "The Evolutionary Consequences of Biological Invasions," *Molecular Ecology* 17 (2008): 351–60; C. W. Whitfield et al., "Thrice Out of Africa: Ancient and Recent Expansions of the Honey Bee, Apis mellifera," *Science* 314 (2006): 642–45; P. Lubinsky et al., "Neotropical Roots of a Polynesian Spice: The Hybrid Origin of Tahitian Vanilla, Vanilla tahitensis (Orchidaceae)," *American Journal of Botany* 95 (2008): 1040–47.

8. Nardi et al., "Population"; Suarez and Tsutsui, "Evolutionary Consequences."

CHAPTER 11 (ROQUERO)

1. Francisco Hernández, *Historia natural de la Nueva España* (Mexico City: UNAM, 1959) 2:118.

2. Felipe Guaman Poma de Ayala, *Nueva corónica y buen gobierno* (Madrid: Historia 16, 1987), A, 220.

3. Ana Roquero, *"Tintorería en la industria sedera europea del siglo XVIII,"* in *Arte de la seda en la Valencia del s. XVIII* (Valencia: Fundación Bancaja, 1997), 125–58.

4. Pierre Joseph Macquer, *Arte de la tintura de sedas* (Madrid: Blas Roman, 1771), 106–107.

5. Jean Hellot, *Arte de la tintura de las lanas y de sus tejidos* (Madrid: Herederos de Francisco del Hierro, 1752), 209–10. Originally published as *L'Art de la teinture des laines et des etoffes de laine en grand et petit teint* (Paris, Vve Pissot, 1750).

6. *Agua regia* is a mixture of nitric acid and hydrochloric acid used to dissolve metals.

7. One pound is a variable measure of weight, depending on the country, region, and era. It equals approximately 460 grams. An ounce is one-sixteenth of a pound, equaling 28.75 grams. A *dracma* is one-eighth of an ounce, equaling 3.594 grams. An *azumbre* is a variable measure of volume of liquid, equaling more or less 2.5 liters.

8. Hellot, *Arte de la tintura*, 249–51.

9. Ibid., 247–48.

CHAPTER 12 (BRUQUETAS)

1. Francisco de las Barras y Aragon, "Una historia del Perú contenida en un cuadro al óleo de 1799," *Boletín de la Real Sociedad Española de Historia Natural* (1912): 224–85. See also the extensive study of Fermín del Pino, ed., *El 'Quadro del Perú (1799),' un texto ilustrado del Museo Nacional de Ciencias Naturales* (Lima: Universidad Nacional Agraria La Molina, 2014).

CHAPTER 13 (SANZ RODRÍGUEZ)
ACKNOWLEDGMENTS
The author thanks the Instituto del Patrimonio Cultural de España and the Museum of International Folk Art for the collaboration through which the present study has been developed. The staff of the IPCE's Investigation Department as well as the personnel of Museo de América and Museo del Traje are also gratefully acknowledged for their collaboration. I am most grateful to Ana Roquero and Susanna Marras for their valuable help and the preparation of reference samples.

1. Ester S. B. Ferreira et al., "The Natural Constituents of Historical Textile Dyes," *Chemical Society Reviews* 33 (2004): 329–36.

2. Dominique Cardon, *Natural Dyes: Sources, Tradition, Technology, and Science* (London: Archetype Publications, 2007).

3. David A. Peggie et al., "Towards the Identification of Characteristic Minor Components from Textiles Dyed with Weld (Reseda luteola L.) and Those Dyed with Mexican Cochineal (Dactylopius coccus Costa)," *Microchimica Acta* 162 (2008): 371–80.

4. Judith H. Hofenk de Graaff, *The Colourful Past: Origin, Chemistry and Identification of Natural Dyestuff* (London: Archetype Publications, 2004).

5. Jan Wouters and Andre Verhecken, "The Coccid Insect Dyes: HPLC and Computerized Diode-Array Analysis of Dyed Yarns," *Studies in Conservation* 34, (1989): 189–200.

6. Ana Serrano et al., "Analysis of Natural Red Dyes (Cochineal) in Textiles of Historical Importance Using HPLC and Multivariate Data

Analysis," *Analytical and Bioanalytical Chemistry* 401 (2011): 735–43.

7. Method 1 was previously optimized by Estrella Sanz et al. in "Characterization of Natural and Synthetic Dyes Employed in the Manufacture of Chinese Garment Pieces by LC-DAD and LC-DAD-QTOF," *e-Conservation* 21 (2011): 41–57.

8. All modules of the LC-DAD-QTOF instrument were from Agilent Technologies, USA. The liquid chromatography system used consisted of a 1200 series model equipped with a ZORBAX SB18 column (50 x 2.1 millimeters i.d.; 1.8 µm particle size). The mobile phase, pumped at 0.8 ml min-1, consisted of 0.1 percent formic acid in water (A) and acetonitrile (B). The column temperature was maintained at 35 degrees Celsius. The gradient applied was from 10 percent B to 95 percent B at 18 minutes. Separated components were detected with a diode array detector, scanning from 200 to 800 nanometers. Detection was carried out on a 6530 Accurate-Mass Q-TOF, operating in ESI negative mode. The mass spectrometer operating conditions are summarized in table 2 (see appendix). Data acquisition and processing were performed using MassHunter Workstation software.

9. Method 2 was optimized in the present work (unpublished data) and was based on the proposal for dye extraction from paint samples by Jana Sanyova in "Mild Extraction of Dyes by Hydrofluoric Acid in Routine Analysis of Historical Paint Micro-Samples," *Microchimica Acta* 162 (2008): 361–70.

10. Ana Roquero, *Tintes y tintoreros de América: catálogo de materias primas y registro etnográfico de México, Centro América, Andes Centrales y Selva Amazónica* (Madrid: Ministerio de Cultura, Instituto del Patrimonio Histórico Español, 2006).

CHAPTER 14 (PHIPPS)

1. See Penny Dransart, "Pachamama the Inka Earth Mother of the Long Sweeping Garment," in *Dress and Gender: Making and Meaning in Cultural Contexts,* ed. Ruth Barnes and Joan Eicher (London: Berg, 1992), 145–63.

2. Red pigments, including cakes of cochineal, were associated with Inca female burials in the province of Salta in Argentina. See Burial 161 in Juan B. Ambrosetti, *Exploraciones arqueológicas en la ciudad prehistórica de "La Paya": (Valle Calehaquí, Provincia de Salta) Campañas de 1906 y 1907* (Buenos Aires: Imp. de M. Biedma é hijo, 1907), 526–27. Other burials in Salta included the ritual child sacrifice Capacocha, discovered in the late 1990s in an ice-covered volcano in the region. The girl and accompanying miniature figures were dressed in red garments. Johan Reinhard and María Constanza Ceruti, *Investigaciones arqueológicas en el Volcán Llullaillaco: Complejo ceremonial incaico de alta montaña* (Salta, Argentina: EUCASA, 2000).

3. See Veronica Cereceda, "Aproximaciones a una estetica Andina: De la Belezza a Tinku," in *Tres reflexiones sobre el pensamiento andino*, ed. Therese Harris, Olivia Cereceda, and Veronica Bouysse-Cassagne (Paris: Hisbol, 1986), 133–231.

4. The digitized version of the full manuscript, whose original belongs to the Royal Danish Library, can be found at "Guaman Poma," Det Kongelige Bibliotek, n.d., http://www.kb.dk/permalink/2006/poma/info/en/frontpage.htm.

5. See Elena Phipps, "Color in the Andes: Inka Garments and Seventeenth-Century Colonial Documents," *Journal of Dyes in History and Archaeology* 19 (2003): 51–59. *See* also Elena Phipps, "Textile Colors and Colorants in the Andes," in *Colors between Two Worlds: The Florentine Codex of Bernardino de Sahagún*, ed. Gerhard Wolf and Joseph Connors (Florence: Harvard University Press, 2011), 256–80.

6. Some recent scientific studies on Andean dyes include J. Wouters and N. Rosario-Chirinos, "Dye Analysis of Pre-Columbian Peruvian Textiles with High-Performance Liquid Chromatography and Diode-Array Detection," *Journal of the American Institute for Conservation* 31 (1992): 237–55; the work of Elena Phipps, Marco Leona, and Nobuko Shibayama at the Metropolitan Museum of Art (2003–2010); Nathalie Boucherie, Witold Novik, and Dominique Cardon, "Prácticas tintóreas y colorantes empleados en la cultura Nasca (Perú): investigación sobre técnicas y conocimientos perdidos," paper presented at Musée du Quai Branly, Paris, November 2013; and the work of Catherine Higgitt and Tibault Devise at the British Museum (2012–2014; see "Andean textiles, organic colourants, biological sources, and dyeing technologies," British Museum, n.d., http://www.britishmuseum.org/research/research_projects/all_current_projects/andean_textiles.aspx). Ethnographic studies of Andean dyeing methods and botanic materials include Hugo Zumbühl, *Tintes naturales para lana de oveja* (Huancayo, Peru: Kamaq Maki, 1979); Pilar Ferro de Salazar, *Manual de tintes naturales siguiéndole el hilo al color* (Bogotá: Nencatacoa Corporación de Artes Textiles, 1996); and Ana Roquero, *Tintes y tintoreros de América de America: catálogo de materias primas y registro etnográfico de México, Centro América, Andes Centrales y Selva Amazónica* (Madrid: Ministerio de Cultura, Instituto del Patrimonio Histórico Español, 2006).

7. See, for example, the Ocucaje textile belonging to the Metropolitan Museum of Art; Elena Phipps, *Cochineal Red: The Art History of a Color* (New York: Metropolitan Museum of Art, 2010), 18, figure 29.

8. Testing was conducted at the Metropolitan Museum of Art by Marco Leona and Nobuko Shibayama using high-performance liquid chromatography (HPLC) on samples selected by the author between 2000 and 2010. Some of the results were published in Phipps, *Cochineal Red*.

9. Two studies identified cochineal in single Paracas or early Nasca textiles: Max Saltzman, "Analysis of Dyes in Museum Textiles: or You Can't Tell a Dye by Its Color," in *Textile Conservation Symposium in Honor of Pat Reeves,* ed. C. McLean and P. Connell (Los Angeles: Los Angeles County Museum of Art, 1986), 32–39; and Masako Saito, "Identification of Six Natural Red Dyes by High Performance Liquid Chromatography," *Dyes in History and Archaeology* 19 (2003): 70–87. See also Elena Phipps and Nobuko Shibayama, "Tracing Cochineal through the Collection of the Metropolitan Museum," paper presented at the Textile Society of America Twelfth Biennial Symposium, Lincoln, NE, October 6–9, 2010.

10. Sophie Desrosiers has drawn attention to the relationship between Paracas embroideries and highland warp-patterned weaving. Her work would also support the highland–coastal link with other textile technologies, such as dyes. See Sophie Desrosiers, "Can We Study Textiles from Other Cultures Without Ethnocentrism? The Andes as a Case Study," Textile Society of America Symposium Proceedings, 2012, http://digitalcommons.unl.edu/tsaconf/674. Also, recent excavations (summer field season 2014) in nearby Chincha Valley by Charles Stanish of UCLA traced trade routes through this region from coast to highland from around this same time period. (Personal communication, September 2014.)

11. See, for example, Luis Rodríguez, Marco Méndez, and Hermann Neimeyer, "Direction of Dispersion of Cochineal (Dactylopius c.) within the Americas," *Antiquity* 75 (2001): 73–77. See also Lucas C. Majure et al., "Phylogeny of *Opuntia* s.s. (Cactaceae): Clade Delineation, Geographic Origins, and Reticulate Evolution," *American Journal of Botany* 99 (May 2012): 847–64. However, an earlier study locates the origin of the cactus in Mexico. See M. Patrick Griffith, "The Origins of an Important Cactus Crop, *Opuntia ficus-indica* (Cactaceae): New Molecular Evidence," *American Journal of Botany* 91 (November 2004): 1915–21.

12. See Phipps, *Cochineal Red*.

13. Yellow components luteolin, fisetin, and sulfuretin were found with the red fringed bag belonging to the Metropolitan Museum of Art. The yellow overdyed on the cochineal would have modulated the red to a more blood red color. Analysis was conducted by Jan Wouters in 2000 for a research project by the author.

14. From the seventeenth century through the end of the nineteenth century, dyers from the Lake Titicaca region used tin as a mordant with cochineal to create a bright orange hue.

15. See Bernabé Cobo, *Historia del*

Nuevo Mundo (Madrid: Ediciones Atlas, 1956), 1:113–16.

16. Testing by N. Shibayama, Metropolitan Museum of Art, 2009. See Phipps, *Cochineal Red*.

17. See Ludovico Bertonio, *Vocabulario de la lengua aymara* (Cochabamba, Bolivia: Centro de Estudios de la Realidad Económica y Social, 1984), 113. For further information on red and blue garments, see Elena Phipps, Johanna Hecht, and Cristina Esteras Martín, eds., *The Colonial Andes: Tapestries and Silverwork, 1530–1830* (New York: Metropolitan Museum of Art, 2004), 273–76, catalog entry 89.

18. Ibid., 274–75, figure 89.

19. Elena Phipps, "Tornesol: A Colonial Synthesis of European and Andean Textile Traditions," in *Textile Society of America, Seventh Biennial Symposium, Santa Fe, New Mexico 2000 Proceedings* (Earleville, MD: Textile Society of America, 2001), 221–30.

20. See, for example, R. A. Donkin, "Spanish Red: An Ethnogeographical Study of Cochineal and the Opuntia Cactus," *Transactions of the American Philosophical Society,* n.s., 67, part 5 (September 1977); Amy Butler Greenfield, *A Perfect Red: Empire, Espionage, and the Quest for the Color of Desire* (New York: HarperCollins, 2005); and Phipps, *Cochineal Red.*

CHAPTER 15 (ÁVILA B.)

1. The two bags that were assayed—catalog numbers COS0089 (where samples were taken from the body of the *costal* and from the ribbon) and COS0170 (where the ribbon was tested)—are part of the collection of the Museo Textil de Oaxaca (MTO). All three samples tested positive for carminic acid using two different procedures. In the first method, the sample is immersed in a dilute solution (10 percent) of sulfuric acid and heated to a boil. If the thread was dyed with cochineal, the solution turns orange while the fiber remains red; Helmut Schweppe, *Practical Information for the Identification of Dyes on Historic Textile Materials* (Washington, DC: Conservation Analytical Laboratory, Smithsonian Institution, 1988). In the second method, the sample is subjected to a few drops of concentrated sulfuric

acid, which becomes red when carminic acid is present. Boric acid is then added and the liquid turns blue to confirm that cochineal was used to dye the fiber; Arie Wallert, "The Analysis of Dyestuffs on Historical Textiles from Mexico," in *The Unbroken Thread: Conserving the Textile Traditions of Oaxaca*, ed. K. Klein (Los Angeles: Getty Conservation Institute, 1997), 74. Bits of thread dyed with cochineal in the laboratory, as well as samples dyed with synthetic reds, served as controls at our laboratory. All MTO textiles cited in this paper were tested using both methods. I am grateful to Héctor Meneses Lozano for performing the initial analyses in 2009 and a second series in 2014, together with Diana Medellín Martínez.

2. Three *costales* from the holdings of the MTO were assayed. The first (COS0311), which tested positive, belonged to collector Ernesto Cervantes Morales, who acquired it around 1950 from an American antiques hunter based in Linares, Nuevo León. The second (COS0325), which also gave positive results, was purchased in 2010 from a gallery in the United States. A more recent bag (COS0160), which I obtained in 1979 from a family in Doctor Arroyo, Nuevo León, was dyed with a synthetic red, but a number of its technical features are shared by the earlier pieces and confirm the provenance remembered by Cervantes.

3. A *sabanilla* in the collection of the MTO (COL0012) tested positive for a sample taken from the border design. Motifs embroidered in the central field, which may have been added at a later date, include a bright red that has run and stained the woolen fabric.

4. QUE0004, a Mazahua *quechquémitl*, tested positive on a sample of the warp.

5. Among Tarascan textiles, the most likely candidates seem to be the handwoven *huanengos* (*huipiles*) decorated with dark red wool collected by Frederick Starr for the Field Museum in Chicago. Another early example of the same type is preserved at the Museo Nacional de Antropología in Mexico City. Wine red wool brocading and embroidery on three handwoven Huichol *quech-*

quémitls and a man's shirt collected by Carl Lumholtz, deposited in the American Museum of Natural History (numbers 65/321, 323, 1304, and 1309), may have been dyed with domesticated or wild *Dactylopius.*

6. Dark red wool embroidery on an old *huipil* from San José Miahuatlán, Puebla, which may date from the turn of the twentieth century (HUI0420), gave negative results.

7. Analyses of supplementary weft samples from *huipiles* probably dating to the 1920s or 1930s from San Juan Chamula (HUI0170) and San Andrés Sakamch'en (HUI0169) turned out negative. The only positive result was on the brocaded weft, also of wool, in an early ceremonial *huipil* of uncertain provenance in the Chiapas highlands (HUI0135).

8. Robert Carlsen and David Wenger confirmed the presence of cochineal on tapestry bands decorating narrow woolen blankets worn by men in Chichicastenango, called *q'uul* in K'iche'; Robert S. Carlsen and David A. Wenger, "The Dyes Used in Guatemalan Textiles: A Diachronic Approach," in *Textile Traditions of Mesoamerica and the Andes: An Anthology*, ed. Margot B. Schevill, Janet C. Berlo, and Edward B. Dwyer (Austin: University of Texas Press, 1996), 372–73. The same authors found carmine on supplementary wefts of silk floss dating to 1910–1930 on weavings from Quetzaltenango, while contemporaneous brocades of the same material from other places in Guatemala were dyed with synthetic colorants.

9. In 1995 Arie Wallert assayed samples I took of two Mitla skirts, two twill-woven wraparounds from the Valley of Oaxaca, an embroidered skirt from Huautla, a Jamiltepec *posahuanque*, and a Quiatoni rebozo, all of which tested positive; Wallert, "Analysis of Dyestuffs," 74–76.

10. Héctor Meneses analyzed a sample of the red warp stripes on a silk rebozo from Coyotepec that dates from about 1890, the only example known of its type (REB0101), to confirm that it was dyed with cochineal.

11. Héctor Meneses tested the purple and magenta silk warp stripes on a Tututepec *posahuanque* that appears to have been woven before 1920 (ENR0182), with negative results for

carminic acid. Arie Wallert analyzed silk samples I took of a Pinotepa de Don Luis wraparound, three Yautepec *huipiles*, and men's trousers from the same locality, which tested positive for fuchsine, magenta, and three unidentified purple, pink, and violet synthetic dyes; Wallert, "Analysis of Dyestuffs," 77–78.

12. Héctor M. Meneses Lozano, *Un paño novohispano, tesoro del arte plumaria* (Mexico City: Apoyo al Desarrollo de Bibliotecas y Archivos de México, A.C., 2008), 22–25, 57–60, 71, 95.

13. Elena Phipps, "Cochineal Red: The Art History of a Color," *Metropolitan Museum of Art Bulletin* 67, no. 3 (Winter 2010): 16–17.

14. A. de Ávila B., "*Kutiere, titia'a*: Historia y simbolismo en los tejidos mixtecos," in *Las rutas de la tierra del sol*, ed. Reina Ortiz Escamilla (Huajuapan de León: Universidad Tecnológica de la Mixteca, 2012), 89–172.

15. *Relación de San Pedro Apóstol Quiechapa*, 1777; Manuel Esparza, *Relaciones geográficas de Oaxaca, 1777–1778* (Oaxaca: CIESAS and Instituto Oaxaqueño de las Culturas, 1994), 273–74. Phipps ("Cochineal Red," 16) writes that cochineal "was rarely, if ever, used on cotton or other vegetal fibers, unless it was painted on the surface as a pigment."

16. Red cotton on a Mexican embroidery sampler signed and dated in 1848 (DEC0036) tested negative for cochineal at the MTO. Carlsen and Wenger (*Textile Traditions*, 369–72) assayed several early Guatemalan cotton textiles for carmine, with no success.

17. Teresa Castelló Yturbide, *Colorantes naturales de México* (Mexico City: Industrias Resistol, 1988), 63. In 1977, prior to her research in Tuxtla, Noguera reported that Zoque people had formerly "dyed cotton and painted their houses with wild cochineal"; Eduardo Noguera, "Representación de invertebrados en culturas prehispánicas," *Anales de Antropología* 14, no. 1 (1977): 127–53.

18. Ámbar Past et al., *Bon: Tintes naturales* (San Cristóbal las Casas: private printing, 1980), 5, 20, 66. Castelló (*Colorantes naturales*, 71) states that *Lantana camara* was used in Chiapas together with cochineal

and limes to obtain a bright red color but does not specify where.

19. Luz Elena Vásquez Dávila, Marco Antonio Vásquez Dávila, and María Beatriz Solís Trejo, "Fitoquímica tradicional: las plantas tintóreas de Santa Ana del Valle, Oaxaca," in *Etnias, desarrollo, recursos y tecnologías en Oaxaca*, ed. Álvaro González Ríos and M. A. Vásquez D. (Oaxaca: CIESAS and Gobierno del Estado, 1992), 230–33. Castelló (*Colorantes naturales*, 68) writes that *Clethra lanata* is used the same way in "Santa Clara del Valle," probably referring to Santa Ana. She adds *Conostegia xalapensis*, *Miconia laevigata*, and *Licania arborea* to the list of "toners" combined with cochineal in Oaxaca, without providing further information.

20. Gary N. Ross, "The Bug in the Rug," *Natural History* 95, no. 3 (1986): 65–73; Castelló, *Colorantes naturales*, 68.

21. Irmgard Weitlaner Johnson, "Old-style Wrap-around Skirts Woven by Zapotec Indians of Mitla, Oaxaca," in *Ethnographic Textiles of the Western Hemisphere*, ed. Irene Emery and Patricia Fiske (Washington, DC: Textile Museum, 1977), 241–43. Morris Stubblefield and Carol Miller translate *balaglaj* as *huboquillo* in Spanish and gloss it as a "plant from the forest which is used for brown dye." They identify it tentatively as a species of *Senecio* (marigold family) and report its stature at around 1 meter; Morris Stubblefield and Carol Miller, *Diccionario zapoteco de Mitla* (Mexico City: Instituto Lingüístico de Verano, 1991), 4, 285. Vásquez, Vásquez, and Solís ("Fitoquímica tradicional," 232) record *gu gi'in* as the name for *Justicia spicigera* in Santa Ana. Johnson's *balaguuguín* is probably *J. spicigera*, since she states that it is cultivated in Mitla and is used together with indigo to dye wool blue. Stubblefield and Miller (*Diccionario*, 289) cite *guiguguiin* as annatto, also a dye plant.

22. Ana Roquero identifies the *tesuate verde* and *tesuate colorado* employed in Hueyapan, Puebla, as different species of *Miconia*, without providing epithets; Ana Roquero, *Tintes y tintoreros de América: catálogo de materias primas y registro etnográfico de México, Centro América, Andes Centrales y Selva Amazónica* (Madrid: Ministerio de Cultura, Instituto del Patrimonio Histórico Español, 2006), 94. Castelló (*Colorantes naturales*, 68) cites *tesuate* from Hueyapan as *Conostegia xalapensis*. Francisco Hernández, the court physician sent to Mexico by Philip II in 1571, wrote that *tezhuatl* "prepared and perfected" cochineal dye.

23. *Conostegia xalapensis* has been shown recently to be especially efficient at accumulating aluminum and can in fact be considered an indicator species for soils with potential aluminum toxicity; I. H. González Santana et al.,"*Conostegia xalapensis* (Melastomataceae): An Aluminum Accumulator Plant," *Physiologia Plantarum* 144, no. 2 (2012): 134–45.

24. The fruits of other species of *Cylindropuntia* and other wild cacti may have been used as well. Before the introduction of limes from Eurasia, these might have been the ingredients that lowered the pH of cochineal dye baths, which master weaver Don Isaac Vásquez has sought out unsuccessfully in Teotitlán (Ross, "Bug in the Rug," 71).

25. Also mentioned were *tatacazcal* (*Cuscuta* sp.), *yerbanís* (*Tagetes lucida*), *flor de gualdria*, and *flor de San Pedro*. Rather than serving as a mordant, some of these may have modified the hue of the colorant on the wool.

26. Jerzy Rzedowski, "Diversidad y orígenes de la flora fanerogámica de México," in *Diversidad biológica de México, orígenes y distribución*, ed. T. P. Ramamoorthy et al. (Mexico City: Instituto de Biología, UNAM, 1998), 129–45; A. de Ávila B., "Las técnicas textiles y la historia cultural de los pueblos otopames," *Estudios de Cultura Otopame* 8 (2012): 133–36. Mesoamerican foods, remedies, and ritual materials show the same strong bias, favoring Neotropical, pantropical, and endemic plants and animals.

27. Pamela Munro and Felipe López gloss *byuug* and *byuhuhg* as a "type of special *corte* (traditional wraparound skirt) formerly worn for weddings." *Zu'uu'dy* seems to relate to *zuu deh*, "to wear clothing in a particular style"; Pamela Munro and Felipe H. López, *Di'csyonaary X:tèe'n Dìi'zh Sah Sann Lu'uc/San Lucas Quiaviní Zapotec Dictionary* (Los Angeles: UCLA Chicano Studies Research Center, 1999), 77, 375.

28. Stubblefield and Miller (*Diccionario*, 38) translate *ladbej* as *manta colorada* (*tinte de cochinilla*).

29. Johnson, "Old-style," 245. Stubblefield and Miller (*Diccionario*, 12, 44, 121) record *nagasbooni* as *estar muy negro*, *bisiujg* as *gusano de mosca*, *bisie'* as *semilla de cacao*, and *xob* as maize.

30. Johnson, "Old-style," 239, 243.

31. Mary Elizabeth King, "Preceramic Cordage and Basketry," in *Guilá Naquitz: Archaic Foraging and Early Agriculture in Oaxaca, Mexico*, ed. Kent V. Flannery (New York: Academic Press, 1986), 157–59.

32. Urbano Alonso, *Arte breve de la lengua otomí y vocabulario trilingüe español-náhuatl-otomí*, circa 1605, ed. René Acuña (Mexico City: Instituto de Investigaciones Filológicas, UNAM, 1990).

33. L. Fermín Tapia García, *Tzon 'tzíkindyi jñò ndá Tzjón Noà yo jñò tzko/diccionario amuzgo-español, el amuzgo de San Pedro Amuzgos, Oaxaca* (Mexico City: CIESAS and Plaza y Valdés Editores, 1999), 72; Barbara Hollenbach, "Apéndices para el vocabulario triqui-español, triqui de San Juan Copala," unpublished manuscript, 2001, 36. The numerical superscripts indicate the tonal pattern; all Otomanguean languages possess phonemic tone. I thank Hollenbach for sharing the unpublished manuscript with me.

34. Anne Dyk and Betty Stoudt, *Vocabulario mixteco de San Miguel el Grande* (Mexico City: Instituto Lingüístico de Verano, 1973), 28 (San Miguel el Grande Mixtec); Richard E. Anderson and Hilario Concepción Roque, *Diccionario cuicateco* (Mexico City: Instituto Lingüístico de Verano, 1983), 99 (Santa María Pápalo Cuicatec). Both syllables in the Mixtec *ndukun* carry the midtone, which is not marked; the final *-n* indicates that the preceding vowel is nasalized.

35. Irmgard Weitlaner Johnson, "Huautla de Jiménez," unpublished field notes, Biblioteca de Investigación Juan de Córdova, Oaxaca, circa 1960; Shun Nakamoto, unpublished field notes on the Popoloca language of San Luis Temalacayuca, Puebla, 2014.

36. Munro and López, *Di'csyonaary*, 60; Stubblefield and Miller, *Diccionario*, 144; Thomas Smith Stark, "Terminología etnobiológica del zapoteco de San Baltasar Chichicapan," preliminary manuscript, El Colegio de México, Mexico City, 2001; Eugene S. Hunn, *A Zapotec Natural History*, part 2 (Tucson: University of Arizona Press, 2008).

37. Searle Hoogshagen and Hilda Halloran, *Diccionario mixe de Coatlán, Oaxaca* (Mexico City: Instituto Lingüístico de Verano, 1997), 441; Paul Turner and Shirley Turner, *Chontal to Spanish-English Dictionary* (Tucson: University of Arizona Press, 1971), 151; Robert M. Laughlin, *The Great Tzotzil Dictionary of Santo Domingo Zinacantán* (Washington, DC: Smithsonian Institution, 1988), 374; "Biodiversidad mexicana: Yucatán," CONABIO, 2013, http://www.biodiversidad.gob.mx/region/EEB/yucatan.html; Maturino Gilberti, *Vocabulario en lengua de Mechuacan*, 1559 (Zamora: El Colegio de Michoacán, 1997), 442. The Tarascan term sounds more like a descriptive phrase than a proper name.

38. Terence Kaufman, "Language History and Language Contact in Pre-Classic Meso-America, with Especial Focus on the Languages of Teotihuacán," paper presented at the III Coloquio Internacional de Lingüística Mauricio Swadesh, Mexico City, 2001.

39. T. Kaufman and John Justeson, "The History of the Word for Cacao in Ancient Mesoamerica," *Ancient Mesoamerica* 18 (2007): 193–237.

40. A. de Ávila B., "Mixtec Plant Nomenclature and Classification" (doctoral dissertation in anthropology, University of California–Berkeley, 2010), 210–19. The Mixtec *ti-* classifier (an abbreviation of the term *kiti*, or "animal") is analogous to the Amuzgo *kí5-* (shortened from *kió'5*, also meaning "animal"), which is evident in the name for cochineal, *kí5ndio'35*. In the Mazatec designation, *čó'* appears to be an animal classifier as well.

41. Phipps, "Cochineal Red," 17; Laurie Adelson and Arthur Tracht, *Aymara Weavings: Ceremonial Textiles of Colonial and Nineteenth-Century Bolivia* (Washington, DC: Smithson-

ian Institution, 1983), 45. Campbell considers Quechuan and Aymaran to be distinct families, although there may be a distant genetic relationship between them; Lyle Campbell, *American Indian Languages: The Historical Linguistics of Native America* (Oxford: Oxford University Press, 1997), 188.

42. Terence Kaufman, "Early Oto-Manguean Homelands and Cultures: Some Premature Hypotheses," *University of Pittsburgh Working Papers in Linguistics* 1 (1990): 91–136.

43. Mary Elizabeth King, "The Prehistoric Textile Industry of Mesoamerica," in *The Junius B. Bird Pre-Columbian Textile Conference,* ed. Anne P. Rowe, Elizabeth P. Benson, and Anne-Louise Schaffer (Washington, DC: Textile Museum and Dumbarton Oaks, 1979), 265–81.

44. Enrique Pérez et al., "*Genipa americana* L. (Rubiaceae): A Tropical Plant with Sandfly Repelling Properties," *Revista Peruana de Entomología* 45 (2006): 111–13; "Minimum Conflict: Guidelines for Planning the Use of American Humid Tropic Environments," Organization of American States, 1987, http://www.oas.org/dsd/publications/Unit/oea37e/ch10.htm#medicinal plants; Sid Perkins, "Mosquitoes, Be Gone!" *Science News for Students,* May 28, 2014, https://student.societyforscience.org/article/mosquitoes-be-gone; John Buckingham, ed., *Dictionary of Natural Products* (London: Chapman and Hall, 1994), 2519; S. M. Bakhtiar Ul Islam et al., "Antimicrobial, Antioxidant, and Cytotoxic Activities of *Bixa orellana* Linn.," *Latin American Journal of Pharmacy* 30, no. 6 (2011): 1126–34.

45. Thomas Eisner et al., "Red Cochineal Dye (Carminic Acid): Its Role in Nature," *Science* 208 (1980): 1039–42; T. Eisner et al., "Defensive Use of an Acquired Substance (Carminic Acid) by Predaceous Insect Larvae," *Experientia* 50 (1994): 610–15; Murray S. Blum and Monika Hilker, "Chemical Protection of Insect Eggs," in *Chemoecology of Insect Eggs and Egg Deposition,* ed. Monika Hilker and Torsten Meiners (Berlin: Blackwell Publishing, 2002), 61–90.

46. Ana Lilia Vigueras Guzmán and Liberato Portillo Martínez, "Factores

limitantes en el cultivo de la grana cochinilla: Usos del pigmento de la grana cochinilla," in *Cría de la grana cochinilla del nopal para la producción de su pigmento,* ed. Celina Llanderal Cázares and Ramón Nieto Hernández (Montecillo: Instituto de Fitosanidad, Colegio de Postgraduados, 1999), 98; J. Gálvez et al., "New Cytostatic Agents Obtained by Molecular Topology," *Bioorganic and Medicinal Chemistry Letters* 6 (1996): 2301–2306. However, F. Pankewitz et al. found that carminic acid does not prevent *Dactylopius* from becoming infected with endosymbiotic *Wolbachia* bacteria; F. Pankewitz et al., "Presence of *Wolbachia* in Insect Eggs Containing Antimicrobially Active Anthraquinones," *Microbial Ecology* 54, no. 4 (2007): 713–21.

47. Ajoy K. Sarkar, "An Evaluation of UV Protection Imparted by Cotton Fabrics Dyed with Natural Colorants," *BMC Dermatology* 4 (2004): 15.

48. Bruce D. Smith, "The Initial Domestication of *Cucurbita pepo* in the Americas 10,000 Years Ago," *Science* 276 (1997): 932–34; Dolores R. Piperno and Kent V. Flannery, "The Earliest Archaeological Maize (*Zea mays* L.) from Highland Mexico: New Accelerator Mass Spectrometry Dates and Their Implications," *Proceedings of the National Academy of Sciences* 98, no. 4 (2001): 2101–103.

49. Lyle Campbell, *American Indian Languages: The Historical Linguistics of Native America* (Oxford: Oxford University Press, 1997), 156–69. Although glottochronological estimates are questioned by many linguists, they have provided rough signposts to correlate the internal branching of the Mesoamerican language families with archaeologically dated cultural innovations.

50. Alex Van Dam, "Species Delimitation of the Cochineal Insects (*Dactylopius*) Using Molecular Phylogenetics and Morphology" (doctoral dissertation in entomology, University of California–Davis, 2013), 49.

51. Kaufman, "Language History."

52. Thomas MacDougall, "Cochineal M.S.," unpublished manuscript, 1972, 25. At the end of the first sec-

tion, the free gloss for the Chontal word-for-word translation adds "the blood of a dog," which must have been sacrificed. The repeated mention of "its bird" may refer to a chicken or turkey, also offered in the ceremony. I thank Danny Zborover and John Monaghan for sharing a copy of this gory yet graceful manuscript with me.

53. Alejandro de Ávila B., "El insecto humanizado: Biología y mexicanidad en los textos de Alzate y sus contemporáneos acerca de la grana," in *La grana y el nopal en los textos de Alzate,* ed. Carlos Sánchez Silva and Alejandro de Ávila B. (Mexico City: Consejo Nacional para la Cultura y las Artes, 2005), 43.

54. Ibid. V. Flores and A. Tekelenburg report a single predator in Peru and Bolivia, a dipteran; V. Flores Flores and A. Tekelenburg, "Dacti (*Dactylopius coccus* Costa) Dye Production," in *Agro-ecology, Cultivation and Uses of Cactus Pear,* ed. Giuseppe Barbiera, Paolo Inglese, and Eulogio Pimienta Barrios (Rome: Food and Agriculture Organization, 1995), 179; Vigueras and Portillo ("Factores limitantes," 83), in contrast, record eight harmful species in Mexico belonging to four different insect orders.

55. MacDougall, "Cochineal," 22–23.

56. Heinrich Berlin, "Las antiguas creencias en San Miguel Sola, Oaxaca, México," in *Idolatría y superstición entre los indios de Oaxaca* (Mexico City: Ediciones Toledo, 1988), 61–62, 111.

57. Ángel María Garibay Kintana, "Códice Carolino," *Estudios de Cultura Náhuatl* 7 (1967): 11–58, 39.

58. Armando Alcántara Berumen, "Entre trama y urdimbre; simbolismo mítico y ritual en San Andrés Tzicuilan, Puebla" (bachelor's thesis in ethnohistory, Escuela Nacional de Antropología e Historia, 1998), 122–23, quoted in Lourdes Báez Cubero, "Tejiendo cosmologías: la indumentaria de los nahuas de la Sierra Norte de Puebla," in *El arte popular mexicano, memoria del coloquio nacional,* ed. Arturo Gómez Martínez (Xalapa: Gobierno del Estado de Veracruz, 2006), 43. The bird that soils a weaver's warp is a widespread theme in Mesoamerican mythology and is represented in pre-Hispanic terracotta sculptures.

59. A. de Ávila B., *"Kutiere, titia'a."* Again we see a parallel with *Bixa* in the Amazon basin: among Tucanoan peoples of southeastern Colombia, annatto is the menstrual blood of Romi Kumu, Shaman Woman. Men rub their bodies with it to imitate women's menses and to appropriate female power thereby; Christine Hugh-Jones, *From the Milk River: Spatial and Temporal Processes in Northwest Amazonia* (Cambridge: Cambridge University Press, 1979), 107.

60. Báez, "Tejiendo cosmologías," 51. *Tencahuipil* is the local name for an old-style *quechquémitl* decorated with a band of red wool woven in a curved manner.

61. Donald B. Cordry and Dorothy M. Cordry, *Mexican Indian Costumes* (Austin: University of Texas Press, 1968), 255 and plate X. *Huipiles* collected before 1940 by Irmgard Weitlaner Johnson in Usila, preserved at the Rijksmuseum voor Volkenkunde in Leiden, show no fuchsine paint.

62. In addition to the highland Mazatec skirts, I am familiar with the following examples of intentional bleeding of synthetic reds and purples, which appear to have developed independently: (a) area of Huautla, Hidalgo (Náhuatl speakers)—embroidered skirts and *quechquémitls;* (b) Huehuetla, Hidalgo (Tepehua people)—brocaded *quechquémitls* (Cordry and Cordry, *Mexican Indian Costumes,* 96–99); (c) Mazahua people, municipalities of Villa de Allende and Donato Guerra, state of Mexico—embroidered underskirts and bags, warp-brocaded sashes and ribbons; (d) Santa María Peñoles, Oaxaca (Mixtec people)—woven bags (Cordry and Cordry, *Mexican Indian Costumes,* 289); Santiago Ixtayutla, Oaxaca (Mixtec people)—brocaded *huipiles,* men's shirts, and trousers (Cordry and Cordry, *Mexican Indian Costumes,* 133). Early museum specimens from two of these areas indicate that the purposeful bleeding of the fugitive dyes is a recent development. One of these specimens, a Tepehua *quechquémitl* acquired by Zelia Nuttall around 1900 (Phoebe Hearst Museum of Anthropology, University of California–Berkeley, catalog number 3-558), appears to show

natural dyes (including probably cochineal) and no running of the colors whatsoever. The other specimens, Mazahua embroideries at the MTO and other collections that date to the nineteenth century, display only stable reds and magentas, along with other fast colors.

63. Wallert, "Analysis of Dyestuffs," 76.

64. Museo Nacional de Antropología, Mexico City, catalog number 24253(59)6.37al-40. Irmgard Weitlaner Johnson, who curated the textile collection of the MNA in the 1950s and 1960s, told me in 1985 that the original accession card for this piece did not record its provenance or ethnic group. Lorena Román, who cleaned and restored this *huipil* at Escuela Nacional de Conservación, Restauración y Museografía, confirmed that cochineal was used to dye the silk weft and to paint the cotton warp in the top section of the central web; Lorena Román Torres, personal communication, November 14, 2014.

65. Van Dam, "Species Delimitation," 39–44.

CHAPTER 16 (CARDON)

1. Dominique Cardon, *Mémoires de teinture: Voyage dans le temps chez un maître des couleurs* (Paris: CNRS Editions, 2013), with color plates illustrated with samples.

2. Jacques Savary, *Le Parfait négociant* (Geneva: Droz, 2011), 1074, 1120. All translations from French to English in this paper are done by the author.

3. Cardon, *Mémoires*, 90.

4. Dominique Cardon, *Natural Dyes: Sources, Tradition, Technology, and Science* (London: Archetype Publications, 2007), 47–48.

5. Well defined by Philippe Minard, "Réputation, normes et qualité dans l'industrie textile française au XVIIIè siècle," in *La Qualité des produits en France (XVIIIè–XXè siècles)*, ed. A. Stanziani (Paris: Belin, 2003), 69–89.

6. William Partridge, *A Practical Treatise on dying of woollen, cotton and skein silk, with the Manufacture of broadcloth and cassimere including the most improved methods in the West of England* (Edington, UK: Pasold Research Fund, 1973), 184; Cardon, *Mémoires*, 354, table 8.

7. Document C 5569, 1734, Archives départementales de l'Hérault, Montpellier, France; Cardon, *Mémoires*, 250.

8. After weaving, the pieces were cut into two halves that were dyed and finished separately, which made dyeing and finishing operations comparatively easier for workers (but the half pieces still weighed between 10 and 12.5 kilograms dry) and allowed for a wider selection of colors in one bale; Cardon, *Mémoires*, 219–20, 247.

9. Document C 5552, 1751–1753, Archives départementales de l'Hérault, Montpellier, France.

10. Document C 2230, 1758, Archives départementales de l'Hérault, Montpellier, France; Cardon, *Mémoires*, 222–23.

11. Cardon, *Mémoires*, 358, table 12.

12. Ibid., 356, table 10.

13. Jean Hellot, *L'Art de la teinture des laines et des etoffes de laine en grand et petit teint* (Paris: Vve Pissot, 1750), 320.

14. Document 3J 342, 1751, Archives départementales de l'Aude, Carcassonne, France; Cardon, *Mémoires*, 253–54.

CAPTIONS

a. Sidney M. Edelstein, "How Napoleon Aided the Early Dyeing Industry of France," *Historical Notes on the Wet-Processing Industry*, revised ed. (New York: Dexter Chemical Corporation, 1972), 17–18.

CHAPTER 17 (VÁZQUEZ/SECO)

1. Pedro Manuel Berges Soriano, "Museo del Pueblo Español," *Anales del Museo Nacional de Antropología* 3 (1996): 65–88. The show, sponsored by the duchess of Parcent, was organized by a large group of intellectuals, political figures, and artists. On display were some three hundred complete outfits, almost four thousand individual items, more than six hundred photographs, and hundreds of watercolors. In the inaugural address, the count of Romanones presented the idea of turning the show into a permanent museum of costume. In 1930 the museum was established in the Godoy Palace on the Plaza de la Marina Española. Four years later it became part of the Museum of the Spanish People, an ethnological museum conceived with a broader vision. Under the leadership of Luis de Hoyos, items were acquired from all regions of Spain. But because of the Spanish Civil War, the Museum of the Spanish People was not able to open. Except for a couple of brief periods, the collections were packed up and stored until 2004, when the Museo del Traje finally opened.

2. *Exhibition of Regional Dress. Guide.* 2nd ed. (Madrid: Artes de la Ilustración, 1925), 62–63: "The first display case on the left, seen from the back of the hall, contains the collection of Mrs. Guiú, also of Barcelona, the majority of it is on display in spite of the lack of space with which we struggled trying to install the largest possible number of items. This collection is of great importance and besides the pieces shown, being mainly the dress of ladies and gentlemen of the 18th and 19th centuries, it contains a series of small objects that complement the rich wardrobe of the nobility of that time." The complete catalog of the exhibition promised in this brief guide was never published; we have only the information gathered in this small book with no illustrations.

3. Thanks to curator Silvia Ventosa, we know that the Museu del Disseny de Barcelona has a total of twenty-one fabrics, almost all of silk and dating from the fourteenth to the nineteenth centuries, acquired from Don Francisco Guiú in 1910.

4. The original linen lining was partially restored at some point in the nineteenth century using a cotton taffeta with a design applied with a roller.

CHAPTER 18 (HEDLUND)

ACKNOWLEDGMENTS

My research has benefited greatly from years of studying and collaborating with many generous scholars, especially Joe Ben Wheat and Kate Peck Kent. Thanks to the late Max Saltzman, David Wenger, and Kathryn Duffy for identifying dyes in those textiles illustrated and mentioned here and in many, many others included in our research. I'm grateful for botanical advice and scientific editing from ethnobotanist Richard Felger. This chapter was also aided by valuable correspondence and conversations with Carmella Padilla, Barbara Anderson, Josie Caruso, Robin Farwell Gavin, Glenna Dean, Cordelia Thomas Snow, Dana Bates, and Hosanna Eilert.

1. Joe Ben Wheat, *Blanket Weaving in the Southwest* (Tucson: University of Arizona Press, 2003), 131, 135; Joe Ben Wheat, "Documentary Basis for Material Changes and Design Styles in Navajo Blanket Weaving," in *Ethnographic Textiles of the Western Hemisphere, Proceedings of the Irene Emery Roundtable on Museum Textiles*, ed. Irene Emery and Patricia Fiske (Washington, DC: Textile Museum, 1977), 420–40.

2. Wheat, *Blanket Weaving*, 131, 135; Wheat, "Documentary Basis," 427.

3. Carmen Sáenz-Hernández, Joel Corrales-García, and Gildardo Aquino-Pérez, "Nopalitos, Mucilage, Fiber, and Cochineal," in *Cacti: Biology and Uses*, ed. Park S. Nobel (Berkeley: University of California Press, 2002), 211–34.

4. Ibid., 226–27.

5. Wade Sherbrooke, "Defense Behaviors of a Cactus Scale and a Predatory Caterpillar: The Role of Cochineal in Multiple Defense Systems," unpublished manuscript, 1982, cited with permission of the author.

6. Cordelia Thomas Snow and Glenna Dean, "Out on a Limb: Cochineal Production in Spanish Colonial New Mexico?" in *Threads, Tints, and Edification: Papers in Honor of Glenna Dean*, ed. Emily J. Brown, Karen Armstrong, David M. Brugge, and Carol J. Condi, Papers of the Archaeological Society of New Mexico, vol. 36 (Albuquerque: Archaeological Society of New Mexico, 2010), 160; Richard Felger, personal communication, 2014.

7. Cordelia Thomas Snow and Glenna Dean note one contemporary Hispanic New Mexican *santero*, or saint maker, known to have harvested wild cochineal in Santa Fe and used it in his paint; Snow and Dean, "Out on a Limb," 162.

8. See Kate Peck Kent, "Archaeological Clues to Early Historic Navajo and Pueblo Weaving," *Plateau* 39 (1966): 40–51, and Wheat, "Documentary Basis," 428, for their first assertions; see Kate Peck Kent, *Navajo Weaving: Three Centuries of Change* (Santa Fe, NM: School of American Research Press, 1985), 44, and Wheat, *Blanket Weaving*, 62, for their amendment.

The quotation is from Kent, *Navajo Weaving*, 44. In Casey Reed and Duane Anderson's article "Making Old Navajo Textiles Talk," *Tribal Art* 32 (2003), the authors assert that they identified Navajo-applied cochineal dye on native hand-spun wool, but their claim rests on whether the material tested was locally sourced hand-spun wool or recarded, respun fiber taken from red trade cloth. Analytical evidence suggests the latter to be more likely in all known cases.

9. Ward Alan Minge, "Efectos del País: A History of Weaving along the Río Grande," in *Spanish Textile Tradition of New Mexico and Colorado*, ed. Nora Fisher (Santa Fe, NM: Museum of International Folk Art, 1979), 8–28.

10. Dorothy Boyd Bowen and Trish Spillman, "Natural and Synthetic Dyes," in *Spanish Textile Tradition of New Mexico and Colorado*, ed. Nora Fisher (Santa Fe, NM: Museum of International Folk Art, 1979), 207–11.

11. Wheat, *Blanket Weaving*, 62, referencing the microfilm edition of the Mexican Archives of New Mexico, roll 6:463, State of New Mexico Records Center, Santa Fe.

12. Minge, "Efectos del País," 19, note 71; Joe Ben Wheat, "A Glossary of Spanish Trade Terms: Cloth and Related Items Compiled from Early Trade Documents and Other Sources," unpublished manuscript, 1995.

13. Josie Caruso, personal communication, 2014.

14. Cf. Wheat, *Blanket Weaving*, 62.

15. Washington Matthews, "Navajo Dye Stuffs," *Smithsonian Annual Report for 1891* (Washington, DC: U.S. Government Printing Office, 1893), 613–16; Charles Amsden, *Navaho Weaving: Its Technic and History* (Santa Ana, CA: Fine Arts Press, 1934), 93; Ulysses S. Hollister, *The Navajo and His Blanket* (Denver, 1903), 103; George H. Pepper, "Native Navajo Dyes," *Papoose* 1, no. 3 (1903): 3–12; H. P. Mera, *Navajo Textile Arts* (Santa Fe, NM: Laboratory of Anthropology, 1948), 10.

16. Nora Fisher, "Introductory Remarks," in *Spanish Textile Tradition*, 212–14; Bowen and Spillman, "Natural and Synthetic Dyes," 209.

17. Lowe Art Museum, 60.220.032. For illustration, see Fisher, "Introductory Remarks," plate 22. For analysis and illustration, see "Joe Ben Wheat Southwest Textile Database," Arizona State Museum, 2014, http://www.statemuseum.arizona.edu/coll/textile/jbw_southwest_textile_database.

18. Dorothy Boyd Bowen, "Saltillo Design Elements," in *Spanish Textile Tradition*, 97, figure 7.

19. David A. Wenger, "Appendix E: Dye Analysis," in *Blanket Weaving*, 359–69, figure E.3.

20. Edward Bancroft, *Experimental Researches Concerning the Philosophy of Permanent Colors* (Philadelphia, 1814), 2:13, cited in Rita Adrosko, *Natural Dyes and Home Dyeing* (New York: Dover, 1968), 28. In *Blanket Weaving*, page 62, Wheat notes that pure lac appears most often in fine, S-spun yarns raveled from worsted fabric and generally suggests a pre-1865 manufacture. Because of contrasting domains of the British Empire and the Spanish colonial world, one might wonder if lac-dyed fabrics were primarily of British origin and cochineal-dyed fabrics were more often Spanish-made, but this idea has not been confirmed in the extant literature and is open to further research. Harold Colton, "The Anatomy of the Female American Lac Insect, *Tachardiella Larrea*," *Museum of Northern Arizona Bulletin* 21 (1944).

21. "Joe Ben Wheat Southwest Textile Database"; numerical designations represent ID numbers of textiles described in the database.

22. Helmut Schweppe and Heinz Roosen-Runge, "Carmine: Cochineal Carmine and Kermes Carmine," in *Artists' Pigments: A Handbook of Their History and Characteristics*, ed. Robert L. Feller (Washington, DC: National Gallery of Art, 1986), 255–83, cited in Snow and Dean, "Out on a Limb," 161.

23. Ana Roquero, *Tintes y tintoreros de América: Catálogo de materias primas y registro etnográfico de México, Centro América, Andes Centrales y Selva Amazónica* (Madrid: Ministerio de Cultura, Instituto del Patrimonio Histórico Español, 2006), 137. See page 345 of Peter Boyd-Bowman, "Spanish and European Textiles in Sixteenth-Century Mexico," *Americas* 29, no. 3 (1973): 334–58.

24. Kathryn Duffy, "Chemical Characterization of New World Dyes and Pigments: Obtaining Chronological Information" (master's thesis, University of Arizona, 2006); K. Duffy and Ann Lane Hedlund, "Understanding Chronology in Historic Period Navajo Textiles: Red Dye Analysis," *SAS Bulletin* 30, no. 1 (2007): 20–23.

25. For eight textiles at the Art Institute of Chicago, see Federica Possi, Lauren K. Chang, and Francesca Casadio, *Surface-Enhanced Raman Spectroscopy (SERS) as a Viable Alternative Technique for Dye Analysis: Application to the Study of Navajo Blankets from the Art Institute of Chicago Collection* (Paris: International Council of Museums, forthcoming). For the Southwest Museum's textile collection, see Kathleen Whitaker, *Common Threads: Pueblo and Navajo Textiles in the Southwest Museum* (Los Angeles: Southwest Museum, 1998) and Kathleen Whitaker, *Southwest Textiles: Weavings of the Pueblo and Navajo* (Los Angeles: Southwest Museum, 2002). For selected specimens from the Textile Museum, see Ann Hedlund, "Wool Yarns in Late Classic Navajo Blankets," *American Indian Art Magazine* 28, no. 4 (2003): 78–85, 92.

26. Wheat, *Blanket Weaving*, 73, 85.

27. Jessica Hemming, "Appropriated Threads: The Unpicking and Reweaving of Imported Textiles," *Silk Roads, Other Roads: Textile Society of America Eighth Biennial Symposium* (Northampton, MA: Smith College, 2002) describes weavers from Indonesia, Nigeria, and New Zealand who "appropriate" yarns from previously woven cloths, highlighting the economic necessity and aesthetic "inclinations" that prompt these actions.

28. For background history and details of the research, see Wheat, *Blanket Weaving*. For a summary of these traits and their time ranges, see Ann Hedlund, *Beyond the Loom: Keys to Identifying Early Southwestern Weaving* (Boulder, CO: Johnson Books, 1997) and Hedlund, "Wool Yarns."

29. Hemmings, "Appropriated Threads."

30. Mera, *Navajo Textile Arts*, 69–74; Wheat, *Blanket Weaving*, 87; "Joe Ben Wheat Southwest Textile Database," textile ID 46, 822; Peabody Museum of Archaeology and Ethnology, 985-27-10/58892; "Joe Ben Wheat Southwest Textile Database," textile ID 1326.

CHAPTER 19 (BOL)

1. James A. Hanson, *Little Chief's Gatherings: The Smithsonian Institution's G. K. Warren 1855–1856 Plains Indian Collection and the New York State Library's 1855–1857 Warren Expeditions Journals* (Crawford, NE: Fur Press, 1996), 4–5, 15.

2. George Catlin, *Letters and Notes on the Manners, Customs, and Conditions of the North American Indians. Written during Eight Years' Travel (1837–1839) amongst the Wildest Tribes of Indians in North America* (New York: Dover Publications, 1973), 1:209.

3. Although broadcloth was produced in other areas of England, cloth from Stroud was noted for its beautiful colors.

4. Lists were also made in gray and black.

5. Don C. Clowser, *Dakota Indian Treaties: From Nomad to Reservation* (Deadwood, SD: Don C. Clowser, 1974), 121–22.

6. Blue stroud cloth, dyed with indigo, was more universally used by Plains Indians.

7. Ronald P. Koch, *Dress Clothing of the Plains Indians* (Norman: University of Oklahoma Press, 1977), 23–26.

8. Ella Cara Deloria, *Dakota Autobiographies* (Philadelphia: American Philosophical Society, circa 1937), 81.

9. James R. Walker, "The Sun Dance and Other Ceremonies of the Oglala Division of the Teton Dakota," *Anthropological Papers of the American Museum of Natural History* 16 (1917): 71.

CAPTIONS

a. Wetherill papers 1762–1899, CD 3479.P5H8, Library of Congress, Washington, D.C.

b. Elena Phipps, *Cochineal Red: The Art History of a Color* (New Haven, CT: Yale University Press, 2010), 36–37.

CHAPTER 20 (BROWN)

ACKNOWLEDGMENTS

I wish to thank the organizers of this exhibition, along with Donna Pierce and Julie Wilson at the Denver Art Museum and Jim Grebl at the San Diego Museum of Art, for their help on this project. Thanks are also in order to my research assistant, Ashley B. Marin.

1. Elena Phipps, *Cochineal Red: The Art History of a Color* (New York: Metropolitan Museum of Art, 2010), 26.

2. Saúl Martínez Bermejo, "Beyond Luxury: Sumptuary Legislation in Seventeenth-Century Castile," in *Making, Using and Resisting the Law in European History*, ed. Günther Lottes, Eero Medijainen, and Jón Viðar Sigurðsson (Pisa: Plus-Pisa University Press, 2008), 94.

3. See, for example, Daniel Mytens the Elder's *Charles I as Prince of Wales*, 1624 (National Gallery of Canada) or Anthony van Dyck's *Portrait of Charles I in Three Positions*, 1635–1636 (Royal Collection).

4. Pablo Pérez d'Ors and Michael Gallagher, "New Information on Velázquez's Portrait of Philip IV at Fraga in the Frick Collection, New York," *Burlington Magazine* 152, no. 1291 (October 2010): 652–59.

5. For a discussion of portraits as living substitutes, see Jennifer Fletcher, "El retrato renacentista: funciones, usos y exhibición," in *El retrato del Renacimiento*, ed. Miguel Falomir (Madrid: Museo Nacional del Prado), 74.

6. Michael Schreffler, *The Art of Allegiance* (University Park: Pennsylvania State University Press, 2006), 101.

7. José Álvarez Lopera, "Eugenia Martínez Vallejo, 'La Monstrua,' vestida," in *El retrato español en el Prado: del Greco a Goya* (Madrid: Museo Nacional del Prado, 2006), 114–15; Alfonso E. Pérez Sánchez, "Velázquez and the Baroque Portrait," in *The Spanish Portrait from El Greco to Picasso*, ed. Javier Portús Pérez (Madrid: Museo Nacional del Prado, 2004), 184.

8. Byron Ellsworth Hamann, "The Mirrors of Las Meninas: Cochineal, Silver, and Clay," *Art Bulletin* 92, no. 1–2 (March 2010): 18–19.

9. Carmen Ripolles, "Hospitality and Empire: Displaying the New World in Early Modern Madrid," presentation at the Sixteenth-Century Society Conference, San Juan, Puerto Rico, October 2013.

10. See Jonathan Brown, *In the Shadow of Velázquez* (New Haven, CT: Yale University Press, 2014), 108–109, in which the author convincingly redates *Las Meninas* to the artist's final year, meaning that Velázquez himself would have painted the cross as an integral part of the original composition.

11. The canvases hung in Kensington Palace until 1977, when Queen Elizabeth II brought them to Ottawa, where they were presented to the National Archives of Canada.

12. Jeremy Baskes, "Indians, Merchants and Markets: Trade and Repartamiento Production of Cochineal Dye in Colonial Oaxaca: 1750–1821," (PhD dissertation, University of Chicago, 1993), 262.

13. Carrie Rebora Barratt and Ellen G. Miles, *Gilbert Stuart* (New York: Metropolitan Museum of Art, 2004), 125–27. See also *Legacy: Spain and the United States in the Age of Independence, 1763–1848* (Washington, DC: Smithsonian Institution, 2007), 212–13.

14. For more on these portraits, see Michael A. Brown, "Portraits and Patrons in Colonial Latin America," in *Behind Closed Doors: Art in the Spanish American Home, 1492–1898*, ed. Richard Aste (New York: Brooklyn Museum, 2013), 136–39, 156–57.

15. See Michael A. Brown, "Image of an Empire: Portraiture in Spain and the Viceroyalties of New Spain and Peru," in *Painting of the Kingdoms: Shared Identities: Territories of the Spanish Monarchy Sixteenth–Eighteenth Centuries*, ed. Juana Gutiérrez Haces (Mexico City: Fomento Cultural Banamex, 2009), 1446–1503.

CHAPTER 21 (KIRBY)

1. Raymond L. Lee, "American Cochineal in European Commerce, 1526–1625," *Journal of Modern History* 23, no. 3 (1951): 206; Robin A. Donkin, "Spanish Red: An Ethnogeographical Study of Cochineal and the Opuntia Cactus," *Transactions of the American Philosophical Society,* n.s., 67, part 5 (September 1977): 23, 37; Eufemio L. Sanz, *Comercio de España con América en la época de Felipe II,* vol. 1: *Los mercaderes y el tráfico indiano* (Valladolid: Servicio de Publicaciones de la Diputación Provincial de Valladolid, 1979), 560.

2. Henri Gautier, *L'art de laver, ou nouvelle manierè de peindre sur le papier* (Lyon: Thomas Amaulry, 1687), 51.

3. Dominique Cardon, *Natural Dyes: Sources, Tradition, Technology, and Science* (London: Archetype Publications, 2007), 610–14.

4. Ibid., 637–50.

5. Ibid., 650.

6. An arroba was a unit of mass (and also capacity) used in Spain, Portugal, and South America, with its value varying from one country to another. The Spanish arroba was equivalent to approximately 11.5 kilograms.

7. Sanz, *Comercio de España*, 579–80; Carla Rahn Phillips, "The Growth and Composition of Trade in the Iberian Empires, 1450–1750," in *The Rise of Merchant Empires: Long-Distance Trade in the Early Modern World, 1350–1750*, ed. James D. Tracy (Cambridge: Cambridge University Press, 1993), 76–81.

8. Sanz, *Comercio de España*, 562–63, 566–68, 582–88.

9. Lodovico Guicciardini, *Descrittione di M. Lodovico Guicciardini patritio fiorentino, di tutti i paesi bassi, altrimenti detti Germania inferiore* (Antwerp: Guglielmo Silvio, 1567), 119–23.

10. Luca Molà, *The Silk Industry of Renaissance Venice* (Baltimore: Johns Hopkins University Press, 2000), 120–37; Lisa Monnas, *Renaissance Velvets* (London: V&A Publishing, 2012).

11. Pietro Andrea Mattioli, *Il Dioscoride dell'Eccellente Dottor Medico M. P. Andrea Matthioli da Siena, coi suoi discorsi, da esso la seconda volta illustrati et diligentemente ampliati* (Venice: Vincenzo Valgrisi, 1548), 535.

12. Jo Kirby, Marika Spring, and Catherine Higgitt, "The Technology of Red Lake Pigment Manufacture: Study of the Dyestuff Substrate," *National Gallery Technical Bulletin* 26 (2005): 74–78.

13. Jo Kirby, "Some Aspects of Medieval and Renaissance Lake Pigment Technology," *Dyes in History and Archaeology* 21 (2008): 100.

14. Guicciardini, *Descrittione*, 119; Louisa Matthew and Barbara Berrie, "'Memoria de colori che bisognino torre a vinetia': Venice as a Centre for the Purchase of Painters' Colours," in *Trade in Artists' Materials: Markets and Commerce in Europe to 1700*, ed. Jo Kirby, Susie Nash, and Joanna Cannon (London: Archetype Publications, 2010), 244–52.

15. NG3098, The National Gallery, London.

16. Jo Kirby, "The Price of Quality: Factors Influencing the Cost of Pigments during the Renaissance," in *Revaluing Renaissance Art*, ed. Gabriele Neher and Rupert Shepherd (Aldershot, UK: Ashgate, 2000), 35–36; Susanne Kubersky-Piredda, "The Market for Painters' Materials in Renaissance Florence," in Kirby, Nash, and Cannon, *Trade in Artists' Materials*, 235; Richard E. Spear, "A Century of Pigment Prices: Seventeenth-Century Italy," in Kirby, Nash, and Cannon, *Trade in Artists' Materials*, 281.

17. NG4452, The National Gallery, London.

18. Jill Dunkerton et al., "Titian's Painting Technique before 1540," *National Gallery Technical Bulletin* 34 (2013): 29.

19. Hugh MacAndrew et al., "Tintoretto's 'Deposition of Christ' in The National Gallery of Scotland," *Burlington Magazine* 127 (1985): 507; Joyce Plesters and Lorenzo Lazzarini, "I materiali e la tecnica pittorica dei Tintoretto della Scuola di S.Rocco," in *Jacopo Tintoretto nel quarto centenario della morte: Atti del convegno internazionale di studi (Venezia, 24–26 novembre 1994)*, ed. Paola Rossi and Lionello Puppi (Padua: Il Poligrafo, 1996), 277.

20. Jan Wouters and André Verhecken, "The Coccid Insect Dyes: HPLC and Computerised Diode-Array Analysis of Dyed Yarns," *Studies in Conservation* 34 (1989): 189–200.

21. NG1047, The National Gallery, London.

22. NG1318, The National Gallery, London.

23. NG5751, The National Gallery, London.

24. NG816, The National Gallery, London.

25. Molà, *Silk Industry,* 129–30.

26. Johann C. Leuchs, *Traité complet*

des propriétés, de la préparation et de l'emploi des matières tinctoriales, et des couleurs, traduit de l'allemand (Paris: De Malher, 1829), 2:137.

27. See, for example, Gautier, L'art de laver, 51; Leuchs, Traité complet des proprieties, 2:137–39.

28. Zahira Véliz, ed., Artists' Techniques in Golden Age Spain: Six Treatises in Translation (Cambridge: Cambridge University Press, 1987), 154.

29. Pierre Pomet, Histoire générale des drogues, traitant des plantes, des animaux et des mineraux (Paris: Loyson and Pillon, 1694), 34.

30. Véliz, Artists' Techniques, 154.

31. NG4454, The National Gallery, London.

32. Jo Kirby, Marika Spring, and Catherine Higgitt, "The Technology of Eighteenth- and Nineteenth-Century Red Lake Pigments," National Gallery Technical Bulletin 28, no. 1 (2007): 75–6.

33. David Saunders and Jo Kirby, "Light-Induced Colour Changes in Red and Yellow Lake Pigments," National Gallery Technical Bulletin 15 (1994): 88.

34. NG111, The National Gallery, London.

35. Kirby et al., "Technology of Eighteenth- and Nineteenth-Century Red Lake Pigments," 75.

36. Kate Stonor and Rachel Morrison, "Adolphe Monticelli: The Materials and Techniques of an Unfashionable Artist," National Gallery Technical Bulletin 33 (2012): 63.

37. Kirby et al., "Technology of Eighteenth- and Nineteenth-Century Red Lake Pigments," 75–76.

38. Jo Kirby et al., "Seurat's Painting Practice: Theory, Development and Technology," National Gallery Technical Bulletin 24 (2003): 27.

39. NG3286, The National Gallery, London.

40. Kirby et al., "Technology of Eighteenth- and Nineteenth-Century Red Lake Pigments," 79–80.

CAPTIONS

a. Hugh McAndrew, Deborah Howard, John Dick, and Joyce Plesters, "Tintoretto's 'Deposition of Christ' in the National Gallery of Scotland," Burlington Magazine 127 (August 1985): 501–17, 512.

b. Ulrich Birkmaier, Arie Wallert, and Andrea Rothe, "A Note on Early

Italian Oil Painting Technique," in Historical Painting Techniques, Materials, and Studio Practice, ed. Arie Wallert, Erma Hermens, and Marja Peek (Los Angeles: Getty Conservation Institute, 1995), 117–126, 123.

c. Ibid., 63.

d. Ashok Roy, "The National Gallery's Van Dycks: Technique and Development," National Gallery Technical Bulletin 20 (1999): 50–83. Roy's colleague Jo Kirby adds, "It has never been possible to perform HPLC analysis to confirm the initial identification of the lake in the Balbi Children via microspectrophotometry in the visible region; no sample is available for this purpose. However, the pigment has the characteristics observed by the same technique in Charity [another van Dyck tested in the National Gallery], which is known to contain cochineal dyestuff, and on this basis, cochineal is the most likely candidate."

e. Karin Groen, "Investigation of the Use of the Binding Medium by Rembrandt: Chemical Analysis and Rheology," Zeitschrift für Kunsttechnologie und Konservierung: mit den Mitteilungen des Deutschen Restauratorenverbandes 11, no. 2 (1997): 207–27, 220.

f. Elena Phipps, Cochineal Red: The Art History of a Color (New Haven, CT: Yale University Press, 2010), 35.

g. Kenneth Chang, "How This Renoir Used to Look," New York Times, April 22, 2014, D2.

CHAPTER 22 (BRUQUETAS/GÓMEZ)

ACKNOWLEDGMENTS
Estrella Sanz Rodríguez carried out most of the analysis by LC-DAD-QTOF. Susanna Marras did the analysis of The Emperor Domitian. Pedro Pablo Pérez identified other pigments by means of SEM-EDX. Tomás Antelo supplied the photographs of El Greco's Apostles series.

1. Anastasio Rojo Vega, El Siglo de oro: inventario de una época (Valladolid: Junta de Castilla y León, 1996), 120, 145.

2. CSR leg. 247, folios 47, 48, Archivo General de Simancas, Simancas, Spain.

3. Estéban García Chico, Documentos para la historia del arte en Castilla (Valladolid: Universidad de Valladolid, 1946), 2:38–39.

4. Rocío Bruquetas, Técnicas y materiales de la pintura española en los siglos de oro (Madrid: Fundación de Apoyo a la Historia del Arte Hispánico, 2012), 492.

5. Julián Zarco Cuevas, Pintores españoles en San Lorenzo el Real de El Escorial (1566–1613) (Madrid: Instituto Valencia de Don Juan, 1931), 253, 257.

6. Matteo Mancini, "Il colori della bottega. Sui commerci di Tiziano e Orzio Vecellio con la corte di Spagna," Venecia Cinquecento. Studi di Storia dell'arte e della cultura 11 (1996): 163–79.

7. Lina Malo Lara and Antonio J. Santos Márquez, "Jerónimo Sánchez Coello: Un discípulo de Tiziano en Sevilla," Archivo Español de Arte 345 (2014): 18, 20.

8. García Chico, Documentos, 47–49.

9. Ibid., 210–12.

10. Carmen Rueda Boluda, "Los documentos," in El retablo y la sarga de San Eutropio de El Espinar (Madrid: Ministerio de Cultura, 1991), 202.

11. Juan J. Martí y Monsó, Estudios artístico-históricos relativos principalmente a Valladolid, basados en la investigación de diversos archivos (Valladolid-Madrid: Imprenta de Leonardo Miñón, 1898–1901), 614.

12. Francisco Pacheco, Arte de la pintura, su antigüedad y grandezas, 1649 (Madrid: Instituto Valencia de Don Juan, 1956), 2:83.

13. Cristóbal Pérez Pastor, Noticias y documentos relativos a la historia y literatura españolas. Collección de documentos inéditos para la historia de las bellas artes en España 11 (Madrid: Real Academia Española, 1914), 172.

14. Vicente Carducho, Diálogos de la pintura: su defensa, origen, esencia, definición, modos y diferencias. . ., 1633 (Madrid: Turner, 1979), 381.

15. "Tractado del Arte de la Pintura, nuevamente corregido con la comunión del famoso y muy diestro Mateo Núñez de Saavedra, pintor y dorador de las Reales Armadas de España, mi maestro," manuscript 5917, Biblioteca Nacional de Madrid; Merced V. Sanz, "Un tratado de pintura anónimo del siglo XVII," Revista de Ideas Estéticas 143 (1978): 252.

16 Rocío Bruquetas, "Reglas para pintar: Un manuscripto anónimo del siglo XVI," Boletín del Instituto

Andaluz del Patrimonio Histórico 24 (1998): 33–44.

17. Made, according to the Parisian druggist Pierre Pomet (1658–1699), with dried bones colored with Mexican cochineal, brazilwood from Pernambuco, English alum, arsenic, and natron lye from Egypt or with sodium oxide; Pierre Pomet, Histoire générale des drogues, traitant des plantes, des animaux et des mineraux (Paris: Loyson and Pillon, 1694), 34, 119.

18. Antonio Palomino de Castro y Velasco, El Museo pictórico y la escala óptica, 1715–1724 (Madrid: Aguilar, 1988), 136, 524.

19. Ibid., 260.

20. CSR leg. 247, folios 47, 48. Archivo General de Simancas, Simancas, Spain.

21. Carmelo Viñas, "Cuadro económico-social de la España de 1627–28, Pragmáticas sobre tasas de mercaderías y mantenimientos, jornales y salarios," Anuario de Historia Económica y Social 1 (1968), 715–72; Carmelo Viñas, "Cuadro económico-social de la España de 1627–28, Pragmáticas sobre tasas de mercaderías y mantenimientos, jornales y salarios," Anuario de Historia Económica y Social 2 (1968): 705–31.

22. Real Cédula en que Su Magestad mande se conserve y guarde la moderación de alquileres de casa y precios de todos los géneros comerciables . . . que se han de vender en esta corte (Madrid: Julián de Paredes, 1680).

23. Pacheco, Arte de la Pintura, 2:83.

24. Study done by Estrella Sanz Rodríguez for this project. The analysis was done with liquid chromatography coupled with a diode array detector and a mass spectrometer with a quadruple-time-of-flight analyzer (LC-DAD-QTOF).

25. Juan J. Martí y Monsó, Estudios artístico-históricos, 614.

26. Pacheco, Arte de la Pintura, 47.

27. Alfonso E. Pérez Sánchez, El Greco: Apostolados (A Coruña: Fundación Barrié de la Maza, 2002), 91.

28. Jo Kirby, Marika Spring, and Catherine Higgitt, "The Technology of Red Lake Pigment Manufacture: Study of the Dyestuff Substrate," National Gallery Technical Bulletin 26 (2005), 71, D7.

29. María Dolores Gayo, "Materiales y apuntes sobre la técnica de ejecución

utilizados por Francisco de Zurbarán en la serie de pinturas de la Cartuja de Jérez," in *Zurbarán: estudio y conservación de los monjes de la Cartuja de Jérez* (Madrid: Ministerio de Educación y Cultura, 1998), 123.

30. Ignacio Cano, *Zurbarán (1598–1664)* (Ferrara, Italy: Fondazione Ferrara Arte, 2013), 206.

31. Rocío Bruquetas and Marisa Gómez, "El retablo mayor de las Mercedarias de Don Juan de Alarcón. II Características técnicas y conservación," *Bienes Culturales: Revista del Instituto del Patrimonio Histórico Español* 2 (2003): 101–11.

CHAPTER 23 (NARUTA-MOYA)

1. Jo Kirby and Raymond White, "The Identification of Red Lake Pigment Dyestuffs and a Discussion of Their Use," *National Gallery Technical Bulletin* 17 (1996): 56–80.

2. Ibid.; R. A. Donkin, "The Insect Dyes of Western and West-Central Asia," *Anthropos* 72, no. 5/6 (1977): 847–80, especially page 853; "Insect Dyes," Antique Rugs of the Future Project, n.d., http://www.azerbaijanrugs.com/arfp-natural_dyes_insect_dyes.htm; Elena Phipps, *Cochineal Red: The Art History of a Color* (New York: Metropolitan Museum of Art, 2010), 9, 11.

3. "Insect Dyes," Antique Rugs of the Future Project.

4. After being harvested, dried, and ground, the insects were dissolved in sourdough or kvass, a fermented drink made from rye bread, to remove fat and improve the dye.

5. "Insect Dyes," Antique Rugs of the Future Project.

6. Bożena Łagowska and Katarzyna Golan, "Scale Insects/Hemiptera, Coccoidea/as a Source of Natural Dye and Other Useful Substances," *Aphids and Other Hemipterous Insects* 15 (2009): 151–67, especially pages 151, 158; Donkin, "Insect Dyes."

7. Łagowska and Golan, "Scale Insects," 158.

8. Richard Brzezinski and Vuksic Velimir Vuksic, *Polish Winged Hussar, 1576–1775* (Oxford: Osprey, 2006), 23–24.

9. Zdzisław Żygulski Jr., "Further Battles for the 'Lisowczyk' (Polish Rider) by Rembrandt," *Artibus et Historiae* 21, no. 41 (2000): 197–205, discusses the subject of the painting and its attribution, including reversal of a 1980s opinion by the investigating committee, now headed by the chair of the Rembrandt Research Project, that this painting was neither of a Polish subject nor by Rembrandt.

10. Phipps, *Cochineal Red,* 31.

11. Kirby and White, "Identification," 4, 7, 18; Nicolas Penny and Marika Spring, "Veronese's Paintings in the National Gallery. Technique and Materials: Part I," *National Gallery Technical Bulletin* 16 (1995): 4–29; Nicolas Penny, A. Roy, and M. Spring, "Veronese's Paintings in the National Gallery. Technique and Materials: Part II," *National Gallery Technical Bulletin* 17 (1996): 32–55.

12. The use of both relatively local and more distantly imported pigments for the same color simultaneously also occurred when indigo dye from India was introduced to Europe, where at least until the 1700s it was used in combination with blue dye traditionally obtained from woad, a local plant. Rita Buchanan, *A Weaver's Garden* (Loveland, CO: Interweave Press, 1987), 106.

13. Martinus Bernhardus von Bernitz, "De usu et utilitate cocci polonici," *Ephemeridum Medico-Physicarum Germanicarum Academiae Naturae Curiosorum* 3 (1672): 143–49; Donkin, "Insect Dyes," 856. See also Franco Brunello, *The Art of Dyeing in the History of Mankind* (Vicenza: N. Pozza, 1973), 230, note 7.

14. Cited in Brunello, *Art of Dyeing,* 228–30. Scientific descriptions of Polish cochineal of this time include D. Wolfe, "An Account of the Polish Cochineal," *Philosophical Transactions of the Royal Society* 54 (1764): 91–98, and H. Baker, "A Farther Account of the Polish Cochineal," *Philosophical Transactions of the Royal Society* 56 (1766): 184–86. See also review in Donkin, "Insect Dyes."

15. William F. Leggett, *Ancient and Medieval Dyes* (Brooklyn, NY: Chemical Publishing, 1944), 67.

16. Paul Mushak, "The Use of Insect Dyes in Oriental Rugs and Textiles: Some Unresolved Issues," *Oriental Rug Review* 8, no. 5 (June–July 1988); Phipps, *Cochineal Red,* 45; R. A. Donkin, "Spanish Red: An Ethnogeographical Study of Cochineal and the Opuntia Cactus," *Transactions of the American Philosophical Society,* n.s., 67, part 5 (September 1977), 39. See also Donkin, "Insect Dyes," 857–58. The market prominence of cactus cochineal from the New World would reverse some of these trade routes, with Kashgar becoming the source of red dyestuffs for the Margilan region of Uzbekistan until 1920, according to master block printers there. Rasuljon Mirzaahmedov, *Secrets of Natural Dyeing* (Paris: UNESCO, 2007), 31.

17. Judith H. Hofenk de Graaff and ICOM Committee for Conservation, *Natural Dyestuffs: Origin, Chemical Constitution, Identification* (Amsterdam: Central Research Laboratory for Objects of Art and Science, 1969), 81; Leggett, *Ancient and Medieval Dyes,* 67–68; Brunello, *Art of Dyeing,* 153.

18. Brunello, *Art of Dyeing,* 153. The National Gallery, using HPLC testing, detected Polish cochineal pigment in a fifteenth-century Sienese manuscript (Kirby and White, "Identification," 14). As less dyestuff is needed for manuscript painting than for large-scale easel painting (Penny and Spring, "Veronese's Paintings," 15), use of Polish cochineal in manuscript illumination may have persisted longer.

19. Looking at ecclesiastical documents of the thirteenth century, Leggett (*Ancient and Medieval Dyes,* 67) reports that excess cochineal in at least one specific case "was sold by the Archbishop of Arles to the Jews of the diocese of St. Chamas," a port town on the southern coast of France. France is also found to be a consumer of Polish cochineal in accounts researched by Donkin ("Insect Dyes," 863), while international trade in Polish cochineal is attributed to Jews and/or Armenians in a number of accounts (Donkin, "Insect Dyes," 856, 860, 863; Łagowska and Golan, "Scale Insects," 158). If Bukhara was then also a center for trade in Polish cochineal, this reference may relate to the historic Jewish quarter there, with specialists in cold silk dyeing, which Calum MacLeod and Bradley Mayhew report to have its origins in forced migrations of the 1300s; Calum MacLeod and Bradley Mayhew, *Uzbekistan: The Golden Road to Samarkand* (New York: Odyssey, 2012), 285–86. It may also relate to Judeo-Christian religious practices involving red dye that Phipps (*Cochineal Red,* 8–9) notes are recorded in the Old Testament.

20. "Insect Dyes," Antique Rugs of the Future Project; Bożena Łagowska, Katarzyna Golan, and K. Stepaniuk, 2008, "Distribution, Host Plants, and Life Cycle of *Porphyrophora polonica* (L.) (Hemiptera: Margarodidae) in Poland," *Proceedings of the XI International Symposium on Scale Insects* (Lisbon: Instituto Superior de Agronomia, 2008), 241–49.

21. Jacob Grimm, *Teutonic Mythology* (London: W. Swan Sonnenschein and Allen, 1880). The church turned Kupula Day into Ivan Kupula Day, overlaying the focus on fire, sun, and fertility with a corruption of the word meaning "to bathe" for Ivan (John) the Baptist.

22. Luba Petrusha, "Kyivan Rus' Київська Русь," Pysanky.info, n.d., http://www.pysanky.info/History/Kyivan_Rus.html.

23. For example, Polish: *czerw, czerwony, czerwiec, czerwiec polski;* Ukranian: черв'як (*cherv'yak*), червоний (*chervonyy*), червень (*chervyen'*), червець (*chervets'*); Belarusian, Bulgarian, Czech, and Croatian are similar, as shown in a chart at "Polish cochineal," *Wikipedia,* 2014, https://en.wikipedia.org/wiki/Polish_cochineal#Linguistics. Modern Polish also uses part of the name of the insect—also the name of the month—to name one of the main host plants, perennial knawel (*czerwiec trwały*).

24. *Ruta* has green foliage; blooms yellow with a flower with five petals, like the perennial knawel; and can be used to produce a green dye. The magic herbal item to search for is sometimes translated as "the fern flower" and even more specifically "the male fern flower." This is another nonexistent item.

25. Sophie Hodorowicz Knab, *Polish Customs, Traditions and Folklore* (New York: Hippocrene Books, 1996), 136.

26. Diana Magaloni Kerpel, "The Hidden Aesthetic of Red in the Painted Tombs of Oaxaca," *Res* 57/58 (2010): 55–74; Magaloni Kerpel, this volume.

27. Polish cochineal dye colors the

wool ground of the Met's Central Asian textile, dating from the second century BCE to the first century CE (four strips with embroidered goats, plaited wool with wool and cotton embroidery, largest fragment 44 x 3.8 centimeters, Metropolitan Museum of Art, purchase, Friends of Inanna Gifts and Rogers Fund, 2000, 2000.507a–d); "The Collection Online," Metropolitan Museum of Art, 2014, http://www.metmuseum.org/collection/the-collection-online/search/328816; a detail (in color) is shown in Phipps, *Cochineal Red,* 11.

28. Phipps, Ibid., 9, 11, citing Judith H. Hofenk de Graaff, W. G. Th Roelofs, and Maarten Roderik van Bommel, *The Colourful Past: Origins, Chemistry and Identification of Natural Dyestuffs* (London: Archetype, 2004), 102–103; inventory number 1295/150, from excavations in Pazyryk Barrow 1, State Hermitage Museum online collections, n.d., https://www.hermitagemuseum.org; Daniel C. Waugh, "State Hermitage Museum: Southern Siberia/Pazyryk," State Hermitage Museum, St. Petersburg, 2007, https://depts.washington.edu/silkroad/museums/shm/shmpazyryk.html; Murat Mambetov and CACSARC-kg, "Ala-kiyiz and Shyrdak, Art of Kyrgyz Traditional Felt Carpets," YouTube video, posted by UNESCO, December 4, 2012, https://www.youtube.com/watch?v=mO2VxDmy4y4.

29. See, for example, Eugene Tiutko, *Atlas of Ukrainian History* (Chicago: Selfreliance Ukrainian Federal Credit Union, 1995) and Malise Ruthven and Azim Nanji, *Historical Atlas of Islam* (Cambridge, MA: Harvard University Press, 2004), 36, 46–47, 54–55, 65, 94–95, 104–105, 174–75. These interconnections are manifested in a number of shared traditions, including in ethnobotany (*Ruta graveleons* is an important plant in each culture), linguistics (the name of the major Slavic god *Dažbog* is traced to Avestan or east Iranian roots or influence), and religion (for example, the roles of decorated eggs in each tradition).

30. Rasuljon Mirzaahmedov (author of *Secrets of Natural Dyeing*), a fifth-generation master weaver of Margilan, Uzbekistan, is undertaking such work; see also "Insect Dyes," Antique Rugs of the Future Project, and UNESCO's 2012 Urgent Safeguarding List, nomination 693, "Ala-kiyiz and Shyrdak, Art of Kyrgyz Traditional Felt Carpets."

CHAPTER 24 (SIRACUSANO/MAIER)

1. Pedro Sanchez de Aguilar, *Informe contra Idolorum cultores del obispado de Yucatan* (Madrid, 1639), 75.

2. Ibid., 68–116.

3. Pablo Joseph de Arriaga, *La extirpación de la idolatría en el Perú* (1621) (Cuzco: Centro de Estudios Regionales Andinos "Bartolomé de las Casas," 1999).

4. Gabriela Siracusano, *El poder de los colores. De lo material a lo simbólico en las prácticas culturales andinas. Siglos XVI–XVIII* (Buenos Aires: FCE, 2005), 306. See also the English-language version: Gabriela Siracusano, *Pigments and Power in the Andes* (London: Archetype, 2011).

5. Jan Wouters and Noemí Chrinos, "Dye Analysis of Pre-Columbian Peruvian Textiles with High-Performance Liquid Chromatography and Diode-Array Detection, *Journal of the American Institute for Conservation* 31, no. 2 (Summer 1992): 237–55; Elena Phipps, "Color in the Andes: Inca Garments and Seventeenth-Century Colonial Documents," in *Dyes in History and Archaeology*, vol. 19, ed. Jo Kirby (London: Archetype, 2003), 51–59; Elena Phipps, "Cochineal Red: The Art History of a Color," New York: *Metropolitan Museum of Art* (2010): 4–48.

6. *Arte, y vocabulario en la lengua general del Peru llamada Quichua, y en la lengua Española* (Lima: Antonio Ricardo, 1586); *Arte y vocabulario en la lengua general del Peru, llamada Quichua, y en la lengua Española* (Seville: Clemente Hidalgo, 1603) (authorship of these books has been attributed to either Ludovico Bertonio, Francisco del Canto, Domingo de Santo Tomás, Diego González Holguín, Diego de Torres Rubio, or Alfonso Bárcena); Diego Gonzalez de Holguín, *Vocabulario de la lengua general de todo el Peru llamada lengua Quichua, o del Inca* (Lima: Francisco del Canto, 1608). Fray Domingo de Santo Tomas's *Lexicon, o vocabulario de la lengua general del Peru* (Valladolid: Francisco Fernández de Córdova, 1560) does not mention the insect but just the grain color as *puca.*

7. Ludovico Bertonio, *Vocabulario de la lengua Aymara* (Juli, Peru: Francisco del Canto, 1612), 211–12.

8. See Phipps, "Cochineal Red," 17–18.

9. Analytical HPLC was carried out on a Gilson 506C HPLC system using a Phenomenex Gemini mm column (25 centimeters x 4.6 millimeters i.d.). Compounds were detected using a 170 photodiode array detector set at 255 nanometers, operated in series with Unipoint System software, recording the absorption spectrum in the range 190 to 700 nanometers. Gradient elution was performed using two solvents, A: MeOH and B: 1 percent (v/v) aqueous ortophosphoric acid. The gradient started with 36 percent A for five minutes and was raised to 90 percent A within ten minutes, followed by twenty minutes at this condition. The samples were treated with a mixture of water:metanol:hydrochloric acid 37 percent (1:1:2, v/v) and kept at 100 degrees Celsius for fifteen minutes. Then the liquid phase was evaporated (50–60 degrees Celsius) under gentle nitrogen flow. The dry residue was dissolved in MeOH and submitted to HPLC.

10. Dominque Cardon, *Natural Dyes: Sources, Tradition, Technology, and Science* (London: Archetype Publications, 2007).

11. Quoted in Eduardo Berberian, *Crónicas del Tucumán. Siglo XVI* (Córdoba: Comechingonia, Revista de Antropología e Historia, Colección Conquistadores de Indias I, 1987), 209.

12. Carlos S. Assadourian, Guillermo Beato, and José C. Chiaramonte, *Argentina de la conquista a la independencia* (Buenos Aires: Paidós, 1992), 2:103.

13. Ibid., 137.

14. Joseph de Acosta, *Historia natural y moral de las Indias. En que se tratan las cosas notables del cielo, y elementos, metales, plantas, y animales dellas: y los ritos, y ceremonias, leyes, y goviero, y guerra de los Indios* (Barcelona: Jayme Cendrat, 1591), 165–66.

15. Bernabé Cobo, *Historia del Nuevo Mundo,* 1653 (Seville: Sociedad de Bibliófilos Andaluces, 1890), 1:444–45.

16. Ibid., 1:444.

17. Adolfo L. Ribera and Héctor Schenone, *El arte de la imaginería en el Río de la Plata* (Buenos Aires: Instituto de Arte Americano e Investigaciones Estéticas, 1948), 60. See Compañía de Jesús, 1766–1770, División Colonia, Sección Gobierno, Archivo General De La Nación, Buenos Aires. See also *Moxos y Chiquitos, tomo* 1. 1767–1768, "Inventario de la Misión de la Santísima Trinidad 1767," folios 12r, 12v, 13r; "Inventario de la Misión de San Francisco Xavier 1767," folios 19r, 19v; "Misión de San Pedro 1767," folios 27r, 28v, 29r; "Misión de Santa Ana de Moxos 1767," folio 36r; "Misión de los Reyes 1767," folios 50, 60v; "San Francisco Borja 1768, efectos de la casa de Indios," folios 160–70; "Misión de San Martín 1768, en muebles de casa y efectos pertenecientes a indios," folios 181r–v, 182v; "Misión de San Joaquin," folio 186v; "Misión de la Puríssima Concepción de la Virgen 1768, en muebles," folio 193r; "Inventario de la Hacienda de Chalguani del Partido de Mizque 1767," folios 202v, 202r, 203r; "Estancia de Abana 1767," folios 228r, 264r, National Archive of Bolivia, Sucre, Bolivia.

18. See Siracusano, *Pigments and Power,* chapters 1 and 3.

19. Another possible use of cochineal can be traced in painting on paper, as the research on Martín de Murúa's *Historia General del Piru* has shown. See Thomas B. F. Cummins and Barbara Anderson, eds., *The Getty Murúa: Essays on the Making of Martín de Murúa's* Historia General del Piru, *J. Paul Getty Museum Ms. Ludwig XIII 16* (Los Angeles: Getty Research Institute, 2008), 142.

20. Many of these results have been published by our team in several journals and books. See A. Seldes et al., *Una serie de pinturas cuzqueñas de Santa Catalina. Historia, restauración y química* (Buenos Aires: Fundación TAREA, 1998); J. Burucúa et al., *Tarea de diez años* (Buenos Aires, Fundación Antorchas, 2000); and Alicia Seldes et al., "Green, Red and Yellow Pigments in South American Painting (1610–1780)," *Journal of the American Institute for Conservation*

41 (2002): 225–42. Also see Gabriela Siracusano, "Polvos y colores en la pintura colonial andina (siglos XVII–XVIII). Prácticas y representaciones del hacer, el saber y el poder" (PhD dissertation, University of Buenos Aires, 2002), 99–114.

21. The Andean highlands.

22. A social and economic system developed by the Spanish Crown in which native communities worked for and provided tribute to Spanish landowners in the Americas. In return, the *encomendero* was responsible for converting native people to Christianity.

23. Inventario de 1718 de los bienes del Marqués del valle de Tojo, folios 28v–29r, Archive of Jujuy, San Salvador de Jujuy, Argentina.

24. Burucúa et al., *Tarea.*

25. Siracusano, "Polvos y colores," 99–100. This identification was developed as part of a collaborative research project granted to G. Siracusano, A. Seldes, J. Burucúa, and M. Maier by the J. Paul Getty Trust in 2000.

26. *Saint Catherine Drinks the Blood from the Side of Christ* and *Child Appearing to Saint Catherine at Communion.* See Siracusano, *Pigments and Power.*

27. Fundación Tarea, *Una serie de pinturas cuzqueñas de Santa Catalina. Historia, restauración y química* (Buenos Aires: Fundación Tarea, 1998). Texts by Gonzalo Abad, José E. Burucúa, Alejandro Bustillo, Andrea Jáuregui, Marta Maier, and Alicia Seldes.

28. Antonio Palomino de Castro y Velasco, *El museo pictórico y escala óptica,* 1723 (Madrid: Aguilar Maior, 1988), 159.

29. Thaddäus Hænke, "Descripción geografica é historia natural del gobierno y distrito de Montevideo," *Telégrafo mercantil, rural, político-económico e historiográfico del Río de la Plata,* 1801–1802, pages 114–17.

30. The *repartimiento* system was key to this. See Jeremy Baskes, "Seeking Red: The Production and Trade of Cochineal Dye in Oaxaca, Mexico, 1750–1821, in *The Materiality of Color,* ed. Andrea Feeser et al. (Farnham, UK: Ashgate, 2012), 101–17.

31. See Phipps, "Cochineal Red," 26.

CHAPTER 25 (ANDERSON)

1. For reds in the pre-Columbian period, see Brittenham and Miller, this volume. For a broad discussion of cochineal in pre-Columbian and viceregal Mexican painting in the context of global painting in the early modern period, see Barbara C. Anderson, "Evidence of Cochineal's Use in Painting," *Journal of Interdisciplinary History* 45, no. 3 (Winter 2015): 1–30.

2. "[G]rana purificada y hecha en panecitos llaman tlaquauac tlapalli, grana recia o fina, venden en los tianguis hecha panecillos para que la comprenlos del tochmitl y los pintores." Piero Baglioni et al., "On the Nature of the Pigments of the *General History of the Things of New Spain:* The *Florentine Codex,*" in *Colors between Two Worlds: The Florentine Codex of Bernardino de Sahagún,* ed. Gerhard Wolf and Joseph Connors (Florence: Harvard University Press, 2011), 86.

3. See Magaloni Kerpel, this volume, and Magaloni Kerpel, "Painters of the New World: The Process of Making the *Florentine Codex,*" in Wolf and Connors, *Colors between Two Worlds,* 47–78.

4. Diana Magaloni Kerpel, "The Hidden Aesthetic of Red in the Painted Tombs of Oaxaca," *Res* 57/58 (2010): 69.

5. C. Miliani, "Materials and Techniques of the Pre-Columbian Mixtec Manuscript, the Codex Zouche-Nuttall," Eu-Artech, 2008, http://www.eu-artech.org/files/Users_report_final_NUTTAL.pdf); C. Miliani et al., "Colouring Materials of Pre-Columbian Codices: Noninvasive *in situ* Spectroscopic Analysis of the Codex Cospi," *Journal of Archaeological Science* 39 (2012): 672–79; Leonor Nayar, "Codices precolombinos," *Consultara de ciencias de la información, documentos de trabajo* 2 (2009): 1–49, 23.

6. Marina Straulino, "A New View: The Conservation and Digital Restoration of the *Mapa de Cuauhtinchan No. 2,*" in *Cave, City, and Eagle's Nest: An Interpretive Journey through the Mapa de Cuauhtinchan No. 2,* ed. David Carrasco and Scott Sessions (Albuquerque: University of New Mexico Press: 2007), 49–80, 60.

7. Ted Stanley, "Case Study: Examination and Analysis of a Mesoamerican Deerskin Map," oral presentation at the American Institute of Conservation Fortieth Annual Conference, Albuquerque, 2012.

8. Sylvia Rodgers Albro and Thomas C. Albro II, "The Examination and Conservation Treatment of the Library of Congress Harkness 1531 Huejotzingo Codex," *Journal of the American Institute for Conservation* 29, no. 2 (1990): 97–111.

9. Mary Elizabeth Haude, "Identification and Classification of Colorants Used during Mexico's Early Colonial Period," *American Institute for Conservation: The Book and Paper Group Annual* 16 (1997): 1–20, 7–8.

10. Richard Newman and Michele Derrick, "Analytical Report of the Pigments and Binding Materials Used on the Beinecke Map," in *Painting a Map of Sixteenth-Century Mexico City,* ed. Mary E. Miller and Barbara E. Mundy (New Haven, CT: Yale University Press, 2012), 91–100, 99; Diana Magaloni Kerpel, "The Traces of the Creative Process: Pictorial Materials and Techniques in the Beinecke Map," in Miller and Mundy, *Painting a Map of Sixteenth-Century Mexico City,* 75–90, 82.

11. Magaloni Kerpel, "Hidden Aesthetic of Red," 71.

12. Magaloni Kerpel, "Traces of the Creative Process," 82–83.

13. Magaloni Kerpel, "Hidden Aesthetic of Red," 83.

14. Bodleian Library, Oxford University, Oxford.

15. Instituto de Antropología e Historia, Mexico City.

16. "Son dichosos en colores, ahora sean de tierra, ahora de zumos de yerbas varias, sin contar la cochinilla, que es carmin rarisimo. Justo es tambien concederlos haber traido á la pintura algo de Nuevo y raro, como es la pintura de las plumas de las aves." Antonio Ponz, ed., *Comentarios de la pintura* (Madrid: Don Xerónimo de Ortega y Hijos de Ibarra, 1788), 236–37.

17. Javier Vázquez, "Presencia de grana cochinilla y añil en las pinturas sobre tabla del S. XVI de Coixtlahuaca, Oaxaca," oral presentation, "Rojo mexicano: Coloquio internacional sobre grana cochinilla en el arte," Mexico City, Palacio de Bellas Artes, November 11–14, 2014.

18. English translation in Zahira Veliz, *Artists' Techniques in Golden Age Spain* (Cambridge: Cambridge University Press, 1986), 73. "Yo he hecho con este color algunos terciopelos bien imitados; pero todos quedan atrás con los de mi compañero Alonso Vásques, que ninguno le igualó en esta parte"; Francisco Pacheco, *Arte de la pintura, su antigüedad y grandezas,* 1649 (Madrid: Ediciones Cátedra, 2009), 485.

19. Oil on panel, circa 1606, in the Museo Nacional de Historia, Castillo de Chapultepec.

20. Oil on canvas, 1605–1607, Hospital de Jesús, Mexico City.

21. Larry Keith, "Velázquez's Painting Technique," in *Velázquez,* ed. Dawson W. Carr and Xavier Bray (London: National Gallery, 2006), 70–91; Bruquetas, this volume.

22. See, for example, Ilona Katsew, *Casta Painting* (New Haven, CT: Yale University Press, 2004).

23. Mark MacKenzie sampled and analyzed the paintings in Santa Fe and analyzed samples of the Villalpando provided by the Denver Art Museum. The examples from the Museo de América, all from large painting series, were analyzed for this project by Estrella Sanz Rodríguez (see her essay, this volume). The paintings include *Betrothal of the Virgin* (MAC19990301) and *The Circumcision of Christ* (MACA20010202) by Miguel Cabrera and dated 1751; another *casta, De Español y alvina, negro torna atrás* (MACC56); and *The Baptism of the King of Texcoco,* circa 1783 (MACMC217).

24. Pacheco, *Arte,* 485.

25. See Anderson, "Evidence of Cochineal."

CAPTIONS

a. Larry Keith, "Velázquez's Painting Technique," in *Velázquez,* ed. Dawson W. Carr and Xavier Bray (London: National Gallery, 2006), 70–79, 7.

b. Joris Dik and Arie Wallert, "Two Still-Life Paintings by Jan van Huysum: An Examination of Painting Technique in Relation to Documentary and Technical Evidence," in *Looking through Paintings: The Study of Painting Techniques and Materials in Support of Art Historical Research,* ed. Erma Hermens,

Annemiek Ouwerkerk, and Nicola Costaras (Leiden: de Prom, 1998), 391–414, 405.

CHAPTER 26 (CURIEL)

1. A large number of pieces that at first were thought to have cochineal in their decoration were carefully sampled and submitted to rigorous laboratory analysis. Not all the furniture selected showed the presence of this dye. The pieces from the Museo Franz Mayer of Mexico City that were studied characteristically used the color red abundantly. I thank Héctor Rivero Borrell Miranda, director of the Museo Franz Mayer, for the facilities made available for the study of furniture from that collection. I also express my gratitude to Mark MacKenzie, director of conservation for the New Mexico Department of Cultural Affairs, who did the sampling and the laboratory work on pieces chosen from the Museo Franz Mayer. In like manner I am indebted to the following people: Carmella Padilla and Barbara Anderson, cocurators of *The Red That Colored the World* exhibition, and Donna Pierce of the Denver Art Museum, all of whom commented on or were otherwise involved in some aspect of this project.
2. Sonia Pérez Carrillo, *La laca mexicana. Desarrollo de un oficio artesanal en el virreinato de la Nueva España* (Mexico City: Instituto Nacional de Antropología e Historia, Editorial Patria, 1990). In regard to Asian lacquers and pre-Hispanic and viceregal lacquerware, see the historiographic discussion in the introductory chapters of Pérez Carrillo's study.
3. Ibid., 146, 204–205, catalog number 40.
4. Museum of International Folk Art, FA. 1993.12.1.
5. A term used by Baltasar de Castiglione to denote a special awareness of social behavior in which courtesy, refinement, and elegance were virtues cultivated by members of the Italian courts.
6. Cf. Fray Francisco de Ajofrín, *Diario del viaje que hizo a la América en el siglo XVIII el p. fray Francisco de Ajofrín,* 2 vols. (Mexico City: Instituto Cultural Hispano Mexicano, 1964). The traveler says, "Today a celebrated painter, a noble Indian, called don Jose Manuel de la Cerda, who has perfected this ability (painting lacquered or varnished trays), succeeds so well that he exceeds in skill and luster the lacquers of China. I saw a dozen large trays of ash that he was painting for her excellency, the Marchioness de Cruilles, Vicereine of Mexico. They are worthy of a person of such high character." Cf. volume 1, page 160. The friar notes in his account much production of cochineal in Oaxaca and includes, on page 112 of volume 2, a drawing of women that harvest cochineal, one of them "loaded down" with the insects.
7. Rich trays, serving plates, and similar utensils of silver were used to carry cups, bowls, or foods to be offered with decorum and dignity to socially important personages. See *Las Meninas,* a famous painting by Diego Velázquez in the Museo Nacional del Prado in Madrid, in which Princess Margarita is approached with a silver salver on which sits a clay jug from Tonalá, Mexico, possibly containing chocolate.
8. Museo de América, 06921.
9. Pérez Carrillo, *La laca Mexicana,* 124–27, 202, catalog number 31.
10. Carlos Espejel, *Las jícaras de Acapetlahuaya* (Mexico City: Instituto Nacional Indigenista, Instituto Nacional de Antropología e Historia, 1973), cited in Martha Turok Wallace and Carlos Bravo Marentes, "Patrimonio aresanal en riesgo," in *Lacas mexicanas* (Mexico City: Franz Mayer Museum, Artes de México, 1997), 60.
11. Museum of International Folk Art, FA.79.25.1.
12. Museum of Spanish Colonial Art, 1956.89.
13. Juan Miguel Serrera, "Notas sobre la presencia durante el siglo XVI de muebles mexicanos en el palacio sanluqueño de los duques de Medina Sidonia," in *Andalucía y América, Actas de las II Jornadas de Andalucía y América (1982)* (Seville: School of Hispanic American Studies of Seville, 1983). The author recorded polychrome tables of lively colors with figurative scenes that conqueror Hernán Cortés sent from New Spain to Empress Isabel in 1539. They must have been pieces that caught one's attention for their rich and unusual colors, of a quality deemed worthy to be sent as a gift to the empress. Although the author claims the pieces are *enconchados* (made with inlaid shell), their dates of manufacture do not support this claim.
14. There was also, especially in the eighteenth century, with the exploitation of the famous American mahoganies, furniture with no paint at all. The influence of English furniture (Queen Anne and Chippendale) led to leaving exposed the rich grains of these woods. In other cases it was the geometric inlay that was featured, in clear opposition to painted furniture.
15. From the scientific point of view, there is yet to be an in-depth study of components and techniques related to the lacquers, varnishes, faux lacquers, paints that imitate lacquers, shiny varnishes, and so on produced mainly in the present-day states of Michoacán, Guerrero, and Chiapas, and comparing this information with what has been found in chronicles and other original sources. There have been some advances in this field. The bibliography is substantial. Cf. Sonia Pérez Carrillo and Carmen Rodríguez Tembleque, "Influencias orientales y europeas," in *Lacas mexicanas* (Mexico City: Franz Mayer Museum, Artes de México, 1997), 31–46, and Marita Martínez del Río del Redo et al., "El maque. Lacas de Michoacán, Guerrero y Chiapas," *Artes de México* 153 (1972). The following works are also interesting: Teresa Castelló Yturbide, *El arte de maque en México* (Mexico: Fomento Cultural Banamex, 1972); Jorge Enciso, "Pintura sobre madera en Michoacán y Guerrero," *Mexican Folkways* 8, no. 1 (1933). Also see the bibliography in *Lacas mexicanas,* 78–79.
16. Museum of International Folk Art, L59.18.11.
17. Museum of Spanish Colonial Art, 1990.80.

CHAPTER 27 (GAVIN/CARUSO)

1. Eleanor B. Adams and Fray Angelico Chavez, eds., *The Missions of New Mexico, 1776: A Description by Fray Francisco Atanasio Dominguez* (Albuquerque: University of New Mexico Press, 1956), 191.
2. Ibid., 133, 184. The term used by Domínguez in his manuscript is *cochinilla; La Provincia del Santo Evangelio de Franciscanos observantes de Nueva España, tiene en el Reyno del Nuevo México, y a su cargo la Custodia de la Conversión de San Pablo, 1776, legajo* 10, part 2, document 43, Biblioteca Nacional de México, Mexico City.
3. William Wroth and Robin Farwell Gavin, *Converging Streams: Art of the Hispanic and Native American Southwest* (Santa Fe, NM: Museum of Spanish Colonial Art, 2010), 202–203.
4. Adams and Chavez, *Missions of New Mexico,* 337. See also Cordelia Thomas Snow and Glenna Dean, "Out on a Limb: Cochineal Production in Spanish Colonial New Mexico?" in *Threads, Tints, and Edification: Papers in Honor of Glenna Dean,* ed. Emily J. Brown, Karen Armstrong, David M. Brugge, and Carol J. Condi, Papers of the Archaeological Society of New Mexico, vol. 36 (Albuquerque: Archaeological Society of New Mexico, 2010), 159–64.
5. Joe Ben Wheat, *Blanket Weaving in the Southwest* (Tucson: University of Arizona Press, 2003), 74.
6. Ilona Katzew, *Casta Painting: Images of Race in Eighteenth-Century Mexico* (New Haven, CT: Yale University Press, 2004), plate 45, *De Español e india nace mestizo* by Buenaventura José Guiol, circa 1770–1780.
7. Adams and Chavez, *Missions of New Mexico,* 131–34.
8. Inventory of the estate of Juan Antonio Fernandes, 1784, number 280, reel 8, frame 811, Spanish Archives of New Mexico, New Mexico State Records and Archives, Santa Fe.
9. Robin Farwell Gavin and Donna Pierce, "The Altar Screens of Bernardo Miera y Pacheco," in *The Art and Legacy of Bernardo Miera y Pacheco,* ed. Josef Díaz (Santa Fe: Museum of New Mexico Press, 2013), 63–102.
10. Donna Pierce and Marta Weigle, *Spanish New Mexico: The Spanish Colonial Arts Society Collection,* 2 vols. (Santa Fe: Museum of New Mexico Press, 1996), 31.
11. E. Boyd, *Popular Arts of Spanish New Mexico* (Santa Fe: Museum of

New Mexico, 1974), 96–98. See also Pierce and Weigle, *Spanish New Mexico*, 32–33, and William Wroth, *Christian Images of Hispanic New Mexico* (Colorado Springs: Taylor Museum, 1986), 59–64.

12. One of these pigments, which became known as Zuñi blue, was formed from ground azurite. Miera y Pacheco viewed it as such a superior pigment that he recommended its export. H. Bailey Carroll and J. Villasana Haggard, trans. and eds., *Three New Mexico Chronicles: The Exposicion of Don Pedro Bautista Pino, 1812; The Ojeada of Lic. Antonio Barriero, 1832; and the Additions by Don José Agustín de Escudero, 1849* (Albuquerque, NM: Quivira Society, 1942) 2:99.

13. Snow and Dean, "Out on a Limb," 162.

14. José Antonio Esquibel and Charles M. Carrillo, *A Tapestry of Kinship: The Web of Influence among Escultores and Carpinteros in the Parish of Santa Fe, 1790–1860* (Albuquerque, NM: LPD Press, 2004).

15. Cleofas Jaramillo, *Romance of a Little Village Girl* (San Antonio: Naylor Company, 1955), 25.

16. Josiah Gregg, *Commerce of the Prairies*, ed. Max L. Moorhead (Norman: University of Oklahoma Press, 1974), 153–54. Rubén Cobos translates *alegría* as "cockscomb" in *A Dictionary of New Mexico and Southern Colorado Spanish* (Santa Fe: Museum of New Mexico Press, 1983).

17. James W. Abert, *Abert's New Mexico Report, 1846–'47* (Albuquerque, NM: Horn and Wallace Publishers, 1962), 41.

18. Stella M. Drumm, ed., *Down the Santa Fe Trail and into Mexico: The Diary of Susan Shelby Magoffin, 1846–1847,* 1926 (Lincoln: University of Nebraska Press, 1982).

19. Chris Wilson, *The Myth of Santa Fe: Creating a Modern Regional Tradition* (Albuquerque: University of New Mexico Press, 1997); Marta Weigle, *Alluring New Mexico: Engineered Enchantment, 1821–2001* (Santa Fe: Museum of New Mexico Press, 2010); Marta Weigle, "Historical Introduction," in Pierce and Weigle, *Spanish New Mexico*, 2:1–25.

20. Weigle, "Historical Introduction," 2:14; Sara Nestor, *The Native Market of the Spanish New Mexican Craftsmen, Santa Fe, 1933–1940* (Santa Fe: Colonial New Mexico Historical Foundation, 1978).

21. Native Market files, Curtin Paloheimo Collection, Acequia Madre House, Santa Fe, New Mexico.

22. Margaret D. Jacobs, "Shaping a New Way: White Women and the Movement to Promote Pueblo Indian Arts and Crafts, 1900–1935," *Journal of the Southwest* 40, no. 2 (Summer 1998): 187–215.

CHAPTER 28 (THOMAS SNOW)

1. Anne Bliss, "Cochineal in Colorado: Or, Is Your Local Cactus Bugged?" *Interweave: Mountain/Plains Fiber Crafts* 1, no. 2 (Winter 1976): 20–21; John Ellis, "An Account of the Male and Female Cochineal Insects, That Breed on the Cactus Opuntia, or Indian Fig. in South Carolina and Georgia," *Philosophical Transactions* 52 (1761–1762): 66–67; Cordelia Thomas Snow and Glenna Dean, "Out on a Limb: Cochineal Production in Spanish Colonial New Mexico?" in *Threads, Tints, and Edification: Papers in Honor of Glenna Dean,* ed. Emily J. Brown, Karen Armstrong, David M. Brugge, and Carol J. Condi, Papers of the Archaeological Society of New Mexico, vol. 36 (Albuquerque: Archaeological Society of New Mexico, 2010).

2. Dennis Reinbartz, "Soldier-Engineer of the Great Southwest: The Cartography," in *The Art and Legacy of Bernardo Miera y Pacheco: New Spain's Explorer, Cartographer and Artist*, ed. Josef Diaz (Santa Fe: Museum of New Mexico Press, 2013), 38–39.

3. George P. Hammond and Agapito Rey, *Don Juan de Oñate: Colonizer of New Mexico, 1595–1628*, Coronado Cuarto Centennial Publications, 1540–1541, vol. 5 (Albuquerque: University of New Mexico Press, 1953), 539–40.

4. Fray Angélico Chávez, *Origins of New Mexico Families: A Genealogy of the Spanish Colonial Period,* revised ed. (Santa Fe: Museum of New Mexico Press, 1992), 33.

5. Ibid.

6. Carmella Padilla, *El Rancho de las Golondrinas: Living History in New Mexico's La Ciénega Valley* (Santa Fe: Museum of New Mexico Press, 2009), 51–53.

7. Chávez, *Origins,* 270.

8. José Antonio Esquibel and John B. Colligan, *The Spanish Recolonization of New Mexico: An Account of the Families Recruited at Mexico City in 1693* (Albuquerque: Hispanic Genealogical Research Center of New Mexico, 1999): 27, 38–39, 44.

9. Linda Tigges, ed., *Spanish Colonial Lives: Documents from the Spanish Colonial Archives of New Mexico, 1705–1774*, trans. J. Richard Salazar (Santa Fe, NM: Sunstone Press, 2013), 235–39.

10. Ibid.

11. Chávez, *Origins,* 137–38.

12. The *protector de indios* was appointed by the governor to protect the interests of the local native population; see Marc Simmons, *Spanish Government in New Mexico* (Santa Fe: University of New Mexico Press, 1990), 67.

13. José Antonio Esquibel, "The Formative Era for New Mexico's Colonial Population: 1693–1700," in *Transforming Images: New Mexico Santos in-between Worlds,* ed. Claire Farago and Donna Pierce (State College: Pennsylvania State University, 2006), 65–79, 283–88.

CHAPTER 29 (GONZÁLEZ/LLORENTE)

1. Guillermo de Osma, "Mariano Fortuny, creador del Delphos," *Datatextil* 8 (June 1998): 27–44.

2. Leatrice Eiseman and Keith Recker, *Pantone: Un siglo de arte en color* (San Francisco: Electa, 2011).

3. Elvira González, "Fortuny vistiendo a Cloilde," Museo Sorolla, May 2012, http://museosorolla.mcu.es/pdf/S7251S pieza mayo.pdf.

4. Madeleine Ginsburg, *La historia de los textiles* (London: Editorial Libsa, 1993), 84–86.

5. Anne-Marie Deschodt and Doretta Davanzo Poli, *Fortuny* (New York: Harry N. Abrams, 2001), 100.

6. Lucina Llorente Llorente, "El artista artesano," in *Inspiraciones* (Madrid: Ministerio de Cultura, 2010), 195–251.

7. The results of his investigations led him to register, in the patent office of Paris, on October 21, 1909, patent 419.269, a process for polychrome printing on fabric and paper.

8. Ilaria Caloi, *Modernità minoica L'arte Egea e L'Art Nouveau: Il caso di Mariano Fortuny y Madrazo* (Florence: Firenze University Press, 2011), 92–97.

9. María del Mar Nicolás, "El legado Fortuny-Nigrin," *Cuadernos de Arte de la Universidad de Granada* 41 (2010): 283.

10. María del Mar Nicolás, *Mariano Fortuny: Entre la modernidad y la tradición* (Madrid: Fundación Universitaria Española, 2000), 181.

11. Claudio Franzini, "L'Opus Magnum di un Hidalgo Veneziano: Biografia di Mariano Fortuny y Madrazo," in *Mariano Fortuny* (Venice: Marsilio, 1999), 56.

12. The study was done by chemist Estrella Sanz Rodríguez in collaboration with the Instituto de Patrimonio Cultural de España (from April 8 to May 30, 2013), using the technique of liquid chromatography coupled with a diode array detector and a mass spectrometer with a quadruple-time-of-flight analyzer.

13. Nilam C. Shah et al., "Silver coloidal pastes for dye analysis of reference and historical textile fibers using direct, extractionless, non-hydrolysis surface-enhanced Raman spectroscopy," *Analyst* 138, no. 20 (2013): 5841–6198; using localized surface plasmon resonance, scanning electron microscopy, and surface-enhanced raman spectroscopy.

14. Guillermo de Osma, *Mariano Fortuny: His Life and Work* (London: Aurum Press, 1980), 119.

15. Frances Pritchard, "Mariano Fortuny (1871–1949): His Use of Natural Dyes," *Dyes in History and Archaeology* 16–17 (2001): 39–42. For this analysis, the techniques used were absorption spectrometry and thin layer chromatography, which do not permit the identification of synthetic dyes.

16. Angela Arteaga carried out the study using thin layer chromatography in May 2010 for an exhibition at the Museo del Traje.

17. Benoit V. de Tapol, "Pigmentos y colorantes de la segunda mitad del siglo XIX: Primera aproximación a la paleta de Fortuny," in *Fortuny (1838–1874)* (Barcelona: Museu Nacional d'Art de Catalunya, 2004), 446–56.

18. María Teresa Escohotado Ibor et al., "Conservación y restauración de un conjunto de paños atribuidos a Fortuny y Madrazo del Paraninfo

de la Universidad Complutense," in *Actas XIII Congreso de conservación y restauración de bienes culturales* (Lleida: Asociación de Congresos de Conservación y Restauración de Bienes Culturales, 2000), 519–26. An analysis was carried out using optical microscopy and spectroscopy IR.

CHAPTER 30 (CHÁVEZ)

1. Ricardo Carvajal, "FDA Requires Label Declaration of Cochineal Extract and Carmine on all Foods and Cosmetics," *FDA Law Blog,* January 5, 2009, http://www.fdalawblog.net/fda_law_blog_hyman_phelps/2009/01/fda-requires-label-declaration-of-cochineal-extract-and-carmine-on-all-foods-and-cosmetics-.html; Miranda Mitti, "Food, Cosmetics Labels to Note Dye Derived from Bug," *WebMD Health News,* January 6, 2009, www.webmd.com/food-recipes/news/20090106/food-cosmetic-labels-to-note-bug-colors.

2. Kristie Lau, "One Tall Strawberry Frappuccino—Extra Insects Please!" *Daily Mail,* March 26, 2012, http://www.dailymail.co.uk/femail/article-2120796/Starbucks-admits-Strawberry-Frappuccino-contains-crushed-bugs.html; Ryan Jaslow, "Starbucks Strawberry Frappuccino Dyed with Crushed Up Cochineal Bugs, Report Says," CBS, March 27, 2012, http://www.cbsnews.com/news/starbucks-strawberry-frappuccinos-dyed-with-crushed-up-cochineal-bugs-report-says/.

3. Center for Science in the Public Interest, "Berries Over Bugs: Dannon Urged to Use Berries, Not Insect-Derived Carmine, to Color its Yogurts," CSPI, July 24, 2013, http://www.cspinet.org/new/201307241.html.

4. Recent additions to the cochineal export trade are Ethiopia and Morocco. Interview with Cristina Masoc, Lanzarote, Spain, October 2, 2014.

5. Susie Emmett, "Seeing Red," *New Agriculturalist On-line,* n.d., http://www.new-ag.info/02-3/develop/dev02.html. For an extensive listing of Peruvian suppliers of cochineal for export, see www.alibaba.com/countrysearch/PE/cochineal.html.

6. Interview with Bulmaro Mendoza, Santa Fe, New Mexico, July 17, 2014.

7. Interview with Moisés Martínez Velasco, Santa Fe, New Mexico, July 11, 2014.

8. Itziar Fernández, "El valle escondido de la cochinilla," *La Provincia: Diario de Las Palmas,* January 2, 2014. In this article Fernández interviews Antoñita García Camacho, a sixty-seven-year-old woman who learned the art of harvesting cochineal from her grandmother. Camacho talks about her experiences growing up on the island, the number of people who used to purchase cochineal, and how it was the main moneymaker for her family and for many from her village.

9. The full master plan for El Rescate del Cultivo de la Cochinilla and its programming for Rutas de la Cochinilla has been published on the Asociación Milana website. See www.tinamala.com/rutas.htm.

10. "XXI Fería Insulare de artesanía de mancha blanca, septiembre de 2009," *Rescate del Cultivo de la Cochinilla,* September 2009, http://www.tinamala.com/feria_2009.htm.

11. Interview with Chano Perera Brito and Cristina Marsoc, Lanzarote, Spain, October 1, 2014. See also "Moda Lanzarote con tintes naturales: la cochinilla en movimiento," *Rescate del Cultivo de la Cochinilla,* 2004, http://www.tinamala.com/modalanzarote.htm.

12. As stated by Eloisa Ferrari, project correspondent for *The Red That Colored the World* exhibition team, in an e-mail dated May 5, 2014. See also the announcement of the FID's formation at http://enesimapotencia.wordpress.com/?s=FID.

13. Gayle Crites, "About the Artist," Chiaroscuro Contemporary Art, 2014, http://chiaroscurosantafe.com/artists/34/.

14. Ibid.

15. Interview with D. Y. Begay by Carmella Padilla, Santa Fe, New Mexico, December 8, 2014.

16. Ibid.

17. Ibid.

18. D. Y. Begay, e-mail to Carmella Padilla, December 8, 2014.

CAPTIONS

a. E-mail from Barbara Mauldin to Carmella Padilla, July 26, 2012, recounting Remigio Mestas's review of textiles at the Museum of International Folk Art in Santa Fe in July 2012.

CHAPTER 31 (CHÁVEZ)

1. For an in-depth discussion and to read about the outcome of this study, see Nora Fisher, *The Spanish Textile Tradition of New Mexico and Colorado* (Santa Fe, NM: Museum of New Mexico Press, 1979). It was reprinted later as *Río Grande Textiles* (Santa Fe, NM: Museum of New Mexico Press, 1994).

2. Carmella Padilla and Donna Pierce, *Conexiones: Connections in Spanish Colonial Art* (Santa Fe, NM: Museum of Spanish Colonial Art, 2002), 137.

3 Interview with Lisa Trujillo, Sixty-Third Traditional Spanish Market, Santa Fe, New Mexico, July 26, 2014.

4. Ibid.

5. Interview with Monica Sosaya Halford, Santa Fe, New Mexico, September 19, 2011.

6. E-mail from James Córdova to Barbara Anderson, October 19, 2014.

7. Ibid.

8. Interview with Felix López, Santa Fe, New Mexico, August 13, 2014.

9. Interview with Arlene Cisneros Sena, Santa Fe, New Mexico, December 22, 2014

10. Interview with Ramón José López, Santa Fe, New Mexico, September 3, 2014.

CHAPTER 32 (PADILLA)

1. All quotes from Orlando Dugi, based on interviews with the artist, Santa Fe, New Mexico, December 4, 2014, and January 7, 2015.

APPENDIX

CHAPTER 4 TRADITION AND INNOVATION *(Pearlstein et al., page 44)*

TABLE 4.1 PREPARATIONS OF CARMINIC ACID COLORANTS

	COCHINEAL RECIPE	DETECTED BY PXRF	PH OF SOLUTION	COLOR OBSERVED	COMMENTS
Sample 1	5% cochineal (wt/vol)	S traces, K traces		deep blood red	no precipitate
Sample 2	5% cochineal, 25% alum	Al, S, K (all traces)	3	deep magenta	no precipitate
Sample 3	5% cochineal, 25% alum, < 1% *Miconia laevigata*	Al, S, Ca, K (all traces)	3	deep magenta	no precipitate
Sample 4	5% cochineal, 25% alum, < 1% *Miconia laevigata*, Ca(OH)2	Al, S, Ca, K (traces)	estimated at 8–10	grape purple	precipitate formed
Sample 5	5% cochineal, 25% alum, 11% FeSO4	Al, S, Fe, Mn (traces), K (traces)		dark blue-purple	no precipitate
Sample 6	5% cochineal, 25% alum, 11% FeSO4, Ca(OH)2	Al, S, Ca, Fe, Mn (traces), K traces	estimated at 7–8	dark blue-purple	no precipitate despite alkali pH
Sample 7	5% cochineal, 11 % FeSO4	Fe, S, Mn (traces), K (traces)		blackish gray	no precipitate

CHAPTER 13 PROOF POSITIVE *(Sanz Rodríguez, page 100)*

TABLE 13.1

ORIGIN TITLE AND/OR DESCRIPTION	AUTHOR/CENTURY	DYES IDENTIFIED (SAMPLES ANALYZED)
1 *Coronation of the Virgin*, main altarpiece, polychrome sculpture	Alonso Sánchez Coello/16th	American cochineal (*Dactylopius*) (red *estofado*, or painting over gilding)*
2 *Annunciation of the Virgin*, main altarpiece, polychrome sculpture	Diego de Urbina and others/16th	American cochineal (*Dactylopius*) (red *estofado*)**
3 *Assumption and Coronation of the Virgin*, panel painting	Pedro de Raxis/16th–17th	American cochineal (*Dactylopius*) (red paint layer)
4 *Crucified Christ*, polychrome sculpture	Pedro de Raxis/16th–17th	1. American cochineal (*Dactylopius*) (red glaze, blood) 2. American cochineal (*Dactylopius*) + dyer's broom (*Genista* spp.) (red glaze + rosy cheek)
5 *Saint John the Evangelist*, polychrome sculpture	Pedro de Raxis/16th–17th	American cochineal (*Dactylopius*) (red *estofado*)
5 *Saint Gregory*, polychrome sculpture	Pedro de Raxis/16th–17th	American cochineal (*Dactylopius*) (red *estofado*)
5 *Bishop Saint*, polychrome sculpture	Pedro de Raxis/16th–17th	American cochineal (*Dactylopius*) (red *estofado*)
6 *Saint Matthew*, altarpiece of Lucena, polychrome sculpture	Mohedano/17th	American cochineal (*Dactylopius*) (red paint layer)
7 *The Savior* (Apostle series), painting on canvas	El Greco/17th	American cochineal (*Dactylopius*) + tannins (ellagic acid) (red paint layer)
7 *Saint Matthew* (Apostle series), painting on canvas	El Greco/17th	American cochineal (*Dactylopius*) + tannins (ellagic acid) (red paint layer)
8 *Temptations of Saint Jerome*, painting on canvas	Zurbarán/17th	American cochineal (*Dactylopius*) (red paint layer)
8 *Mass of Father Cabañuelas*, painting on canvas	Zurbarán/17th	American cochineal (*Dactylopius*) (red paint layer)
8 *Saint Nicholas*, painting on canvas	attributed to Zurbarán/17th	American cochineal (*Dactylopius*) + brazilwood (*Caesalpinia* spp.) (red paint layer)
9 *Emperor Domitian*, painting on canvas	circle of Zurbarán/17th	American cochineal (*Dactylopius*) (red paint layer)*
10 *Saint Anthony*, main altar, painting on canvas	Juan de Toledo?/17th	American cochineal (*Dactylopius*) (red paint layer)
11 Colonial textile, Peru	anonymous/16th–17th	1. American cochineal (*Dactylopius*) + luteolin yellow dye + barberry (*Berberis* spp.) (fiber) 2. American cochineal (*Dactylopius*) + barberry (*Berberis* spp.) (fiber)
11 Colonial textile, Peru	anonymous/16th–17th	1. American cochineal (*Dactylopius*) (fiber) 2. American cochineal (*Dactylopius*) + aurone-chalcone yellow dye (*Coreopsis* spp., *Bidens* spp.?) (fiber)
11 Tray, polychrome on wood	anonymous/17th–18th	American cochineal (*Dactylopius*) (red paint layer)
11 Tray, polychrome on wood	anonymous/18th	American cochineal (*Dactylopius*) (red paint layer)
11 *Circumcision of Christ*, painting on canvas	M. Cabrera/18th	American cochineal (*Dactylopius*) (red paint layer)
11 *Betrothal of the Virgin*, painting on canvas	M. Cabrera/18th	1. American cochineal (*Dactylopius*) (red paint layer) 2. American cochineal (*Dactylopius*) + indigo (*Indigofera* spp.) (dark red paint layer)
11 *Castas*, painting on copper	anonymous/18th–19th	American cochineal (*Dactylopius*) (red paint layer)
11 *Castas*, painting on copper	anonymous/18th–19th	American cochineal (*Dactylopius*) (red paint layer)

11	*Conquest of Mexico: The King of Texcoco Baptized with the Name of Ferdinand*, painting on copper	anonymous/18th–19th	American cochineal (*Dactylopius*) (red paint layer)
11	*Circumcision of Christ, enconchado* (mother-of-pearl painting)	anonymous/17th–18th	1. American cochineal (*Dactylopius*) (red paint layer) 2. American cochineal (*Dactylopius*) + luteolin yellow dye (red paint layer)
11	*Betrothal of the Virgin*, *enconchado*	anonymous/17th–18th	1. American cochineal (*Dactylopius*) + madder (red paint layer) 2. American cochineal (*Dactylopius*) + unidentified dye (red paint layer)
12	Dress, smooth velvet and satin-pleated silk	M. Fortuny/20th	1. Rhodamine B + American cochineal (*Dactylopius*) (pleated fiber) 2. American cochineal (*Dactylopius*) (velvet fiber)
12	Cape in gros of Naples, stenciled red silk	M. Fortuny/20th	Unidentified synthetic dye (fiber)
12	Delphos dress, satin-pleated silk	M. Fortuny/20th	American cochineal (*Dactylopius*) + old fustic (*Chlorophora tinctoria* L.) (fiber)
12	Delphos dress, satin-pleated silk	M. Fortuny/20th	Old fustic (*Chlorophora tinctoria* L.) + American cochineal (*Dactylopius*) (fiber)
12	Stockings	anonymous/18th	American cochineal (*Dactylopius*) + indigo traces (*Indigofera* spp.) (fiber)
12	Shoes, brocaded silk	anonymous/18th	American cochineal (*Dactylopius*) (fiber)
12	Corseted doublet	anonymous/18th	American cochineal (*Dactylopius*) + indigo (*Indigofera* spp.) (fiber)

1 Church of El Espinar/El Espinar Church (Segovia)
2 Basílica of La Asunción de Nuestra Señora (Colmenar Viejo, Madrid)
3 Fundación Lázaro Galdiano (Madrid)
4 Seminary of San Cecilio/Seminary of San Cecilio (Granada)
5 Cathedral of Granada
6 Church of San Mateo (Lucena, Cordova)
7 Museo del Greco/El Greco Museum (Toledo)
8 Monastery of Guadalupe (Cáceres)

9 Private collection
10 Church of Las Mercedarias/Las Mercedarias Church (Madrid)
11 Museo de América (Madrid)
12 Museo del Traje (Madrid)

* Analysis carried out by Susanna Marras employing LC-DAD-QTOF.
** Analysis carried out by Ángela Arteaga and María Dolores Gayo using thin-layer chromatography (TLC).

CHAPTER 21 ONE OF THE MOST BEAUTIFUL REDS *(Kirby, page 174)*

TABLE 21.1 RED LAKE PIGMENTS IN SIXTEENTH-CENTURY VENETIAN PAINTINGS

DATE	ARTIST	PAINTING	DYES PRESENT
1475–80	Workshop of Giovanni Bellini	*The Adoration of the Kings* (NG3098)	Polish cochineal[A]
probably 1500–25	Francesco Bissolo	*The Virgin and Child with Saints Michael and Veronica and Two Donors* (NG3083)	kermes[A]
ca. 1502	Giovanni Battista Cima da Conegliano	*Saint Catherine of Alexandria* (Wallace Collection, London)	kermes[B]
ca. 1502–04	Giovanni Battista Cima da Conegliano	*The Incredulity of Saint Thomas* (NG816)	lac[C]
1508–10	Titian	*Christ and the Adultress* (Glasgow Museums, inv. no. 181)	kermes[D]
ca. 1510	Titian	*The Holy Family with a Shepherd* (NG4)	kermes + madder[D]
ca. 1510–12	Titian	*Portrait of a Lady "La Schiavona"* (NG5385)	kermes + madder[D]
ca. 1512–14	Titian	*Jacopo Pesaro Being Presented by Pope Alexander VI to Saint Peter* (Koninklijk Museum voor Schone Kunsten, Antwerp, inv. no. 357)	kermes + madder[E]
ca. 1514	Titian	*Noli me tangere* (NG270)	kermes + madder[D]
ca. 1517–19	Sebastiano del Piombo	*The Raising of Lazarus* (NG1)	kermes + madder[F]
1522	Lorenzo Lotto	*The Virgin and Child with Saints Jerome and Nicholas of Tolentino* (NG2281)	scale insect dyestuff + madder[G]
probably 1523–31	Vincenzo Catena	*Portrait of the Doge, Andrea Gritti* (NG5751)	kermes[H]
1525–35	Paris Bordone	*The Virgin and Child Enthroned with Four Saints* (Gemäldegalerie, Berlin, inv. no. 191)	kermes
ca. 1535	Titian	*The Music Lesson* (NG3)	kermes + madder, possibly also brazilwood[D]
begun 1540–43; completed 1550–60	Titian and workshop	*The Vendramin Family, Venerating a Relic of the True Cross* (NG4452)	Kermes with trace lac; lac; cochineal[D]
ca. 1545	possibly by Jacopo Tintoretto	*Jupiter and Semele* (NG1476)	lac; lac + madder[I]
1545–48	Workshop of Jacopo Tintoretto	*Apollo and Diana Killing the Children of Niobe* (Courtauld Institute Gallery, London, P.1978.PG.458)	kermes[I]

Table 21.1 continued, next page

completed 1547	Lorenzo Lotto	*Portrait of Giovanni della Volta and His Family* (NG1047)	kermes (and a trace of carminic acid)[H]
1554–5	Jacopo Tintoretto	*The Crucifixion* (Accademia Galleries, Venice)	cochineal (or possibly Polish cochineal)
later 1550s	Jacopo Tintoretto	*Deposition of Christ* (National Gallery of Scotland, Edinburgh)	lac; kermes; cochineal[J]
ca. 1555–60	Titian	*Venus and Adonis* (J. Paul Getty Museum, Los Angeles, no. 92.PA.42)	cochineal + madder[K]
ca. 1559–75	Titian	*The Death of Actaeon* (NG6420)	cochineal[D]
1562	Paolo Veronese	*The Consecration of St Nicholas* (NG26)	cochineal or Polish cochineal[D, H]
1566–7	Jacopo Tintoretto	*Christ before Pilate* (Scuola di San Rocco, Venice)	probably cochineal[L]
ca. 1570	Paolo Veronese	*The Rape of Europa* (NG97)	variety of cochineal
ca. 1571	Titian	*Tarquin and Lucretia* (Fitzwilliam Museum, Cambridge, inv. no. 914)	kermes; brazilwood[M]
1573	Paolo Veronese	*The Adoration of the Kings* (NG268)	cochineal (not Polish cochineal)[D, H]
ca. 1575	Jacopo Tintoretto	*The Origin of the Milky Way* (NG1313)	lac[N]
ca. 1575	Paolo Veronese	*Unfaithfulness* (NG1318)	cochineal[H]
ca. 1575	Paolo Veronese	*Happy Union* (NG1326)	cochineal[H]
1575–80	Jacopo Tintoretto	*Christ Washing the Feet of the Disciples* (NG1130)	lac; kermes; madder[N]
ca. 1575–80	Jacopo Tintoretto	*Portrait of Vincenzo Morosini* (NG4004)	kermes[N]
ca. 1576	Jacopo Tintoretto	*The Last Supper* (Church of San Stefano, Venice)	cochineal
1577–81	Jacopo Tintoretto	*The Brazen Serpent* (Scuola di San Rocco, Venice)	probably cochineal[L]
1577–81	Jacopo Tintoretto	*Jonah and the Whale* (Scuola di San Rocco, Venice)	cochineal[L]
1577–81	Jacopo Tintoretto	*The Pillar of Fire* (Scuola di San Rocco, Venice)	cochineal[L]
1579	Jacopo Tintoretto and studio	*Federigo I Gonzaga Relieves the Town of Legnano* (Bayerische Staatsgemäldesammlungen, Munich, Alte Pinakothek, inv. no. 7307)	cochineal[O]
1580	Jacopo and Domenico Tintoretto and studio	*Federigo II Gonzaga Takes Parma* (Bayerische Staatsgemäldesammlungen, Munich, Alte Pinakothek, inv. no. 7306)	cochineal[O]
1580	Jacopo and Domenico Tintoretto and studio	*Federigo II Gonzaga Defends Pavia* (Bayerische Staatsgemäldesammlungen, Munich, Alte Pinakothek, inv. no. 7308)	cochineal[O]
ca. 1580 and later	Italian, Venetian	*Portrait of a Bearded Cardinal* (NG2147)	lac[I]
1590	Palma Giovane	*Mars and Venus* (NG1866)	cochineal[H]
ca. 1600	Leandro Bassano	*The Tower of Babel* (NG60)	cochineal[H]

Notes

A Jo Kirby, Marika Spring, and Catherine Higgitt, "The Technology of Red Lake Pigment Manufacture: Study of the Dyestuff Substrate," *National Gallery Technical Bulletin* 26 (2005): 86.

B Jill Dunkerton, "The Restoration of Two Panels by Cima da Conegliano from the Wallace Collection," *National Gallery Technical Bulletin* 21 (2000): 64.

C Jill Dunkerton and Ashok Roy, "The Technique and Restoration of Cima's 'The Incredulity of S. Thomas,'" *National Gallery Technical Bulletin* 10 (1986): 14.

D Jill Dunkerton et al., "Titian's Painting Technique before 1540," *National Gallery Technical Bulletin* 34 (2013): 28–9, 41, 49–50, 61, 66, 98.

E Hélène Dubois and Arie Wallert, "Titian's Painting Technique in 'Jacopo Pesaro Being Presented by Pope Alexander VI to Saint Peter,'" *Restoration, Journal of the Koninklijk Museum voor Schone Kunsten, Antwerp* 3, no. 1 (2003): 36.

F Jill Dunkerton and Helen Howard, "Sebastiano del Piombo's Raising of Lazarus: A History of Change," *National Gallery Technical Bulletin* 30 (2009): 43–44.

G Jill Dunkerton, Nicholas Penny, and Ashok Roy, "Two Paintings by Lorenzo Lotto in the National Gallery," *National Gallery Technical Bulletin* 19 (1998): 55.

H Jo Kirby and Raymond White, "The Identification of Red Lake Pigment Dyestuffs and a Discussion of Their Use," *National Gallery Technical Bulletin* 17 (1996): 70–71.

I Joyce Plesters, "Tintoretto's Paintings in the National Gallery. Part III: Technical Examination of the Four Remaining Works Attributed to or Associated with Tintoretto," *National Gallery Technical Bulletin* 8 (1984): 25, 28, 30.

J Hugh MacAndrew et al. "Tintoretto's 'Deposition of Christ' in the National Gallery of Scotland," *Burlington Magazine* 127 (1985): 512, 515.

K Ulrich Birkmaier, Arie Wallert, and Andrea Rothe, "Technical Examinations of Titian's Venus and Adonis: A Note on Early Italian Oil Painting Technique," in *Historical Painting Techniques, Materials, and Studio Practice: Preprints of a Symposium Held at the University of Leiden, the Netherlands, 26–29 June, 1995, ed.* Arie Wallert, Erma Hermens, and Marja Peek (Marina del Rey, CA: Getty Conservation Institute, 1995), 123.

L Joyce Plesters and Lorenzo Lazzarini, "I materiali e la tecnica pittorica dei Tintoretto della Scuola di S.Rocco," in *Jacopo Tintoretto nel quarto centenario della morte: Atti del convegno internazionale di studi (Venezia, 24–26 novembre 1994), ed.* Paola Rossi and Lionello Puppi (Padua: Il Poligrafo, 1996), 277.

M Michael Jaffé and Karin Groen, "Titian's 'Tarquin and Lucretia' in the Fitzwilliam," *Burlington Magazine* 129 (1987): 169.

N Joyce Plesters, "Tintoretto's Paintings in the National Gallery. Part II: Materials and Technique," *National Gallery Technical Bulletin* 4 (1980): 37, 39, 41.

O Andreas Burmester and Christoph Krekel, "'Azzurri oltramarini, lacche e altri colori fini': The Quest for Lost Colours," in *Tintoretto, The Gonzaga Cycle, ed.* Cornelia Syre (Munich: Alte Pinakothek, Bayerische Staatsgemäldesammlungen, 2000), 193–212.

A

'Abbas I, Shah of Persia, 20, 72–75, 293n5
Abert, James W., 248
abolitionism, *84–85*
accla, 106
Acolhuacan, 26
Acosta, José de, 214
Adams, John, 86
affamées, 136
Afghanistan, 207
Aguilar de la Sal, Pedro, 192
ahuaqui, 106
Akinsemoyin, Oba, King of Lagos, 84
Alarcón, Juan de, 199, *199*
albayalde, 245
albumin, 262
alegría, 248, 308n16(1)
Aleppo, 20
alizarin, 68
alkali calcium salts, 47
almuada de la cruceta, 120
alum, 44, 47, 94, 109, 122, 134, 180, 262, 289n8
Alzate y Ramírez, José Antonio de, *18–19, 57, 90–91*
amantecayotl, 223
Amsden, Charles, 151
Amsterdam, Netherlands, 65
Andean region: color and culture in textiles, 106–17; keros from, 44–51; regional oil paintings, 47, 98–99, 212–19. *See also* Incas
añil, 214
animal fibers, 26, 28, 108–15, 121
annatto (*achiote*), 26, 30, 35, 125, 126, 128, 299n59
Anne, Queen of England, 169
aqua fortis, 134
aqua regia, 180, 296n6(1)
Aragón, José, 245
Aragón, Rafael, 245
Arbery, Katie, 87
Archuleta-Sagel, Teresa: *Gemini Blues, 276–77, 281*

Argentina, 47, 214, 215–16, 296n2(2)
Armenian cochineal, 20, 21, 68, 74, 100, 174, 178, 180, 202
Armijo, Vicente de, 255
Arriaga, Pablo Joseph: *Extirpation of Idolatry in Peru,* 212
Arte y vocabulario en la lengua general del Peru, 212
Art Institute of Chicago, 260, 262
Arts and Crafts movement, 23, 258
Asante kingdom, 86
Asia, cochineal in, 20, 65, 68–71. *See also specific countries*
Asociación Milana, 272
Aurangzeb, emperor, 71, 293n11
Avila, Hernando de, 193
Avison, Cathryn, 273, *273*
axin, 30
Aymara culture, 113, *114–15*
Aztecs: cochineal as tribute, 26, 220; cochineal use, 18; feather paintings, 223; monuments, 40, *40–42;* murals, 31; Spanish conquest, 54, 166; terms for cochineal, 26

B

Baca, Cristóbal, 255
Baca, Diego Manuel, 255
Baghdad, *cremesi* silks of, 68
Bakst, León, 258
Balbi, Gio Agostino, *187*
Bancroft, Edward, 152
Banks, Joseph, 18
barberry, 103
Baring Brothers (London), 65
barníz de pasto (mopa mopa), 47, 51
Baskes, Jeremy, 22
Bassano, Leandro: *Tower of Babel,* 312
bateas, 234–35, 235–36
baúles de donas, 236
bayeta cloth, 146, 151, 157, 244, 251, *254,* 255, 274, 284

beeldleí, 146
Begay, D. Y.: *Palette of Cochineal,* 274–75, *275*
Bellini, Giovanni: *Adoration of the Kings,* 177, 311
Benavides, José Manuel: *St. Librada,* 245, *250*
Benin, 86
Berrocal Evanan, Pompeyo, 268
Bertonio, Ludovico: *Vocabulario,* 212
Bertuch, Friedrich Justin, *93*
Besnar, Emile, 260
Betrothal of the Virgin, 226–27, 227
biil, 146
bingata, 81
Bissolo, Francesco: *Virgin and Child with Saints Michael and Veronica...,* 311
body paint, 30, 36, *126,* 126–27, 128, 160
Boilat, David: *Esquisses Sénégalaises, 82–83*
Bolivia, 112, *112,* 212, *219,* 241, 266
Bonampak murals (Chiapas, Mexico), 18, 20, 35, 36–39, *36–39*
Bonaparte, Napoleon, *141*
Bonnard, Pierre, 260
bon teint, 140
books, *200–201. See also* ink
Bordone, Paris: *Virgin and Child Enthroned with Four Saints,* 311
botas, 254
Bowen, Dorothy Boyd, 152
Boyd, E., 151
brass, 262
Brazil, 71
brazilwood, 26, 29, 103, 176, 190, 193, 197, 262, 274
Breyn, Johann Phillip, *202–3*
British East India Company, 71
Brusatin, Manlio: *Storia dei colorei,* 56
Bukhara, Uzbekistan, 207, 304n19
bultos, 22, 245, *247–50,* 276, *280–81*
Burgos, Spain, 64

Byron, Lord: *Don Juan,* 23
byuug, 122, 128, 298n27

C

Cabrera, Miguel, 227, 310
cacao, terms for, 125
Cádiz, Spain, 64, 65
Caillié, René, 82, 84
Callañaupa Álvarez, Nilda, 266
Callañaupa Quispe, Fidelia, 266, *266–67*
Callaway, Mariah, 87
Camino Real, 22, 146, 252, 255
camisa, 112
Campeche wood, 54, 255
Campero y Herrera, Juan J., 215–16
Canaletto, 20; *A Regatta on the Grand Canal,* 180, *181*
Canary Islands, 21, 66, 262–63, 266, 272, *272–73*
Capponi family, 64
Carcassonne, France, *134–36*
Cárdenas, Bartolomé de, 192
Carducho, Vicente, 215; *Dialogues on Painting,* 192
carmine, 180, 182, *188–89,* 266–75; Andean lake pigments, 44–51; of the Indies, 190–201
carpintería de lo blanco, 232
Carreño de Miranda, Juan: *Eugenia Martínez Vallejo, 168,* 169
Carson, Kit, *146–47*
Casados, Antonio: *Holy Child of Prague,* 245, *250*
casta painting, 227
Castiglione, Baltasar de, 307n1(5)
Catena, Vincenzo: *Portrait of the Doge, Andrea Gritti, 178,* 311
Catlin, George, 158
Center for Science in the Public Interest (CSPI), 266
Central Asia: cochineal use in, 71, 207, 208–9; red colorants in, 68; *suzani* needlework, *70*

unpicking yarn, 157

upholstery, *140–41*

Urbina, Diego de, 193; *Assumption of the Virgin, 190–91,* 310

urine, chemical reaction with dyes, 97

V

vaieta de grana, 154, 157

Van de Velde, Henri, 258

Van Dyck, Anthony, 20; *Balbi Children, 186–87*

Van Gogh, Vincent, 20; *Shoes, 188*

Van Huysum, Jan: *Vase of Flowers,* 229, *230–31*

Vargas, Diego de, 255

varnish, 20, 21, *280, 282*

Vásquez de Coronado, Francisco, 146

Vázquez, Alonso, 20; *Immaculate Conception,* 223; *Martyrdom of St. Hippolytus,* 223

Vázquez, Juan Bautista, 195

Vecellio, Cesare, *58*

Vegetable Dyes Bulletin, 251

Velázquez, Diego de, 20; *Don Sebastián de Morra,* 169; *King Philip IV of Spain, 166–67,* 168; *Las Meninas, 168,* 169, 302n10(1), 307n7(1); *St. John the Evangelist on the Island of Patmos,* 223, *225*

Vélez, Luis, 190

Vendramin, Gabriel, 177

Venice, Italy, 57, 177–78, 180, *181, 185,* 190, 192, 260, 263

Veracruz, Mexico, 65, 238

Verelst, Johannes: *Sagayenkwaraton,* 169, *169*

Verhecken, Andre, 100

vermilion, 34, 48, 146, 151, 160, *187,* 197, 216, 220, 222, *246, 249*

Veronese, Paolo: *Adoration of the Kings,* 312; *Happy Union,* 312; *Rape of Europa,* 312; *Unfaithfulness,* 178, *178,* 312

Villalpando, Cristóbal de: *Joseph Claims Benjamin as His Slave,* 227, *227*

violin varnish, 20, 21

View of Seville, 60–61, 63

Vogue magazine, 23, *264–65*

W

Wagner, Richard, 258

waiuru, 106

Walker, James R., 160

Wallert, Arie, 297n9, 297n11

Wari culture, 109, *110–11,* 214

Washington, George, 169, *170–71,* 171

wech lu'um, 26

Wenger, David, 152, 154

West, Benjamin: *Death of General Wolfe at Quebec,* 166

West Africa, slave trade, 82–87

Wetherill, Samuel, *163*

Wheat, Joe Ben, 151, 152, 154, 157, 301n20

Workshop of Mythological Themes (Pátzcuaro, Mexico), 232, 234

Wouters, Jan, 100

X

Ximénez, Francisco, 44

Xiu family papers, 39

Xochicalco, 34

Y

Yamazaki Seiju, 76

Yoruba people, 86–88

Yoshioka Tsuneo, 76

yūzen, 76, 80, 81

Z

Zacatecas, Mexico, 34

Zamora, Antonio, 244

Zapata (Zapaca), Marcos: *Isaiah,* 216, *217*

zapatos, 142, *142–43*

Zapotec red, 35, *35,* 220

Zapotecs: cochineal use, 30, 54, 90, 120–21, *123, 124,* 127, 268; Monte Alban wall paintings, 18, 37, 220; mural painting, 31, 35, *35,* 208, 220, 222

Zuccaro, Federico, 190

Zuñi blue, 307–8n12(2)

Zurbarán, Francisco de, 20, 193, 223; *Mass of Father Cabañuelas, 196–97,* 310; *St. Nicholas of Bari,* 197, *197,* 310; *Temptations of St. Jerome,* 197, *197,* 310

Zurbarán, Francisco de (workshop): *Emperor Domitian on Horseback,* 197, *198–99,* 310

zu'uu'dy, 122

FOR THE MUSEUM OF INTERNATIONAL FOLK ART

Project Director: Marsha C. Bol
Editors: Carmella Padilla and Barbara Anderson
Copy Editor: Peg Goldstein
Spanish Language Editor: James Gavin
Editorial Assistance: Elaine Higgins and Cristin McKnight Sethi
Photographer: Blair Clark

FOR SKIRA RIZZOLI

Associate Publisher: Margaret Rennolds Chace
Senior Editor: Christopher Steighner
Proofreader: Tanya Heinrich
Production Director: Maria Pia Gramaglia
Production Manager: Rebecca Ambrose

Art Direction / Designer: Sarah Gifford
Typefaces: Sentinel, Balance
Color separations: Embassy
Printing: Elegance

A Red Like No Other is the companion publication to the exhibition
The Red That Colored the World (May 17, 2015, to September 13, 2015)

Museum of International Folk Art
706 Camino Lejo
Santa Fe, NM 87505
www.internationalfolkart.org

A Red Like No Other has been made possible in part by a major grant from the
National Endowment for the Humanities: Celebrating 50 Years of Excellence.
Any views, findings, conclusions, or recommendations expressed in this book do not
necessarily represent those of the National Endowment for the Humanities.

This book is also made possible by support from the International Folk Art
Foundation and Museum of New Mexico Foundation.

First published in the United States of America in 2015 by

Skira *Rizzoli*
NEW YORK

Skira Rizzoli Publications, Inc.
300 Park Avenue South
New York, NY 10010
www.rizzoliusa.com

© 2015 Museum of International Folk Art

2015 2016 2017 2018 / 10 9 8 7 6 5 4 3 2 1

Distributed in the U.S. trade by Random House, New York
Printed in China
ISBN: 978-0-8478-4643-6
Library of Congress Control Number: 2015934253

INTRODUCTORY IMAGES

Case Ceremonial mantle, Bolivia, Aymara, eighteenth–nineteenth century. Camelid hair, 77¼ x 41 in. Metropolitan Museum of Art, bequest of John B. Elliott, 1997 (1999.47.251). © The Metropolitan Museum of Art. Image source: Art Resource, NY.

End pages Pages 45–46 of anonymous manuscript *Mémoires de teinture*, ca. 1763. Photo: Dominique Cardon/Pierre-Norman Granier.

Page 1 Detail of sarape, Saltillo region, Mexico, ca. 1750–1800. Wool, cotton, 93 x 63 in. Museum of International Folk Art, IFAF Collection, gift of the Fred Harvey Collection, FA.1979.64.101.

Page 2 Orlando Dugi, evening gown (from the Red Collection), Santa Fe, New Mexico, 2014. Hand-dyed silk duchesse satin, silk organza, and silk thread; cut glass and sterling silver beads, French coil, Swarovski crystals, vintage beads and crystals; lining of duchesse satin and tulle, 63 x 52 in. Collection of the artist.

Page 4 Farmers harvesting *Dactylopius coccus* (cochineal) from *Opuntia cochenillifera* cactus and roasting and drying the insects to prepare carmine dye, Mexico, ca. 1800. Hand-colored copperplate engraving from Bertuch's *Bilderbuch fur Kinder* (*Picture Book for Children*), Weimar, Germany, 1807. Photo: SSPL/Science Museum/Art Resource, NY.

Orange

mème bouillon des jujubes Retranche
$\frac{2}{4}$ de tartre

2 onces Coch.lle fine a la Rougie
2.e Composition

Orange
Pale ou
Abricot

5.e furtet au Bouillon

1 once Coch.lle a la Rougie

Couleurs Dor Cassies Jonquilles &.ª

on fait les Couleur dor, cassies jonquilles, chamoix apres
Le Bouillon D'Ecarlatte, en mettant dans le mème Bain les
Ingredients Necessaires

A La Suite du Bouillon mouillés les draps en Blanc

Couleur
D'or

7.e furtet Revenu 2 heures ⎫
le Bain Rafraichi ⎬
4.e Composition ⎬ par piece
un soubçon de garance ⎭

a la suite du bouillon les draps mouill[és]
6.e furtet Revenu 3 heures
le bain rafraichi

Cassie.